D0421236

THE ROUTLEDGE INTERNATIONAL HANDBOOK OF INTERCULTURAL ARTS RESEARCH

DRILL HALL LIBRARY
MEDWAY

For artists, scholars, researchers, educators and students of arts theory interested in culture and the arts, a proper understanding of the questions surrounding 'interculturality' and the arts requires a full understanding of the creative, methodological and interconnected possibilities of theory, practice and research. *The Routledge International Handbook of Intercultural Arts Research* provides concise and comprehensive reviews and overviews of the convergences and divergences of intercultural arts practice and theory, offering a consolidation of the breadth of scholarship, practices and the contemporary research methodologies, methods and multi-disciplinary analyses that are emerging within this new field.

Pamela Burnard is Professor of Arts, Creativities and Education at the University of Cambridge, UK.

Elizabeth Mackinlay is Associate Professor in the School of Education at the University of Queensland, Australia.

Kimberly Powell is Associate Professor of Education and Art Education at The Pennsylvania State University, USA.

P04020063/6/1
KZ01M
7/3/18

The Routledge International Handbook Series

3068649

THE ROUTLEDGE INTERNATIONAL HANDBOOK OF INTERCULTURAL ARTS RESEARCH

Edited by Pamela Burnard, Elizabeth Mackinlay and Kimberly Powell

Routledge
Taylor & Francis Group

LONDON AND NEW YORK

First published 2016
by Routledge
2 Park Square, Milton Park, Abingdon, Oxon OX14 4RN

and by Routledge
711 Third Avenue, New York, NY 10017

First issued in paperback 2017

Routledge is an imprint of the Taylor & Francis Group, an informa business

© 2016 selection and editorial matter, Pamela Burnard, Elizabeth
Mackinlay and Kimberly Powell; individual chapters, the contributors

The right of Pamela Burnard, Elizabeth Mackinlay and Kimberly Powell to
be identified as the authors of the editorial material, and of the authors for
their individual chapters, has been asserted in accordance with
sections 77 and 78 of the Copyright, Designs and Patents Act 1988.

All rights reserved. No part of this book may be reprinted or reproduced or
utilized in any form or by any electronic, mechanical, or other means, now
known or hereafter invented, including photocopying and recording, or in
any information storage or retrieval system, without permission in writing
from the publishers.

Trademark notice: Product or corporate names may be trademarks or
registered trademarks, and are used only for identification and explanation
without intent to infringe.

British Library Cataloguing in Publication Data
A catalogue record for this book is available from the British Library

Library of Congress Cataloging in Publication Data
The Routledge international handbook of intercultural arts research /
Edited by Pamela Burnard, Elizabeth Mackinlay and Kimberly Powell.
pages cm
Includes bibliographical references and index.
1. Arts—Cross-cultural studies. I. Burnard, Pamela, editor. II. Mackinlay,
Elizabeth, editor. III. Powell, Kimberly Anne, editor.
NX170.R685 2016
306.4′7—dc23
2015027924

ISBN 13: 978−0−8153−5368−3 (pbk)
ISBN 13: 978−1−138−90993−9 (hbk)

Typeset in Bembo
by Swales & Willis Ltd, Exeter, Devon, UK

CONTENTS

FOR USE IN THE LIBRARY ONLY

Contents

Contents

Contents

FIGURES

TABLES

MUSICAL EXAMPLES

VIDEO CLIPS

The video clips referenced in Chapter 35, Developing dialogues in intercultural music-making are available to download as eResources at www.routledge.com/9781138909939. The video clips have been used with permission from the Kronos Performing Arts Association, Mhararano Mbira Academy and Exeter Contemporary Sounds.

CONTRIBUTORS

Eeva Anttila is a Professor in Dance Pedagogy at University of the Arts Helsinki, Finland. Her current research interests include somatic approaches to dance pedagogy, embodied learning, and collaborative, embodied writing. She has published widely in national and international journals and edited books.

José Luis Aróstegui is a Professor at the University of Granada, Music Education Department, Spain. He is an elected member of the ISME Board (2012–14) and editor of the *Revista Internacional de Educación Musical* journal. He is also a member of several Editorial and Advisory Board journals.

Cassandre Balosso-Bardin is researching the Mallorcan bagpipes at SOAS under the supervision of Keith Howard. She is co-convening a new course in Digital and Traditional Broadcasting while actively pursuing her international performance practice. She is the founder of the *International Bagpipe Organisation* and organizes the biennial international bagpipe conferences,. She is currently completing a PhD at SOAS, London, UK.

Katelyn Barney is Research Fellow in the Aboriginal and Torres Strait Islander Studies Unit at the University of Queensland, Australia. She is also an Office for Learning and Teaching National Teaching Fellow. Her research focuses on collaborative research with Indigenous Australian women performers, facilitating support for Indigenous Australian students and teaching and learning approaches in Indigenous Australian Studies. She is Managing Editor of the *Australian Journal of Indigenous Education* and co-leader of the Australian Indigenous Studies Learning and Teaching Network.

Brydie-Leigh Bartleet is the Deputy Director of the Queensland Conservatorium Research Centre and convener of the Bachelor of Music Honours Program at Queensland Conservatorium Griffith University, Australia. She has worked on a range of major Australian government-funded projects that examine community music, arts-based service learning with Australian First Peoples, intercultural community arts, as well as arts-based health and wellbeing for refugee and asylum seekers. In recent years she has secured over half a million dollars worth of competitive grants, and has over 90 publications.

Amanda Bayley is Professor of Music at Bath Spa University, UK. She is editor of *The Cambridge Companion to Bartók* (Cambridge University Press, 2001) and *Recorded Music: Performance, Culture, and Technology* (Cambridge University Press, 2010) for which she received the Ruth A. Solie Award from the American Musicological Society in 2011.

Diana Blom is Associate Professor in Music at the University of Western Sydney, Australia. She is a composer and keyboard performer, undertakes research into tertiary performance; response to music; and through practice-led approaches, contemporary classical repertoire. She has curated several themed projects resulting in concerts and score/CD publications involving Australian and international composers– *Antarctica, new music for piano and/or toy piano*; *Shadows and Silhouettes, new music for piano with a Western–Chinese confluence*.

Adrienne Boulton-Funke is a PhD candidate in Curriculum at the University of British Columbia, Canada, specializing in Art Education. Her research interests include the potentiality of contemporary art practices in arts-based educational research and the work of Deleuze and Guattari in de-articulating research methodology and design. Her current work explores the potential of art encounters with secondary visual art teacher candidates.

Liora Bresler is a Professor at the University of Illinois, Champaign, USA. Her research and teaching focus on Arts and Aesthetic Education, Qualitative Research Methodology and Educational/Artistic. She is the co-founder and co-editor of the *International Journal of Education and the Arts*. With 100+ papers, book chapters and books on the arts in education, including the *International Handbook of Research in Arts Education* (Springer, 2007), and *Knowing Bodies, Moving Minds* (Springer, 2004), Liora is an international leader in the arts educational field.

Pamela Burnard is Professor of Creativities in Education, Arts and Industry, University of Cambridge, UK. Her research interests include diverse creativities, digital technologies, inter-cultural arts and intersections between education and industry. Her books include *Musical Creativities in Practice* (Oxford University Press, 2012), *Creativities in Higher Music Education* (Routledge, 2013), *Teaching Music Creatively* (Routledge, 2013), *Activating Diverse Musical Creativities* (Bloomsbury, 2014) and *Bourdieu and the Sociology of Music Education* (Ashgate, 2015). She is Co-convener of the British Educational Research Association (BERA) *Creativity in Education* SIG and Convener of the Creativities in Intercultural Arts Network http://www.educ.cam.ac.uk/centres/cce/initiatives/projects/cian.

B. Stephen Carpenter, II, is Professor of Art Education at The Pennsylvania State University, USA and Professor in Charge of the Art Education Program. He is author of journal articles and book chapters on art education, visual culture, digital and hypertext computer technology and curriculum theory. He is co-author of *Interdisciplinary Approaches to Teaching Art in High School* (National Art Education Association, 2006) and is co-editor of *Curriculum for a Progressive, Provocative, Poetic, and Public Pedagogy*. Steve was editor of *Art Education*, the journal of the National Art Education Association (2004–06) and co-editor of the *Journal of Curriculum and Pedagogy* (2010–13).

Elena Cologni is an artist, academic and educator, she has a PhD in Fine Art (with psychology and philosophy) from University of the Arts, London Central Saint Martins College, 2004 (CSM). Her academic positions as artist include a Post-Doctorate Fellowship at CSM (Arts and Humanities Research Council UK, 2004/06), a Research Fellowship at York Saint

John's University (Arts Council of England, 2007/09). She contributes to the Commonwealth Intercultural Arts Network (University of Cambridge). She is the founder and director of Rockfluid, an umbrella interdisciplinary project which was the outcome of a residency at the University of Cambridge, Faculty of Experimental Psychology. Rockfluid was awarded two Grants of the Arts (2011–13 and 2014–15) by the Arts Council of England, and was included in the Arts Council of England's Escalator programs: Visual Art at Wysing Arts Centre, Cambridgeshire, and live art at Colchester Arts Centre. As part of this, Cologni has developed many international site-specific interventions, most recently at Impington Village College, Cambridgeshire (75 Gropius Art Residency 2014–15), and the IART European/Unesco funded residency in Sicily, Italy (2015).

Samantha Dieckmann is completing a PhD at the Sydney Conservatorium of Music, University of Sydney, Australia, where she teaches in the Music Education Unit. Samantha's regard for developing communities has shaped her academic interests. She was awarded a Bachelor of Music (Music Education) with First Class Honours for her thesis on refugee and asylum seeker community music programmes in Sydney and is currently working as a research assistant on a research project in this field. Samantha's doctoral research addresses the role of music in identity formation and cross-cultural exchange in a culturally diverse Sydney locality. She has presented at national and international conferences and is the assistant editor of *Research Studies in Music Education*.

Chartwell Dutiro (MA SOAS) is a musician–singer–songwriter–composer–teacher and founding Artistic Director of the Mhararano Mbira Academy. A world-class mbira player, he uses the instrument as an educational tool to encompass both traditional and contemporary perspectives, to challenge stereotypes and encourage creative engagement. Living now in the UK, Chartwell draws on his experience of growing up in rural, segregated Zimbabwe to build bridges between cultures.

Kerry Freedman is Professor of Art + Design Education at Northern Illinois University and past Head of the Art + Design Education Division, USA. Professor Freedman's research focuses on questions concerning the relationship of curriculum to art, culture and technology. Throughout her career, she has investigated sociocultural aspects of art education and promoted cultural and intercultural understanding through her teaching, research and writing. She is an elected member of the national Council for Policy Studies in Art Education.

Charles R. Garoian, Professor of Art Education, Penn State University, USA, is author of *Performing Pedagogy: Toward an Art of Politics* (SUNY Press, 1999); co-author of *Spectacle Pedagogy: Art, Politics, and Visual Culture* (SUNY Press, 2008); and *The Prosthetic Pedagogy of Art: Embodied Research and Practice* (SUNY Press, 2013).

Peter Gouzouasis is a musician and Professor at the University of British Columbia, Canada. His books include *Pedagogy in a new tonality: Teacher inquiries on creative tactics, strategies, graphics organizers and visual journals in the K-12 classroom* (Sense, 2011) and *Being with a/r/tography* (Sense, 2008).

Anne Harris is an Australian Research Council Fellow 2014–16 researching the commodification of creativity, and a Senior Lecturer at Monash University, Australia. She is interested in the intersection of creativity and arts, digital media, diversity and social change. She has

published widely on the arts and cultural, sexual and gender diversity, most recently *Critical Plays: Embodied Research for Social Change* (Sense, 2014).

Kate Hatton (FRSA) is Head of Inclusive Education Programmes at the University of the Arts London (UAL), UK. She is Chair of the Inclusive Arts Education Forum (IAEF) and a member of the Runnymede Trust Academic Forum and the Commonwealth Creativities in Intercultural Arts Network (CIAN). She disseminated work at the BIBAC conference, Cambridge University (2014). Her work in UK art education settings covers more than 20 years in a number of managerial and teaching roles. Her doctoral thesis was: *A Study of Black Experiences of Art Education in England: How to Promote Fairer Access and Inclusion for a Wider Audience* (2009). She also edited *Towards an Inclusive Arts Education* (Trentham Books, 2015).

Arthur Hibble, MBBS, MMedSci., FRCP, FRCGP is Visiting Professor at Anglia Ruskin University, UK. He was a family doctor in Stamford, UK for 28 years and GP Dean for the East of England before retirement. Current interests are global health workers' education especially in Eastern Africa and inter-professional learning.

Ylva Hofvander Trulsson (MMus, MEd, PhD) works at the Faculty of Fine and Performing Arts at Lund University, Sweden. She was visiting scholar/postdoc at the Faculty of Education, University of Cambridge, UK (2012–14), in a research project called *Musical Learning and Discipline – Discourses on Social Mobility of Immigrant Parents and their Children*. Her research focuses on perspectives on class formation in relation to parents' choices, concerted cultivation, migration and social mobility. Ylva is also visiting scholar at Hedmark University College, Norway, (2013–16) in association with the research project 'Musical gentrification and sociocultural diversities'. Ylva has been recognized nationally and internationally for her theory-driven research of music education, minorities and social mobility.

Gotzon Ibarretxe is an Associate Professor at the University of the Basque Country (Spain), Music Education Department. He has also taught music at the Public University of Navarre (Spain). He received the *Orfeón Donostiarra-University of the Basque Country* Research Award for his work 'Basque Choral Movement: tradition, culture and education' (2004). From 2000 to 2005 he was President of the Music Section at the Basque Studies Society and he has also been editor of the *Musiker* journal. He is a member of the Editorial and Advisory Boards of several music and music education journals.

Rita L. Irwin is Professor of Art Education, and the Associate Dean of Teacher Education at the University of British Columbia, Vancouver, Canada. Her research interests include preservice and inservice arts teacher education, curriculum studies, artist-in-schools programmes, and sociocultural issues investigated through many forms of arts-based educational inquiry including a/r/tography. She is also committed to leadership in arts education and is the current President of the International Society for Education through Art and is on the Forum of the World Alliance for Arts Education.

Lindy Joubert is a senior lecturer in the Faculty of Architecture and Planning at The University of Melbourne, Australia. She is Founding Director of the UNESCO Observatory and consultant at UNESCO, Paris; Vice President World Craft Council Asia Pacific – South Pacific region. Lindy was Director of the Asia Pacific Confederation for Arts Education; and team leader for numerous community architecture, art and health projects. She has had

34 international exhibitions, six in New York City. She is Editor-in-Chief of the UNESCO Observatory e-journal; series Editor-in-Chief of the UNESCO Observatory Global Village Reading Series; and editor of 'Educating in the Arts: The Asian Experience, Twenty-four essays' (Springer, 2008).

Sidsel Karlsen is Professor of Music Education at Hedmark University College in Norway as well as docent at the Sibelius Academy, University of the Arts Helsinki in Finland. She has published widely in international journals and contributed to numerous anthologies. Her research interests include music education and diversity, music and identity and the interplay between formal and informal arenas for learning.

Patricia Leon Lashley–Charles is a Trinidadian born creative writer, poet, arts and heritage project designer, public speaker and an advocate for cultural diverse arts. Patricia has been living in England for the last 14 years and is married with two children. In 2011 Patricia was diagnosed with the disabling condition fibromyalgia which has left her dependent and unable to walk. Life has since been centred on raising a young family and becoming a warrior and advocate for chronic illness sufferers, but she also uses her time for writing in her journal. She is hoping to publish a memoir of her life later this year and is also working on an anthology of poems.

Natalie LeBlanc studied at Concordia University (Montreal, Canada), where she received a Bachelor's degree in Fine Arts and a Master's degree in Art Education. She is currently completing her Doctorate in Curriculum and Pedagogy at The University of British Columbia, specializing in Art Education. Her artistic practice is fuelled by her interests in arts-based (educational) research; practice-led research; inquiry; living pedagogy; life history; and the dialectics between art and writing.

Carl Leggo is a poet and Professor at the University of British Columbia, Canada. His books include: *Growing Up Perpendicular on the Side of a Hill* (Creative Book Publishers, 1994); *View from My Mother's House* (Creative Book Publishers, 1999); *Come-By-Chance* (Breakwater Books, 2006); *Teaching to Wonder: Responding to Poetry in the Secondary Classroom* (Pacific Educational Press, 1998); and *Sailing in a Concrete Boat: A Teacher's Journey* (Sense, 2012).

Samuel Leong (PhD) is Professor, Associate Dean (Quality Assurance & Enhancement) and Head of the Cultural & Creative Arts Department at the Hong Kong Institute of Education, Hong Kong, China. He is also Director of the UNESCO Observatory for Research in Local Cultures and Creativity in Education. His publications include chapters in *Using Music Technology in Music Education, Musicianship in the 21st Century*, the *Oxford Handbook of Music Education*, the *International Yearbook for Research in Arts Education* and the *International Handbook of Creative Learning*.

Lillian Lewis is a PhD student and graduate teaching assistant in the Art Education Program at The Pennsylvania State University and an adjunct assistant professor in the Online Master of Arts in Art Education Program at University of Florida. Her research interests include exploring relationships between formal and informal learning with emphasis on community and art museum contexts, curriculum theory and pedagogy, and implications of social, visual, and media culture on art education. Lillian has worked as a K-12 art teacher, served as curator of education at the San Angelo Museum of Fine Arts, and as the coordinator for the Zoller Gallery of Art at Penn State.

David Litchfield is an illustrator from Bedfordshire in the UK. He is represented internationally by The Bright Agency. David first started to draw when he was very young, creating Star Wars and Indiana Jones 'mash up' comics for his older brother and sister. Since then David's work has appeared in magazines, newspapers, books and on T-shirts. He has exhibited his illustrations in both solo and group shows in the UK, Europe and America. David's first self-written and illustrated picture book 'The Bear & The Piano' will be published by Frances Lincoln in September 2015.

Marián López Fdz. Cao PhD in Fine Arts. Masters in psychotherapeutic intervention. Accredited Art Therapist from FEAPA. Professor at the Faculty of Education, Complutense University of Madrid, Spain, since 1992. From 2007 to 2011 she was the Director of the Institute of Feminist Research. She is currently the Director of the Escuela Complutense Latinoamericana, Director of the scientific journal *Papers of Art Therapy and Art Education for Social Inclusion*, Director of the editorial collection *Possibilities of Being through Art* (with 18 educational guides), which has received awards for its egalitarian nature. She is the principal researcher of an R&D project on *Women and Museums* and President of MAV NGO, Women in the Visual Arts. She has published several books on art therapy, art education, and art and women.

Elizabeth Mackinlay is an Associate Professor in the School of Education at the University of Queensland, Brisbane, Australia where she teaches Arts Education, Indigenous Education, Qualitative Research Methods and Women and Gender Studies. Her research interests centre around the ethics and politics of research and representation, autoethnography, decoloniality and feminist writing practices. Liz is currently co-editor of the *Australian Journal of Indigenous Education* (AJIE and is the author of numerous journal articles, book chapters and books including *Disturbances and Dislocations: Understanding Teaching and Learning Experiences in Indigenous Australian Women's Music and Dance* (Peter Lang, 2007).

Kathryn Marsh is Associate Professor of Music Education at the Sydney Conservatorium of Music, University of Sydney, Australia. Her research interests include children's musical play, children's creativity, and cultural diversity in music education, most recently exploring the role of music in the lives of refugee children. She is editor of the journal *Research Studies in Music Education* and has written numerous scholarly publications, including *The Musical Playground: Global Tradition and Change in Children's Songs and Games* (Oxford University Press, 2008) which won the Folklore Society's Katherine Briggs Award and American Folklore Society's Opie Award.

Koji Matsunobu holds teaching and research positions at the University of Queensland, Australia, and the University of Kumamoto, Japan. He teaches music education and world music courses, and has written widely on matters of spirituality, creativity, qualitative research, world music pedagogy and arts integration.

Heidi May is an Assistant Professor of Art in the Department of Art at Columbus State University, Columbus, Georgia, USA. Her research interests as a practising artist and interdisciplinary researcher include notions of network, self and learning in art and education; relational, digital and social art practices; and media culture. Her art practice is informed by her academic research, which has been published in *Art Education*, *Canadian Art*, *Media-N* and the *Journal of the International Digital Media Arts Association*.

Conal McCarthy is Associate Professor and Director of the Museum & Heritage Studies programme at Victoria University of Wellington, New Zealand. His latest book, an edited collection on contemporary museum practice, including collections, exhibitions and education, appeared in a new series *International Handbooks of Museum Studies* (Wiley-Blackwell, 2015).

Jonathan McIntosh is Lecturer in Ethnomusicology at Monash University, Australia. He has undertaken extensive fieldwork in Bali, Indonesia, primarily examining children's and teenagers' practice and performance of traditional dance, music and song. Recent publications have appeared in *Asia Pacific Journal of Anthropology*, *Asian Music* and the *International Journal for Music Education*.

Laura Miettinen is a doctoral candidate in music education at the Sibelius Academy, University of the Arts Helsinki. She holds Master's degrees in music education (Sibelius Academy) and in sociology (University of Birmingham, UK). Her research interests include intercultural education and interaction, multicultural music education and critical pedagogy.

Helen Julia Minors is Associate Professor and Head of Department of Music and Creative Music Technologies at Kingston University, London, UK. She has published widely including: *Music, Text and Translation* (Bloomsbury Academic, 2013); and book chapters in *Bewegungen zwischen Hören und Sehen* (Königshausen & Neumann, 2012) and *Erik Satie: Art, Music and Literature* (Ashgate, 2013).

Dónal O'Donoghue is Associate Professor in the Department of Curriculum and Pedagogy, The University of British Columbia, Canada, and a Faculty Member of Green College. In the Department of Curriculum and Pedagogy, he serves as Chair of Art Education. Dr O'Donoghue's research interests are in Art Education, Arts-Based Visual Research Methodologies, Curriculum Theory, and Masculinities. He has published widely in these areas, and received the 2010 Manuel Barkan Memorial Award from the National Art Education Association (United States) for his scholarly writing. Dr O'Donoghue currently serves as Editor of *The Canadian Review of Art Education*. As an artist, he has exhibited his work in Europe and North America.

John O'Flynn is Senior Lecturer and Head of Music at St Patrick's College, Dublin City University, Ireland. He has previously penned several book chapters and journal articles on intercultural music education. Published ethnographic studies to date include *The Irishness of Irish Music* (Ashgate, 2009), a chapter on music transmission and identity among young Irish traditional musicians in *Learning, Teaching and Musical Identity* (edited by Lucy Green; University of Indiana Press, 2011). He is co-editor of *Music and Identity in Ireland and Beyond* (Ashgate, 2014).

Sandy O'Sullivan is an Aboriginal Australian (Wiradjuri) Senior Indigenous Researcher at Batchelor Institute of Indigenous Tertiary Education, Australia. She has a PhD in Fine Art and Performance, is an enduring Australian Learning and Teaching Fellow, and is undertaking Australian Research Council funded work examining First Peoples museums around the world.

Jean Penny is a Senior Lecturer, flautist/researcher in the Faculty of Music, Universiti Pendidikan Sultan Idris, Malaysia. Dr Penny's work is grounded in Western art music cultures – principally new music performance, intercultural studies and practice-led research. Major projects include *The Imaginary Space: Developing Models for an Emergent Malaysian/Western Electroacoustic Music* and *Spectromorphological Notation*. Dr Penny is Chief Editor of the *Malaysian Music Journal*.

Kimberly Powell is Associate Professor of Education and Art Education at The Pennsylvania State University, USA. Her research focuses on artistic practice and performance as critical sites for social action, with a particular interest in theories of embodiment and the senses. Her publications include articles in *Anthropology & Education Quarterly*, *International Journal of Education & the Arts*, *Journal of Curriculum Theorizing*, *Qualitative Inquiry* and *Studies in Art Education*. She was a section editor for the *International Handbook of Research in Arts Education* and has authored several book chapters.

Tina K. Ramnarine is Professor in Music at Royal Holloway University of London, UK. She undertakes interdisciplinary research investigating music, globalization and politics. Her publications include the books *Creating Their Own Space* (University of the West Indies Press, 2001), *Ilmatar's Inspirations* (University of Chicago Press, 2003), *Beautiful Cosmos* (2007), *Musical Performance in the Diaspora* (Pluto Press, 2007) and *Global Perspectives on Orchestras* (Oxford University Press, 2016).

Carmen Robertson is an Associate Professor of Art History at the University of Regina in Canada. She is a Lakota-Scottish scholar whose current research includes a critical investigation of the work of Anishinaabe artist Norval Morrisseau, forthcoming as a monograph with University of Manitoba Press. In addition to published essays on Morrisseau's art in scholarly journals and edited collections, Robertson also co-authored the award-winning, *Seeing Red: A History of Natives in Canadian Newspapers* (University of Manitoba Press, 2011) and has published essays related to constructions of Indigenous peoples in Canada's press. An independent curator, Robertson has also curated and co-curated contemporary art exhibitions and written numerous curatorial essays.

Valerie Ross is an established composer and researcher. She has received composition and fellowship awards from the Rockefeller Foundation, Commonwealth Foundation and Japan Foundation. Professor Ross is the Director of the Centre for Intercultural Musicology at Churchill College, University of Cambridge. She also heads the Music Therapy, Rehabilitation and Wellness interdisciplinary research group at Universiti Teknologi MARA, Malaysia.

Violeta Schubert is an anthropologist and Lecturer in Development Studies in the School of Social and Political Sciences, The University of Melbourne, Australia. Violeta's research and publications focus on the intersections between culture, kinship and identity. A key focus of Violeta's research relates to problems of identity, power and the relational dynamics and tensions that arise as individuals and communities engage with modernity. She has conducted extensive fieldwork-based research in the Balkans, and her doctoral thesis, *Too Many Men: The Problem of Bachelorhood in a Contemporary Macedonian Village*, focuses on kinship structures and sentiments, gender roles and perceptions of personhood and individualism.

Christopher Schulte is Assistant Professor, Co-Chair and Graduate Coordinator of Art Education in the Lamar Dodd School of Art at The University of Georgia. He earned his BA and MA in Art Education from the University of Northern Iowa (2004, 2006), and his PhD in Art Education from The Pennsylvania State University (2012), USA. His teaching and research interests explore the intra-actions that play out between historical and contemporary theories of children's art and culture, postmodern constructions of childhood, early childhood and elementary art education, curriculum and pedagogical studies, poststructural theory, and the use of qualitative research methodologies. He is currently the Editor of Book & Media Reviews

for the *International Journal of Education & the Arts*, a member of the Editorial Review Board of *Visual Arts Research* and *Art Education*, and serves as a guest reviewer for the *International Journal of Qualitative Studies in Education*.

Stephanie Springgay is an Associate Professor in the Department of Curriculum, Teaching, and Learning at the Ontario Institute for Studies in Education, University of Toronto, Canada. Her research focuses on the intersections between contemporary art and pedagogy, with a particular interest in theories of movement and affect. Her most recent research–creation projects are documented at www.thepedagogicalimpulse.com and www.artistsoupkitchen.com. She has published widely in academic journals and is the co-editor of the book *Mothering a Bodied Curriculum: Emplacement, Desire, Affect* (University of Toronto Press, 2012; with Debra Freedman); co-editor of *Curriculum and the Cultural Body* (Peter Lang, 2007; with Debra Freedman); and author of *Body Knowledge and Curriculum: Pedagogies of Touch in Youth and Visual Culture* (Peter Lang, 2008).

Pat Thomson is a Professor of Education, School of Education, at the University of Nottingham, UK and Director of the Centre for Research in Schools and Communities. She is an Adjunct Professor at the University of South Australia and a Visiting Professor at Deakin University, Australia. Her current research focuses primarily on the arts and creativity and school and community change; details of projects can be found at www.artsandcreativityresearch.org.uk. Her most recent publications include *Researching Creative Learning: Methods and Issues* (Routledge, 2010; with Julian Sefton-Green), *The Routledge Doctoral Student's Companion* and *The Routledge Doctoral Supervisor's Companion* (Routledge, 2010; with Melanie Walker), *School Leadership: Heads on the Block?* (Routledge, 2009) and *Doing Visual Research with Children and Young People* (Routledge, 2008).

Laura Trafí-Prats is an Associate Professor at the University of Wisconsin-Milwaukee, USA where she teaches courses in art education, and visual studies. Her research focuses on art-based processes of exploration, contestation and interpretation of urban space and place where knowledge is constructed as a co-existing palimpsest of encounters, cultures and experiences. She is currently working on a book manuscript that studies how contemporary cinema portrays global childhoods beyond the dominant pedagogical and political frameworks that currently regulate the lives, bodies and movements of children. This book uses a Deleuzian perspective to reflect on how cinema can be used as a thinking machine to put us outside our own thoughts, and guide artists/teachers/researchers in a radical transformation of pedagogy.

Sarah E. Truman is a PhD Candidate at the University of Toronto in Curriculum Studies (OISE), Canada, and Book History & Print Culture (Massey College). Sarah researches walking and its relationship with writing and art practices, intertextuality/marginalia, affect theory, post-humanism, and public pedagogy. Sarah is a National Magazine Award winner, and an Ontario Arts Council Grant recipient; her book, *Searching for Guan Yin* (White Pine Press) was published in 2011. She is a founding member of the Hamilton Perambulatory Unit.

Charlotte Tulinius, MD, MHPE, PhD, MRCGP is Associated Professor of Postgraduate Education, University of Copenhagen, Denmark, Visiting Professor for Research & Faculty Development at The Presbyterian University of East Africa, Kenya, and senior member at St Edmund's College, Cambridge University, UK where she leads interdisciplinary groups of educators, researchers and artists.

Sue Uhlig is originally from the Chicago area. Teaching kindergarten through eighth-grade art so close to many Frank Lloyd Wright houses, Sue became fascinated by architecture and began to volunteer for events associated with Wright's buildings. For the past ten years, Sue has taught art appreciation and art education courses at Purdue University, and recently participated in a six-week trip to Morocco and Tunisia as part of a Fulbright-Hays Study Abroad Program for Post-Secondary Educators. Sue is a PhD student in the Art Education Program at The Pennsylvania State University, USA.

Heidi Westerlund is Professor of Music Education at the Sibelius Academy, University of the Arts Helsinki, Finland, being responsible for the doctoral studies of music education. Her research focuses on philosophical and theoretical issues concerning teacher education, higher music education, collaborative learning, cultural diversity and democracy in music education. She has led several intercultural projects in Cambodia, Nepal and Israel. She has published widely in international and national journals, written numerous book chapters, and has served as Associate Editor and review reader in several international journals. Currently, she is the Editor-in-Chief of the *Finnish Journal of Music Education*. Westerlund has also held leadership roles in national and international organizations, such as the International Society for Philosophy of Music Education.

Trevor Wiggins is a Research Associate of SOAS, London University, UK. His work straddles ethnomusicology and aspects of arts/music education. He has published many articles and CDs drawing on his work in northern Ghana and is the co-editor of *The Oxford Handbook of Children's Musical Cultures* (Oxford University Press, 2013) and of the journal *Ethnomusicology Forum* (Routledge).

ACKNOWLEDGEMENTS

This book was motivated by the collective interests and energy of all those who supported the launch of the Creativities Intercultural Arts Network (CIAN), the CIAN Fora Series (2012) and the vision of presenters who attended the inaugural biennial Conference *Building Interdisciplinary Bridges Across Cultures* (BIBAC 2014) held in Cambridge. It was at this conference that we recognized the need to better connect a scholarly network of intercultural artists, researchers and academics through research on critical issues about the intercultural arts field. This handbook marks the first of many publications on intercultural arts theory, practice and research.

We owe a debt of gratitude to our publisher, Philip Mudd, and all on the Routledge production team who were so supportive of our vision and so efficiently and smoothly produced this *Handbook*. Thank you to the contributing authors who have each outlined the central themes and challenges for current research in the field of intercultural arts. The authors have diverse backgrounds and span a number of arts disciplines. They come from different parts of the globe: Australia, New Zealand, Canada, China, Japan, Malaysia, Sweden, Norway, Finland, Denmark, Spain, Italy, Ireland, the UK and the USA.

A special thank you to the handbook administrator, Afrodita Nikolova who enabled the efficient dance of files between contributing authors and co-editors. A special thanks also to Ana-Maria Mocanu who worked tirelessly with us in the final days and hours of bringing the manuscript together. We also want to extend our thanks to illustrator-graphic artist David Litchfield who drew the front cover expression to acknowledge the complexity of locations, identities, and modes of expression in a global world, and the desire to facilitate awareness, dialogue and understanding across a vast sea of intercultural possibilities. We are also grateful to Patricia Leon Lashley-Charles whose precious poem is dedicated to the field of intercultural arts *research* through which intercultural arts *practice* is enabled by *theory* seeking and thinking in irreducible ways.

AN INTERCULTURAL ARTS DEDICATION

Hail Global Voices!

We hear them from deep within the African plain, across Asia, the Pacific islands, the
 Americas and the Caribbean.
The winds blowing us towards this adopted land, Mother England
We hear them chanting, drumming, as they dance and sway, writing history of yes-
 terday, translating, becoming, these global voices, drowned for centuries by the
 enslavers of our traditions and human civilization.
Yet we return to where it hurts most, to the European soil where all but our souls
 were taken,
We hear the beatings of the heart of our ancestors calling out to us to become
To be still, to be heard, for this time the true essence of us will be revealed.

Global voices echoed yesterday, dancing on the soil of disarray
Drumming deep into the consciousness of ALL, that we are here, we are here . . .
Listen; there is something to be taught.
We are teachers of our cultures, yet our cultures so many have denied,
Listen; there is something to be heard,
The mystical voices of our ancestors live on and their legacy to celebrate
Our voices will be heard, and a breathing space to express, explore, educate.
Our adopted land has become home, as we carry our ancestral expressions wherever we go.
Deep within our souls, our culture arises, not simply to entertain but to penetrate the
 hearts and minds of humanity.

So let us continue this creative dialogue from amongst each nation humbly gathering
 in this land we now call home.
Where the winds blow cold and the sun we seldom see.
Yet watch us rise and let our voices lead you to the spirit of togetherness,
Creating a tapestry of beauty and out of many, there will be ONE voice . . .
These global voices no longer cower, but emerge, and embrace the true
Essence of who we are, on this journey of love.

Patricia Leon Lashley-Charles

1

INTRODUCTION AND OVERVIEW

*Pamela Burnard, Elizabeth Mackinlay
and Kimberly Powell*

Intercultural arts

Intercultural contact and interaction has become ubiquitous in today's complex, globalizing world where arts engage cultures and cultures frequently intermingle. For artists, scholars, teachers, researchers and students of culture and the arts today, the nature and impact of 'intercultural arts', particularly in different disciplines and practices, can mean many things. Turning theory and research into informed practice is not easy. At present there is no single text that brings together the significant literature about what 'intercultural arts' might mean, and how the concept could be defined and enacted.

In a recent addition to *The Routledge Handbook* series, Jane Jackson (2014) offers an introduction to central themes and challenges for current research 'paying particular attention to the language dimension of intercultural communication research and practice as explored in *The Routledge Handbook of Language and Intercultural Communication* (p. 2). What does acting 'interculturally' in today's increasingly interconnected world mean? It is here that the work of transforming intercultural communicative competence and intercultural citizenship into informed practice becomes a challenge. Yet intercultural arts offer a significant means for international and intranational communication that we cannot ignore.

The Routledge International Handbook of Intercultural Arts Research is unique in that it offers a consolidation of the breadth of scholarship, burgeoning practices and contemporary research methodologies, methods and multidisciplinary analyses that are emerging within this new field. It is a timely volume that explores theoretical, practical and research issues raised by leading scholars and practitioner-researchers from diverse arts disciplines. The *Handbook* outlines the central themes and challenges for current research in the field of intercultural arts, paying particular attention to the broad spectrum of intercultural arts research in practice and theory.

Aims, contexts and organization

Throughout the *Handbook* there is a strong emphasis on interdisciplinarity, with chapters drawing from research in education, sociology, cultural studies, psychology, philosophy, politics, anthropology, Indigenous studies, literature and history.

There is also a strong emphasis on problematizing the term 'interculturality'. The term 'intercultural' acknowledges the complexity of locations, identities and modes of expression

in a global world, and the desire to raise awareness, foster intercultural dialogue and facilitate understanding across and between cultures.

Intercultural arts research is critical to, and aimed at, informing artistic, cultural and educational judgements and decisions for the better understanding of phenomena which are pertinent to the discipline of intercultural arts. Both researchers and practitioners are interested in theorizing about intercultural arts practice. Some researchers argue that in walking through the terrain of intercultural arts research we can hope for improvement *in* and *for* education. Using an 'intercultural' lens means looking at the arts in the context of a diverse range of theories (that include, but are not limited to, feminist approaches, critical theory, post-humanism, Indigenous perspectives, postcolonial and decolonial critiques) in order to examine how arts practices vary across different global contexts, idioms and performance conditions and what these practices might entail.

The contents of the *Handbook* acknowledge the breadth of scholarship and burgeoning practice within a range of academic disciplines and contexts in which the intercultural arts influence theory, practice and research methods. At the same time the *Handbook* tells many stories about the way that intercultural arts frame and influence the theories and practices of renowned and emerging artists, scholars, researchers and educators. Each chapter reviews, synthesizes and provides a critical interrogation of key contemporary themes in intercultural arts. Authors continually question, challenge and problematize the meaning of 'interculturality' by exploring theoretical frameworks that embody and engage distinctive epistemologies and ontologies in the context of intercultural arts. Authors consider precisely how such theoretical perspectives relate to and begin to en- and un-tangle the philosophical beliefs, personal positioning and political positioning which underpin and give life to intercultural arts practices and research.

Following the introduction, the thirty-nine chapters are organized into three parts:

- Part I: Theory
- Part II: Practice
- Part III: Research.

Part I: Theory

In a provocative piece entitled 'The offence of theory', poststructuralist feminist educator Maggie MacLure asserts that the 'value of theory lies in its power to get in the way: to offend and interrupt' (2010, p. 277). MacLure invites us to consider the power of theory to resist the reproduction of the status quo and the taken for granted, in order to open up new possibilities for knowing, thinking and doing. Indeed, she suggests that theory is needed to show, engage and become entangled with 'intolerable complexity' (2010, p. 278) and further writes that 'theory stops us from forgetting, then, that the world is not laid out in plain view before our eyes . . . it stops us from thinking that things speak for themselves' (2010, p. 278).

Part I of this *Handbook* immerses itself in the 'offensive' process of theorizing intercultural arts as a political and methodological imperative. As practice, intercultural arts exists on the borders between performing bodies, bodies of knowledge and bodies of culture. As Mignolo (2011, n.p.) suggests, 'interculturality is the celebration by border dwellers of being together in and beyond the border'. In the interactive and discursive borderlands of intercultural arts practice, power relationships ebb and flow intersubjectively and intercorporeally to at once challenge and celebrate such moments of performative encounter. In this movement, those with power and those without place themselves in conversation. Indigenous and non-Indigenous

peoples meet, interaction takes place between the Global South and the Global North, those on the margins step into the mainstream and the mainstream makes moves to meet them halfway. However, what happens in the in 'between' of intercultural arts is neither an innocent nor neutral practice and theorizing intercultural arts by necessity engages with the 'ethico-onto-epistemological' (after Barad, 2006) entanglements which come hand in hand with notions of dialogue, difference, otherness and diversity. These are not easy, safe or comfortable discussions to have and yet they hang expectantly in the air, waiting for the conversation to begin. In being 'offensive', the aim of this part is to 'unsettle' our knowing, thinking and doing about, and in relation to, intercultural arts, rather than to define it.

If we position theory in this way, as 'impure and indecisive' (MacLure, 2010, p. 280), the potential is opened for the authors in Part I to take their intercultural arts knowing, thinking and doing in many different directions. At the heart of all of the chapters in this part, is a desire to complicate the notion of interculturality itself and to position intercultural arts knowing, thinking and doing as transnational bodies-identities-*in*-politics-ethics. Part I comprises eleven chapters. Chapters 2, 3 and 4 engage Indigenous perspectives to theorize intercultural arts within and beyond coloniality, with specific reference to Indigenous art and the intercultural context of museum spaces. Here, the authors problematize the ways in which the West gazes, captures and displays an understanding of Indigenous Others. They privilege Indigenous systems of knowing, thinking and doing and offer new ways of thinking about art and the museum as transformative spaces for intercultural mediation, dialogue and transformation. Carmen Robertson's piece (Chapter 2) suggests that intercultural knowledge holds within it 'contradictory complexity' that works to provoke dialogue and contends that Indigenous theories of art open the possibility for undoing unproductive hegemonic and colonial representations and interpretations of Indigeneity. Similarly, Conal McCarthy (Chapter 3) argues that if museum practice is to be seen as transformative social dialogue and intercultural mediation, the epistemologies, ontologies and methodologies of Maori thinkers and practitioners must be positioned as central to the process. In Chapter 4, Sandy O'Sullivan continues this line of thinking and seeks to 'puzzle out' the intercultural relationship between the museum and Indigenous Australian Communities with a focus on the necessity for Aboriginal and Torres Strait Islander voices to be heard, and ongoing agency for communities within the system to be privileged, so that an Indigenous owned identity can be recast.

The second set of chapters in Part I (5–7) engage with discourses of postcolonialism, critical race theory and whiteness studies, cosmopolitanism and decoloniality to complicate intercultural arts research, relationships and representations through the entanglements of race, power and privilege. In Chapter 5, Kate Hatton places a politic of 'poetics' at the forefront of her thinking about intercultural arts research and practice, and, with reference to poststructural thinkers such as Deleuze and Guattari, Cixous and Fanon, suggests that such a creative turn makes possible the intersection and intertextual layering of histories and identities within and against colonial borders. Drawing upon the work of Cixous, Elizabeth Mackinlay's Chapter 6 reads intercultural arts research, writing and practice as an opportunity to ask questions about the moral obligations we hold to work in a manner that opposes the epistemological violence of taking from the Other, disrupting the dominance that makes such appropriation possible, and imagining an intercultural arts practice where things might be otherwise. Thinking closely about the ways in which global culture co-exists and overlaps with the local, José Luis Aróstegui and Gotzon Ibarretxe (Chapter 7) turn their attention to the context of intercultural arts in higher education to explore the possibilities that discourses of cosmopolitanism hold for acknowledging the political and power implications of any educational practice.

Chapters 8, 9 and 10 in Part I bring an embodied, affective and material dimension to our knowing, thinking and doing about interculturality, complicating the notion of collaboration in intercultural arts. In conversation with theorists Ahmed and Appadurai, Anne Harris (Chapter 8) theorizes ethno-cinematic and collaborative video-based research as a moment for intercultural encounter in which affective experiences can be recombined with commodified creativity to address the power of arts in both translocal and transglobal contexts, on the way to constituting new creative and social imaginaries. Brydie-Leigh Bartleet (Chapter 9) challenges us to look at our collaborative intercultural arts practice through a language of 'compassionate love', urging us to respond to the demand that a practice of love holds for performing a willingness towards dialogue and ethical responsibility in the moment of intercultural encounter. In Chapter 10, Katelyn Barney discusses Nakata's framework of the 'cultural interface' and the concept of the 'contact zone' to at once question and promote the taken-for-granted assumption that intercultural arts collaborations exist within relationships grounded in reconciliation politics, promises of mutual benefit, and respect.

The final two chapters in Part I (11–12) consider the performative, political and ethical nature of relationships that take place on the borders of intercultural arts practice. Ylva Hofvander Trulsson and Pamela Burnard (Chapter 11) position intercultural research settings as intersubjective meetings between 'insiders' and 'outsiders' and assert the necessity of practising responsible reflexivity to engage the researcher's understanding of ethics, voice, representation and text. In the final chapter of this part, Cassandre Balosso-Bardin (Chapter 12) reflects upon the longstanding relationship between academia and performance by exploring her intersubjective role as musician and researcher in the field. While such an encounter between identities is not always easy or comfortable, she suggests that 'intermusability' (intercultural musical ability) opens up new possibilities for knowledge-making and creativity across and between local and global borders.

Our aim in Part I, then, is to bring a series of offensive theoretical moves into play to continue to trouble the ways in which we might seek to define and thereby confine interculturality in and through the arts.

Part II: Practice

As a concept, practice connotes various meanings. We might conceive of practice, for example, as rehearsal or training, genre or convention, habit or expectation, or as method or procedure. It is a term that refers to both process and product, and because the former refers to something that is always in the making, practice remains open to difference, intertwined with concepts such as temporality, change, movement, environment and form. Even the most repetitive and mundane act is capable of producing something new. Theoretical orientations such as social practice theory concern the analysis of social structures and the ways in which individuals act within those structures, making and potentially transforming their worlds (e.g., Bourdieu, 1977). This view of practice entails thinking about the ways in which human activity is always constituted by and within existing political, social, cultural, and economic conditions, and at the same time, how individual agency might challenge and improvise within these existing conditions in order to push against existing constraints and reconstitute limits. While social practice theory is not a dominant theoretical frame for Part II, it has significantly influenced views and interpretations of socially and critically engaged art practice. Yet, a focus on intercultural arts practice entails thinking not only about what arts practice *is* but also what it *does*, or what it produces. In the same way that theory is positioned as 'impure and indecisive' in Part I of this *Handbook*, practice is similarly addressed by authors in Part II. Intercultural arts practices

are examined, interrogated, constructed and positioned across multiple contexts. Practice is considered within contexts of art, performance, audience, everyday activity, pedagogy and research. If the previous section of the *Handbook* explicitly addresses theories for intercultural arts, then chapters in this section constitute praxis – the process through which theory might be realized through practice, embodiment and experience with the world.

The authors in Part II of the book all work with a fluid conception of intercultural arts practice. The term 'intercultural', according to Jonathan Hay (1999), connotes a type of space rather than a fixed place as well as an operational movement of displacement, a 'slippage between categories, making it possible to seize a given practice in its character as movement, or event' (p. 8). Hay argues that this sets forth a 'latent nomadic energy' in a constant acknowledgement of others (p. 9). Bouchard (2011) and Marks (2000) similarly note a space of in-betweenness inferred by interculturality, with Marks noting the role of embodied experience in a transnational and postcolonial world. These ideas also suggest that the location of culture is difficult to define as it is destabilized through the connotations of in-betweenness and fluidity.

The first three chapters (13–15) address performance practices across global contexts as continually constructed, dynamic and fluid, existing both within and between locations. Koji Matsunobu (Chapter 13) explores the pedagogy and location of contemporary Japanese *noh* practice, pedagogy and training across three different sites, highlighting the embodied nature of intercultural practice. Trevor Wiggins (Chapter 14) challenges ideas such as local culture, cultural heritage and ownership of cultural materials in Northern Ghana by taking into account increasingly global influences of popular music, technology and the media on local practices of music and dance. Analysing two performance pieces for solo flute, Jean Penny (Chapter 15) discusses the ways in which these works articulate both explicit and subtle juxtapositions of cultures and conceptualizes Foucault's heterotopia as a performance ecology that allows for intercultural exchange.

In Chapters 16 and 17, the authors examine and interrogate gender as an intercultural category for the consideration of art education. Dónal O'Donoghue (Chapter 16) extends understandings of boys' art education by invoking intercultural practices of thinking, opening up and interrogating the space between gender practices and of art education, while Marián López Fdz. Cao (Chapter 17) describes a workshop based on women artists' experiences as an example of a methodology that introduced intercultural art experiences to migrant women populations. While different in focus and context, both authors elaborate the complexities of gender within a political and cultural landscape.

Art practice as research, and research practice as art is a significant theme in this section of the *Handbook*, and Chapters 18 to 21 highlight their intertwined relation. Charlotte Tulinius and Arthur Hibble (Chapter 18) explore the intercultural space of medical practice and artistic expression for Nordic General Practitioners. The next three chapters (19–21) explore themes of participatory art research that pursue the potential for critical pedagogy, social action and/or civic engagement. Sue Uhlig, Lillian Lewis and B. Stephen Carpenter II (Chapter 19) discuss participatory performances with water filter production as acts of participatory public pedagogy. Similarly, Elena Cologni (Chapter 20) describes her creative process with socially engaged, participatory and dialogic art in a changing social and political landscape in Italy. Laura Trafi-Prats (Chapter 21) examines art research in the form of urban spatial practices in a prison-turned-museum in Uruguay.

Pedagogy as, and in relation to, art practice is also explored in this section of the book. Uhlig, Lewis and Carpenter (Chapter 19), discussed above, explore public pedagogy as social action. Kimberly Powell and Christopher Schulte (Chapter 22) draw from their pedagogical experiences with food and drink as an artistic practice of hospitality that underscores material and

sensorial aspects of interculturality. Adrienne Boulton-Funke, Rita L. Irwin, Natalie LeBlanc and Heidi May (Chapter 23) discuss how a pedagogical intervention in a teacher education course became a site for intercultural *intra*ventions, leading to deeply personal examination of one's ontology as artist and as educator; their emphasis is on a pedagogy of becoming and on ontological processes in practice-based research.

Another theme in this section concerns the embodied, material and performative nature of intercultural arts research practice. The chapters by Trafí-Prats and by Powell and Schulte (both above) draw from these perspectives, as do the final two chapters in this section, which emphasize research as enactment and/or performance. Sarah Truman and Stephanie Springgay (Chapter 24) explore walking as an artistic practice and as research, a proposition that draws from actualities and potentialities, that shifts walking's relationship to research through processes such as defamiliarization. Charles Garoian (Chapter 25) writes about his own performance piece, an account of 'metaphorical swimming' in art research and practice via what he calls an apprenticeship in sensuous signs, emphasizing the entanglement of materials, memory, improvisation, words, actions, images and sounds.

Our consideration in Part II is to bring attention to art practice as a form of entangled engagement and enactment, capable of producing new possibilities for intercultural theory, pedagogy, research and artistic genres.

Part III: Research

Part III comprises fifteen chapters. They locate core themes, debates and discussions of how the principles that are critical for intercultural arts research concerning 'power' and 'voice' work together. Since the principles are interlocking, this can be seen: (i) with the more concrete questions facing researchers in diverse contexts which focus on who has a say, whose viewpoints count and the sociopolitical dimensions, ethical and insider-outsider issues underpinning research in the diverse contexts in which they are most likely to be challenged (such as higher education settings); (ii) in specific cultural research, such as in Chinese or Balinese research; (iii) in children's playgrounds, playgroups and other settings with minority and marginal groups; (iv) in visual arts culture research; and (v) in interdisciplinary performative research involving both music and poetry.

The issues and challenges that run through intercultural arts research methodologies and methods offer insight into the distinctive multidisciplinary character of this field of study, with ethics, theory-building, and forms of research that are new to the field. Authors address questions that researchers and artist-practitioners face in intercultural settings (wherein research is motivated by and rooted in intercultural arts-based considerations of fairness, equity, reflexivity, collaboration, ethics, voice, cultural sensitivities and uncertain knowledge) and in traversing the links from theory to research design and the foundations for intercultural practice; and then back again. Chapters in this section focus on new forms of representation, and the distinctions, challenges and possibilities of arts-informed, arts-inspired and arts-related intercultural research. Authors tackle the challenges of intercultural research, addressing interculturally sensitive methodological issues and issues of audience. In this section, the practice of methodology and methods in intercultural arts research and the enunciations adopted by theoretical literature (such as analytic philosophy, linguistics, sociology, semiology and anthropology – to speak of a few) which privilege a particular point of view, are critically explored.

The first set of chapters is focused directly on intercultural arts research issues. In the opening six chapters (26–31), authors Pat Thomson, Eeva Anttila, Diana Blom, Liora Bresler,

Violeta Schubert and Lindy Joubert, and Samuel Leong explore core themes of 'voice', ethics, language, culture and the language–culture nexus. They include a 'spectrum' of academic- and artist-researcher autobiographical, autoethnographic and ethnomethodological journeys whose arguments rest squarely on the need for critical reflexivity, values and the positioning and recognition of the researcher's presence. Deep and complex epistemological issues include methodological issues in research with (rather than on/for) people. Here, researcher ideology and pragmatics, discourse and language use, and how language systems are put to use and represented differently underpin the ways in which the research is about getting or generating knowledge. Each chapter is informed by different theories, theorizing and terms that fit different theories of knowledge (epistemologies). Each methodology (which refers to the theory of getting knowledge) provides the way in which the researchers go about the research with people. Each author suggests possible future directions for intercultural arts research and calls for more critical attention to such notions as 'voice' (Pat Thomson in Chapter 26), intercultural 'dialogue' (Eeva Anttila in Chapter 27), 'intercultural-historical-autoethnographic writing' (Diana Blom in Chapter 28), interdisciplinary, intercultural 'travels' (Liora Bresler in Chapter 29) mutuality and 'interculturality' (Violeta Schubert and Lindy Joubert in Chapter 30) and glocalization (Samuel Leong in Chapter 31).

Choice of research methodology and methods, and positioning of researchers are of particular importance in Chapters 32–40 which situate the study of specific intercultural arts practices in diverse settings.

This second set of chapters is focused directly on intercultural arts research projects and each depends on the researcher's orientation to a particular intercultural arts project. There are two clusters of chapters (32–33 and 34–37), each with a wide range of intercultural practices and research projects on/for/within settings. The first cluster includes an intercultural arts research project set in playground and playgroup settings involving immigrant children and their mothers in Australia (Kathryn Marsh and Samantha Dieckmann in Chapter 32). This is then followed by research currently taking place at the University of the Arts Helsinki, Sibelius Academy in Finland (Sidsel Karlsen, Heidi Westerlund and Laura Miettinen in Chapter 33) involving three projects: a Finnish–Cambodian intercultural project, a project on co-constructing Nepalese music teacher education through Finnish–Nepalese collaboration, and a collaborative project on visions for intercultural music teacher education in two higher music education contexts in Israel and Finland. These authors look closely at some of the dilemmas and debates produced 'by the epistemological and methodological entanglement with human beings' (Griffiths, 2011, p. 42) and the need for further understanding and education improvement.

The next group of chapters (34–37) is about intercultural arts practice and specifically addresses researching intercultural music practices and reflections on research processes such as intercultural gamelan learning in Bali and the UK (Jonathan McIntosh and Tina K. Ramnarine in Chapter 34); and how dialogues develop between musicians throughout the process of creative collaboration and across diverse cultures such as within a collaboration set up to combine mbira music from the Shona tradition of Zimbabwe with a contemporary string quartet (Amanda Bayley and Chartwell Dutiro in Chapter 35). In Chapters 36 and 37 we look closely at the mediating cultures and intercultural music practice of African music in Dublin (John O'Flynn in Chapter 36) and an intercultural production of *A Midsummer Night's Dream* (Helen Julia Minors in Chapter 37). In Chapter 38 Valerie Ross puts forward a different but related argument in her framing of intercultural music composition research. Each of these chapters illustrates research in which the methodology or epistemology of the research is itself a reason for claiming it to be specifically intercultural arts research with epistemological positions and/or methodological approaches which are, themselves, interculturally just.

The final two chapters are interdisciplinary. Kerry Freedman (in Chapter 39) features intercultural visual cultures as a fusion of subcultures, which cross over and among many related forms of visual culture. In Chapter 40, Peter Gouzouasis and Carl Leggo share an intercultural arts research collaboration; an autoethnographic journey which engages them in an intercultural creative inquiry of composing and performing music and poetry, in which they learn to attend to the liminal spaces that exist around, through, in-between and within the arts.

Similarly, as with each of the researchers' journeys featured in Part III, in the conduct and performance of their research, what emerges is a relational act between the intercultural arts participant and the researcher, where cultural meanings merge to generate new knowledge; a coming together of new songs.

Conclusion

In this *Handbook* authors consider what intercultural arts means and problematize questions that arise for artists, educators and artist-researchers in their engagement in and across that fractured past and present. We are reminded of Maxine Greene's insistence that in order to be fully wide awake to the possibilities intercultural arts hold for living, loving and responding to what is happening in the world with care and compassion, it is essential for us to always be in 'quest' – to be willing to pose questions on both sides of the border (2001, p. 159). This *Handbook* responds to Greene by asking how, and in what ways, do (and can) contemporary artists, researchers and educators employ critical, socially and ethically engaged, performative and democratizing practices to shake up and disturb the continued hegemonic re/production, ownership and re/presentation of knowledge within the kinds of matrices of domination and coloniality that Hill-Collins (1990) and Mignolo (2011) speak of. In this discussion, the authors argue for raising awareness of intercultural arts' entanglement with the ethico-onto-epistemological aims and processes of our practice within and against systems of power and privilege so that we can be more attentive to the embodied, affective, material and performative nature of our work As Morwenna Griffiths (2011, p. 37) meaningfully reminds us:

> Unlike the physical sciences, educational research is always on/for/with other people and getting knowledge on/for/with other people is a complex matter. It is complex for three main reasons: human agency; social relations and especially the effects of power; and ethics.

Amid these dynamics, whose voices speak most loudly in the practice of intercultural arts, whose voices are silenced or erased, what kinds of voices speak most powerfully together and in what ways, are some of the pressing concerns that authors seek to address. The *Handbook* offers insights into the challenges that researchers, practitioners, researcher-practitioners and academics face in this burgeoning field which sits on the borders between the local and the global, between cultural narratives of authenticity and academic discourses replete with multiple truths, and, between community agendas and the increasingly individual and competitive environment of neo-liberal institutions. Of critical importance to artist-researcher-educators in intercultural arts is the ways in which such encounters of history, identity, knowledge, power and practice become performances and performative representations of the very in-betweenness they seek to portray. 'Questions, questions, freedom and unease' (Greene, 2001, p. 167) characterize the discussions in this *Handbook*; it is this aspect of 'being marvelously incomplete' (Greene, 2001, p. 159) and 'becoming inbetween' to which intercultural artist-researcher-educators move to make sense of.

References

Barad, K. (2006). *Meeting the universe halfway*. Durham, NC: Duke University Press.

Bouchard, G. (2011). What is interculturalism?/Qu'est ce que l'interculturalisme? *McGill Law Journal, 56*(2), 435–469.

Bourdieu, P. (1977). *Outline of a theory of practice*. Cambridge: Cambridge University Press.

Greene, M. (2001). *Variations on a blue guitar*. New York: NYL Teacher's College Press.

Griffiths, M. (2011). *Educational research for social justice: Getting off the fence*. Buckingham: Open University Press.

Hay, J. (1999). Toward a theory of the intercultural. *RES: Anthropology and Aesthetics, 35*(Spring), 5–9.

Hill-Collins, P. (1990). *Black feminist thought: Knowledge, consciousness and the politics of empowerment*. Boston, MA: Unwin Hyman.

Jackson, J. (2014). *The Routledge handbook of language and intercultural communication*. London: Routledge.

MacLure, M. (2010). The offence of theory. *Journal of Educational Policy, 25*(2), 277–286.

Marks, L. U. (2000). *The skin of the film: Intercultural cinema, embodiment, and the senses*. Durham, NC: Duke University Press.

Mignolo, W. (2011). *Decolonial aesthetics (1)*. Retrieved from https://transnationaldecolonialinstitute.word press.com/decolonial-aesthetics.

UNIVERSITIES AT MEDWAY LIBRARY

PART I

Theory

2

THE BEAUTY OF A STORY

Toward an Indigenous art theory

Carmen Robertson

Introduction

Art is a fake category—I don't know what we are talking about when we say art.
(Cherokee artist Jimmie Durham, 2009)

Heiltsuk artist Shawn Hunt, based in Vancouver, BC, plays with reinterpretations of stories and extends mythology into contemporary art. In a recent newspaper interview he explained, "When I create art—I try to do things so you're initially struck by its beauty and then you're lured in and there's multilayers of meaning . . . so much of it comes from stories." "When you are dealing with native art, you've automatically introduced 10,000 plus years of culture" (Lederman, 2014, p. L1). Hunt echoes countless Indigenous artists, scholars, and community members who acknowledge that storytelling plays an integral role in the arts. Whether ancient or contemporary, stories permeate Indigenous art forms. How does narrative inform Indigenous art? How might it lead toward art theory? Such questions guide this brief inquiry while opening a discourse related to contemporary Indigenous arts.

Cynthia Freeland's *Art Theory: A Very Short Introduction* (2003), part of a popular Oxford University Press series, provides lay readers with a general sense of what art theory entails. She clarifies that "rather than create obscurity through jargon and weighty words," a theory should "systematically unify and organize a set of observations, building from basic principles" (2003, p. 1). This explanation sounds good in principle but for those who have read Eurocentric art theory extensively, Freeland's words offer little help in deciphering the overwhelming variety of arts practices, and cultural nuances that appear to defy unification in considerations of art, not to mention the verbose jargon that complicates much extant theory. Moreover, Indigenous arts pose great challenges to conceptions of Western art theory because of the wide-ranging forms of artistic expressions, unique cultural applications, and ceremonial usage, complicated further by a veil of colonialism that has impacted arts practices since contact. Clearer articulations of Indigenous art theory necessarily increase the communicative capacities of interculturality. Formulations of discourses related to Indigenous art theory expand the ways in which differences can be understood and valued, shifted and reconceived.

American educational theorist John Dewey advanced in his 1934 *Art as Experience* that art is a universal language, and felt that everyone could have a genuine emotional encounter

with art from another era or culture. While I agree with Dewey that it would be difficult for anyone to not be moved by many different works of art produced throughout the world over time, his Modernist and essentializing theory limits the power of the piece because it leaves little space for considering works within a specific cultural context. His "universal" language infers a Eurocentric bias, a Modern structure that privileges Western as a measure for all other artistic expressions.

Postmodern theorists have discounted the totalizing metanarrative and championed a pluralistic model where, as Lyotard notes in *The Postmodern Condition* (1979), the *petit récits* or little narratives are a way to shift away from the grandiose claims of "truth" and "progress." That said, curator and art critic Hal Foster (1985) cautions against the idea that postmodernism is wholly productive in considering art theory because he recognizes a reductive view of postmodernism as problematic. Pluralism, in consideration of non-Western art, might simply be a way to reify power relations. Nigerian curator Okwui Enwezor, who curated a watershed contemporary global exhibition at *Documenta 11* (2002), contends that binary considerations of Western and non-Western art are unproductive and limiting (O'Neill, 2007). He chooses instead to consider the wide range of artistic practices in contemporary culture, while maintaining that opposition to colonialism serves as a main point of intersection with this array of practices (O'Neill, 2007). Yet, Enwezor concedes that regardless of his efforts to curate differently, power relations continually disrupt ways in which Indigenous arts are engaged.

Formulating art theory is a tricky business in these postmodern times because the welcoming dismissal of a metanarrative masks the politics of viewing and display. African American artist and cultural critic bell hooks has written extensively about art and visual politics, advancing art theory in the process. "Learning to see and appreciate the presence of beauty," hooks argues, "is an act of resistance in a culture of domination that recognizes the production of a pervasive feeling of lack, both material and spiritual, as a useful colonizing strategy" (1995, p. 124). While she specifically references African American art and African American viewers, her statement speaks to minority arts and marginalized viewers more generally. Interrogating ways in which aesthetic sensibility is shaped by resistance preoccupies many Othered contemporary artists and theorists, including Vietnamese filmmaker Trinh T. Minh-ha. While recognizing that contemporary arts by marginalized artists are often inherently political, she reminds us, "Aware that oppression can be located both in the story told and in the telling of the story, an art critical of social reality neither relies on mere consensus nor does it ask permission from ideology" (Minh-ha, 1991, p. 7). Colonialism and power are ever present in considerations of non-Western contemporary art, yet as Trinh T. Minh-ha acknowledges, story plays a decisive role in the equation. Deciding who tells a story, how that story is told, and the roots of story remain central to the creative process because, perhaps more than any other epistemological tradition, the relationship between the visual, oral, and textual, implicitly informs Indigenous aesthetic traditions.

Whether art offers a visual articulation of cultural stories, reveals dominant oppression, or helps communicate the oral enactment of a story, it remains at the core of traditional and contemporary Indigenous art mediums. Today, Quechua women in the highlands of Peru, for example, sing traditional songs as they weave cultural designs into cloth using backstrap looms, ancient technology, to produce art imbued with aesthetic and spiritual significance. The process of creation involves story at its core: the symbolic associations within the design tell a story; the performative action of weaving the cloth and singing imbue spiritual significance into the warp and weft acknowledging the enduring cultural importance of cloth. The weaver's own artistic sensibility, role in community, and cognizance of future generations, further evoke storied art. Such narratives, however, are not stuck in the past, frozen in time. The complicated colonial history of the conquest of the Andes necessarily weaves its way into the works of art

impacting traditional and contemporary narratives, just as the weaver's agency and personal creativity shape the art production. How this art is displayed or viewed further intersects with contemporary narratives.

Concepts that maintain the diversity of Indigenous arts in relation to notions of interconnectedness, considerations of future impact, performative gestures, elements of ceremony, and the realities of colonial oppression inform theoretical discussion of Indigenous art. That bell hooks (1995) identifies beauty as a means of resistance and transformation in larger cultural processes of renewal or decolonization connects with concepts advanced by Indigenous theorists. However, many theorists consider notions of art beyond the confining term of beauty, especially when considering contemporary Indigenous arts that confront colonialism both head on and tangentially. French philosopher Jacques Rancière's (2004) aesthetic theory has become a reference point in visual arts and informs this analysis. Rancière argues that aesthetics is necessarily politicized and notes: "Artistic practices are 'ways of doing and making' that intervene in the general distribution of ways of doing and making as well as in the relationships they maintain to modes of being and forms of visibility" (2004, p. 13). Art, for Rancière, can be implicitly political without announcing itself as such because forms of politics are invested in the visual by the maker and the viewer. This is especially the case with contemporary Indigenous art where the politics of aesthetics resonate deeply. Placing art in galleries and institutions activates intercultural understandings because an object or performance takes on new meanings as curators and audiences encounter the work and add new dimensions to the unfolding stories.

Interculturality and Indigenous arts

Contradictory complexity exists in situations of intercultural knowledge production and always has. Policies are emerging worldwide around concepts that underline the rights of all cultures to contribute to the cultural landscape of a given society in which they are present. Art institutions are good examples of sites that provoke cultural dialogue. Understanding Indigenous art can help to reinforce the fabric of a given community and has the capacity to broaden intercultural exchange. It is important, however, to encourage audiences to *look* in fresh ways because the history of hegemonic cultural relations continues to impact interpretations. Colonialism has long hampered transformative dialogue and has problematized reception of Indigenous arts. Better articulating Indigenous theories of arts can help to undo unproductive ways that audiences approach this work.

Early on, the discipline of anthropology, represented in its extremes, often amounted to a destruction of the Other's value and identity. Material culture and Indigenous arts were targets as such discourses found their way into art criticism, art institutions, and scholarship. Because much was published out of the discipline of anthropology during the twentieth century, based on a set of pre-conceived racial ideas encouraged by Primitivism and troubled by nation building, skewed notions of Indigenous arts were widely disseminated. Such concepts resisted notions of interculturality and entrenched cultural categories. Indigenous artists and scholars of Indigenous arts (including a new generation of anthropologists) have lately worked to shake off the various ways in which hegemonic ideas shaped knowledge-making. Contemporary conceptions of interculturality recognize the need to enable each culture to survive and flourish, making efforts to formulate discourses of art theory all the more significant.

It was not until the 1990s, when academics made a concerted effort to step away from Primitivist discourses, that a significant realization of the multifaceted discourses surrounding Indigenous arts began to develop. Cultural assumptions regarding so-called Primitive art were historically influenced by social Darwinism and imperialism, pervasive concepts largely

unquestioned until well into the twentieth century. Anthropologist Sally Price's influential *Primitive Art in Civilized Places* (2001) offers an indictment of ongoing discourses surrounding Primitive art in the twentieth century. She argues that Primitive art was constructed upon a central Modernist understanding of art as a "universal language." One effect of this was that an innocence and naivety associated with Primitive art romantically pitched non-Western artists as purified and unpolluted by Western civilization. Modernists sought to appropriate the unmediated energy of Primitivist arts, situating the art of Indigenous peoples in a positive light, yet at the same time presenting it as something Other—a binary to Western artist expression.

The discourse around Primitivism gained ground when Enlightenment belief in progress intersected with science to create ethnocentric categorization of cultures that led to the discipline of anthropology as argued by Johannes Fabian (2014). The terms Primitive and Primitive art remain highly problematic both because of their colonial baggage and the various usages over time. In *French Primitivism and the Ends of Empire 1945–1975*, art historian Daniel J. Sherman "treats primitivism as at once a discourse, a myth, a fantasy, part of a larger colonial or neocolonial apparatus, and a metaculture" (2011, p. 5). Sherman's framing of Primitivist discourse as naturalized is useful to understanding how it has shaped knowledge production and discourse around Indigenous arts. His argument helps elucidate the diverse and varied modes in which Primitivism entangled with Indigenous art, especially prior to 1990.

In the discipline of art history, distinctions between Primitivism and Modernism were distorted early in the twentieth century, when Picasso's exploitation of African masks for *Desmoiselles D'Avignon* sparked, as Price characterized, European art history to "turn a corner" (2001, p. 130). Hers was not a new idea as art historian Robert Goldwater claimed this territory in his classic *Primitivism in Modern Art* (1938 [1986]) positing that Gauguin had primed Modern art with his trips to Tahiti. Still, Price demonstrates that, while changes have occurred, there remains much work to be done, especially in the area of art criticism. In the afterword to her latest edition of her text, Price encourages an intercultural conception of art theory where a "variety of discourses" that diverse peoples call on to "think and talk about it [art]" dismantles the History of Art's "Western-authored metanarrative" (2001, p. 133).

As noted, links between the Primitive and the Modern preoccupied artists, art historians, and critics throughout much of the twentieth century. This changed with *Primitivism in 20th Century Art: Affinity of the Tribal and the Modern*, a controversial 1984 exhibition mounted by New York's Museum of Modern Art and curated by Kurt Varnedoe, that elicited much criticism in its pairing of anonymous non-Western art with celebrated Modern art. Art historian Ian McLean (2011) argues that, since the critical reception of *Primitivism in 20th Century Art*, non-Western art has become an important topic of discussion throughout the world. This has led to a variety of intercultural dialogues that provide agential ways in which Indigenous art takes on new meanings.

For example, art historian Ruth B. Phillips argues that when Eurocentric notions of Modernist Primitivism were introduced to Indigenous artists in North America in the mid-twentieth century by displaced European immigrants, the new arrivals, long steeped in the tenets of Modernist Primitivism, introduced artistic concepts to Indigenous artists that were repurposed as "countermodern" in ways that were "dialogic" and benefitted both the immigrant and the Indigenous artist (Phillips, 2008, p. 49). Such encounters helped to shift the meanings of Primitive "so that modernist primitivism could become indigenous modernism" (Phillips, 2008, p. 67). Art historian Bill Anthes adds that not all forms of Primitivism should be viewed as cultural theft but as a more complex relationship that "opened up the notion of a 'third space' . . . and provided a platform from which Native and non-Native artists asserted the value of cultural difference" (2006, pp. 87–88). This reconsideration helps to recast Primitivist tropes, the hangover

of ethnography, and other hegemonic systems of representation that reproduce asymmetries of power in new and productive ways that engage more directly with the production and communication of intercultural knowledges.

Repositioning art

American Chippewayan or Anishinaabe literary theorist Gerald Vizenor (1999, 2008) worries that the distraction of colonialism impedes engagement with Indigenous arts. Native survivance, he asserts, is a way to engage more productively in interculturality, because it is an active sense of presence and agency and must remain central to all sorts of discourses. "The nature of survivance is unmistakable in Native stories, natural reason, remembrance, traditions, and customs," explains Vizenor, who recognizes resistance in personal attributes such as humor, spirit, cast of mind, and moral courage in literature (2008, p. 1). The concept of survivance has been embraced in visual and performative art practices and with the popularity of Vizenor's concept it has become a forceful organizing aspect of theory. Survivance is now situated conspicuously in discussions of contemporary Indigenous art.

It was not until a pivotal essay written by Cree filmmaker Loretta Todd in 1992 for the art exhibition *Indigena*, which coincided with the 500th anniversary of Columbus's arrival, that an opening for theoretical discussion around contemporary Indigenous arts in Canada was advanced. She posited that Edward Said's *Orientalism* (1978) should challenge Indigenous scholars and artists to write about theoretical issues rather than allowing non-Indigenous scholars to formulate discourse (Todd, 1992). More recently, Todd addressed Native aesthetics in cyberspace in her contribution to *Transference, Tradition, Technology* (2005). In this essay she challenges Indigenous media artists, specifically, to explore narrative forms within virtual space, saying: "There may be other ways to imagine cyberspace, not as a place born of greed, fear and hunger but instead a place of nourishment" (Todd, 2005, p. 163) enacting agency and considering storytelling as a way to decolonize cyberspace. Ever cognizant of colonial issues, Todd presses artists to find ways to insert traditional cultural concepts into non-traditional arts practices. Such theoretical musings have sparked deep theoretical discussions at conferences and symposia yet no text has been advanced on the topic to date.

The recent publication, *Centering Anishinaabeg Studies: Understanding the World Through Stories* (Doerfler, Sinclair, & Stark, 2013), has addressed art theory with the inclusion of two essays related to Anishinaabe arts and culture in an attempt to consider artwork specific to one particular First Nation. As part of a larger movement within Indigenous Studies, by specifically focusing concepts to a particular cultural group, scholars and community members take up key ideas within a particularized milieu through language and culture while avoiding homogeneous generalizations. *Centering Anishinaabeg Studies* responds to this direction in relation to the Anishinaabeg (plural form of Anishinaabe) nation of the Great Lakes region that straddles the border of Canada and the USA and is made up of Ojibway, Odawa, and Algonkin peoples, who all share closely related Algonquian languages. While notions of storytelling can be applied more broadly to Indigenous art theory without, I believe, losing nuanced cultural origins, this discursive strategy importantly brings together original language and stories to think deeply about Anishinaabeg cultural ways. Literary scholar David Stirrup's essay (2013) on art provides a theoretical frame for understanding twenty-first-century Anishinaabeg paintings based on story, while Native American Studies scholar Molly McGlennen (2013) argues that contemporary Anishinaabeg art can be interpreted as a creative expression of traditional modes of storytelling. Vizenor's notion of survivance remains present throughout these and other essays in this collection.

McGlennen engages works by three internationally known Anishinaabe artists, George Morrison, Norval Morrisseau, and Rebecca Belmore, to explain how art "can be viewed as a vibrant continuation, adaptation, and creative expression of traditional modes of storytelling" (2013, p. 346). Noting that each of the works exemplifies how "artistic expression is storied expression" (2013, p. 346), McGlennen rightly states that it is insufficient to discuss these artists in relation to only European aesthetic traditions but story and performative elements must be engaged to situate them within a discourse of Anishinaabeg culture. Stirrup employs works by less well-known contemporary Anishinaabe artists, Andrea Carlson, Jim Denomie, and Star Wallowing Bull, to reinforce the interconnectedness of story and art, the verbal and the visual. He concludes that both "illustrating and enacting story-as-process becomes a means of addressing and reorienting experience" as "a Native story, circulating outwards from an Anishinaabeg center" (2013, p. 312). Story, he argues, provides both a "model and source" for intellectual and aesthetic engagement. Stirrup, like McGlennen, utilizes narrative productively in relation to art, recognizing that narrative offers wider applications than a reading of subject, and is inherent in the formation of the concept.

Theory into practice

Performance as a key form of expression is an integral area of contemporary Indigenous arts practice. Performance artists today embody transformative storytelling practices that have long been part of Indigenous arts practice. Mixing oratory, song, music, spectacle, ceremony, and narrative, pre-contact gatherings brought together communities to engage in performative storytelling events across North America prior to the arrival of settlers. Performativity advanced by Derrida (1988), Foucault (1977, 1978), and, notably, Butler (1990, 1993, 1997) explicates how acts of communication construct and perform an identity. Considered here as embodied gestures that both reinforce and complement the transmission of knowledge, performativity plays a key role in Indigenous storytelling. Canada's west coast First Nations potlatches long exemplified this multifaceted practice with their mix of ceremony, gift exchange, oratory, and ritual performance. Building on Appadurai's (2011) concept of "thing-ness," Fred Meyer recently advanced that Australian Western Desert acrylic paintings as objects "perform" or "bring into being" local Aboriginal identities that shape audience reception with their circulation, extending opportunities for intercultural exchange (2014, p. 355). Certainly, contemporary performance flows from traditional ceremony and shapes practices that intermix core cultural expressions. The body is often linked to specific sites as is the case in performances by Rebecca Belmore, an internationally known, multi-disciplinary artist whose work is implicitly grounded in the performativity.

Setting into motion noted theoretical concepts demands exemplars to more fully engage abstract ideas. I offer two. "Following the things themselves," as Appadurai asserts (2011, p. 5), informs theoretical discussion because the movement of objects and/or practices between "regimes of value" tends to be unstable. Meyer (2014) adds that focusing on intercultural movement or circulation of objects and activities beyond what he views as mostly static cultural categories is a more productive way to understand art. I shall follow two pieces of art to help shape this inquiry and inform this discussion: *Androgyny*, painted by Anishinaabe artist Norval Morrisseau (1931–2007) in 1983, and Anishinaabe artist Rebecca Belmore's (1960–) *Blood on the Snow* from 2002. Both artists have similar cultural backgrounds but their artwork comes from different periods of contemporary art. Morrisseau performatively shaped his identity as a shaman artist and his arts practice was based in two-dimensional art, while Belmore creates two- and three-dimensional works that emerge from her performance-based practice.

The creative process of making each of these works imbued them with story, yet additional stories and understandings resonate with the works far beyond their creation dates. These two art works continue to move viewers who intermix new, changing, and divergent narratives when exhibited.

Morrisseau inspired a new art movement that draws on Indigenous sources for his unique visual vocabulary. Belmore, who represented Canada at the Venice Biennale in 2005, is one of Canada's best-known performance artists. While their work has little commonality in style or form, both of these artists utilize concepts of aesthetic politics, survivance, and performativity with story in creating and presenting their work. Like Morrisseau's *Androgyny*, Belmore's *Blood on the Snow* serves as an example of Rancière's intersection of aesthetics and politics—a result of an interchange between the work of art and its interpretation rather than any overt political message presented in the art. Vizenor's concept of survivance, too, is key to fully engaging with these works. *Androgyny* redirects colonial narratives by focusing on new pathways, directions that reference spiritual interconnectedness, gender identity, and relationships between the past, present, and future. *Blood on the Snow* confronts viewers with past and present histories or ongoing colonial clashes, but also posits change in order to re-imagine a transformative future. Aspects of performativity emerge in each work as both Morrisseau and Belmore enact gestures that both reinforce and complement the transmission of knowledge in the process of creating their work. While Belmore anchors creative expression in performance art, making links to performativity clear, Morrisseau's determined performance as a shaman artist, his performative utterances to Canada's Prime Minister, his painting a work as a purposeful gift exchange and teaching, uncovers *Androgyny*'s performative foundation.

An Indigenous artist who shook Canada's art world in 1962 when his work was debuted in a contemporary gallery in downtown Toronto, the Pollock Gallery, Morrisseau was the first Indigenous artist in Canada to breach the divide of exhibiting Indigenous art in contemporary art galleries. His story, however, is complicated by a media-driven construction of him as an "Imaginary Indian," the problematic frame that Vizenor (2008) argues has distracted the Western world. Morrisseau's art practice troubled his home community and he was scorned for breaking protocols and revealing cultural stories to outsiders in the 1960s. Yet these images, outside of his Anishinaabe cultural sphere, ironically revealed little meaning for viewers without esoteric knowledge of the larger cultural stories, who often viewed them as exotic, primitive tribal expressions rather than as contemporary art. Morrisseau continued to use cultural stories throughout his career as he pushed story in new directions. When Morrisseau painted the vast six-meter long mural *Androgyny* as a gift to the Canadian people, after a successful twenty-year career, he enacted an exchange that united cultural protocols, personal aims, and national purposes.

Morrisseau offered *Androgyny* as a gift to the Canadian people with certain reciprocal expectations inherent in Anishinaabek ceremonial exchange. The then Prime Minister of Canada, Pierre Trudeau, accepted the painting from the senior artist and it was accessioned into the Indian Art collection at Indian Affairs, the colonial branch of the government that oversees First Nations people. Both the gifting and the painting situate ceremony as a central concept to this theoretical understanding of art and build intercultural knowledge through the exchange and movement of the object. "In Anishinaabe tradition, an offering is a gift. It's a gesture of relationship between people, animals, spirits, and other entities in the universe, given in the interests of creating ties, honoring them, or asking for assistance and direction," explain Jill Doefler, Niigaawewidam James Sinclair, and Heidi Kiiwetinepinesiik Stark in the introduction to *Centering Anishinaabeg Studies* (2013, p. xv), reminding readers that an offering carries with it responsibility articulated in cultural protocols. They reiterate that the acceptance of the offered

gift also forges a bond that should be "a mutually beneficial partnership, not only for participants, but for the universe around them" (2013, p. xv). This ceremonial exchange is central to the narrative surrounding *Androgyny*. Morrisseau deliberately offered his painting as a gift to the Prime Minister and forcefully states his wishes for a formal ceremony at the Department of Indian Affairs to present the art directly to the leader of the country hoping to facilitate and inspire a different relationship for First Nations with Canada—a symbolic gesture for future change. The painting itself is impressive. The boldly colored visual explication of animals, humans, and spirit beings living within an interconnected universe, layers of storytelling and cultural ontology are invested in this work. Concepts of interconnectedness and considerations of future generations are not only central to the painting but also impact ways in which this painting was intended by Morrisseau to serve as a catalyst.

Elements of ceremony exist in the visual narrative and also in the act of painting and giving. Instigated in order to engage and transformatively inspire new ways to consider Canada's future relations with its original peoples, Morrisseau's gift was a significant gesture. Clearly, the Prime Minister viewed the gift differently. Despite introductory remarks by government officials that noted, "It is a way not only of communicating with each other, but of communicating with the people we are here to serve: the native people of this country," and that, "Indian artists have opened our eyes to the subconscious relationships that exist between our environment, the animals and people that populate our corner of the world," the importance of the painting was not fully appreciated in the sense Morrisseau intended (Jerusalem, 1983, n.p.) because it hung, until 2006, mostly unnoticed in the large office complex that houses the bureaucracy related to the Department of Aboriginal and Northern Affairs. The artist's generous gift, laden with ceremonial protocol was misunderstood as simply a pretty picture rather than one of relational accountability as a way to inspire new stories.

When Rebecca Belmore created *Blood on the Snow* (2004), she, like Morrisseau, drew on interconnections with the past, the present, and the future, using story in her art-making process and as a way to instigate intercultural knowledge. An oversized duvet of sorts, the installation commands a 610 by 610 cm space that also completely covers a chair situated in the center of the piece. The overwhelming blanket of white is disturbed only by a thin seeping line of red at the top end of the chair. White and red, the symbolic application of color references purity, passion, nationalism, violence, and erasure. The blanket, too, signifies warmth and protection defying any one narrative. A historic massacre at Wounded Knee that occurred in 1890 when more than three hundred Sioux were killed by the US army is one of the powerful stories evoked by the piece. Historic photographs that document the carnage visually recall the eeriness of the fresh layer of snow that blanketed the site. This installation is not simply a story of historical conquest it also speaks directly to the ongoing, contemporary colonial ills in Canada with regard to missing and murdered Indigenous women, a key theme in Belmore's performative arts practice. Confronting past and present cultural inequities activates dialogue and transformative change rather than simply drawing attention to seemingly static cultural categories.

This installation was part of Belmore's 2002 exhibition *The Named and the Unnamed* that art historian Charlotte Townsend-Gault describes as "a sequence of tableaux which picture violation" (2002, p. 9). Luiseño performance artist James Luna posits in the *The Named and the Unnamed* catalogue that Belmore is the "recipient of a spiritual gift" (2002, p. 51) and that work such as *Blood on the Snow* stems from such a gift. Gifting, here, takes a different meaning from Morrisseau's gift exchange between himself and a nation, yet, at its root, the cultural protocols of gift giving remain. The bond involves giving and receiving; each action requires reaction.

Blood on the Snow was part of an exhibition of new work, making it one aspect of a larger narrative. This is a common convention in Belmore's arts practice. Confronting viewers

with five works of resistance, curators Daina Augaitis and Kathleen Ritter describe Belmore's practice as a "singular, compelling, polemical voice . . . manifest in sculpture, video or photography . . . grounded in the performative" (2008, p. 9). *Blood on the Snow* resonates deeply when considered with the other works included in the 2002 exhibition. These include a video projection and installation titled *The Named and the Unnamed* (244 by 274 cm) that extends her performance *Vigil*, done the same year in downtown Vancouver, into the gallery space; *The Great Water* (457 by 914 by 107 cm), an installation that alludes to a capsized canoe covered with black canvas; *State of Grace* (2002), a photograph of the artist sliced by vertical ribbons; and *Song*, positioned near *State of Grace*, a single eagle feather hanging from the ceiling on a filament responds to air currents in the room. It is difficult to disentangle the five works as each offers a piece of a whole, which Townsend-Gault describes as an "historical and epistemological disruption between humans and the world they inhabit" (2002, p. 9). This wholeness links directly to the overarching sense of narrative inherent in the creative expression.

Conclusion: Indigenous art, interculturality, and storytelling epistemology

The heart of working toward a theory of Indigenous arts is situated in a paradigmatic understanding of story. Both Belmore and Morrisseau enact story in the very fabric of their arts practices, moving its significance beyond subject and object to the core of the creative process. This, to me, is the essence of moving toward a theoretical framing of Indigenous arts. While narrative firmly connects the viewer with the subject in many aspects of traditional and contemporary artistic expressions, it is the deeper epistemological foundation of how we come to know that directs this exploration. Storytelling as a cultural way of knowing evokes this essence.

How Indigenous artists create art is at issue here. Art as process is steeped in the experience of story. While this might appear simplistic because story typically means something directly related to the telling, how story instigates art is decidedly more sophisticated and complex. Within epistemological framings of Indigenous narrative resides worldview. Transmission of knowledge about one's culture through a systemic narrative process reveals more than simply what is told, it is also how it is told—keeping in mind that such structure deviates culturally. Still, researchers have demonstrated that commonalities exist between Indigenous worldviews as a result of people's connected relationship to their environment (Fitznor, 1998; Gill, 2002). To that end, Cree educational scholar Margaret Kovach (2010) acknowledges that Indigenous ways of knowing derive from teachings transmitted generationally by storytelling. The act of transmitting knowledge remains key to considerations of art process and art theory.

Conceptions of spirituality, attachment to place and to all living things emerge through storied patterns inherent in oral traditions. Cree theorist Willie Ermine explains epistemology through the Cree term *mamatowisin* as the "capacity to tap the creative life forces of the inner space by the use of all the faculties that constitute our being—it is to exercise inwardness" (1995, p. 104). Such knowing is made manifest through creative expression. Creativity, then, operates as a fulcrum, a point of rest in which story expresses systems of belief. Epistemology reveals ways of being. Indigenous artistic output, whether painting, sculpture, dance, song, performance, oratory, or an interconnected expression, possesses, at its essence, a storytelling way of knowing.

Contemporary Indigenous arts reflect concepts of ontology and epistemology. While stories told by Indigenous artists are specific to a person, a culture, a time, inform this conception, neither subject nor object explains this concept fully. Rather, it is Indigenous ways of knowing and being that systematically unify and organize art through story—the root of "what it means

to be a participant in an ever-changing and vibrant culture in humanity" (Doerfler et al., 2013, p. 1). The art examples by Morrisseau and Belmore described above, illustrate notions of how story links to a process of art production. Performative gestures broaden the enactment of the storytelling as an embodiment of process. Neither subject nor object explains this concept fully. Rather, it is Indigenous ways of knowing that systematically unify and organize art through story. Such stories inherent in objects and activities, while in many contexts are particular to specific cultural contexts, through movement into galleries and institutions facilitate intercultural discourses.

The fabric of a culture, which weaves story into its ways of knowing, helps mould the myriad creative expressions present in contemporary Indigenous arts. However, these stories are not static, stuck in the past, nor simply culturally bound. Narrative shaped by concepts of survivance, performativity, and the politics of aesthetics unify and organize a set of observations that move toward a theory of art and open avenues for intercultural discourses. From this set of systematically unifying and organized observations, building from basic principles, pathways toward Indigenous art theory emerge that engage new stories and new understandings. It is in this way that we appreciate the beauty of story when experiencing a work of art.

References

Anthes, B. (2006). *Native moderns: American Indian painting, 1940–1960*. Durham, NC: Duke University Press.

Appadurai, A. (Ed.). (2011). *The social life of things*. Cambridge: Cambridge University Press.

Augaitis, D., & Ritter, K. (Eds.). (2008). *Rebecca Belmore: Rising to the occasion*. Vancouver, BC: Vancouver Art Gallery.

Butler, J. (1990). *Gender trouble: Feminism and the subversion of identity*. London: Routledge.

Butler, J. (1993). *Bodies that matter: On the discursive limits of "sex."* London: Routledge.

Butler, J. (1997). *Excitable speech: A politics of the performative*. London: Routledge.

Derrida, J. (1988). *Limited Inc* (Trans. S. Weber & J. Mehlman). Evanston, IL: Northwestern University Press.

Dewey, J. (1934/2005). *Art as experience*. New York, NY: Penguin/Perigree.

Doerfler, J., Sinclair, N. J., & Stark, H. (Eds.). (2013). *Centering Anishinaabeg studies: Understanding the world through stories*. East Lansing, MI: Michigan State University Press.

Durham, J. (2009). Interview with Jimmie Durham and Manuel Ciraquaqi. *Bomb*. Retrieved from http://bombmagazine.org/article/6268/jimmie-durham.

Ermine, W. (1995). Aboriginal epistemology. In M. Battiste & J. Barman (Eds.), *First Nations education in Canada* (pp. 110–112). Vancouver, BC: University of British Columbia Press.

Fabian, J. (2014). *Time and the other: How anthropology makes its object*. New York: Columbia University Press.

Fitznor, L. (1998). The circle of life: Affirming Aboriginal philosophies in everyday life. In D. C. McCance (Ed.), *Life ethics in world religions* (pp. 21–39). Atlanta, GA: Scholars Press.

Foster, H. (1985). *Recodings: Art, spectacle, cultural politics*. Seattle, WA: Bay Press.

Foucault, M. (1977). *Discipline and punish: The birth of the prison* (Trans. A. Sheridan). New York, NY: Random House.

Foucault, M. (1978). The history of sexuality: An introduction (Trans. A. Sheridan). New York, NY: Random House.

Freeland, C. (2003). *Art theory: A very short introduction*. London: Oxford University Press.

Gill, J. H. (2002). Native American worldviews: An introduction. New York, NY: Humanities Press.

Goldwater, R. (1938; 1986). *Primitivism in modern art*. Cambridge, MA: Harvard University Press.

hooks, b. (1995). Beauty laid bare: Aesthetics in the ordinary. In b. hooks (Ed.), *Art on my mind: Visual politics* (pp. 119–125). New York, NY: The New Press.

Jerusalem, C. (1983). Norval Morrisseau fonds. *Intercom Newsletter* (April). Department of Indian Affairs, Aboriginal Affairs and Northern Development Aboriginal Art Collection archives.

Kovach, M. (2010). *Indigenous methodologies: Characteristics, conversations, and contexts*. Toronto, ON: University of Toronto Press.

Lederman, M. (2014, November 19). Sometimes a table is not just a table. *The Globe and Mail*, p. L1.

Luna, J. (2002). An Indian artist sees: Notes on an exhibition of the work of Rebecca Belmore. In S. Watson (Ed.), *Rebecca Belmore: The named and the unnamed* (pp. 51–52). Vancouver, BC: Morris and Helen Belkin Art Gallery.

Lyotard, J.-F. (1979). *The postmodern condition* (Trans. G. Bennington & B. Massumi). Minneapolis, MN: University of Minnesota Press.

McLean, I. (Ed.). (2011). *How Aborigines invented the idea of contemporary art*. Brisbane: Institute of Modern Art.

McGlennen, M. (2013). Horizon lines, medicine painting, and moose calling: The visual/performative storytelling of three Anishinaabeg artists. In J. Doerfler, N. J. Sinclair, & H. K. Stark (Eds.), *Centering Anishinaabeg studies: Understanding the world through stories* (pp. 341–359). East Lansing, MI: Michigan State University Press.

Meyer, F. (2014). Showing too much or too little: Predicaments of painting indigenous presence in Central Australia. In L. R. Graham & H. G. Penny (Eds.), *Performing indigeneity: Global histories and contemporary experiences* (pp. 351–389). Lincoln, NB: University of Nebraska Press.

Minh-ha, Trinh T. (1991). *When the moon waxes red: Representation, gender, and cultural politics*. New York, NY: Routledge.

O'Neill, P. (2007). Curating beyond the canon: Okwui Enwezor interviewed by Paul O'Neill. In P. O'Neill (Ed.), *Curating subjects* (pp. 50–85). London: Open Editions.

Phillips, R. B. (2008). The turn of the primitive: Modernism, the stranger and the Indigenous artist. In K. Mercer (Ed.), *Exiles, diasporas and strangers* (pp. 46–71). London: Inivia.

Price, S. (2001). *Primitive art in civilized places* (2nd ed). Chicago, IL: University of Chicago Press.

Rancière, J. (2004). *The politics of aesthetics* (Trans. G. Rockhill). London: Continuum.

Said, E. (1978). *Orientalism*. New York, NY: Vintage Books.

Sherman, D. J. (2011) *French Primitivism and the ends of empire*. Chicago, IL: University of Chicago Press.

Stirrup, D. (2013). Story as process and principle in painting. In J. Doerfler, N. J. Sinclair, & H. K. Stark (Eds.), *Centering Anishinaabeg studies: Understanding the world through stories* (pp. 297–316). East Lansing, MI: Michigan State University Press.

Todd, L. (1992). What more do they want? In G. McMaster & L. Martin (Eds.), *Indigena* (pp. 71–79). Gatineau, QC: Canadian Museum of Civilization.

Todd, L. (2005). Narratives in cyberspace. In M. Townsend & C. Hopkins (Eds.), *Transference, technology: Native new media, exploring visual and digital culture* (pp. 152–163). Banff, AB: Walter Phillips Gallery.

Townsend-Gault, C. (2002). Have we ever been good? In S. Watson (Ed.), *Rebecca Belmore: The named and the unnamed* (pp. 9–50). Vancouver, BC: Morris and Helen Belkin Art Gallery.

Vizenor, G. (1999). *Manifest manners: Narratives on post-Indian survivance*. Lincoln, NB: University of Nebraska Press.

Vizenor, G. (2008). *Survivance: Narratives of native presence*. Lincoln, NB: University of Nebraska Press.

3

THEORISING MUSEUM PRACTICE THROUGH PRACTICE THEORY

Museum studies as intercultural practice

Conal McCarthy

Introduction: the intercultural museum

The museum has usually been seen either as a temple or a forum, a beacon of cultural democracy or a space where peoples, identities and nations are made and unmade in the image of powerful elites. The literature of museum studies and related fields is full of critiques of museums as power houses of social inequality or engines of public good. In these studies, the arts are marginalised as reflections of social relations. The problem with this black and white model of museums, as with other cultural institutions, is that Foucauldian theories of discourse, representation and power/knowledge restrict academic analysis by focusing on the contest of good/bad ideas at the expense of what people do, in other words of social practice. In this handbook, by contrast, intercultural arts are understood as places where cultures meet, negotiate, translate and intermingle, making an important contribution to scholarship in the arts and humanities by examining the intersection of theory and practice. It seems to me that what is required, as well as attention to history and theory in academic scholarship, is a sense of *practice* which grounds the phenomenon or object of study in its context amid the swirl of lived social relations.

The notion of artistic 'practice' is ubiquitous in art criticism, loosely referred to as the 'work' artists do. Professional practice in museums is similarly generally seen in somewhat narrow terms as a set of working methods or ways of doing things in this particular industry which is officially sanctioned and formally described through codes or manuals. In this chapter, I take this basic understanding of professional practice, and position it within a more complex framework drawing on anthropology, sociology and the tradition of practice theory which theorises practice as the *things that people do*. In short I propose a re-theorising of museum practice by grafting on to it critical theories of cultural practices (Turner, 1994), and in particular Bourdieu's (1977) theory of practice which conceives of social action as part of a field. In doing so, I argue that theorising practice through practice theory lends a greater sophistication, depth and complexity to the study of cultural heritage in relation to social institutions and particularly non-Western perspectives on arts and heritage. How can these ideas be put into practice with students of museum studies and museum professionals? Through a case study of the yearly *wānanga* (workshop) which takes place on a Māori *marae* (village complex) in the Museum and Heritage

Studies programme at Victoria University of Wellington, I show how this model of a grounded museum studies as intercultural practice can be put to work and incorporate indigenous perspectives into teaching and research, theory and practice.

Background: the absence of practice in museum studies

What is the place of museum practice within museum studies? While there has obviously been much useful academic research on what museum professionals do, readers do not really find much direct writing about museum practice in the literature of museum studies, which has been concerned rather more with academic theory than with the everyday work of museums and galleries. The incorporation of social and cultural theory into the subject from the 1980s on was necessary for strengthening museum studies, and has produced much work of a high quality that has added immeasurably to the breadth and depth of the subject (Macdonald & Fyfe, 1996). However, this drive to theorise museums did have the unintended consequence of unhinging much research and writing about museums from current practice in museums (Grewcock, 2013). There has been an explosion of publishing, mostly written by academics and critics from a wide range of disciplinary backgrounds who have had plenty to say about museums, which furnish concrete manifestations of any number of fashionable scholarly topics, but that is arguably of limited actual use to museums, those who work in them or those who use them (Rice, 2003; Spiess, 1996; Starn, 2005). Indeed, research conducted among graduates of museum studies suggests many find the university curriculum too theoretical, and complain there should be more practical content in courses (Duff, Cherry & Sheffield, 2010, p. 376). Likewise museum professionals sometimes regard university programmes as out of touch and believe that degrees in museum studies are not necessarily good preparation for the workplace (Davies, 2007).

'Practice' is one of those ubiquitous words often heard in relation to galleries and museums, the visual arts and heritage, but what does it really mean? In art history and curatorial studies, and even more so in art criticism, there is a widespread habit of referring to contemporary art and curatorial 'practice', meaning the work(s) of an artist/artists whatever form or medium that might take, but this appears to be a loose application of the word that is not necessarily related to academic theories of social and cultural practice surveyed below (Schjeldahl, 2011). 'Theory' has been a buzzword in humanities scholarship for the last 30 years, though academic work on museums is often criticised for being overly theoretical and not grounded in current practice. Lois Silverman and Mark O'Neil (2012, p. 195) have complained with some justification that much theory is 'jargon–ridden, pretentious, and difficult to understand'. Some traditionalists working in museums do not appreciate the value of theory at all, seeing it as the ethereal product of ivory tower academics with little relevance to the demands of their working day. But of course 'common sense' is no excuse, as it is really just 'old theory', they remind us (Silverman & O'Neil, 2012, p. 195). At the same time they recognise that the museum profession finds 'graspable explanations' helpful to 'support and guide its practice'. The problem, according to Silverman and O'Neil, is that 'our demanding daily schedules leaves little time for deep, critical and sustained discussion and analysis of theory' and therefore a 'deeper and more complex understanding of the museum experience' (2012, pp. 193–194). They contend that 'too many museums remain uncommitted to the development of a deeper understanding of the field as a cornerstone of practice' (Silverman & O'Neil, 2012, p. 194).

Of course the relationship of theory and practice is rather more complex than naturalised understanding of abstract ideas in the academy and real work in the museum. This false dichotomy is harmful to both university research and professional work, as Hilde Hein observes:

> The challenge that museums face in a time of transition is obscured on the one hand by theoretical rhetoric that interprets museums from a distance and ignores their concrete vulnerabilities, and, on the other, by too close a focus on the immediate exigencies of circumstance, which then discourages speculative contemplation.
>
> *(Hein, 2000, p. ix)*

In order to overcome the false split between theory and practice, I argue that theories often underpin practical work, but equally practice should be understood as something that goes beyond mere day-to-day tasks and practical procedures – it could be argued that every time we carry out some activity or procedure, a theory or set of assumptions is in place to give meaning to that action. In a recent book, I put forward an integrated model of museum theory, practice, research and professional development which overcomes some of these problems by seeing them as part of the same continuum (McCarthy, 2015). Drawing on work by other scholars (McLeod, 2001; Simmons, 2006), I conclude that professionals in the field become researchers, and academics are immersed in practice – everyone collaborates in the service of common goals.

One part of the world where theory and practice, museum studies and museum practice, seem to be coming together is Canada. At a 2010 conference marking the 40th anniversary of the museum studies programmes at the University of Toronto, *Taking Stock: Museum Studies and Museum Practices in Canada,* Jennifer Carter and her colleagues positioned themselves as 'scholar practitioners' who cut across disciplinary differences to establish a common ground for discussion in 'issues-based dialogue':

> We intend that the term scholar practitioner refer to a variety of practices that currently characterize how museum scholars, professionals, and consultants engage in their work be it research, practice, or scholarship. While the term practitioner generally refers to someone who practices in the field, such as a museum educator or curator, the term scholar practitioner expands upon this concept to include scholars conducting fieldwork research and practitioners conducting scholarly research. Conclusions may fold back into practice and enrich our understanding of the nature and value of museum work.
>
> *(Carter et al., 2011, p. 417)*

The papers from this conference advance the conversation in several areas. Elise Dubuc for example talks about the need for an 'enlarged' pedagogy of museum studies programmes in response to the allied professionalisation and diversification of museum practices in a changing world which are characterised by 'interdisciplinarity, professionalization, globalization and new technologies' (Dubuc, 2011). Lyn Teather has a long-term interest in 'weaving back together a widening theory practice split in arts, culture and heritage work' (2009, p. 30). Teather seeks to empower the professional through reflexive learning and professional development: in other words a 'Critical Reflexive Museum Practice' (CRMP) (Teather, 1991, 2009). Teather's CRMP navigates a path beyond the 'dysfunctional divide' of practitioners and theorists by acknowledging that any theoretical precept relates to practice and vice versa (2009, p. 27). She argues that university curricula should employ action research through field work in museums which moves from theory to practice and back to theory. This 'theory-practice-theory' (Teather, 2009, p. 27) learning cycle reconnects the university and museum, advocating a critical museology while being wary of an 'extreme critical stance' which can 'block a transformative practice' (Teather, 2009, p. 28). Other scholars involved in museum studies, information studies and related fields at the University of Toronto recommend ways of 'challenging the idea that theory and practice exist as separate areas of knowledge'. Students engage

in 'reflexive case studies', by using an active learning framework to observe professionals at work or by participating themselves in museum work, such as mounting a real exhibition in a museum setting. In so doing, they argue, theory and practice are 'not presented as dichotomous educational goals' (Duff et al., 2010, p. 379).

Yet another scholar in Canada whose academic work *on* the museum is thoroughly grounded on her experience working *in* the museum is Ruth B. Phillips. In her book reflecting on the indigenisation of the Canadian Museum, Phillips contends that museum studies needs to make more use of case studies which provide both 'a site for theoretical analysis *and* models of innovative practices' (2011, p. 21). As a teaching methodology and pedagogy this has the appeal of opening out into museum training and 'inoculating' students against unrealistic and individualised models from the academy, instead preparing them for the negotiation and compromise required in the pluralist world of the museum, especially in working with native and tribal peoples. The equation Phillips proposes for research is an ideal synthesis for academics, students and professionals to aspire to: 'history + theory + practice = critical museology' (McLeod, 2001, p. 16). At this point, this chapter moves into the realm of practice theory, so I want to explore this field in more depth before assessing how it can strengthen and refine museum practice, and the artistic and cultural practices which it collects, exhibits and interprets.

Theoretical framework: practice theory

So what is practice? Most people would point to common sense dictionary definitions which describe the *practising* of a profession, the ongoing pursuit of a craft, or the practising of a skill to become proficient in it (note the difference between practice [noun] and practise [verb] in British English). Broader meanings include: action, regular activity, training and work (OED online). Here we have to note the difference between *practice* singular (understood as human action in general) and *practices* plural (seen as particular routinised types of behaviour) (Reckwitz, 2002, p. 249). Whereas professional practice in museums is generally seen in somewhat narrow terms as a set of working methods which is officially sanctioned, I want to take this basic understanding and re-theorise it by grafting on to it critical theories of cultural practices (Turner, 1994).

What I want to focus on here is the analytical purchase of practice theory for theorising museum practice and artistic practice in museums. In this chapter I argue that practice theory brings clarity to the analysis of museum practice and opens it up to critical interrogation. Of course we need to be mindful while focusing on professional practice not to treat it as a natural category that is somehow below the level of critical enquiry. In my research on museums in New Zealand, I found that the professionalisation of museum practice protected entrenched interests, thereby resisting change and inhibiting experimentation, for example smothering Māori efforts to regain control of their alienated ancestral heritage. When in the 1980s the ground-breaking exhibition *Te Maori* initiated sweeping changes in the ways in which Māori objects or *taonga* were dealt with in collections, exhibitions and public programmes, it was possible for these changes to occur because the sector was relatively unprofessionalised (McCarthy, 2007).

In itself, local museum practice in New Zealand museums was a relatively self-interested and conservative European paradigm that was part of the domination of indigenous material culture and heritage within the British Empire. However, despite a history of British colonisation familiar to other former settler colonies such as Australia and Canada, the indigenous Māori people have engaged with museums successfully over the last 30 years so that now aspects of professional practice are strongly inflected by Māori perspectives and values, e.g., collection care incorporates elements of *tikanga* (cultural practice) in the management of *taonga* (treasures)

by *kaitiaki* (literally 'guardians', but also the term used for Māori collections staff). In my book *Museums and Māori* (2011), based on interviews with over 60 academics, professionals and community leaders, a political analysis of the dramatic changes in New Zealand museums over the last three decades reveals both the resistance of mainstream museology to different ways of doing things and the power of indigenes to adapt and steer mainstream institutions to their own goals and interests.

The turn to practice, seen in much recent work in science and technology studies, has much to offer the study of museums and the arts by avoiding the preoccupation of cultural theory with language and meaning. Attention to practice, seen as emergent, performative and relational (Pickering, 1995; Pickering & Guzik, 2008), allows scholar/practitioners to be more attentive to the complex organisational interplay of things, people and organisations with their constantly changing networks of social and material agency. It is thus eminently suited to seeing objects, collections, exhibitions, and the professionals who manage them, within a broader social context without losing sight of the often intimate relations between them.

Where did practice theory come from? Practice theory has a long academic genealogy with the work of sociologists such as Pierre Bourdieu, who sought to balance the study of powerful structures in society by paying more attention to human action. As well as schools, asylums and other institutions, Bourdieu took a great interest in museums, photography, literature and other arts, and the ways in which, while supposedly being open to all, they actually preserved social distinctions:

> The museum, as it isolates and separates (*frames apart*), is undoubtedly the site *par excellence* of that act of *constitution* . . . through which both the status of the sacred conferred on works of art and the sacralizing disposition they call for are affirmed and continually reproduced.
>
> *(Bourdieu, 1995, p. 294)*

Sadly, only a handful of scholars have picked up on Bourdieu and practice theory in museum studies and related fields (Grenfell & Hardy, 2007). In curatorial studies, Paul O'Neill is one, who in describing the rise of the curator as a creatively active producer or agent in the creation of art who works with rather than against artists and community, quotes Bourdieu's point that the creator of value and meaning of an artwork 'is not the producer who actually creates the object in its materiality, but rather the entire set of agents engaged in the field' (O'Neill, 2007, p. 15). Museum director and academic Anthony Shelton, well known for his groundbreaking work with native peoples at the Museum of Anthropology at the University of British Columbia in Vancouver, has recently presented a manifesto (Shelton, 2013) for critical museology drawing on Bourdieu's field theory. Critical museology analyses 'operational museology', which has 'constructed the museum's institutional authority on an uncritical acceptance of empirical methodologies anchored in theories of objectivity' (Shelton, 2013, p. 11). In opposition, Shelton argues that 'museological practices should be understood in relation to the field in which they unfold'. 'This reflexivity is a necessary condition for establishing a theory of practice,' he adds, 'from which a practice of theory can emerge' (2013, p. 14).

In my own work analysing art and culture, museums and indigenous people in a former settler society, I have found art history and theory little help, but Bourdieu's work is useful in investigating the complex relations between things, people and society (Bourdieu 1984, 1993; Bourdieu & Darbel, 1991). While working in and studying museums, I have always sought ways to link object and subject, structure and agency, production and reception within the same analytical frame. As Steinmetz points out, Bourdieu is often understood as a crudely structuralist

theorist of reproduction who underestimates social agency, but his key concepts should really be understood as inherently historical and open to 'conjuncture, contingency and radical discontinuity' (Steinmetz, 2011, p. 46). In contrast to some cultural studies where theory becomes a heuristic device, or a box to place data into, or even a concept imposed on or read off a topic/ site, Richard Harker and his New Zealand colleagues argue in an important book on Bourdieu's 'practice of theory' that theoretical work has to be grounded 'through empirical research and ethnographic investigation' (Harker, Mahar & Wilkes, 1990, p. 10). They describe his work as 'generative structuralism' which accounts for 'both the genesis of social structures and of the dispositions of the habitus of the agents who live within these structures' (1990, pp. 3–4). A useful formulation is provided: '(habitus × capital) + field = practice' (1990, p. 7). I have always found this formula very appealing because it links the notions of 'habitus' and 'field' in pointing to 'practice', the everyday social actions and things that people do, so helpful in thinking about art and culture. In looking at objects in social and relational rather than philosophical or aesthetic terms, Bourdieu provides a useful model of material culture, in which, as John Codd put it, art is seen as 'a cultural product situated at a conjuncture of economic, social and historical conditions, any of which may change with the course of time' (Codd, 1990, p. 153). As Bourdieu wrote, 'The experience of the work of art as being immediately endowed with meaning and value is a result of the accord between the two mutually founded aspects of the same historical institution: the cultured habitus and the artistic field' (1993, p. 257).

According to Harker et al. (1990, pp. 8, 9) Bourdieu's theory of the field construes social domains as 'a field of forces, a dynamic space in which various potentialities exist' including 'areas of struggle'. Another French scholar, Michel de Certeau, although very different in orientation, sees the practice of everyday life in similar terms, as tactical 'ways of operating', thus demonstrating that people do not simply consume products in a passive way (de Certeau, 1988, p. xi). For anthropologists, analysing cultural practices allowed them to take account of both structure and agency, because practice provided a more complete account of the social world, showing that people are not simply victims of brute social and economic forces looming over them from above (Sahlins, 2005). As Sherry Ortner argues, practice theory situates cultural processes in the grounded social relations of people and institutions, revealing the dialectical connections between the practices of social actors on the ground and the systems that constrain them but which are also capable of being transformed by them. It therefore gives us the tools to examine 'the production of social subjects through practice in the world' as well as 'the production of the world itself through practice' (Ortner, 2006, p. 16).

In an important book on the 'practice turn', Theodore Schatzki and his co-authors call practice a 'set of actions', but also a 'nexus of doings and sayings' which combines the things that people say and write as well as do (Schatzki, Knorr-Cetina & von Savigny, 2001, pp. 48, 53). Furthermore, Schatzki et al. say that practices are 'embodied, materially mediated arrays of human activity centrally organised around shared practical understanding' (2001, p. 2). In a similar vein Andreas Reckwitz explains that practice is not just doing anything at all, but is a 'routinized type of behaviour consisting of several elements interconnected to one another: forms of bodily activities, forms of mental activities, "things" and their use, a background knowledge in the form of understanding, know-how, states of emotion and motivational knowledge' (Reckwitz, 2002, p. 249). This 'block' or complex of 'body/knowledge/things' is understandable not just to those carrying out the practice but to outside observers as 'a routinized way in which bodies are moved, objects are handled, subjects are treated, things are described and the world is understood' (2002, pp. 249–250).

What does practice theory have to offer the study of professional practice? Theorising museum practice as a social practice provides a focus on practice as an important domain of

museum work in its own right. 'Practice, broadly speaking, is what we do,' writes Joy Higgs, 'and more specifically what we as practitioners do in particular practice communities and how others engage with this practice' (Higgs, 2010, p. 1). Another advantage of practice theory, is its capacity to strengthen and redirect, and refine research on/in/through museum practice. By foregrounding action and performance, and exploring human patterns of behaviour in the workplace, practice theory positions practice as the first object of enquiry and consequently reveals embodied actions, meaning formed by doing, and the performance of everyday work.

The turn to practice, then, allows scholar/practitioners to be more attentive to the complex organisational interplay of things, people and organisations with their constantly changing networks of social and material agency. In place of the theoretical obsession with representation, the idea of practice as 'thought-in-action' emphasises immanence and becoming (Thrift, 1996, p. 7; Thrift, 2008). In summary, practices can be seen as the 'regular, skilful "performance" of human bodies' (Reckwitz, 2002, p. 251). As Reckwitz puts it: 'Practice theory "decentres" mind, texts and conversation. Simultaneously, it shifts bodily movements, things, practical knowledge and routine to the centre of its vocabulary' (2002, p. 259).

Another advantage of practice theory, is its capacity to strengthen and redirect, and refine research on/in/through museum practice. By foregrounding action and performance, and exploring human patterns of behaviour in the workplace, practice theory positions practice as the first object of enquiry and consequently reveals embodied actions, meaning formed by doing, and the performance of everyday work. Currently museum studies lacks the kind of wide-ranging and detailed empirical studies of professional practice in museums that are found in practice-based enquiry in hospitals, schools and other professional settings. This is necessary because the sector in countries such as New Zealand and Australia is still fragmented and under-professionalised with staff who come in to museums from different backgrounds (usually without degrees in museum studies), with little sense of unified professional identity. The lack of a research base for professional work in the contemporary museum is a serious shortcoming. We need more research on professional practice in museums, studies of staff working in exhibitions, collections, marketing, public programmes and other functions and roles *across* the organisation, not just directors, curators and educators, and the traditional focus on 'the stuff' at the expense of what people do in museums. If museums are the site of analysis, the place where all disciplines and methods are brought to bear on the problems and issues facing professionals today, and if the findings of this research are fed back into university teaching and professional development working in partnership with them, then practice will become a more important part of museum studies, grounding and consolidating it to better serve academics, students, professionals and indeed museums themselves.

Finally, I have applied this model described here, a museum studies grounded in practice, to a new book: *Museum Practice* (McCarthy, 2015), which is part of the series *International Handbook of Museum Studies*. Whereas the other volumes in this series cover museum theory, media and transformations, this one focuses on current practice. It sets out to balance theory and practice, analysis and debate with an assessment of recent trends which is grounded in and illustrated by concrete examples and case studies. As a handbook, I see this volume not as a textbook as such, but a reference work which describes and critically analyses current practice from the gound up in order to provide a clear overview of the contemporary museum at work. No less than 27 authors, who are mostly experienced professionals, write about a broad range of topics unprecedented in their scope and detail: mission, governance, policy, audience, ethics, value, economics, marketing, collections planning, management and care, conservation, repatriation, curatorial theory and practice, exhibition development, design and display, community engagement, visitor research, educational and public programmes, and digital heritage in its many forms.

Putting (practice) theory into practice: *Wānanga Taonga*

Merely writing this book about museum policy and practice was not enough. While writing it I have tried, with some success, to direct the findings from the research back into a university course on the same topic as part of our Master's degree at Victoria University, as well as professional development in the wider sector. Since 2013, we have held weekend *wānanga* (workshops) on a *marae* (meeting place) outside Wellington exploring Māori approaches to a range of museological topics including governance, collections, exhibitions, community engagement, conservation and research. Through a partnership between our university programme and the national museum sector training organisation National Services Te Paerangi, we brought together Māori experts from museums, university and local community to speak to the students and professionals who attended the course, mixing together and learning from one another. This was an example of the kind of blended learning I am advocating in this chapter, in which theory and practice, university and museum, come together to address common concerns.

The *Wānanga Taonga* (workshop on cultural treasures) has now been run annually for the past three years as a weekend sleepover (Friday–Sunday) held on *Hongoeka marae* near Plimmerton. It is offered to a total of 40–50 people, made up of Museum and Heritage Studies and other university students, university staff and heritage professionals from the local sector. *The wānanga* aims to equip students and professionals with the knowledge, understanding and skills to work with Māori communities and appreciate different cultural perspectives on heritage reflecting the latest thinking on values education (Atkinson 2014). The participants are required to go through a *pōwhiri* (welcome ceremony), sing a *waiata* (song) and deliver a *mihi* (introduction in the Māori language), help out in the *whare kai* (dining room), and participate in workshops on a variety of topics including *tikanga taonga* (Māori cultural practices for looking after treasures), the Treaty of Waitangi, *mātauranga Māori* (Māori knowledge), and *kaupapa Māori* (Māori-based methodologies). An important part of the process is the opportunity to mix with and learn from the small local community, the Ngati Toa people, and see firsthand how they view the landscape, care for their *taonga* (treasures), engage with museums and the local city council, and consider their future cultural heritage development. In this specific context, museum and heritage practice is seen as something concrete, connected, performed, and intimately linked with people's lives and wider environment.

The learning style is based on the Māori *whare wānanga* (tribal houses of learning) in which students sit around in a circle inside the meeting house engaging in discussion, group work and activities. Readings are examined, and then participants are asked to consider scenarios they may face in the workplace and come up with responses to do with how they would deal with Māori objects, communities and worldviews. The *wānanga* ends with a panel of Māori heritage professionals talking about current issues in the sector. The *wānanga* is taught with staff of Te Kawa a Māui, and offered in partnership with National Services Te Paerangi, the training organisation based at Te Papa. It is very attractive for professionals in local organisations who want to know more about this important area of current practice, and reflects the programme objectives of bringing together theory and practice, and developing an Indigenous Museology that will serve the needs of Aotearoa New Zealand into the future.

The *wānanga* run in 2013 and 2014 received very positive feedback through informal channels from both students and professionals, particularly for the sense of immersion in Māori culture, the opportunity to apply theory to practice and the shared learning experience and opportunity for university–sector networking. In 2015 we conducted a more formal evaluation of the *wānanga*. All of the sessions were ranked higher than a 2-point average on a scale where 1 = very helpful. A sample of comments for what participants 'most enjoyed' include:

'1: learning about the spirituality of the customs and the taonga of the Maori; 2: getting to know fellow students; 3: the immersion of the time in terms of being at the marae and its customs.' (MHST student)

'All of it! Each discussion was interesting. Staying at the marae was a unique experience for me.' (Professional)

'Learning history of Hongoeka and Ngāti Toa Rangatira's *mātauranga tuku iho* (knowledge handed down). Awesome speakers and discussion.' (Professional/MHST student)

Other comments that illustrate how participants appreciated this experience include:

'It was very valuable to our studies giving us insight we wouldn't have learnt any other way.' (MHST student)

'Hongoeka was an excellent choice of location – very special to stay in this community and I found myself admiring the place, the people and the work they have done. Added value moving away from University environment.' (Professional)

Conclusion: intercultural arts practices

In this *Handbook*, the term 'intercultural' points to the complexity of locations, identities, and modes of expression in a global world, and the desire to facilitate awareness, dialogue or understanding across contexts. The term interculturality suggests that artistic and cultural practice resides both in a location – whether geographical, spatial, or corporeal – and also within an in-between space – among and within individuals, milieu, social constructs, and cultures. In addition the editors argue that the word 'practice' refers to conceptual processes as well as to processes of making and becoming. These ideas have, I hope, been reflected in the discussion of museum studies and practice, New Zealand museums and indigenous cultural/museum practices surveyed in this chapter. The experience of museums in the South Pacific is in line with this theoretical framework, reinforcing the notion of museum practice as something flexible, interconnected, and performed, a social practice which is imbedded in local political and cultural contexts. I have shown how an understanding of both arts and heritage, and the museological work which manages, displays and interprets it, as *intercultural practices*, aids in the wider critical analysis of museums and indigenous people and culture. I have also demonstrated how indigenous museum workers transformed the ways in which they collected, exhibited and managed their cultural heritage – in other words through the emerging Māori museum practice seen in local institutions – by educators, curators, managers and other staff, who likewise work to decolonise the institution through their actions. In conclusion, museum studies/practice can be seen as intercultural mediation, the work of changing society by actively working on, in and through the social.

References

Atkinson, J. (2014). *Education, values and ethics in international heritage: Learning to respect.* Farnham: Ashgate.

Bourdieu, P. (1977). *Outline of a theory of practice* (Trans. R. Nice). Cambridge: Cambridge University Press.

Bourdieu, P. (1984). *Distinction: A social critique of the judgement of taste* (trans. R. Nice). London: Routledge and Kegan Paul.

Bourdieu, P. (1993). *The field of cultural production: Essays on art and literature.* New York, NY: Columbia University Press.

Bourdieu, P. (1995). *The rules of art: Genesis and structure of the literary field* (trans. S. Emanuel). Stanford, CA: Stanford University Press.

Bourdieu, P., & Darbel, A. (1991). *The love of art: European art museums and their public* (trans. C. Beattie & N. Merriman). Oxford: Polity Press.

Carter, J., Castle, C., & Soren, B. (2011). Introduction: Taking stock – museum studies and museum practices in Canada. *Museum Management and Curatorship, 26*(5), 415–420.

Codd, J. (1990). Making distinctions: The eye of the beholder. In R. Harker, C. Mahar, & C. Wilkes (Eds.), *An introduction to the work of Pierre Bourdieu: The practice of theory* (pp. 132–159). London: Macmillan.

Davies, M. (2007). *The tomorrow people: Entry to the museum workforce.* Report to the Museums Association and the University of East Anglia. http://www.museumsassociation.org/download?id=13718 (1 November 2013).

De Certeau, M. (1988). *The practice of everyday life.* Berkeley, CA: University of California Press.

Dubuc, E. (2011). Museum and university mutations: The relationship between museum practices and museum studies in the era of interdisciplinarity, professionalisation, globalisation and new technologies. *Museum Management and Curatorship, 26*(5), 497–508.

Duff, W., Cherry, J., & Sheffield, R. (2010). 'Creating a better understanding of who we are': A survey of graduates of a museum studies program. *Museum Management and Curatorship, 25*(4), 361–381.

Grenfell, M., & Hardy, C. (2007). *Art rules: Pierre Bourdieu and the visual arts.* New York, NY: Berg.

Grewcock, D. (2013). *Doing museology differently.* London: Routledge.

Harker, R., Mahar, C., & Wilkes, C. (Eds.). (1990). *An introduction to the work of Pierre Bourdieu: The practice of theory.* London: Macmillan.

Hein, H. S. (2000). *The museum in transition.* Washington, DC: Smithsonian Institute Press.

Higgs, J. (2010). Researching practice: Entering the practice discourse. In J. Higgs, N. Cherry, R. Macklin & R. Ajjawa (Eds.), *Researching practice: A discourse on qualitative methodologies* (pp. 1–8). Rotterdam: Sense Publishers.

Macdonald, S., & Fyfe, G. (1996). *Theorizing museums: Representing identity and diversity in a changing world,* Cambridge, MA: Blackwell.

McCarthy, C. (2007). *Exhibiting Maori: A history of colonial cultures of display.* New York, NY: Berg.

McCarthy, C. (2011). *Museums and Maori: Heritage professionals, indigenous collections, current practice.* Wellington: Te Papa Press.

McCarthy, C. (Ed.). (2015). *Museum practice.* Malden, MA: Wiley Blackwell.

MacLeod, S. (2001). Making museum meanings: Training, education, research and practice. *Museum Management and Curatorship, 19*(1), 51–62.

O'Neill, P. (2007). The curatorial turn: From practice to discourse. In J. Rugg & M. Sedgwick (Eds.), *Issues in curating contemporary art and performance* (pp. 13–28). Bristol: Intellect.

Ortner, S. (2006). *Anthropology and social theory: Culture, power and the acting subject.* Durham, NC: Duke University Press.

Phillips, R. B. (2011). *Museum pieces: Towards the indigenization of Canadian museums.* Montreal, QC: McGill-Queen's University Press.

Pickering, A. (1995). *The mangle of practice: Time, agency and science.* Chicago, IL: University of Chicago Press.

Pickering, A., & Guzik, K. (Eds.). (2008). *The mangle in practice: Science, society and becoming.* Durham, NC: Duke University Press.

Reckwitz, A. (2002). Towards a theory of social practices. *European Journal of Social Theory, 5*(2), 243–263.

Rice, D. (2003). Museums: Theory, practice and illusion. In A. McClellan (ed.), *Art and its publics: Museum studies at the end of the millennium* (pp. 77–95). Oxford, MA: Blackwell.

Sahlins, M. (2005). *Culture in practice: Selected essays.* New York, NY: Zone Books.

Schatzki, T. R., Knorr-Cetina, K., & von Savigny, E. (2001). *The practice turn in contemporary theory.* London: Routledge.

Schjeldahl, P. (2011). Of ourselves and our origins: Can we speak sensibly about what we like about art? *Frieze,* 137 (March). Retrieved from http://www.frieze.com/issue/article/of-ourselves-and-of-our-origins-subjects-of-art/ (1 December 2013).

Shelton, A. (2013). Critical museology: A manifesto. *Museum Worlds, 1,* 7–23.

Silverman, L., & O'Neill, M. (2012). Change and complexity in the 21st century museum. In G. Anderson (Ed.), *Reinventing the museum: The evolving conversation on the paradigm shift* (pp. 193–201). Lanham, MD: AltaMira Press.

Simmons, J. E. (2006). Museum studies training in North America. In S. L. Williams & C. A. Hawks (Eds.), *Museum studies: Perspectives and innovation* (pp. 113–128). Washington, DC: Society for the Preservation of Natural History Collections.

Spiess, P. D. (1996). Museum studies: Are they doing their job? *Museum News, 75*(6), 32–40.

Starn, R. (2005). A historian's brief guide to new museum studies. *American Historical Review, 110*(1), 68–98.

Steinmetz, G. (2011). Bourdieu, historicity, and historical sociology. *Cultural Sociology, 5*(1), 45–66.

Teather, L. (1991). Museum studies: Reflecting on reflective practice. *Museum Management and Curatorship, 10*(4), 403–417.

Teather, L. (2009). Critical museology now: Theory/practice/theory. *Muse, 27*(6), 23–32.

Thrift, N. (1996). *Spatial formations*. Thousand Oaks, CA: Sage.

Thrift, N. (2008). *Non-representational theory: Space, politics, affect*. London: Routledge.

Turner, S. (1994). *The social theory of practices: Tradition, tacit knowledge and presuppositions*. Chicago, IL: University of Chicago Press.

4

RECASTING IDENTITIES

Intercultural understandings of First Peoples in the national museum space

Sandy O'Sullivan

Introduction

Ethnographic museums have been difficult places for Indigenous Peoples[1] and our[2] Communities. The ongoing social history project of the nineteenth and twentieth centuries placed museums as authorities over our cultures, with many collections possessing significant artifacts and some holding captive the bodies of our ancestors (Gallagher, 2010, p. 70). It is only through recent and hard-lobbied changes in legislation that modifications to these practices have begun over the last few decades (Gallagher, 2010; Yellowman, 1996; Young, 2010). Even with a greater level of engagement, the measures to ensure the agency of First Peoples remain difficult and costly legal entanglements for both museums and communities, frequently placing each at odds with the other (Krmpotich, 2010; Lonetree, 2013; Mulk, 2009). This engagement is the backdrop to the engagement between Communities and museums, and points to a difficulty for the institution of the museum to comprehend what Communities value.

In order to recast our identities within the museum space, Communities must be assured that we are heard when we make the most basic of requests around repatriation of our ancestors and the return of sacred objects. With this expectation as the baseline, this chapter explores how we repair and build our relationships with the museum space by having our multiple voices present in leading change from within the system. It also calls for moving beyond approaching every interaction as isolated through parsimony and accord, and towards ongoing agency within the system. Presented across this chapter is a puzzle around that space of engagement that incorporates a necessary articulation of the intercultural relationship between museum professionals and the Communities they represent and engage.

Representation matters: the case for a parallel journey

In 2009 I began five years of research that initially involved a comparative review of museums across Australia and the United States. The brief of the research was simple: to ask museum professionals what work or activities best engaged and represented their country's own First Peoples. The two country sites originally selected were the United States and Australia. As a Wiradjuri academic my focus was on the importance of insider engagement in the review, so Australia was an obvious national site. With significant financial support from the Australian

Research Council, the project applied an imperative around knowledge that would enhance Indigenous engagement within mainstream cultural spaces. The United States was identified as an aspirational comparative nation-state, with both countries sharing resonances around engagements between Indigenous Peoples and the post-invasion occupier nation.

New Zealand, as one of our nearest, similarly colonised nations, has a robust and engaged representation of Maori Peoples across their national museums, including in the internationally lauded Te Papa (Carey, Davidson & Sahli, 2013). While their spaces are significant, some key markers that connect Australian Indigenous populations with the communities of the United States are not shared with our Maori cousins. In particular a larger number of Indigenous languages and uniquely identified communities span the modern nations of Australia and the United States, in both cases in the hundreds. Beyond language and separate yet similar reflections of identity and belonging, the US and Australia also share a relative percentage of Indigenous to non-Indigenous populations, and are spread across a similar vast landmass. Though these connections form the comparative base, there are also differences, particularly in relation to agency, self-determination and—relevant to the context of museums—volume and scope.

Across the modern social history museum there has been a shift in engagement with represented Indigenous communities. Our more active participation in the development of programs such as the Native American Graves Protection Repatriation Act, an Act written from a body of work enacted for the National Museum of the American Indian (Chari & Lavallee, 2013, p. 20), has led to the direct involvement of First Peoples as curators, administrators and leading figures in the development of both mainstream and our own Indigenous-led spaces (Lonetree, 2013). The hundreds of tribal museums throughout the United States, the few Indigenous-led and curated spaces across Australia, and the national museums that had, as their brief, the representation of all Peoples, were the first ports of call for the research.

The personal, the political and the insider process

Before I began this study, I had worked extensively across the repatriation of human remains and cultural materials. I was familiar with the complex nature of this work and understood the difficult relationships that it carries between communities and museums. In 2009, while a visiting scholar at a university in the United States, I took time to view their anthropology museum. As I entered the foyer I spotted a curator I had engaged with on a repatriation process some years before. The process had been both problematic and fruitful, resulting in a clearer understanding of the cultural items that the museum held, but not in the act of repatriation. I was about to greet them when I believe I saw them retreat to avoid me. Regardless of whether I read this reaction correctly, my perception of the response was to be both amused and dismayed, and it began a journey towards wondering why we—as Indigenous Peoples—are sometimes perceived as problems for museums to solve, rather than potential partners in the solution that our communities and the museum require (Lonetree, 2013).

In responding to this moment, the project has sought out positively charged activities, exhibitions, processes and engagements that have endorsements and interest for both parties. Through applying a combination of phenomenology and narrative inquiry, the study aimed to use Indigenous concepts of yarning (Fredericks, 2010; Kovach, 2010; Rigney, 1999) and to focus on the measures that each museum articulated. At the centre of the research was the notion that our voices could be privileged (Fredericks, 2009; Graham, 2008; Kovach, 2010; Rigney, 1999) to give a greater sense of self-determination and a more appropriate level of representation. Aboriginal academic Aunty Mary Graham's treatise to remember that value is about connections and knowledges, not objects, led the early discussions around representation.

As a marker for positively charging the research, "what works?" became the main question for each of the 450 museums reviewed in this study. With a focus on representation and engagement of First Peoples, the question was fraught for many of the museums that initially expressed concerns about answering this, reflecting that the question should instead be put to First Peoples' Communities. As an important first act in this research, I spoke to groups of Aboriginal and Torres Strait Islander Australians to find out what they expected from museums. I was surprised to hear that many community members felt, conversely, that I should instead be speaking to museums, as they were the ones who lead, evaluate and strategise these processes. While both the museums and the Communities were effectively suggesting that success markers were set by the other, I used these consultations as a measure to clearly articulate an approach that would affect the relationship change that Communities sought.

In retrospect and after five years and 450 museums, it is clear that in asking museum professionals "what works," the accountability is allocated back to the museum, requiring them to evaluate their own parameters. If the responsibility to engage, represent and accurately reflect who we are as First Peoples then lies with the museum, any oversight cannot be dismissed as a fault of the community. The name of the project, *Reversing the gaze*, acted as a reminder of this scrutiny; it would be the museum that would be asked to showcase its successes and understand how, and why and for whom they "work." Further, it would be the people of the museum that would ultimately determine what works, and they—rather than the buildings or processes they inhabit, became central as the agents of intercultural exchange. As an Indigenous researcher and as an Aboriginal woman, I have been culturally instructed to understand that as custodians of Indigenous knowledges we should be the ones who determine whether a research activity that includes us is relevant or "works." Although the material is submitted here and in other academic forums for both Indigenous and non-Indigenous Peoples to consider, using these same measures, the research primarily belongs, and is addressed to Indigenous Peoples.

The day the wheels came off: shifting ontologies

At the end of an early focus group session, an Aboriginal Elder asked me if the research would include museums in the United Kingdom. Thinking that she was confusing the current project with my work on repatriation, I explained that this research would shift focus from European museums to how we are being represented in our own countries, and across our own stories of nation. She repeated, "Yeah, I was right there listening to you, that's what I mean, why aren't you asking them." Her argument was that "You can tell a lot about how people represent others by how they represent themselves" (Focus Group, personal communication, 2009), and that empathy shown to their representations of other First Peoples might be examined through the lens of their own nuanced values and comprehension.

After more than a decade of focused work around the museum space and thinking about representation and engagement of our peoples, I felt—appropriately—like an infant being helped through a difficult first puzzle. In further discussion, the Wiradjuri Elder—who does not wish to be named—suggested that by inquiring about First Peoples it would compel the museum staff to consider that their institution operates within an existing and enduring cultural frame from which they present the culture of others. Only a few years before, this had become a contentious issue when many major museums in Europe and North America signed the *Declaration on the Importance and Value of Universal Museums* (DIVUM, 2002) suggesting that the "universal" was possible in approach and scope, and that some museums sat above culture, having a more over-arching brief (Mason, 2013). Beyond important concerns that not a single museum from Africa or Asia was considered, the accord was immediately challenged as elitist and positioned

from a space of cultural erasure. Although the declaration is rarely invoked by its constituent members, it is a worrying reminder of the extent to which some major museums will go to demonstrate that they operate disconnected from the community that they inhabit (Herle, 2008; Marceau, 2007; Thompson, 2003).

The Elder's suggestion was followed and the result has had a profound impact on the research findings and, reflected in some of the broader reporting, on the research participants. In prompting a simple, positively charged question around First Peoples in the context of Britain, the research process would reveal denial, anger, obfuscation, redirection, misdirection and, in some cases, engagement. Some of the findings are detailed here as measures in understanding the investment and capacity in supporting the voice of First Peoples, but also in revealing the underlying concerns of some museum professionals when considering, for the first time, that they are engaged in an intercultural exchange, rather than an act of representation.

Britain in deep time

Having comprehensively considered critical race issues, my approach was not naive—I was aware of the political implications of using terms such as "Indigenous" in the UK, and of explicit concerns about how published material could be co-opted in racist or misleading ways (Johnson & Goodman, 2013). In the UK Information Sheet provided to museums, I devoted an entire page to both addressing and assuaging concerns that resulting research might fuel nationalist and racist rhetoric, or challenge cultural diversity, immigration or aspirations of a multicultural nation. Appropriately, as spaces of inclusion, policies of diversity are often built into a range of national museum spaces (Simon, 2010, p. 214), and many curators and museum professionals have voiced a concern that their involvement in the study may be counter to their institutional mission.

Following the first four months of museum review in the United States and Australia, across countries that reflected a complex yet familiar set of narratives of identifying and defining First Peoples and First Nations, I landed in Britain to begin to consider First Peoples representation across their museums. The process of museum selection across the United States and Australia was difficult, but primarily reflected museums that represented and/or engaged First Peoples. National and State museums across both countries often articulated this as a part of their brief, Indigenous nation-based museums were clear in their acts of representation, and while none of this process was unproblematic or homogeneous, the process resulted in a set of measures, specific examples and processes that are being disseminated as we approach the final stages of the research. Even as the results, scope and impact varied, the museum staff could comprehend the picture that the project was building of success in engagement and representation, frequently expressing satisfaction in being involved in an edifying project and looking forward to the findings.

Positionality is key to Indigenous engagement in research (Smith, 1999), so the information sheet provided to museums explained who I am, including my cultural background as a Wiradjuri woman. My cultural identity is important across all of my work in Indigenous research as it reveals my insider status. In the context of this work it is particularly relevant, though many Indigenous researchers would argue it always is (Kovach, 2010, p. 39) as it positions who we are in the world (Graham, 2008). As a gesture of introduction, when I met museum staff I would ask about their cultural backgrounds. For non-Indigenous curators across the United States and Australia, they would often articulate their lack of connectedness to the material presented, although sometimes they would explain their own cultural background in relation to the work we were discussing.

I had a similar experience when I visited two of the museum systems across Great Britain — National Museum Wales, comprising of seven museums, and National Museums Scotland, comprising of four—with curators from both museums, respectively, articulating their connection to Wales and Scotland. Both of these systems consist of a range of museums that have the names "Wales," "Welsh," "Scotland" or "Scottish" in them. Across England there is no formal system that unifies with a centralising name, and there is only one museum that contains the word "English": the Museum of English Rural Life (MERL). Although a university-based museum, MERL does contain a national collection and their engagement in the project assisted in informing some of the structures of Englishness. The majority of national museums in London have an international brief, though most contain at least a modest amount of English or British material across their collections. Many flagged in the initial review that they were not particularly engaged in English representation/s. This signposted two things for the project: first of all that a sometimes seamless conflation of "England" with "Britain" would prove problematic across the review and, second, that the absence of spaces of representation highlighted a deeper issue in the fabric of museum management across the nation.

Scotland as a site of engagement

The first visit to the National Museum of Scotland (NMoS) followed eight months of museum visits across Australia and the United States. The NMoS was, at the time, undergoing a major renovation to its larger museum space, and so my focus was only on the Scotland Galleries. A nation-focused space, the multi-storied/storied visitor experience follows a chronology from deep time in the basement gallery up to the contemporary era. Accompanied by the Curator of Scottish Life and the Diaspora, David Forsyth, I was introduced to a museum that was much like any Indigenous museum I have visited before or since. In the galleries that covered deep time, I was reminded of museums like the Mashantucket Pequot Museum, the Ziibiwing Center of Anishinaabe Culture and Lifeways run by the Saginaw and Chippewa Communities, and the Bunjilaka Aboriginal Cultural Centre at the Melbourne Museum, with all of these using the terms "we" and "us" to describe First Peoples of an earlier era (Grieves, 2013). Unlike many mainstream museums, First Peoples museums will often connect deep history to the present, through the use of first-person collective language (Lonetree, 2013). In the deep-time descriptions of life, the visitor reads first-person narratives that both respond to the archaeological record confabulating with imagined scenarios. As the visitor moves up the chronological layers within the NMoS, they encounter the space of Scotland being colonised and transformed, still further up Scotland's participation in the project of British colonisation is revealed, until finally the last two levels deliver a contemporary Scotland and a rooftop view of the City of Edinburgh. The contemporary gallery clearly manifests the Indigenous museum by centring identity and nation on difference and protest. The formation of the Scottish Parliament crescendos across the gallery, the history leading to it variously describes an oppressed, othered Community finally free of English Imperial decisions and some of the markers of this oppression across the 20th century. Representations include two negative portrayals of former Prime Minister Thatcher: one satirising her as a vampire, the other using her words framing Scotland as financially reliant on Empire. The movement and struggle towards autonomy are at the heart of the descriptions of a modern Scotland and Scottish identity (Trevor-Roper, 2008).

Prominent in the "Modern Scotland" gallery, *One nation, five million voices* is a video installation that shows just how this sense of identity is based on nationhood, rather than ethnic origin, with first-person explanations of cultural practices, perceptions, food and ephemera recalled

both by Scottish-born and seemingly heritaged Peoples, foreign-born or second-generation Scots, and people new to Scotland, all articulating what Scotland means to them. Irn Bru, haggis, kilts, Scottish disposition, foreigners mixing up Scotland with Britain or England, Scots and Gaelic words, songs, fried foods, ways of thinking, being and imagining—ontologies, axiologies and epistemologies—are all played out as humorous, affectionate markers of Scottish identity. They operate within an insider, location-based museum that has roots that are not, to borrow the DIVUM idea, universal (Cheape, 2010).

These reflections on Scottish identity and the nation-status of the museum move beyond the representation of self in the museum, and into the relationship with other represented communities. Chantal Knowles, a then curator at the National Museum of Scotland, described her experience of working with representatives of the Canadian nation of the Tlicho, of whom the NMoS holds a significant collection. In 2008 the NMoS mounted an exhibition with the Tlicho that focused not only on a collection that dated back to an older age of colonisation and acquisition, but with revised knowledge and contemporary materials from the Tlicho. Importantly, the exhibition included the stories of the Tlicho nation, and of the relationship between Scottish and Tlicho Peoples. Knowles discusses the contentious term of "nation" in the context of a shared difficult naming for both Tlicho and Scotland, as both inhabit internationally unrecognised nationhood (Knowles, 2011). Her discussion of this shared history goes some way to explaining the less problematic engagement with the *Reversing the gaze* research project for both Scotland and Wales, two countries that can draw a strained, shared relationship as insider, colonised and coloniser.

The problem with Britain

As I began to engage with museums in England, I found the concept of First Peoples harder to articulate. I had the experience in Scotland and Wales of the many curators and professionals across their museums expressing interest and engagement as together we navigated what First Peoples might mean. Engagements that had been relatively fluid across the US, Australia, Scotland and Wales were strained when I asked about the representation of Early Peoples in England. Many of the museum professionals in England expressed concerns over the exclusion of others in the community, and the potential for the articulation of English cultural identity or Englishness to be divisive. I was warned off the process of inclusion by many people, and after a number of frank discussions started to doubt the helpfulness of discussing First Peoples in England. Remembering the brief to find out how they treated their own Peoples, I pondered the resistance, the idea that the modern English person had sprung from nowhere, and as though a cultural through-line did or could not exist. I did, however, understand that it could prove difficult to demonstrate and unhelpful to frame a contemporary connection, so the research refocused to Early Peoples in deep time, often framed in the European lexicon as pre-history (Gamble, 2015, p. 153), a seemingly safer topic.

There were a number of concerns that would remain for some of the participating museums. Two different museum professionals, both archaeologists, asked me to clearly articulate the parameters I was using to define Early Peoples in England. They were directed back to the scope of the project, where it required the museum to frame their markers of success in representing First Peoples. The argument being that if they were representing First Peoples—and I only visited museums that held collections or an exhibition schedule that included local Early Peoples—then surely they had to have some perspective on those parameters. Some discussed the blending of ethnicities to make the modern English person and the notion that this blend may dilute a connection to land or Indigeneity. To an Aboriginal person from a mixed heritage,

these were difficult conversations, and highlighted some of the concerns around the intercultural space of understanding identity. If your epistemology frames that in order to be English your entire body must have descended from a deep-time ancestor, then what did they think of me? What do they think of other Indigenous Peoples who have shared ancestry; do they see us as diluted, inauthentic? Does this affect how they engage in representation of others?

After an unsuccessful visit to a range of museums in England that was more destabilising than edifying, I came to realise that they needed some support in understanding the underpinning ideas of the project. To open the dialogue, I would explain the stories I heard in Scotland and Wales, and ask if they thought that these countries had First Peoples, and if they also had multi-cultural communities that might see their claim to First Peoples as divisive. Many of the curators knew the *One nation, five million voices* installation from the NMoS "Modern Scotland" gallery, and we were able to discuss their use of multicultural voices that still managed to represent a sense of nationhood while showing historic connection to land and contemporary ideas of place and culture. Through these discussions I realised that while the entire project would help our Communities in the way my Elder had forecast by suggesting connections and obligations, that it would also assist curators and museum professionals in exploring the location and cultural place of their museum, as well as their own cultural contributions.

In the first review year I was also assisted by a number of curators and museum professionals across England who helped shape the new direction of the project, including Dr Oliver Douglas from MERL and Stephen Welsh, the Curator of Living Cultures at Manchester Museum. When I returned the following year, their encouragement and ideas supported a new strategy of requesting a direct response to specific work in the approached museum space. In the original plan this may have contracted the findings by removing the agency of the staff to determine the best markers of success, but the choice remained to either find a way to get them to engage, or to abandon their inclusion.

That this process was challenging for many museum professionals across England speaks not to their lack of engagement, but to the very few conversations that have occurred across the space of the social history museum. Many reflected on the difficult discussions around the development of a Museum of Britain variously framed as Museums of British History and Britishness that was announced as a plan of the former Education Minister, Lord Baker, in the lead up to the millennium (Greig, 1997). The subsequent discussions and the further decisions not to progress it were in part informed by public sentiment that it was seen as potentially cul-turally divisive and celebrating Empire (Colley, 2007; Huntley, 2008) and many curators used it by way of explanation for the lack of interest or engagement in my study. The irony that the birthplace of the modern museum (Bennett, 1995), responsible for displaying the spoils of colonisation, no longer had the capacity to celebrate their own cultures without extreme intro-spection and obfuscation (Gilroy, 2002), provided me with a specific problem that I needed to solve. And it would be thinking through the intercultural relationships formed in the prob-lematising of colonisation that would culminate in a revelation during a visit to the Museum of London in 2012.

Museum of London: place, peoples and colonial perspectives

Imagine for a moment that Australia had a national museum dedicated to Aboriginal and Torres Strait Islander Peoples. Imagine the reaction if that museum, with a curatorial process set and carried out primarily by Indigenous Australians, focused the crowning glory on the project of colonisation. In Bunjilaka Aboriginal Cultural Centre's award-winning museum space, their historical path tracks deep time to the present, and there is a sadness voiced by the digital cultural

interpreter that leads visitors through the colonisation of the cultures that honour Bunjil, the great spirit (Harford, 2013). In the Ziibiwing Center of Anishinaabe Culture and Lifeways, Saginaw and Chippewa Communities show a carriage of destruction wrought by invasion and colonisation as well as their predictions and survival through it (Lonetree, 2013). While there can be a kindness demonstrated across Indigenous-led retellings of the stories of contact and invasion (Lonetree, 2013), the notion of the colonial project as edifying, improving and enhancing First Peoples cultures is appropriately absent (Sleeper-Smith, 2012) from the progressive contemporary museum space.

The Museum of London, a space that follows chronology from deep time to the present era, is located next to the ruins of the ancient Roman wall, built following their invasion of Britain 2,000 years ago. As a place-based museum, it explores a fixed geography against a chronology that draws visitors through the museum. There are two clear moments that define the story told by the museum in the formation of Londinium/London. The first is that Roman invasion is largely treated as positive and city and nation building. It is depicted as welcomed by most of the inhabitants, and a speedy process, reflected in the conflation of events and the collapsing of time periods that span several hundred years. It is made clear that through the Empire's introduction of clothing, trinkets, industry, law and order, invention, wealth, all framed as positive, edifying acts for First Peoples, the Romans *made* London, and also made London and the lives of the Peoples *better*.

But the museum also holds indications of the impact of First Peoples across the geography of London, and their remnants are revealed across the modern landscape. At an early point in the deep history section of the museum, *London before London*, the city is described as "founded" by Romans 2,000 years ago. With no sense of inconsistency and across the same panel-section we observe two glaring ambiguities. There is an object, a copy of the *Dagenham Idol*, a sculpted deity that dates to at least 2,000 years prior to Roman invasion, found in the ruins of communities that existed prior to colonisation. On the other side is a remarkable claim, the museum that talks about the nation-forming power of colonisation and finds no framing for First Peoples, describes that for "almost half a million years . . . the Thames Valley was home to close knit communities of hunters." Of all of the 450 museum spaces of representation for First Peoples, this was the only one I encountered that talked about peopled communities so old that they existed before modern humans.

On further discussion with the research team from the Museum of London, they flagged that many of these ambiguities will disappear over the next decade to mark a changing understanding of what forms history. Like the representations of First Peoples at the NMoS, the Museum of London has engaged an interpretive process of thinking about the space of *London before London*, where poetry has been used to frame the "we" and "I" of the everyday life of the people who inhabited the Thames Valley before invasion. It is, however, unsettling to consider that across a modern museum the act of colonisation could actively erase ideas about human continuity of connection to land, even where alternative narratives were revealed.

Compounding this erasure was the replacement and valorising of the invader. The Roman wall outside the museum acts as the conqueror's visible mark on the land, and a sign that the narrative of the Museum of London shows that colonisation advanced London and the people of Britain. As an Aboriginal Australian who also shares British ancestry, celebrating the act of being colonised, suggesting that it improved, enhanced and edified the Peoples and the landscape is a profound and deeply problematic measure to consider. If colonisation—as we see it through the Museum of London visitor journey—made Britain better, then does this approach argue a British perspective on colonisation as cultural edification, rather than decimation?

Intercultural engagements

The focus of this research project is not only to find out "what works," but to also consider the participants in the space of representation and engagement. Each museum, museum system, curator, and the community/ies that they engage, all have a role in the space of representation. Of the 450 visited museums, those that were community run and led shared more than just a greater level of direct engagement to a community; they consistently demonstrated a diversity and complexity in their community. Across these spaces, humour, exceptionalising, divergent views, quirky characters, and subverted ideas of the exhibited culture, did not demonstrate inconsistency, instead it showed a robust, diverse and contemporary Peoples.

Aunty Mary Graham's (2008) argument that knowledge, rather than objects, inform an understanding of who we are as First Peoples, makes a case for ephemera to be a side issue in our broader representation and for our intercultural understandings to be prominent and visible, centring our knowledges, ideas and thoughts as not "othered," but ideas to be engaged. The intercultural space of the museum is then an exchange between the visitors—often from outside of the culture—and the community represented, through their community voice held to account in the role of curator, museum director, education facilitator, or cultural interpreter. In incorporating the figurative and literal voice of First Peoples into the museum, we shift from a collective, nameable and classifiable set of communities to embodying the greater complexity of individuals, artists and community members, as we speak the human experience both of being representative of our communities, and in failing at the colonial task of embodying a pan-Indigenising or pan-community representation. We shift from being observed artifacts to agents of our own representation.

The attempt in focusing this chapter nearly exclusively on the problem of First Peoples representation across the more difficult terrain of Britain and the impossible lens of England, is not to create an untenable idea of Indigenous identity across these spaces. Instead, it is a strategy to tease out the potential for cultural interlocutors who possess culture, as separate from the institution of the museum. And further, as actors in the process of representation, the potential to engage the museum within its culture and place.

Notes

1 "Indigenous," "First Nations," "First Peoples," "Aboriginal" and within my own national community, Indigenous, Indigenous People(s), First Peoples, First Nations, First Nations' Peoples, Aboriginal Peoples and Communities have all been variously problematic terms. These terms have similarly difficult origins, history and use across our correlate international communities. The term *nation* reflects a framing of cohesion that is sometimes at odds with the colonial decimation of our communities and imposes a specific idea of collective agency that is not always accurate. Similarly, *First Peoples* suggests a sequence where we can become relegated to history, *Indigenous* is often seen as a cold non-naming, and *Aboriginal/Aborigine* has been frequently cast as the central term of the coloniser to erase our individual cultural communities. Each of these terms is variously used and curated across this research. "First Peoples" became the primary pan-Indigenous descriptor that seemed to create less concern during initial inquiry, though rarely without discussion. In selecting this framing there remains an ongoing requirement to ensure the term does not challenge a contemporary reading of First Peoples and with a clear directive that a problematic collective term should never be used in place of the preferred nomination by an individual, community or collective. I would never use the term Aboriginal, First Peoples, First Nations, Indigenous Australian to describe myself; I am—and always will be—Wiradjuri.

2 "Our" and "we" are used throughout the text to avoid a removed authorship and situate the author as conspicuously representing an Indigenous perspective. The term "Indigenous" is always capitalised as in each case it represents the short form for a proper noun, i.e., Indigenous Australian, Indigenous American, etc. Other terms like First Peoples, First Nations' are capitalised. "Communities" applies the same proper noun principle when it remains a short form for the collective of First Nations Communities or for singular Communities.

References

Bennett, T. (1995). *The birth of the museum: History, theory, politics.* London: Routledge.

Carey, S., Davidson, L., & Sahli, M. (2013). Capital city museums and tourism flows: an empirical study of the Museum of New Zealand Te Papa Tongarewa. *International Journal of Tourism Research, 15*(6), 554–569.

Chari, S., & Lavallee, J. M. (Eds.). (2013). *Accomplishing NAGPRA: Perspectives on the intent, impact, and future of the Native American Graves Protection and Repatriation Act.* Corvallis, OR: Oregon State University Press.

Cheape, H. (2010). The Society of Antiquaries of Scotland and their museum: Scotland's national collection and a national discourse. *International Journal of Historical Archaeology, 14*(3), 357–373.

Colley, L. (2007). Does Britishness still matter in the twenty-first century—and how much and how well do the politicians care? *The Political Quarterly, 78*(s1), 21–31.

Fredericks, B. (2009). The epistemology that maintains White race privilege, power and control of Indigenous Studies and Indigenous Peoples' participation in universities. *ACRAWSA E-journal, 5*(1), 1–12.

Gallagher, S. (2010). Museums and the return of human remains: An equitable solution? *International Journal of Cultural Property, 17*(1), 65–86.

Gamble, C. (2015). The anthropology of deep history. *Journal of the Royal Anthropological Institute, 21*(1), 147–164.

Gilroy, P. (2002). *There ain't no black in the Union Jack: The cultural politics of race and nation.* New York, NY: Routledge.

Graham, M. (2008). Some thoughts about the philosophical underpinnings of Aboriginal worldviews. *Australian Humanities Review, 45*, 181.

Greig, G. (1997). *Baker's pounds 110m tribute to Britannia.* NI Syndication Limited.

Grieves, G. (Curator). (2013). *First Peoples* [Exhibition]. Melbourne, VIC: Bunjilaka Aboriginal Cultural Centre, Melbourne Museum Australia.

Harford, S. (2013, September 6). First peoples share rich cultural legacy. *The Age.* Melbourne, VIC.

Herle, A. (2008). Relational objects: Connecting people and things through Pasifika styles. *International Journal of Cultural Property, 15*(2), 159–179.

Huntley, D. (2008). *Britain's history in a new national museum.* Harrisburg: Weider History Group.

Johnson, A. J., & Goodman, S. (2013). Reversing racism and the elite conspiracy: Strategies used by the British National Party leader in response to hostile media appearances. *Discourse, Context and Media, 2*(3), 156–164.

Knowles, C. (2011). Objects as ambassadors: Representing nation through museum exhibitions. In S. Byrne, A. Clarke, R. Harrison & R. Torrence (Eds.), *Unpacking the collection: Networks of material and social agency in the museum* (pp. 231–247). New York, NY: Springer.

Kovach, M. (2010). *Indigenous methodologies: Characteristics, conversations, and contexts.* Toronto, ON: University of Toronto Press Inc.

Krmpotich, C. (2010). Remembering and repatriation: The production of kinship, memory and respect. *Journal of Material Culture, 15*(2), 157–179.

Lonetree, A. (2013). *Decolonizing museums: Representing Native America in national and tribal museums.* Chapel Hill, NC: The University of North Carolina Press.

Marceau, C. (2007). The ethics of collecting: Universality questioned. *Museum International, 59*(3), 80–87.

Mason, R. (2013). National museums, globalization, and postnationalism: Imagining a cosmopolitan museology. *Museum Worlds, 1*, 40.

Mulk, I. (2009). Conflicts over the repatriation of Sami cultural heritage in Sweden. *Acta Borealia, 26*(2), 194–215.

Navajo officials win bid to buy back tribal artefacts at contested auction. (December 16, 2014). *The Guardian.* Retrieved from http://www.theguardian.com/world/2014/dec/15/navajo-tribal-masks-paris-auction?CMP=share_btn_fb.

Rigney, L. (1999). Internationalization of an Indigenous anticolonial cultural critique of research methodologies: A guide to Indigenist research methodology and its principles. *Wicazo Sa Review, 14*(2), 109–121.

Simon, N. (2010). *The participatory museum.* Santa Cruz, CA: Museum 2.0.

Sleeper-Smith, S. (Ed.). (2012). *Contesting knowledge: Museums and Indigenous perspectives.* Lincoln, NE: University of Nebraska Press.

Smith, L. (1999). *Decolonising methodologies: Research and Indigenous peoples* (2nd ed.). London: Zed Publishing.

Thompson, J. (2003). Cultural property, restitution and value. *Journal of Applied Philosophy, 20*(3), 251–262.

Trevor-Roper, H. (2008). *The invention of Scotland*. New Haven, CT: Yale University Press.

Yellowman, C. H. (1996). "Naevahoo'ohtseme" we are going back home: The Cheyenne repatriation of human remains—a woman's perspective. *St. Thomas Law Review, 9*(1), 103.

Young, J. (2010). Responsive repatriation: Human remains management at a Canadian national museum. *Anthropology News, 51*(3), 9–12.

5

A POETICAL JOURNEY

In what ways are theories derived from postcolonialism, whiteness and poststructural feminism implicated in matters of intercultural arts research?

Kate Hatton

Introduction

This chapter examines the shaping and forming of intercultural arts research, and poetics of the artistic journey. It will identify some of the implications from postcolonialism (Gandhi, 1998; McLeod, 2000), whiteness (Gillborn, 2008; Picower, 2009) and poststructural feminism (Adams St Pierre, 2010; Cixous, 1998), on the conceptual framing of intercultural arts subjects. Language, narratology, insider/outsider dynamics, whiteness, subjectivities, homogeneity of culture and cultural difference make and remake intercultural creative concerns, as do relationships between the intercultural, interdisciplinary, intersectional and intertextual. Such relationships are embodied within intercultural arts practices. Journeys by creative practitioners, attempting to negotiate art education to form learner and artistic identities, are also noted later on in this text. However, to begin with, I explore notions of intercultural art and intersections with associated research fields, to examine the idea of a working theory of interculturality.

Intercultural arts: intersections and identities

Intercultural arts research is wide ranging, requiring an awareness of the interdisciplinary nature of contemporary theory, in particular that which confronts and questions characteristics of identity and insider/outsider relationships as well as the position of the viewer. Creativity often is developed by cultural experiences occurring both inside and outside the institution. Advantageous theoretical positions enable the understanding of a developing, organic mode of creativity across such boundaries. The metaphor of the rhizome, for instance (Deleuze & Guattari, 1987), implies intersecting, increasing stretching of roots, informing our understanding of intercultural creative practices (Hickey-Moody, 2015, p. 47). Communication theory also focuses on the importance of understanding narratives from diverse cultures in 'glocal' contexts, speaking to the notion of the intercultural as an ideology which has local, global and social obligations (Holliday, 2013; Patel & Sooknanan, 2011).

To some degree, many existing theoretical positions and readings of artistic practices encapsulate similar concerns, noting not only the importance of cultural understanding, but also of background social, political and geographical histories. In Frida Kahlo's art work for example, an intercultural voice can be found through her idea of promoting Indigenous dress over the Western contemporary dress of the time. In the work, 'My dress hangs there', Kahlo appears to be speaking back to the Western gaze (Aragon, 2014) and was, perhaps unknowingly, constructing an intercultural setting for her work, by means of her powerful statement of self. This is communicated in her interpretation of the theme of portraiture, the materiality of the work (its fashion and fine art significations) and its associated cultural meanings, suggested by the promotion of Indigenous Mexican dress. Sonia Boyce similarly appears to confront the Western gaze in her self-portraits. Writers and artists may provide critically examinations of standard theoretical and cultural contexts of creativity, through their work (Bailey, Baucom & Boyce, 2005), offering a broader cultural vision.

Intercultural art work is also found in various visual artistic and written forms, supporting one's analysis of the changing and discursive natures of identity, particularly in boundary-crossing art work. In broader definitions of creativity, spoken language may be as powerful as written language, for instance, in the uses of orality as an art form (Anim-Addo & Scafe, 2013; Scafe, 2013). Here, understanding individual narratives of self, allows us to seek deeper intercultural knowledge around arts practitioners' dismantling of disciplinary boundaries, to find their creative voices. Therefore, intercultural and interdisciplinary art works often appear to *avoid* universalising conditions of language, using more appropriate local and personal creative forms, (as perhaps in reggae styles of music or punk forms of expression). Perceived and distinct absences suggested by interdisciplinary or intercultural work may be presented using a stronger voice by those who engage with them. This strength of voice, I would argue, is often found in the development of a 'poetics' of subject. Here, I also suggest an understanding of poetics as a theme many postcolonial, poststructural feminist writers such as Hélène Cixous (1998; Cixous & Calle-Gruber, 1997) and artists have adhered to, since their work forms poetical and hybridised ways of understanding and representing cultural signs, and artistic language.

The poetics of identity: 'replacing' histories

To understand this notion of poetics, creative and cultural discourse from non-Western derivations as in Caribbean literatures (Scafe, 2011) are interesting by way of broadening the scope for artists. Griffiths (2014, p. 47) argued for Glissant's idea of replacing 'history' with a relational opposite in which there is poetic intention, 'leading to an embrace of difference at the level of the whole world'. In Glissant's approach, which sits within a postcolonial setting, Occidental poetics are 'unsayable'. He advocates a kind of intervention allowing creativity to develop abstractly. Yet, at the same time, this looks to the future; a future based on a re-working of Western thinking around the role of cultural experience and artistic production.

Interestingly, the concept of intercultural difference, history and postcolonialism is dealt with both in a poststructural and intercultural way. Griffiths (2014, p. 49) observes:

> Where the poststructuralists (Deleuze and Guattari in particular) embrace a rhizomatic logic of intersecting minor languages with no dominant formations as settled in advance, Glissant insists on a Fanonian passage through the historical and lived experience of the specter of the minority language, which is no less historical in its disavowal of 'History'.

Griffiths highlights art forms reliant on Indigenous readings of culture and black histories, citing Fanon (1966) as a significant cultural and critical source. In tandem with this approach, non-linear versions of reading cultural history are suggested by the work of Deleuze and Guattari (1987), whose ideas around rhizomatic thinking conflate with the organic, 'naturally occurring' spaces of Glissant's ways of thinking about culture. Rhizomatic thinking based on the broader cultural and critical possibilities of a subject, is linked to the intercultural, by way of intersecting personal experiences with culture, offering opportunities for creating and understanding the layers of experience most peoples' identities will represent. Furthermore, this idea of broadening an understanding of the poetics of identity and history can also be made sense of, by applying wider poststructural and critical race theories to a subject. This is not about replacing one history with another but understanding the on–going and intersecting histories at play in someone's identity formation. Postcolonial theory, therefore, may be adopted, but only if a critical and reflective approach is used and its own histories are deeply scrutinised in the process. The growing field of intercultural theory is one area to look more towards in terms of a more holistic way of thinking about poetics, identity and history as it has the possibility of foregrounding the intersecting and intertextual layering of histories and identities, thus equalising the status of each within creative production.

The intercultural and the intertextual

Another significant question in the context of discussion around critical identity is how does the intercultural form differ from the intertextual? Although there are similarities in terms of acknowledging that some cultural associations are at work, these texts cannot function on their own (Paatela-Nieman, 2008); it seems the intertextual, although a 'discussion' between fields (Parkin-Gounelas, 2001), often relies on more than one field of points of reference. It carries an invisible structure. It can refer to the following: one idea being replaced by another; the importance of pastiche; the significance of a language of signs which, although they may be culturally derived, tend to foreground displacement, disruption or replacement within a new system of signs.

The intercultural is more a study of the 'unsayable', of overlapping cultural and social identities. Some artists might attempt to work in overtly intercultural and intertextual ways, as in the work of Grayson Perry, a UK artist who boldly mixes, layers and reconfigures 'texts' from visual and material culture on art works such as ceramic pots. The intercultural or intertextual art work therefore requires a new form of critical thinking, devoid of any conceptual hierarchies of thinking around process, subject matter and creativity. The intertextual idea comes from the philosophical work of writers such as Julia Kristeva, Hélène Cixous, Luce Irigaray and Jacques Derrida. Here, overlapping discourses of postmodernism and poststructuralism, particularly those noting specific forms of *language* as problematic, are highlighted. Intertextuality is used in growing, dominant and 'deliberate' sets of representations of visual and written texts. Formats of this type of analysis have even become pattern forming. These sets of theories often appear to have a Eurocentric focus but can be applied widely.

Alternatively, intercultural theory notices more inherent and organic social and cultural 'differences' particularly in the thinking of local languages and cultures. It eschews hegemonic representations of meaning or universal tropes of contemporary discourses, criticising 'fake universality' as Glissant had attempted to explore, within his western identity discourses. The intercultural works more like a rhizomatic approach (or, the 'antillinite' from Glissant), indicating creolisation of culture and its thinking together with a localised, and often poetic, form of expression. This 'poetical' version of cultural or intercultural thinking works well aside *some* forms of poststructural theory and thinking, particularly ideas moving back to the essential idea

of the artist, and of the art work as a personal and poetic cultural experience (see Cixous (1998) and Scafe's (2011) work on writers from the Caribbean). Often, in this poetic way, personal, cultural histories of self are mapped out, explored, or alluded to, within the creative work in a subtle construction of meaning.

Contexts for reading theory in the intercultural arts space

Moving further with this form of analysis, various theoretical ideas might enhance or develop the intercultural voice. I noted at the beginning, the significance of whiteness, anti-racism and postcolonial studies to this arena of thought. In order to develop an understanding of interculturality one also needs to understand deeply the positions that illuminate identity and culture. Postcolonial studies, anti-racism and whiteness studies have a variety of origins and applications that suggest such a context. Therefore, it is worth a short introduction to their place in critical and cultural theory.

Critical theorists (Barry, 2002; Brooks, 2007) have noted Western critical theory developed from a range of approaches: liberal humanism, poststructuralism, feminist critique, new historicism and cultural materialism, to name but a few. Writers built on such approaches, presenting deeper concerns: queer theory (Butler, 2004), race (Cashmore & Jennings, 2001), identity theory (Hall, 1997), globalisation (Ritzer & Atalay, 2010), sustainability theory (Edwards, 2007; Lewis & Potter, 2011), decolonising research (Tuhiwai-Smith, 1999). Brooks argues a distinction between Australian and British cultural studies, particularly where diasporic and postcolonial ideas are examined. She suggests a newly forming 'nexus' between intersections of transnationalism, transculturalism and the postcolonial, whereby 'the intersection of transculturalism and transnationalism with discourses on the postcolonial has provided fertile territory for reconceptualising debates on subjectivity and identity' (Brooks, 2007, p. 189).

Such cultural studies sources give the reader a 'taster' of the multiplicity of theory available in critical thinking and writing. It is the challenge of the intercultural researcher to also examine ways in which Indigenous art forms and intercultural practices may arise within such debates, recognising that the practice of decolonising research is also valid (Tuhiwai-Smith, 1999). Furthermore, the significance of intersections of 'different' arts practice to this view of *interculturality* is considered by some writers (Hickey-Moody, 2015; Martin, 2004). Arts practice may work well around hybridised intercultural theory because in art education practice closely relates to theory, providing broader contexts of thinking about art and its production. Arts research can often be interdisciplinary as well as intercultural. There may have been attempts to solidify interdisciplinary approaches in art courses (in the UK, interdisciplinary courses may be found at the Royal College of Art and the University of the Arts in London, and in the United States at the University of Washington). However, many interdisciplinary courses in art schools in the UK work with existing art forms and do not look to wider non-Western contexts, where sound, music, orality, craft making, film and performance may be accepted as mainstream disciplines. This approach is replicated in school-based learning where the art curriculum suggests formal contexts for study. The cultural dimension of this is limited. Where one speaks first from one's own cultural identity and place is particularly relevant in an intercultural arts setting, allowing an 'authentic' social and cultural voice to develop. Learning how to achieve this is often especially difficult for unpractised researchers and practitioners, or those who work in rigidly defined disciplines where self-reflection is not required. In such cases, confronting head on one's own identity and culture is necessary, to start debate and discussion.

The whiteness discourses in anti-racist theory (Gillborn, 2008; Picower, 2009) and feminist poststructural ideas around identity and subjective (life) writing (Anim-Addo & Scafe, 2013;

Cixous, 1998; Nasta, 2006; Scafe, 2013) are hugely relevant to interculturality in the ways they confront and examine the reflective self, a practice researchers and artists often perform as a natural part of their work. Gillborn (2008) usefully devoted a chapter to living in and around: 'White world: Whiteness and the performance of racial domination'. He suggests those of us who may identity ourselves as 'White' would

> probably be surprised at the idea of 'White World': they see only the world; its Whiteness is invisible to them because the racialized nature of politics, policing, education and every other sphere of public life is so deeply ingrained that it has become normalized, unremarkable and taken for granted.
>
> *(Gillborn, 2008, p. 162)*

Gillborn, in recognising the extreme 'nature' of white cultural identity and its construction, explores how whiteness performs every day, how it becomes normalised, how institutional narratives work to privilege whiteness as a dominant social discourse. This gives one starting point for discussion around the 'self' and its social, cultural (and some may say, political) positioning.

Omi and Winant's work (1986) supports similar ideas, examining the ontological positioning of race, from socially and politically engineered racist understandings of ethnic identity. Historically, the US has 'rigidly defined and enforced' perceptions of racial identity, based on skin colour; recently moving from a 19th-century pseudo-scientific notion of racial hierarchies towards a sociocultural understanding of race, has interested Western cultural theorists. Omi and Winant's work (1986) supports similar ideas, examining the ontological positioning of race, from socially and politically engineered racist understandings of ethnic identity. Their work on 'racial formations' (1986) gives interesting accounts of the ways in which beliefs and myths of racial stereotyping are founded, and how fixed racist assumptions can be rejected. This opens up wider discussion for the intercultural researcher.

Furthermore, anti-racism's relationship to postcolonialism may be developed in the re-reading of a history. Anti-racist ideas reject the clearly marked, binary practices of colonisers, towards oppressed groups. This avers politically and socially driven visual, and written, representations found in historical art. Postcolonial narratives can powerfully highlight questions about raced and classed historical representations, providing new contexts shaped by the storying of colonisation and the colonised, often originating from voices of the oppressed. As Brooks notes:

> The concept of the postcolonial is not about describing a particular state of historical or contemporary relations as they apply to one society rather than another. It is about 're-reading' and rethinking 'colonization' as part of what Hall describes as 'an essentially trans-national and transcultural "global" process' (1996: 247). It is about the deconstruction of the binary structures within which relationships are framed and represented.
>
> *(Brooks, 2007, p. 190)*

Postcolonialism is, in a sense, a warning of the possibilities of how marginalisation can occur, or 'in other words, while postcolonial subjects must work to stay alive, postcolonial intellectuals are free to partake in a "carnivalesque collapse and play of identities"' (Ahmed, 1995, in Gandhi, 1998, p. 56).

However, institutional identities may dominate such discourses, through teaching structures and development of subjects. The student often becomes part of a pedagogised identity

(Atkinson, 2002) replicating perceived 'norms' around academic disciplines. Intercultural ways of thinking may not be encouraged, meaning the academic or the student feels marginalised or an outsider (within). Gandhi suggests:

> The problem with 'positionality' accordingly devolves upon the progressive intellectual task of continually resisting the institutional procedures of co–option – such an intellectual must relentlessly negotiate the possibility of being, in Spivak's elusive terminology, 'outside in the teaching machine'.
>
> *(1998, p. 59)*

Gandhi reproduces Spivak's warning to academics, recognising the power of institutional discourse where falsehoods are created (Gandhi, 1998). Since this early period of critical understanding, there are many postcolonial studies in academic departments attempting to reconstruct and debate colonial rule and the continuing debates arising from this. McLeod usefully reminds us that, 'the generalising tendency of postcolonialism is perhaps its greatest weakness' (McLeod, 2000, p. 245).

Postcolonialism is, therefore, a complex term. On the one hand it opens up debate on histories of identities, power and domination. On the other hand, it constructs its own hierarchies of discourse which is again, complex terrain for the critical theorist. Said (1978), Fanon (1966) and Hall (1997) have all pointed out the continuing representation of less than positive cultural identities is founded on a lack of clear thinking around cultural hybridisation and the colonial or postcolonial self. Therefore, many cultural discourses, including those of the critic, need to be more carefully examined. Identity, if seen and read in the postcolonial world, reveals a continuing tension between the oppressor and the oppressed which may only be reconceptualised when all participants in the critical debate continue to examine their own cultural positions and identities and their continuing privileges and powers, to help equalise the status of all within the creative space.

Double or multiple identities are found in postcolonial literature. Writers adopt different languages at different times in their work. Barry (2002) suggested Yeats (an Irish poet from a Protestant background) was both coloniser and the colonised. Achebe (a Nigerian writer from Lagos) identified both with village life and also the 'sophisticated' life of the city, where he lived. He asks, 'Who is telling the story?' (Barry, 2002, p. 283). The place from which the story was told gives one perspective, but also significant are the languages and identities the writer uses in telling the story. What matters to intercultural ways of thinking here is perhaps how a dominant discourse such as whiteness can occur which colonises the creative space.

Whiteness and poststructural feminism: developing the intercultural artistic 'voice'

Whiteness, poststructural feminism and anti-racism are linked discourses (Cixous, 1998; Dolby, 2001; Gannon, 2006; Picower, 2009). These debates crucially acknowledge power structures and ways in which voices operate against them. Intercultural arts settings recognise power structures exist but can identify where the voice comes into play, as a subjective and forceful means of writing (e.g., in the case of Cixous' '*l'ecriture feminine*' and life writing and Atta's (2008) coming of age novel). Such creative work often means speaking back, to the global and local (glocal) context. Cixous is speaking forcefully against patriarchy to empower the 'other', in particular women. Atta relates how the histories of a place affect individual voices. Yet subjective experiences are still spectacles of difference in many forms of creativity.

Parkins (2014) discussed the visibility and invisibility of women in visual culture and fashion discourses; how they are seen and experienced, both included and excluded. Drawing on feminist and postcolonial theory, the visibility and variability of women and their opacity in contemporary modernist life are noted. To understand this better, she suggests applying intercultural sets of theory, since this

> means recognising the way that racist and colonialist representational regimes themselves incorporated images of opacity. Designers, magazine editors and film celebrity culture trafficked in stereotypical representations of racialized women as exotic and subversively sexual. Of course, such figurations turned on the notion of mystery, which was frequently bound up with depictions of 'veiled' women.
>
> *(Parkins, 2014, pp. 68–69)*

This is complicated terrain as there are different feminist readings on representation and the makers of such representations can be women. Yet, by using written language rather than visual imagery, there are sometimes more opportunities to engage with feminist creative discourses, as in the work of Cixous. Shirin Neshat, an Iranian artist, used feminist writings about the veil in interdisciplinary creative responses to her subject. Traditional music, poetry and song merge with modernist techniques. Photography and film are incorporated, to help make her work both in interdisciplinary and intercultural ways.

The educational setting can also be explored to highlight how power and difference is constructed as 'whiteness' within a postcolonial world. Nadine Dolby, an education theorist, clarified how the construction of whiteness in an educational situation may occur when the majority of students are black. Her description of the position of white management at Fernwood, a predominantly black school in Durban, South Africa, to reinforce a white identity for the school, is interesting to note in the context of an institution constructing its whiteness:

> Though the majority of Fernwood's population in 1996 is black, the management persists in actively producing a 'white' identity for the school . . . This whiteness is detached from any relation to the nation state of South Africa. Instead it is linked to two imagined spaces and refuges of whiteness: a local whiteness that resides in the practices of elite Durban schools, and a global whiteness that resides in the remnants of British Empire.
>
> *(Dolby, 2001, p. 48)*

This disparity represents the power of the institution over individual voices. Students simply want an education embracing their needs yet many institutions do not recognise what those needs are. Critical race theorists and anti-racism writers routinely acknowledge such socially constructed realities of race in predominantly white institutions, and the difficulties faced by those who want to make changes for the better (Gillborn, 2008; Rollock, 2013).

Creative learning stories of power and voice

Feminist poststructural theory, as exemplified in the work of scholars such as Gannon (2006) and Olesen (2005), help make sense of matters of exclusion by implicating notions of power, the authority of the individual voice and the diversity of that voice. The privileging of the voice and the subjective experience over common institutional structures and ideologies is a dominant theme within feminist theory. Here, individual stories matter. Therefore, the experiences of my

research participants in my doctoral study, which examined black students' experiences of art education in England (Hatton, 2009), were interesting as they refer to culture, arts and subjectivities, and the effects of whiteness on black students' creative journeys. In my wider doctoral data, my participants' stories, which formed the major part of my data, often revealed a lack of opportunity within the art curriculum to explore their cultural identity. There were implications of not understanding and using theory from intercultural arts research in the art education field. My data showed often conflicting views between the student and the institution in terms of cultural identities. Black students appeared to view the art curriculum as elitist, lacking in originality, and predominantly Eurocentric in focus, particularly in terms of the practical curriculum. This matters to a formation of an intercultural arts curriculum and practice.

As noted in the previous section, feminist poststructural theory is important to a study of this kind, in terms of our understanding of the individual experience but also in seeing how such theory and associated themes such as anti-racist approaches may be used together. This is important to intercultural arts research. Feminist poststructural theory helped form a relationship for me with the culturally informative research methods I used. I attempted to follow the ideas of Gannon, who highlights the notion of a lived experience being important to a sense of gaining strength. She writes, 'The authority of the story begins with the body and memories of the auto-ethnographic writer at the scene of the lived experience' (Gannon, 2006, p. 475). Further, in terms of how intercultural arts contexts might be presented to students, it seems from my research, there was a consciousness of black identities within the institution, yet my participants also spoke about segregated course images and prejudice in the selection process and in the everyday structures of the arts curriculum. Black students simply did not feel a part of some teaching situations and felt they saw white students' work being supported in ways theirs would not be. The ways in which black students worked was often criticised, as in the work of two students, Stella and Esme, and their experiences suggest there were clear expectations from their predominantly white tutors that their work should conform to what the black students saw as 'white' traditions, such as 'doing florals' (Stella, personal communication, 2008), and 'using geometric shapes' (Esme, personal communication, 2008). This and other similar detail was evidenced in the 'Stories of experience' reflections in the courses. For example, Stella, a student in an art college who found it difficult confronting experiences of racism, noted, 'The safe students get the top grades' (Stella, personal communication, 2008). These 'safe' students tended to be white and middle class. Stella's dissertation research did, however, give opportunities to visit certain places in her home environment (Brixton) where she had never before felt welcomed (the tanning shops and the hairdressers who sold skin lightening creams). This enabled her to ask questions around identity, race and culture in a context of learning which she may not have found possible in the provincial art school setting where her college was, and she felt this was empowering.

Social and cultural meanings that emerge out of such experiences are closely linked to identity and factors influencing identity, such as family, cultural traditions and gender, ideas which Bhopal has studied in wider higher education settings (Bhopal, 2010). Social and cultural meaning can also be found in auto-ethnographic accounts, or life writing (Nasta, 2006). Life writing and its associated creative forms can liberate the voice in a creative way, but this is not a common Western approach to artistic endeavour. Scafe's research work (Anim-Addo & Scafe, 2013; Scafe, 2013) examines the 'conventional articulations of space' and uses reference to the creative practices of black women writers and poets such as Jean Binta Breeze to highlight how women's voices in particular can be expressed in creative oral form. This search for an 'authentic' creative, intercultural voice seems relevant to this discussion since orality, literature and poetry are not routinely accessible in arts education institutions.

The ways in which theories of postcolonialism, anti-racism and poststructural feminism could similarly be used to make sense of matters of exclusion is significant to stories of power and voice, as these theories support a broad conceptual framing of issues of identity and matters relating to feelings of exclusion. Working in an interdisciplinary way with theories was essential to my own understanding of the experience of exclusion in the art institution in Western culture, and why it was so difficult for black students to make their voices heard. Issues of power, Enlightenment inheritances, postcolonialism and the resistance of the institution to 'allow in' the academic field of black culture were also issues the theory I used helped to unravel.

My doctoral data, therefore, gave me a strong sense of how far black students felt excluded from art education and the urgency of this matter in terms of what might be done about this situation to rescue significant creative practices. This appears contingent upon the institution recognising how all creativity is in some ways intercultural and that dominant discourses only serve to abandon significant creative practices. The key features of the stories I discovered were about identity, finding a voice and the possible need for a re-conceptualisation of art education. I was surprised in my data analysis about how far individuals saw the impact of racism not just on them but also on the institution and, therefore, consider this could have a lasting impact on the future visions of art education.

Finally, the sense of a cultural self was very important to my research participants and this was reflected not only in terms of being recognised as an individual but also in how the curriculum might embrace individual identities and new or original art works. This area requires further research to situate a number of issues, yet the ways in which intercultural voices are hidden from institutional discourse, remains one of the key problems for those approaching work around intercultural arts and associated research fields. How and where do we find the creative discourses we need to hear?

Conclusion: moving back to poetics

In this chapter I attempt to show how understandings of interculturality may be developed, and how theories around 'race', identity, postcolonialism and whiteness operate in the reconfiguration of intercultural arts practice and research. Poetical journeys feature strongly in this context. What I suggest, is a broader social discourse around researching creativity, in order to seek further intercultural possibilities within art education and its wider creative practices. Stereotyping of artistic knowledge and of art and artists occurs in many creative places. This affects progress in research. In research and in arts practice we need to be more aware of the 'glocal' side of interculturality; where the local refers to the global, and vice versa. Paatela-Nieman (2008) hints that the intercultural and the intertextual are linked. Here, visual cultures may be understood differently, especially in a non-Western framework. By offering a number of ways to see how local and global texts can be examined interculturally, we move away from limiting structures found within formal disciplines of creative theory and practice. Yet, it is also necessary to see that academic teaching in art and design subjects is not only bounded by the limitations of the institution, but sometimes by the expectations of students and their learning cultures (Radclyffe-Thomas, 2007).

In some cultural discourses (Mercer, 2002), it is suggested we develop knowledge of how a poetical application of postcolonialism, anti-racism and poststructural feminism might work in local academic fields, thereby viewing personal research journeys as both intercultural and interdisciplinary. Theories of postcolonialism, anti-racism, whiteness theory and poststructural feminist theories may, however, provide tools to assist wider explorations of identity within intercultural discourses. The readers of this chapter might consider how to develop their own

researcher journey. They may consider how a poetical application of postcolonialism, anti-racism and poststructural feminism might work in their academic research fields. The research journey then becomes personal, intercultural and interdisciplinary. Adopting broader cultural understandings, imagining a reconceptualising of self, developing a sense of how the subjective experience matters to creativity, are all important. It is significant that such experiences may be written, spoken, sung, drawn, performed, painted or constructed in a number of equally relevant forms of creative expression – indeed, 'whatever becomes familiar to the self, one's own indigenous territory, becomes the ground for the new' (Hickey-Moody, 2015, p. 47).

References

Adams St Pierre, E. (2000). Poststructural feminism in education: An overview. *International Journal of Qualitative Studies in Education, 13*(15), 447–515.

Ahmed, A. (1995). The politics of literary postcoloniality. *Race and Class, 36*(3), 1–20.

Anim-Addo, J., & Scafe, S. (2013). Affect and gendered creolisation. *Feminist Review, 104*, 1–4.

Aragon, A. F. (2014). Uninhibited dress: Frida Kahlo, from icon of Mexico to fashion muse. *Fashion Theory, 5*, 517–550.

Atkinson, D. (2002). *Art in education: Identity and practice*. Dordrecht: Kluwer.

Atta, S. (2008). *Everything good will come*. Oxford: New Internationalist Publications.

Bailey, S. A., Baucom, I., & Boyce, S. (2005). *Shades of Black: Assembling Black arts in Britain*. Durham, NC and London: Duke University Press.

Barry, P. (2002). *Beginning theory: An introduction to literary and cultural theory*. Manchester: Manchester University Press.

Bhopal, K. (2010). *Asian women in higher education*. Stoke-on-Trent: Trentham.

Brooks, A. (2007). Reconceptualising representation and identity: Issues of transculturalism and transnationalism in the intersection of feminism and cultural sociology. In T. Edwards (Ed.), *Cultural theory: Classical and contemporary positions* (pp. 183–209). London: Sage.

Butler, J. (2004). *Undoing gender*. New York, NY: Routledge.

Cashmore, E., & Jennings, J. (Eds.). (2001). *Racism: Essential readings*. London: Sage.

Cixous, H. (1998). *Stigmata: Escaping texts*. London: Routledge.

Cixous, H., & Calle-Gruber, M. (1997). *Hélène Cixous rootprints: Memory and life writing*. London: Routledge.

Deleuze, G., & Guattari, F. (1987). *A thousand plateaus: Capitalism and schizophrenia*. Minneapolis, MN: University of Minnesota Press.

Dolby, N. (2001). *Constructing race*. New York, NY: State University of New York Press.

Edwards, T. (Ed.) (2007). *Cultural theory: Classical and contemporary positions*. London: Sage.

Fanon, F. (1966). *The wretched of the earth*. New York, NY: Grove Press.

Gandhi, L. (1998). *Postcolonial theory: A critical introduction*. Edinburgh: Edinburgh University Press.

Gannon, S. (2006). The (im)possibilities of writing the self-writing: French poststructural theory and autoethnography. *Cultural Studies – Critical Methodologies, 6*(4), 474–495.

Gillborn, D. (2008). *Racism and education: Coincidence or conspiracy?* London: Routledge.

Griffiths, M. R. (2014). Toward relation: Negritude, poststructuralism, and the specter of intention in the work of Edward Glissant. *Discourse* (Winter), 31–53.

Hall, S. (Ed.). (1997). *Representation: Cultural representation and signifying practices*. Thousand Oaks, CA: Sage.

Hatton, C. (2009). *A study of Black experiences of art education in England: How to promote fairer access and inclusion for a wider audience*. PhD thesis. Department of Educational Studies, University of Sheffield, UK.

Hickey-Moody, A. (2015). Cultural territories of inclusive education. In K. Hatton (Ed.), *Towards an inclusive arts education* (pp. 39–58). London: Trentham/IOE Press.

Holliday, A. (2013). *Understanding intercultural communication: Negotiating a grammar of culture*. Abingdon: Routledge.

Lewis, T., & Potter, E. (Eds.). (2011). *Ethical consumption: A critical introduction*. London: Routledge.

McLeod, J. (2000). *Beginning postcolonialism*. Manchester: Manchester University Press.

Martin, J. (2004). *The intercultural performance handbook*. London: Routledge.

Mercer, K. (2002). Ethnicity and internationality: New British art and diaspora-based Blackness. In R. Araeen, S. Cubitt & Z. Sardar (Eds.), *The third text reader on art, culture and theory* (pp. 116–123). London: Continuum.

Nasta, S. (Ed.). (2006). *Wasifiri: Life writing edition.* London: Routledge.

Olesen, V. (2005). Early millennial feminist qualitative research: Challenges and contours. In N. K. Denzin & Y. S Lincoln (Eds.), *The Sage handbook of qualitative research* (pp. 235–278). Thousand Oaks, CA: Sage.

Omi, M., & Winant, H. (1986). *Racial formations in the US.* New York, NY: Routledge.

Paatela-Nieman, M. (2008). The intertextual method for art education applied in Japanese paper theatre: A study on discovering intercultural differences. *Journal of Art and Design Education, 27*(1), 91–104.

Parkin-Gounelas, R. (2001). *Literature and psychonanalysis: Intertextual readings.* Basingstoke: Palgrave.

Parkins, I. (2014). Texturing visibility: Opaque femininities and feminist modernist studies. *Feminist Review, 107,* 57–74.

Patel, F., Li, M., & Sooknanan, P. (2011). *Intercultural communication: Building a global community.* London: Sage.

Picower, B. (2009). The unexamined Whiteness of teaching: How White teachers maintain and enact dominant racial ideologies. *Race, Ethnicity and Education, 12*(2), 197–215.

Radclyffe-Thomas, N. (2007). Intercultural chameleons or the Chinese way? Chinese students in Western art and design education. *Art, Design and Communication in Higher Education, 6*(1), 41–55.

Ritzer, G., & Atalay, Z. (Eds.). (2010). *Readings in globalisation.* Oxford: Blackwell.

Rollock, N. (2013). A political investment: Revisiting race and racism in the research process. *Discourse: Studies in the Cultural Politics of Education, 34*(4), 492–509.

Said, E. (1978). *Orientalism.* New York, NY: Pantheon.

Scafe, S. (2011). The lesser names beneath the peaks: Jamaican short fiction and its contexts 1938–1950. In L. Evans, M. McWatt & E. Smith (Eds.), *The Caribbean short story: Critical perspectives* (pp. 44–58). Leeds: Peepal Tree Press.

Scafe, S. (2013). Circuits of identity and production of gendered, spatial affects in the work of three women poets. Abstract. *Centre for Caribbean Studies.* http://www.gold.ac.uk/caribbean/behind-the-looking-glass/currentresearchfocusmay2013/ accessed 9/12/14

Tuhiwai-Smith, L. (1999). *Decolonising methodologies: Research and Indigenous peoples.* London: Zed Books.

6

IN DANGER OF RELATION, IN DANGER OF PERFORMANCE, IN DANGER OF RESEARCH

An ethical conversation with Hélène Cixous about writing as intercultural arts praxis[1]

Elizabeth Mackinlay

> I fled the orange, my writing fled the secret voice of the orange, I withdrew from the shame of being unable to receive the benediction of the fruit giving itself peacefully, for my hand was too lonely, and in such loneliness, my hand no longer had the strength to believe in the orange . . . my writing was separated from the orange, didn't go to it, didn't call it, didn't carry the juice to my lips.
>
> *(Cixous, 1994, p. 86)*

Introduction

Working in intercultural arts is a dangerous practice. The word 'danger' is used doubly here to invoke, on the one hand, the potential the concept of 'interculturality' holds to bring into being an *in-betweenness of self* and Other which is at once transgressive, innovative and empowering. On the other hand, it is this very term 'in-betweenness' which lays bare the possibility for power and privilege to be mis/used/represented to perpetuate and reproduce dominance of self in relation to Other. In this chapter I take up the dangerous entanglement of 'interculturality' and 'in-betweenness' in the context of my white-settler-colonial personal-as-political-as-pedagogical-as-performative relationships with Indigenous Australian people, and in conversation with French feminist philosopher Hélène Cixous with specific reference to her 1994 essay entitled 'To live the orange'. In this work, Cixous highlights that being intercultural is always already a dangerous move towards being two and being-in-relation – the nature of the being in that moment is intersubjective, intercorporeal and in-between. Cixous suggests evocatively that the practice is not an innocent one and she asks under what conditions may I 'live the orange'? Her work reminds us that to 'live the orange' is a political act (1994, p. 90) – indeed a dangerous act – and calls us to remember the necessity of an ethical relation in being two. In Cixousian terms, intercultural arts practice then can be read as a moment to not forget, to recall, to rejoin, to reflect and relate to, through and with difference. To 'live the orange' in intercultural arts

practice, is to ask questions about the moral obligations we hold to work in a manner that works against the epistemological colonial violence of taking from the Other, disrupting the colonial dominance that makes such appropriation possible, and imagining an intercultural arts research practice where things might be otherwise.

Alongside an engagement with Cixous' thinking around 'the duals, the duos, the differences, all the dyads in the world: each time there's two' (Derrida, in Cixous 1994), I engage in a playful way with her thinking about, with and through writing to explore the 'dangerous' nature of research-as-writing-as-performance which thinks, lives and breathes interculturality, moves politically in a dance with decoloniality *and* responds 'ethico-onto-epistem-ologically' (Barad, 2006, p. 90) through the arts. This chapter, then, much like Cixous herself, seeks to deliberately and most certainly avoid becoming a 'dutiful daughter' and perform academic writing according to the status quo – that is, the master's rules which would look for and expect rationality, logic and truth. Poetic memory combines with autoethnographic 'storyline' (see Mackinlay, 2015) writing techniques to imagine that my words and worlds and those of Hélène Cixous enter into a dialogue in and around the ethics and politics of interculturality. Along the way, Cixous and I are joined by words in a language not my own and those of feminist writer Virginia Woolf, to engage and enhance writing in and around interculturality as all at once affective, material and critical. In this way, this chapter presents an analysis of the intercultural ethico-onto-epistemological politics of researching, writing and being-in-relation as a white settler colonial woman with Indigenous Australian peoples. In Section one, I first consider why writing with Hélène Cixous problematises, politicises and therefore holds the possibility for research and writing interculturality with an ethical attentiveness to disrupting coloniality. Paying homage to the structure of her essay, Section two dives deeper into Cixous' thinking around the ethics of interculturality through a discussion with her of 'To live the orange'. The chapter then takes an/other creative turn in Section three and presents an autoethnographic reading of the dangers of intercultural arts praxis. With the subtitles 'tripping, swaying and dreaming' as 'moments of becoming' signposts, this section seeks to bring the reader with me into the affective, material, relational and colonially bound moments of being 'intercultural' and 'in-between'. The writing in this section is story-like, fluid and flows into a meeting in a garden with Hélène Cixous and Virginia Woolf who explore with me the ethico-onto-epistemological of researching and writing interculturality. Where we end up as writer and reader I cannot say but my wish is complexly simple – together we will explore how a 'dangerous' approach to writing (Cixous, 1994, p. 90) might challenge and fracture the authority and aesthetics of patriarchal and colonial academic writing practices in intercultural arts research praxis.

One: a note on writing with Hélène Cixous

'Write! What? Take to the wind, take to writing, form one body with letters. Live! Risk: those who risk nothing gain nothing, risk and you no longer risk anything', urges Cixous (1991, p. 41) and it is her call for texts and bodies to take new flights of danger that this chapter on the ethics and politics of writing intercultural arts responds to. I cannot claim any kind of subjectivity as philosopher or psychoanalyst in my reading of Hélène Cixous' work; rather, it is the entanglement of poetics, the political, playfulness and performativity in her writing, which drew me close to her. I found myself buzzing around her words like a bee in search of the most fragrant blossoms of an orange tree, trying to puzzle out my experience of being a white settler colonial woman, teaching Indigenous Australian studies, all the while embraced as mother and wife in an Aboriginal family.

My writing as an academic in ethnomusicology and education had become stuck, stalked and 'partially submerged' (Greene, 1994, p. 109) by what the 'One-Eyed Father' (Haraway, 1997, p. 45) had said and continues to say about acceptable writing-as-research practices. I struggled to reconcile the mixed up personal-professional-political-pedagogical locations I found myself in and how I might come to write these worlds of shared, material, embodied and affective experience in a way that responded to an ethical call for something more than a reproduction of colonial 'monovocals' and 'master narratives' (Nadar, 2014, p. 23). The black words I wrote on white paper claimed to be 'working towards social justice' for Indigenous Australian people, but I felt trapped and frustrated by their inability to engage in the kind of decolonial work in intercultural arts contexts that I was espousing. I turned my back on everything I knew and placed myself in the 'school of writing' with Hélène Cixous in an 'attempt to unerase, unearth and to find the primitive picture again, ours, the one that frightens us' (Cixous, 1991, p. 9).

Described by Bray (2004, p. 20) as a 'post-structuralist feminist of difference', Cixous' writing takes many forms of expression including poetic fiction, chamber theatre, philosophical and feminist essays, literary theory and literary criticism (Sellers, 1991, xxvi). Cixous (1994, p. xvi) tells us that each form of written expression possesses a 'particular urgency, an individual force, a necessity'. The necessity that Cixous speaks to is associated with the concept of *écriture féminine* or 'feminine writing' (Sellers in Cixous, 1994, p. xxix) in which she seeks to write as a woman in order to empower women. Indeed, Cixous' work is dedicated to liberating women's words, worlds and writing from the seat of patriarchal oppression. In arguably her most celebrated piece, 'The laugh of the Medusa' (Cixous, 1976), Cixous affirms the location of women's otherness in the female body and urges women to 'write your self. Your body must be heard' (p. 880) as a revolutionary strategy for destroying, subverting and deconstructing the patriarchal order. Cixous (in Cixous & Clement, 1986, p. 72) explains that writing in the feminine is 'a place . . . which is not economically or politically indebted to all the vileness and compromise. That is not obliged to reproduce the system'. Cixous (1976, p. 892) encourages a refusal to be 'impressed by the commotion of the phallic stance' and a desperate yearning for us to go further still to 'Shrug off the old lies, dare what you don't dare' (Cixous, 1991, p. 40). This, she suggests, is what writing *will* do – writing must no longer be determined by the past and instead must seek to break up, to destroy, and to foresee the un-seeable (Cixous, 1976, p. 875).

In the context of working with Indigenous Australian peoples in intercultural arts praxis, then, Cixous' work speaks to the possibility writing holds for deconstructing the mixed up past and present contexts of colonialism through an attention to the in-betweenness of difference. Indeed, much of Cixous' work turns around and around the politics of difference and she writes that she is constantly impelled to ask herself at once questions of the 'single and double':

> Questions of the ethical, politico-cultural, aesthetic, destinal value of this constitution; questions of the necessity of writing for [herself] and for others; of the usefulness, the strangeness of forever being here and elsewhere, ever here as elsewhere, elsewhere as here, I and the other, I as other . . . Stretching out existence, enlivening it, troubling it, surprising it.
>
> *(1994, p. xv)*

Her words speak to the peculiar, uncomfortable and yet dialogic doubleness inherent in-between. She, with and of her texts, sits always on the borders and I wonder about 'the materiality, the locatedness, the worldliness' (Ahluwalia, 2005, p. 141) that lies over and under Cixous' texts that lead her to such an attentiveness towards the ethics and politics of difference. As I descend into the depths of her work, I discover that while Cixous has spent much of her

adult life writing and living in France, 'to be French' and 'being French' has always been puzzling and problematic for her. The daughter of a French/Spanish/Jewish father and German/Jewish mother, Cixous was born in 1937 in Oran, Algeria. Her childhood was spent in the 'Mediterranean atmosphere of a French colony in North Africa' (Penrod, 2003, p. 136) and Cixous reflects on this experience in the following way:

> North Africa was an arid and perfumed theater, salt, jasmine, orange blossoms, where violent plays were staged. The scene was always war . . . we always lived in the episodes of a brutal Algeriad, thrown from birth into one of the camps crudely fashioned by the demon of Coloniality. One said: 'the Arabs'; 'the French'. And one was forcibly played in the play, with a false identity. Caricature camps. The masks hold forth with the archetypal discourses that accompany the determined oppositions like battle drums.
>
> *(1997, p. 262)*

As she alludes to here, Cixous' experiences of being and not being French, of belonging and not belonging to Algeria and France, are intertwined with the history of French colonialism. Cixous refers to this history as a 'double contradictory memory' (1997, p. 261) in which France granted her German family French nationality in 1918 at the end of the First World War. 'The same France', she writes, 'threw us out of French citizenship in 1940 in Algeria and deprived us of all civil rights' (1997, p. 261). For Cixous, on the one hand, to say 'I am French' is a 'lie or legal fiction'; and yet on the other, to say 'I am not French' a 'breach of courtesy' (1997, p. 261). She sits on the borders – neither French, nor German nor Algerian – a fluidity in her being and belonging in which she finds herself rejoicing in her 'French passporosity', *'perfectly at home, nowhere'* (1997, p. 261).

It is Cixous' own alterity and shifting colonial subjectivity – indeed her Algeriance as a Jewish Franco-Maghrebian – which arguably makes it possible for her to ask questions of the 'I and the other, I as other' (Cixous, 1994, p. xv). Algeria, for Cixous, was the 'land of the eyes' where the anguish and suffering of the Other wrought by the phenomenon of colonialism was everywhere and necessarily inescapable:

> We sent looks at each other, we saw, we couldn't *not* see, we knew and we knew that we knew we knew, we were nude, we were denounced, threatened, we flung taunts, we received glances. It was the land of the other, not of the fellow human being. The other: foretells, forewarns me, forecasts me, alerts me, alters me.
>
> *(Cixous, 1997, p. 270)*

Here Cixous positions herself as always already in both 'passance' (passing by) and 'arrivance' (movement) between I and Other, this culture and that culture, this language and that language, and it is her own questioning of all of these doubles which means that her writing can never 'settle in' (Cixous, 1997, p. 270). For me, it is Cixous' embrace and entanglement in, through and as writing of her interculturality, alterity and shifting colonial subjectivity that makes her a most necessary companion in this search for an affective and critical – perhaps, even, decolonial – writing practice in intercultural arts. It is Cixous' (1991, p. 40) resolve to *'dare what you don't dare'* and to 'never make you're here anywhere but *there*', to which this chapter now responds through my own yet 'Other' story. To danger then in writing we must necessarily go as an autoethnographic reading of the ethico-onto-epistemological dimensions of own intercultural arts praxis begins.

Two: a story about oranges

The woman in the vertical suit[2] sat in her high-backed blue-flecked swivel chair and regarded Elizabeth coolly, her slate laced eyes not blinking nor giving anything. In her right hand she held a slim silver fountain pen. Later she would use this weapon of black ink to make her mark of domination on a white page, but for now it tapped out a steady beat on the clean laminate desk. It marched to the beat of her own drum, and like the boots of soldiers on concrete paths, called others to join her. The tapping was tick-tock timed to the clock like a countdown to missile launch, and with each passing second a rash began to blotch and creep its way from her chest to her cheeks. Elizabeth watched it scrambling and scrawling an age-old rage that reeked in refusal and race/d across her body. She struggled to control an urge to itch and squirm, but the woman in the vertical suit continued to sit unnervingly still.

'Let me just explain to you Liz . . . this whole business of intercultural engagement is *dangerous* business. Non-Indigenous people like you, with your publicly performed personal-political-pedagogical palaver, proclaiming to work with and for Indigenous people, are *dangerous*. Loose cannons who spend and waste precious time talking and being-in-relation with Indigenous people, then fire bullets and barrages of anti-colonial-de-colonial research agendas, aims and outcomes into the centre where and when the war should already have been won!'

She smiled then, and Elizabeth could almost be fooled into thinking she was sympathetic had her grimace not been framed within pursed lips of steel.

'You see, you need to realise that it's a fight for knowledge at all costs, waged on a battle ground where words like relationship, ethics and love are our prime targets and must be obliterated. They don't serve me, nor those of my kind, well. We will continue to use the selfsame dichotomous and direct commands to get in and get out as quickly as we can to get the job done. You *have* to understand Liz . . . '

Her voice droned on. But it was too late; Elizabeth had heard all that she *could* stand. Just when she was quite sure she was going to die from the brutal diatribe cloaked as it was in blah blah blahness, her mobile mercifully rang. It shrieked and echoed an irritation towards the woman in the vertical suit that she could barely contain.

Elizabeth smiled apologetically, 'Do you mind if get that? It might be the school about my children . . . '

The woman in the vertical suit threw her hands up in the air. 'If I had a dollar for every time a female academic asks to be excused because she chose to breed and feed instead of read, I'd be a . . . '

Elizabeth tried to ignore her words that had become the wrong kind of whine and scrambled around in her bag. She found her phone buried at the bottom but it was not a number she recognised.

'Hello? Liz speaking.' There was a pause. 'Who is this?'

A thick French accent answered.

'Dear Liz, "There is a memory in our forgetfulness"' and Elizabeth recognised Hélène's voice at once.

'And [Indigenous people]? What are you doing? You are forgetting?'

Elizabeth was not quite sure what she meant and so said nothing, waiting for Hélène to 'put the word in [her] ear' (Cixous, 1994, p. 86) as she knew she would.

'Can you smell that?' Hélène asked, 'The perfume of those oranges?'

Elizabeth looked around the stark office and was surprised to see a farmhouse style wooden fruit bowl, distressed in white paint, tucked away on a corner book shelf holding three fresh oranges. She took a moment to smell and breathe in the sweet aroma of ripe citrus fruit.

'Yes,' Hélène whispered, 'I can sense that you too have entered into this moment to live the orange – and after all, is that not why I have called?'

Elizabeth glanced across and saw that the woman in the vertical suit, was now preoccupied with checking messages and email on her iPhone.

'Ah yes, Vivre l'orange,' Elizabeth said softly. 'I've looked at this essay of yours count-less times Hélène and after each reading I feel like I've been . . . "eating the forbidden fruit" (Cixous, 1993, p. 21) and consuming with each mouthful the political and ethical dimensions of my academic life. The concept of "living the orange" asks uncomfortable questions about who I am in relation to Others, who I/we/they might be in the process of becoming in relation to Others through my/our/their academic work and what happens in that material yet intercul-tural, intercorporeal and intersubjective moment of being in-between.'

Hélène's voice dropped and closed the distance between us. 'It sounds like you are full to overflowing with the taste of it and I wonder, why is this so important to you Liz?'

'For me it's the "r" word – response-ability. What response-ability do we hold in that moment of intercultural encounter for responding in a profoundly loving, ethical and non-violent way to the materiality of the Other?'

'Yes, "the love of the orange is political too" (Cixous, 1994, p. 90), there is no epistemologi-cal, ontological, methodological or pedagogical innocence to be found there,' Hélène added. 'Indeed, it is replete with many dangers: "dangers of error, of falseness, of death, . . . of complic-ity . . . of blindness, of injustice, of hypocrisy. That we fear and that we seek. For we fear the greatest danger which is forgetting to fear"' (Cixous, 1994, p. 90).

Elizabeth frowned and shook her head. 'But what now Hélène? How do I/they/we begin to un-forget the dangers?'

'I ask you to not flee the question, hold the orange in your hand and "change from feet to blood"' (Cixous, 1991, p. 3).

'I beg your pardon?' Elizabeth asked.

'If you hold, as I do, that creativity and intercultural arts praxis is about justice through a response-able ethical and political loving to difference and the other, then the orange is a beginning. Starting out from the orange all voyages are possible. Become, "freely, a dangerous woman. In danger of writing"' (Cixous, 1994, p. 90).

There was a moment of silence and then Elizabeth heard a soft click as Hélène replaced the handset in its cradle. She sat for just a moment, 'quite far from the peel of the world, in truth' (Cixous, 1994, p. 88) to collect her thoughts but soon found that she was alive and orange all over.

'I'm terribly sorry,' Elizabeth said hurriedly to the woman in the vertical suit. 'I have to go!' She had places to go, people to see, oranges to behold.

'Yes, yes, I heard,' the suit didn't even bother to look up from her mobile screen. 'Something strange about fruit, and it's not even citrus season.'

Elizabeth grabbed her bag and raced out of the door into the 'storm of the world' (Cixous, 1994, p. 89) that is being, doing, knowing *and writing* intercultural arts research praxis.

Three: in danger of relation, in danger of performance, in danger of research[3]

Elizabeth found herself a woman in danger one October afternoon almost ten years ago on the other side of the world. She had been working in the university library all morning and her head was buzzing, clouded, fuzzy. 'Writing was in the air around [her]', close but inacces-sible, and she was frustrated by how easily she had been swept along by what others had said. She stepped outside into an avenue lined with red, orange, yellow and gold; the cool caress of

winter approaching refreshed her thinking heart. Her feet beat a steady rhythm on the pavement and she found herself becoming the music, becoming the words that played around in her head. 'In danger of writing, in writing of danger', she sang softly to herself. 'But if I wrote, who might I be? (after Cixous, 1991, p. 29). And if I am write, what might I white? And if I am white, what might I write?' Her breath caught in her throat, strangling her song, and she stopped dead in her tracks. 'White write, write white?' She stumbled and fell into a memory from which she feared she would, and yet perhaps, never awake.

Tripping

Ngalhi? Yamulu bajinda? A-jirda ngalki a-mijiji[4]
Was it twenty years ago?
The trip that became her life began.
Did she arrive or not depart from?
Burrulula in the Northern Territory.
Saltwater breathing life.
Her husband's Yanyuwa Aboriginal family.
She walked, ran and danced.
Her way around people, country.
Cultural practices not her own.
Certainty blinding her blundering plundering.

Yinda a-nungarrima, barra! Ma, a-murdu, a-mijiji
Questions spewed wildly from her mouth.
Booming and broadcasting her desire.
Feet stamped heavily in places.
Where she should have tippy toed.
She watched herself watching others watching herself.
She being–there.
Her white shadow forever bright.
Burning a difference.
She would not yet see.

Yinda a-ngalki, a-mijiji, a-murdu
She ignored it.
Looking naively without looking.
Into the face of the others.
With expectation of something returned.
Her tape recorder in front.
Dutifully they sang for her.
She, quite happy to take.
To receive the generosity and gifts.
Glistening like diamonds.
As she looked on high from the ivory tower.

Jirda!!! A-tjitjitjirla, a-mjijii, a-murdu – yinda a-kurdardi!
She knows not when.
But, it happened.
She caught a glimpse.

The selfsame staring back at her.
She abhorred what she saw.
The asymmetry of the gift.
The impossibility of reciprocity.
Her knowledge seeking colonial presence.
Wanting possession of another.
Real colonial violence her self.
Had stopped her from seeing.

Warriya a-ngarna a-luku, a-mjiji, warriya a-ngarna a-luku
After all of the looking.
She had been doing at the.
Other asked her silently and without need or response.
To look at herself.

Swaying

Elizabeth moaned softly as she dreamt. She restlessly turned her mind and body over and over, trying to find a more comfortable place to be.

Ngardidjara yakajamala mala, mala, mala/
ngadidjara ngardidjara yakajamala
She saw herself small and silent
Pausing under a gentle Casuarina tree.
Watching the sun dance lightly.
Signs lurking in the muddy depths.
Against the hard trunk she leans.
A mermaid sings a siren's song.
Bark, leaves and lifeblood whisper to her.
Calling, bringing back.
Wrapping her completely in the swaying.

Yinda a-nungarrima a-ngardirdji a-mijiji,
yinda a-Yanyuwa a-barratha
From one side to the other.
Shifting from here to there.
From then to now, from self to other.
Beginning to breathe again.
'Yes, this is the place.
"Go backwards and forwards."
"feel it quietly, round, smooth, heavy."
And so to hold it day after day.'

Yalayka a-mijiji! Yalayka!
Bawuji barra – kurdukurdu, yalayka!
Swaying now to a rough rhythm.
Reaching forward, steadying, failing.
Dark mangrove mud covers her.

Skin changing colour, turning over.
Backwards and backwards again.
From black to white – right? What!

Kurda, a-warriya a-ngarna-luku, ngarna ngalhi?
She is dizzy now, dizzy Miss Lizzie.
Her family call her name.
Her three boys, a Yanyuwa father and two Yanyuwa sons.
She has forgotten herself.
Swaying now to the other.
Side of the river.
Where are/there are other selves.
White selves like her.

Kirna balirra, ngarna a-wunahka, kirna balirra
Sighing, she blends in.
White skin does at home.
Close your eyes.
Open them slowly.
And quickly see it again.
Whiteness.
Not pure, always already marked.
Grubby, messy.
Spots of racism on blankets of colonialism.
Smudges of ignorance and stupidity.
Old blemishes and new stains.
Screams curdle in blood slaughters.
Now just as they did then.

Yinda nomore a-mjiji, yinda a-nungarrima,
a-Yakibijirna –inne a-wunhaka?
Desperately she wants to sway.
Back over to the other side.
Her Yanyuwa family and the Casuarina tree wait.
In their alterity for her to see.
But again the *White* self.
The distance between them.
She heaves with the stench of it.
Rotting, retching, purging, swaying.
Lurching, not knowing.
She staggers and falls heavily to the ground.

Dreaming

She dreamt then, long and hard, of an orchard. She saw two women, one English, the other French, sitting under an apple tree on large calico deck chairs. They were drinking tea and eating scones with jam with the tantalising aroma of ripening fruit as third company, and in the middle of conversation.

VIRGINIA

'Quite so,' Virginia nodded. 'And "the human frame being what it is, heart, body, brain all mixed together, and not contained in separate compartments . . . a good dinner is of great importance to good talk" (Woolf, 1929/2001, p. 14).'

HÉLÈNE

'Everyone is nourished and augmented by the other' (Cixous, 1991, p. 42), added Hélène.

VIRGINIA

Virginia looked conspiratorially at her friend. '"The truth is", her voice a low whisper, "I feel the need of an escapade . . . I want to kick up my heels and be off. I want to embody all those innumerable ideas and tiny stories which flash into my mind at all seasons" (Woolf, 1980, p. 131).'

HÉLÈNE

Hélène grabbed Virginia's hands, 'What are you waiting for? "Write [then]! What? Take to the wind, take to writing, form one body with letters. Live!" (Cixous, 1991, p. 41).'

VIRGINIA

'For once truth does not escape me,' Virginia declared triumphantly. 'In writing [I'm] "like a voyager who touches another planet with the tip of [her] toe, upon scenes which would have always gone and will go on, unrecorded, save for this chance glimpse. Then it seems to me that I am allowed to see the heart of the world uncovered for a moment" (Woolf, 1980, p. 153).'

HÉLÈNE

'This is "the work of un-forgetting, of un-silencing, of unearthing, of un-blinding oneself, and of un-deafening oneself", Hélène replied softly. "Loving, saving, naming what would be erased and annihilated is political in an immediate sense" (Cixous, 1994, p. 83).'

VIRGINIA

Virginia sighed. 'What are these [writing] ceremonies dear Helene and why do we take part in them?' (after Woolf, 1938).

HÉLÈNE

Hélène sat quietly.

VIRGINIA

'It is a constant idea of mine,' continued Virginia, '"that behind the cotton wool [of everyday life] is hidden a pattern" (Woolf, 1976, p. 72) and I feel that by writing I am doing what is far more necessary than anything else, I am searching for "moments of being" (Woolf, 1976, p. 73).'

HÉLÈNE

'The orange is a moment' (Cixous, 1994, p. 88), Hélène murmured.

VIRGINIA

'The orange? I am quite sure I don't know what you mean Hélène!' Virginia looked quizzically at her friend.

HÉLÈNE

'Here we are two in our materiality of being, being two, being intersubjective, being intercorporeal and being in–between. Being between two is a moment to live the orange.' She paused, trying to find the right words. 'The question for us is under what conditions may we live the orange? To live the orange is a political act and there is an ethical necessity in being two.'

HÉLÈNE

Hélène stopped speaking and gestured towards a woman asleep on the grass in front of them, lying awkwardly. The woman stirred, frowning slightly, at once comforted and disquieted by the conversation that swirled in and out of her dream.

HÉLÈNE

'Look at Elizabeth, the wind knocked out of her, a trampled space, her "lovely mouth gagged with pollen" from these apple trees (Cixous, 1976, p. 878). Her words, her writing, her self has been "separated from the orange, [she] didn't write the orange, didn't go to it, didn't call it, didn't carry the juice to her lips" (Cixous, 1994, p. 86) and now the flesh of her body recoils from her bones in hunger, her heart shrivels in thirsty pain.'

VIRGINIA

Virginia knew the feeling all too well.

HÉLÈNE

'Yes, above all, "writing: a way of leaving no space for death, of pushing back forget-fulness, of never letting oneself be surprised by the abyss. Of never becoming resigned, consoled" never turning over in bed to face the wall and drift asleep again as if nothing had happened; as if nothing could happen' (Cixous, 1991, p. 3).

Hélène reached into her bag and walked over towards the sleeping woman.

VIRGINIA

'What on earth are you doing now? Can't you let the poor girl rest colonially, I mean . . . comfortably?'

HÉLÈNE

Hélène ignored Virginia, bent down beside Elizabeth and gently placed an 'orange back into the deserted hands of [her] writing' (Cixous, 1994, p. 86).

Conclusion: freely into the danger of intercultural research-as-writing

This chapter, then, is an attempt to do *more* with writing in intercultural arts research to draw attention, in ways both overt and subtle, to the ethico-onto-epistemological dimensions of what we do. For, indeed, we are doing *something* and yet I wonder how often we attend to the

dangers of doing writing? Until now, I have waited – poised just on the analytical edge – to explain for you how, why and what are the words that have become this writing and your reading. I have not wanted to interfere in this in-between and intimate moment for 'not everyone carries out reading in the same way' (Cixous, 1993, p. 19). As Cixous suggests, 'reading is eating the forbidden fruit' (1993, p. 21) and in this chapter I have invited you to take a bite of the affective, material, relational and ethical dimensions of 'living the orange'. The reading and writing of this chapter is intended to be a 'provocation, a rebellion' (Cixous, 1993, p. 21) for us as intercultural arts researchers, writers and practitioners to 'oppose norms, break loose from rigid concepts, at our own risk and peril, to arrive at a new freedom for our thoughts' (Lie, 2012, p. 43). This provocation is dangerous praxis and yet one to which I cannot help but freely respond. Is that not my response-ability as a white settler colonial woman? Is it not one that we all hold once we enter into an intercultural arts praxis?

The word 'danger' is used in this chapter to invoke on the one hand the potential interculturality holds to bring into being an in-betweenness of self and Other which is at once transgressive, innovative, and empowering. On the other hand, however, it is the very in-betweenness that lays bare the possibility for power and privilege to be mis/used/represented to perpetuate and reproduce dominance of self in relation to other. The playful, poetic and political nature of Hélène Cixous' work is a constant reminder that the language, knowledge and performativities I hold as a white settler colonial woman are powerful. Her writings, alongside those of Virginia Woolf who kindly agreed to make a cameo appearance in this piece today, call me in Cixousian terms, to 'unforget' and act on the sense of response-ability I have to come clean. To own up, to use my white race power and privilege to shake, rattle and roll our intercultural research and writing practice into a more ethical way of attending to our complicity in the wound up, bound up colonial past and present of this moment. It is more than that though – it is also attending in writing to the ways in which our words-as-worlds-as-works engage in a performance and perpetuation of dominance – white supremacist imperial capitalist patriarchy bell hooks would call it – and forever seeking to be 'wide awake' to the incompleteness and possibility of a justice for Indigenous people which is not here yet. To 'live the orange' in intercultural arts research-as-writing practice, is to ask questions about the moral obligations we hold to work in a manner that works against the epistemological violence of taking from the Other, disrupting the dominance which makes such appropriation possible, and imagining an intercultural arts practice where things might be otherwise. Is this not what we think intercultural arts research-as-writing practice might do?

Notes

1 In this chapter, 'praxis' is defined as the process by which a theory, lesson, or skill is enacted, embodied, realised and performed. It brings to our awareness the relationship between theory and practice.

2 The 'woman in the vertical suit' depicted here is a fictional character and does not represent a 'real' person, but rather a montage of the many different kinds of colonial characteristics I have seen in people I have worked with in academic and research work over the past 20 years.

3 This is a modified version of a story and poetry published in an article entitled 'In danger of writing: Performing the poetics and politics of autoethnography with Hélène Cixous and Virginia Woolf' in *Qualitative Research Journal* 2015. It has been reprinted here in a slightly revised form with full copyright permission of the journal.

4 The non-English language included here is Yanyuwa – the language of my husband's family. It is not translated, as a statement of philosophical and political refusal in regards to what Western knowledge production and colonisation wants, that is, to know, possess and therefore control the colonised. This act of non-translation by a non-Indigenous woman of an Indigenous language is intended to unsettle, to challenge and to disrupt the binaries, the status quo and begin a process of 'fracturing the locus of coloniality' (Lugones, 2010).

References

Ahluwalia, P. (2005). Out of Africa: Post-structuralism's colonial roots. *Postcolonial Studies, 8*(2), 137–154.

Barad, K. (2006). *Meeting the universe halfway*. Durham, NC: Duke University Press.

Bray, A. (2004). *Hélène Cixous: Writing and sexual difference*. Basingstoke: Palgrave Macmillan.

Cixous, H. (1976). The laugh of the Medusa (K. Cohen & P. Cohen, Trans.). *Signs, 1*(4), 875–893.

Cixous, H. (1991). *Coming to writing and other essays* (S. Suleiman, Ed., S. Cornell, Trans.). Cambridge, MA: Harvard University Press.

Cixous, H. (1993). *Three steps on the ladder of writing* (S. Cornell & S. Sellers, Trans.). New York, NY: Columbia University Press.

Cixous, H. (1994). *The Hélène Cixous reader* (S. Sellers, Ed.). London: Routledge.

Cixous, H. (1997). My Algeriance, in others words, To depart not to Arrive from Algeria. *Triquarterly, 100*, 259–279.

Cixous, H., & Clement, C. (1986). *The newly born woman* (B. Wing, Trans.). Manchester: Manchester University Press.

Greene, M. (1994). Postmodernism and the crisis of representation. *English Education, 26*(4), 206–219.

Haraway, D. (1997). *Modest_Witness@Second_Millenium.FemaleMan©_Meets_OncoMouse™: Feminism and technoscience*. New York, NY: Routledge.

Lie, S. (2012). Medusa's laughter and the hows and whys of writing according to Hélène Cixous. In M. Livholts (Ed.), *Emergent writing methodologies in feminist studies* (pp. 41–54). London: Routledge.

Lugones, M. (2010). Towards a decolonial feminism. *Hypatia, 25*(4), 742–759.

Mackinlay, E. (2015). Making an appearance on the shelves of the room we call research: Autoethnography-as–storyline–as–interpretation. In P. Smeyers, D. Bridges, N. Burbules & M. Griffiths (Eds.), *International handbook of interpretation in educational research* (pp. 1437–1456). London: Springer.

Nadar, S. (2014). Stories are data with soul: Lessons from Black feminist epistemology. *Agenda: Empowering women for gender equity, 28*(1), 18–28.

Penrod, L. (2003). Algeriance, exile, and Cixous. *College Literature, 30*(1), 135–145.

Sellers, S. (Ed.). (1991). The *Hélène Cixous reader*. New York: Routledge.

Woolf, V. (1929/2001). *A room of one's own*. London: Vintage Press.

Woolf, V. (1938). *Three guineas*. London: Hogarth Press.

Woolf, V. (1976). *Moments of being: Unpublished autobiographical writings* (J. Schulkind, Ed.). Orlando, FL: Harcourt.

Woolf, V. (1980). *The diary of Virginia Woolf, Volume III: 1925–1930* (A. E. Bell, Ed.). London: Hogarth Press.

7

INTERCULTURAL EDUCATION AND MUSIC TEACHER EDUCATION

Cosmopolitan learning through popular music

José Luis Aróstegui and Gotzon Ibarretxe

Introduction

The 21st-century emigration phenomenon brought about by economic growth, student mobility and tourism as well as global interconnectivity of the digital era, has given rise to a global culture which coexists and overlaps with the local, and makes space for "cultural hybridization" (Kraidy, 2005). This has had important consequences for education, which has become necessarily intercultural and cosmopolitan (Rizvi, 2009). In this chapter we will review the concept of interculturality through the lens of Global Studies in education, cosmopolitan learning and a post-colonial approach, to discuss how music has contributed to the development of intercultural education and intercultural competencies in music teacher education. From the outset it is important to acknowledge that our discussion is linked intimately to our own intercultural subjectivities. Our shared social construction is based on our Hispanic tradition—in this context intercultural education emerges as a way to empower Indigenous cultures in Latin America; it combines with a European perspective and desire to give an answer to the problem of cultural difference at schools (Osuna, 2012); and intermingles with international literature where a Western and white perspective dominates.

By discussing the concept of identity and cultural diversity, we will first review the linked concepts of multiculturality and interculturality, and discuss their implications for education and music education. Next, we will discuss the context of the Basque Country, Spain, and the implications of practices carried out with popular music during primary teachers' training as an illustration of intercultural arts practice. Throughout this chapter we explore the ways in which interculturality is part of our daily world, and the ways that different cultural layers coexist. We will conclude with thoughts about the way music education has to be decolonized by intercultural musical practices and by expanding the local and global cultural horizons of people, and suggest a shift in focus from music to students diversity and from identity to inequalities is needed to acknowledge the political and power implications of any educational practice.

Identity and cultural diversity: steps towards interculturality

Culture can be defined as a particular set of rules and knowledge to interact with other persons in a particular society (e.g., Bourdieu, 1990; Foucault, 1977). Every individual will comply with those rules in a different way, depending on the group or class to which he or she belongs, his or her subject positions such as gender and class. The culture of the individual is dependent upon the culture of a group or class and, at the same time, the culture of the group or class is dependent upon the culture of the whole society to which that group or class belongs (Elliot, 2010). Every set of rules defines how we see reality and this includes how we perceive ourselves and the others, which is what we call personal and social identities (Lamont, 2002). As these identities depend on the contexts in which a particular set of rules and knowledge is made, identity, knowing, and social membership entail one another (Lave & Wenger, 1991). The aforementioned set of rules and knowledge which constitute the identity we call culture, comprises any human construction: spiritual and material, intellectual and affective, scientific and artistic, ways of life, values, traditions and beliefs and so forth (UNESCO, 2009). Each society allows and determines specific options for every aspect of its culture, each of them enforcing groups and individuals in different directions if they want to succeed in that group and society. This is the reason that social identities often collide with others, as cultural practices may be interpreted in different ways from different frameworks.

It follows then that "cultural diversity" implies that every person perceives the same situation differently according to his or her own cultural set of rules and also how every person recognizes other identities. The concepts of "interculturality" and "multiculturality" emerge as a way of understanding conflicts caused by different interpretations of the same "facts." Multiculturalism denotes the presence of various cultures in the same society, that is, each culture preserves its own identity and remains static, with no "external influence," while interculturalism refers to the interrelationship among cultures and, therefore, their mutual influence with blurred borders, thus denoting and accepting changes. In other words, "while multiculturalism refers to a way of understanding diversity, interculturality is referred to the very existence of diversity" (Arriarán & Hernández, 2010, p. 88).[1]

The concept of "multiculturalism" refers to contact among cultures, especially in cities and in certain countries where migration and Information Technology have had an impact in most of the population. Multiculturalism recognizes the political and economic asymmetries and their impact on racial segregation. Multicultural heterogeneity is conceived as juxtaposition and dispersion among groups as a way to guarantee individual rights for people who belong to "their" community (García Canclini, 1995), that is, they think and act as a member of a minority (e.g., African Americans in the US, the Romany population in Europe). This works to essentialize minority identities and, therefore, each group is entitled to claim difference in language, quotas for jobs and receive services or make a space for their difference in institutions such as schools, universities and government agencies.

"Interculturalism," in turn, understands the relationship between different cultures as a social space to be shared where different cultural characteristics form a code that generates continuity between cultural differences (Solís, 2001). Here the focus is on the cultural convergences and on the inventory of similarities, that is, on those elements that have been spread and are shared by different groups, thus paying attention to the way each culture interprets and creates one "supra-culture" with which that cultural diversity is identified. This supra-culture can play the role of enabling coexistence in social situations of confrontation between cultures and of abolishing xenophobia and intolerance of any type (Solís, 2001). From this perspective, it could be argued that only an intercultural school is truly educational, a venue where differences are valued and

grounded in democratic values. Democracy in this sense means the acknowledgment of cultural differences among groups that, at the same time, are still part of a single community (Casquette, 2001). A democratic school should, therefore, promote the reciprocal assimilation of differences between cultures (Gijón, 2005). As Lorenzo (2004, p. 82) highlights:

> The intercultural school is certainly an elaboration and a product of democratic societies. Its essence is the development of genuine citizenship, with all the values and implications brought out for each student, whether he or she belongs to a majoritarian or a minority culture. It is, therefore, to treat every subject with equal rights regardless the culture which they belong to. It is to shift from a conception of subjects just as inhabitants of a territory to citizens exercising rights and duties.

In the end, the recognition of different social identities ends up linked to a political system that acknowledges minority rights, thus allowing coexistence together—indeed, if we deny cultural diversity within a particular culture or society, it is likely that the flip side of homogeneity will bring out discrimination.

The school system cannot ignore these differences in students if it does not want to discriminate as well. When teachers choose and reject experiences of difference which their students bring, they are discriminating against those students whose identity does not fit well with the school culture given. On the contrary, teachers can acknowledge cultural diversity in their classrooms, thus transforming the borders of the school culture. This is why intercultural education is necessarily democratic. Pérez Tapias (2013, p. 152) defines intercultural education as "the search of values and principles able to be shared by everybody" based on our differences rather than on their denial. For this, he suggests that intercultural education must: be focused to deconstruct discrimination and prejudgment; the entire school community must be constructed from intercultural patterns; there must be adequate economic conditions for every group; and, each interlocutor has to accept that they do not hold the monopoly on truth. No fundamentalism is possible in an intercultural education—for Pérez Tapias (2013), justice is the starting point.

Multiculturalism and interculturalism in music education

Music has been widely used in multicultural education as a way to show the cultural diversity of the world (e.g., Schippers, 2010). Its first and major implication has been the inclusion in the curriculum of different music genres coming from different cultures, the so-called "musics and dances of the world" which have been part of music teachers' training in many colleges of education. Drawing upon the work of scholars such as Anderson and Campbell (2010), the major concepts and debates in multicultural music education are: (1) the focus on the musical content that teachers should teach and students learn; (2) the "authenticity" of musical experiences provided; (3) what musical cultures are to be included as part of the curriculum; and, (4) the repercussions of multicultural music education to benefit students, schools and society. The practice of multiculturalism in music education has been developed and carried out from an ethnomusicological approach. Grounded in Western thought and colonial expansion, ethnomusicology has always held an interest in "folk" and "other" cultures (Campbell, 2003). This interest in "other" cultures was transferred to music education, and music teacher education in the 1960s onwards sought "to expand upon students' perceptions of music and its makers" (Campbell, 2003, p. 20). From this perspective, music education students are cultivated in musical diversity when it is considered worthy to be taught and learned so that they can recognize value in different musical expressions.

The question remains, then, what do we understand as value and what musics should be selected according to these criteria of value? The most usual answer is that the "authenticity" of music to be played in classrooms is the key to value in a multicultural experience. Authenticity itself, however, is a problematic term, even more so when translated into classroom music education practice. For example, the classroom setting is often located far away from the "natural" setting of the music and it can also be difficult to provide representative examples of the musics from specific cultures. An "absolute" authenticity (Palmer, 1992, p. 33) is impossible as "transferring music from its original cultural context to the classroom increases the chances that authenticity will be in jeopardy" (p. 33). According to Palmer, the emphasis in educational practices is usually on the intellectual content, to the detriment of cultural, aesthetic, sociological and psychological aspects. Green (2006) also links authenticity to meaning, wondering "whether the problem of authenticity in the classroom is an adult construction, caused by too much focus on the product" (p. 114). Thus, the key is to aim "not for the authenticity of the music *product*, but for the authenticity of the musical learning *practice*" (Green, 2006, p. 114). For Green, musical authenticity will emerge when music-learning authenticity comes from the students' musical autonomy, since the more they participate on their own, the more they will learn independently and the larger will be their involvement with both the inherent meanings of music and the delineated as well. Similarly, Campbell suggests then that we have to look for what is authentic for students rather than from the musical content:

> Authentic interventions are the ways and means of nurturing children's musical development . . . They become authentic when they are rooted in children's actual needs and interests . . . These interventions are not intended as dogmatic or universal principles to abide by but are meant to be malleable and affective in the hands of the thoughtful teacher.
>
> *(2010, p. 248)*

In other words, the answer is to pay attention to students' diversity and needs rather than to musical diversity.

Whether intentional or not, a multicultural perspective that tends to focus only on diversity of cultures, implies the division of the world into two: "own" culture and the "others." During the era of industrialization and modernity, Western culture conceived some groups (e.g., men, white, property owners, bourgeoisie, adults) as civilized, free and therefore superior beings, while others (e.g., women, non-white, people without property, proletariats, savages, and infants) as subjugated and inferior (Fernández Enguita, 1999). This hierarchy based on binary oppositions explains how differences become inequalities. The reason for this contradictory effect is that, while paying attention to the cultural object, considering all of them equal, multicultural education is perpetuating injustice. As Gorski notes, "most intercultural education practice supports, rather than challenges, dominant hegemony, prevailing social hierarchies, and inequitable distributions of power and privilege" (Gorski, 2008, p. 515).

In this division of the world into binary oppositions—one free and another dominated—music is no exception. From this perspective, Western classical music was considered as *superior* and the musics performed by "others"—for example, women, folk performers and/or non-Western musicians—were positioned as *inferior* and, therefore, not considered worthy to be included in the academia. Multiculturalism and ethnomusicology took a step towards recognizing the value of "other" musics (Volk, 1998). O'Flynn (2005) reflects on the multicultural concept of "world music education," arguing that the use of this term often "carries

implicit assumptions about (a) the possibility of a universal system of music education; and (b) a taxonomy of 'exotic' music(s) subsumed within a 'pan-Western' view of music and musicality" (p. 194).

Intercultural competence and cosmopolitan education

What can be considered as "external" or "internal" to one culture has always been a complex task, as culture itself is a dynamic concept. Traditionally, the limits of our own community coincided loosely with nation-states, however, what we now understand as "our community" in a global world has changed dramatically. This can largely be attributed to the mobility of people and cultures, money and capital, technology and innovation, mass media and multimedia files, ideas and ideologies, and, the wishes and hopes that shape people's lives (Rizvi, 2009). The world is becoming increasingly interconnected and interdependent (Starkey, 2012) and these "extended communities" demand a new educational approach which becomes "cosmopolitan," involving a significant departure from the dominant nation-centric tradition of thinking about education (Hannerz, 2004).

Cosmopolitan education is often promoted "from above." For example, the *Melbourne Declaration on Educational Goals for Young Australians* stresses the ideas of global citizenship and intercultural understanding (Barr et al., 2008) and the European *Lisbon Declaration* promotes a "response to globalisation and the shift to knowledge-based economies" (European Parliament and Council of the European Union, 2006). While such a cosmopolitan view is necessary in our current global world, it should not imply any weakening of local or national affiliations, as it might imply an imposition of a hegemonic culture presented as "global" and a cultural colonization of the rest. Bates (2014) finds three potential risks in what he refers to as cosmopolitanism in music education *from above*—a near-exclusive focus on classical music in the sense earlier discussed of Western cultural assimilation; the proliferation of multicultural music curricula as it pays attention to external groups and might forget internal differences; and "a somewhat myopic promotion of digital technologies" (p. 310).

A key challenge associated with the implementation of educational programs designed to develop cosmopolitan sensibilities relates to the need to consider seriously issues of cosmopolitanism "from below" in the everyday, ordinary and organic relationships that people are increasingly able to forge across national borders; and further, to take into account the diverse ways in which transnational mobility of people and ideas, along with capital, is "transnationalizing" the spaces in which we live and work (Vertovec, 2009). This in turn can transform local lives, social institutions, cultural practices and even the sense of identity and belongingness (Rizvi, 2009). For example, Jenkins (2004) argues that in the age of global media convergence there is emerging among young people a cultural form he calls "pop cosmopolitanism." This cosmopolitan education *from below* entails for music education to move towards an intercultural concept of music education which O'Flynn (2005) describes as "intermusical." He writes, "a broad application of intermusicality suggests a framework by which we might profile and interpret the musical backgrounds of teachers, students, their parents and other community members" where musical practices are connected to "practices and conceptions of music in the communities and societies concerned" (2005, p. 199) that, in consequence, are relevant to the community in question.

For this, we need teachers with intercultural competences that go beyond the mere addition of a repertoire of musics and dances of the world in programs. Teachers must be interculturally competent and be aware of the unjust relationships such practices might carry out. Thus, intercultural education would refer to the treatment of cultural diversity through holistic educational

processes in permanent change with the purpose, among others, to encourage reflection about my position and my relationship with other identities, and about the different cultures living in the world based on principles of communication, respect and tolerance (Pérez-Aldeguer, 2013).

Intercultural competence in Europe and new teacher education programs in Spain

We now turn to discuss the concept of "intercultural competence" with reference to our work at the University of the Basque Country (Spain) with students training to become music educators. Like most universities in Europe, over the last decade, the University of the Basque Country has implemented the European Credit System adapted to the new European Space for Higher Education. During the 2011–2012 school year, we saw the need for training in the environment of emerging fields, such as the design and development of innovative educational projects, the use of Information Technologies and the assessment by competencies. Thereby, second-year students enrolled in the Primary Teacher Education degree were invited to create an album cover to be used to advertise a music CD. This activity had a primarily aesthetic function, but it could also have had an educational function due to the special connection with these products and the culture of popular music, and the production of new methodologies of teaching and learning at the university too. In this way, the activity would not only create connections between popular music from the 1960s onwards (e.g., rock, pop, heavy metal, folk) and renowned visual artists associated with art movements such as Pop Art, Dadaism, Fluxus and New Realism, but also between the teaching methods and artistic subject content in teacher education. We expected to share information for cooperation between faculties of different artistic areas at the university. Moreover, this activity would facilitate the use of the multimedia resources, and the practical knowledge of diverse artistic cultures among the students. Finally, these students would be qualified for jobs that required practical application of artistic skills and intercultural competence (Emmanuel, 2003; Essomba, 2010; Ibarretxe & Díaz, 2008).

The research process

Our starting point was that popular music allows us to delve into the modern and cosmopolitan culture of students as well as to develop new forms of learning and adoption of elements from popular music, which makes possible a truly intercultural music education because of its global grasp and because of its commitment to different music and visual cultures. Thus, the objectives of the album cover activity were:

- to identify the interaction of the musical and visual cultures which initial teacher training students live;
- to examine the role and presence of popular music and art in the shaping of students' professional identity;
- to analyze the importance of interculturality with pop music in the training of teachers' competences.

Prior to creating their album covers, the students were encouraged to select and listen to different CDs. They were given a sheet of paper so that during the listening they could take note of the music genre, lyrics, singers and their characteristics; and then they were asked to make an assessment of the activity and the usefulness that the activity could have when they became teachers. A pilot study was carried out in two parts. We first interpreted the iconic imagery

collected from students' works (89 in total) through the use of visual ethnography (Harper, 2003; Hernández, 2003). Second, we interpreted the modes of reception and construction of meaning by the students through the use of a narrative model (Denzin & Lincoln, 2003) by means of the students' observations and comments about their works. This was supplemented by the students' reflective responses to the following questions:

- What materials, techniques and processes have you used to design the album cover?
- What kind of music, singer or musical group have you chosen?
- What kind of relationship have you established between music or textual data and image? In what way do you personally identify with those aspects?
- What do you mean about the concept of teacher identity?
- What do you think about the ICTs and multimedia resources used to carry out the activity? And the incorporation of new technologies in your teacher training?
- How can this activity help to reinforce the acquisition of intercultural competence and skills related to the professional training? What do you think about this methodology of learning art and music education?
- How have these professional skills been acquired in a real context of traineeships?

Our research showed that most of the students' covers were photomontages (62%) created using programmes such as Photoshop or PowerPoint. However, 21% of students used traditional techniques such as drawing, watercolours or colored pencils. As for the musical genres chosen for the covers, rock, pop and pop-rock represented 64% of the total. It included both national and international musical groups. The results reflected that students' musical interests were mainly linked with the most up-to-date popular music. Singers and groups that represented rock music were most preferred (40%). Ska, reggae and hip hop, as well as Western "classical" music were rarely included while students showed some interest in folk (12%), heavy metal (10%), and Latin American music (7%).

In addition, 36% of the singers chosen were from the Basque Country. This percentage fits with the percentage of works they selected by topics of identity, political and social criticism. Among the most cited Basque groups were the rockers Berri Txarrak, Ken Zazpi, Esne Beltza, Gatibu and Fito y los Fitipaldis; the songwriters Mikel Laboa and Mikel Urdangarin; or the folk music of *Kepa Junquera's trikitixa* (the Basque diatonic accordion). Among the Spanish musicians, students' choice highlights pop, pop–rock and rock music of Amaral, Jarabe de Palo, Maldita Nerea and David Bisbal; punk music of Ska–p; or the flamenco guitarist Paco de Lucía. Students chose the following musicians and musical styles from the international arena: AC/DC, Alphaville, The Beatles, Bob Dylan, Bob Marley, Coldplay, Evanescence, Fort Minor, Kings of Leon, Michael Jackson, Muse, Neil Young, Old Crow Medicine Show, Rammstein, REM and Yiruma.

Strategies of representation

The album covers created by the students were used to express feelings such as passion, hope, hate, loneliness, pain, happiness, silence, freedom or love. But they were also used to reclaim diversity and identity, or political and social issues. In fact, more numerous topics chosen by the students were related to individual feelings, as well as those related to identity, or political and social criticism. Sometimes there was a close relationship between the lyrics or the title of the song and what the album cover represented. Moreover, life experiences of students (memories, moments and insights) were often related to the songs: the experience of being in an

NGO, taking a trip or reliving a happy time of life. However, in most cases the cover depicted sensations that accompanied the musical experience—for example, when a student said he disconnected from the world with Bob Marley's music, or when another student remembered the first time she fell in love with *Angie* by the Rolling Stones.

The original album covers did not always match with the themes of the songs. There were CDs recorded live in which other self-referential elements appeared assiduously, and the cover designs were represented by a picture of the singer or a self-portrait. This was the case, for example, of the album *Bob Dylan Live 1966* chosen by a student. He attempted to put himself in the place of the singer, and painted the face of Bob Dylan just as he saw him. He explained:

> When I hear Bob Dylan's music time seems to stop, and that brings me a moment of creativity. I see him through his special eyes. A geometric shape with a sharp and large nose. Frizzy hair and a big mouth that reflects sadness. Straight lines are in contrast to his thought and his life without boundaries.

Basque cultural references also appear on students' album covers: photos illustrating Basque sports, Picasso's *Guernica* or diverse landscapes with different customs and lifestyles. Nevertheless, it should be emphasized that some covers included symbolic elements of the city which connect local aspects with the global culture. This is the case of the student who chose Kepa Junquera's *Bilbao 00:00* (1998), which not only incorporates, among others, Bilbao's tram and the image of the Guggenheim Museum Bilbao, but also organizes the entire composition of his cover around this last image: the Guggenheim Museum is the visual metaphor that mirrors the modernity, cosmopolitanism, the international relations and the global culture.

In this sense, *Bilbao 00:00* is a tribute to Junquera's city of birth, but above all this double album is a mix of traditional and contemporary elements, and features a cast of national and international musicians, including Béla Fleck, Carlos Beceiro of La Musgaña, Fain Dueñas of Radio Tarifa, and Paddy Moloney of the Chieftains. It is important to remember that Junquera has sought the collaboration of the most prestigious musicians in the world, and he has recorded some of the best-known Basque traditional songs with renowned singers of very different musical styles. Hence, his music has been classified as folk music, but also as world music: his work *Hiri* (City, 2006) was selected as best world music album (*World Music Charts Europe*) in 2007.

Conclusion: cosmopolitan learning and professional identity

The research illustrates how students' identities are positioned in relation to musical and visual imagery. It also shows the opportunities for an intercultural teacher education which places the university within an interconnected cultural and global context—an experience that starts and finishes with students' cultures, while expanding their horizons through arts and respecting "other" identities. In our work, we can easily find three different identities coexisting at the same time in student's art work and yet articulated differently in each: the Basque, the Spanish and the global that, at the same time are intermingled. For instance, is Picasso's *Guernica* "Basque" because of the topic depicted and its symbolism? Is it perhaps "Spanish" as Picasso was born in Málaga and professionally raised in Barcelona, or international as he also worked in Paris and he is a landmark in the History of Art? Or is *Fito y los Fitipaldis* "Basque" because it was founded in Bilbao, part of the "Spanish" culture as you can hear its music all over the country or "international" because it is also well known in Latin America and because they play pop rock music? The answer to these questions about what is "external" or "internal" to each cultural layer is to be answered by every person involved on the project from his or her own

identity while acknowledging the others' different positions and meanings. This seemed to be the case in this experience—the process of creation and the final products became meaningful in different senses, thus becoming "authentic" for participants.

Further, from the works created by the students, it is easy to observe that there is no primacy at all of Western classical music, quite the opposite. Although present in some of the student's art work, it is far from that dominant model so much documented in prior research (Aróstegui, 2004; Kingsbury, 1988; Nettl, 1995; Small, 1980; Vasconcelos, 2002), where the great masters were venerated while popular music was relegated out of the academia. Activities such as the album cover project discussed above can be a privileged agent of transformation and social change. Students considered that the creation of an album cover was definitely something new, but most of all, it allowed them to have a more practical and realistic understanding of the subjects studied in class. Many of them felt it was an effective learning tool which could be applied during the practice sessions, so they valued this as important experience during training, while, at the same time, this activity can help students to develop skills directly related to the inclusion and attention to musical and personal diversity. The artistic-musical activities have also helped students reinforce their generic skills related to their professional training.

Finally, our research reaffirms the use of popular music and art as an alternative cosmopolitan music education that promotes intercultural dialogue and cultural exchanges. These are examples of a real "aesthetic cosmopolitanism" in the sense defined by Regev (2013) as a gradual formation and a tool to shape world culture as an interconnected entity in which social groups from many parts of the world share popular music's aesthetic similarities, despite their different cultural backgrounds. In this way, inequalities are not eliminated, but the gap between different social groups has been narrowed, due to the similar—and also hybrid and multiple—artistic forms and cultural practices around popular music.

Note

1 The concepts of multiculturalism and interculturalism are not always employed as they have been defined here. Different authors employ both in different ways. On the one hand, Solís (2001) and some other authors use these terms as equivalent. On the other, McLaren (1995) defines interculturality as the common place shared for different cultures. In this chapter we will follow Arriarán's and Hernández's differentiation between these two concepts.

References

Anderson, W. M., & Campbell, P. S. (2010). Teaching music from a multicultural perspective. In W. M. Anderson & P. S. Campbell (Eds.), *Multicultural perspectives in music education* (Vol. 3, pp. 1–7). Lanham, MD: MENC/Rowman & Littlefield Education.

Aróstegui, J. L. (2004). Much more than music: Music education instruction at the University of Illinois at Urbana-Champaign. In J. L. Aróstegui (Ed.), *The social context of music education* (pp. 127–210). Champaign, IL: CIRCE, University of Illinois.

Arriarán, S., & Hernández, E. (2010). El paradigma del multiculturalismo frente a la crisis de la educación intercultural. *Cuicuilco, 48,* 87–105.

Barr, A., Gillard, J., Firth, V., Scrymgour, M., Welford, R., Lomax-Smith, J., & Constable, E. (2008). *Melbourne declaration on educational goals for young Australians.* Melbourne, VIC: Ministerial Council on Education, Employment, Training and Youth Affairs.

Bates, V. C. (2014). Rethinking cosmopolitanism in music education. *Action, Criticism, and Theory for Music Education, 13*(1), 310–327.

Bourdieu, P. (1990). *The logic of practice.* Stanford, CA: Stanford University Press.

Campbell, P. S. (2003). Ethnomusicology and music education: Crossroads for knowing music, education, and culture. *Research Studies in Music Education, 21,* 16–30.

Campbell, P. S. (2010). *Songs in their heads: Music and its meaning in children's lives*. New York, NY: Oxford University Press.

Casquette, J. (2001). *Vivencia y convivencia. Teoría social para una era de la información*. Madrid: Trotta.

Denzin, N. K., & Lincoln, Y. S. (Eds.). (2003). *Collecting and interpreting qualitative materials*. Thousand Oaks, CA: Sage Publications.

Elliot, T. S. (2010). *Notes towards the definition of culture*. London: Faber and Faber.

Emmanuel, D. T. (2003). An immersion field experience: An undergraduate music education course in intercultural competence. *Journal of Music Teacher Education, 13*, 33–41.

Essomba, M. A. (2010). Teacher education for diversity in Spain: Moving from theory to practice. In T. Burns & V. Shadoian-Gersing (Eds.), *Educating teachers for diversity: Meeting the challenge* (pp. 219–236). Paris: OECD Publishing.

European Parliament and Council of the European Union. (2006). Recommendation of the European Parliament and of the Council of 18 December 2006 on key competences for lifelong learning (2006/962/EC). *Official Journal of the European Union*. Retrieved from http://eur-lex.europa.eu/ LexUriServ/LexUriServ.do?uri=OJ:L:2006:394:0010:0018:en:PDF.

Fernández Enguita, M. (1999). *La escuela a examen: un análisis sociológico para educadores y otras personas interesadas*. Madrid: Pirámide.

Foucault, M. (1977). *Discipline and punishment*. New York, NY: Pantheon.

García Canclini, J. (1995). *Consumidores y Ciudadanos*. Mexico: Grijalbo.

Gijón, J. (2005). La estrategia del "Ratón de Troya": Una propuesta para el trabajo colaborativo entre profesores en ambientes multiculturales. *Profesorado, revista de currículum y formación del profesorado, 9*(1). Retrieved from http://redes-cepalcala.org/inspector/DOCUMENTOS%20Y%20LIBROS/ FORMACION/TRABAJO%20COLABORATIVO%20ENTRE%20PROFESORES.pdf.

Gorski, P. C. (2008). Good intentions are not enough: A decolonizing intercultural education. *Intercultural Education, 19*(6), 515–525.

Green, L. (2006). Popular music education in and for itself, and for "other" music: Current research in the classroom. *International Journal of Music Education, 24*(2), 101–118.

Hannerz, U. (2004). Cosmopolitanism. In D. Nugent & J. Vincent (Eds.), *A companion to the anthropology of politics* (pp. 69–85). Oxford: Blackwell.

Harper, D. (2003). Reimagining visual methods. In N. K. Denzin & Y. S. Lincoln (Eds.), *Collecting and interpreting qualitative materials* (pp. 176–198). Thousand Oaks, CA: Sage Publications.

Hernández, F. (2003). *Educación y cultura visual*. Barcelona: Octaedro.

Ibarretxe, G., & Díaz, M. (2008). Metaphors, intercultural perspective and music teacher training at the University of the Basque Country. *International Journal of Music Education, 26*(4), 339–351.

Jenkins, H. (2004). Pop cosmopolitanism: Mapping cultural flows in an age of media convergence. In M. Suarez-Orozco & D. Qin-Hilliard (Eds.), *Globalization: Culture and education in the new millennium* (Chap. 6). Berkeley, CA: University of California Press.

Kingsbury, H. (1988). *Music, talent and performance: A conservatory cultural system*. Philadelphia, PA: Temple University Press.

Kraidy, M. (2005). *Hybridity or the cultural logic of globalization*. Philadelphia, PA: Temple University Press.

Lamont, A. (2002). Musical identities and the school environment. In R. MacDonald, D. Hargreaves & D. Miell (Eds.), *Musical identities* (pp. 41–49). Oxford: Oxford University Press.

Lave, J., & Wenger, E. (1991). *Situated learning: Legitimate peripheral participation*. New York, NY: Cambridge University Press.

Lorenzo, M. (2004). Instituciones y escenarios para un currículum multicultural. *Bordón, 56*(1), 84–93.

McLaren, P. (1995). *Critical pedagogy and predatory culture: Oppositional politics in a postmodern era*. London: Routledge.

Nettl, B. (1995). *Heartland excursions: Ethnomusicological reflections on schools of music*. Chicago, IL: University of Illinois Press.

O'Flynn, J. (2005). Re-appraising ideas of musicality in intercultural contexts of music education. *International Journal of Music Education, 23*(3), 191–203.

Osuna, C. (2012). En torno a la educación intercultural: Una revisión crítica. *Revista de Educación, 358*, 38–58.

Palmer, A. J. (1992). World musics in music education: The matter of authenticity. *International Journal of Music Education, 19*, 32–40.

Pérez-Aldeguer, S. (2013). El desarrollo de la competencia intercultural a través de la educación musical: Una revisión de la literatura. *Revista Complutense de Educación, 24*(2), 287–301.

Pérez Tapias, J. A. (2013). Educar desde la interculturalidad: Exigencias curriculares para el diálogo entre culturas. In J. Gimeno (Ed.), *Saberes e incertidumbressobre el curriculum* (n.p.). Madrid: Morata.

Regev, M. (2013). *Pop-rock music: Aesthetic cosmopolitanism in late modernity*. Cambridge: Polity Press.

Rizvi, F. (2009). Towards cosmopolitan learning. *Discourse: Studies in the Cultural Politics of Education, 30*(3), 253–268.

Schippers, H. (2010). *Facing the music: Shaping music education from a global perspective*. New York, NY: Oxford University Press.

Small, C. (1980). *Music, society, education*. London: John Calder.

Solís, D. (2001, November). *Educación y diversidad cultural: Breve agenda de investigación en educaciónpara la multiculturalidad*. Keynote presented at the "Segunda Reunión Nacional de la Red de Educación Intercultural," Universidad Pedagógica Nacional. Tepic, Nayarit, Mexico. Retrieved from http://www.socolpe.org/data/normalarmenia/BIBLIOGRAFIA/Educaci%F3n%20y%20diversidad%20cultural.doc.

Starkey, H. (2012). Human rights, cosmopolitanism and utopias: Implications for citizenship education. *Cambridge Journal of Education, 42*(1), 21–35.

UNESCO. (2009). *Investing in cultural diversity and intercultural dialogue*. Paris: UNESCO.

Vasconcelos, A. (2002). *O conservatório de música: Professores, organizaçao e políticas*. Lisboa: Instituto de Inovaçao Educacional.

Vertovec, S. (2009). *Transnationalism*. London: Routledge.

Volk, T. M. (1998). *Music, education and multiculturalism: Foundations and principles*. New York, NY: Oxford University Press.

8

AFFECT AND THE SOCIAL IMAGINARY IN ETHNOCINEMA

Anne Harris

Other things can happen when the familiar recedes. This is why affect aliens can be creative: not only do we want the wrong things, not only do we embrace possibilities that we have been asked to give up, but we create life worlds around these wants.

(Ahmed, 2010, p. 218)

Globalisation is not simply the name for a new epoch in the history of capital or in the biography of the nation-state . . . it is marked by a new role for imagination in social life.

(Appadurai, 2000, p. 13)

Storytelling is crossing a border, you know, because even your characters are from the other side . . . and when you are researching a story, you're crossing over to other territories. I'd like to look at it from the other way, because it is not just us finding a story, the story finds us.

(Bobis, 2014)

Introduction

The Filipina novelist Merlinda Bobis – like both Appadurai and Ahmed in their own ways – asks us to move past familiar horizons and imagine something beyond life as we know it. For Bobis, as she narrates in her short film for the collaborative arts project *Art/Hope/Culture,* these are gendered, raced, classed and embodied landscapes. For Appadurai, globalisation is evolving along a 'double apartheid' (2000, p. 3), characterised by a divorce between the first form – Western internal or parochial concerns that can be characterised as 'Americanization disguised as human rights or as MTV' (p. 2) – and the second form which Appadurai calls that of the poor, or 'globalizations from below' (2000, pp. 2–3). Intercultural arts practices in research contexts (like *Art/Hope/Culture*) can critically theorise this divorce, and also push back against it by offering new forms of institutional practice that resist the Western universalising aesthetic and theoretic through deep intercultural collaboration. Appadurai 'makes it clear that globalization has given the imagination a *larger* role in social life' (Robbins, 2003, p. 203) and in social

imaginaries of those publics which do not yet exist. These publics might well grow out of the most ordinary of collaborative relationships, in the most local of contexts.

Other scholars too invite 'an intense attention to the *poesis*, or creativity, of ordinary things' (Stewart, 2008, p. 565), and this chapter attends to the inherently cultural aspects of creative collaborative research. Creativity has shifted gears in recent times, and often (but not always) now appears as a decoupling from localised and manual arts practices, including intercultural applied arts methodologies such as ethnocinema and ethnovideo. Yet collaborative research work can contribute much-needed perspectives to the commodification of creativity and its implications for cultural and transcultural work, understandings, and social change. I have argued previously (Harris, 2014a, 2014b) that video and other visual research forms can no longer make truth-claims (if ever they could) about cultural, collective, or indeed even individual representation, and Stewart too points out the limitations of such representational thinking:

> My story, then, is not an exercise in representation or a critique of representation; rather it is a cabinet of curiosities designed to incite curiosity . . . it tries to deflect attention away from the obsessive desire to characterize things once and for all long enough to register the myriad strands of shifting influence that remain uncaptured by representational thinking. It presumes a 'we' – the impacted subjects of a wild assemblage of influences – but it also takes difference to be both far more fundamental and far more fluid than models of positioned subjects have been able to suggest.
>
> *(Stewart, 2008, p. 584)*

Intercultural arts are characterised by these 'myriad strands of shifting influence' and a resistance to a presumed 'we'. This gives intercultural art and research practices an inherently multidirectional character (Harris, 2013, 2014a). The methodology of ethnocinema is not a typical 'ethnomethodology'[1] but rather a way of making relationship across cultural boundaries – be they ethnic, gendered, raced, sexualised or geographical. It is no easy business to be truly collaborative, and scholars offer many reasons why we cannot or are not allowed to by our institutions, overcrowded schedules, funders, or ethics approval systems. Yet artists have long known the indispensable value of working this way. As bell hooks claimed, 'academics are only concerned with subaltern pain' (in Harris, 2013, p. 4), but this fetishisation of adversity is now thankfully expanding to include other kinds of explorations across cultural borders in the sites and practices where multiple voices (including researchers ourselves) are present and equally interrogated, as part of a thoroughly critically reflexive practice. To this end, this chapter draws on video exemplars from the Creative Research Hub (www.creativeresearchhub.com), a site for the exchange of collaborative and arts-based research work by the author and my collaborators.

The presence in the website of multiple voices is not incidental. Indeed, in the collaborative research relationships developed during this (and other) projects, 'we wondered how straining so hard to work interculturally might be re-segregating us in ways that are unhelpful or at best archaic' (Harris, 2013, p. 4). Ethnocinema as method is not artificially about how much footage each of us shoots of one another, although of course it does attend to processual and product-based concerns. More importantly, 'Ethnocinema . . . involve[s] a willingness from scholar/researchers to reject calls to frame ourselves as expert' (Harris, 2013, p. 4), and this is the heart of its epistemological and heuristic differentiation. It is really a methodological innovation of 'doing' not 'what has been done'.

In arguing for the advantages of co-researched intercultural arts, which adopt reflexive and intersubjective perspectives, I am performing a philosophical, methodological and political act of 'occupying the academy' with the voices of my collaborators and the impact of our relationships.

In section one below, I foreground the *Art/Hope/Culture* project as an example of arts research that is interculturally collaborative while digitally created and circulated. In section two, I extend Ahmed to help lay out a notion of creativity that helps us understand how a contemporary 'creativity imperative' bears upon arts-led research methods, particularly intercultural collaborative ones such as ethnocinema.[2] In the third section I return to Appadurai and how his formation of a social imaginary intersects with Ahmed to offer a conceptual approach to working interculturally through ethnocinema in ways that can be, at once, globally circulable, deeply collaborative and localised.

Affective collaborations

In this section, I offer a means of 'performing praxis' that is based on inclusion, where multiple voices are present through the use of links to the Creative Research Hub website featuring video exemplars of both collaborative and digital applied practice. The collaborative work shared there adopts reflexive and relational perspectives as core to culturally sensitive epistemologies and the ways in which we, as co-producers of new knowledge, create meaning in the academy but also through public dissemination and social media. The Creative Research Hub[3] is a website that models ways of doing arts-based research that might point the way toward methodological innovations for those working at the intersection of intercultural and interdisciplinary arts. Through distinct projects and texts, the website offers exemplars of ways to work together interculturally, collaboratively, which includes at times projects that are ethnocinematic in process or in product (or both).

One example is the project *Art/Hope/Culture*[4] a visual ethnographic exploration of ten migrant women artists in Australia, and the impact of migration on their/our art-making processes. In this study, my research partner Enza Gandolfo and I worked with women from a wide range of cultures and arts disciplines about the impact of migration on our art-making both 'back home' and in resettlement. We were interested in how art-making practices did or did not shift during and after migration, and also the ways in which the products of our art-making are perceived or functioned differently in the new country from the old. Nine of the artists are featured in 3–5-minute videos of their work and reflexive commentary on both their interculturality and their evolving art-making processes.[5]

Enza and I began the project from our own collaborative and individual roles as artists impacted by migration. We formed the project by networking with women artists like ourselves who were similarly impacted by migration. Ultimately we worked with ten women from their early thirties to late sixties, who worked in visual art, dance, film, drama and creative writing. Both Enza and I engaged artistically and personally with the ten participants; Enza primarily led the interviews and I filmed. From the footage, I worked with my ongoing film editor-collaborator Alta Truden (herself a migrant artist) and in collaboration with the women featured in each video.

Though in this project the outcomes remained focused on the ten participants (unlike in strictly ethnocinematic projects, where both parties equally share the collaboration), both Enza and I established our research relationships with the women out of our own experiences, proceeded dialogically, and worked from the opportunity provided by the collaborative video-making as ethnocinematic process does. Our stories came to bear in these interviews, and although the films themselves are not, strictly speaking, ethnocinematic in that none of the women shot footage of me (a usual part of the 'collaborative video' work that characterises ethnocinema), the process was thoroughly so; that is, through the *doing* of making videos together, the process was ethnocinematic. The relationship was multidirectional throughout, the women helped to shape the direction of the enquiry, and the mutuality was centred in our shared artist identities, not embedded in a differentiation of researcher–researched at any time.

This mutuality was perhaps most profoundly seen in our interview with the Filipina novelist and performer Merlinda Bobis. Her deep relationship with creative writing as 'storying lives' and as a political act had a profound impact on me. Enza and I had flown to Sydney from Melbourne (in Australia) to interview Merlinda and several other artists, and then taken a train an hour from Sydney to the university town where Merlinda works. It had been a long day by the time the interview was over, and so moved was I by her reflection on art, migration, longing and alienation that I was overcome with tears, and, as we three walked back to the train station, I could not stop crying. As a migrant from the United States to Australia, my 'migrant differ-ence' often remains invisible to most people until I speak and sound different. After 17 years in Australia, I am still 'othered' by my accent every time I speak. For migrants of visible difference, the othering happens before they even open their mouths, and the experience of alienation for all of us continues to be painful.

In addition, for many 'Asian' migrants like Merlinda, racism and subaltern stereotypes of weakness or other vulnerabilities run high and so the need for those like Merlinda to become an actor in her writings was clear – she needed to *show* not *tell* her tales, in a most literal of ways. She describes it this way:

> I started as a poet but the poetry, you know, could not contain the stories I wanted to write; the stories became bigger. So it became the novel, but at the same time I realised that in my arts practice, in my story practice . . . I've always written with a body, the body has always been there, the body doing and being 'done to' – the agency of the body or the lack of agency of the body and so I thought one other way – it was not enough to just work with text and that kind of behind-the-lines body involvement. I had to actually bring the story with my body to the audience. That's why I went into performance.
>
> But even the idea of 'exoticising, orientalising the self' – this can be a strategy. So you have to look at 'exotic' me, to listen to me then. So I thought, that's a way. I thought from poetry on the page, I went into performance. But I thought it's not enough – if you want the bigger audience . . . to listen to you, you find a form. So you're crossing. So that crossing border is a very strategic thing, but the interesting thing, as well – storytelling is crossing a border, you know, because even your characters are from the other side, even if they're of you, once they have a life of their own they're from the other side, and when you are researching a story, you're crossing over to other territories. But I just realised that there's another consequence. I'd like to look at it from the other way, because it is not just us finding a story, the story finds us.

For Merlinda, and myself too, the story that has found us as migrant women artists continues to be one of difference, of the body, of loss and of home. These border-crossing aspects of Merlinda's story, and of our collaborative relationship, were what kept me crying with identi-fication, grief and validation on our walk to the train that night. These new surroundings are characterised by new accents, new cadences, new syntax (affecting migrant creative writers), new colours, new light, new vistas (for visual artists), and new rhythms, paces and embodiments (for dancers and performers). In other words, migration has creative and epistemological con-sequences for those trying to make sense of finding themselves in a new place, but it also has corporeal implications.

I have written elsewhere about Ahmed's analysis of the 'melancholy migrant' trope (Harris, Marlowe & Nyuon, 2014) which binarises the traditional and backward migrant against the

progressive and 'free' host culture. This can present as a malaise in which this 'well-documented experience for many migrants and refugees . . . [who find] that their background and training are neither valued nor acknowledged in a new country' (Harris et al., 2014, p. 6). But this, we pointed out, is distinct from Ahmed's critical interrogation within mainstream media of a 'melancholy migrant who is always backward-looking, always nostalgically longing for home' (Harris et al., 2014, p. 6). For the women migrant artists we worked with in *Art/Hope/Culture*, home could be constructed – sometimes reconstructed – as a magical idealised not-place, through their art-making. Like memory, and not like digital media and social media which bring faraway places 'nearer', art-making plays a powerful symbolic role in mediating (and remediating) what was left behind, at the same time as it helps makes sense of and construct what now surrounds the migrant artist. For women, these processes are often in tension with family duties and the push-and-pull of the here-and-now of home-making (literal home-*making*) in a new country and a new culture which vies for attention with art-*making*. We wondered together whether in this way of thinking, art could (or has) *become* home.

In this new home-making, migrant artists, or even those like Enza – working interculturally as a child of migrants – confront many challenges, but also encounter creativity in what seems to be a distinct way from other artists. Creative art-making is largely still framed in an exoticised 'melancholy migrant' way that impossibly demands and yet devalues 'traditional art' from the migrant artist (Harris et al., 2014). In *Art/Hope/Culture*, we all discussed at length even the name of the project as including the words 'migrant women artists' because of its unwanted remarginalising potential. As many of the artists pointed out, white artists remained culturally and racially unmarked but 'migrant' artists are, although in my experience as a white migrant artist from a Western/northern states nation I am still routinely labelled as non-Australian if not 'migrant'.

Ok-Hean Chang, a Korean artist collaborator from this project, has noted the 'ethnic' ways in which she has been labelled despite the abstract nature of her paintings, not identifiable at all as 'Korean' or culturally distinct in any visible way. Yet many artists did acknowledge a double-bind which pushed them toward 'cultural' funders rather than 'mainstream arts' ones, not by choice but by the type of work that is rewarded, and other procedural hurdles. All of which contribute to a slide toward the marginalised category of 'migrant artist' whether willingly or unwillingly.

Ethnocinema is a 'pedagogical and methodological borderland, a meeting-place, importantly both *of* and *beyond* culture' (Harris, 2013, p. 13). If 'working with' is a growing concern in research cultures, then ethnocinema and other arts-based practices may return the cultural contextual nature to creative practice. For artists who research, collaboration comes naturally. We know that – as Merlinda's video reminds us – intercultural knowledge creation occurs between, across and through us. It is important to continue to seek new ways for 'working with' in film, video and other digital media, where too often the body can be lost, the intersubjective can become a broad but anonymous (and opportunistic) global flow or abstraction. Affect scholars are returning us to the intensities that unexpectedly catch (and sometimes cripple) us as messy bodies-in-motion, who long for and belong to groups and other assemblages, not all of them explicitly cultural, but all of them always intercultural. Whether ethnic, religious, sexual, gendered or otherwise diverse intersections, creative approaches can assist in this often-painful border-crossing work.

Challenging the 'creativity imperative'

In the practice of ethnocinema, intercultural collaborative filmmaking provides the moment for intercultural encounter in which creative affective experiences can be recombined with

creativity (like video and other digital media) to address the power of arts in both translocal and transglobal contexts. Ahmed draws clear but critical lines between happiness, creativity and class:

> The limitation of this geneaology of morals is not so much that it locates happiness in good fortune (I think this location helps us to understand what happiness is about) but rather that it identifies fortune with creativity. Nietzsche suggests that the fortune is a feeling that allows the 'well-bred' to identify happiness with action. 'All *this*,' he suggests, 'is diametrically opposed to "happiness" as understood on the level of the powerless . . . he identifies with the gesture "we the happy ones" by describing it as purely creative'.
>
> *(Ahmed, 2010, p. 206)*

That is, happiness becomes an expedient act of imagination and creativity. She reminds us that they are interlocking impulses, but that 'the creativity of feeling does not require the absence of an object' (Ahmed, 2010, p. 25). Perhaps not, but the feeling required the presence (foretold, remembered or directly experienced) of that object at some point. Ahmed has written about the wilfulness of subjects as co-constitutive with objects, but here I am drawing attention to her suggestion of film and filmic collaborators as culturally co-constitutive, fellow travellers in a moving out of the 'this'. For Ahmed, the hegemonic happiness imperative represents the known world, the local, and the habitual. Her cultural and experiential horizon that goes beyond the happiness imperative can only be reached by imagination at first, and it requires a kind of travelling into the unknown, both of which require 'other kinds of critical and creative writing that offer thick descriptions of the kinds of worlds that might take shape when happiness does not provide a horizon for experience' (2010, p. 14); exactly what Merlinda narrates in her film. Intercultural creative collaboration such as ethnocinema provides encounters for co-imagining these new horizons. Culturally imbued creativity, the creativity of a global becoming intersects with localised knowledge and understandings, producing the creativity of the new, the non-habitual.

So by formulating (and rejecting) a creative imperative, taking a macro approach to the need for creativity in contemporary culture and discourse can help clarify some aspects of its social function (and by extension its insistence through commodification even into the spheres of collaborative intercultural arts practices like ethnocinema). Creativity has become a marker of urbanity, reproduction and mobility. Yet certainly cultural and arts heritage continues to happen and to be visible in this 'creative economy' which positions and leverages every product or service by its capital value. What then is the relationship between cultural industry and creative industries, or how might we compare how the capital value of creativity counteracts the cultural long-term benefit of creative and cultural development as a practice?

Even (or perhaps most poignantly) in the marketplace absence of affective collaborative arts, generative creativity can be found. Like other affective intensities such as desire, creativity co-exists with the repetition of the habitual and the mundane in that, 'even if desire fails to find objects adequate to its aim, its errors can still produce pleasure: desire's fundamental ruthlessness is a source of creativity that produces new optimism, new narratives of possibility' (Berlant, 2012, pp. 43–44). A contemporary creativity imperative that insists on the democratic character of creativity (anyone can and has the right to be creative) also insists on its happiness. What does it mean to have a happy creativity, one that bears more similarity to arts therapy perhaps than the transgressive social critique of some of history's great works of art, or some kind of 'right' creativity better-matched to contemporary productivity imperatives? Berlant has addressed precarious publics and the aesthetics of affect drawing on attachment theory (psychoanalytic), which explains affective attachments for objects – but can it also explain creativity-attachment,

as a doing-attachment? Certainly when we collaborate interculturally, these are highly affective engagements, affective doings. Commodity culture represents not the absence of affect, though, but one of a different kind. The intensities associated with marketplace value are another kind of flattening out of difference.

A contemporary 'creativity affect' has come to represent a necessary component of the productive (happy) citizen who can be original yet commodifiable, a sphere almost solely referencing technology in modern discourses. Here intercultural diversity is replaced with a hegemonic 'global' creativity that looks and sounds the same worldwide. This global creativity imperative is still characterised largely by Western aesthetics, ideals, practices and values, and intercultural arts collaboration must in some sense always be in conversation with this global construction of creativity. But considered more broadly, what does it mean to 'feel' creative, to have a 'creative intensity' in an intercultural context? *Art/Hope/Culture* seeks to explore these connections between feeling, intensities and creative practice as a means to a new social imaginary, and toward which Appadurai helps find a way.

A new social imaginary through intercultural arts

If interactive forms of creative research such as ethnocinema offer some promise for intercultural relationships, both local and global, then the *doing* of ethnocinema (rather than the commodified creative output) might offer possibilities for new social imaginaries or what Ahmed has called the 'kinds of worlds that might take shape' beyond the current habituated, culturally estranged, or commodified ones. Appadurai's theorisation of the social imaginary intersects with affect in important ways that can assist in this horizon-extending, and provide an antidote to the narrowing of commodification culture. A 'social imaginary', as Taylor (2004) describes it, is a set of notions about groups that can be affectively or empirically assembled, always emerging and co-constituted by the group that imagines them. Appadurai links it to a globalising impulse that characterises modern life, education, art and subjectivity, through social and digital media. For ethnocinema and other digital research methods that draw on digital and online technologies for their making and disseminating, and to some extent for their community-building and community-maintaining function, Appadurai's formation is interculturally resonant.[6]

Appadurai takes it further: by imagining multiple modernities or the ways in which cultures (particularly non-Western cultures) require their own theories and practices, he requires localised and intercultural practices (research ones, arts ones, communications ones) to counteract the global flows that are naturally occurring as a result of digital technologies.

Contemporary digital culture is by its very nature intercultural, moving at it does 'at high speeds across various kinds of previously impervious boundaries' (Appadurai, 1996, p. 34). To help examine the cultural dimensions of globalisation, Appadurai's (1996) construct of the five dimensions of global cultural flow which he terms as interrelated 'scapes' – ethnoscapes, mediascapes, ideoscapes, finanscapes and technoscapes.[7] Appadurai, of course, helps us think about the complexities of identities contextualised within contemporary global flows, but also how we might collaborate intersubjectively within these flows. For him, both migration and media are interwoven with boundary-crossing of all kinds, including methodologically. That is, Appadurai continues to bring us back to the layered nature of ideas, practices, image-making and identity (both assembled and individual). These nuances are at the heart of ethnocinematic intercultural arts-based research. But what does Appadurai's framework of 'global flows' have to say to Ahmed's notion of a happiness imperative and the ways in which that imperative circulates globally, through inter- and transculturality?

Appadurai tells us that his core conceptualisation of the social imaginary hinges upon the 'conditions under which current global flows occur: they occur in and through the growing

disjunctures between ethnoscapes, technoscapes, finanscapes, mediascapes and ideoscapes' (1996, p. 37). He stresses that such disjunctures of course have always existed but the 'speed, scale and volume' (p. 37) are what is increasing, causing rippling effects. The significance of his notion of 'disjunctures' for ethnocinematic researcher-collaborators can be seen most clearly in his mediascapes and ideoscapes 'which are closely related landscapes of images' (Appadurai, 1996, p. 35), but certainly post-representational. 'What is most important about these mediascapes', he says, 'is that they provide . . . large and complex repertoires of images, narratives, and ethnoscapes to viewers throughout the world, in which the world of commodities and the world of news and politics are profoundly mixed' (p. 35). This can be good news for intercultural collaborators and producers from non-dominant regions as well, but it can be reifying depending on how those images are read in the hegemonic distance.

Appadurai's new and imagined social worlds and global relationships might cause lines between so-called real life and 'fictional landscapes' that 'are blurred, so that the farther away these audiences are from the direct experiences of [metropolitan life], the more likely they are to construct imagined worlds that are chimerical, aesthetic, even fantastic objects, particularly if assessed by the criteria of some other perspective, some other imagined world' (Appadurai, 1996, p. 35). In this way, intercultural collaborative arts offer an *embodied* experience of Appadurai's mediascaped global flows, both infused with the freedom and complexities of technology as it creates new social (and cultural) imaginaries.

What Appadurai calls 'the growing disjuncture between territory, subjectivity, and collective social movement' (1996, p. 189) has implications for both happiness (as conceived by Ahmed) and collaborative relationships (as present in ethnocinema). His work – and Ahmed's too – represents efforts to 're-situate the politics of cultural difference against a picture of disjunctures in the global cultural economy' (1996, p. 150), one that is now inexorably tied to digital production and circulation.

Thus, it is perhaps not going too far to suggest that ethnocinema and other collaborative person-to-person arts methods can help create new social imaginaries in which intercultural (and other) borders are crossed (or made fluid) through building loving relationships in research settings. Rather than a positivist 'objectivity imperative', the creative collaboration breeds love in the doing, and these relational foundations imbue the work and the social relations differently. That is, it is not through the research object itself, but through the relationship that grows in the doing, that cultural barriers and alienation are bridged. Berlant approaches this imaginary in describing the way love (and thus affective creativity) can invert conventionality and the banal – and get us to new social imaginaries:

> Thus to love conventionality is not only to love something that constrains someone or some condition of possibility: it is another way of talking about negotiating belonging to a world. To love a thing is not only to embrace its most banal iconic forms, but to work those forms so that individuals and populations can breathe and thrive in them or in proximity to them. The convention is not only a *mere* placeholder for what could be richer in an under-developed social imaginary, but it is also sometimes a profound placeholder that provides an affective confirmation of the idea of a shared confirming imaginary in advance of inhabiting a material world in which that feeling can actually be lived. In short, this affair is not an assignation with inauthenticity.
>
> *(Berlant, 2008, p. 3)*

Intercultural research and arts collaborators, too, work within conventions that must be understood in order to be upended. The inclusivity and mutuality that is at the heart of the

ethnocinematic method is itself an affective challenge to conventionality in contemporary commodified creativity, and to neoliberal research contexts and practices.

Conclusion

In this chapter I have applied Ahmed's notion of the happiness imperative to a creative imperative, in which creativity has become a commodified and sanitised requirement for global citizenship. By looking at the ways in which this kind of creative gentrification preferences some and excludes (usually localised, culturally oriented) others, I have suggested that intercultural collaborative arts practices such as ethnocinema can offer one way to push back against this imperative and offer new kinds of social imaginaries. In this work, the cultural anthropologist Arjun Appadurai offers a framework for moving forward in affective and culturally fluid ways. By using video and online media to circulate these products, the long-term and highly affective intercultural relationships that accompany the making of these kinds of videos suggest one way in which local arts and globalised creativity practices might be joined.

By doing so, new counterpublics are possible in response to the hegemonising forces of a neoliberal creativity that (based largely in the global north/cultural West) seeks sameness and convention in its global circulability. Merlinda calls us to re-imbue creative practice with the body, or rather to remember that "the body has always been there, the body doing and being "done to"". In the practice of ethnocinema, intercultural video collaboration provides the moment for intercultural bodily encounters in which affective experiences can reimagine commodified creativity to address the power of arts in both translocal and transglobal contexts, on the way to constituting new creative and social imaginaries.

Notes

1 Collaborative arts-based methods such as ethnocinema/ethnovideo suggest that as notions of culture are changing so too must research and pedagogical practices. As global mobilities muddy the waters of articulable cultural values and subjectivities, emerging research methods present an urgent imperative to engage more 'real world' practices and epistemological frameworks for cultural and discursive border-crossing. Visual cultures are one ascendant imperative changing the face of all other cultures as digitality goes global and changes the course of global and cultural flows. This chapter, and ethnocinema more generally, challenge the complexity of visually representative research, for researchers who approach collaborative work as informed by intersubjectivities that are 'patchy and material' (Stewart, 2007). This collaborative culture-based video work requires the co-producers to grapple with this idea of 'constituting a compositional present', rather than some finite notion of truth or even representation. Some scholars, especially Hito Steyerl (Steyerl & Olivieri, 2013), are calling this a 'post-representational turn', a proposition I find useful in relation to ethnographic or ethnocinematic video research, and to intercultural collaboration overall.

2 Ethnocinema and ethnovideo are collaborative intercultural video methods I developed largely during my doctoral study from 2007–2010 in a series of collaborative videos made with South Sudanese young women in Melbourne, Australia. It is built upon the work and conceptual arguments of visual anthropologist Jean Rouch, who pioneered what he called 'cine-ethnography' and 'ethno-fictions' to better problematise the 'truth-claims' of traditional visual ethnography. My book *Ethnocinema: Intercultural arts education* (Harris, 2012) details this project and method.

3 The Creative Research Hub can be viewed at www.creativeresearchhub.com, and is a website that houses a range of arts-based research projects, several of them involving the use of ethnocinema or ethnovideo. It was built as a central place to display primarily creative and practice-led research that is heavily video-influenced. It also features books and articles associated with this research, by researchers in Melbourne including collaborators Anne Harris and Enza Gandolfo, and others with whom we have worked.

4 With thanks and deep personal and scholarly appreciation to Dr Enza Gandolfo, my collaborator in this project, and with whom my own arts practices in the ever-presence of migration continue to grow.

5 The tenth artist was not involved in a video-making process as she had moved back to Israel by then. Her interview commentary was still included in the project. The ten women artists involved in the *Art/Hope/Culture* project were: Merlinda Bobis (creative writing and performance), Jigzie Campbell (dance and performance), Lella Carridi (visual arts and creative writing), Ok-Hean Chang (painting), Sivan Gabrielovitch (theatre), Mehwish Iqbal (multimedia visual art), Helen Kassa (film, spoken word, poetry), Hiromi Tango (installation), My Le Thi (installation), and Yumi Umiumare (dance). The project ran throughout 2013–2014, and was funded by the Victorian Womens' Trust, the Maribrynong City Council Community Grant Program (Melbourne) and internal funds from our respective institutions, Victoria University and Monash University, both in Melbourne, Australia. Part of our collaborative process was also writing about our own migration-inflected experiences, as both Enza and I are creative writers, but neither of us to this date has made videos of our own experiences as part of this project, although the project is not finished at the time of writing. Its main culminating arts events to date have been the hugely successful 'Transience' exhibition at the Footscray Community Arts Centre in March 2014 and artist talks at the Immigration Museum of Victoria (2015).

6 Benedict Anderson names a 'new form of imagined community, which in its basic morphology set the stage for the modern nation' (1983/2006, p. 48). Taylor's social imaginary is comprised of 'interlocking causes' (pp. 70–71), that lead us to an articulation of '"multiple modernities", the plural reflecting the fact that other non-Western cultures have modernized in their own way and cannot properly be understood if we try to grasp them in a general theory that was designed originally with the Western case in mind' (Taylor, 2004, p. 1).

7 Appadurai's five 'scapes' are: ethnoscapes ('the landscape of persons who constitute the shifting world in which we live') [1996, p. 33]; ideoscapes ('the master-narrative of the Enlightenment'), [p. 36]; mediascapes ('the electronic capabilities to produce and disseminate information') [p. 35]; finanscapes ('the accelerated circulation of global capital'); technoscapes ('the global . . . configuration of technology'), [p. 34].

References

Ahmed, S. (2010). *The promise of happiness*. Durham, NC: Duke University Press.

Anderson, B. (1983/2006). *Imagined communities: Reflections on the origins and spread of nationalism*. London: Verso.

Appadurai, A. (1996). *Modernity at large: Cultural dimensions of globalization*. Minneapolis, MN: University of Minnesota Press.

Appadurai, A. (2000). Grassroots globalization and the research imagination. In A. Appadurai (Ed.), *Globalization* (pp. 1–21). Durham, NC: Duke University Press.

Berlant, L. (2008). *Female complaint: The unfinished business of sentimentality in American culture*. Durham, NC: Duke University Press.

Berlant, L. (2012). *Desire/love*. Brooklyn, NY: Punctum Books.

Bobis, M. (2014). *Art/Hope/Culture* (Merlinda Bobis video). Retrieved from www.creativeresearchhub.com.

Harris, A. (2012). *Ethnocinema: Intercultural arts education*. The Netherlands: Springer.

Harris, A. (2013). Ethnocinema and the impossibility of culture. *International Journal of Qualitative Studies in Education, 27*(4), 546–560.

Harris, A. (2014a). *The creative turn: Toward a new aesthetic imaginary*. Rotterdam: Sense Publishers.

Harris, A. (2014b). Ethnocinema and video-as-resistance. In A. Hickey-Moody & T. Page (Eds.), *Arts and pedagogy as cultural resistance* (pp. 153–168). Rotterdam: Sense Publishers.

Harris, A., Marlowe, J., & Nyuon, N. (2014). Rejecting Ahmed's "melancholy migrant": South Sudanese Australians in higher education. *Studies in Higher Education*, DOI: 10.1080/03075079.2014.881346.

Robbins, B. (2003). Cosmopolitanism, America, and the welfare state. In W. Fluck & T. Claviez (Eds.), *Theories of American culture: Theories of American studies* (pp. 201–224). Tubingen: Gunter Narr Verlag.

Stewart, K. (2007). Cultural poesis: The generativity of emergent things. In N. K. Denzin & Y. S. Lincoln (Eds.), *Collecting and interpreting qualitative materials* (pp. 565–586). Thousand Oaks, CA: SAGE.

Steyerl, H., & Olivieri, D. (2013). Shattered images and desiring matter: A dialogue between Hito Steyerl and Domitilla Olivieri. In B. Papenburg & M. Zarzycka (Eds.), *Carnal aesthetics: Transgressive imagery and feminist politics*. London: Palgrave Macmillan/IB Tauris & Co Ltd.

Taylor, C. (2004). *Modern social imaginaries*. Durham, NC: Duke University Press.

9

THE ROLE OF LOVE IN INTERCULTURAL ARTS THEORY AND PRACTICE

Brydie-Leigh Bartleet

Introduction

This chapter explores how concepts of love, in particular compassionate love, can provide a way of theorizing and embodying intercultural arts practices. By focusing on love in this context, we bring to the fore the importance of intimacy, interaction, trust, honesty, openness, caring, courage, fairness, faithfulness, gratitude, respect, dialogue and ethical responsibility in our intercultural artistic practices. For love demands that we show: "a willingness toward dialogue, a willingness toward responsibility, a choice for encounter and response, a turning toward rather than turning away" (Bird Rose, 2011, p. 5). As Bird Rose's words suggest, this means that love is first and foremost a verb, a participatory emotion, and a social practice that can both inform and underpin intercultural arts practice (hooks, 2000). Moreover, this calls us to consider how we can love across difference as intercultural artists, not by reducing identity to notions of sameness, but by the recognition of irreducible differences between us (Irigaray, 2002). In other words, by focusing on love, we are challenged to consider ways of engaging in intercultural practices and dialogue that seek "relationships across otherness without seeking to erase difference" (Bird Rose, 2004, as cited in Barney, 2014, p. 2). Herein lies the potential of love as a powerful concept in intercultural arts theory and practice. In this chapter I explore these ideas in relation to theoretical perspectives on love from bell hooks (2000), Paulo Freire (1970), Luce Irigaray (2002) and Judson Laughter (2014), as well as my own experience working in intercultural arts settings with Warumungu and Warlpiri musicians in Central Australia, to consider how the concept of love can provide a useful framework within intercultural arts theory and practice on the ground.

Positioning love

Love is that strange concept that appears to be ever present, but rarely named, in academic discourses and theory throughout history. The Ancient Greeks acknowledged several forms of love, among them: sexual passion; parental, filial, and conjugal affection; fraternal feeling; friendship; love of country; love of wisdom. Philosophically, the nature of love has, since the Ancient Greeks, been a mainstay, producing theories that range from the materialistic conception of love to theories of love as an intensely spiritual affair that permit us to touch divinity

(Singer, 1984, 1994). However, as Luce Irigaray has criticized in her book *The Way of Love* (2000, pp. 1–12), this has largely been formulated by men only, and driven by a love of wisdom rather than a search for the articulation of the wisdom of love. She believes we still lack the words, gestures and ways of engaging with one another that allow us to move beyond models of domination and appropriation, toward love and respect in difference (Bostic, 2002, p. 606).

Various authors have attempted to provide frameworks for love. Irving Singer's books *The Nature of Love: Plato to Luther* (1984) and *The Pursuit of Love* (1994) set out to provide ways of defining love. Singer initially suggested that, "love is a way of valuing something. It is a positive response toward the 'object of love'—which is to say, anyone or anything that is loved" (1984, p. 3). A decade later, Singer wrote *The Pursuit of Love*, where he creates "a systematic 'mapping' of the concept of love" (p. xii). Here he categorized three regions within love's domain: sexual, social, and religious love. Importantly, for Singer these types of love are not hierarchical. For Singer, humans inherently engage in a multitude of simultaneous love relationships as they appraise and bestow value and receive appraisals and bestowals of value in return. As Schoder (2010, p. 4) observes, progressing to new regions of love creates a greater capacity to give and receive love, but it does not supersede the prior loves. Thus, Singer's theory is pluralistic in that it recognizes the importance of all love relationships in the larger concept of love. Mike Martin's work, *Love's Virtues* (1996), presents a complementary and pluralistic concept of love as virtue-structured ways to value people and it is the conscious and fluid interplay of virtues such as caring, courage, fairness, faithfulness, fidelity, gratitude, honesty, and respect and wisdom that defines love (p. 21). Acts of love encompass these virtues, and each virtue directly or indirectly bolsters and supports the other virtues (Schoder, 2010, p. 6).

Within the context of intercultural collaborations with Australian Aboriginal teachers and mentors in relation to her work in anthropology and conservation, Bird Rose (2011) speaks about the power and complexity of love, which is full of problems as well as possibilities. She suggests that love in a time of extinctions calls forth a series of questions, once of which is particularly applicable to an intercultural arts context, that is, "How to invigorate love and action in ways that are generous, knowledgeable, and life-affirming" (Bird Rose, 2011, p. 2) The answers for Bird Rose lie in her Aboriginal teachers' philosophical ecology, and their "cross-species kinship" with plants and animals: "Their relationships are tactile, and are embedded in creation, ethics, and accountability. When speaking about the current extinction crisis—one that cannot be unmade, but one toward which we owe an ethical response 'that includes turning towards others in the hopes of mending at least some of the damage'" (2011, p. 5). Or, in the words of an Aboriginal teacher of hers, Hobbles Danaiyarri:

> We can come together, join in, make it more better out of that big trouble. You know, before, Captain Cook bin making a lot of cruel, you know. Now these day, these day, we'll be friendly, we be love meself [one another], we'll be mates. That be better. Better for make that trouble.
>
> *(Bird Rose, 2004, p. 6)*

In a similar vein, Somerville, Davies, Power, Gannon and de Carteret's (2011) work explores the concept of love in relation to place in Australia. Of particular relevance here, is their work on the deep place learning that occurs in cultural contact zones and the significant relationships and ties that stem from them:

> Contemporary cultural contact zones inevitably carry with them the distinct individual, familial and collective histories that each person brings with them into the present.

They have trajectories into pasts and they open towards futures. The risky borderwork that we advocate in the contact zones where human subjects collide does not elide differences, nor does it reify them. It does not seek to flatten out or homogenize our specificities. Rather, through reflexivity and careful listening, and through a willingness to suspend meaning, it opens up possibilities for deep engagement across difference and for transformation into the future. This is a pedagogy of ethical uncertainty entailing mutual responsibilities and unpredictability within pedagogical relationships.

(*Somerville et al., 2011, p. 6*)

Speaking from an education context, McWilliam and Jones (1996) also recognize the important intersection of love, ethics and pedagogical relationships, suggesting: "Ethical issues in the classroom should not be addressed as though pleasure and desire have nothing to do with a love of knowledge and a capacity to produce exciting pedagogical exchanges" (p. 136). Likewise, authors in Liston and Garrison's (2004) volume argue, from a wide range of intellectual perspectives and personal experiences, that love should be made a part of each student's classroom experience and explore a range of models of loving care appropriate to student–teacher relationships.

These aforementioned scholars have primarily focused on a type of Platonic love that is commonly referred to as *compassionate love* (Silverman, 2012). In compassionate love there is a specific focus on the good of the other (Underwood, 2009). In giving this kind of other-centered love one tries to truly understand and accept the conditions and state of the recipient in order to enable the recipient to flourish. "Altruistic love," "unconditional love," and "agape" are other terms sometimes used to describe this kind of love. Compassionate love can be seen in actions, expressions, and words, but at the core of the construct is a motivation to stretch and to give. As Underwood (2009, p. 4) explains, the "why" of the action, the reason for the behavior, the motivation behind the action are all important to categorizing something as compassionately loving in nature. The ultimate focus is the giving of self for the good of the other. Compassionate love can be expressed in the context of other kinds of love and altruistic behaviors, but somehow reaches beyond them (Underwood, 2009, p. 4). As Underwood (2009) explains, compassionate love both addresses human suffering *and* encourages human flourishing.

Positioning myself and my intercultural arts work

Before moving to a discussion of love in intercultural arts theory and practice, it is important to acknowledge the cultural politics that are evoked by my personal background and subjectivities. As an intercultural arts practitioner and researcher I have been working alongside Warumungu and Warlpiri musicians and Elders in Central Australia for the past six years. This has manifested in an arts-based service-learning program that I have run with my husband, Gavin Carfoot, and colleague Naomi Sunderland in collaboration with Barkly Regional Arts and Winanjjikari Music Centre in Tennant Creek. This also formed part of a larger national study into arts-based service learning with First Peoples, which we conducted with colleagues from Curtin University and the University of Western Sydney and communities in the Northern Territory and Western Australia. For our particular program, each year since 2009 this has involved taking a small group of university students from Brisbane to Tennant Creek for approximately two weeks to take part in this program. A defining feature of our work has been the desire to relinquish some of the power and control associated with our positions as university lecturers, and to place the responsibility for deciding on activities and approaches in the hands of community members. In order to enact this approach, we have developed a strong partnership with the regional arts organization Barkly Regional Arts and

Warumungu and Warlpiri musicians and sound engineers at the Winanjjikari Music Centre. As we have documented elsewhere (e.g., Bartleet & Carfoot, 2013; Bartleet, Bennett, Marsh, Power, & Sutherland, 2014), in many cases this has provided an organic context for intercultural engagement. As such, the program has differed from year to year in response to community needs, such as setting up a recording studio, undertaking song writing and recording projects, running collaborative music workshops in schools, and working and performing at the Desert Harmony Festival.

It is no accident that I am deeply drawn to working in intercultural contexts having grown up in and between cultures my whole life as a White woman in both Australia and South Africa. In both these cultural contexts my White settler status has underpinned my intercultural experiences and left me acutely aware of the power and privilege, as well as the shame and discomfort, associated with this colonial position. Since my early experiences growing up in politically turbulent apartheid South Africa, I have been curious about music's power to facilitate cultural connection and allow people to find strengths in one another, to heal and reconcile the past, and facilitate new intercultural understandings. In the different cultural contexts my music making, learning and teaching have taken me since, I have been drawn to the way that music acts as a tool for interpersonal connection and engagement between people, cultures, communities, and institutions.

In recent years I have done a lot of soul searching, trying to work out why I feel so compelled to do this work; to ask myself, honestly, what are the deep-seated reasons for taking my students on this journey with me? My colleagues and I have written variously about the motivations for our intercultural work (see Bartleet et al., 2014), but in all this work there is a consistent thread that has never been named before. Not once. *Love.* Love is the unwavering force that motivates me to do this work. A shared love of music is what brings us together and small but significant acts of love are ultimately what guide our interactions when we are working together. By this I mean, "compassionate love," where there is a specific focus on the

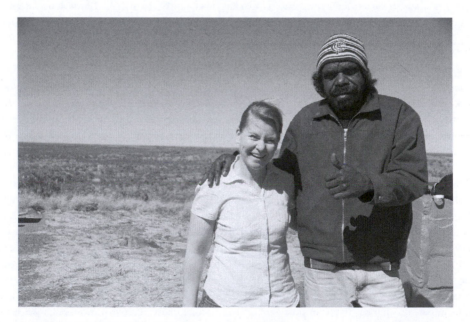

Figure 9.1 Brian Morton and Brydie in Tennant Creek (2014).

good of the other. When I reflect on the deep affection and musical connections that I have shared with musicians and Elders over the years, I think in particular of musicians, such as Brian Jakkamarra Morton (my uncle[1]), who has invested so much time in our musical collaborations over the years. I think of him affectionately putting his arm around me saying, "I love you, Nungarayi.[2] I love all you guys." I think of him letting my little girls (known in Tennant Creek by their Warumungu skin name, *Nampin*[3]) climb over his guitar as he was teaching us a song, and remember his wife bringing his youngest granddaughter to meet me. In these moments I see the presence of *love*, and its capacity to allow us to find a path toward connection, in spite of the overwhelming cultural politics and dynamics of past histories and current realities. I am not suggesting that love can wipe away the lingering darkness and dangers in colonization, but rather it can provide a compass for how to step forward.

Love-as-action

How can we choose love when we have experienced so little of it? We choose love by taking small steps of love every time there is an opportunity. . . . Each step is like a candle burning in the night. It does not take the darkness away, but it guides us through the darkness.

(Nouwen, 1997, as cited in Laughter, 2014 p.2)

As intercultural artists we often find ourselves in unfamiliar territory as we work in and between different cultural settings that are sometimes familiar and other times foreign to us. With that lack of familiarity often comes a degree of fear, whether it be a fear of doing the "wrong thing," offending someone or breaking some sort of cultural taboo, or worse yet, evoking the kind of colonial complacency that continues to inflict such harm and damage (Tuck & Yang, 2012). That fear is not necessarily a bad thing. It can encourage humility and reflexivity and a deep cultural learning experience, but I have also seen it act as a barrier to connections and communications on the ground. It can lead to an over-thinking of the intercultural arts projects that we are engaging in. Time and time again I have seen this in my students' eyes and actions as they enter the Winanjjikari Music Centre (WMC) and Barkly Regional Arts (BRA) in Tennant Creek for the first time. Their apprehension is palpable and written all over their bodies. Likewise, the WMC musicians will often hold back and watch, waiting to see if these students can be trusted. Interestingly, this is almost always short lived, and only seems to last as long as it takes to get a guitar out the case, a microphone set up or a pair of drumsticks shared. Truth be told, this has become increasingly easier (for want of a better word) over the years that we have been collaborating with WMC and BRA given that we have already built up a degree of trust. While each new cohort of students then rides on the coat tails of this trust, it is ultimately the music making that still seems to allow us to move forward and begin playing together.

Intercultural music making demands small, yet significant, gestures of extending a hand and sharing. Whether it be playing a song for somebody, jamming together, teaching the lyrics to a song in language or even just setting up a stage, these gestures require the kind of "reaching out" toward another person and giving of self that Underwood (2009) speaks of. It also points to the dynamic and contingent interplay between the sorts of virtues that Martin (1996) documents, such as caring, courage, fairness, gratitude, honesty, respect and wisdom, among others and what hooks (2000) calls "love-as-action" (p. 165). To illustrate this further, I recall a moment during the first year we travelled to Tennant Creek when a local Indigenous man, Anthony "Junkyard Dog," appeared at WMC and migrated toward two of the students, Ryan and Amie. After telling them about his life as a painter and bush mechanic, and sharing stories

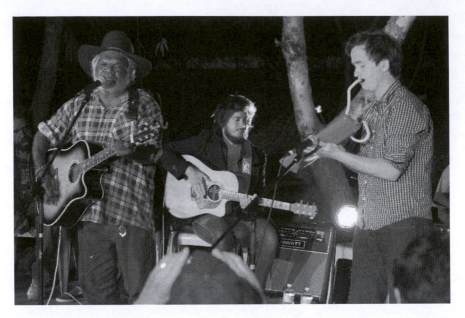

Figure 9.2 WMC musician Lesley Thompson performing his song "Walapanba" with Josh Lovegrove and Euan Cumming (2014).

of his life on the highway, his homelessness, and playing for Port Power, Anthony asked them if they could help him set some lyrics he had written to music. The lyrics are about a White set‐ tler who came to his father's land. What followed happened so quietly, there was no fanfare or performance, but it was a genuine and reciprocal example of love-as-action through the crafting of an important song:

> When the three of us sang the song Anthony was very moved and ended up in tears, it was a special moment. I felt extremely privileged to be welcomed by him and invited to collaborate on something extremely personal and important. He wanted us to record these songs so he could give them to his father and his sons. I felt proud that I had the skills to work with him and produce a song that we were really happy with.
>
> *(Ryan, fieldwork diary, June 2009)*

At the start of this trip Ryan and Amie, and indeed Anthony, were unsure what to do, but in this small step of working together, this songwriting process involved a reciprocal reaching out to one another. To work effectively it involved embracing the dimensions of love in all that they did—"care, commitment, trust, responsibility, respect, and knowledge" (hooks, 2000, p. 94). When we take actions such as this as intercultural artists, an ethic of love can act as a compass for how we engage and connect with people, places, arts practices, and pedagogies. This resonates with the work of many educators teaching and learning in Indigenous stud‐ ies/performance in tertiary classrooms and with non-Indigenous students (Mackinlay, 2010; Mackinlay & Barney, 2014).

 The story I have shared here is not one about grand gestures of love that have swept people off their feet. Rather, what I have been talking about relates to small, but significant, steps of what Laughter (2014) calls "micro-kindness." Laughter's theory of micro-kindnesses is designed to provide an alternative to the current emphasis on racial micro-aggressions where the focus

is purely on negative consequences. Instead, Laughter focuses on micro-kindnesses as a way of taking positive steps in our interpersonal and intercultural interactions (Laughter, 2014, p. 6). As he suggests, instead of focusing on what *not to do*, the inclusion and discussion of micro-kindnesses can provide the opposite: a description of conscious actions to pursue in our inter-cultural arts work. He defines micro-kindnesses as "brief verbal, behavioral, or environmental acts of respect, consciously intended to provide a potential space for positive and humanizing interaction" (p. 7). While this might entail the sorts of musical interactions I have spoken about so far, it can equally be applied to the moments when the guitars are laid down and the songs have ended and we are simply sitting with one another and being in one another's company. This reminds me of the first time I went to Borroloola in the Northern Territory with my col-league Liz Mackinlay for a research project in 2008 and had been invited to go "out bush" with the women so they could sing and dance. I vividly recall how privileged and nervous I felt, but also how unsure I was of what to do. During this moment, I was given the opportunity to enact a small micro-kindness of getting a glass of water that ended up teaching me volumes about the importance of love in this context. We wrote about this moment:

> As the troupie comes to a halt on the gravel just off the Robinson River Road, Jemima, Dinah, Amy and Alieta suddenly get up and pile out the back one by one. Brydie lingers for a moment not sure what to do. Maybe sensing her slight apprehen-sion, our marruwarra (the important culture lady) asks Brydie to get her a drink of water. Brydie is grateful for the task and busies herself looking for a clean plastic cup. As she hands her water and watches her slowly put it up to her lips, Brydie sees her grandmother in her marruwarra's face; both such strong, determined and admirable women. As Brydie helps her out the truck, with her skinny fragile arm interlinked in hers, she feels herself slide into the role of a doting granddaughter. It is a role that comes instinctively to her, as she gently eases our marruwarra down onto the ground and guides her to the blanket laid down by the fire. We sit in a circle as the pink sunset rippled across the clouds behind us. The rhythm starts with a hairbrush tapping a small round tin and our voices filled the night sky. Sister, granddaughter, daughter, niece; these are the lenses through which Brydie has defined her sense of self and experienced the significant relationships with the women in her life. These are the lenses through which she experienced that night out in the bush. These are the lenses through which she related, understood, cared for, learnt from and ultimately loved these women.
>
> *(Mackinlay & Bartleet, 2012, p. 80)*

The movement that I made to reach out was instigated by our murruwarra. She may have just been thirsty (it was a hot and humid evening!), but something tells me she knew I needed to feel useful. I needed to find some way of connecting. I needed to be given the chance to show a small act of kindness to feel at ease, given the enormity of what these women were sharing with me. What that small act did was it prompted me to draw on my womanly subjectivities, which are by their very nature, bound up in love-as-action.

When thinking about the action of reaching out, it does bring up the question of what motivates us to take these loving actions, to tend to another's needs. Underwood (2009) tells us that when it comes to love these are always mixed, so in compassionate love as expressed in daily life there are frequently motives that can sometimes obstruct orientation toward the good of the other. As Underwood tells us, so many self-centered motives can get in the way, such as the need for reciprocal love and affection, the need to be accepted, guilt, fear, seeing others as an extension of one's own ego, the control of others through indebtedness, a desire to avoid

confrontation, a desire to look well in the eyes of others (2009, p. 14). If I am honest, the desire to do the right thing, to be accepted, and ultimately loved, by those I have been collaborating with have probably pervaded many of the loving gestures I have made as an intercultural artist, whether I am aware of it or not. But this does not take away from the genuine motivation I have also had to respond to the desires and needs of those I have worked with. As Underwood (2009) reassures, our motives are always mixed. This is why at the end of the day, despite these mixed motivations, the phrase "centered on the good of the other" is so important in compassionate love (Underwood, 2009, p. 14).

I am not naively suggesting that by focusing on the needs of others and practicing acts of micro-kindnesses all the complexities and issues surrounding interpersonal interactions and intercultural politics are washed away. Nor are the colonial/decolonial politics, which are at once the same, different and entangled with other kinds of intercultural politics, minimized. Rather, as Laughter suggests, "the practice, study, and teaching of micro-kindness can only help support the work of broader systemic change for social justice" (Laughter, 2014, p. 11). This leads to the idea that by practicing an ethic of love we have the capacity to be liberated from dominating ways of being in the world, and can learn to engage with one another in a different way. This does not take away the darkness of cultural domination, but provides a guiding light toward a path forward.

Love-as-liberation

Love moves us beyond categories and therein lies its power to liberate.

(hooks, 2013, p. 199)

Following the theoretical perspectives espoused by hooks (2013), when this connection between cultures, theories and practices is guided by an ethic of love we have the potential to oppose domination in all its forms. This resonates with the work of Deborah Bird Rose (2004) when she speaks of this ethic of connection. Drawing on the work of Levinas, Rose states: "There is no self without other. Life with others is inherently entangled in responsibility" (2004, p. 13). She goes on to say:

> This ethic of connection, of mutually implicated humans whose primary duty is to respond to the calls of others, particularly those who are vulnerable, does not demand a suppression or denial of one's own self. Rather to the contrary, the argument is that one finds one's own self in responding to others, and so both self and other become entangled in ethical relationships.
>
> *(Bird Rose, 2004, p. 13)*

Similarly hooks describes this love ethic as the precursor to change: "To bring a love ethics to every dimension of our lives, our society would need to embrace change" (hooks, 2000, p. 87). This process comes from decolonizing minds and hearts through the act of love, and moving toward liberation from dominating ways of thinking, acting and being. This move toward *change* in our hearts and minds (Mackinlay, 2010) is something I have observed countless times in my students, as well as my own experiences. For the choice to love is a choice to connect—to find ourselves in the Other (hooks, 2000, p. 93) and to ultimately change. Once again, music and the arts more broadly, provide a powerful means to take such actions. Such insights are echoed in the reflections of James—a former student participant in the Winanjjikari Service Learning Program who is now co-manager at the WMC:

As a musician I was blown away by the realisation that the simple of act of jamming along with some of the members of the Tennant Creek community was all it took to begin to build a really strong rapport, sense of mutual respect and ultimately life-long friendships. Without music acting as that medium I don't think we would have ever been able to break down some of the cultural barriers that existed between the two groups as successfully and genuinely as we did.

(James, fieldwork diary, 2009)

This movement toward cultural connection rather than separation that James describes can be thought of as embodying an ethic of love. As James' reflections allude, being guided by such a love ethic can lead to transformational learning experiences. This also resonates with the insights that come from Paulo Freire's work, where he asserted that education was an act of love, that educators must risk acts of love, and that education should aim at establishing a world where it would be easier to love. He wrote, "From these pages I hope at least the following will endure: my trust in the people, and my faith in men and in the creation of a world in which it will be easier to love" (Freire, 1970, p. 24). According to Freire, education occurs "when [the teacher] stops making pious, sentimental, and individualistic gestures and risks an act of love. True solidarity is found only in the plenitude of this act of love" (1970, p. 35). For Freire, being fully human, reading and writing the word and world, being in the world, with the world, and with each other, were predicated on conscious acts of love that precipitated further love (Schoder, 2010, pp. 1–2). This is something we have observed repeatedly in the ways that the WMC musicians, particularly the Elders, have approached their teaching of our students. In these settings, the most powerful and important part of the learning process comes from the intersection between relationship building and shared music making.

The kind of connections I have described in this chapter, where musicians are not subsumed into a sense of sameness, but rather feel a sense of "solidarity" also resonate with Luce Irigaray's writings on love, in particular her book, *The Way of Love* (2002). What Irigaray's work aims

Figure 9.3 WMC musicians (including James on drums) and Griffith students performing "Jam Café" at the Desert Harmony Festival (2014).

to do is think through a way of truly being *with* the other. Of relevance to the idea of love-as-liberation in intercultural arts is Irigaray's (2002) notion that if we are genuinely interested in forging the conditions for democracy, and working against the forces of domination, we need to change our intimate engagements and practices (the way we speak to, interact with, and respond to one another), as well as aim at transforming broader macrostructural forces and institutions. As intercultural artists Irigaray's work challenges us to focus on how we can love across difference, not by reducing identity to notions of sameness, but by recognition of the irreducible differences between us. To love across difference, for Irigaray, requires a reformulation of the central logic of Western love, transforming it from a system of desire based on possession, exchange or absorption/consumption, to one that acknowledges and respects irreducible differences (Blue, 2005).

Conclusion

In this chapter I have aimed to share a frank reflection on the ways in which thinking and enacting an ethic of love, driven by acts of micro-kindness, can provide useful ways of theorizing and embodying intercultural arts practices. I have been cautious to acknowledge that this focus on love does not necessarily produce the perfect antidote to the ravages of colonization that continue to pervade our lives and work. This is not always easy. As hooks contends (2013), to live our lives based on the principles of a love ethic (showing care, respect, knowledge, integrity, and the will to cooperate), we have to be courageous. We have to sometimes learn how to face our fears in order to embrace love. However, once we do, and we reach out for that sense of connection I have described, once we have chosen to embrace a love ethic, allowing it to govern and inform how we think and act, "knowing that when we let our light shine, we draw to us and are drawn to other bearers of light. We are not alone" (hooks, 2000, p. 101). Commitment to a love ethic can transform our lives and practices as intercultural artists, by offering us a different set of values to live by. In large and small ways, we make choices based on a belief that virtues of love, such as those described in this chapter, provide a way for us to connect theory, vision and practice. Such connections are important, for as hooks (2013, p. 7) reminds us, intercultural arts theory *and* practice need to be in constant dialogue with one another, otherwise our work in this field risks becoming a topic of inquiry with no relation to transformative learning or practical change.

Acknowledgements

My sincere thanks to my collaborators in Central Australia for the love they have shown my family, colleagues, students and myself. Thank you to Naomi Sunderland for introducing me to the work of Laughter (2014), and to Gavin Carfoot and Naomi for their love and collaboration over the years. Much of the thinking and initial research for this chapter was undertaken during a fellowship at the Centre for Commonwealth Education at Cambridge University late in 2013, and my thanks go to Pamela Burnard, the staff at the Centre and my fellow CIAN Fellows Liz Mackinlay, Jean Penny, Andrew Blackurn and Sam Curkpatrick for their collegial support during this time.

Notes

1 "Uncle" is a classificatory relationship that relates to the kinship system, which is a feature of Aboriginal social organization and family relationships across Australia.

2 Nungarayi is my "skin name." Members of each kinship group have a "skin name." This complex system determines how people relate to each other and their roles, responsibilities and obligations in relation to one another, ceremonial business and land.
3 "Nampin" is my twin girls' "skin name"—see explanation in the above footnote.

References

Barney, K. (Ed). (2014). *Collaborative ethnomusicology: New approaches to music research between Indigenous and non-Indigenous Australians.* Melbourne, VIC: Lyrebird Press.

Bartleet, B. L., & Carfoot, C. (2013). Desert harmony: Stories of collaboration between Indigenous musicians and university students. *The International Education Journal: Comparative Perspectives. Special Issue: Global 21st Century Professionals: Developing capability to work with Indigenous and other Traditionally-Oriented Peoples, 12*(1), 180–196.

Bartleet, B. L., Bennett, D., Marsh, K., Power, A., & Sunderland, N. (2014). Reconciliation and transformation through mutual learning: Outlining a framework for arts based service learning with Indigenous communities in Australia. *International Journal of Education and the Arts, 15*(8), http://www.ijea.org/

Bird Rose, D. (2004). *Reports from a wild country: Ethics for decolonisation.* Sydney, NSW: University of New South Wales Press.

Bird Rose, D. (2011). *Wild dog dreaming: Love and extinction.* Charlottesville, VA: University of Virginia Press.

Blue, G. (2005). *The way of love* (2002) by Luce Irigaray. *Culture Machine, 1*(0). Retrieved from http://www.culturemachine.net/index.php/cm/article/view/180/161.

Bostic, H. (2002). Luce Irigaray and love. *Cultural Studies, 16*(5), 603–610.

Freire, P. (1970). *Pedagogy of the oppressed.* New York, NY: Continuum.

hooks, b. (2000). *All about love: New visions.* New York, NY: Harper.

hooks, b. (2013). *Writing beyond race: Living theory and practice.* New York, NY: Routledge.

Irigaray, L. (2002). *The way of love.* New York, NY: Continuum.

Laughter, J. (2014). Toward a theory of micro-kindness: Developing positive actions in multicultural education. *International Journal of Multicultural Education, 16*(2), 2–14.

Liston, D. P., & Garrison, J. W. (Eds.). (2004). *Teaching, learning, and loving: Reclaiming passion in educational practice.* New York, NY: Routledge Falmer.

Mackinlay, E. (2010). A pedagogy of heart which beats to the rhythm of relationships: Thinking about ourselves as music educators in relation to Indigenous Australia. *Australian Kodaly Journal, 1*, 17–23.

Mackinlay, E., & Barney, K. (2014). Unknown and unknowing possibilities: Transformative learning, social justice, and decolonising pedagogy in Indigenous Australian studies. *Journal of Transformative Education, 12*(1), 54–73.

Mackinlay, E., & Bartleet, B. L. (2012). Friendship as research: Exploring the potential of sisterhood and personal relationships as the foundations of musicological and ethnographic fieldwork. *Qualitative Research Journal, 12*(1), 75–87.

Martin, M. (1996). *Love's virtues.* Lawrence, KS: University of Kansas Press.

McWilliam, E., & Jones, A. (1996). Chapter 8: Eros and pedagogical bodies: The state of (non) affairs. *Counterpoints, 127*–136.

Schoder, E. M. (2010). *Paulo Freire's pedagogy of love.* Doctoral thesis, Rutgers University-Graduate School of Education, New Jersey.

Silverman, M. (2012). Community music and social justice: Reclaiming love. In G. Macpherson & G. Welch (Eds.), *The Oxford handbook of music education* (pp. 155–167). Oxford: Oxford University Press.

Singer, I. (1984). *The nature of love: Plato to Luther* (2nd ed.). Chicago, IL: University of Chicago Press.

Singer, I. (1994). *The pursuit of love.* Baltimore: Johns Hopkins Press.

Somerville, M., Davies, B., Power, K., Gannon, S., & de Carteret, P. (2011). *Place pedagogy change* (Vol. 73). Rotterdam, The Netherlands: Sense Publishers.

Tuck, E., & Yang, K. W. (2012). Decolonization is not a metaphor. *Decolonization: Indigeneity, Education & Society, 1*(1), 1–40.

Underwood, L. (2009). Compassionate love: A framework for research. In B. Fehr, S. Sprecher & L. G. Underwood (Eds.), *The science of compassionate love: Theory, research, and applications* (pp. 3–25). New York, NY: John Wiley & Sons.

10

AT THE CONTACT ZONE AND THE CULTURAL INTERFACE

Theorising collaboration between Indigenous
and non-Indigenous people in research
and contemporary music practices

Katelyn Barney

Introduction

Lexine stood in the front of the lecture room and tapped her laptop to begin her PowerPoint presentation. She turned to face the class and looked out at the sea of thirty faces. She had sung at many performances, but seemed a little nervous in the university setting. 'I acknowledge the traditional owners of the land on which we meet today. Thank you Katelyn for inviting me to your class'. We smiled at each other. I was very keen for Lexine to attend this class, which was part of a course I was coordinating on Indigenous Australian music at the University of Queensland. Lexine continued, 'I'll start off by telling you a little bit about my experiences, if that's okay. I identify as a Torres Strait Islander[1] and I have been involved in collaborative research with non-Indigenous ethnomusicologists since 2001, when I was invited to tell my Indigenous music life story. I answered questions to an interested researcher who was collecting data about Indigenous female performers in the southeast Queensland region. I enjoyed the research process, but have never witnessed the result'. The next slide was a picture of Lexine and me. 'Ah, my life with Doctor Katelyn Barney', she said with a giggle, and I wondered what she would say. 'The next researcher to come my way was Katelyn Barney, who was working on her PhD in 2004. I again had an opportunity to share my story about my identity, performance and my love of music. I found I had a very strong interest in music research and enquired to Katelyn how I might be able to further collaborate with her. It's been quite a journey.'[2]

While there are many examples of intercultural collaboration between Indigenous and non-Indigenous people, Somerville and Perkins (2003, p. 255) note that the literature often glosses 'over the negotiations of collaboration' and few have discussed how the collaborative research process and the politics between Indigenous and non-Indigenous people in intercultural research works in practice. The 'contact zone' and the 'cultural interface' are used in this chapter to theorise collaboration in two interrelated spaces—performance and research. The chapter uses these theoretical lenses to explore how intercultural arts collaborations between non-Indigenous and Torres Strait Islander people occur in practice and the ways performers and researchers negotiate the mutual benefits and, at times, the difficulties, of intercultural collaboration. I draw on my

own experiences as a non–Indigenous ethnomusicologist undertaking collaborative research with Torres Strait Islander researcher and musician Lexine Solomon (Barney & Solomon, 2010) and interviews with Torres Strait Islander musicians Uncle Seaman Dan and Will Kepa along with their non–Indigenous collaborator Karl Neuenfeldt to explore the politics and positioning of non–Indigenous and Indigenous people at the contact zone/cultural interface of collaborative spaces.

My positioning

My own passion and interest in collaboration is drawn from my experiences as a non–Indigenous researcher undertaking collaborative ethnomusicological projects: one with Lexine Solomon, a Torres Strait Islander performer and researcher over the last ten years about how Torres Strait Islander women express their identities through contemporary music; and another with Monique Proud, an Aboriginal researcher exploring the contemporary music making in her own community of Cherbourg in Queensland, Australia. In my role as Research Fellow in the Aboriginal and Torres Strait Islander Studies Unit at the University of Queensland, I have also had the opportunity to collaborate with Indigenous colleagues on a number of teaching and learning projects. Most recently, my collaborations with Indigenous people have involved establishing the Australian Indigenous Studies Learning and Teaching Network with Torres Strait Islander academic Martin Nakata and Aboriginal academic Cindy Shannon. The network is a collaboration between Indigenous and non–Indigenous scholars who have an interest in improving teaching practices in Indigenous studies at tertiary level. Nakata's concept of the 'cultural interface' has influenced my thinking and numerous other researchers (e.g., Dillon, 2007; McGloin, 2009; Page, 2014) in relation to considering the complexities and tensions between Indigenous and non–Indigenous domains. I have also been drawn to Somerville and Perkin's (2003) theorising of a related concept, the 'contact zone', as a way of exploring how Indigenous and non–Indigenous musicians and researchers negotiate and mediate numerous borders between self and other, between Indigenous and non–Indigenous, and move between and across borders in the contact zone through collaboration (for further discussion, see Barney, 2014).

The contact zone and the cultural interface

The term 'contact zone' was coined by feminist anthropologist Mary Louise Pratt to describe aspects of cultural contact in historical contexts. Pratt describes the contact zone as 'the social spaces where cultures meet, clash and grapple with each other, often in contexts of highly asymmetrical relations of power, such as colonialism, slavery, or their aftermaths as they are lived out in many parts of the world today' (Pratt, 1992, p. 33). She acknowledges the ongoing effects of colonisation and notes that the contact zone 'is an attempt to invoke the special and temporal correspondence of subjects previously separated by geographic and historical disjunctures, and whose trajectories now intersect' (1992, p. 7). From my reading of her work, Pratt hopes to 'decolonize knowledge' by analysing historical texts by those who had been colonised to attempt to find alternative possibilities to the forces of colonisation. Paul Carter (1992) similarly bases his analysis of the contact zone on historical texts and explorers' accounts of first contact of the colonisers with Aboriginal peoples. His focus is on the spaces in between, rather than the texts themselves, to explore the 'intervals of difference' that embody alternative possibilities (1992, p. 179). Other anthropologists and ethnomusicologists have also theorised and applied the concept of the contact zone. Clifford expanded the concept to include 'cultural tensions within the same state, region or city', suggesting distance in social terms while at the same time drawing attention to the politicised nature of the contact zone (1997, p. 204). Bendrups (2008)

and Mackley-Crump (2013) both use the term to explore Pacific festivals as transcultural contact zones with multiple points of contact and interaction 'where the boundaries between curator and visitor, or performer and audience, are sometimes blurred' (Bendrups, 2008, p. 17). Other critical conceptualisations of the zone of cultural contact include Bhabha's (1994) 'third space', Anzaldua's (1987) 'borderlands', Giroux's (1992) 'border crossing', hooks' (1990) 'the margins and the edge', and Soja's (2000) 'third space'.

Nakata's theoretical model of the 'cultural interface' also offers a useful framework to explore spaces of cultural contact. Nakata describes this as:

> the intersection between two different cultures—the Islander and the non-Islander, the latter express as Australian, Western, mainstream or whatever. The position is often represented theoretically as a simple intersection of the two different and often contesting elements which give rise to a 'clash of cultures' . . . [but] the reality . . . is much more than this.
>
> *(2007, p. 198)*

Nakata uses the concept to explore the daily negotiations made by Torres Strait Islander people in colonised contexts with non-Torres Strait Islanders and the colonisers. Using the framework of Indigenous standpoint theory, Nakata provides a way of understanding Islander subjectivities within colonial relations of power. He describes the cultural interface as a 'lived location' (2007, p. 210) where the boundaries are not clear, a space of 'possibilities' (2007, p. 200) and a 'beginning point' for interaction, development, change and transformation (2002, p. 286). Nakata views the cultural interface as also a space of tension where individuals might be working to produce cohesive social practices and relationships, but there may be conflicts and contestations (2007, p. 199).

Both the cultural interface and the contact zone are concepts that relate to the interculturality of colonised contexts and emphasise colonial relations of power between Indigenous and non-Indigenous people. The concepts are spaces of *possibilities* as well as *tensions*, where questioning, communication, negotiation and dialogue between Indigenous and non-Indigenous people are central. They are described as complex spaces where there can be *border crossing*, multiple zones of contact and inherent complexity. *Transformation* and *ethical responsibility* are also discussed in relation to both concepts.

Intercultural collaborative research and music making in the Australian context

In the context of research, collaboration implies a partnership where both partners bring and gain knowledge from the collaborative process. While it can occur to varying degrees and in diverse ways, Wali suggests the 'underlying spirit is that of working, learning, and moving toward positive social change together' (2006, p. 6). However, collaboration is much more than this, and at the centre is dialogue. Byrne-Armstrong argues that collaboration can only occur if we 'move towards joining with people in conversation to examine the taken-for-granted assumptions and practices informing any research context' (2001, p. 110). In the context of Indigenous research, Nakata emphasises the need to develop and nurture working collaborations, 'relationships and dialogue at the level of scholarly knowledge production' (2004, p. 4). It is a specific form of dialogue, however, that seeks 'relationships across otherness without seeking to erase difference' (Rose, 2004, p. 21). Further, Langton argues that intercultural dialogue arises from the intersubjectivity of Indigenous and non-Indigenous people in dialogue and

involves a process of testing imagined models of each other's 'other', and continually adjusting these models to find ways of understanding each other (1993, p. 35). Collaborative research projects 'not only have the potential to engender new and more productive research agendas but may also change radically conventional ways of establishing identity by questioning hitherto unchallenged assumptions, themselves contingent on colonial power relations' (Smith, Burke & Ward, 2000, p. 21).

In the Australian context, the history of research with Indigenous people is linked closely with the deepest traumas of colonisation. Researchers entered communities often without invitation or permission, and sought to access and 'take' knowledge (Langton, 1993). As Huggins notes, 'there is a long history of violence, mistrust, guilt and fear that cannot be erased overnight' (Huggins, 1998, p. 84). As a result, Maddison argues that relationships between Indigenous and non-Indigenous people are 'stuck' (2011, p. 5). However, there are many examples of Indigenous/non-Indigenous Australian music research and recording collaborations that demonstrate close community collaboration and engagement and could be described as examples of what Hayward (2005) calls 'culturally engaged research and facilitation' (see also Barney & Solomon, 2010; Corn & Gumbula, 2002; Dan & Neuenfeldt, 2013; Mackinlay, 2010). There are also many examples of Indigenous and non-Indigenous Australian contemporary music making in Australia. These include historical examples such as Warumpi Band and Yothu Yindi and, more recently, the Medics, Busby Marou, Thelma Plum and Andrew Lowden, and Geoffrey Grurrmul Yunupingu and Michael Hohnen. This does not mean that there are no discomforts to negotiate in collaborative processes between Indigenous and non-Indigenous people. The contact zone and cultural interface provide useful theoretical perspectives to explore these complexities.

Intercultural performance as contact zone and cultural interface: a collaboration between Torres Strait Islander and non-Indigenous musicians

I would now like to focus on one example of collaborative contemporary music making between non-Indigenous musician, researcher and producer Karl Neuenfeldt and Torres Strait Islander musicians Uncle Henry Seaman Dan (hereafter Seaman Dan) and Will Kepa (see Figure 10.1). This is part of a larger study exploring how collaboration is played out in specific instances of intercultural musical collaboration between Indigenous and non-Indigenous peoples. Karl Neuenfeldt has co-produced over 30 CDs and DVDs in collaboration with Indigenous communities and artists in the state of Queensland, Australia. As a researcher, he has published widely on Indigenous peoples' popular music. He began collaborating with Torres Strait Islander musician Seaman Dan in 1999 while undertaking research and their collaborations have led to eight Seaman Dan albums, two Australia Record Industry Awards (ARIAs) and they continue to perform and record together. Neuenfeldt states:

> Initially, in 1999, I was one of the producers, but that evolved into a quasi-manager and song-writing collaborator role. I had a background as a gigging muso for 20 years . . . so I was aware of the process of musical collaboration. I also was very interested in Torres Strait Islander music and culture . . . and Seaman Dan's stories. I perceived collaboration as a challenge. Plus the songs we co-wrote had an outlet as we had gotten either grants or production money.
>
> *(Karl Neuenfeldt, personal communication, October 13, 2013)*

Figure 10.1 A collaboration between Torres Strait Islander and non–Indigenous musicians. Back row (l–r): Bernard Fernandes, Karl Neuenfeldt, Will Kepa, Ben Hakalitz. Front row (l–r): Nigel Pegrum, Henry 'Seaman' Dan (photo by Baruka Tau, used with permission from Karl Neuenfeldt).

Seaman Dan is a Torres Strait Islander musician whose musical career flourished at the age of 70 (see Dan & Neuenfeldt, 2013). He describes his collaboration with Neuenfeldt in the following way:

> He started me on my music career in a professional sense. I was just singing at parties and singing in hotels, singing for my supper and enjoying it. So he helped me a lot. He showed me how to perform professionally.
>
> *(Seaman Dan, personal communication,*
> *March 10, 2014)*

Will Kepa is a Torres Strait Islander musician, producer, and sound engineer who began collaborating with Karl Neuenfeldt and Seaman Dan on the second Seaman Dan album as a roadie and then as a session musician on the third album. Describing his collaborations with Neuenfeldt and producer Nigel Pegrum, he states:

> A lot of our collaborations have been in the studio and the first time I worked with both those guys was on Seaman Dan's third recording. Nigel Pegrum was my drum teacher and then I met Karl. I first came as a session musician and they decided to take me under their wing and mentor me in learning how to record and the art of

production. We then started to venture out into Cape York and Torres Strait communities. Seven or eight years later we've come out with about eleven recordings.

(Will Kepa, personal communication,
November 13, 2013)

Roles and ethical responsibilities

Both Indigenous and non-Indigenous musicians have important roles to play at the contact zone/cultural interface of the collaborative musical process. As Nakata notes, Islanders at the interface must negotiate many roles on a daily basis 'responding, interacting, taking positions, making decisions and in the process re-making cultures' (2002, pp. 285–286). For example, Will Kepa notes his role as a Torres Strait Islander producer on recording projects with Neuenfeldt has been to 'think quickly on both sides—both culturally and work wise' to negotiate with the diverse Indigenous communities they work with and 'show that you do respect where you are'.

On the other hand, McGloin (2009) argues that non-Indigenous people experience the cultural interface as a site of struggle, attempting to recognise their position in ongoing colonial power relations while balancing their roles and responsibilities when working with Indigenous people. Certainly non-Indigenous people can be viewed warily because, as Neuenfeldt notes, 'there is sometimes an underlying assumption that a whitefella must be ripping off the blackfella somehow. That is the legacy of mistrust and missionisation'. Further he states that:

> Realistically 25 per cent of people are going to loathe you, 25 per cent are going to love you and it's the other 50 per cent you can only convince of your good intentions by being in for the long haul and not being a 'blow-in', blow in and out like the wind. That takes stamina.

(Karl Neuenfeldt, personal communication,
October 13, 2013)

But non-Indigenous people can also be key facilitators for the process of recording and performing because:

> They are usually essential in the overall process of writing, recording, distribution, etc. A 2 per cent minority does not have a broad presence in the music industry . . . There are certainly some Indigenous audio engineers, but not many. So non-Indigenous collaborators are essential.

(Karl Neuenfeldt, personal communication,
October 13, 2013)

Both Indigenous and non-Indigenous collaborators have responsibilities in this in-between space. A recurring focus is on having clear, tangible benefits for Indigenous communities. As Neuenfeldt notes, 'For me, the proof is in the music. If we hear music we have produced being used in communities as part of the soundtrack of their lives then that is very gratifying'.

Relationships and tensions

Relationships between Indigenous and non-Indigenous people are central to the contact zone and the cultural interface as they are both concepts about the intersections between Indigenous and non-Indigenous domains. The relationship that is formed through collaborations is

emphasised by both Indigenous and non-Indigenous performers. Will Kepa points to the benefits of the relationships that come from collaborating musically:

> The relationships and bonding that has come about because of that process is beneficial, not only for self but also for colleagues, peers . . . the bond that can be created out of music is so special. It's really hard to explain . . . The word family comes to mind when I think of collaboration, and bond, and friendship for a lifetime.
>
> *(Will Kepa, personal communication,*
> *November 13, 2013)*

Similarly, Seaman Dan describes his relationship with Neuenfeldt as 'solid. He's helped me a lot. He's a good friend . . . We're comfortable doing things together . . . They've [Karl and producer Nigel Pegrum] taught me how to perform in the studio' (Seaman Dan, personal communication, March 10, 2014).

Nakata (2002, p. 285) describes the cultural interface as a space where we 'live and learn' and certainly both Indigenous and non-Indigenous musicians learn and receive knowledge from each other through the process of mutually engaging in collaboration. Will Kepa states that 'I've learnt all I know through these projects and from Nigel and Karl', while Seaman Dan notes that the learning 'works both ways'. Neuenfeldt agrees and states that:

> It has been a big learning curve for myself and Nigel Pegrum and also Seaman Dan, who has become very polished as an entertainer and interviewee. We collaborated because the music benefitted from doing so. We knew things musically and industry-wise he did not know and vice versa he knew many things culturally we did not know.
>
> *(Karl Neuenfeldt, personal communication,*
> *October 13, 2013)*

Yet there can also be tensions and negotiations that must occur in collaborative processes at the contact zone/cultural interface. For Somerville and Perkins (2010: 15), the contact zone has been useful to explore 'productive tension' inherent in their Indigenous/non-Indigenous collaborations. Similarly, the cultural interface is described as a 'place of tension that requires constant negotiation' (Nakata, 2002, p. 285). The musical collaborators note that there have been very few tensions in their collaborative interpersonal relationships as musicians. Will Kepa notes that, for him: 'I've been lucky enough to work with people who are always open minded, questioning stuff in a relaxed manner . . . free to collaborate and share ideas' (Will Kepa, personal communication, November 13, 2013).

However, tensions can arise within/from the larger community and extended family of Indigenous performers:

> Between the two of us [Karl and Seaman Dan] personally [there has] very rarely [been tensions] but there are also issues with an extended family and the broader community . . . There is a raft full of moral obligations and professional ethics that are hard to implement sometimes because it really is a parallel universe most times. People, in particular in remote communities, have many priorities and your project is rarely one of them, and a minor one at that.
>
> *(Karl Neuenfeldt, pers. comm.,*
> *October 13, 2013)*

The transformation that can occur through the process of mutually engaging in collaborative music making is emphasised in relation to the contact zone and the cultural interface. As Nakata notes (2002, p. 286), the interface is a space where people can 'interact, develop, change, and transform', while Somerville (2014, p. 17) describes the contact zone as a 'space of transformation'. Musician Will Kepa reiterates this:

> Especially for people in communities who are not used to giving out their songs and their words, it can be a little bit personal but when you share that, it can be a real blessing sometimes, it can be life changing for some people.
>
> *(Will Kepa, pers. comm., November 13, 2013)*

Transformation, learning, and tensions are also all evident in collaboration research relationships between Indigenous and non-Indigenous people and I now shift to explore the experiences Torres Strait Islander researcher and performer Lexine Solomon and I have had working together.

Intercultural research as contact zone and cultural interface: a collaboration between a Torres Strait Islander performer/researcher and a non-Indigenous researcher

Torres Strait Islander performer Lexine Solomon was one of the women I interviewed for my PhD on Indigenous women who perform in contemporary music contexts. After I completed the project, Lexine asked me if I would like to work on a project together. We decided to explore the contemporary music performances of Torres Strait Islander women performers and secured funding from the Australian Institute of Aboriginal and Torres Strait Islander Studies (AIATSIS). We hoped to provide the performers with a platform to have their say and be recognised as a unique part of Australia's diverse Indigenous population. We devised the interview questions together and I undertook the ethical clearance. Between September 2007 and December 2008, we initially travelled across Australia to undertake interviews with Torres Strait Islander women (see Figure 10.2). Our agendas for the project were slightly different, yet complementary. Lexine hoped to gather data about other Torres Strait Islander female artists and hear about their challenges in performance, while I was particularly interested in finding ways to foreground women's voices and critique theories of marginalisation in relation to Torres Strait Islander women performers.

Roles and responsibilities

My role in the project was to facilitate and write the grant application, complete ethical clearance processes and analyse data alongside Lexine, and co-present and co-write articles with her. Lexine emphasises our different roles and responsibilities in the project:

> You [Katelyn] as the researcher, you're collaborating and then you're reviewing, always looking for the themes. You're the one that's looked at it and seen well how do we keep this relevant to what we set out to do. That's the hard yakka. That was the hard job. Making sure all collaborations were receiving what we set out to get. That's difficult. You're playing three and four roles while I'm trying to stay true to my culture, keep protocols, if they say you're going to eat you eat, or if they say you stand then you stand or don't come in yet I'm not ready. You had to go with the flow.
>
> *(Lexine Solomon pers. comm., March 12, 2011)*

Figure 10.2　The author and Lexine Solomon on Thursday Island, Torres Strait.

As Lexine states above, we brought different skills to the project. Mine in interviewing Indigenous Australian women performers, transcription and analysis, planning and implementing research, and writing reports and articles, while Lexine brought her experiences as a Torres Strait Islander woman performer, her understandings of cultural protocols and her many connections to interviewees. The projects occurred as a result of many conversations with Lexine; she was closely involved in conceptualising/viewing the projects from her own unique perspectives and relationships with her community while I too came with my own ethnomusicological research background and music experiences.

Border crossing and tensions

Haig-Brown poses the question 'Does the process of doing research separate a researcher from the community' (2001, p. 21) in the contact zone? Certainly this is an important issue in collaborative research with Indigenous people. Lexine had to cross borders in her roles as researcher, community member, and fellow performer. For her there were many obligations to fellow Torres Strait Islander women performers, to family, to community, to the university, and to the funding body:

> At times during the collaborative process I felt as though I was betraying my fellow Indigenous female performers who are friends and sometimes family. I am now the researcher when previously I was being researched. I am wearing a myriad of hats in order to ensure that the voice heard within the research is not mine, but the voice of the one who has allowed me to tell their 'music story'.
>
> *(Solomon, 2014, p. ix)*

This resonates with Canadian Indigenous scholar Kovach who points out 'we can only go so far before we see a face . . . and hear a voice whispering, "*Are you helping us*"' (2010, p. 31).

Lexine speaks of feeling like she has 'betrayed' family and friends by undertaking research on them and the importance of having the correct 'voice' in the research. This is also an important lesson for me as a non-Indigenous researcher. If non-Indigenous researchers want Indigenous people to collaborate more strongly as co-researchers, co-presenters, co-writers and undertake their own research on their own communities, it is important to be aware that they might need to negotiate complex and difficult borders between their positionings as community member and researcher and maintain both their community obligations as well as their research agendas.

The contact zone, as Pratt observes, is permeated by power and it is important to acknowledge that as a non-Indigenous researcher I come from a place of white race, colonial power and privilege. I am part of a 'growing community of non-Indigenous academics' who want to 'move beyond the binaries found within Indigenous-settler relations to construct new, mutual forms of dialogue, research, theory, and action' (Kovach, 2010, p. 12). Opinions of Indigenous Australians about whether or not non-Indigenous people should engage in research and write about Indigenous people are diverse. Langton has argued that 'essentialism has become a fundament of Aboriginal activism in modern Australia, with the result that anthropologists . . . tend not to be taken seriously because their authors are not ethically "Aboriginal"' (Langton, 2011, p. 1). From my perspective, Langton seems to be acknowledging that non-Indigenous people can bring important skills and knowledge to research with Indigenous communities. Yet, as Hayward (2005) notes, 'it is clearly not enough for the [non-Indigenous] researcher to ask someone to collaborate with them in undertaking *their* research. The collaborative aspect requires consideration of what the collaborator wants.' In this case, Lexine's and my own 'wants' were quite similar—to document the experiences of Torres Strait Islander women contemporary musicians—and the collaborative process with Lexine happened organically through our ongoing relationship and conversations. The tensions in the collaborative project were not so much between me and Lexine, but were discomforts that we experienced individually, yet we faced these issues together. Lexine and I were able to talk about her role as researcher/community member and my positioning as a non-Indigenous researcher working in Indigenous spaces.

Possibilities and transformation

Pratt (1992) characterises the contact zone as being filled with 'possibilities' while Nakata similarly describes the cultural interface as a 'space of possibilities' (2007, p. 200) and certainly the potentialities of collaborative research are particularly important. Lexine highlights that for her there have been unexpected outcomes of our collaboration:

> Looking back over the last ten years of collaborating with the now Dr Katelyn Barney, we have co-researched more than twenty-two Indigenous female artists about their music and from this research we have been published and co-presented at music conferences across Australia and New Zealand. I have loved the opportunity to collaborate and see the importance of my topic of interest. The other great bonus from all of this process over the ten years of collaboration is that the doctor and I have become good and close friends.
>
> *(Solomon, 2014, p. ix)*

This resonates with Haig-Brown's (2001, p. 257) assertion that 'the rewards of this engagement are that both participants are transformed in the process'. I too have learnt much from Lexine about music making, about her culture and her community. I have gained insight into the importance of being flexible during the research process, at times waiting for an invitation to

begin discussing research and the role of social interactions, such as sharing meals and visiting homes, as a way of establishing connections. I have also learnt about the importance of listening carefully, always taking others' perspectives seriously and nurturing relationships through all stages of a research project and beyond. These have been exciting and unexpected benefits of collaborative research experiences for me.

Lexine states that our project has steered her own interests because:

> I have now commenced a PhD researching more about my music identity as a female Torres Strait Islander singer, songwriter and performer and I am absorbed with the importance of finding my way . . . I find I am heard, I can learn and there starts my practice in protecting the way my collaborations are recorded.
>
> *(Solomon, 2014, p. x)*

As Lexine notes we have co-written articles and co-presented at conferences and forums over the last eight years (e.g., Barney & Solomon, 2009, 2011) and, as described in the short narrative at the beginning of the chapter, she has also joined me in the university classroom to allow students to enter into a dialogue with her about her experiences and learn about the tensions and borders she negotiates between community member, researcher and collaborator.

Conclusion

The contact zone and the cultural interface are both useful theoretical tools to explore how intercultural musical and research collaborations between non-Indigenous and Indigenous people occur in practice. From my perspective, collaborative research between Indigenous and non-Indigenous people holds the potential to allow non-Indigenous and Indigenous people to work equally together, to learn from each other, connect, and resist oppression of Indigenous people. Transformation is possible in these contexts, with both performers and researchers noting the mutual benefits of these processes. But the journey is not simple for either Indigenous or non-Indigenous people at the cultural interface/contact zone and there are many discomfort zones to negotiate as Indigenous and non-Indigenous researchers and musicians work together. In these performance and research spaces, communication, negotiation and dialogue between Indigenous and non-Indigenous people are central. They are complex spaces where border crossing occurs.

The two collaborations I have described here are not the first of their kind, but certainly *relationship* and dialogue seem central in successful musical and research collaborations. As Seaman Dan notes, 'music brings people together' (Seaman Dan, pers. comm., March 10, 2014), but it is difficult to say in concrete terms why music making and music research provide such significant vehicles for Indigenous and non-Indigenous individuals to creatively collaborate. Both contexts certainly provide powerful spaces in the contact zone/cultural interface for Indigenous and non-Indigenous people to connect, share and learn from each other both musically and culturally. There is much work to be done to improve relations between Indigenous and non-Indigenous people and collaboration can offer a way forward for them to jointly work together. Music making and research collaborations provide a powerful space in the contact zone for Indigenous and non-Indigenous people to connect, share and learn from each other. Importantly, Indigenous and non-Indigenous performers and researchers continue to strive together to find 'a new way of thinking and talking [and performing and researching] about our past, and about how we might live together in the present and in the future' (Maddison, 2011, p. 5) in order to build better relationships between Indigenous and non-Indigenous people.

Acknowledgements

I wish to thank Uncle Seaman Dan, Will Kepa, and Karl Neuenfeldt for participating in my research project exploring intercultural musical collaborations between Indigenous and non-Indigenous musicians. Thanks also to Lexine Solomon for her ongoing research collaborations and friendship.

Notes

1 The Torres Strait Islands are a cluster of islands bridging the sea between Cape York, Australia, and Papua New Guinea. There are hundreds of islands but only some are inhabited with eighteen Indigenous communities in the region and two on the Australian mainland at nearby Cape York Peninsula. They number approximately 30,000 people within an overall Indigenous Australian population of approximately half a million (ABS, 2007). Although Islanders are recognised as having strong ties to the Torres Strait Islands, many moved to mainland Australia to further their education and employment opportunities after World War Two. Approximately two-thirds of Torres Strait Islanders now live on mainland Australia, yet many maintain connections with the Torres Strait Islands.
2 This text is adapted from Solomon (2014, p. ix).

References

ABS (Australian Bureau of Statistics). (2007). *Census*. Canberra: Australian Government Printing Service.

Anzaldua, G. (1987). *Borderlands / La frontera: The new mestiza*. San Francisco, CA: Spinsters/Aunt Lute.

Barney, K. (Ed.). (2014). *Collaborative ethnomusicology: New approaches to music research between Indigenous and non-Indigenous Australians*. Melbourne, VIC: Lyrebird Press.

Barney, K., & Solomon, L. (2009). Looking into the trochus shell: Autoethnographic reflections on a cross-cultural collaborative music research project. In B. Bartleet & C. Ellis (Eds.), *Music autoethnographies: Making autoethnography sing/making music personal* (pp. 208–224). Bowen Hills, QLD: Australian Academic Press.

Barney, K., & Solomon, L. (2010). *Performing on the margins: Conversations with Torres Strait Islander women who perform contemporary music*. St Lucia, QLD: Aboriginal and Torres Strait Islander Studies Unit, The University of Queensland.

Barney, K., & Solomon, L. (2011). Songs for survival: Exploring resilience and resistance in the contemporary songs of Indigenous Australian women. In A. Brader (Ed.), *Songs of resilience* (pp. 49–72). Buckinghamshire: Cambridge Scholars Press.

Bendrups, D. (2008). Pacific festivals as dynamic contact zones: The case of Tapait Rapa Nui. *SHIMA: The International Journal of Research into Island Cultures, 2*, 14–28.

Bhabha, H. (1994). *The location of culture*. London: Routledge.

Byrne-Armstrong, H. (2001). Whose show is it? The contradictions of collaboration. In H. Byrne-Armstrong, J. Higgs & D. Horsfall (Eds.), *Critical moments in qualitative research* (pp. 106–114). Oxford: Butterworth Heinemann.

Carter, P. (1992). *Living in a new country: History, travelling and language*. London: Faber and Faber.

Clifford, J. (1997). *Routes: Travel and translation in the late twentieth century*. Cambridge, MA: Harvard University Press.

Corn, A., & Gumbula, N. (2002). Nurturing the sacred through Yolngu popular song. *Cultural Survival Quarterly, 26*(2), 40–42.

Dan, H. 'Seaman', & Neuenfeldt, K. (2013). *Steady, steady: The life and music of Seaman Dan*. Canberra, ACT: Aboriginal Studies Press.

Dillon, S. C. (2007). Maybe we can find some common ground: Indigenous perspectives, a music teacher's story. *The Australian Journal of Indigenous Education, 36*, 59–65.

Giroux, H. A. (1992). *Border crossing: Cultural works and the politics of education*. New York, NY: Routledge.

Haig-Brown, C. (2001). Continuing collaborative knowledge production: Knowing when, where, how and why. *Journal of Intercultural Studies, 22*(1), 19–32.

Hayward, P. (2005). Culturally engaged research and facilitation: Active development projects with Small Island Cultures. In M. Evans (Ed.), *Refereed papers from the First International Small Islands Cultures Conference, Kagoshima University Centre for the Pacific Islands, February 7–10* (pp. 55–60).

hooks, b. (1990). *Yearning: Race, gender and cultural politics.* Boston, MA: South End Press.

Huggins, J. (1998). *Sister girl: The writings of Aboriginal activist and historian Jackie Huggins.* St Lucia, QLD: University of Queensland Press.

Kovach, M. (2010). *Indigenous methodologies: Characteristics, conversations and contexts.* Toronto, ON: University of Toronto Press.

Langton, M. (1993). *Well, I heard it on the radio and I saw it on the television: An essay for the Australian Film Commission on the politics and aesthetics of filmmaking by and about Aboriginal people and things.* Sydney, NSW: Australian Film Commission.

Langton, M. (2011). Anthropology, politics and the changing world of Aboriginal Australians. *Anthropological Forum, 21*(1), 1–22.

Mackinlay, E. (2010). Big women from Burrulula: An approach to advocacy and applied ethnomusicology with the Yanyuwa Aboriginal Community in the Northern Territory, Australia. In K. Harrison, E. Mackinlay & S. Pettan (Eds.), *Applied ethnomusicology: Historical and contemporary approaches* (pp. 96–115). Newcastle: Cambridge Scholars Press.

Mackley-Crump, J. (2013). The festivalization of Pacific cultures in New Zealand: Diasporic flow and identity within transcultural contact zones. *Musicology Australia, 35*(1), 20–40.

Maddison, S. (2011). *The real challenge for black-white relations in Australia: Beyond white guilt.* Sydney, NSW: Allen and Unwin.

McGloin, C. (2009). Considering the work of Martin Nakata's 'cultural interface': A reflection on theory and practice by a non-Indigenous academic. *The Australian Journal of Indigenous Education, 38*, 36–41.

Nakata, M. (2002). Indigenous knowledge and the cultural interface: Underlying issues at the intersection of knowledge and information systems. *IFLA Journal, 28*, 281–291.

Nakata, M. (2004). *Indigenous Australian studies and higher education* (Wentworth Lecture, 2004). Canberra, ACT: Australian Institute of Aboriginal and Torres Strait Islander Studies. Retrieved February 20, 2013, from http://aiatsis.gov.au/sites/default/files/docs/presentations/2004-wentworth-nakata-indig enous-australian-studies-higher-education.pdf.

Nakata, M. (2007). *Disciplining the savages: Savaging the disciplines.* Canberra, ACT: Aboriginal Studies Press.

Page, S. (2014). Exploring new conceptualisations of old problems: Researching and reorienting teaching in Indigenous studies to transform student learning. *The Australian Journal of Indigenous Education, 43*(1), 21–30.

Pratt, M. L. (1992). *Imperial eyes: Travel writing and transculturation.* London: Routledge.

Rose, D. (2004). *Reports from a wild country: Ethics for decolonisation.* Sydney, NSW: University of New South Wales Press.

Smith, C., Burke, H., & Ward, G. K. (2000). Globalisation and Indigenous peoples: Threat or empowerment? In C. Smith & G. K. Ward (Eds.), *Indigenous cultures in an interconnected world* (pp. 1–24). Vancouver, BC: University of British Columbia Press.

Soja, E. W. (2000). *Postmetropolis: Critical studies of cities and regions.* Oxford: Blackwell.

Solomon, L. (2014). Foreword. In K. Barney (Ed.), *Collaborative ethnomusicology: New approaches to music research between Indigenous and non-Indigenous Australians* (pp. ix–x). Melbourne, VIC: Lyrebird Press.

Somerville, M. (2014). Creative collaborations. In K. Barney (Ed.), *Collaborative ethnomusicology: New approaches to music research between Indigenous and non-Indigenous Australians* (pp. 9–24). Melbourne, VIC: Lyrebird Press.

Somerville, M. & Perkins, T. (2003). Border work in the contact zone: Thinking Indigenous/non-Indigenous collaboration spatially. *Journal of Intercultural Studies, 24*(3), 253–266.

Somerville, M. & Perkins, T. (2010). *Singing the coast.* canberra: Aboriginal Studies Press.

Wali, A. (Ed.). (2006). *Collaborative research: A practical introduction to Participatory Action Research (PAR) for communities and scholars.* Chicago, IL: Field Museum.

11

INSIDER, OUTSIDER OR CULTURES IN-BETWEEN

Ethical and methodological considerations in intercultural arts research

Ylva Hofvander Trulsson and Pamela Burnard

Introduction

In qualitative research, the 'researcher is the instrument'. Therefore, the task of explicitly putting reflexivity to work and identifying oneself is important. In order to clarify your researcher identity and stance vis-à-vis participants, you must, as Gray (2008, p. 936) notes, 'address questions of the researcher's biographical relationship to the topic', such as gender, ethnicity, and socioeconomic status, as well as acknowledging the levels of privilege and power conferred by personal history. In the field of intercultural research we, as researchers, meet with individuals and families, communities and organizations, who might have directly experienced the trauma of torture and devastations of war or challenges like migration, alienation and political or religious persecution – individuals who, because of these experiences, have been damaged and stigmatized. Racism and stigmatization can appear in relation to ethnic background, disability, social status, etc. and often turns up in contexts where there is a limitary attitude against individuals who challenge norms. These norms or expectations can create, in turn, an immobile position for the marked individual. When we are entering these intercultural research fields we must also challenge our self-understanding and how we interpret the degree of privilege our position carries. The interpersonal meeting can both question and confirm our conceptions of ourselves. In qualitative research, when investigating dimensions of interpersonal dialogue, it becomes important to narrow the focus on perspectives of identities and abilities.

The aim of this chapter is to problematize the 'insider/outsider' relation in intercultural research settings and discuss the ethical and methodological challenges, with focus on the intersubjective meeting. Practising responsible reflexivity must engage the researcher's understanding of subjectivity, intersubjectivity, voice, representation and text. With reference to reflexivity specifically, Pillow (2010) advises that 'data' should be analysed responsively and reflexively, and points out that the positioning might change from a postmodern stance or a poststructuralist stance. This chapter also aims to critically view both the researcher's and the informant's perspectives and visualize power relations that operate in the process of data collection. This analysis is based on Bourdieu's theories about *capital* (1979, 1984).

The context of the intercultural interview

The interview brings the other into view and is perhaps the oldest of all methodologies in social science. Asking interviewees questions to gain new knowledge is and has been a common practice among anthropologists and sociologists since the start of their disciplines. In qualitative research settings, it is widely acknowledged that the researcher has power over the informants within the research relationship; bringing the other into view means adopting perspectives that reflect the viewpoints of those who are not powerful, not white, not English-speaking and not among the privileged classes (Del Busso, 2007; Kvale, 2006; Thomsson, 2002). There is recognition of power biases, which need to be corrected in research not only in terms of who the gatekeepers of knowledge are but also in terms of how 'objective' facts and subjective truths are selected and which ones are excluded. From our experience, the intercultural interview creates platforms for knowledge exchange and emotional meetings, sometimes disclosure of the person being interviewed, and sometimes a therapeutic tool for telling the story of experiences that are not often told, understood or appreciated.

The interpretation of positioning in the interview setting

Through the lens of Pierre Bourdieu's theories and tools we can visualize how power operates between different groups in society and shed light on how it might affect the data collection in an interview context. Bourdieu (1979, 1984, 1996, 2004) describes an individual's assets and resources as capital. The acquisition and mastery of different forms of capital can guarantee a diversity of power holdings depending on the type of capital, and the field in which they operate. Bourdieu describes four kinds of capital. *Economic capital* represents wealth and economic heritage. *Cultural capital* is described as capital based on background and affiliation, such as class, education and other qualifications that can be used as cultural resources. Cultural capital is, according to Bourdieu (2004), the capital valued most highly, and there is no clear economic link or market attached to this capital. The third kind of capital is *social capital*, described as resources based on family and group membership, relationships, personal contacts and networks. Social capital has a clear economic consequence. The fourth kind of capital is *symbolic capital*, which is the sum of the other types of capital when they become visible, legitimate and recognized as having a value (Broady, 1990). Because capital is not static, it is the subject of battles. Groups, classes and families develop strategies to maintain or increase capital holdings or discourage others from doing so (Söderman, Burnard, & Hofvander Trulsson, 2015). In a society, different groups have different cultural capital depending on where you come from and what groups you belong to. For groups with an immigrant background, the interpretation of cultural capital and class identification and status can sometimes become complicated.

Social mobility (Giddens, 2009), downward mobility (Bourdieu, 2004), social immobility or class remobility (Hofvander Trulsson, 2010a, 2013, 2015) are all examples of how different capitals can play out in a situation of migration. Unfortunately the most common is downward mobility. Through our research with families with immigrant backgrounds, living in exile, we have noticed among them a recurrent will to verbally position themselves, in regard to class background (economic and cultural), reasons for their situation in the new country and their aspirations (Hofvander Trulsson, 2010b, 2015). We have found in many countries that most families who have their children in music education during leisure time, have a 'middle class identity', or a middle to upper class aspiration. Hofvander Trulsson (2013, 2015) has shown the pivotal importance of music education to minority groups, as a tool for reconstructing cultural

and social capital, in relation to the majority as well as the minority society. Thus, music, much like language, has an empowering potential in its ability to strengthen the internal social bonds within minority groups and provide its users with agency. In musical settings, cultural differences are often assets and can be used as competitive benefits. Language, arts and music are universal and important expressions and markers of identity, both socially and culturally (Burnard, 2011; Karlsen & Westerlund, 2010; Söderman, 2007, 2010; Stokes, 1994). These perspectives of positioning in the interview setting, where gender, class and cultural imprints impact the way people talk and present themselves, are central to the use of reflexive analysis strategies in qualitative research. Pillow (2010) invites us to interrupt these common practices and engage with new culturally reflexive and ethical tools for researcher reflexivity: for collecting data, equalizing the research relationships, for doing data collection 'with' instead of 'on', and for practices that lead to 'multi-vocal' texts and the exploration of differing writing and representation styles.

Ethical considerations in data collection

Power should be made visible in the interview context, which means that the researcher has to relate and reflect upon it, and engage in a critique beyond 'a certain kind of paralyzed reflexivity' (Pillow, 2010, p. 277), particularly with regard to the analysis of collected data (Burnard, 2011; Hofvander Trulsson, 2010a). Kvale and Brinkmann (2009) highlight the power asymmetry of the research interview and state that it is often overlooked by the researcher who might put too much focus on the open understanding of the data and the close personal interaction between the parties. For example, informants might, more or less consciously, express what they think the interviewer wants to hear.

The researcher's perspective generates questions like: What does the researcher bring to the field, according to culture, ethnicity, gender, religion and class, but also, and maybe most importantly, attitudes? How can researchers come into contact and get access to a marginalized group in society and how do media portrayals of minority groups affect our data collection and analysis? The key point here is that reflexivity offers an invitation to not only the readers of the research but those whose reality has been 'captured' to challenge the accounts offered to them, and reminds both readers and researchers alike that these accounts, as textual creations, are, at best, a co-construction which is insightful; at worst, a particular individual researcher's interpretation.

The informant's perspective generates questions like: How does the informant interpret the researcher? What answers does the informant assume the researcher is looking for? What picture of him- or herself does the informant want to convey to the researcher? In groups living under a higher degree of exclusion and vulnerability, a stronger 'we' identity is often apparent, which should lead researchers to raise more questions and more reflection on the un-thought and unconscious categories of thought – that is, the unpacking of assumptions, reading deeply to uncover our own entrenched opinions, talking to a peer research group so as to ensure we cannot 'fix' a project but rather uncover hegemonic preconditions of our own practices. For intercultural researchers to make their way into new cultures and new relationships, we must learn how to represent, see and understand these experiences, before we can see the questions that arise in-between cultures.

Language issues in intercultural research

The intercultural researcher's role and job is to represent, in whatever form, fashion or mode is appropriate, the voice of the participants. This is where the practices of reflexivity need

to become more complex. Language limitations may appear in the interview and when transcribing the material. Our experience is that to understand and do justice to the informants' statements, the processing of the interviews has been crucial. Kirsten Hastrup (1995, p. 27) says 'my argument starts from a discussion of categorisation as a particular reflection upon the world; the aim is to demonstrate the potential mismatch between words and the realities they name'. In other words, in this context, translation is never a possibility in any language, and the impossibility takes on a different nature in intercultural contexts. In her book *Reflexive Interviews* (2002), Heléne Thomsson describes different experiences of interviewing women with foreign backgrounds. She discusses how the informant's language limitations can overshadow an entire conversation and how the researcher's position can limit the interview. Several aspects of power relationships can affect what is said in the interview; for example, the researcher might use a more academic language than some informants. But the opposite could also appear. Occupational status between the parties, educational attainment and ethnicity can all affect the outcome of the interview (Hofvander Trulsson, 2010a). Thomsson also writes about the use of an interpreter, which she does not recommend, since it may constrain the interview when a third party is used to translate what is said. This third party might also have difficulties holding back his own comments on the statements. Via the interpreter there can be an undesired interpretation of what is said, because 'language difficulties are so much more than translation problems' (Thomsson, 2002, p. 98). Kvale and Brinkmann (2009) highlight the point that in postmodern thinking there is an approach to interviewing that focuses on the interview as a space for production of knowledge. Similarly, Rice (2009, p. 257) advises that 'strong reflexivity' is an imperative and best described as a form of 'embodied engagement' that fully engages the researcher in relation to others. Kohler-Riessman (2007) argues that the interviewees provide their information and interpretations, but it is the researcher that constructs the interview and makes the final interpretation. The researcher listens to what is said or not said, and how something is said, representing multiple levels of linguistic interpretation and analysis. The research interview is a conversation about the human life-world, where the oral discourse turns into text interpretation (Hofvander Trulsson, 2010a).

Insider or outsider in cultural contexts

Today, there is extensive debate about the pros and cons of researchers being 'outsiders' or 'insiders' in relation to the communities or the phenomena they study. Kerstetter (2012) discusses the consequences of the dichotomy of outsider/insider and emphasizes the relative nature of researchers' identities in relation to research context. She says that community-based researchers often enter communities as 'outsiders', whether by virtue of their affiliation with a university, level of formal education, research expertise, race, socioeconomic status, or other characteristics. Many of these traits – such as level of formal education and access to resources – also connote a more privileged and powerful status in the larger society. Recent research has attempted to move beyond the strict outsider/insider division to underline the relative nature of researchers' identities and social positions in relation to the studied context.

Robert Merton (1972) summarized these opposing standpoints as two different doctrines and says that the outsider doctrine values researchers who are not from the communities they study, as observers and neutral. The outsider researcher is thus 'valued for the objectivity, which permits the stranger to experience and treat even his close relationships as though from a bird's-eye view' (Kerstetter, 2012, p. 100). The insider doctrine, on the other hand, suggests that outsider researchers will never truly understand a culture or situation if they have not experienced it.

The insider further contends that 'insider researchers are uniquely positioned to understand the experiences of groups of which they are members' (Kerstetter, 2012, p. 100). The degree of insider/outsider status means detailing the amount of experience, or lack thereof, with the target population. In the literature we can read an expressed dichotomy of insider/outsider, which also can be understood in the context of knowledge, like inside knowledge, that the outsider does not have. This dichotomy is further analysed and problematized in the next section.

According to Kerstetter (2012) insider researchers are able to recruit informants more easily than outsider researchers and, by using their shared experiences, are able to gather a richer set of data. Outsider researchers could be accused of never truly understanding a culture or situation if they are not part of it. Insiders may be sharing experiences, like, for example growing up in similar neighbourhoods, with a child-rearing ideology that creates a similar social and cultural capital or other commonality. This common habitus can be important, but there are risks in that too, such as becoming blind to phenomena and discourses in the field where power relations might be internalized. The outsider is valued for objectivity and distance but might find it hard to analyse what is behind the discourses he or she sees and hears.

Researchers in the space between

Mercer (2007) raises the notion of 'the space between' and that is probably the most common situation for researchers, to fall somewhere between that of insider and outsider. There are a few researchers who have raised issues concerning 'the space between'. Robert Merton (1972) wrote about the insiderism among American sociologists in the 1960s. He shed light on hegemonies and doxa within the research field and gave examples from the polarized conditions that pervaded American society during that time. He described how previous generations of male sociologists, mainly recruited from the white elite, defined the field and directly and indirectly divided the research areas where sociologists with Afro-American backgrounds or women could research within. He called it 'patterned expectations' (Merton, 1972, p. 103), which was an appropriate selection of problems to investigate. He wrote:

> The handful of Negro sociologists were in large part expected, as a result of social selection and self-selection, to study problems of Negro life and relations between the races just as the handful of women sociologists were expected to study problems of women, principally as these related to marriage and the family.
>
> *(Merton, 1972, p. 103)*

This kind of 'insiderism' that was developed as a result of the discriminating factors in American society seems to have led to a kind of protectionism among African Americans. One can identify a Black standpoint, linked to the theory and societal context, that only they could study the Afro-American group. Merton described it as a strong doctrine of insiderism and referred to an article written by a group of coloured intellectuals, who said, 'only black ethnologists can understand black culture, only black sociologists can understand the social life of blacks' (1972, p. 103). In the weaker form of the doctrine, some practical concessions were made in the article, and Merton summarizes the situation as being that there were too few coloured scholars at the time, and because of that it was proposed that some white professors with relevant experience might be brought into the 'black programs'. 'Any white professors involved in the programs would have to be black in spirit in order to last' (1972, p. 104). With this example we can see the complexity within the field of research, where racial and gender aspects always play a role, not only for the informants but also the researchers involved

(Dwyer & Buckle, 2009). Using Bourdieu's tools, this situation can be interpreted as 'I know because I am one' or 'I know because I've been there' and tells us that our bodyhexis is always to be taken into account in the meeting with another person with the historical layers/doxa included, no matter what role we carry. Does this also mean that insider knowledge is the most important when you investigate a phenomenon? Can only women study women, and men, men? And, in intercultural research, can only a researcher with similar experiences (i.e., war experiences, refugeeism or poverty) view and describe similar circumstances? The values that the categorization might bring are results of norms in the culture, the historical experiences and political and media discourses.

The impact of discriminating aspects in intercultural arts research

The variety of ways in which discrimination, oppression and violent acts have been played out in history also shows how contextual they are; they strike both up and down in the society's hierarchies, where almost anyone can become a target: Jews, Roma, Indigenous groups, immigrants, homosexuals, women, for example. Bourdieu (2004) highlights the importance for the interviewer to be not only neutral, but to actively follow up the interviewees' statements and responses. These types of interviewers do not strive to be the 'objective' scientists, but participate in the conversation by asking and questioning. Throughout history, though, there are also many examples of scientists and researchers who have experimented with groups of people in a most unethical way. The objective role has given them a much too distanced position in relation to the studied object; the lack of empathy has had far-reaching consequences for the individual's life. Randy Moore (2002) writes about the complex interactions between science, governmental policies and ethics and gives a rich background to Nazi acts and how science interacted with and legitimated them. Examples of unethical acts and direct and indirect violence of researchers can be found in Nazi science, tobacco research and measuring the skulls of Indigenous peoples to determine their intellectual capacity; an infamous example is the Tuskegee syphilis experiment in Alabama.

James A. Banks (1998) writes about his experiences at a university in the US in the 1960s, which subsequently became a catalyst for research questions he continues to study. One question that he examines in the article 'The lives and values of researchers: Implications for educating citizens in a multicultural society', is 'why were the slaves pictured happy?' (p. 4). As a young student he was astonished at how slavery was described in the course literature. His examples give a retrospective reflection of how researchers, who historically mainly had a background in the upper classes, in many cases showed a lack of respect and compassion for the people and the environments they studied. Banks gives a few examples where researchers showed a problematic stand in their analysis: 'Philips identified with slave owners rather than with the people who were enslaved (1918)'; 'Murray views welfare mothers as burdens on the nation (1984)' (from Banks, 1998, p. 5).

In the above cases, researchers were outsiders in relation to the communities they studied. They described cultures and peoples of whom they had little insider knowledge and for whom they had little respect or compassion. Banks points at the key challenge in research analysis and refers back to the authors of 'the happy slave' myth; he asks: 'Whose values and beliefs do they reflect?' (Banks, 1998, p. 4). Banks refers to Merton (1972) and describes the epistemological crisis during the 1960s and 1970s, which was characterized by heated discussion and debates of questions such as: Who should speak for whom? Who speaks with moral authority and legitimacy? 'Can the outsider ever understand the cultures and experiences of insiders or speak with moral authority about them?' (Banks, 1998, p. 6). Merton writes 'Either the insider or the

outsider has access to sociological truth' (Merton, 1972, p. 40) and concludes that both insider and outsider perspectives are needed in the process of truth seeking.

Cultures in-between and norms in society

In the late 1990s, a more nuanced version of insider/outsider doctrine was discussed: the 'space between', which usually is characterized as a multidimensional space, where researchers' identities, cultural backgrounds and relationships to research participants influence how they are positioned within that space. In Stuart Hall and Paul du Gay's book *Questions of Cultural Identity*, Homi K. Bhabha (1996) writes about the 'cultures in-between'. He problematizes what 'in-between' means in a minority and racial context and how different generations handle a migration process, and the relationships, bonds and sympathies that are developed because of that. The capitals, like cultural (access to education), social (religious, political, cultural) and economical (financial, ownership) have changed in nature with the process of migration. This leads, according to Bhabha, to a situation described as *cultures in-between*, which he also names as 'cultural hybridisation' (p. 54). Bhabha (2005) expresses himself as follows about multicultural-ism and being in a minority situation:

> On the one hand, multiculturalism actually is prevented in practice, although it is always recognized and affirmed in theory. There arises a natural norm, established and directed by the host society or the dominant culture, where the argument seems to be, that other cultures are good, but we must adapt them to our own terms. The second problem concerns the well-known phenotype that in societies where multiculturalism exists, still different forms of racism are common. The reason is that the universalism, which para-doxically allows ethnocentrism, in itself, conceals ethnocentric norms, values and interests.
>
> *(Bhabha, 2005, pp. 284–285)*

Here Bhabha shows how host societies more or less require minority groups to adopt their norms. This could be interpreted as the majority society's citizens assessing life and the world from their own position and experience.

The third identity

The concept of the 'third identity' is developed by Katrin Goldstein-Kyaga and Maria Borgström (2009), who describe the identities of globalization's footsteps as cross-border, mul-tidimensional, contextual and changeable in different situations. They emphasize that the iden-tity is diverse and multidimensional since the context in which people live also affects them. Goldstein-Kyaga and Borgström (2009) have studied young people in multicultural areas in Sweden, and they believe that these urban spaces, dominated by several different nationalities, provide encounters between different minority cultures. The individual is, however, character-ized by more than the present context of living, but also by the majority culture which affects the environment in terms of laws, rules and structures in the school and community. This mul-ticultural mix of cultures and nationalities in which children grow up and develop is something they call *the third identity*, which can be understood as an identity melting-pot of many differ-ent cultural contexts, navigating in contextual behavioural patterns. The concept of the third identity is inspired by Bhabha's (1994) theories and described as an 'in-between place' or 'third place'. Goldstein-Kyaga and Borgström (2009) argue that the concept of ethnicity has become too narrow to describe the situation in which people find themselves in a globalized society.

121

Today's society, in general, and especially in big cities, is characterized by flowing, changing boundaries, where people's identity cannot be described in terms of belonging to individual and distinct groups.

There are, and maybe, to some extent, always have been parallel movements in societies, where ideologies and lifestyles collide with political or religious stands. Considering traditional perspectives together with detraditionalizing we want to highlight that people can be on different levels of one or the other. These perspectives are reflected in children in school environments and in leisure time activities. Recruitment for music schools and access to instruments, educational choices, and opportunities to get around in society interact with many different perspectives related to the background, experience, parents and relatives, teachers, recreation and other children. These opportunities and influences interact with and influence individuals at many different stages in their lives (Burnard, 2011).

The space between in Indigenous settings

Hybridity is a concept that has been used (in post-structural and postmodern analysis and especially in post-colonial theory) by theorists like Stuart Hall, Homi K. Bhabha and Gayatri Spivak. The concept has its origin in the 20th century where it described a biological categorization of different species and plants. In the middle of the 20th century, this led to divisive discussions about race, and categorizations of race. People who had a mixed race, could be categorized as 'hybrid' (Brömssen, 2006).

Linda Tuhiwai Smith (1999) highlights another angle of hybridity, with the concept of 'the space between', describing her own experience occupying the 'space between' as a Maori researcher in New Zealand:

> I was an insider as a Maori mother and an advocate of the language revitalization movement, and I shared in the activities of fund raising and organizing. Through my different tribal relationships I had close links to some of the mothers and to the woman who was the main organizer . . . When I began the discussions and negotiations over my research, however, I became much more aware of the things which made me an outsider. I was attending university as a graduate student; I had worked for several years as a teacher and had a professional income; I had a husband; and we owned a car, which was second-hand but actually registered. As I became more involved in the project . . . these differences became much more marked.
>
> *(Tuhiwai Smith, 1999, pp. 137–138)*

Tuhiwai Smith (1999) illustrates the multidimensionality of the 'space between', drawing on her ethnicity, community work, education and income, to problematize her position as a complete insider in relationship to her research participants. She points out that her identity as a researcher led the women she interviewed to treat her differently than they might otherwise have done if she were visiting their house as a mother. Her role as researcher put her in a new position too. Tuhiwai Smith (1999) noted how the women's practices – cleaning their homes, preparing food, etc. were performed not only as signs of respect but also as strategies 'to keep the outsider at bay, to prevent the outsider becoming the intruder' (p. 138). Her identity as a researcher clearly outweighed other identities and relationships she shared with her research participants. However, this 'outsider' status was also probably mediated by her ethnicity and shared experiences, allowing her access to a community that might not otherwise have been available to a researcher who did not share those characteristics.

Ethical and intersectional considerations in data collection

In every research study, the initial decisions have far-reaching consequences. These initial considerations draw the lines for what kind of analysis and interpretation one can do. Every design is also related to ethical issues, which need to be recognized. When categorizing informants, intersectionality becomes important in order to challenge our pre-understanding of the context we are studying.

The risk of grouping people, such as parents with a foreign background, individuals with a working-class background, coloured women, white men and so on, is that it simplifies the study by presupposing that people in a group are similar and homogeneous in their lifestyles or in their professional lives (Hofvander Trulsson, Burnard & Söderman, 2015). Intersectionality holds that the classical conceptualizations of oppression within society, such as racism, sexism, homophobia, and religion– or belief-based bigotry, do not act independently of one another; instead, these forms of oppression interrelate, creating a system of oppression that reflects the 'intersection' of multiple forms of discrimination. Cultural patterns of oppression are not only interrelated, but are bound together and influenced by the intersectional systems of society (Collins, 2000; McCall, 2005).

The global rise in migration also increases cultural exposure and emphasizes the need for analytical and methodological tools to investigate the areas where social diversity rubs against and challenges our prejudices. There are a multitude of attitudes about diversity, which have implications in every decision we make throughout the research process, from design, to the choice of theory and analysis of data. Another ethical question is how we handle provoking quotes from our informants? Quotes that could be misused by journalists or media, quotes that, for example, could reinforce prejudices and stereotypes of religious contexts? If we choose to publish these provoking quotes, the soil we plant them in becomes very important. Prejudices against immigrants and Indigenous groups are difficult to change and because of that, we, as researchers, have a central responsibility to analyse possible outcomes before we publish.

Interview studies in qualitative research require sociological sense and gaze. Bourdieu (1984, 1996) calls this reflexive sociology, which can be interpreted as deep knowledge about the topic and the phenomenon under study. The sociological gaze enables us to perceive and monitor where the interview actually takes place and pay attention to the impact of the social structure. Bourdieu's (1979) view of reflexivity and reflection means that the researcher is perceived as inserted in a social field with specific power relations. These, in turn, generate a certain habitus, which results in patterns of behaviour among the participants, both informants and researchers. The foundation of reflective empirical research consists of a reconstruction of social reality, where the researcher interacts with the researched by their presence (Hofvander Trulsson, 2015). There is also a process surrounding the positions of being an 'insider' or an 'outsider'. A researcher can go from being an outsider in relation to the examined context, to becoming an insider. This process determines the conditions for all participants.

Intercultural arts research is a most heterogeneous field with few limits in terms of research topics, angles and questions. Intercultural arts research acknowledges the complexity of locations and identities in a global world, as well as the desire to create dialogue and understanding across cultures. This chapter has tried to map how concepts of insider, outsider and the space between hang together and work in empirical contexts. For the researcher the challenge of intercultural research (an interpersonal meeting which also involves a meeting of self) is not simply the need for a methodological tool for equalizing and making visible power relations and practices of gathering data as 'truths', but rather a reflexive tool which can work to counter comfortable research practices: researching within discomfort zones is key.

References

Banks, J. A. (1998). The lives and values of researchers: Implications for educating citizens in a multicultural society. *Educational Researcher, 27*(7), 4–17.

Bhabha, H. (1994). *The location of culture.* London, New York: Routledge Classics.

Bhabha, H. (1996). Culture's in-between. In S. Hall & P. de Gay (Eds.), *Questions of cultural identity* (pp. 53–60). London: SAGE Publications.

Bhabha, H. (2005). Det tredje rummet. In C. Eriksson, M. Eriksson Baaz & H. Thörn (Eds.), *Globaliseringens kulturer: Den postkoloniala paradoxen, rasismen och det mångkulturella samhället.* Falun: Nya Doxa.

Bourdieu, P. (1979). *Outline of a theory of practice.* Cambridge: Cambridge University Press.

Bourdieu, P. (1984). *Distinction: A social critique of the judgement of taste.* London: Routledge.

Bourdieu, P. (1996). *The rules of art.* Cambridge: Polity.

Bourdieu, P. (2004). *Praktiskt förnuft: Bidrag till en handlingsteori.* Uddevalla: Daidalos.

Broady, D. (1990). *Sociologi och epistemologi: Om Pierre Bourdieus författarskap och den historiska epistemologin.* Stockholm: HLS Förlag.

Brömssen, Kerstin von. (2006). Identiteter i spel-den mångkulturella skolan och nya etniciteter. In H. Lorentz & B. Bergstedt (Eds.), *Interkulturella perspektiv: Pedagogik i mångkulturella lärandemiljöer* (pp. 41–69). Lund: Studentlitteratur.

Burnard, P. (2011). Rivers of musical experience: A tool for reflecting and researching individual pathways. In C. Harrison & L. McCullough (Eds.), *Musical pathways* (pp. 168–179). Solihull, West Midlands: National Association of Music Educators (NAME).

Collins, P. H. (2000/1990). *Black feminist thought: Knowledge, consciousness, and the politics of empowerment* (2nd ed.). New York: Routledge.

Del Busso, L. (2007). III. Embodying feminist politics in the research interview: Material bodies and reflexivity. *Feminism & Psychology, 17*(3), 309–315.

Dwyer, S. C., & Buckle, J. L. (2009). The space between: On being an insider-outsider in qualitative research. *International Journal of Qualitative Methods, 8*, 54–63.

Giddens, A. (2009). *Sociology* (6th ed.) Cambridge: Polity Press.

Goldstein-Kyaga, K., & Borgström, M. (2009). *Den tredje identiteten: Ungdomar och deras familjer i det mångkulturella, globala rummet.* Huddinge: Södertörn Academic Studies.

Gray, B. (2008). Putting emotion and reflexivity to work in researching migration. *Sociology, 42*(5), 935–952.

Hastrup, K. (1995). *A passage to anthropology: Between experience and theory.* Abingdon: Routledge.

Hofvander Trulsson, Y. (2010a). *Musikaliskt lärande som social rekonstruktion: Musiken och ursprungets betydelse.* Lund: Lunds universitet. Malmö Academy of Music. (Diss.).

Hofvander Trulsson, Y. (2010b). Musical fostering in the eyes of immigrant parents. *Finnish Journal of Music Education (FJME), 13*(1), 25–38.

Hofvander Trulsson, Y. (2013). Chasing children's fortunes: Cases of parents' strategies in Sweden, the UK and Korea. In P. Dyndahl (Ed.), *Intersection and interplay: Contributions to the cultural study of music in performance, education, and society* (Perspectives in Music and Music Education, No. 9) (pp. 125–140). Lund: Malmö Academy of Music, Lund University.

Hofvander Trulsson, Y. (2015). Striving for 'class remobility': Using Bourdieu to investigate music as a commodity of exchange within minority groups in Sweden. In P. Burnard, Y. Hofvander Trulsson & J. Söderman (Eds.), *Bourdieu and the sociology of music education* (pp. 29–42). London: Ashgate.

Hofvander Trulsson, Y., Burnard, P., & Söderman, J. (2015). Bourdieu and musical learning in a globalised world. In P. Burnard, Y. Hofvander Trulsson & J. Söderman (Eds.), *Bourdieu and the sociology of music education* (pp. 209–222). London: Ashgate.

Karlsén, S., & Westerlund, H. (2010). Immigrant students' development of musical agency: Exploring democracy in music education. *British Journal of Music Education, 27*(3), 225–239.

Kerstetter, K. (2012). Insider, outsider, or somewhere in between: The impact of researchers' identities on the community-based research process. *Journal of Rural Social Sciences, 27*(2), 99–117.

Kohler-Riessman, C. (2007). *Narrative methods for the human sciences.* London: Sage.

Kvale, S. (2006). Dominance through interviews and dialogues. *Qualitative Inquiry, 12*(3), 480–500.

Kvale, S., & Brinkmann, S. (2009). *Den kvalitativa forskningsintervjun.* Lund: Studentlitteratur.

McCall, L. (2005). The complexity of intersectionality. *Signs: Journal of Women, Culture and Society, 30*(3), 1771–1800.

Mercer, J. (2007). The challenges of insider research in educational institutions: Wielding a double-edged sword and resolving delicate dilemmas. *Oxford Review of Education, 33*, 1–17.

Merton, R. (1972). Insiders and outsiders: A chapter in the sociology of knowledge. *American Journal of Sociology, 78*, 9–47.

Moore, R. (2002). Can 'good science' come from unethical research? *Journal of Biological Education, 36*(4), 170–175.

Pillow, W. S. (2010). 'Dangerous reflexivity': Rigour, responsibility and reflexivity in qualitative research. In P. Thomson & M. Walker (Eds.), *The Routledge doctoral student's companion: Getting to grips with research in education and the social sciences* (pp. 270–282). London: Routledge.

Rice, C. (2009). Women's embodied lives imagining the Other? Ethical challenges of researching and writing. *Feminism Psychology, 19*(2), 245–266.

Söderman, J. (2007). *Hiphopmusikers konstnärliga och pedagogiska strategier*. Lund: Media-Tryck.

Söderman, J. (2010). *Hiphop som mångkulturell folkbildning*. In P. Lahdenperä & H. Lorentz (Eds.), *Möten i mångfaldens skola. Interkulturella arbetsformer och nya pedagogiska utmaningar*. Lund: Studentlitteratur.

Söderman, J., Burnard, P., & Hofvander Trulsson, Y. (2015). Contextualising Bourdieu in the field of music and music education. In P. Burnard, Y. Hofvander Trulsson & J. Söderman (Eds.), *Bourdieu and the sociology of music education*. London: Ashgate.

Stokes, M. (1994). *Ethnicity, identity and music: The musical construction of place*. Oxford and Providence, USA: Berg.

Thomsson, H. (2002). *Reflexiva intervjuer*. Lund: Studentlitteratur.

Tuhiwai Smith, L. (1999). *Decolonizing methodologies: Research and Indigenous peoples*. London: Zed Books.

12

A MUSICIAN IN THE FIELD

The productivity of performance as an intercultural research tool

Cassandre Balosso-Bardin

Introduction

How does an intercultural performer/researcher's status and identity shift over time in the field as locals adapt to this new presence? How does an outsider become a partial insider and is this an advantage for the research? Drawing upon my work as an ethnomusicologist in Mallorca between 2011 and 2014, the discussion in this chapter inscribes itself in intercultural arts on different levels. Euba and Kimberlin describe intercultural activity as involving elements from two or more cultures (1995, p. 2). The creative process may be intercultural through the blend of cultures in the artistic product but performance can also be intercultural if the work of art and the performer are from different cultures (Euba & Kimberlin, 1995, p. 3). Additionally there is a constant shift between arts-practice and research and such movement in and of itself is integral to interculturality. Indeed, my 'intercultural' identity as researcher was constantly re-negotiated by the Mallorca locals as they developed strategies to relate to me as both researcher and practitioner. In this chapter, I first position myself and my identity as a performer and then examine ethnomusicological literature which relates to the link between performance and research as well as the interculturality of researchers as practitioners. By looking at the interaction between myself as ethnomusicologist and local people in Mallorca, my aim in this chapter is to show how the practice of music was essential to build a bridge between my insider and outsider status and ultimately establish meaningful intercultural links with local musicians.

A musician in the field

When I began my work at Mallorca, I was a professional musician with an international background with no previous ties to the field but with past bagpiping experiences that facilitated access to local music making. After studying the recorder and cello for 13 years at my local music school in France, I successfully auditioned for a conservatoire position with Jean-Pierre Nicolas, a renowned recorder player in Orsay, near Paris. A year later, I applied for the musicology course at the Sorbonne. I became involved in early music projects and orchestras including the prestigious Centre de Musique Baroque de Versailles. At the age of 19, I ordered my first set of Galician bagpipes and from then on my interest in folk music grew exponentially. After completing my Prix de Conservatoire and a Bachelor of Arts in Musicology, I turned my full

attention to ethnomusicology and folk music. Before arriving in Mallorca, I had participated in many multi-cultural projects based in London, France and Sweden, expanding my musical knowledge and collaborating with international musicians from India, Turkey, Sweden, Greece and the UK among other places. By the time I left for fieldwork, I had established myself as a recorder and bagpipe player both in London and in Britain's wider bagpiping community. Throughout my stay in Mallorca, I continued my musical practice as I returned periodically to France and to London for important commitments.

Despite having experienced many different musical cultures, the initial contact with the field was culturally surprising. I was accustomed to Galicia where musicians and locals were very social, always ready to welcome outsiders into their homes and families. I arrived in Mallorca for the autumn and winter months, after the summer frenzy. I was all set to start my study of the local bagpipes, the *xeremies*. My goal was to create an anthropological portrait of the instrument, understanding its place in Mallorcan society. For the first two months my fieldwork stalled. I met a few older bagpipe players (*xeremiers*), I talked to three researchers who were residing on the island, I started learning Catalan and followed a few leads, but I did not know how to meet younger participants with whom I could become friends and I was politely ignored when I tried speaking to a couple of musicians after their concerts whether I introduced myself as a musician or a researcher. I was socially isolated and my English teaching job was completely detached from the musical world I was seeking entry into.

My position in the field, however, shifted dramatically thanks to one contact, Toni Torrens, a local pharmacist and patron of Mallorca's musical traditions. In 1994, Toni Torrens organised the first *trobada*, a bagpipe gathering in Sa Pobla with a Saturday night concert and a Sunday instrument fair. I offered to play at the concert with my folk trio as a way of introducing myself as a musician to the community. Toni accepted and, in November 2011, I performed in front of a 300-strong audience, a large proportion of which were from the world of the *xeremies*. At the concert, I was able to say a few words in Catalan to show my commitment to the language before explaining in Castilian the reason for my presence in Mallorca. These few words, combined with a good performance, established the basis for an intercultural dialogue and radically changed social interaction in the field. The number of people who congratulated us on the music and offered their help for my research amazed me. By the next day, I had four or five invitations to different events and many more open doors. The following week I started to forge new friendships with younger musicians.

This single event opened the doors to the field not once but over and over again as my reputation as a musician preceded me. I was using music making as a tool, not only to participate and socialise but also to open the dams inside people, showing them that I was up to the task and worthy of the knowledge they were now willing to impart. My newly acquired status as a professional musician helped to lend legitimacy to my research. I was never asked to prove myself musically. On the contrary, I was invited a couple of times to guest at performances. I interpreted these moments not only as a great display of trust and friendship from the musicians and a satisfying let out for my personal musical craving, but also a way for the groups to show our relationship to the audience. This benefitted both parties – I was getting more exposure as a researcher/musician and they were inviting an outsider to perform with them, capturing the interest of the public through this intercultural collaboration.

My status as a proficient musician meant that I was also regularly invited to share feedback after performances or rehearsals, a process that gave me an insider's position and included me in the musical conversation. Although I was encouraged to play in informal settings such as bagpipe gatherings – not to do so would have been disappointing both to the *xeremiers* and to myself – I was also able to navigate with my camera and notebook, fulfilling my expected role as

a researcher. Rather than damaging my relationship with people, the fact that I was a musician but chose to concentrate on the research meant that I was no threat to the highly competitive market. At the same time, I understood the intricacies of the field that led to interesting conversations as people opened up about the music and their relationships within the scene. Although I came to learn most of the local repertoire thanks to regular rehearsals and group lessons I participated in, few people realised this because I was seldom performing, focusing on building my identity as a researcher. This, however, did not prevent me from recently becoming the go-to expert for local fipple flutes – whistle-like instruments such as the recorder – a role which I gladly embraced as it allowed me to access the field from another point of view and gain insider's knowledge through a slightly different network, initiating new conversations.

However, being accepted and welcomed as a researcher thanks to musical credentials did not mean that I immediately became a musical insider. This process took much longer than anticipated, although, in retrospect, I probably experienced the same stages a young bagpipe player would go through before he would be fully accepted by his elders. Before becoming a *xeremier*, I not only had to play adequately and in style, I also had to understand what the role implied. In November 2010 Miquel Tugores, one of the most established *xeremiers* of the island, promised me that the following summer I would 'understand' what it meant to be a *xeremier*. He had felt my confusion about the lack of a spontaneous musical scene such as those found in the UK, in Galicia or even in the French folk world. Unofficial social music making seemed to be non-existent, the only moments I heard bagpipes were in regulated events such as processions, dances or gatherings organised by the council or local committees. Mallorcan bagpipes, the *xeremies*, are never played alone.[1] The traditional formation on the island is composed of one bagpiper, a *xeremier*, and one flute and drum player, a *flabioler*. These two musicians form a *colla*. *Collas* are often constituted early on and rarely change members. This means that both *colla* musicians share a very strong musical connection. Since the bagpipe boom of the 1990s, many people started learning and playing the bagpipes and the flutes and drums. This led to the formation of larger groups, *bandas*, which slowly replaced *collas* in village festivities. This gradual change became a bone of contention between *collas* and band members. Arguments emerged concerning the quality of the interpretation, the difficulty of performing in a group or in a duet and the vitality of the overall performance. Musicians who were part of well-established *collas* deplored the local *bandas* taking over the celebrations. But why exactly was this a problem, apart from the obvious financial reasons implied by less work? I understood, as Miquel Tugores had promised me, the following summer when I witnessed a *colla* animating an entire village into a state of revelry, leading the people through the celebration for hours on end. The music was energetic, but it was more than that. The transformative power of the *colla* was staggering. Two musicians had created a state of celebration that I had rarely witnessed on the island however much I had looked for it. Group performances tended to be tamer, much more controlled both musically and emotionally.

So how did my position as a musician in the field help me comprehend the vital role of the *xeremies*? How did I understand that these wild moments created by one *colla* were, to borrow Timothy Rice's expression, the soul filling experience I had been yearning for during my entire fieldwork (Rice, 1994, 1997)? The full extent of the role and status of the *xeremier* dawned on me 18 months after arriving on the island, when I was finally accepted as a musical insider. During the Mallorcan Sant Antoni celebrations of Barcelona, *xeremier* Miquel Tugores handed me his instrument. With this simple gesture, Miquel was publicly giving me his seal of approval, establishing that I had acquired sufficient musical and cultural knowledge to lead the people in his stead. Miquel Tugores was offering me an intra-cultural experience: in an instant, he had made a *xeremiera* of me. This was a deeply honouring moment and a sign that I had finally been

accepted into the small circle of the most established *xeremiers* of the island. The music 'filled my soul' – as Rice would put it (1994, 1997) – and I experienced the music directly, gaining insight through the 'lived experience' (Titon, 1997, p. 87). My actions were culturally relevant and accepted by the community and I was offered the opportunity to exercise the *xeremier*'s transformative power.

Thanks to this simple gesture of trust, I became fully aware of the responsibility of the *xeremier*. It was not a simple case of playing tunes adequately; the *xeremier* had a duty to fulfil towards the people they were leading. Music became a channel that encouraged the transformation to happen. I understood the importance of being a skilled *xeremies* player – technique was only the means to an end, enabling a satisfying performance which slid to the background of consciousness as the musicians led the people through space and enhanced their experience, lifting them out of everyday life and accompanying them into a state of revelry. This experience shows how music practice was an essential element to a deeper level of intercultural communication. Had I not been able to play the bagpipes to an adequate level, I would not have been offered the experience of playing for the people and I might not have come to understand the nature of the *xeremiers*' role during celebrations.

Theorising performance and research in the field in ethnomusicological research

My fieldwork experience in Mallorca inscribed itself in a theoretical frame developed by anthropologists and ethnomusicologists over the course of the 20th century. Indeed, music research and performance should be intimately related. As early as 1909 Abraham and Hornbostel were advocating the benefits of learning the music 'to the contentment of the natives', claiming that this practice would aid the researcher to understand 'what the natives consider essential to their music – their point of view often deviates considerably from the European one' (Abraham & Hornbostel, 1909, pp. 15–16, in Cottrell, 2007, p. 86). However, performance as a research process did not become a central component of ethnomusicology until the 1950s when Hood began to teach ethnomusicology through performance – in a practice to develop deeper appreciation and understanding of what he called 'bimusicality' (Hood, 1960). Here, Hood was promoting interculturality by encouraging students to embrace other musical cultures; by acquiring new practical skills they were creating bridges between their musical background and other musical cultures. Hood set up many music ensembles at University of California, Los Angeles (UCLA), as he developed the ethnomusicology programme. Students were introduced to a variety of musical cultures and encouraged to develop new ways of approaching musical thought through practice (Howard, 2007).

Despite the shortcomings of such ensembles – such as a quick turnover of students, the inability to develop musical proficiency in such a short time and the artistic compromises imposed on the ensemble leaders (Hughes, 2004; Solís, 2004; Trimillos, 2004) – they potentially opened new worlds to the students. These ensembles inscribe themselves in the growing emphasis on participant observation techniques developed in anthropology since the beginning of the 20th century. Music practice became text and a valid method of understanding other musical cultures for ethnomusicologists and other social scientist researchers. By immersing themselves into the daily lives of the other and sharing their activities, anthropologists were more likely to establish a good rapport and thus gather better qualitative data. Since 1960, ethnomusicologists have increasingly applied performance as a methodology in the field (Hood, 1960; Shelemay, 1997; Solís, 2004). John Blacking, a trained anthropologist and ethnomusicology scholar, learned to perform in the field as a research technique but, while he remained a strong advocate for learning

music from local practitioners, he expressed the limitations of this technique and emphasised the importance of 'eliciting constructive responses from one's teachers and critics, and to have discussions with those who are experts' (Blacking, 1973, p. 215). Additionally, Blacking did not encourage his students to acquire musical proficiency as he felt that this would take up too much time and distract the student from anthropological work (Baily, 1994, 2008; Howard, 1991, 2007).

Many ethnomusicologists have experienced performance as an integral and necessary part of the research process. Rice's experience of learning the Bulgarian bagpipe helped him gain valuable insights into the processes involved with the instrument and its music. Indeed, solving the 'mystery of the bagpiper's fingers' led him to acquire a better understanding of the culture from the perspective of the insiders (Rice, 1997, p. 110). Acquiring performance skills was a key aspect to his research as he understood the learning process one had to go through in order to play adequately. By mastering the bagpipes and becoming bi-musical, Rice was bridging the cultural gap, facilitating intercultural communication and understanding. However, while Rice's experience led him to merge both fieldwork and 'fieldplay', his playing did not feed into a professional performance practice beyond what was relevant to the field and to his research (1997, p. 107). Rasmussen, too, was regarded as a legitimate researcher by the local musicians due to her ability to perform local music at the beginning of her fieldwork (Rasmussen, 2004).

However, despite the widespread use of practice-based research, ethnomusicologists tell us about their work as professional performers in the field. Professor and Lebanese musician Jihad Racy gives us some insight as to how an academic pursues such a double career. When asked in an interview why he decided to become a researcher and a musician, Racy answered that he 'had no choice; I simply wanted to do both' (Marcus & Solis, 2004, p. 158). Here, Racy is putting into simple words what is actually a complex issue in the world of ethnomusicology. It may be of consequence that his training in Arabic music began when he was a child in his country of birth, Lebanon. This adds some legitimacy to his playing, as he 'looks right' (Howard, 2007) – he can represent the culture without anybody questioning his credibility (Trimillos, 2004, pp. 33–34), fulfilling the role of the 'culture bearer' who 'embodies immediate authenticity, an insider who "culturally knows"' (Trimillos, 2004, p. 38). However, one does not always have to be from the place of origin to be seen as a culture bearer. Trimillos describes how he is respected as a Japanese *koto* player despite being from a Filipino background. His credibility stemmed from the combination of his *koto* teacher's reference, his training on the *koto*, his lectures on Japanese music approved by the Japanese community and his physical appearance, which, when in a kimono, could be mistaken for Japanese, thus leading the audience to perceive the performance as more 'authentic' (Trimillos, 2004, pp. 36–37). Here, interculturality is subjected to yet another factor: the audience. They can accept or reject the performance based on the performers' skill and how they relate to the culture they are representing.

There are similarities and differences in the above cases. While Racy's intercultural status stems from his origins and the music he learned in his native country, Trimillos is just as well received due to his expertise and knowledge in Japanese music. Additionally, Trimillos' interculturality is not only manifest through his experience of Japanese music and culture as an American with a Filipino background, but also through the approval of the Japanese community that sees him as a legitimate representative of their culture. In another example, John Baily established his performance credentials thanks to many hours of practising and playing in Afghanistan. Baily rejected Blacking's comment that one should only aim to be an 'average' practitioner. With performance in his background, when he arrived in Afghanistan he took lessons with three different teachers, establishing himself as a proficient *rubāb* player both locally and internationally (Baily, 2008). Perhaps because of his training as a psychologist, Baily introduces the concept of

'intermusability', a term that reflects the position of musicians in today's world where one can learn more than one style: '"inter" refers to more than one and "musability" is the contraction between music and ability' (Baily, 2008, p. 132).

Cottrell offers yet another perspective. As a professional saxophonist at the time of his field-work, he considered himself a 'native ethnomusicologist' (Cottrell, 2004, p. 15) and explores the advantage and disadvantage of this position. On the one hand he could call upon a lifetime of experience: he had a strong network of people to work with, he was immersed on a daily basis in the world he was studying and he had an emic understanding of its inner workings. On the other hand, Cottrell acknowledges that some aspects of the field may have been less obvious to him than to an outsider due to his familiarity with the scene. Additionally, Cottrell often found himself in a double bind because of his dual identity: despite his ongoing research, his professional performances could not suffer from distractions and he was expected to socialise normally rather than leave to write up his notes. 'Going native' is an ongoing issue in the social sciences and the subjectivity of an insider's perspective is criticised by Kluckhohn (1949) and Spradley (1979) who assert that such researchers are unable to obtain a 'fresh' view of their culture. However, in response to the postmodern turn, many scholars now agree that an insider's perspective can bring just as much insight as an outsider's, with the capacity to touch upon issues that might not have been addressed by outsider researchers (Foley, Hurtig & Levinson, 2001; Marcus, 1998).

Experiencing the field as a researcher: interculturality and identity in ethnomusicological research

According to Clifford, participant observation in the field 'obliges its practitioners to experience, at a bodily as well as an intellectual level, the vicissitudes of translation. It requires arduous language learning, some degree of direct involvement and conversation, and often a derangement of personal and cultural expectations' (Clifford, 1988, p. 24, in Solís, 2004, p. 2). Many perspectives on fieldwork in ethnomusicology are given in Barz and Cooley's (1997) edited collection but the approaches are often different. For example, for Kisluik the scholar is defined by her relationships to others in a field that changes over time as identities evolve and new experiences lead to new interpretations (1997, p. 29). Beaudry adds that one does not have to be part of the action per se and that simple social presence can be seen as a participatory act (1997, pp. 73–74). Titon explores 'new fieldwork' and sees 'experiencing and understanding music . . . as a lived experience' (Titon, 1997, p. 87). Titon views fieldwork as a journey that transforms the ethnomusicologist through their relationships and intellectual collaborations with other people. This echoes Kisluik's thoughts about the identity of the ethnographer that is shaped through the 'quality and depth of research relationships' (1997, p. 32). She found that her close friendship with her research assistant was crucial in defining herself and that the researcher's identity was further established by 'making [*themselves*] known to *them*' (Kisluik, 1997, p. 32). What emerges from these ethnomusicologists' experiences is that the researcher is well and truly embedded in the field. Indeed, fieldwork is now viewed as an 'experiential place' (Rice, 1997, p. 105) where individuals interact with each other in a cycle of relationships. Identities are created and re-examined throughout the fieldwork period (Kisluik, 1997, p. 29). One of the strongest thoughts that emerge from reflexive articles such as Kisluik's is that the anthropologist is not a separate entity but well and truly embedded in the field, bound by his or her interaction with traditions and people (Rice, 1994, p. 308).

Titon writes that we assume various roles and identities according to context (Titon, 1997, p. 95) and I also assumed several roles during my year in Mallorca. I arrived in the field

as a French student from a London university. I was ethnically an outsider in the field but musically inside: I was not Mallorcan but I understood music and was learning their music fast (cf. Rice, 1997, p. 110). Yet, rather than this being negative, my outside identity often played to my advantage. My interest in local culture and my linguistic skills (good Spanish and tentative Catalan) made me stand out from the millions of tourists who visit the island every year. The low status of an outsider is very strong and the assigned Catalan word '*forraster*', outsider or foreigner in Catalan, is generally pejorative (Waldren, 1996). Inhabitants of neighbouring villages are *forrasters*; for certain left-wing Mallorcan independentists[2] mainland Spaniards are *forrasters*, threats to local culture and language. In certain political circles foreigners from abroad carry less stigma than mainland Spaniards and are more likely to be called *estranjeros*, a more neutral term than the word *forraster*. I was considered an *estranjera* with a deep interest in local culture. Thanks to this, I was more readily accepted than other foreign newcomers among the *xeremiers*. Increasingly, as time went by, I proved I was, as bagpiper Miquel Tugores said, 'part of the club'. My status as an ethnic outsider was beneficial to my fieldwork as it guaranteed a sense of neutrality that no *xeremier* can experience due to his or her political, musical or geographical allegiances. Once my interest in bagpipes was accepted – I was often asked how I had chosen the subject – I was able to move freely among different groups in Mallorca, although making sure that I was not betraying anyone's trust. My intercultural status paradoxically gave me more freedom than a cultural insider so I could witness many more events than a local *xeremier* ever would. Loyalty to a certain village or celebration meant that musicians might never experience festivities in other villages. This, they felt, was important to my study since I could be impartial and give a voice to musicians all over the island.

The researcher's position can be considered as a performance. For a whole year I fulfilled the role I had chosen, continuously reinforcing my status as a researcher through note taking, recording and photography. My researcher identity became important both to myself and to the people I was working with. While Jackson (1989) might argue that field notes should not be taken in public and hinder fluidity in research, I found that taking notes in public helped establish my researcher identity. Despite the isolation brought on by the act of writing field notes (Barz, 1997, p. 52), I inserted myself in the community as a legitimate researcher by taking notes. People interacted with my research performance by asking how many biros I had used up, giving me photocopied articles, introducing me to people they deemed important for my study, and organising outings that would help my research. I became part of the musicians' experience with my constant questions and note taking. Communication was going both ways, establishing an intercultural dialogue as I asked questions about them and their musical practice and they responded by being curious about my researcher's practice. Unlike Barz, who was asked to put his pen down and learn orally (1997, p. 48), my identity was forged by writing notes as people rehearsed, played and talked. This research performance was embraced by Mallorcans and they came to welcome and expect it from me. After a few months in the field, some musicians invited me to conduct formal interviews with them. The simple act of holding a pen and balancing a notebook on my lap both gave me a sense of purpose and asserted my position as a researcher. Interculturality was here fully in play as I occupied the position of an approved outsider witnessing the inside. Dialogue was moving in both directions. I was observing the musicians' activities, recording them in my language and through my academic and musical understanding; they were carrying on as usual, allowing me to be among them and expecting me to represent them and their actions accurately in my work. Carrying a professional-looking camera or a Zoom recorder had the same effect – they became my instruments and helped forge my identity, legitimising my presence on the field. Like other researchers,

I occasionally found myself collecting data alongside journalists and other photographers, but my privileged position with the *xeremiers* led to personalised exchanges of information and data. Indeed, the musicians asked me several times to document a concert officially and share my photos over the social media.

Furthermore, I was given nicknames that reflected I had become an outsider on the inside. During a trip to Galicia a *xeremier* talked about me to some Galician friends, referring to me as '*nostra etnomusicologa*', our ethnomusicologist. With the possessive, the *xeremiers* both acknowledged the intercultural interaction with the outside – the ethnomusicologist – and the inside – I was 'theirs'. In another Mallorcan bagpiping circle I was nicknamed the '*Archiduquesa*', Archduchess after the Austrian Archduke Ludwig Salvator who lived in Mallorca in the second half of the 19th century. The Archduke collected information about local traditions and customs and published the documentation in nine encyclopaedic volumes called: *Die Balearen: in Wort und Bild geschildert* (Salvator, 1897). This was the first comprehensive detailing of the island's local customs and it included accounts about the use of the *xeremies*. Despite the fact that I am not an aristocrat, parallels were drawn between the Archduke – a self-made scholar, recording in minute detail everything from local architecture to the agricultural cycle and its celebrations – and myself, a foreign student interested in local culture and with the firm intention of learning all I could about the *xeremies*. By giving me this nickname, the *xeremier* was showing his respect for my work, inscribing it in the short but significant canon of publications about the island's music, informally adding me to the lineage of scholars who studied Mallorcan culture. My presence and intercultural status had been approved of and legitimised by the people I had come to work with; they strengthened my credibility and made me worthy to speak on their behalf (Solís, 2004).

Concluding remarks: researcher as performer as researcher

Although performance and musical practice were central to my research, neither was the object or the subject as I was focusing on the status of the *xeremies* in Mallorcan society rather than the music per se. Over time, however, both were essential to the research process. High-level performance was an extremely useful tool in the field just as the field then fed into later performances, infiltrating and influencing the music. The artistic process inevitably became infused with the cultural knowledge acquired in the field, both merging and creating an intercultural music shaped by the performer's voice, adding to the musician's intermusability (Baily, 2008, p. 132). Returning to my home from the field, I did not become a performer of Mallorcan bagpipes and music despite having been accepted musically by the locals. Both of these would have been frowned upon by my Mallorcan teachers. While I learned the 'proper' way in the field, once I was back in London and in a creative process, I let my inspiration run free, conscious of the rules but aware I was not following them to the letter. Indeed, over the years I have come to view my practice as a creative musician as a separate process to that of the musician in the field. Although musical and bagpipe skills were essential to my status and identity in the field, distancing myself from the arts practitioner/researcher role once back 'home' meant that I could develop an artistic creativity without being overly concerned about stylistic rules learned in the field. While I respected these, I then chose to adapt the music to serve personal aesthetics elaborated over the years. This, in a way, can be viewed as the fusion of Mallorcan music with my personal intercultural musical practice or, as Baily would have it, my intermusability.

Although performance is a central part of my identity, both as a musician and a researcher, this conscious divide enables a wider range of creativity relatively free from the theoretical concerns of ethnomusicology (such as authenticity). This division between performance and academic research might seem slightly schizophrenic, but it is one way of coping with the strict

requirements of ethnomusicology and its limitations or even nostalgia for the past (Howard, 2007, p. 174) and the constant recreation an artist goes through, influenced by new sounds, the music industry and his or her own creative ideas which might seem traitorous to an eth-nomusicologist. Instead of being incompatible, I regard both worlds as complementary as they constantly interact. This leads me full circle. An integral part of the field, the ethnomusicologists' presence inevitably influences relationships around him or her, creating 'awareness within the community' (Shelemay, 1997, p. 200). As an intercultural performer, he or she interacts in yet a different dimension, impacting through musical exchanges and verbal discussions the field. The ethnomusicologist inevitably changes the field. Maybe, as an external influence, this should be regarded as a natural process of human exchange and communication, leading to new ideas and collaboration, forging what will become the future field.

Notes

1 See Artigues (2000) for a short introduction on Mallorcan musical style.
2 Mallorcan independentists belong to left-wing independence parties which support the separation of Catalonia and the Balearic islands from the Spanish nation.

References

Abraham, O., & Hornbostel, E. (1909). Voschläge fur die Transkription exotischer Melodien. *Sammelbänder der Internationalen Musikgesellschaft, 11*(1), 1–25.

Artigues, A. (2000). *Xeremies, El sac de gemecs catala de Mallorca*. Palma: Edicions Cort.

Baily, J. (1994). *John Blacking: Dialogue with the ancestors* (John Blacking Memorial Lecture 1991). London: Goldsmiths College.

Baily, J. (2008). Ethnomusicology, intermusability, and performance practice. In H. Stobart (Ed.), *The new (ethno)musicologies* (pp. 117–134). Lanham, MD: The Scarecrow Press.

Barz, G. (1997). Confronting the field(note) in and out of the field: Music, voices, text, and experiences in dialogue. In G. F. Barz & T. Cooley (Eds.), *Shadows in the field: New perspectives for fieldwork in ethnomusicology* (pp. 45–62). New York: Oxford University Press.

Barz, G., & Cooley, T. (Eds.). (1997). *Shadows in the field: New perspectives for fieldwork in ethnomusicology*. New York, NY: Oxford University Press.

Beaudry, N. (1997). The challenges of human relations in ethnographic enquiry: Examples from Arctic and Subarctic fieldwork. In G. F. Barz & T. Cooley (Eds.), *Shadows in the field: New perspectives for fieldwork in ethnomusicology* (pp. 63–86). New York, NY: Oxford University Press.

Blacking, J. (1973). *How musical is man?* Seattle, WA: University of Washington Press.

Cooley, T. (1997). Casting shadows in the field: An introduction. In G. F. Barz & T. Cooley (Eds.), *Shadows in the field: New perspectives for fieldwork in ethnomusicology* (pp. 3–22). New York, NY: Oxford University Press

Cottrell, S. (2004). *Professional music-making in London: Ethnography and experience* (SOAS Musicology Series). Aldershot: Ashgate.

Cottrell, S. (2007). Local bimusicality among London's freelance musicians. *Ethnomusicology, 51*(1), 85–105.

Euba, A., & Kimberlin, C. T. (1995). *Intercultural music 1*. Bayreuth: Bayreuth University.

Foley, D., Hurtig, J., & Levinson, B. (2000). Anthropology goes inside: The new educational ethnography of ethnicity and gender. *Review of Research in Education, 25*, 37–98.

Hood, M. (1960). The challenge of 'bi-musicality'. *Ethnomusicology, 4*(1), 55–59.

Howard, K. (1991). Un homme musical: Entretien avec John Blacking. *Cahiers de Musiques Traditionelles, 3*, 187–204.

Howard, K. (2007). Performing ethnomusicology: Exploring how teaching performance undermines the ethnomusicologist within university music training. In N. Kors (Ed.), *Musike 3: Networks and islands* (pp. 25–32). Den Haag: Semar Publishers.

Hughes, D. (2004). When can we improvise? The place of creativity in academic world music perfor-mance. In T. Solís (Ed.), *Performing ethnomusicology: Teaching and representation in world music ensembles* (pp. 261–282). Los Angeles, CA: University of California Press.

Jackson, M. (1979). *Paths toward a clearing: Radical empiricism and ethnographic enquiry.* Bloomington and Indianapolis: Indiana University Press.

Kisluik, M. (1997). (Un)doing fieldwork: Sharing songs, sharing lives. In G. F. Barz & T. Cooley (Eds.), *Shadows in the field: New perspectives for fieldwork in ethnomusicology* (pp. 23–44). New York, NY: Oxford University Press.

Kluckhohn, C. (1949). *Mirror for man.* New York: Whittlesey House.

Marcus, G. (1998). *Ethnography through thick and thin.* Princeton, NJ: Princeton University Press.

Marcus, S., & Solís, T. (2004). 'Can't help but speak, can't help but play': Dual disclosure in Arab music pedagogy. In T. Solís (Ed.), *Performing ethnomusicology: Teaching and representation in world music ensembles* (pp. 155–167). Los Angeles, CA: University of California Press.

Rasmussen, A. (2004). Bilateral negotiations in bimusicality: Insiders, outsiders, and the 'real version' in Middle Eastern music performance. In T. Solís (Ed.), *Performing ethnomusicology: Teaching and representation in world music ensembles* (pp. 215–228). Los Angeles, CA: University of California Press.

Rice, T. (1994). *May it fill your soul: Experiencing Bulgarian music.* Cambridge: Cambridge University Press.

Rice, T. (1997). Toward a mediation of field methods and field experience in ethnomusicology. In G. F. Barz & T. Cooley (Eds.), *Shadows in the field: New perspectives for fieldwork in ethnomusicology* (pp. 101–120). New York, NY: Oxford University Press.

Salvator, L. (1897). *Die Balearen, In Wort und Bild geshildert.* Leipzig: Brockhaus.

Shelemay, K. (1997). The ethnomusicologist, ethnographic method and the transmission of tradition. In G. F. Barz & T. Cooley (Eds.), *Shadows in the field: New perspectives for fieldwork in ethnomusicology* (pp. 189–204). New York, NY: Oxford University Press.

Solís, T. (Ed.). (2004). *Performing ethnomusicology: Teaching and representation in world music ensembles.* Los Angeles, CA: University of California Press.

Spradley, J. P. (1979). *The ethnographic interview.* United States: Wadsworth Group, Thomas Learning.

Titon, J. T. (1997). Knowing fieldwork. In G. F. Barz & T. Cooley (Eds.), *Shadows in the field: New perspectives for fieldwork in ethnomusicology* (pp. 87–100). New York, NY: Oxford University Press.

Trimillos, R. D. (2004). Subject, object, and the ethnomusicology ensemble: The ethnomusicologist 'we' and 'them'. In T. Solís (Ed.), *Performing ethnomusicology: Teaching and representation in world music ensembles* (pp. 23–52). Los Angeles, CA: University of California Press.

Waldren, J. (1996). *Insiders and outsiders, paradise and reality in Mallorca.* Providence, RI: Berghahn Books.

PART II

Practice

13

CONFORMING THE BODY, CULTIVATING INDIVIDUALITY

Intercultural understandings of Japanese *noh*

Koji Matsunobu

This chapter is concerned with understanding the nature of embodied learning of Japanese *noh* performance and its nature as an intercultural art. *Noh* is one of the traditional forms of musical drama in Japan. Deriving from the 13th century and developed throughout the samurai sovereignty, it portrays and expresses medieval Japanese aesthetics and religious worldviews. What distinguishes *noh* from other types of theatrical and musical performances in Japan is its inheritance of the medieval values: For instance, actors and musicians rehearse together only once on the day of performance. Sometimes there is no rehearsal at all. Performers are expected to embody and fully memorize every part of the play and respond to any change on the spot. They believe rehearsing many times devalues the idea of "*ichigo-ichie*," or one chance, one meeting, proposed by Sen no Rikyu (1522–1591). This indigenous notion—often emphasized and practiced in the tea ceremony—suggests each encounter in life is precious, and so much so that it will not happen again. It suggests that we must appreciate each moment as if it is the only chance to enjoy it.

In recent years, Japanese *noh* has been performed and appreciated outside Japan, and newly composed English *noh* pieces are attracting a wider audience. *Noh* is also included in the arts curriculum outside of Japan, such as in Singapore (Costes-Onishi, 2013; Rajendran, 2013). Nakanishi (2014) reports that *noh* is studied at the National School of the Arts in Singapore, highlighting the link between the *noh* curriculum and the Suzuki training method. The latter is based on the pedagogy of *kata*, literally meaning "form," "pattern," or "mold." *Kata* exists in Japanese performing and martial arts. It is a set of highly stylized physical movements that have been developed and preserved by precedent artists. *Kata* is the basis for the development of modern approaches to the arts, such as the Suzuki violin method (Murao, 2003). The intercultural nature of *kata* has been discussed by scholars working in intercultural contexts from such perspectives as embodiment theory (Powell, 2012), spirit bonding and liberation (Kato, 2004; Matsunobu, 2011b), the source of authenticity (Keister, 2004), non-verbal pedagogy (Ikuta, 1987), and the form–content dualism (Yano, 2002). Drawing on the pedagogy of *kata* through the case of *noh* performing arts, this chapter reveals an intercultural art practice that is seen as continually evolving, constructed, and dynamic.

Drawing on its aesthetic value and pedagogy, I explore the pedagogy and location of *noh* practice in today's society. What are the characteristics of embodied learning in *noh* practice? How does the pedagogy of imitation and repetition (Matsunobu, 2011b) apply to *noh* training?

What is the nature of pedagogy pertaining to each place of practice and learning? What is the intercultural nature of *noh*? In order to explore these questions, three settings are chosen for inquiry: the traditional context of *noh* learning at a teacher's lesson place (called *okeikoba*); a teacher education program at the tertiary level; and schools in Japan. Keister (2008) argues that traditional Japanese arts are now learned outside what are considered to be traditional contexts, such as schools, universities, community centres, and cultural centres. Each venue provides a unique pedagogy and serves as a "place" for knowledge transmission. This report is based on systematic observations of multiple learning places.

Into the field

I was a relative outsider to the field of *noh* practice. Trained as a musician, I had performed and researched western and Japanese music. *Shakuhachi* music and practice has been a window for me to understand intercultural perspectives and contexts of practice in which North American and Japanese players negotiated their values, musical senses, and pedagogies (Matsunobu, 2011a, 2012). However, my expertise in *shakuhachi* music was not easily transferable to the present inquiry, as in the Japanese context, the worlds of *shakuhachi* and of *noh* art do not cross. As is often the case with Japanese music, the cultural system of music is genre specific. The notation system, for instance, is unique to each genre, instrument, and school. *Gagaku* court music is written down on its own terms, and its notation shows very little in common compared to, for instance, that of *koto* music. The notation for *noh* singing is significantly different from that of the *noh* flute called *nokan*. For many *shakuhachi* players trained in the *tozan* school, reading sheet music written in the style of the *kinko* school is often challenging. The same holds true for other aspects of music practice, such as the places of practice and the repertoire.[1]

To embark on this project, I started my *noh* training in the *kita ryū* (school), one of five *shite* performing groups. In *noh* drama, the main character is performed by an actor called "*shite.*" The *shite* often acts as a deity, demon, spirit, old man and woman, with or without a mask. The secondary character, called *waki*, plays roles such as a monk and priest, with no mask. Whereas *waki* roles are always humans, the *shite* act as a living person as well as supernatural beings, and often shift from one form to another, beyond space and time. Both *shite* and *waki* actors sing and dance. *Noh* learners typically learn *shite* performances through singing and dancing.

As I began my study, I discovered many aspects of *noh* singing and acting that are liberating compared to other forms of art. Among the many surprises I experienced with my *noh* training was that there is no predetermined, fixed pitches for singers (in the *shite* roles). Each person sings on a pitch that is most comfortable to him or her. In the lesson context, the teacher sings on his own pitch. The student follows the teacher. But the student does not have to sing in the same pitch as the teacher. Singing pitches are not determined by the accompanying instruments either because the function of these instruments is to add a percussive effect to the music rather than a series of notes on specific pitches to form a melody.[2] Referring to this aspect, my teacher likes to say, "*noh* singing is warm and inviting, isn't it?" This liberating aspect seemed to appeal to many people, in particular those who came from western music backgrounds, like me.

Although *noh* training in the traditional path is an enduring process, *noh* is not only for dedicated practitioners but open to a variety of people. As in other forms of Japanese arts, a late start in *noh* learning is commonly observed. Many begin *noh* lessons at different stages of life: they rarely begin at school, but start rather in college, after getting married, or during retirement. Apart from some exceptions (such as those born into the iemoto families in which the transmission of artistry and authority is patrimonial), lay people come late into arts learning. Like other forms of Japanese arts, *noh* practice can be a form of self-cultivation rather than that of

entertainment. In these forms of artistic practice, the goal is to engage in life and make it a part of everyday experience towards spiritual maturity (Keister, 2005).

Although most professional *noh* players and actors are men, this is not the case with students and amateur performers. The learning community is open to both male and female students. This holds true in other forms of Japanese arts such as tea ceremonies and flower arrangements. Given this androcentric hierarchy of Japanese arts, some scholars reported that female practitioners who pursue the course of study with no professional aspirations—the main body of hobbyists in today's "lesson culture" (Moriya, 1994)—find participation in the traditional forms of community arts (e.g., Kato, 2004; Mayuzumi, 2006). This observation applies to *noh*. *Noh* is also open to foreigners. Although the number of such practitioners is small and they are mostly westerners, they not only enjoy watching *noh* performances but also engage in training, just as the Japanese practitioners do. A Russian practitioner I interviewed said that the language was not so much of a problem in the initial process of learning as she did not have to understand the meaning of lyrics. She found *noh* singing more like chanting than singing in that it is a mixture of patterns. As a student of Japanese language, she was able to follow the teacher's singing. It was in a later stage that she needed to cope with the understanding of the language from the medieval era, a challenge also experienced by native Japanese practitioners.

The allure of *noh* as an intercultural practice comes in part from its emphasis on tradition, its long history and refined aesthetic forms; for tradition can be a source of authenticity for foreign practitioners (Matsunobu, 2011a). At the same time, just as many forms of traditional music have been recategorized and "discovered" as new genres or practices (e.g., *shakuhachi* as "world music" rather than "folk music"), *noh* is perceived and experienced as a creative art by modern practitioners with little exposure to the tradition. For them *noh* is a "cool" hobby rather than the pursuit of *wabi-sabi* (ageing) quality. Although the language can be a hindrance for wider participation in *noh*, its emphasis on embodiment and its avoidance of mind-centredness and individuality, as discussed below, make it more accessible to others. As *noh* meets non-traditional learning sites, students, venues, and purposes, it takes on the nature of an intercultural art.

Vignette: the first lesson

Yamamoto-san, a female student with ten years' experience in studying *noh*, went on the stage to learn a new *oshimai* (an excerpt of a piece with dance movements). She stood behind the teacher. Each held a fan in the right hand. She sat with her knee on the floor. The teacher, waiting up to this point, turned back to her briefly and confirmed that she was ready. They started singing the first line of the accompanying song together. After the first line, she stood up and started following the teacher, moving her legs, arms, and the fan in the same manner as the teacher. After the first line, she focused on moving without singing. The teacher demonstrated the entire cycle of movements until the end, which took about five minutes. Yamamoto-san followed him. The teacher repeated this cycle three times with no interruption and very little explicit verbal explanation. Yamamoto-san followed him each time. She was expected to learn and embody a series of movements by following the teacher. Observing several lessons of other students, I could not help but wonder how they remembered the series of movements just by imitating the teacher on the spot. They did not depend on choreography or video recordings. When it was my turn, the teacher said, "Please follow me." As expected, I was completely lost in a few seconds.

As a beginning student, I had asked some experienced students how they practiced and remembered the movements. They responded that the initial process was very hard; however,

after learning a few pieces they began to see patterns of movements. Later, I noticed that the teacher sometimes addressed names of certain movements, such as *shikake*, *hiraki*, and *shitome*, during the dance lesson. These are the names of basic movements in *noh* dance, or what can be referred to as *kata*. As defined earlier, *kata* is a set of basic movements unique to each school and genre. For instance, *shikake* refers to a set of actions involving raising the right hand while making four steps starting with the left leg. *Noh* dance is a series of set movements. *Yūya*, the first piece that students normally learn in the *kita* school, consists of 13 sets. There are believed to be 47 total basic movements, and combinations of these movements create a variety of dance movements suited for the nuances of scenes and the expressions of songs. A teacher explained:

> When demonstrating an *oshimai*, we often address the names of *kata* so that the students would memorize them. A beginning student is occupied with just moving. As you get used to it, you naturally associate the name of a *kata* to its movement. Upon hearing "*shikake*," your left leg naturally steps forward and your right hand goes up. Each movement is not that complicated. Once you get used to these patterns, you will be able to dance. It takes 6 or 7 pieces for a student to reach this level.
>
> *(Personal communication, October 2, 2014)*

Gifu-san, an experienced student who has been practicing *noh* for over 20 years, used a metaphor to explicate her view of *noh* dance. She observed that *noh* dance is like a train with a series of cars. Each car has a different colour and shape. "If you are a beginner, you won't see the details of each car but feel as if the entire piece is like a long train with no connections between the cars" (personal communication, September 21, 2014). She also added that *noh* dance students are often too occupied with each movement and lacking a sense of the flow of the movements. Thus, she believes that a set of movements should not be learned individually but in *sequence*, a point also made by Nakanishi (2010). This is probably the reason why my teacher as well as other teachers taught the entire cycle of a dance piece in sequence while singing. They did not focus on individual *kata* movements. They taught parts in the flow of movements. Gifu-san observed that the individuality of each performer manifests itself in the ways they fashion the "joints of the cars" (connections of the movements), a critical point for a dance to flow, and the expression of each car.

As the vignette above indicates, the student of *noh* dance attentively has to observe how the teacher steps and moves his legs, toes, hands, and the *ougi* (a fan) by following him from behind. I found this process very demanding; so did other beginning students. I could not recognize each set of movements, or *kata*, in sequence. It was not until I joined a four-day workshop tailored to school children that I finally understood divisions of the individual sets of movements. In this workshop, a teacher taught each movement by holding students' hands and leading their steps. Since only four *kata* movements were introduced in this workshop, it was easy for beginners to focus on each movement. The teacher constantly reminded them of each movement in words. This step-by-step approach was observed, however, only in this workshop setting, and never at the lesson place. This indicates that the pedagogy of *noh* is not fixed. It responds to a variety of needs and practices of each place, which in turn creates a space for intercultural experiences and embodied knowledge.

In the same four-day workshop, the school students studied *takasago*, a piece often included in school music textbooks, with dance movements. While *takasago* in the original format is sung with no dance, the teacher's improvisations added the dance part to let the students experience simultaneous singing and dancing. This transformation was a result of the recontextualization of traditional forms of expression (Schippers, 2010). As *noh* is recontextualized and practiced in

each place, it allows for a new form of practice and pedagogy to develop, asking for redefinition of the authenticity of *noh* expression and impression.

Pedagogy of *kata*

One feature of *noh* dance is the evidence of *kata*. Each set of movements, such as *shikake, hiraki*, and *shitome* is a *kata*. As introduced above, I suggest that *kata* is the basis upon which Japanese performing arts can be conceived as intercultural practices and mechanisms for the transmission of embodied knowledge. The difference between *kata* and what we are familiar with as "form" (called *katachi*) is that the former is a content-attendant, embodied, habitual, contextualized, and value-laden form, whereas the latter is an abstract and empty form. Yano (2002) observes that the western dualism between form and content, each of which traditionally corresponds to the false and the true, dissolves into continuous and interpenetrating parts in the theory of *kata*. *Kata* is content attendant upon form. The creative goal of *kata*-training is "to fuse the individual to the form so that the individual becomes the form and the form becomes the individual" (Yano, 2002, p. 26). *Kata* exists in *judo, kendo, aikido, sado* (tea ceremony), *kabuki* acting, as well as in *noh* theatre performance. In these performing and martial arts, the emphasis of practice is placed more on the embodiment of basic forms than the promotion of individual expressions. George Fuchs in Pronko (1968, pp. 150–151) explicates:

> The Japanese art of acting is indebted for this supremacy of style to its vital connection with fundamental principles, that is, with the elementary physical sources of mimic art. These principles are identical with those of the dance, of acrobatics, of wrestling, and of fencing.

A series of highly stylized and formal body movements is formulated in every art form. In *kabuki* acting, the actor does not try to create or recreate an expression or feeling as it arises in actuality; rather he reduces it to its barest essentials. "What is important is that the actors re-create and execute the proper physical and vocal mannerisms conventionalized by the Kabuki style" (Turse, 2003, p. 7). The purpose of mimicking the model is to embody it as one's second nature. In *sado*, practitioners repeat patterned behaviours until these become their own natural expressions. In *judo*, practitioners repeat the patterns of throwing their opponents to the extent that they can apply these patterns as an automatic response in a real situation. When this is achieved, "they are no longer imitating but creating because the throw is now theirs, and not merely a pattern they have borrowed from another practitioner" (Turse, 2003). The reason *noh* teachers emphasize *kata* is that each body differs to a great extent. One naturally develops an idiosyncratic, individual "habit," acquired through the course of learning. This is called *kuse* in Japanese. Often, the student habituates the body to the task in a way that feels most comfortable to him or her. When individual rendition is not yet polished, it is not called individuality but individually acquired habits. In *kata*-based learning, any kind of personalization before the *kata* becomes one's natural habit is not considered genuine learning. Individuality naturally emanates from each person's acting because each body is different.

Kata is a medium for not only the mastery of the aesthetic dimension of artistry but also the social dimension as *kata* involves the body as an agent of social interaction. The social aspect of *kata* was evident, for example, when the primary school children in schools learned the manner of bowing and using the fan: before and after each lesson, the teacher encouraged them to put the fan in front of them and bow to the teacher. The students say "*yoroshiku onegaishimasu*" (thank you for your help in advance[3]) at the beginning of the lesson and "*arigatou gozaimashita*"

(thank you very much) at the end. This formalized process was also observed across the lesson locations, though the extent of formalization varied from teacher to teacher. Normally, they did not reinforce this moral aspect to adult students.

Formal patterns of behaviour on stage are also considered *kata*. For instance, a series of formulaic actions expected of *jiutai* singers (a choir formed by the *shite* group) on stage is executed as follows. While sitting, they put the fans right next to them on the floor. Then, they bring the fans to their front just before singing, and they sing while holding the fans. When they leave the stage, they reverse these actions. Before leaving, they all turn right and stand on their right legs. Then, they leave one after another.[4] As suggested by Keister (2004), Hahn (2007), and Kikkawa (1984), through the embodiment of a series of *kata*, students are expected to master structures of art, patterns of artistic and social behaviours, and moral and ethical values. This means that learning artistry has to be achieved through a variety of channels.

Kata defines what is appropriate and provides a model. It also restricts students' individuality and creativity for the sake of accommodating the body to the model. Although this aspect of *kata* learning may look rigid, *kata* also allows for wider application and participation in performing arts, with its emphasis on content-attendant, embodied art forms. Another aspect of *kata* is its non-verbal orientation.

Non-verbal orientation

In the beginning of my study, I was made aware of a particular point highlighted by specialists of Japanese arts regarding the use of verbal instruction. Hare (1998) observes that verbal instruction and understanding are intentionally avoided in *noh* lessons as they may distract from a whole-body grasp of artistry. Keister (2004) notes that "with training based on *kata*, there is no artistic content for the performer to cognitively 'grasp,' but instead a surface aesthetic that 'grasps' or transforms the performer, shaping the artist into the form of the art itself" (p. 103).

Aspects of non-verbal teaching and non-conceptual understanding were most evident in *noh* singing during my workshops. Most teachers and students used song books that provided two kinds of information: the lyrics and markers for rhythm and intonations. The latter are presented in the number and shapes of dots put next to each word. There may be small characters around the dots to indicate specific pitch movements. Understanding the beat is relatively easy; reading the signs for intonation and pitch movements is much harder. My teacher, when teaching his lesson, did not explain how to read these signs. His idea is that students should learn music by ear first and understand what each sign means later, which was how he had learned *noh* singing. Young students under the direct tutelage of *noh* masters typically embody the art of *noh* singing before understanding the notation system.[5] One day I asked a senior student to teach me how to read and sing a specific sign. She responded, "I now understand most of these signs as I have been doing this for ten years. It took ten years. Our teacher doesn't teach this stuff explicitly. Our teacher believes learning by ear is the best."

This was not the case, however, with his teaching in the university context. At a two-day intensive seminar for teacher education students, the teacher spent more than an hour explaining this complicated notation system. Realizing this teaching difference, I went back to his lesson place, or *okeikoba*, and asked him about a specific way of counting the beat in a piece. He explained why certain syllables had extended notes and irregular rhythmic patterns while others did not. A peer student with ten years of experience then remarked, "I've never heard of such things!" The teacher responded, "We don't talk about such things during lessons. We let students follow and sing after us. Later, they understand theoretical parts. If you remember by *atama* (the head), you won't be able to sing. You will only forget." It took ten years for

this student to finally "conceptually" understand this specific rule of reading notation. This suggested that mind–centred interpretation and understanding is intentionally avoided in the process of *noh* learning. Instead, imitation of the model and repeated practice was celebrated.

Here, the notion of "interpretation" needs a careful examination. A *noh* teacher I interviewed specifically referred to the issue of interpretation. She observed:

> There is room for interpretation in *noh* acting. The acts of looking at the moon and of looking at the water on the pond should be differentiated. You imagine how each comes about in your acting. But it is not your own interpretation. As you follow your teacher, it naturally comes out. It is based on the mastery of an appropriate *kata*. You learn by the body. It is not coming from the head.

Interpretation in the arts often involves digging out hidden meanings inherent in the works of art and devising ways to construct one's own unique expression. The notion of interpretation as an individual rendition of otherwise formulaic performance runs counter to the idea of an expression naturally out of the trained body. In this context, individuality develops from an embodied apprehension of the form rather than from analytical interpretation. This is why *noh* teachers do not emphasize interpretive activities in teaching *noh* singing and dancing. *Kata* underscores embodiment of *noh* as intercultural practice.

Coda

This chapter addressed pedagogical issues involved in the learning process of *noh* dancing and singing. They offer implications to the intercultural practice of the arts. Among them, Zeami's suggestion that students should not copy the *yū* (or *katachi*) but embody the *tai* (or *kata*) of acting deserves our attention. Zeami emphasized that when the role is embodied physically, the character naturally takes on the personality. Expression is not necessarily an act of objectifying one's emotion or realizing one's inner life but a matter of physical imitation. *Noh* performer Hisao Kanze once said, "To convey true expression we wear masks" (in Takemitsu, 1995, p. 58) to suggest that facial expression of emotion is not of central importance in *noh* acting.

In today's context of formal education, educators tend to emphasize *yū* over *tai*, *katachi* over *kata*, interpretation over embodiment, and individuality over imitation. The *noh* pedagogy suggests a different path. It helps us clarify the role of imitation and embodiment as a pedagogy that fosters individuality. It builds individual expressions on the tradition. With no base of the tradition, the result will not be truly individual. Often, we tend to think that emphasizing imitation of a model is against our goal of developing students' individuality. We too often misunderstand and forget that imitation is a "medium" of mastering the artistry, not the goal. *Noh* training is never aimed at standardization of expressions. Interestingly, a significant number of *noh* practitioners, when asked about their views of what makes *noh* most interesting to them, responded simply, "individuality." They said, "You see individuality very clearly in *noh* performance." A master in the *kanze* school stated, "You often hear in education that individuality is important. That's because kids are pushed to do so without a right path. In *noh*, they learn the right path to be individual."

The study of *noh* facilitates an intercultural understanding of performing arts through its emphasis on *kata*, or embodied form, and related perspectives on individuality, creativity, expression, interpretation, and form/content dualism. The underlying pedagogy of Asian arts may provide a similar insight as they often take a similar shape. Calligraphy is a form of art that requires imitation of a model in order to cultivate individuality. The Japanese performing arts

and martial arts take the form of *dō* (as in *aikidō*, *judō*, and *kendō*), a path of self-cultivation, with a series of ideal models to embody. These arts are practiced in ways to enhance one's personality through achieving mind–body oneness (Yuasa, 1987). Liberating aspects of these art forms may be examined further to enrich our discussion of intercultural arts.

This chapter is an attempt to bring an embodied understanding to the concept of interculturality through a cultural practice that is fused onto the body via *kata*. A cultural practice that is continually evolving and open for "recontextualization" (Schippers, 2010). Just as culture is like a malleable creature such as an octopus rather than a fixed object (Schweder, 1991), a cultural practice is also in a fluid state. As discussed above, *noh* is now practiced in different sites than its original context. Each place invites participation of wider community and audience. The existence and interaction of these multiple learning places contribute to the creation of an intercultural space for *noh* experience. Moving from one place to another allows for experiencing such a cultural practice as a process of translation.

Notes

1 This may suggest two warnings for fieldworkers. First, specialists of one genre of Japanese music are not usually versed in other genres of Japanese music. Second, it is difficult for an outsider to understand the cultural practice of a specific genre of music, as its system is unique to a specific group, and only so much can be identified as the common ground for aesthetic understanding.

2 These four accompanying instruments are the *kotsuzumi* (a shoulder drum), *otsuzumi* (a hip drum), *taiko* (a stick drum), and the *nokan* flute. Even the *nokan* is considered as providing a percussive effect rather than a melody.

3 The phrase *yoroshiku onegaishimasu* can be translated several ways, one of which is "I humbly ask you to be kind to me and take good care of me." This phrase is often used before people begin something together. The teacher may respond by bowing (not as deep as the student does) and saying the same phrase as a sign of acceptance.

4 A set of actions expected of *jiutai* singers vary from school to school. For instance, singers in the *kita* school hold the fans on their laps while singing; in other schools, the way of holding the fan is not the same.

5 There are differences of degree to which teachers underscore the importance of note reading. Some teachers teach them upfront when students take the first lesson, others do not.

References

Costes-Onishi, P. (2013). Pedagogical issues in multicultural education: An autoethnography of the challenges in delivering "A" levels non-western music curriculum in Singapore schools. In C. H. Lum (Ed.), *Contextualized practices in arts education: An international dialogue on Singapore* (pp. 281–300). Singapore: Springer.

Hahn, T. (2007). *Sensational knowledge: Embodying culture through Japanese dance*. Middletown, CT: Wesleyan University Press.

Hare, T. (1998). Try, try again: Training in noh drama. In T. P. Rohlen & G. K. LeTendre (Eds.) *Teaching and learning in Japan* (pp. 323–344). Cambridge: Cambridge University Press.

Ikuta, K. (1987). *Waza kara shiru* [Knowing through waza artistry]. Tokyo: Tokyo Daigaku Shuppankai.

Kato, E. (2004). *The tea ceremony and women's empowerment in modern Japan: Bodies re-presenting the past*. London: Routledge.

Keister, J. (2004). The shakuhachi as spiritual tool: A Japanese Buddhist instrument in the West. *Asian Music, 35*(2), 99–131.

Keister, J. (2005). Seeking authentic experience: Spirituality in the Western appropriation of Asian music. *The World of Music, 47*(3), 35–53.

Keister, J. (2008). Okeikoba: Lesson places as sites for negotiating tradition in Japanese music, *Ethnomusicology, 52*(2), 239–269.

Kikkawa, E. (1984). *Nihon ongaku no biteki kenkyu* [The aesthetics of Japanese music]. Tokyo: Ongaku no Tomosha.

Matsunobu, K. (2011a). Spirituality as a universal experience of music: A case study of north Americans' approaches to Japanese music. *Journal of Research in Music Education, 59*(3), 273–289.

Matsunobu, K. (2011b). Creativity of formulaic learning: Pedagogy of imitation and repetition. In J. Sefton-Green, P. Thomson, L. Bresler, & K. Jones (Eds.), *Routledge international handbook of research on creative learning* (pp. 45–53). New York: Routledge.

Matsunobu, K. (2012). The role of spirituality in learning music: A case of North American students of Japanese music. *British Journal of Music Education, 29*(2), 181–192.

Mayuzumi, K. (2006). Tea ceremony as a decolonizing epistemology: Healing and Japanese women. *Journal of Transformative Education, 4*(1), 8–26.

Moriya, T. (1994). "The lesson culture" (M. Eguchi, Trans.). In A. Ueda (Ed.), *The electric geisha: Exploring Japanese popular culture* (pp. 43–50). New York: Kodansha International.

Murao, T. (2003). Suzuki mesodo "kira kira boshi hensokyoku" ni miru "kata kara no gakushu" ni tsuite [Learning through *kata* in Twinkle, Twinkle, Little Star Variations in the Suzuki violin method]. *Gendai no esupuri, 428*, 165–175.

Nakanishi, S. (2010). Learning skill in noh: Focusing on the process of "flow" arising. *Journal of Hokkaido University of Education at Kushiro, 42*, 163–171.

Nakanishi, S. (2014). Singapore no SOTA ni okeru geijutu kyoiku: Engeki course no jugyo ni chakumoku shite [Arts education at SOTA in Singapore]. *Japanese Journal of Music Education Research, 42*(2), 110.

Powell, K. A. (2012). Pedagogy of embodiment: The aesthetic practice of holistic education in a taiko drumming ensemble. In L. Campbell & S. Simmons (Eds.), *The heart of art education* (pp. 113–123). Reston, VA: The National Art Educators Association.

Pronko, L. C. (1968). *Theatre: East and West*. Berkeley: University of California Press.

Rajendran, C. (2013). Brief encounters with traditional theatre forms: In critical dialogue with the contemporary. In C. H. Lum (Ed.), *Contextualized practices in arts education: An international dialogue on Singapore* (pp. 341–357). Singapore: Springer.

Schippers, H. (2010). *Facing the music: Shaping music education from a global perspective*. New York: Oxford University Press.

Schweder, R. A. (1991). *Cultural psychology: Thinking through cultures*. Cambridge, MA: Harvard University Press.

Takemitsu, T. (1995). *Confronting silence: Selected writings* (Y. Kakudo & G. Glasow, Trans.). Berkeley, CA: Fallen Leaf Press.

Turse, P. (2003). Martial arts and acting arts. *Journal of Theatrical Combatives*. Retrieved from http://ejmas.com/jtc/jtcart_turse_0503.htm.

Yano, C. R. (2002). *Tears of longing: Nostalgia and the nation in Japanese popular song*. Cambridge, MA: Harvard University Asia Center.

Yuasa, Y. (1987). *The body: Toward an Eastern mind-body theory*. Albany: State University of New York Press.

Zeami. (1984). *On the art of the nō drama: The major treatises of Zeami* (T. Rimer & M. Yamazaki, Trans.). Princeton, NJ: Princeton University Press.

14

AN INTERCULTURAL CURRICULUM

Where schooling the world meets local ecologies

Trevor Wiggins

Introduction

Concerns for the cultural content of the whole school curriculum have been an ongoing debate for at least the last 40 years. Efforts at a 'multicultural' curriculum in music in the 1980s were frequently criticised from opposing viewpoints; seen as both insufficiently valuing the 'home' culture and failing to pass on its values, while doing violence to the culture of others through representing them in ways so limited as to be tokenist and sometimes using poor quality materials. Educators have frequently been caught between the proverbial rock and a hard place in being required by governments (of every persuasion and hue) to improve the standards of education as reported in international tables of excellence based on exam performance, pass on the 'home' culture emphasising the essential commitment to values of good citizenship, and prepare children for a role in the global economy and culture. Through technology, the world view characterised as 'cosmopolitanism' (e.g., Breckenridge, Pollock, Bhabha, & Chakrabarty, 2002) is no longer available only to a small group of people. Although a child might still be physically located in one place, some boundaries of the world that he or she inhabits and constructs have disappeared as the world is accessed through cell phones and tablet computers, so the child may become the traveller that James Clifford describes (1997, p. 36), perhaps struggling to identify some elements of what is 'home'. One of my areas of research interest is the often slippery connection between theoretical constructs for delivering a balanced, culturally empowering education (multicultural education, cultural diversity, or intercultural education being three such), and the lived experience of children in different contexts. While the theories may apply to many aspects of the curriculum, they are often most sharply focused in areas of the arts where there is considered to be a 'tradition' that should be continued. Music and dance are most often associated with community rituals that are the embodiment of culture. While there are very few societies that can truly claim to be mono-cultural in the sense of there being no external influences, I consider that intercultural elements have become more common across all societies in the last 20 years, bringing into sharper focus questions of belonging to a culture and owning cultural artefacts.

Schooling the world

Carol Black directed the film *Schooling the World* (2010) using material shot mostly in the Himalayan foothills, India and the USA. It contrasts educational practices in several locations and interrogates the notion that these are the best preparation for life in that society, offering a critique of the perceived values of that society. The film argues that the concept of 'schooling' and the institution of 'school' are inseparable from a colonial attitude towards other people, and that the aims of organisations like the World Bank in promoting universal education are, in fact, undermining traditional societies and forcing them to conform to a norm of corporate business dominated by western capitalism. The main argument in the film is that traditional cultures know about their own specific climate, soil, water, but once they have been educated in 'modern' schools, they literally do not know how to survive in their own environment.

The proponents of the different perspectives in the film each value an idealised version of what they believe is individual and community success. When Julian Schweitzer, Director of Human Development for the South Asia region of the World Bank asserts, 'We see education as crucial. It's an absolutely necessary condition for sustained poverty reduction' (*Schooling the World*, 2010), he is valuing those qualities of life that generally need a higher national income in a capitalist society, such as health care and good nutrition. He conveniently forgets that there is not much evidence that more money results in a happier life, or that in many western societies, some people are so busy pursuing 'poverty reduction' in their own lives that they have little time to enjoy much quality of life. On the other hand, the rather idyllic view of a traditional upbringing, embedded in a society where there is no separate special world for children and everyone is happy learning how to maintain and live on their land, is almost mythic. As the anthropologist Arjun Appadurai put it, 'Natives, people confined to and by the places to which they belong, groups unsullied by contact with a larger world, have probably never existed' (1988, p. 39). Living in a subsistence agrarian environment is often hard, involving long hours of work, a relatively short life-expectancy and high infant mortality. It might be argued that this could be addressed in a less capitalist society, but that argument is beyond the scope of this chapter which operates within the current reality of a predominance of capitalism and its global effects.

A case study of schooling

Returning to my focus on education and the curriculum offered to children, I want to consider the attributes and challenges of interculturality – living in a space that is defined by cultural polyphony – by considering a case study of music and dance in a specific geographic location. My chosen case study is in a relatively remote location in the north of Ghana where recent years have seen many changes and interculturality can be seen regionally, nationally and internationally. I have been researching the music and culture of the town of Nandom for more than 25 years, beginning with learning to play the local xylophone in 1989 through to being made an honorary chief of the town in 2013. Nandom is not an area of stable settled community owing allegiance to a single 'chief' that is often an assumed model in Africa. There was constant mobility as people lived in extended family groups, farming the area around the house, hunting further afield, and defending themselves against slave raiders and enemies. As a family grew, young people might explore further and set up a new location, becoming more independent by negotiation with other residents and the observance of traditional rituals (Lentz, 2013). When the British arrived here as the colonial power in the 1920s, they installed some people as 'chiefs' – a concept previously unknown locally – and started to reorganise and 'modernise'

the society. Some promising young men – especially those related to a chief – were sent for schooling in a primary school that opened in the district administrative centre in Lawra in 1935 (Gandah, 2004). Some of the brightest students then went on to the Middle School in Tamale that had a mix of boys from the whole of northern Ghana and required boarding, completely away from the 'home' culture for most students.[1] Kumbonoh Gandah makes references to the role he and another student, Polkuu Konkuu (who became the Nandom Naa [chief] in 1958) played in school performances in the 1940s (Gandah & Lentz, 2008, p. 39). Gandah narrates that these were run as a competition between each 'tribal group' and that the winning students each received a plastic toy aeroplane for the best performance. Some aspects of local culture were already, at this point, identified as 'presentational' and performative and offered to 'others' outside their home culture. The curriculum of the school was academically British, although some local farming practices and crafts such as pottery were included. The arts taught were mostly western – Gandah mentions Shakespeare, learning four-part harmony, and singing 'God Save the King' in his autobiography (Gandah & Lentz, 2008) – with local culture represented through performances of material that the students had learned at 'home'. *Schooling the World* poses a rhetorical question: 'If you want to change an ancient culture in a single generation, how would you do it? You would change the way it educates its children' (trailer available at http://schoolingtheworld.org/film/hd-trailer/, accessed 15 October 2014). That accurately describes what happened in northern Ghana.

Polkuu Konkoo became a teacher at the first government primary school in Nandom that opened in 1946, and worked as a teacher for more than a decade. The ability to move, live and work in the coloniser's world conferred material benefits – on colonial terms and within con-strained limits, of course (e.g., Guha & Spivak, 1988). As well as the government curriculum, Polkuu used his ability as a musician and dancer to make sure that local music and dance were part of the curriculum that was offered to the children in Nandom. Drawing on his experience at school in Tamale, Polkuu wanted to develop Nandom music and dance as a performance to be used on public occasions, thus having a different function from the recreational and ritual dances celebrated by local people. Polkuu worked with other local musicians to adapt and develop a new Nandom dance style, *Bewaa*. This new dance became very popular, especially with young people, because, although it had similarities with their traditional dances, it was exciting and they could dance with a partner. Polkuu later formed a performance group outside the school (the Nandom *Sekpere* group) that became highly successful, competing throughout Ghana and invited to perform on national occasions. Some group members, for example the xylophone player Joseph Kobom Taale (who was my xylophone teacher from 1989 until his death in 1995), were still at school when they joined this group.

In summary, here is the situation in Nandom between about 1950 and around 1990. Nandom people may have an ancient culture, but the town itself is not that old – probably less than 150 years. Some settlements in the area are older and have their own variants of language and culture, seeming similar when viewed from a distance but critically different for local people. Education and schooling were imported to focus mostly on national citizenship, learning a colo-nial language and a national/international curriculum for maths, humanities and science. A few students did very well and progressed through schooling to higher education both in Ghana and also abroad (the current Nandom Naa, Puoure Puobe, was one of the first Ghanaian students to study in Italy). Many students, however, struggled with a curriculum that had limited local relevance. Good teachers often did not want to live in this remote and poor area of the country with few facilities and limited opportunities to supplement their state teaching income with individual tuition for the children of more affluent parents. The academic standards reached by the majority of students in school were low across the whole of the north of Ghana compared

with the more affluent south (and this has not changed significantly to the present day).[2] The curriculum taught little of relevance to those living in a subsistence agrarian society but children growing up in this area knew little about life elsewhere in Ghana (or the world) except for those who were sent to visit relatives living further south. Dance groups and xylophone players existed in some schools because the children danced at home and some children learned to play the xylophone from a relative, but it was hard for a school to afford to buy their own xylophone and keep it in good repair, with little incentive for doing so as this was not a part of any formal school assessment.

Local economies and ecologies in Nandom

I want to consider the effect on Nandom culture, mostly as experienced by children, caused by the move away from a subsistence agricultural environment with limited personal mobility to a digitally connected world where people have access to radio, TV, phones, etc. Whereas in some parts of the world, these changes happened over more than 100 years as the technologies were invented, in Nandom this arrived in less than 20 years. From about 1990, things began to change quickly. First a national electricity supply replaced haphazard local power generators and batteries, and is now being extended into the surrounding villages. Just into the 21st century, cell phone technology arrived with new phones costing from around £20/30USD. Around the same time, a local radio station was set up (Radio FREED) with some external funding and a community development brief. The transmitter has a range of about 60 km so can reach all of the outlying villages. As of 2012, there is now a second radio station in Nandom, funded by the local MP, as a result of a dispute about perceived political bias at Radio FREED. Television has not really arrived here as a broadcast medium – national stations can only be received poorly with additional aerials – but DVDs are very popular. Landline broadband connections go only as far as the regional capital, Wa – so Internet connections in Nandom are wireless and mostly very slow (2G); direct satellite installations and 3G/4G mobile technology are on the way. Many adults now have a cell phone and some are starting to use it to access the Internet and social media, but for most it is still just a telephone. Teenagers want a phone as soon as they can afford it, are avid consumers of ringtones and exchange music through any means possible.[3]

The media world of children in Nandom is now a highly international mix and perhaps justifies the label 'cosmopolitan', limited albeit by their economic situation. The radio stations play pop music from outside Africa about half the time, mostly tracks from the United States of America (USA), with rap and reggae being most popular. Ghana has a thriving pop music industry with its own idiomatic style, currently blending Highlife (a syncretic mix of traditional Ghanaian songs with jazz standards) with Rap to make a style called Hiplife. This style has lyrics that are often in Twi (one of the most common Ghanaian languages), perhaps mixed with vernacular English. There are some recordings of local Dagara music from the Upper West region but these tend to be recent events or local established xylophone players performing funeral songs. There are no local studio recording facilities and only a few fairly basic ones in Wa (regional capital 100 km away), so there is no local pop music or anything recognisable as a local style using local language, rather than a more general Ghanaian style that owes more to southern antecedents. One might expect that a style like Rap/Hiplife would lend itself to local adaptation but, working with Radio FREED, I could find only three young musicians in the whole area who were able to rap in the local language. The playlists of both Nandom radio stations are very similar and dictated by tracks available at little or no cost. The radio stations make little money and struggle to meet their costs and upkeep. Local people do not

want to pay much for events to be announced and no local business has yet seen any advantage in advertising. Generally, there is little advertising visible or experienced in Nandom. Around the time of the annual cultural festival, Kakube,[4] there is an influx of posters from breweries promoting beer or sugary soft drinks, and from phone companies (Power to YOU! being Vodafone's slogan), but for the rest of the year, any advertising is mostly for political parties or health announcements.

To summarise, local children have media access to a number of cultures outside their own (begging for the moment the question about how locally this is defined) and show a good level of awareness of dress and lifestyles in places like the USA. In contrast, their access to local culture is through direct observation and engagement with little media presence. This has two effects: it makes the local less accessible because it is not there 'on demand' as are the other cultural offerings, and this also carries the message that their culture is less interesting and worthy of attention because it is broadcast much less than the more cosmopolitan styles.

Historically, Nandom culture has ancient roots but, like all except perhaps the most remote cultures, it has constantly been remade by each generation, incorporating new ideas both local and from external influences. The physical arrival of the colonial invaders brought formal schooling that was intercultural in some respects but not through any intent of the colonial powers, and the subsequent independent nation of Ghana has adopted something close to an international curriculum. *Schooling the World* seems to suggest that each generation of children should be content with being inducted into a local world for which they care and which, in its turn, provides for them. The local Nandom ecology would struggle to provide for the numbers of people now living there without some substantial changes to traditional farming and energy practices. Hunting for wild animals such as antelope was a significant source of protein 60 years ago, but game has all but disappeared outside the game reserves. Similarly, trees for firewood – and for making the traditional xylophones – are becoming scarcer. Burning areas of bush/grass at the end of the rainy season was the traditional way of clearing land and flushing out animals to hunt, and burning is of benefit to both the land and some plants, but this has been mostly stopped in the last 20 years because of the damage done to other people's property as the fires, once started, are not controllable. An induction for children into land management and farming would have to tread an interestingly political path between traditional approaches for increasing land fertility, managing animals and utilising/evaluating modern farming techniques from a variety of sources. Questions of culture, cultural transmission, and an intercultural curriculum would also have to tread a path that was more of a debate than induction or simple instruction, important though these modes would be.

In school, children's access to cultural materials is limited. Music, dance, and local culture do feature in the curriculum as a topic within Religious and Moral Education, but this focuses more on being able to respond with a good 'right' answer about religious beliefs, moral behaviour and appropriate community spirit. None of the primary or junior secondary schools in the area is connected to the electricity grid, so they have no facilities for playing music, viewing video or accessing recorded media, except on battery-powered devices. Government funding for the schools is very limited (around 3USD per student a year to provide for all student needs and maintain the building) and parent–teacher associations cannot raise as much money to support the school as is possible when parents are more wealthy. Limited funding also means that schools cannot pay local musicians/dancers to teach, so have to rely on their goodwill. During my research in Nandom, teachers told me that they bring local musicians into school occasionally and the children enjoy this very much but music as a topic, and more importantly as an ongoing practical engagement, is not present or supported. It is also possible to see the

development of an increasing dislocation between the musical tastes of parents and children. When I questioned Nandom children in 2006, many were happy to be listening to any music but a significant number did not want to listen to the 'old-fashioned' music of their parents or to perform local dances (see Wiggins, 2013). Subsequent research has shown this trend increasing as more children have access to their choice of music, with the situation moving towards that common in many western societies where it seems that music taught in schools seems frequently to come loaded with cultural values that the children do not aspire to (e.g., Kertz-Welzel, 2013).

The power of music

In recent years, there has been substantial research published into the benefits of engagement with music in the curriculum. An article by Susan Hallam, *The Power of Music* (2010) draws together and summarises these benefits. Practical engagement with music is particularly effective for children through the ages of five to twelve in supporting the development of skills in language, phonology and reading. These are vital skills for children in Ghana who often need to engage with multiple languages and are taught exclusively in English – their non-native official national language – from the age of twelve. Hallam also notes several studies such as Spychiger et al. (1995) show that 'increasing the amount of classroom music within the curriculum did not have a detrimental effect on language and reading skills despite a reduction in time in these lessons' (Hallam, 2010, p. 278). Hallam summarises the conclusions from her extensive survey of research into music in education: '[There is] a strong case for the benefits of active engagement with music throughout the lifespan' (Hallam, 2010, pp. 281–282).

If there is such a strong case, why are not more governments requiring and emphasising music in the curriculum? There are global league tables published by the Programme for International Student Assessment (PISA) – part of The Organisation for Economic Co-operation and Development (OECD) whose mission is, 'to promote policies that will improve the economic and social well-being of people around the world' (http://www.oecd.org/about/, accessed 4 November 2014). PISA publishes league tables of attainment for students aged fifteen in areas like maths, reading and science.[5] Most governments seem to make the apparently obvious assumption that, in order to improve performance in those areas evaluated by PISA (who thereby validate the apparent pre-eminence of these curriculum areas), they should give more time and resources to them – an assumption not supported by the music data. This is not the whole story though, and even PISA point out, for example, that the equality of distribution of resources seems statistically to have an impact on attainment as well as total spending on education. In Ghana, the unit of resource available to schools is very low by international standards and this is further exacerbated by the economic situation where the local communities in the north are less able to support schools financially. On that basis, though, bringing in local musicians, learning to play local instruments, sing and dance might be both an effective intervention to raise standards and highly cost-effective as it does not involve purchasing materials from outside Ghana.

An intercultural curriculum

Returning to the notion of an Intercultural Curriculum for Nandom, what would this look like? The Irish National Council for Curriculum and Assessment offers the following guidance:

An Intercultural Education has two focal points:

- It celebrates and recognises the normality of diversity in all areas of human life and sensitises the learner to the idea that humans have naturally developed a range of different ways of life, customs and worldviews, and that this breadth of human life enriches all of us.
- It promotes equality and human rights and challenges unfair discrimination.

(http://www.ncca.ie/en/Curriculum_and_Assessment/Inclusion/ Intercultural_Education/, accessed 22 October 2014)

Rather than the sense of somehow 'understanding' another culture that was so often criticised in 'multicultural education' this focuses on recognising and accepting diversity, and supporting equality. Cultural materials are still probably one of the most utilised resources for this type of education but contain the possibility of erroneous assumptions that emphasise the gap between the teacher and the student. As suggested earlier, the children in Nandom now have access to a wide range of cultural artefacts that can be accessed through the media – probably as wide as their parents – but this does not mean they see and understand them in the same way as their parents or other people in different locations.

Processes of 'bricolage' are well documented, where a musical style acquires a meaning that is far removed from its creation, a telling example being the adoption of ska by the white skinhead culture in 1970s Britain (Middleton, 1989). Simply hearing music from elsewhere conveys very little of that culture in a way that an uninformed listener can access. Children in Nandom have an extensive familiarity with the range of music broadcast by the local radio stations and can sing many of the songs, sometimes without seeming to understand much of what the song is about. In 2006, I found children happily singing 'Fuck you, you hoe, I don't want you back' from the album, *I Don't Want You Back* by Eamon (Jive, 2004, available at http://www.azlyr ics.com/lyrics/eamon/fuckitidontwantyouback.html, accessed 1 December 2014) without any concern about how this might be perceived and understood in other places. Nandom children now have experience of a cultural mix of music, extending from local to national and international, although limited by the range of music that the local radio stations can acquire for little money (and questions of payment to artists for public performance over the air do not even begin to be considered), or the ability of the children to access and exchange music through mp3 players or phones. Children receive no instruction in musical skills within the curriculum and the opportunities to acquire these in the community are reducing rapidly. No local teacher is trained in music or the arts so they bring only enthusiasm and whatever understanding they have developed outside their training, leading to a limited curriculum in these areas.

The concept of an intercultural curriculum in Nandom brings a number of aspects into sharp focus, beginning with questions of ownership of cultural materials and what is 'ours'. The Nandom region, along with much of Ghana, would struggle positively to identify those aspects of culture that are uniquely 'local'. Language, music and dance often change gradually across a region in one direction and perhaps abruptly in another, but generally with considerable borrowing. What is 'ours' is defined in opposition: Nandom as opposed to the next town, Upper West region as opposed to Upper East, northern as opposed to southern Ghana, Ghana as opposed to other West African countries. This pattern is, of course, repeated in most other places around the world although the differences in language and dance may be on a larger scale than is the case here. But regionality and issues of difference are becoming more important as people do not want to see themselves as a small and indistinct part of a large group (e.g., Paasi, 2009), or they wish to change their allegiance to a cultural, political or economic region – in evidence in Ukraine in 2014 as well as being a common occurrence within Ghana. In Nandom, there is not much doubt what traditional music is local – through creation, adaptation or adoption – but

there is no local popular music that has access to the media for distribution, nor facilities for young people to develop it. There are more facilities at a regional level, but even these are poor compared with the opportunities and glossy production available in the major cities further south. One might expect that the Ghanaian government would welcome a national identity that lessened the regional differences and distrust that have been a factor since Ghana was formed by colonial powers. In fact, the declared policy of the Ghanaian government is to value its cultural diversity but this is harnessed towards national identity, as expressed in the objectives of the Cultural Policy of Ghana: 'To foster national unity among the diverse ethnic groups of Ghana by promoting cultural interaction and inter-ethnic understanding through programmes that create an enabling environment for national development' (National Commission on Culture 2004, 3.2.3, available at http://www.s158663955.websitehome.co.uk/ghanaculture/privatecontent/File/CULTURAL.%20POLICY%20-%20FINAL.pdf, accessed 8 November 2014). The policy further states: 'Production of Musical instruments shall be encouraged, so that all schools and communities can own their own instruments' (8.3.7).

Implementing this requires funding and real commitment to a diversity of culture – regional diversity is at the heart of the effective implementation of the policy, as it is for an intercultural curriculum. A uniform approach to cultural provision across such a varied country will satisfy very few people, however simple it is for those who have to manage and implement it. Music is arguably unique in the extent to which the cultural messages it carries are not fixed but clearly understood by the receiver in their own way. The receiver quickly decides if they wish to identify with that group or not, and in some cases, such as that described by Kertz-Welzel (2013), the cultural message can be rejected within the same community.

Returning to musicians in Ghana, many of them build on their heritage and experience to create interesting syncretic intercultural music. The traditional Ageshe dance from the Ewe area now has a section where the lead drummer imitates reggae rhythms, and musicians from near Nandom, such as Aaron Bebe Sukura (http://aaronbebe.com/), are using the xylophone to create new 'world music' sounds. But Aaron Bebe creates his music with musicians and studios in the capital, Accra, 900 km south of Nandom. Development is more difficult for aspiring musicians based in Nandom who have no local resources except their voices and bodies. The best local rapper that I found in 2011, Pope from Eremon (Figure 14.1), sings his lead part and adds as much backing as he can with his voice. In his dress, he is able to represent his intercultural location with his western jeans, bright shirt and belt buckle made from a local calabash as these are all available locally. Hopefully, resources for the arts will follow!

Intercultural education is best, or intercultural education – at best?

Without wishing to sound negative, I consider that trying to present knowledge of intercultural materials in music is fraught with difficulty. The students might not want to receive the message. Although, on the one hand, students in Nandom recognise that they have a cultural heritage that should be continued or at least preserved in some way, they frequently also consider that someone else should do it because they are not interested in being old-fashioned or 'colo' (colonial). They want to be intercultural in their own way. Interestingly, those aspects of the local music that best adapt to a public performance of culture (specifically, *Bewaa* dancing) are present in the senior schools where there is a high level of students from outside the region, so a greater sense of cultural mix. At the Nandom Senior School speech day in 2013, both the *Bewaa* group and the cadet corps gave displays. Each generation needs to renew the culture for themselves if it is to stay alive, not just statically preserved. Intercultural teaching, needs a special sort of teacher and *animateur*: one who can encourage the students to use what they have, understand something of

Figure 14.1 Pope, a rapper from Eremon (photo by Trevor Wiggins, 2011).

their heritage, understand how it is different from that of other cultures (while probably already having some intercultural attributes), and then support their creativity in responding to the cosmopolitan world in which they live. This is the opposite of the aim of multinational companies who want their product to be the same everywhere, and it gives the lie to the idea that multinationals want to give 'Power to You' – provided you choose what they offer.

The approach that builds on the past to create a new future has been known for a long time in Ghana and even has its own word in the Akan language, *Sankofa* (reach back and bring it). Trying to restrict young people to a preserved culturally pure ghetto as implied by *Schooling the World* is very unlikely to be successful, however cogent its arguments about the violence done to people by the model of western schooling. Equally, the whole-hearted embracing of the values of the western school system and of 'global' pop music that represents only one wealthy sector is likely to leave many young people feeling cheated. The children of northern Ghana already have access to many aspects of an intercultural curriculum but have the 'lite' version as a result of limited economic resources and facilities.

The key to an intercultural curriculum is fostering creativity to enable students to understand the 'other' through engaging with it, not just observing it, and we know from Hallam's (2010) research that it is the practical engagement with music, not learning about it, that is important. Although there are many examples of people doing great creative work with minimal facilities, it is harder to motivate children when the alternatives are so glossily presented, even if the contents are sometimes vacuous.

What conclusions can I draw from my case study of Nandom as representing many locations worldwide that are economically challenged, and where access to a wider world through the

Internet has arrived very swiftly? The Internet provides a great opportunity for intercultural communication and learning but is potentially a Trojan horse, particularly in the poorest areas. Interculturality in the arts can be highly attractive but is more difficult to manage when the economic inequality is greater. Many commentators are predicting the highest economic growth in Africa in the near future, including Bill and Melinda Gates, who draw on their experience and observation to propose that, 'The lives of people in poor countries will improve faster in the next 15 years than at any other time in history. And their lives will improve more than anyone else's' (http://www.gatesnotes.com/2015-annual-letter?WT.mc_id=01_21_2015_DO_GFO_domain_0_00&page=0&lang=en, accessed 25 January 2015). Against that, the equality of income distribution in African countries like Ghana is generally worse than in more wealthy locations (http://en.wikipedia.org/wiki/List_of_countries_by_income_equality, – summarising data from the United Nations Development Programme, the World Bank and the CIA, accessed 25 January 2015) so the remote areas will not share as much of the uplift unless more positive steps are taken to fund education at a realistic level for all students. We have a duty through intercultural education to show that the culture of all peoples is to be valued and admired, that it is not validated solely by economic success, and not sufficiently recognised by a token engagement because we have to teach 'our own' culture.

Notes

1 It is frequently almost impossible to identify distinct cultural boundaries in Ghana as practices, styles, costume and musical instruments change almost independently. Neither is language a good indicator as there are around 100 languages and dialects in Ghana (some mutually intelligible), and groups of people sometimes change their language for administrative advantages or alliances.

2 For example in the 2013 Basic Education Certificate Examination (BECE) in Ghana, four out of the five lowest-placed school districts were in the Upper West (where Nandom is) or Northern regions (Source: http://graphic.com.gh/juniors/junior-news/15757-nkoranza-north-tops-2013-bece.html, accessed 22 October 2014). For Secondary Schools in the Nandom area, 80% of the students are not from the area (Nandom District Chief Executive, Cuthbert Baba Kuupiel, interviewed by Carola Lentz, 2 Dec. 2013).

3 For more about this, see Tyler Bickford's (2013) analysis of teen music-sharing culture in the USA.

4 The Kakube festival is a development of the traditional practice, at the end of harvest, of gathering the last grain to brew beer, then inviting neighbours to share it. Since 1989, this has been developed, mostly at the instigation of Naa Puoure Puobe, into a four-day cultural celebration, display and competition.

5 There is not a single country in Africa participating in PISA although every other continent is represented.

References

Appadurai, A. (1988). Putting hierarchy in its place. *Cultural Anthropology, 3*, 36–49.

Bickford, T. (2013). Tinkering and tethering in the material culture of children's mp3 players. In P. S. Campbell & T. Wiggins (Eds.), *The Oxford handbook of children's musical cultures* (pp. 527–542). Oxford and New York: Oxford University Press.

Breckenridge, C. A., Pollock, S. I., Bhabha, H. K., & Chakrabarty, D. (2002). *Cosmopolitanism*. Durham, NC: Duke University Press.

Clifford, J. (1997). *Routes: travel and translation in the late twentieth century*. Cambridge, MA: Harvard University Press.

Gandah, S. W. D. K. (2004). *The silent rebel*. Accra, Ghana: Sub-Saharan Publishers.

Gandah, S. W. D. K., & Lentz, C. (2008). *The silent rebel: The missing years: Life in the Tamale Middle School (1940–47)*. Legon, Accra, Ghana: Institute of African Studies, University of Ghana.

Guha, R., & Spivak, G. C. (1988). *Selected subaltern studies*. New York, Oxford: Oxford University Press.

Hallam, S. (2010). The power of music: Its impact on the intellectual, social and personal development of children and young people. *International Journal of Music Education, 28*, 269–289.

Kertz–Welzel, A. (2013). Children's and adolescents' musical needs and music education in Germany. In P. S. Campbell & T. Wiggins (Eds.), *The Oxford handbook of children's musical cultures* (pp. 371–386). New York: Oxford University Press.

Lentz, C. (2013). *Land, mobility, and belonging in West Africa*. Bloomington, IN: Indiana University Press.

Middleton, R. (1989). *Studying popular music*. Milton Keynes: Open University Press.

Paasi, A. (2009). The resurgence of the 'Region' and 'Regional Identity': Theoretical perspectives and empirical observations on regional dynamics in Europe. *Review of International Studies, 35*, 121–146.

Schooling the World. (2010). Film. Directed by Carol Black [DVD]. Malibu, California: Lost People Films.

Spychiger, M., Patry, J., Lauper, G., Zimmerman, E., & Weber, E. (1995). Does more music teaching lead to a better social climate? In R. Olechowski & G. Svik (Eds.), *Experimental research in teaching and learning* (pp. 322–326). Frankfurt am Main: Peter Lang.

Wiggins, T. (2013). Whose songs in their heads? In P. S. Campbell & T. Wiggins (Eds.), *The Oxford handbook of children's musical cultures* (pp. 590–608). Oxford and New York: Oxford University Press.

15

THE MEDIATED SPACE

Voices of interculturalism in music for flute

Jean Penny

Music for flute and voice, undertaken by one performer, may include poetry or narrative, singing while playing, phonemes uttered or sung, murmuring, whispering, breath sounds and a variety of articulations. These sounds, in combination with various flute tones, evoke a particular aesthetic and perception. Multiplicities of identity arise, questions of performer persona, location and dimension, and new layers of meaning emerge. A shift occurs; as Connor writes, 'Listen, says a voice: some being is giving voice' (Connor, 2000, pp. 3–4). The cultural significance of language, the sounds of Western and Eastern flute, and voice traditions challenge and disrupt perceptions, providing a platform from which to construct experiential intercultural analysis.

This chapter considers two works for solo flute in explorations that include shifting characteristics of composition, tone, language and investigations of heterotopia – defined here as an ecology of the performance space. Heterotopias[1] are difficult to decisively define. Michel Foucault suggests: 'We might imagine a sort of systematic description . . . that would, in a given society, take as its object the study, analysis, description, and "reading" . . . of these different spaces' (Foucault, 1984, p. 4). Heterotopia is proposed here as a place of connectivity, of interweaving different perspectives of experience and practice; of modes of interaction; and a place of others as seen through the self.

Five main sections are contained within this chapter. *Interculturalities: sonority, identity and score* examines timbral and physical aspects of contemporary flute techniques, and the score as a context for activating shifts in cultural expectations and understandings. *Heterotopia* is then posited as a context, as a space between cultures which activates performative relationships. *Connecting aesthetics: contexts, processes and dialogues* delves into cultural contexts, artistic processes and the performance space. *Theories and methods for an intercultural flute practice* articulates questions for investigation, and the importance of descriptive analysis in this performance context. Two flute works – Tōru Takemitsu's *Voice* and Kaija Saariaho's *Laconisme de l'aile* – are explored, and the theories, questions and methods applied through performance analysis. These works articulate both explicit and subtle juxtapositions of cultures that will be shown to activate shifts in the performer's conceptualisation and interpretation. *Concluding reflections* provides a summary of heterotopian aspects, and of the performance as a space for the interplay of correspondence and the engagements of intercultural exchange.

Interculturalities: sonority, identity and score

Flute playing techniques using vocalisation and breath tone stretch back across centuries, with examples from across the world including singing while playing in West Africa, and air/breath tone used by Andean flute players (Penny, 2009, p. 35, fn 15). In Western Art Music, these techniques were established in the early 1970s in the music of Tōru Takemitsu and others, including George Crumb and Brian Ferneyhough (Reardon-Smith, 2013). They are now common practices in solo flute works, creating effects that reposition the flute as a multi-sonority instrument. Sounds might range from buzzing (unison flute and voice) to polyphony (separate lines sung and played) to hybrid textures employing varieties of breath, voice and tone. It has become a mode of expression that might depict transitions, multiplicities – implications of multiple layers, perspectives and sound sources – and diverse musical characterisations.

The player is required to develop a new physicality embodying these techniques through varieties of embouchure movements, throat and mouth shaping and a new theatricality that may involve narration. The notion of the instrument as an extension and amplifier of the body (Emmerson, 2000, p. 206) is expanded further into signification of voice and language, and allusions of multiple identities may arise. The flautist's identity, repositioned and transformed by sensations of multiple presences suggested by narration, breath tones, altered proximities and a projection of intimacy or inner self, can present an ambiguous image, changeable and unpredictable.

This investigation is grounded in the musical score, the score as 'cultural marker' (Coessens, 2014, p. 178) and its temporal realisation. The score–performer interface thus activates an environment for explorations of the voice as cultural signifier, as articulation of synthesised cultural processes and techniques, as implied identity, and as symbiosis of cultural 'norms' and artefacts. Intercultural explorations here focus on a synthesis created through cultural knowledge and practices; of knowledge generated in the engagements of performance.

Crucial to this discussion is cultural analysis of aesthetic blend and processes of exchange in performance, in developing 'cultural flux rather than categorization . . . understanding boundary crossing and making room for the need to create multiple identities' (Lau, 2004, pp. 38–39). A context for understanding is created through Takemitsu's *Voice* and Saariaho's *Laconisme de l'aile*, where performative analysis forwards the experience of interculturality. This experience includes sensations created in performance of new connections of one's own culture to another through, for example, shifting timbres from blended instrumental techniques or feelings of ritual that may arise from perceived stillness of time and musical flow. These elements are explored in detail in the analysis section below.

Asian composers activating shifts between cultures include Tōru Takemitsu (1930–96) and Isang Yun (1917–96), who blended characteristics of traditional music practices with Western styles and techniques. Yun's flute works – for example, *Concerto for Flute and Small Orchestra* (1977) – demonstrate the transferral of traditional Korean instrumental techniques to Western instruments (Kim, 2009, p. 10). Embouchure-manipulated pitch changes on a Western flute, for example, suggest the techniques and sounds of music for the *Tai-keum* (a large Korean flute). Compositional techniques include 'many long sustained notes with non-standard indications of vibrato, large interval tremolos, trills, many different dynamic levels, and grace notes with large leaps: all of these are derived from the Korean practice of *Sigimsae*, of which there are four main categories: *Yueosong* (vibrato), *Junsung* (grace notes), *Choosung* (ascending glissando), and *Toesung* (descending glissando)' (ibid., p. 50).

Tōru Takemitsu wrote:

> By cultivating within my own sensitivities those two different traditions of Japan and the West, then, by using them to develop different approaches to composition.

I will keep the developing status of my work intact, not by resolving the contradiction between the two traditions, but by emphasizing the contradictions and confronting them.

(Takemitsu 1994, loc. 967)

This tenet is clearly realised in many of his works, including *November Steps* (1967) for biwa, shakuhachi and Western orchestra in which an interweaving of sonorities from the two sound worlds occurs. Rather than striving to meld these elements, Takemitsu suggests that, 'Through juxtaposition it is the difference between the two that should be emphasized' (ibid., loc. 1541).

Instrumental ontologies, including aspects of sound production and player–instrument relationships, reveal that Western and Eastern instruments create and sustain performative and musical knowledge carrying specific and imagined information into performance practices and connections (Penny, 2014, p. 44). Traditions and memories of sound and associations, gestures of breath and tone create a dialogue, and draw the player into and out of disparities of sounds and of thought. Using voice repositions the flautist, simultaneously imprinting a perception of human-ness and inviting a reappraisal of musical expression of the flute. The voice may invoke a particular cultural relationship or presence, the language itself representing location or culture, infusing the music with multiple layers and significations. There can be a dissolving of barriers and a disruption to the 'norm' that provokes and engenders the development of shifts in understandings and the acquisition of knowledge.

Cultural re-evaluations from these perspectives arise from entering the performance space as a space for thinking, where we, as musicians and listeners, explore our inner selves, our sonic selves and the selves of others. A sense of dialogue emerges in performance as melded musical lines, sonorities and gestures create movement from one imagined culture to another, both challenging and re-defining cultural knowledge. Articulation of this performative experience exemplifies the goals of interculturality to achieve symbiosis and cultural flux.

Heterotopia

The definition of heterotopia proposed above as a place of connectivity, of the interweaving of different experiential perspectives of practice, of modes of interaction, and as a place of others as seen through the self permits identification of an environment and framework to explore and articulate the performer's response to works for flute and vocalisation. Transferring these explorations into the centre of performance engenders new modalities of reflection as perspectives of cultures interweave, dissolve, emerge and develop.

A recent study of intercultural music performance in Malaysia[2] articulated heterotopia through the performative lens; the performance creating the context for understanding artistic realisation of intercultural knowledge and experience through collaborations, music creation and reflective symbiosis. The performance became the space between cultures, the space to evaluate connections, to reassess values and for self-reflection: the place for artistic 'living reality'. This adaptation of Foucault's theory of heterotopia as a method of exploring the performance space and processes transforms awareness and facilitates construction of 'the space between' cultures. A flexible approach and an ability to construct an immersion in multiple, sometimes diverse, elements – suggestiveness and evocation rather than transplantation of materials (Lau, 2004) – is necessary. This view of heterotopia focuses on music performance and the exchange/collaboration/connections that may occur in that space. Performances of the flute works examined in this chapter provide material for gaining insight through this heterotopian space, where mediation and 'cultural flux' processes reveal multiple identity formations and new understandings.

Connecting aesthetics: contexts, processes and dialogues

In attempting intercultural musical dialogues we are assisted by questioning understandings and knowledge of our 'own' culture, an 'other' culture and methods of interconnection. Western aesthetics, as represented by a selection of writers here, relate to a way of thinking that articulates the role of art and musical dialogue. Important theorists and their relevance to this investigation are briefly mentioned here.

Hans-Georg Gadamer in *Truth and Method* (1975) discusses contexts for understanding, and understanding as an event. These events contain a divergence of perspectives and dialectics that come together as advanced understanding. Drawing this concept out into the performance space and zones of interaction – the interface of instrumental performance and audience – establishes a context for understanding. The performance space becomes a 'malleable and adjustable force . . . [where] new relationships with audiences result as diffusion, sound and performer location, components of sounds, the physicality of performance, the visible and invisible elements create different experience' (Penny, 2009, p. 182).

Nicolas Bourriaud (1998 and 2011) posits art as a way of living: 'The role of artworks is no longer to form imaginary and utopian realities but to actually be ways of living and models of action within the existing real, whatever the scale chosen by the artist' (1998, p. 13). This transfers into the analysis of performance, the processual interactions and responses to contexts, ideas and sounds, where the 'space between things' can be a place to evaluate reality, to re-evaluate values and for self-reflection (Penny, 2014). Bourriaud writes about the space between things as a vital point of interest. It is this space, rather than things themselves, 'the event rather than the monument' (Bourriaud, 2011, p. 11), that is significant. Additionally, Foucault, according to Bourriaud, is less interested by what an image says than by what it produces – by the behaviour it generates, and what it leaves barely seen among the social machinery in which it distributes bodies, spaces and utterances (ibid., p. 13).

Tim Ingold takes an anthropologist's outlook of processes and correspondences, of thinking through making that can be applied to performance.

> A . . . thing . . . is a 'going on', or better a place where several goings on become entwined. To observe a thing is not to be locked out but to be invited in to the gathering. We participate, as Heidegger rather enigmatically put it, in the thing 'thinging in a worldling world'.
>
> *(Cited in Ingold, 2010, p. 6)*

This concept adds richness to the explorations of the performance space as an ontology of flow, of growth and movement, a place for correspondences with sound through the instrument, the transducer that 'converts ductus into material flux' (ibid., p. 128).

Considering East/West dialogue in music, ethnomusicologist and flautist Frederick Lau makes succinct observations about contemporary cross-cultural compositions, advocating a flexible approach to interculturality rather than a rigid employment of familiar cultural artefacts to denote an exoticism or pseudo synthesis. He argues for new methods of analysis and cultural flux; for understanding boundary crossing and making room for the need to create multiple identities (Lau, 2004, pp. 38–39).

Steven Connor has explored the significance of the human voice in a variety of contexts, describing re-locations and re-balancing of perceptions created by speech: 'When I speak, my body becomes a potential, a projective and a sequential thing, not a given thing, opening itself, and me its vehicle, to ongoingness' (Connor, 2009, para. 4).

'Uttering is outering', he says, 'the giving forth of something which, far from expressing something previously inner, is actually drawn to, even drawn out of, the utter, the infinitively outermost' (ibid., para. 6). The use of voice in the flute works discussed here brings the persona of the performer into a new perspective, creating a new duality and repositioning of the flautist. The voice depicts a human identity, communicates cultural information, and creates a changed sense of location and relationships.

Crossing and merging these theoretical borders enriches the study of the performance space, establishing approaches and a shape for investigation, and providing a framework for experiential response and interchange.

Theory and methods for an intercultural flute practice

This enquiry takes the perspective of the flautist as practitioner/researcher, examining a personal view of performance in relation to practice. Experiential research ultimately seeks a subjective analysis of process and response through description, here referenced through three streams: artistic practice as research, theory, and as a heterotopian model. A layering of philosophical and cultural principles with aspects of the events of the performance space aims to reveal processes and connections, identities and ambiguities.

Research questions may revolve around exploring cultural aesthetics, the voice as mediator, and the performance space as heterotopia. These questions have been posed in relation to Malaysian/Western music collaborations (in *The Imaginary Space* project, 2012–14), and can be applied to an exploration of intercultural flute practice. For example:

- How do we negotiate spaces between internal and external interculturalities, create musical 'correspondence', shared experience of cultural diversities, and how do these inform our understandings?
- How can the environment of performance create new knowledge?
- How does a 'clarity of understanding' (Gadamer, 1975, p. 263) through context occur?
- How is a specific performance a 'way of living' (Bourriaud, 1998, p. 13)?
- How can a synthesis of East/West cultural elements create understanding in music?
- What elements are introduced by vocalisation, and how do these inform understandings of culture?
- How can heterotopia be understood in the performance space?

Flexible research modes and the value of description in music/artistic research have been recognised as critical to gaining profound understandings of artistic practice. Marc Leman writes of how verbal and graphic descriptions provide the space for interaction between experience of involvement and the cultural context (Leman, 2008, p. 7). Descriptive methods provide insight into the intersections and symbiosis occurring through differing approaches to sonorities, techniques, gestures of breath and philosophical approaches that can shift the performer from one culture to another and one performance mode to another.

The works: Tōru Takemitsu's *Voice* (1971) and Kaija Saariaho's *Laconisme de l'aile* (1982)

The two works explored here for flute and poetic vocalisation, Takemitsu's *Voice* and Saariaho's *Laconisme de l'aile*, articulate a crossing of cultures and perspectives, and create a setting for dialogue and exploration. Composed eleven years apart, one can trace a change and expansion in

vocalisation into extended passages and narration: traits which became more common toward the end of the twentieth century. Streams of investigation are linked to the concept of heterotopia as outlined above: the performance space as an ecology of relationships and context for cultural understanding. The signification of language and voice located within these instrumental works, and poly–cultural and identity ramifications are reflected upon.

Vocalisations in these works meld with flute and breath; they emanate from whispers, exclamations, pitches or speech; they suggest location, other presences and diverse manifestations of self. Disembodiment of voice can be implied as perceptions of proximity and sound sources become ambiguous, creating a sensation of external commentary of inner thoughts, of looking in from outside. In performance these sensations appear to extend the personal space of the performer, to unveil aspects of self normally hidden, and to create a sometimes-startling intimacy (Penny, 2009, p. 126).

Research questions are posed from the performative, experiential perspective as the environment of performance creates the context in which to observe and analyse. Fused sonorities of voice, language and flute, posited as inherent cultural markers are explored. Mediation through the performer's experience, the interactions between performer, composer, the score, instrument, and performance space provide the setting for action, for reflecting on cultures and synthesis, and for exploring art as a living reality.

Tōru Takemitsu: *Voice for solo flutist* (1971)

Text and voice

Qui va la? Qui que tu sois, parle, transparence!

Who goes there? Speak, transparence, whoever you are!
(From Shuzo Takiguchi: Handmade Proverbs to
Joan Miró *(1970); score notes)*

In this work, the text above is uttered in a variety of ways: spoken into the flute with lips almost entirely covering the mouthpiece; as normal speech; whispering or shouting with the lips off the instrument; moving gradually from a voiced consonant to unvoiced; humming, shouting and singing (score notes). Additional extended flute techniques include colourations such as breath tones, whistle tones, strong accented tonguing, finger tapping, unfocused tone, intense tone and microtones. A duality of performer identity is explored through multiple aspects of the composition – flautist/narrator, questioner/answerer, French text changing to English text, and Japanese/Western musical characteristics and cultural perspectives.

Cultural perspectives in Voice

Voice is written for a modern Western flute in such a way as to suggest and evoke the aesthetic of traditional Japanese flute through sonic and theatrical characterisation, a sense of timelessness and space. A wide range of colours is used: 'hollow' tone, glissandi or portamento, altered colourings of pitches, merged voice and flute, blends of sustained sound fading, and merging with silence. In addition, this work introduces the Japanese concept of *Sawari* – the use of extraneous noise as equally important as resonant instrumental sound (Anderson, 2014, p. 14) commonly associated with *shakuhachi* music – through breath tone, breath attacks, keyclicks and whistle tones. Further influences of *shakuhachi* playing include microtones (*meri-kari* – lowered and

raised pitches activated through varied breath pressure and altered fingerings), the use of uneven and flexible vibrato tempi, and fortissimo and pianissimo breath attacks.

The sound of the Noh flute (or *NohKan*) is generally high-pitched and has a very direct tonal colour, strong note attacks, and breathiness. Traditionally used in the ensemble accompanying Noh theatre, Noh flute music frequently consists of short motivic melodies with characteristic 'flick' gestures at the ends of phrases, long mellifluous ornaments, and a distinctive static quality. The ritualised performance of Noh represents and underlines the theatrical narrative that is often about humans and spirit. The use of narrative in *Voice* may be interpreted as the 'spirit' character of Noh theatre. An exclamatory, stylised performance manner comprising sudden accents, extremes of range, percussive effects, highly ornamented flute lines and layered voices add further theatricality; the use of voice amplified by the flute tube, transformation of voice to flute sound, and creating polyphony of voice and flute present the performer's voice as character, commentator and identity.

Influences of *ma* (the Japanese concept of space or silence; the space between things) are seen in short and long pauses scattered through the work; the presentation of sound and silence as equally intense; and a rhythmic flow that at times creates a sense of incongruence and flexibility as bars are given an overall duration without specific note durations. The idea of *ma* can be related to the heterotopian space, as 'the space between things', as the relationships between performative and spatial elements. This manifests in *Voice* as an interface between sound and silence; performer and audience; and Western and Eastern cultures. Takemitsu writes: 'this ma, this powerful silence . . . gives life to the sound and removes it from its position of primacy' (1994, loc. 956).

The French and English languages depict different aspects of the character and structure of the work. Phonemes and sharp attacks (French) establish an abruptness and dramatic exclamatory atmosphere in the first part of the work; toward the end the language changes to English, becoming increasingly gentle, with breathy, indistinct whistle tones, pure sonorities, flexible and ethereal sounds mixing voice and flute and fading to the end with a final 'whoever you are'.

Modern Western flute sonorities and numerous extended techniques are used. The capacity of this instrument for sonic malleability creates a sense of integration and dialogical connection through an easy merging of sonic characteristics from East and West. Western modes of thinking manifest in a questioning of identity, cultural 'norms' and an emphasis on disrupted expectations could be attributed to aspects of this work.

Heterotopian analysis of Voice

A model of heterotopia as a representation of an ecology for investigation of *Voice* can be seen in Figure 15.1 below. As a context for understanding, the intersections progress from score to text, voice and characterisation, to flute, sonorities, gesture and physicality, to symbiosis of cultural elements, and self-reflection. These culminate in a manifestation of the performance as artistic living reality – as process driven, and as correspondence and progress. This space of experience sees the voice as mediator – as character (spirit), as timbre and as a shifting cultural signifier. Transferral of cultural knowledge occurs through this mediation and synthesis of perspectives.

Performance

Performance explorations initially focus on demanding extended techniques – on understanding and assimilating notation, and developing familiarity and agility with each motif. The significance of the sonorities – the effects of articulations, finger percussion, melding voice and breath, alterations of tone and pitch – are uppermost in the mind, as the resonances of the work are

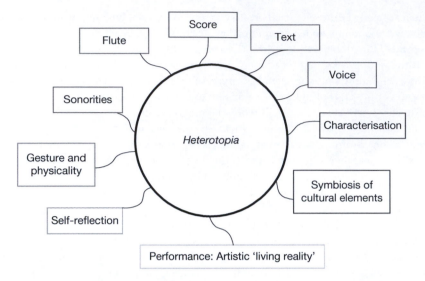

Figure 15.1 Heterotopia – *Voice*.

gradually revealed and placed. One is inspired to investigate, to research traditional practices of flute playing and theatre, of language enunciation and meaning. Imperatives of performance in this music include powerful demands on physical and mental stamina.

The composer has melded three traditions of musical aesthetics in this work (Japanese, French, English); how does the performer approach this? As correspondence? As instability? As flux and symbiosis? There is an alteration in the relationship with the instrument, as playing techniques alter lip shapes and proximities, and the physical gestures of projecting the voice take the body into an ostensibly complex location. Remembered timbres of Noh flute and *shakuhachi* resonate in the head and become a performative goal, aided by the resonance and tonal flexibility of the modern flute. A dialogue between these colours is carried out, experimentations with breath intensity, projection, balancing of voice, use of vibrato, articulation techniques, ornamentation and silence. Voice contains both '*ma*' (space or silence) and fluidity; repose and ambiguity. Exploring the relationship between sound and silence discloses a performative tension; a resolve is sought as the work drives forward. The words create a further dichotomy, with the French and English languages juxtaposed with sensations of ritualistic Japanese drama. The sense of moving toward a mix of aesthetics is powerful, but these questions are not necessarily resolved, as the moment of performance draws the player this way and that, moving from one to the other, in a heightened sense of accord.

The transformative power of the performance space (heterotopia) generates understandings of subtle differences in sound, of cultural narratives, of the inner space experienced through gesture and the body and the outer space of external relationships. This is an arena for dramatic exchange, of transmogrifying sounds, of voices underscoring, exclaiming, colouring, commenting, punctuating and spatialising.

Kaija Saariaho: *Laconisme de l'aile* (1982)

Laconisme de l'aile elaborates an idea of flute/bird connection – in this case representing flight rather than birdsong. Notational representations of visual and aural flight are created among an

environment of sonic transitions, from voice to flute, from pure tone to harsh. Timbral transformations and destabilisation continue throughout, as the voice and air 'interrupt' the flute. The composer writes:

> The possibility to move from secret whispers into clear, beautiful and 'abstract' sound was one of the starting points for *Laconisme de l'aile* . . . Another important image . . . was that of birds, . . . the lines they draw in the sky when flying.
>
> *(Saariaho, cited in Hoitenga, 2011, para. 2)*

Text and voice

The text used in this work is a fragment of a poem by French poet Saint-John Perse (1887–1975), from a collection entitled *Oiseaux* (Birds):

> *Ignorant de leur ombre, et ne sachant de mort que ce qui s'en consume d'immortel au bruit lointain des grandes eaux, ils passent, nous laissant, et nous ne sommes plus les memes. Ils sont l'espace traverse d'une suele pensee.*
>
> Ignorant of their shadow, knowing of death only that immortal part which is consumed in the distant clamour of great waters, they pass and leave us, and we are no longer the same. They are the space traversed by a single thought.
>
> *(Perse, 1963/2014, p. 639)*

While the poem was not the inspiration for the piece's conception, it describes images that the composer had already imagined: 'that of birds, fighting gravity, flying away, secret and immortal' (Hoitenga, 2011, para. 2). The text is spoken and sounded during the work, and is interrupted by and transformed into pure flute sound – a transformation that continues from one sound to another throughout the work.

A Finnish composer uses the French language in this work; text, vocalisation, flute and electronic sound effects are the tools of the musical engagement. The flautist's voice is used as recitation, whispering, singing while playing, articulations such as 'tttttt . . . ' and sounds with the instrument on and off the lips. Saariaho also uses key and tongue percussion and extremes of volume, extending the sonic palette with an imaginative merging of multiple aspects of the performer that brings the interior and intimate (breath and voice) into focus. The text provides a metaphor for this investigation: the 'event' of flight, the transformations of performance, and the experiential exchange underlining and expanding understanding of culture and transition. The discourse and interplay as event opens up possibilities and new ways of transforming experience.

Performance

The performance environment for *Laconisme de l'aile* is a dynamic context of evolving and fluctuating energy. The flautist shifts away from the normative playing role as the work begins with recitation of the poem, melding eventually with breath and flute tone, stuttering articulations, then a flight upwards: 'a line in the sky' (Hoitenga, 2011, para. 2). Key slaps create a polyphony with over- and under-pressure flute tone, interspersed with glissandi, trills and breath tones. Further dialogical interplay between flutter-tongued fragments and crushed notes lead to full tone vibrato that quickly dissipates into pianissimo flutter and breath trill. Gliding up and down through this shifting set of timbres, which later include whispering and pitched

singing, multiphonics, tongue pizzicato, pitch bends, combined breath and tone and recitation provokes an astonishing sense of movement, culminating in rising microtonal runs that fade away to extended whistle tones at the end.

In performance one is immersed in this flow of multiplicities, propelled through the music into vibrant textures and trajectories. Physical sensations and gestures are enlarged further by the electronics, which add a spatiality that greatly enhances performer response, even through the relative lightness of the sound effects. Amplification, reverberation with variable reverb tempo (around 2.5 seconds, bright) and harmoniser – microtonal pitch shifting (50 cents both sides) and multiple speakers are optional, but desirable performance facilitators. In the centre of this sound field, the flautist feels an envelope and enrichment in the sounds, a heightened sense of awareness of micro sound structures and performative malleability.

The voice symbolises and creates a human presence, the presence of the flautist. Vocalisations meld with flute and breath, emanating from whispers, pitches or speech; they suggest location, other presences and diverse manifestations of self (Penny, 2009, p. 126). Whispered voice evokes close proximity, ambiguities of identity and revelation of the inner self; singing while playing suggests multiple characters – as invisible extensions of the self; spoken words introduce a new persona and repositioning of the self in the space. Is the performer a flautist, singer, speaker, French, Finnish, Australian, near or far, hidden or exposed? These are powerful ambiguities, questioning our values and knowledge, and selves.

Creating this symbiosis within performance mediates the context and signifies a melding of cultural knowledge and transferral. Shifting perception of performer identity (flute, text and voice), and disrupted expectations of cultural 'norms' (performative behaviour and positions) provoke new explorations and new understandings, as shown in Figure 15.2 below.

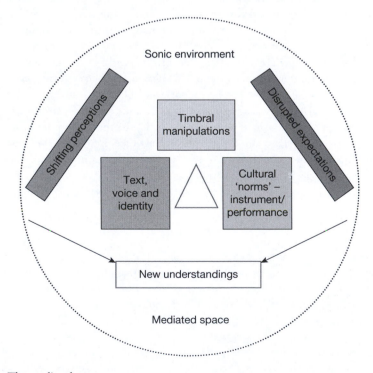

Figure 15.2 The mediated space.

Heterotopian analysis of Laconisme de l'aile

The heterotopian space in this work involves imaginative exchange processes within the transitionary and transformative sonic environment, re-evaluations of performer identity and reality, symbiosis of cultures and disciplines, and self-reflection. A 'fusion of horizons' (Gadamer, 1975, p. 304) emerges through engagement with text and the dialogical interplay of flute and voice; cultural narratives are constructed, along with significations and attribution of sonic meanings. The inner space – sensing of body movements, and the outer space – sensing of the external world, couple together as perception and action.

The idea of the heterotopian performance space expands into a correspondence with the score, the 'mediator between mind and sound' (Leman, 2008, p. 218), and the concept of the score as relationship. Yolande Harris posits that, rather than considering the score as a set of instructions, it can be seen as 'facilitating and articulating *relationship*; relationship between time and space, the visual and the sonic, one person and another' (Harris, 2014, p. 196). *Laconisme de l'aile* is a score containing music notation, text and instructions for electronics. The composer's representation of the work (score) presents the performer with an inherently intercultural artefact that initiates the performance space relationships. The performer encounters the pages, deciphers the notations, structures an interpretation and sets about creating the work's realisation. These processes do not necessarily move from one to the other, but develop in tandem in a fluid accumulation of responses and emerging clarity. Within these processes, the inner self/body (mental and physical responses) converges with the external world (score and presentation) to induce perception and insights for performance.

Concluding reflections

This chapter has explored performative spaces between cultures that emerge in contemporary music for flute. Two exemplars were analysed as locations of intercultural connection and creation of the heterotopian space as a performative context of understanding. Referenced through theorists and musicologists, the discussion moved through reflections on interconnecting sonic cultures, performer identity and significations of the human voice.

Performances generate cultural knowledge transferral through embedded gestural and sonic means. Synthesis of musical elements is activated by the physicality of performance and imaginative responses to sonic artefacts, including intuitive judgements of timbres and sound movement, and real-time interpretation of the symbiosis of cultures within the performance space. Knowledge from perception, cognition, emotion and gesture is unified and synthesised through the performance and activation of imagination. Cultural collaborations are thus played out in performance as works become spaces for experiencing exchange by performer and audience.

Negotiating spaces of performance and cultures creates a 'correspondence', a 'going on', an ontology of flow of growth and movement (Ingold, 2013). This ontology incorporates shared experience of cultural diversities, leading toward understanding process and the 'event' of performance. Artefacts of cultural traditions may locate music; synthesis of these challenges perceptions and engenders knowledge of difference from the inside, from the internal physical, aural and imaginative responses of the performer. The model of intercultural heterotopia shows that the activities of performance can create a space for articulating and realising this artistic activity as a living reality.

Narratives in the works discussed here are both embodied and disembodied as the words suggest meanings and the performer's voice suggests multiple identities. The words themselves become sonic units – transmogrifying the flute tones and sonic identity of the player. Shifts occur

within the performer as cultural practices, sonic memories, spatial realities and imagination are activated and bound up by the soundscape – by the music's beauty and flow, and the physical drive required to perform it. It is the sound, and the imagination of the sound, that binds it all together, that energises the performer and creates the environment of the heterotopian space.

Exploring interchanges, renewed and shifting perspectives and disrupted expectations leads to new understandings of musical performance: a 'clarity of understanding' realised through the heterotopian context. The performer's understandings, the negotiations and relationships created within the space and in correspondence with an audience, thus converge as a 'way of living' that becomes a shared experience of cultural diversity.

Notes

1 From the Greek: *heteros*, other; *topos*, place. www.collinsdictionary.com
2 *The Imaginary Space: Developing models for an emergent Malaysian/Western electroacoustic music* (2012–14). Fundamental Research Grant Scheme, Ministry of Education, Malaysia.

References

Anderson, C. (2014). The use of traditional Japanese music as an inspiration for modern saxophone compositions: An interpretive guide to Joji Yuasa's *Not I but the Wind . . .* and Masakazu Natsuda's *West, or Evening Song in Autumn.* Doctor of Musical Arts dissertation, University of Illinois. [online] https://www.ideals.illinois.edu/bitstream/handle/2142/49546/Christopher_Anderson.pdf?sequence=1 (accessed 23 February 2015).

Bourriaud, N. (1998). *Relational aesthetics.* Paris: les presses du réel.

Bourriaud, N. (2011). Introduction. In M. Foucault, *Manet and the object of painting* (pp. 9–19). London: Tate Publishing.

Coessens, K. (2014). Interlude III: The score beyond music. In P. de Assis, W. Brooks & K. Coessens (Eds.), *Sound & score: Essays on sound, score and notation* (pp. 178–184). Ghent: Leuven University Press.

Connor, S. (2000). *Dumbstruck: A cultural history of ventriloquism.* Oxford: Oxford University Press.

Connor, S. (2009). The Chronopher. A talk given at the Curtis R. Priem Experimental Media and Performing Arts Center (EMPAC), Rennselaer Polytechnic Institute, Troy, NY. www.stevenconnor.com/chronopher/ (accessed 26 April 2011).

Emmerson, S. (Ed.) (2000). *Music, electronic media and culture.* Aldershot, UK: Ashgate.

Foucault, M. (1984). *Of other spaces, heterotopias.* From: *Architecture/Mouvement/Continuité* (Trans. J. Miskowiec). From lecture 'Des Espace Autres' (March 1967). [online] http://foucault.info/documents/heterotopia/foucault.heterotopia.en.html (accessed 28 November 2014).

Gadamer, H.-G. (1975). *Truth and method,* 2nd rev. edition (trans. J. Weinsheimer & D. G. Marshall). New York: Crossroad.

Harris, Y. (2014). Score as relationship: From scores to score spaces to scorescapes. In P. de Assis, W. Brooks & K. Coessens (Eds.), *Sound & score: Essays on sound, score and notation* (pp. 195–205). Ghent: Leuven University Press.

Hoitenga, C. (2011). The flute music of Kaija Saariaho: Some notes on the musical language. [online] http://hoitenga.com/site/wp-content/uploads/2011/05/Saariaho-Musical-Language2.pdf (accessed 30 November 2014).

Ingold, T. (2010). *Bringing things to life: Creative entanglements in a world of materials.* [online] http://eprints.ncrm.ac.uk/1306/1/0510_creative_entanglements.pdf (accessed 30 November 2014).

Ingold, T. (2013). *Making: Anthropology, archaeology, art and architecture.* Abingdon & New York: Routledge.

Kim, J.-H. (2009). Multicultural influences in the music of Isang Yun as represented in his Concerto for Flute and Small Orchestra. Doctor of Musical Arts dissertation, The University of Alabama. [online]. http://acumen.lib.ua.edu/content/u0015/0000001/0000171/u0015_0000001_0000171.pdf (accessed 12 May 2015).

Lau, F. (2004). Fusion or fission: The paradox and politics of contemporary Chinese avant-garde music. In Y. U. Everett & F. Lau (Eds.), *Locating East Asia in Western art music* (pp. 22–39). Middletown, CT: Wesleyan University Press.

Leman, M. (2008). *Embodied music cognition and mediation technology*. Cambridge, MA: The MIT Press.

Penny, J. (2009). *The extended flautist: Techniques, technologies and performer perceptions in music for flute and electronics*. Doctor of Musical Arts thesis [online] http://www.griffith.edu.au/__data/assets/pdf_file/0003/184782/penny_the_extended_flautist.pdf.

Penny, J. (2014). Unravelling intercultural knowledge through performative contexts: A flautist's perspective. In C. S. C. Chan & J. Penny (Eds.), *Sustainability in music and the performing arts: Heritage, performance and education* (pp. 37–56). Tanjong Malim: Penerbit Universiti Pendidikan Sultan Idris.

Perse, S.-J. (1963/2014). *Collected poems by Saint-John Perse* (trans. Fitzgerald 1966). Princeton, NJ: Princeton University Press.

Reardon-Smith, H. (2013). *The other flautist: Vocal sounds in contemporary flute music*. M.Phil. thesis, University of Queensland. [online] http://espace.library.uq.edu.au/view/UQ:305621 (accessed 30 November 2014).

Saariaho, K. (1982). *Laconisme de l'aile*. Hameenlinna, Finland: Jasemuiikki Oy.

Takemitsu, T. (1971). *Voice*. Paris: Editions Salabert.

Takemitsu, T. (1994). *Confronting silence: Selected writings* (trans. Y. Kakudo & G. Glasow). Berkeley, CA: Fallen Leaf Press, Kindle edition.

Yun, I. (1977). *Concerto for flute and small orchestra*. Berlin: Bote & Bock.

16

FRAMING "BOYS' ART EDUCATION" THROUGH AN INTERCULTURAL LENS

Dónal O'Donoghue

Introduction

An often-cited quote from Gilles Deleuze's work is: "Something in the world forces us to think. This something is an object not of recognition but of a fundamental encounter" (Deleuze, 1994, p. 139). During the fall of 2013, I found myself in the situation that Deleuze's words express. I received an invitation to address a gathering of teachers, researchers and policy-makers on the subject of "Boys' Art Education" in Canberra Australia.[1] Curious to figure out what this concept of "Boys' Art Education" might *mean* and *do*, I turned to the work of contemporary artists, queer theorists, and intercultural scholars. In particular, Gérard Bouchard's (2011) intercultural work, while developed within the context of ethnocultural diversity (and its management), seemed useful for this project, especially his idea that "the spirit of interculturalism invites us to recognize the diversity of situations in order to provide a diversity of solutions" (Bouchard, 2011, p. 467). For me, Bouchard's ideas provided an opportunity to approach this concept of "Boys' Art Education" from the side rather than from head on. Indirectly, they called for an attention to the political potential of art itself in the education of boys; that is, art's potential to open worlds to boys that are not normally available to them and art's capacity to address boys as always becoming beings, as beings who are always in potential to be or do otherwise. This chapter is intended as an inquiry into the concept of "Boys' Art Education." It suggests that this concept ought to be welcomed for the types of thinking it activates, demands and makes possible, while, at the same time, resisted for its anti-intellectual impulses. Arguing that art has the potential to bring boys into contact with other ways of inhabiting and dwelling in the world, with ways of seeing, feeling, sensing and thinking, this chapter aims to extend current understandings of the concept of "Boys' Art Education" as presently articulated in the literature (see, for example, Bradley, 1986; Chalmers, 2001; Chalmers & Dancer, 2007, 2008; Imms, 2000, 2003a, 2003b, 2004, 2006, 2012) by invoking intercultural practices of thinking.

Where to begin . . . turning to contemporary art practice

The task of figuring out what might be meant by the term "Boys' Art Education" is a complex one, and one that is contingent on a whole range of diverse factors. At its most general level, one could say that the term stands for everything that pertains to the experience of educating boys in and about art, in schools and elsewhere. This includes boys' experiences of being educated

as art makers and receivers. And, it might even be suggested that "Boys' Art Education" is a particular approach to the practice and theory of art education that is gaining some currency in an educational world increasingly dominated by markets (Waslander, Pater & van der Weide, 2010). Adding the qualifier "boys" to the term art education does enact a shift in emphasis, no matter how slight. It does so in ways not dissimilar from how other theories and practices of art education such as Discipline-Based Art Education (Dobbs, 1989; Eisner, 1990; Greer, 1984), Visual Culture Art Education (Duncum, 2002, 2009; Freedman, 2003; Garoian, 2006; Tavin, 2005), Multicultural Art Education (Chalmers, 1996; Collins & Sandell, 1992; Stuhr, 1994) and Social Justice Art Education (Quinn, Ploof & Hochtritt, 2012) have done in the past.

And yet, the project of figuring out what might be meant by the term "Boys' Art Education" is one that could perhaps be explained by reference to an artwork that I saw recently at the 2014 Whitney Biennial at the Whitney Museum for American Art in New York City. Entitled *945 Madison Ave* and conceptualized by the Brooklyn-based artist Zoe Leonard, the way in which this artwork was produced was quite straightforward, but the manner in which it functioned was not. Sectioning off an area on the fourth floor of the museum, Leonard created an enclosed room, dark in the inside, lit only by the light that came through a small opening that she had created on the Marcel Breuer signature window of the museum. This light that streamed in through the opening projected an image of the street outside—Madison Avenue— on the surrounding walls, with the result that the space that Leonard created functioned as a camera obscura. The light that streamed through this opening also illuminated the space. Because it was a real-time projection of the external environment, the image on the interior walls of the installation was never fixed. It changed constantly, even if not considerably, as it reflected and was a reflection of light changes in the outside world, movement on the street, and so on. Without expecting to, viewers found themselves positioned inside what appeared to be a large camera box that functioned as an image-receiving device. Inside, viewers' eyes adjusted to the dark and they began to notice the projected image of the street outside.

As viewers walked between the apparatus of the projection, the projection, and the surface that received it, their encounters in and with the work opened it to unanticipated interpretations, while at the same time closing it down to others. Every interpretation, one might say, brought the work into being differently, while at the same time fixing it for the one who was interpreting. One could further say that the very possibility of the work and the manner in which it functioned was enabled by "a complex constellation of modes" (Kishik, 2012, p. 35)—a multiplicity of occurrences and elements that interacted with one another: light; dark; the form of the room; the small opening in the existing window; the outside; the space that is bounded by the street; the activity of the street, as well as the receptive viewer inside the installation, the informed, curious onlooker, and the patient observer all worked together, to varying degrees, to co-produce this work with the artist. In other words, the functionality of the work was contingent on the range of factors and yet the idea of the work was not reducible to the successful actualization of any one of these factors. While Leonard put certain conditions in place for the work to function, she could never fully control how it would actually function. Neither could she fully control how it would appear to others, or, indeed, how much it would change over time. For instance, the projected image had a different intensity on an overcast day than it had on a bright sunny day. Factors beyond the artist's control played a significant role in how the work functioned, with the effect that she was but one of many producers of the work. Like Leonard's, *945 Madison Ave*, then, when we talk about art education for boys in and through the concept of interculturalism, we never just simply talk about it in isolation from other factors. Rather, we talk about it in relation to many different and intersecting discourses—discourses about gender, schooling,

learning, masculinities, sexualities, education, and so on. Any attempt to understand boys' art education demands that we slow down our interpretative processes in order to look for that which might not be immediately visible or easily apprehended on first glance.

Engaging in conversations about boys, men and the performance and representation of masculinities seems to be a growing phenomenon in the art and curatorial worlds. In both worlds, there seems to me to be a growing interest in addressing what it means to be a boy and a man at the present time through art making and exhibition making. During the past two years, for instance, a sizeable number of large, medium, and small scale exhibitions have been hosted by national museums, commercial galleries, artist-run spaces, and university-based galleries. These exhibitions aim to address, or at least bring to attention, issues of boyhood and masculinity, both their representation and production. For example, in 2014 at the Musée d'Orsay in Paris, a large-scale survey of representations of the male nude from the 1800s to the present day was staged. Several months previously a similar exhibition was held at the Leopold Museum in Vienna entitled *Nude Men from 1800 to the Present Day*. The objective of that show, the curators tell us, was "to clearly show . . . competing models of masculinity, the transformation of ideas about the body, beauty and values, the political dimensions of the body, and last but not least the breaking of conventions" (Leopold Museum, 2013, n.p.). Also during 2014, Duke University in the United States staged an exhibition entitled, *Masculinities: Mainstream to Margins*, while the exhibition *Company of Men* curated by Damien Hinds was shown in Melbourne Australia and later in Sydney. Hinds' show "[explored] the complexities, difficulties and joys of masculinity, gay sexuality and contemporary gay life" (de Jonk, 2014, n.p.). In Ireland, *Lost Boys: The Territories of Youth* was a group show staged at the Lewis Glucksman Gallery. This exhibition explored the ways in which boyhood and masculinity are performed, negotiated and read in and through place.

Also in 2014, *"I'm Your Man"*, curated by Lauren Kalman and Milleei Tibbs was staged at the ISE Cultural Foundation NY. The curators tell us the exhibition

> explores the construction of masculine identity through performance [and] questions the idea that the white male is the norm by bringing to light his place of privilege and therefore subjective perspectives, expectations, and advantages that are attached to the male body.
>
> *(ISE Cultural Foundation NY, 2014, n.p.)*

Included in the show was the work of Jesse Burke, an American artist. In his series of photo-based works, entitled *Intertidal*, featuring 18 colour images hung at various levels, Burke examined, what he called, "the ambivalent domain between the heroic ideal of masculinity and the true reality of being male" (Clampart, 2010, n.p.). It is the space, as R.W. Connell (2000) reminds us, within which many men reside: that is "in a state of some tension with, or distance from, the hegemonic masculinity of their culture or community" (Connell, 2000, p. 11). By photographing men in his social and family circles, and in the places in which he encounters them, Burke gives visual form to the physical spaces in which they hang out, dwell, and come into contact with one another. Further, in doing so he intimates the types of intimate negotiations that happen between men in these settings. As these men connect with each other and come to understand or represent themselves in relation to themselves and the other, Burke is there to give visual form to such negotiations. The title of Burke's series, *Intertidal* is indeed interesting to think more about to the extent that it opens a space for us to consider the production of masculinity and its relation to factors outside of, and beside it. The term intertidal is oftentimes used to describe the landmass above water at low tide and underwater at high tide.

It comes into visibility under certain conditions and disappears under others, much like certain performances of masculinity, one might say. The intertidal zone has the quality of being visible and invisible, at times submerged, and at other times exposed. It becomes visible or loses visibility as a result of forces other than itself—the sea moves as it is pulled by the moon and sun. When it is visible, it marks that the tide is out while its invisibility marks that the tide is in. So, it can be present or absent, or present in its absence. The intertidal zone can appear as either land or sea depending on the time at which one encounters it. Further, it is an adaptive space that contributes to the production of life and to sustaining many different life forms. For that reason, we might say, it is a place of great abundance, a place of much activity. It is a place of survival, of negotiation, and yet it is a hard place, where survival for many has to be fought and won.

Likewise, for 2013, one could point to several exhibitions that explored boys' and men's lives. For example, *Boys Club*, a group exhibition at the University of Winnipeg Canada "explored representations of masculinity"; *Full Frontal*, a small exhibition, staged in Vancouver Canada, examined the representation of the male body; *"Be A Man,"* staged in London, was an exhibition that brought together the work of seven artists from the 1920s to the present day to "explore masculinities from a range of perspectives." In that show, the work of Mahtab Hussain was included. Hussain spent three years photographing Pakistani communities in Birmingham, focusing in particular on what it might mean to be the British Pakistani male at the present time. Included in the exhibition were works from his series called *You Get Me?* This was a collection of photographs, which, he says, "[address] the changing identity of young British working–class Asian men in England." Focusing on young men's capacities to live in the world, which can be welcoming and hostile, familiar and foreign, while simultaneously producing a world, Hussain pictures young Pakistani men as highly visible and yet invisible in many quarters of the city.

Arguably, the staging of these exhibitions and the ideas that are produced by engaging with the works shown hold promise for developing a different or perhaps more nuanced language for how boys are addressed by the world, and how they, in turn, address the world to make it otherwise. These provocations (playing with finite representations in infinitely differing ways) together with some of the thinking practices prompted by intercultural theory perhaps offer ways into thinking and talking about this concept of "Boys' Art Education" – attempting a definition, if you will. For Roland Barthes (2012, p. 58), "to 'define' [is] to mark out borders, frontiers." That is, to begin the work of separating out, drawing lines and creating boundaries no matter how prone they are to change. To define, of course, is to do the work of identifying and enacting criteria for inclusion and exclusion, from which whole new categories of insiders and outsiders, of those who belong and of those who do not, are established. Engaging in definitional work of any kind provides opportunities to imagine what something might be or become. For these reasons, then, there are, one could argue, many different types of negotiations involved in defining "Boys' Art Education," from identifying issues to imagining ways of addressing them, managing them, and advocating for them.

Elaborating a "Boys' Art Education": possibilities and problems

To begin the work of defining and elaborating the conditions of a "Boys' Art Education," it is important to acknowledge that art educators are already in the business of providing an education in art to boys, and have been for some time. But perhaps the sex of students has mattered less in the past than it does in the present time since the project of imagining or designing art programs for individuals based on their biological sex did not seem as pressing before now.

Perhaps what has mattered more was what it meant to make things (aesthetic forms) and engage with the things made by others. Since art education, or variations of it, first appeared in public education in the late nineteenth century, boys have studied art and received an education in it. In other words, boys' relationship with art education has a long history. So one might say that whenever educators create learning experiences for, or interact with, boys in art education classes, they are already doing boys' art education, even if these educative engagements have not been recognized as such. That being said, it is equally important to acknowledge that this project of identifying, articulating, and elaborating a "Boys' Art Education," like any project, is not a disinterested one. It is political by its nature, in the same way that any project that attempts to propose something new, something other, something that has not existed previously, is political.

When presented with the concept of "Boys' Art Education," one is required to take seriously its possibilities and limitations, as one attempts to figure out what it might mean. When presented with the concept of "Boys' Art Education," one is also required to resist the anti-intellectual impulses that underpin it and its seemingly self-evident meaning. In the words of Eve Kosofsky Sedgwick (1993, p. 17), "Anti-intellectuals today . . . are happy to dispense with the interpretative process and depend instead on appeals to the supposedly self-evident." And for Edward Said (1994, p. xi), the responsibility of the intellectual is "to break down the stereotypes and reductive categories that are so limiting to human thought and communication." To engage in the interpretative work that Sedgwick calls one to do, and to participate in a dismantling of stereotypes that Said sees as a central purpose of the intellectual's work, one might begin by saying that an art education designed specifically for boys is a good thing, and that there is merit to imagining a form of art education that would respond to the needs, hopes, capacities, preferences, abilities, and learning practices of a set of individuals in our world known as boys. Not only does imagining a boys' art education invite us to identify content, activities, experiences to which all boys should have access, but it also likely goes some way to increase boys' creative and imaginative capabilities, develop their capacities to interact with the world analytically by asking critical questions of things that appear in the world as normal or given. However, no matter how well intentioned one's desire for a "Boys' Art Education" might be; no matter how deeply one is invested in knowing more about how boys learn in the art class and build a relation with art; one cannot deny that an art education designed specifically for boys is founded on, and carries with it certain assumptions about boys – who they are, what they like and are like, what they can and cannot do, what they should be encouraged to do, and how they think, act, and interact with the world. In other words, to imagine an art education for boys is, at the same time, to reduce boys to a set of common characteristics and traits, which is not beneficial to all boys, if, indeed, it is beneficial to any boy. For instance, wouldn't such a move be particularly harmful to those boys who neither display these identified traits and characteristics nor conform to them nor learn to appear as if they possess them? And so, perhaps one might speculate that to engage in such a project is to run the risk of limiting what a boy can become rather than enabling him to become more than, or different from what he at first imagines for himself. It is to ignore the intercultural nature of masculinities (and boyhood) and the experience of living in the world as a boy and identified as such (Jandt and Hundley, 2007).

Surely one cannot acknowledge the perceived benefits of a boys' education without also acknowledging that any such gender-specific art education program runs the risk of becoming subject to the "if only . . . " impulse or syndrome, which curriculum scholar, Bill Pinar (2006) writes about. In his critique of the social engineering tendencies of educationalists, and the reluctance of the "academic field of education" to take leave of such tendencies, Pinar writes,

> If only we can find the right technique, the right modification of classroom organiza-
> tion . . . if only we teach according to "best practices", if only we have students self-
> reflect or if only we develop "standards" or conduct "scientific" research, then students
> will learn what we teach them. If only we test regularly, "no child" will be "left behind."
>
> *(Pinar, 2006, p. 109)*

And so, following Pinar's caution, we ought to be mindful of the risks of falling prey to, or into the trap of thinking if only we diversified our art curriculum; if only we included more "computer design and digital photography" and less "drawing and painting," as the 2008 Ofsted Report in England suggests; if only we incorporated more physically demanding tasks into our art classes; then boys would elect to study art in school in numbers comparable to girls. And, further, they would achieve results that equalled or exceed but definitely did not lag behind their female classmates. A more recent Ofsted Report (2012, p. 10) with data derived from subject inspections of 96 primary schools, 91 secondary schools and seven special schools between the years 2008 and 2011, reports, "In 2011, 26% of girls gained grades A★ or A in GCSE art and design compared with 12% of boys, and 83% gained grades A★ to C compared with 65% of boys." Of course, issues of subject choice and subject performance are far more complicated than is often imagined.

The possibility, then, of elaborating a "Boys' Art Education" is closely tied to the ability to be able to claim beyond reasonable doubt that all boys share in common an essence which is exclusive to boys, not to be found in girls, and not affected by the various qualifiers that we could place in front of the word boy—qualifiers that acknowledge particularities and differences among boys, qualifiers such as gay, straight, white, brown, black, rich, poor, immigrant, Aboriginal. One might ask: Does the "gay boy," "straight boy," "white boy," "brown boy," "black boy," "rich boy," "poor boy," "immigrant boy," "Aboriginal boy," or indeed the "poor white boy" or the "gay poor immigrant boy" all share a common essence? Surely not. Further, the possibility of elaborating a "Boys' Art Education" depends on the ability to be able to claim that boys are distinctly different from girls; that they approach art learning differently from girls; that their learning needs ought to be supported differently from girls'; that distinct conditions need to be put in place for them to learn to live in the world with art; and last, as already mentioned, that in their difference from girls, they share among themselves common ways of doing, thinking, learning, and talking. Given that Connell (2000, p. 12) argues that "men's bodies do not determine the patterns of masculinity, as biological essentialism and pop psychology would have it," doesn't an argument made for a type of art education based on biological sex seem somewhat problematic? Several other questions come to mind. For instance, might such a project be viewed as one that leans toward the principles of conformity, standardization, certainty, and knowability, while at the same time leans away from such principles as indeterminacy, contingency, uncertainty, unknowability, and radical diversity? Might such a project be viewed as being somewhat intolerant or impatient toward inconsistencies, ambiguities, misalignments, and mismatches? Might a project such as this encourage one to believe that he or she knows best what is good for somebody else, without first taking time to get to know aspects of that somebody else?

We might ask what evidence there is to suggest that one's sex should be a primary determining factor in the design and provision of art learning experiences for school children. Relatedly, who or where is the boy when he is being addressed as a student by his art teacher in the art class surrounded by other students, other learners, other boys and/or girls? In this pedagogical exchange, does he present as boy first and a student second, a learner third perhaps? Does his "boyness" precede all and any interaction with him? Addressed as a learner, a student, even an

artist-student in this pedagogical exchange, perhaps his "boyness" or the fact that he is a boy matters less than what we imagine. What I am trying to open here for thought is the idea that perhaps a student's gender might not always matter to the extent that we think it matters or ought to matter in the pedagogical encounters and exchanges that we have daily in our class-rooms or other educational spaces. And isn't the project of identifying and articulating a "Boys' Art Education" already limited by and contained within current understandings of what a boy is, current understandings of what art education is and can do, hence the usefulness of intercul-turalism as a frame for thinking critically about this concept of "Boys' Art Education"?

The problem of a "Boys' Art Education" becomes all the more problematic and trou-bling when we acknowledge that the designations of boy and girl no longer accommodate the scope of gender identifications that individuals can and might choose to represent themselves. Recently, the Vancouver School Board—the school district in my home city and the school district within which many graduate students enrolled in our Art Education Program at UBC already teach and many of our art teachers in preparation will likely teach after graduating—passed a sex-neutral third person pronoun policy whereby students have the right to ask to be addressed by a pronoun suitable to the student's identified identity; gender specific or indeter-minate. According to the policy, these sex-neutral pronouns – xe, xem, or xyr – will likely be used by transgender students, but can also be used by intersexed students or anyone who believes that gendered pronouns are unsuitable for that person's identification. Further, students have the option to choose to use any washroom facilities that they prefer, including a unisex washroom option. Relatedly, Australians have the option of selecting "x" as their gender on their passport applications – signifying indeterminate, unspecified or intersex. In 2012, a simi-lar option was introduced for New Zealanders. In Europe, Germany was the first country to legally recognize a third gender as recently as 2013. Similar to intercultural focused scholarship, these realities of lived experience complicate and extend understandings of gender identity and gender politics.[2]

In efforts to imagine a "Boys' Art Education," the focus is likely to shift away from the nature of art and its educative potential to concerns for what boys seemingly want and need. Attention shifts to the types of curricular experiences and pedagogical approaches that might best serve their perceived needs and wants. In other words, if, as David Kishik (2012, p. 35) says, drawing on Deleuze's example, "a workhorse may be more similar to an ox than to a racehorse," might we say that a "Boys' Art Education" is more closely aligned to other types of activities that are produced in response to the perceived needs of boys than it is to art education itself and the opportunities that art education offers to learn about art and living in the world? On many occasions, I have noticed that in efforts to identify and elaborate an art education for boys, the concept of *boy* seems to remain stable. It seems to remain unchallenged, unchanged and intact—not troubled, if you will. It seems as if art education has to change to accommodate some concept of a boy, whereas neither art education nor conceptions of "boy" are ever stable entities in themselves.

Given that Leo Bersani (1995, p. 42) reminds us that "heterosexuality . . . promotes the myth that there really is a difference between the two sexes," might we view attempts to imagine and articulate a "Boys' Art Education" as an effort to downplay the homosexual inti-mations that art in school often carries for boys. Philip Kennicott (2011, n.p.) reminds us that "Artists with same-sex desires have played a disproportionate role in the creation of Western art, especially in the past century." Surely this has filtered down into the school system, with the result perhaps that art in schools can, at times, and depending on a range of other factors, be perceived as a subject less suitable for boys than girls, less suitable for "manly men" and more suitable perhaps for men who supposedly display traits and characteristics considered effeminate.

It could be said that homophobia itself is part of the problem that we are trying to address here, even though we may not be naming it as such. Given that Audre Lorde (1984, p. 45) definition of homophobia—"the fear of feelings of love for members of one's own sex and therefore the hatred of those feelings in others"—might we speculate that there is perhaps a possibility that boys fear being seen as other than they wish to be seen should they become "too attached" or indeed overly identified with art in school. Further, might this contribute in ways that we do not yet know to why boys tend not to elect art education courses in numbers similar to girls?

Might we even say that producing a "Boys' Art Education" is indeed a form of commodity production, a gesture in the direction of developing and marketing boutique programs aimed at boys, and boys only? Might there be neoliberal undertones to be gleaned from this move to articulate gender-specific art education programs that claim to take into account, gendered ways of learning? Further, to pursue and make explicit what art education does or can do for boys is to simultaneously make it available for surveillance, for disciplinary intervention, and to reduce if not to eliminate its capacities to always be more than one expects it to be. If we say it does this and this and not that, then an art education that fails to deliver on these identified outcomes can only be considered a failed art education, and not worthy of support or resources. Further, as we talk about and describe the types of experiences that we provide boys in our classes there is a danger that these experiences become the ones that we say boys value most and benefit most from, as they seem to correspond with their perceived needs.

Concluding thoughts

To return to where I began: Perhaps, instead, what we ought to be pursuing is a re-engagement with the possibilities that art offers for forming a life, one among many, while simultaneously ensuring that art education does not find itself in the position of having to regulate gender performance and appearance. We need to keep alive the idea that an education in art fosters ways of living in, and connecting with, the world in non-habitual ways. Perhaps what we are talking about when we summon the concept of "Boys' Art Education" is, in fact, the space between ideas about what a boy is and ideas about what art education is, which are always shifting, of course. To draw attention to the space between boys' worlds and art education worlds, between the practices of producing boys and producing art education, is to put both concepts into play, and watch how each play out in relation to the other, and in response to one another. And so perhaps we ought to be asking, in what ways can art education offer boys a place to become knowledgeable about the world. Since we already seem to be asking what art education can learn from boys and how it should function as a result of that learning, now perhaps we ought to begin from the other way around with the question: How might art education address boys as men becoming? In other words, what ways can art education contribute to how boys see themselves and others in the world?

As I mentioned at the beginning of this chapter, one of my intentions in writing it was to push this idea of "Boys' Art Education" to a different place, different from the one in which it tends to be conceptualized and spoken about in the present moment. One way of doing this is to invoke practices of thinking that are specific to interculturalism: intersectionality, interactivity, complexity, curiosity, and the recognition that situations and occurrences are diverse, situated, oftentimes contradictory and always becoming. My hope is to extend this idea of "Boys' Art Education" out of and away from the hospitable terrain in which it finds a home in gatherings such as the one in which I participated in Canberra, Australia. Gatherings such as these can provide terrains in which this concept can take root easily and without too much discomfort. In undertaking this task of extending this concept of "Boys' Art Education" to a different place,

my intention is to point to some of the possibilities as well as the limitations and drawbacks of taking seriously this idea of "Boys' Art Education." My hope is that this chapter has brought to the surface aspects of the unconscious, the unthought, and the unstated in this thing called "Boys' Art Education."

Notes

1 The 2014 *Boys' Art Education Symposium*, held at St Edmund's College, Canberra, Australia, July 3–4.
2 Interestingly, as Chávez (2013, p. 84) points out, "Halualani, Mendoza, and Drzeweicka's (2009) review of the development of critical intercultural communication scholarship also neglects mention of queer or trans approaches or the salience of transgender or sexuality to the development of this scholarship."

References

Barthes, R. (2012). *How to live together: Novelistic simulations of some everyday spaces*. New York: Columbia University Press.

Bersani, L. (1995). *Homos*. Cambridge, MA: Harvard University Press.

Bouchard, G. (2011). What is interculturalism?/Qu'est ce que l'interculturalisme? *McGill Law Journal, 56*(2), 435–469.

Bradley, L. S. (1986). Art and the American boy. *Art Education, 39*(5), 45–47.

Chalmers, F. G. (1996). *Celebrating pluralism: Art, education, and cultural diversity*. Los Angeles, CA: Getty Education Institute for the Arts.

Chalmers, F. G. (2001). Art education in a manly environment: Educating the sons of the establishment in a 19th century boys' school. *Studies in Art Education, 42*(2), 113–130.

Chalmers, F. G., & Dancer, A. A. (2007). Art, boys, and the boy scout movement: Lord Baden-Powell. *Studies in Art Education, 48*(3), 265–281.

Chalmers, F. G., & Dancer, A. A. (2008). Crafts, boys, Ernest Thompson Seton, and the woodcraft movement. *Studies in Art Education, 49*(3), 183.

Chávez, K. R. (2013). Pushing boundaries: Queer intercultural communication. *Journal of International and Intercultural Communication, 6*(2), 83–95.

ClampArt. (2010). *Jesse Burke: Intertidal*. http://clampart.com/wp-content/uploads/2012/05/Press-Release-Burke.pdf.

Collins, G., & Sandell, R. (1992). The politics of multicultural art education. *Art Education, 45*(6), 8–13.

Connell, R. W. (2000). *The men and the boys*. California: University of California Press.

de Jonk, T. (2014). *Company of men exhibition 2014*. http://vimeo.com/86811402.

Deleuze, G. (1994). *Difference and repetition*. New York: Columbia University Press.

Dobbs, S. M. (1989). Discipline-based art education: Some questions and answers. *NASSP Bulletin, 73*(517), 7–13.

Duncum, P. (2002). Clarifying visual culture art education. *Art Education, 55*(3), 6–11.

Duncum, P. (2009). Visual culture in art education, circa 2009. *Visual Arts Research, 35*(1), 64–75.

Eisner, E. W. (1990). Discipline-based art education: Conceptions and misconceptions. *Educational Theory, 40*(4), 423–430.

Freedman, K. (2003). *Teaching visual culture: Curriculum, aesthetics and the social life of art*. New York: Teachers College Press.

Garoian, C. R. (2006). Art education in the silent gaps of visual culture. *Visual Arts Research, 32*(2), 48–55.

Greer, W. D. (1984). Discipline-based art education: Approaching art as a subject of study. *Studies in Art Education, 25*(4), 212–218.

Halualani, R. T., Mendoza, S. L., & Drzeweicka, J. A. (2009). "Critical" junctures in intercultural communication studies: A review. *The Review of Communication, 9*(1), 17–35.

Imms, W. D. (2000). Boys' rates of participation and academic achievement in international baccalaureate art and design education. *Visual Arts Research, 26*(1), 53–74.

Imms, W. (2003a). Boys talk about "doing art": Some implications for masculinity discussion. *Australian Art Education, 26*(3), 29–37.

Imms, W. (2003b). Masculinity: A new agenda for art education? *Canadian Review of Art Education, 30*(2), 41–64.

Imms, W. (2004). Malcolm's story. *Art Education, 57*(2), 40–46.

Imms, W. (2006). The interplay of art education curriculum and boys' negotiation of multiple masculinities. *Australian Art Education, 29*(1), 86–107.

Imms, W. D. (2012). Masculinity and visual culture. *Asia-Pacific Journal for Arts Education*. http://www.ied.edu.hk/cca/apjae/apjae.htm.

ISE Cultural Foundation NY. (2014). "I'm your man." http://www.iseny.org/im-your-man-2/.

Jandt, F., & Hundley, H. (2007). Intercultural dimensions of communicating masculinities. *The Journal of Men's Studies, 15*(2), 216–231.

Kennicott, P. (2011). Art has yet to face up to homosexuality. *The Washington Post*, July 1. http://www.washingtonpost.com/lifestyle/style/art-has-yet-to-face-up-to-homosexuality/2011/06/28/AGByfotH_story.html.

Kishik, D. (2012). *The power of life: Agamben and the coming politics*. Redwood City, CA: Stanford University Press.

Leopold Museum (2013). *Nude men: from 1800 to the present day*. http://www.leopoldmuseum.org/media/file/292_NM_Pressetext_englisch.pdf.

Lorde, A. (1984). *Sister outsider: Essays and speeches*. Berkeley, CA: The Crossing Press.

The Office for Standards in Education, Children's Services and Skills (Ofsted). (2012). Making a mark: Art, craft and design education, 2008/2011. www.ofsted.gov.uk/ publications/110135.

Pinar, W. (2006). *The synoptic text today and other essays: Curriculum development after the reconceptualization*. New York, NY: Peter Lang.

Quinn, T., Ploof, J., & Hochtritt, L. (Eds.). (2012). *Art and social justice education: Culture as commons*. New York: Routledge.

Said, E. (1994). *Representations of the Intellectual: The 1993 Reith Lectures*. London: Vintage Books.

Sedgwick, E. Kosofsky. (1993). *Tendencies*. Durham, NC: Duke University Press.

Stuhr, P. L. (1994). Multicultural art education and social reconstruction. *Studies in Art Education, 35*(3), 171–178.

Tavin, K. M. (2005). Opening re-marks: Critical antecedents of visual culture in art education. *Studies in Art Education, 47*(1), 5.

Waslander, S., Pater, C., & van der Weide, M. (2010). Markets in education: An analytical review of empirical research on market mechanisms in education. *OECD Education Working Papers, No. 52*, OECD Publishing. doi: 10.1787/5km4pskmkr27-en.

17

BIO-CARTOGRAPHIES OF IDENTITY

A feminist approach to an intercultural art practice

Marián López Fdz. Cao

In this chapter feminist methodologies will be introduced as a way to enrich intercultural practices. A workshop from women artists' experiences will be shown as an example of methodology that can join interculturality and feminism, and as a possible way to deconstruct identity not only from hegemonic cultural bias but also from an androcentric one. On this level, we want to put into consideration how women's practices as well as non-Western practices have been undermined by hegemonic culture, showing that if the aim of new practices in art education is to open and re-elaborate cultural bias we have to deconstruct objectivity including aspects such as non-essentialism and situated knowledge as a tool for an egalitarian and democratic society.

Introduction and methodology

Feminist methodologies as tools in the deconstruction of culture: feminist standpoint, situated knowledge and the experiences of women

Feminist methodologies have resulted in a shift in epistemology, highlighting the social construction dimension of knowledge and the ideological underpinnings behind them (Keller, 1983; Gilligan, 1982; Harding, 1986, 1991, 1993, 1998; Hartsock, 1987; MacKinnon, 1989). In this respect, standpoint theory gains prominence and is used to illuminate and further explore the social—and discursive—nature of the processes of construction of both meaning and identity. Moreover, standpoint epistemologies provide a viable alternative to traditional scientific knowledge construction through denaturalizing the existent systems of power and knowledge, promoting, at the same time, the perspectives of the marginalized, generating extensive theoretical and methodological discussions among scholars pertaining to social sciences (Harding, 1987; Hartsock, 1983, 1997). Today, the explanatory power, heuristic value, and emphasis on reform of the feminist standpoint theories are widely recognized.

One of the objectives of this chapter is to analyze reality, including practices that have been undermined and forgotten because of their belonging to the field of women as a subjugated collective, and to "move" the focal point of knowledge from the male-centered position to a view that, at least, is more inclusive and multidimensional. In our case, we would shift it to bring the

practices of women from marginality into visibility. Standpoint theory becomes a powerful tool for analysis when a critical awareness of reality is assumed. As Haraway writes:

> A standpoint is not an empiricist appeal to or by "the oppressed" but a cognitive, psychological, and political tool for more adequate knowledge judged by the non-essentialist, historically contingent, situated standards of strong objectivity. Such a standpoint is the always fraught but necessary fruit of the practice of oppositional and differential consciousness. A feminist standpoint is a practical technology rooted in yearning, not an abstract philosophical foundation.
>
> *(Haraway, 1991, pp. 198–199)*

In relation to the feminist standpoint and the experience of women, Donna Haraway develops an interesting concept: situated knowledge. Situated knowledge is the place from where knowledge is spoken. The body materiality of a subject is modeled in a historical and cultural process, in which Haraway selects three items—race, gender, and class—the *topos* from which to speak.

From the concept of situated knowledge derives the reformulated notion of "objectivity", permeated by the term "vision", which Haraway uses as a metaphor for the production of knowledge: vision is an interpretative tool. The recognition that all eyes are a technological, material and historical product is the first step toward accepting the fact that objectivity is a conversation of different situated knowledges, views built with various variables in which democracy, the exercise of equality, can mitigate the asymmetry of the members engaging in the conversation.

The concept of women's experience holds, for Haraway, a major power, not only in its eagerness to discover, locate and find common experiences, allowing them to speak in their individuality, incorporating experience in the form of narration, but because this invites the possibility of telling the experience again. On the one hand, the concept of women's experience responds to a critical exercise that rejects the univocity of knowledge, science and art as unique optics allowing, at the same time, the creation and use of other lenses, and the exercise of other narratives, other fictions, as intentional building-bricks of the construction of meaning.

In reference to the important concept of *situation*, Simone de Beauvoir defined situation as the social, economic and political context that can hinder or intervene in the project of each subject. In this sense, Haraway's concept of situation goes beyond Beauvoir's definition, as every context in which knowledge is constructed is determined by origin, class, and gender, among others. What women have in common in this respect is a shared experience of being subject to domination; an experience inherent to a specific sexuated body, an understanding of subjectivity in relation to the body. This is a condition—the sexual body—that our society has turned into the axis of the domination of women, leading them to follow a certain code of conduct, considering them a *topos*, and limiting them in the exercise of their rights as citizens.

One of the achievements of feminist methodology and epistemology has been the deconstruction of the cognitive process, the dissolution of the separation of knowledge and policy from the cognitive subject (Harding, 1993; Snyder, 1995). In other words, the deconstruction of the cognitive process has involved the creation of a consensual objectivity, an objectivity understood as knowledge located in conversation, of subjects as multiple partners in the construction of meaning, and in a continuous solid reflexivity, without abandoning a project of social emancipation.

The experience of women becomes a powerful artifact, an extraordinary tool to acknowledge other points of view that switch on new lights and move the autarchic axes of hegemonic knowledge to the light of the critical margins. Women's experience becomes a liberating artifact because it gives rise to the construction of multiple narratives that generate new and valuable speeches for knowledge, science, culture and art.

In this chapter, I present the development of a project and methodology within a gender perspective, applicable to an intercultural art education, developed with migrant women by the Research Group 941035: Art Applications for Social Integration from the University Complutense of Madrid and connected with the Masters on Art Therapy and Art Education for Social Inclusion. Our methodology involved the following tenets: first, the articulation of "situated" biographies in a workshop I directed for women from different origins, locating their life paths which are crossed because of their origin, and discourses on gender in each specific culture; and, second, the development of instruments of "autoreflexive" assessment, allowing a self-critical vision of the researcher regarding his/her preconceptions about the origin, but also, about gender in the group of people with whom he/she works. Our experimental project had six specific objectives:

1 Generating a space for encounter, where new networks can be created.
2 Fostering autonomy, decision-making and self-knowledge.
3 Bringing about empowerment: feeling able and present, taking part, as well as boosting self-esteem and seeing themselves as creators.
4 Working on uncertainty in the not-knowing that is characteristic of art, and transferring it to the not-knowing of life.
5 Working on disappointment, the so-called "end of the honeymoon" of the migratory process and of the encounter with the other.
6 Focusing on the constitution and the reflection on identity related to both cultural backgrounds and to pre-assigned gender roles, having as a starting point the fact that identity is always under construction.

Working with migrants, working with women: fundamentals

Before presenting the experimental work carried out with a group of women coming from different parts of the world, we first performed a search for theoretic documentation that would give us the security of a solid base from which to face the project of human development through art with migrant people. These foundations are based, on the one hand, on a theory of attachment (Bowlby, 1999) linked to the concept of creating a space of security for creation, and, on the other hand, on situated imagination, linked to situated knowledge, as a resource that possesses the potential to imagine change. We decided to set ourselves as goals some of the concepts that we had encountered in previous experiences and that had been confirmed by the investigations consulted. The objectives that we intended to tackle had to do with uncertainty and anxiety (Gudykunst, 1988, 1993, 1994, 1995), resilience (Cyrulnic, 2003), stress and vulnerability (Sayed-Ahmad Beirutí, 2010), feeling "oneself" again (Kim, 2005), loss and grief (Grinberg & Grinberg, 1984; Sayed-Ahmad Beiruti, 2010), dissonance and disappointment, tolerance to frustration, reconstruction of support networks and empowerment.

The experience: biographies of your territory

The workshop was part of the ARIADNE (Art for Intercultural Adaptation in New Environment) European project that was designed to apply artistic activities as a means of social inclusion. The research consortium included the Greek associations Osmosis and the University of the Peloponnese, the UK Tan Dance, Wales and Momentum Arts, the French Elan Interculturelle and the Hungarian Artemiszio. The project was based on the following activities: best practices collection and analyses; methodologies; description and its application to various workshops that used visual arts, dance; and Theater of the Oppressed (Boal, 1979) as a means of cohesion and social bond.

The main objective was to introduce art as a way of enriching intercultural experiences, not only among the members of the consortium with migrant populations, but among the migrants from different social and cultural backgrounds. Artistic practice was used to focus on aspects of identity that, facing the concept of identity as understood to mean nationality, had to do with cultural, geographical, social, economic and gender origins.

In this way, artistic expression, through empathy with migrant women artists' experiences was a detonator for reflections on prejudices, preconceptions and fear toward what is new and different in a new/other culture, which served as a catalyst for reflection and for cross-cultural transformation. Interculturality joined to the base of the deconstruction of identity, allowing culture and identity to be seen as something dynamic, organic and continually changing.

On the other hand, artistic process served to focus on specific important issues of the migratory experiences such as uncertainty and anxiety (Gudykunst, 1988, 1993, 1994, 1995), as well as loss, grief, empowerment, resilience and networking. The creative process can help foster the capacities that not only help individuals to tolerate uncertainty, but can also help them to profit from the benefits of this tolerance.

The process of co-creation helped to dissolve the barriers against the "other." It was therefore a valuable instrument in the reconstruction of social and human networks when these have been lost or when they have not yet been found in the new context. Working with migrant women from different backgrounds opened the discussion on the different identifications of the cultures of origin, on the one side, and the host culture on the other, along with stereotypes that represent different populations and, above all, taking into account women's singularity and desires beyond mandates and appointments.

Our research group, *Applications of art in social integration* from the Complutense University of Madrid, decided to focus on how feminist methodologies could serve as an enriching element for working with migrant women. The terms of gender that the culture of origin requires crossed here with gender mandates of the host culture. Thus, the work of reflection on identity must take into account not only the outlook of two different cultures, but expectations about women or men imposed by each particular culture. In this way, this approach could also apply to mixed groups and male groups.

The workshop took place on the last week of February and the first of March in 2012. It was held on daily from 10:00 am to 2:00 pm. Beyond our general objectives set in the beginning, our specific objectives were adjusted to the demands of the women themselves.

At the beginning of the workshops, an agreement was made between participants and workshop facilitators, where issues such as confidentiality, punctuality and mutual respect were set. These were the keystones of a space for personal development, where facilitators and participants committed to the path that we were to tread together, in a place of trust, freedom, listening and containment.

Development

The methodology that guided our workshop was a fundamental aspect of its development. In the first hour, we introduced the work of one or several women artists whom we thought could be interesting for different reasons: because the artists had experienced for themselves the process of migration; because they had worked with gender stereotypes; or because they had been introspective. The artists' biographies served to open the participants' visual and sensorial imaginary, allowed the women to think in different creative keys beyond drawing and painting, and showed them that the artists were women who also chose topics that had to do with themselves and their vulnerability. By way of provoking empathy, the artist biographies also helped

participants by endowing them with a kind of empowerment in their self-concept as potential creators: they were migrants, women and creators. This methodology became interesting from the beginning, because in most of the cases it motivated women to ask themselves about their lives and their motivations and also allowed them to express themselves freely through art.

In this first session, the prospective goals were presented, and it was made clear that the space belonged to them and that the creative process would foster an improvement in the quality of life and in their own introspection. The first hour of the workshop dealt with the acquaintance of the work of a woman artist or artists (see Table 17.1) and a group discussion. During this hour, we tried to reflect together on the artist's creative process. We used the artist's words and

Table 17.1 Working with the life of a woman: artists as references

Artist	Topic	Objectives
Frida Kahlo	Seeing oneself	Reflecting on identity. Fostering autonomy. Favouring empowerment.
Ana Mendieta/Esther Ferrer	The body, an intimate and personal territory, the imprint we leave	Recognizing oneself in one's body; the body as the locus of thought and action. Knowing of the body as a mark in space and in our life.
Louise Bourgeois	The home	Reflecting on the ideals about inhabitation: the abandoned house (left behind), the current home (that we have), the dreamed home (that we look for).
Mona Hatoum	The map	Connecting with the neighbourhood and the gazes. Acknowledging the power of our own gaze to name, inhabit, and own the space.
Shirin Neshat	Writing/inscribing the body	Working, on our own bodies, on the written desires and the fulfilled goals.
Sophie Calle/Annette Messeguer/Grete Stern	Ironies of heterodesignation, laughing at ourselves	Playing with external impositions. What others say about us. Learning to ironize and subvert the statements.
Lygia Clark	Inter-relational objects	Making objects that oblige us to communicate, that will interweave us.
Kim Sooja	The suitcase	Reflecting on what we have brought with us, what has been useful, what we have forgotten, both materially and symbolically.
Closure	Exhibition and self-evaluation	Reflecting on the workshop journey, recounting our experiences, summing up our journey and thinking about what this experience can contribute to our life project.

the artist's writings, trying to delve deep into her process and relate it with the experience of migration, loss, grief and reconstruction, always in the context of creation and its performative possibilities and always implicated in action. From these reflections, a proposal for open action was made. Then followed two hours for tranquil artistic work and its development, in which we welcomed intimacy, communication, and mutual knowledge through joint work in a climate of peace and respect. There was room for coffee, rest, walks around the place for the contemplation of one's own and others' works, all in a time and a space favorable to reflection, improvement and rectification, the pleasure of making, feeling and sharing. The last hour was left to comment on one's own work, and we also invited participants to think about the workshop, about the pathways that the experience had opened, and about the paths we were treading. We also dedicated time for closure, comments, and feedback on group and personal work.

Once the space of trust was established—this was achieved thanks to the bonds created among the women, the new friendships and the attachment with the art facilitator—the workshop began to function as a place of freedom. More space was dedicated to talk about the events of the week, the women's feelings and their emotional self-awareness.

The various creators gave way to different levels of reflection and commitment. Each one of them opened up potential works and creative reflections. Frida Kahlo and the associated topic, "Seeing Oneself," for example, allowed participants to be centered on themselves. After showing the artist's work, particularly the series of self-portraits she made throughout her life, participants were invited to reflect on how Kahlo was building her identity first as a person suffering from the consequences of an accident, then as a Mexican linked to a revolution, and finally, as a mother or artist. From her writings and experience, women began to link their identities to similar aspects of Kahlo's life paths: as coming from a place or forever nomads, as a case, as emotionally connected to something or someone: "Although I do not intend to go back," wrote one participant, "I stay here for now or move to another country, but I really live in a suitcase."

All this served to confirm how the creative process opened pathways of analysis beyond a formal approach. Artist Ana Mendieta, an immigrant artist living in the US but originally from Cuba, related her identity from the perspective of her body attached to strong and powerful natural instincts as an integral part of herself. The Spanish artist Esther Ferrer, based in France, claims, through the works shown, the territory of her body as "intimate and personal" where nothing and nobody is allowed to interfere. These few sessions of intensive work allowed us reflection, communication and a focus on time in the body-space.

Artist Mona Hatoum opened up the possibility of walking, recognizing and appropriating the space. Hatoum displays maps and territories of affections—real and invented geographies—cartography through which she makes space habitable again. One of the women participants in the workshop showed how she appropriated public space: "The map meant the path of my life. Mine started when I left Peru. My trip to Spain. I'm still looking for my star away from home." To do this work, we invited women to leave the neighborhood, taking traces of sidewalks, balconies, photographing tours, walks, everyday spaces and new spaces. The camera helped them to embrace the places they considered alien. One participant commented:

> We borrowed traits of Madrid streets and captured them in our imprints, now we are the city where we live for countless reasons or maybe one . . . to mix them with our life maps, our own creative maps made for daily living and walking.

In the next step, we offered them plans of the neighborhood, to be re-created by women, where their real traces could be incorporated. In some cases, the map became a vital map, where lifetime was incarnated in space, real places and territories.

187

In her artwork, Louise Bourgeois signaled the way to think of the house as a secure place and also as a trap. The house that we have left behind, the house that we have, the house we long for. Bourgeoise offers a particular mindset of the house to women: a place, sometimes, to run away from, sometimes a shelter, but sometimes a trap and a deadly place. We encouraged participants to think about the workshop room in these modes: the house they left in their country; the house they are inhabiting now; and their dream house. In many cases, their childhood home was considered to be an abandoned house and the current home as transient, which they believed stood as a metaphor for what drew them to adulthood, the life of the vital decisions.

Annette Messeguer helped to introduce irony in the women participants' own identity. Through collage with pictures from magazines, we reviewed the here and now of her personal insertion in everyday life, using humor and irony about prejudices and stereotypes that are dumped on women, and on foreign women in particular.

Engaging with the artwork of Shirin Neshat meant engaging in an exercise in intimacy, a self-discovery and a reconciliation with their own skin and space of existence. Through the projection of verses from the Koran, but also poems written by women over their own bodies, Neshat calls for reflection on prescriptions and proscriptions. Thus, her work invites reflection, with meaningful phrases written on the body (or projected) such as thoughts or ideas that might focus on wishes or impositions. One of the participants wrote down on her left hand all the dreams she had before arriving in Spain and, on the other hand, all of her wishes that had been fulfilled. When she looked at the result, she realized that many of the desires projected in her migration project responded to impossible desires.

Lygia Clark's art invited them to make sensorial objects that put them in contact with the others in the workshop. Clark is an artist who includes in her works the direct participation of the public. This concept served us as a key element of our workshop beyond the identity work because of the opportunity to connect and bond with others. Participants searched for possible "inventions" that helped them to connect with each other, inventing artifacts that should be "used" in connection to another person to function, as gloves to give care, for example.

Finally, the art of Kim Sooja helped them to reflect about what they needed to put in their symbolic suitcase. This artist reflects on the big bales that people create when seeking refuge in cases of large forced migration, obliged to flee only by taking personal things put in a bundle. Thus, we proposed to the participants to reflect on things that they have brought, things never needed, as well as things sorely missed. We asked them to consider "symbolic" elements that should be part of your next "suitcase." Uncertainty became, in many of the processes, one aspect to enjoy, offering women the opportunity to shape their own identity, beyond clichés, stereotypes and gender mandates. In this sense, uncertainty became an element offering new possibilities of constructing oneself, without the weight of rules, predictability or fixed social and cultural expectations.

The symbolic presence of the artists, along with their identity processes, highlighted the importance of, on the one hand, creating scenarios, and on the other, of figures of "empowerment" that reinforced the efforts of the participants, not only from the position of the artists, but also from their status of migrant women.

Achievements

The workshop space and its broad timing brought about a symbolic space where the anxiety of everyday life was left out, behind the workshop walls. The unease before the white page, of not knowing, gradually lost importance within the context of an audience and facilitators who did not judge but helped and encouraged them to go on as well as allowing for the possibility of

not doing. This, coupled with active listening, allowed the surfacing of fears, latent feelings, and desires in a climate of trust and calm, an unusual space for those who face the ongoing novelties and difficulties implied in living in a new country.

The variety of techniques that were used in the workshops helped them to face creation from perspectives that did not force their artistic abilities. Writing on the body, taking photographs, using the body in space, sewing—such processes allowed for an approach to art from comfortable standpoints, from their "own" places. Step by step, the participants became aware of their potential. One of the women confessed proudly, after looking at her work, that she "had never before felt that she was able to create"; prior to the workshop, she had seen herself as someone who could only repeat or help in the creation of "others".

Through the workshop, participants were able to re-encounter the symbolic geography that had been lost when inhabiting the new place. They gradually came to terms with their present and their future expectations. They learnt to recognize the limits of their expectations in the new place, recognizing the disappointment of some of their desires, of the, at times, disproportionate hopes that originated in their own shortages being compensated by imaginations about new horizons. The network of support and self-confidence was built imperceptibly, with the help and the love of a sponge cake brought by one of the participants, a blog created by another and a friendship that grew among them and prevails today.

Conclusions: some reflections on the workshop from the perspective of a contemplative feminist investigation

Art educators are creative and are subject to experiencing emotions and affect. They are also marked by the construction of cultural and gender identities. They are, in effect, corporal subjects, as Seyla Benhabib (1992) terms it, and they perceive from a particular point of observation, which also includes cognitive and affective aspects. In adapting the contribution of a/r/tography, a term coined by Rita Irwin and her collaborators (Irwin and deCosson, 2004), art educators are shaped by being at the same time artists, researchers and educators, from their cognitive and affective observation places. Therefore, the observations should also, as much as possible, rely on the intrinsic relation of linked subjects, with their narratives crisscrossing each other and with their different "I"s present in each inter-relation. In these, the gender identity of each art educator, as well as their cultural identity, emerges with corresponding prejudices, stereotypes and presuppositions, emanating from their own specific situated knowledge.

Reflecting on how to observe, as well as how to observe ourselves, took up a great amount of our time in both the design of, and reflection on, the workshop: for example, we reflected on whether or not to do the project with or without a pre-test and post-test, with or without a recorder, with or without video, etc. Each one of these choices might contribute to the process or might intimidate the participants; they might activate certain resistance among participants; they might revive old or new paucities of confidence or feelings of control and deceit. The "how," in the psychosocial intervention through art, is as important as the "what," because everything that occurs is worthy of observation and analysis. The instruments of observation sometimes act as metaphors for unequal power that immigrants might feel toward native persons, especially when it is only immigrants that are being observed and analyzed.

As previously pointed out, when carrying out the workshop, besides being careful, subtle and delicate in relationships, one should also take care to use an affective intonation, denoting respect rather than control. The instruments used, therefore, must be coherent with these principles of respect. The accompaniment provided in the workshop should not be from a position of power but rather at the side of the participants in order to provide security and well-being.

Only from this position can the participants begin to confront their fears and worries in order to transform them. The accompaniment, thus, should entail anything but judgment of others. The workshop should be run so as to provide elements that help us to put ourselves in the place of others. Accordingly, the workshop would provide elements that might help the participants to comprehend themselves and to reconstruct their life projects.

This was so because what we were looking for in the participants was a more intense search within themselves—more than the concrete acquisition of specific capacities, or more than the modification of behavior or the adherence to concrete objectives. All of this helped us to question the objectives of adaptation present in Western societies. As members of these societies, we reflected upon our prejudices regarding non-Western women, on the complexity and richness of human beings—women and men—beyond the societal objectives of inclusion, homogeneity and adaptation.

The feminist methodology of art education deals with the construction of gendered identity, be it male, female or transgendered. The educators and participants themselves embody gendered constructions, as well as social and cultural constructs, all of which are elements to be kept in mind with regard to psychic suffering, the possibility of recovery and improved psychosocial stability.

Therefore, the inclusion of gendered and feminist perspectives presumes that educators will keep in mind women's difficulties, but also those of men, in recognizing that they themselves, in their personal life projects, are also influenced and therefore constructed by the cultures in which they live and the gender in which they have been socialized.

Today we are facing new perspectives in cultural practice and, also, new ways to approach the analysis of culture that creates certain diffractions, which have not yet been seen and that now may be a new focus, a new optical lens, following the concept of "visual metaphors" by Donna Haraway: located ways of seeing; and multiple eyes seeking conversation that contribute to the democratic exercise of questioning and thinking together. In all of these reflections, gender—as well as class and origins—has an important role in terms of deconstructing fixed cultural prejudices. Identity, as a fluid, flexible and in-construction element permeates arts as a response of human experience. Art processes and art objects, derived from experience, in Dewey's terms (1934), should help us to think on and reinvent what humans are able to become, including silenced impoverished groups and women's experiences all over the world. Only taking these elements into account, can art serve as a universal human experience showing not only what we have been, but what we can become.

References

Benhabib, S. (1992). *Situating the self: Gender, community and postmodernism in contemporary ethics*. Cambridge: Polity Press.

Boal, A. (1979). *Theater of the oppressed*. London: Pluto Press.

Bowlby, J. (1999). *Personality and mental illness: An essay in psychiatric diagnosis*, Volume 2. London: Routledge.

Cyrulnic, B. (2003). *Le murmure des fantômes*. Paris: Odile Jacob.

Dewey, J. (1934). *Art as experience*. London: Penguin Books.

Gilligan, C. (1982). *In a different voice*. Cambridge, MA: Harvard University Press.

Gringberg, R., & Gringberg, L. (1984). *Psychoanalytic perspectives on migration and exile*. New Haven, CT: Yale University Press.

Gudykunst, W. B. (1988). Uncertainty and anxiety. In Y. Y. Kim & W. B. Gudykunst (Eds.), *Theory in intercultural communication* (pp. 123–156). Newbury Park, CA: Sage.

Gudykunst, W. B. (1993). Toward a theory of effective interpersonal and intergroup communication: An anxiety/uncertainty management (AUM) perspective. In R. L. Wiseman & J. Koester (Eds.), *Intercultural communication competence* (pp. 33–71). London: Sage Hall.

Gudykunst, W. B. (1994). *Bridging differences* (2nd ed.). Thousand Oaks, CA: Sage.

Gudykunst, W. B. (1995). Anxiety/uncertainty management (AUM) theory: Current status. In R. L. Wiseman (Ed.), *Intercultural communication theory* (pp. 8–58). Beverly Hills, CA: Sage.

Irwin, R., & de Cosson, A. (Eds.). (2004). *A/r/tography: Rendering self through arts based living inquiry*. Vancouver, BC: Pacific Educational Press.

Haraway, D. (1991). *Simians, cyborgs and women: The reinvention of nature*. New York: Routledge.

Harding, S. (1986). Primatology is politics by other means. In Ruth Bleier (Ed.), *Feminist approaches to science* (pp. 77–118). New York: Pergamon Press.

Harding, S. (1987). Is there a feminist method? In S. Harding, *Feminist methodology* (pp. 1–14). Bloomington, IN: Indiana University Press.

Harding, S. (1991). *Whose science? Whose knowledge?* Ithaca, NY: Cornell University Press.

Harding, S. (1993). "Rethinking standpoint epistemology: What is 'strong objectivity'?" In L. Alcoff & E. Potter (Eds.), *Feminist epistemologies* (pp. 49–82). London and New York: Routledge.

Harding, S. (1998). *Is science multicultural? Postcolonialisms, feminisms, and epistemologies*. Bloomington, IN: Indiana University Press.

Hartsock, N. (1983). *Money, sex and power: Toward a feminist historical materialism*. New York: Longman.

Hartsock, N. (1987). The feminist standpoint: Developing the ground for a specifically feminist historical materialism. In S. Harding (Ed.), *Feminism and methodology* (pp. 157–180). Bloomington: Indiana University Press.

Hartsock, N. C. M. (1997). The feminist standpoint: Developing the ground for a specifically feminist historical materialism. In L. Nicholson (Ed.), *The second wave: A reader in feminist theory* (pp. 216–240). New York: Routledge. (Original work published 1983.)

Keller, E. F. (1983). *A feeling for the organism: The life and work of Barbara McClintock*. New York: Freeman.

Kim, Y. Y. (2005). Adapting to a new culture: An integrative communication theory. In Gudykunst (Ed.), *Theorizing about intercultural communication* (pp. 375–400). Thousand Oaks, CA: Sage.

MacKinnon, C. (1989). *Toward a feminist theory of the state*. Cambridge, MA: Harvard University Press.

Sayed-Ahmad, Beirutí. (2010). Experiencia de migración y salud mental. Hacia un Nuevo modelo de salud. In L. Melero Valdés (Ed.), *La persona más allá de la migración* (pp. 259–292). Valencia: Generalitat Valenciana.

Snyder, G. (1995). *The practice of the wild*. San Francisco, CA: North Point Press.

18

UNFOLDING DISSONANCE

An example of how arts-based research can transform the understanding of reflexive medical praxis through interculturality

Charlotte Tulinius and Arthur Hibble

> During call time
>
> He twists his hands during the entire consultation, run with a telephone interpreter.
>
> His gaze never crosses mine.
>
> From a culture where deviant sexuality is both unthinkable, illegal and filled with fathomless shame, he asks for medicine that can cure his homosexual obsessive thoughts.
>
> I try to communicate Nordic values and perceptions, contact the support centre and try to keep calm, but inside my heart is bleeding.
>
> I want to say that everything will be ok, but I have no guarantees for that at all.
>
> *(Nordic GP blog, exhibited 2011 as part of the research project 'Being a GP in the Nordic Countries' (Tulinius, Hibble, Stensland, & Rudebeck, 2013, p. 121))*

In this chapter we will describe how Nordic family doctors (GPs) were allowed to unfold their everyday professional dilemmas through an arts-based research project, giving body to their experienced dissonance, in creative and artistic representations. We offer an example of an intercultural exploration of the traditional art of medicine as interpersonal relations, and the arts as giving spaces to unfold the intra-personal emotional and aesthetic perspectives of medical professional work. We also describe some of the challenges that faced us as research project leaders, the courage it took for the doctors to participate, the project set-up and the communication of the results to an audience of 'academic excellence'. All examples used in this chapter come from a comprehensive description of the project which is published as 'Being a GP in the Nordic Countries' (Tulinius et al., 2013).

This chapter has been divided into several parts. First, there is a clarification of how we have used the concept of interculturality. Next, we offer a description of the concept developed in our project, 'Intercultural Dissonance in Medical Professionalism'. Following this is a description of how we created the space for dissonance to unfold in an intercultural arena. After

explaining how we recorded the intercultural dissonance of medical professionalism, we give examples of artistic and creative expressions of the dissonance. We then unfold a description of voices contributing to the dissonance and the way we could listen to these voices. We describe how dissonance was demonstrated through the sharing of uncertainty and how the traditional academic order was challenged. The final section offers a re-interpretation of the dissonance of medical professionalism, with the use of an intercultural lens.

The concept of interculturality in this chapter

The interculturality addressed in this chapter comes from the world of medical professionals. We have been guided by Hans-Georg Gadamer, Donald Schön, and Lucian Israel. Gadamer states that intercultural dialogue can clarify 'the conditions in which understanding takes place' (1975, p. 263). Gadamer's aesthetics is deeply respectful of art's ability to disrupt and challenge customary expectations. It attributes an ethical significance to art as being able to reveal the limitations of fixed cultural expectancy and to open the spectator towards the other and the different (Gadamer, 2007).

Donald Schön (1983, 1987) described the complex dialogue between the biomedical/technical-rational culture and the culture of everyday practice. This results in a reflexive dialogue within the practitioners and within the institutions of the profession as the discourse of evidence-based facts and that of professional artistry.

The art of the medical profession, 'the art of healing' or 'the art of doctoring', has been dominated by descriptions based on theories about the patient–doctor relationship. Lucian Israel (1982, p. 137), however, writes about doctors as artists:

> Charity, logic, intuition, knowledge: We cultivate all of these, all of our lives. As with any artists, a gift is not enough. There is also the need of the passage of time, the gradual build/up of thought and memory, the mind's work on accumulated data.

Although acknowledging the influence of the human brain, his interpretation of the art of healing is still within the technical-rational paradigm, where doctors will process their experienced 'data'. Being a doctor is more than just systematising experiences, it also asks for the integration of the aesthetic and emotional aspects of life.

In the same way that art reflects and reflects upon society, so does general practice. The personal and professional development of a General Practitioner (GP) reflects the community in which she practises. In our research project we added the dimension of the art and creative representations of professional life produced by the GPs themselves to allow the description of GPs' professional lives through an intercultural dialogue. In this way we challenged the medical technical-rational description of the 'art' of healing.

The interculturality addressed in this chapter is that of a reflexive profession building bridges between the cultures of the techno-rational evidence-based thinking, the humanistic art of medicine and artistic/creative performance. *Reflexivity* is one of the pillars of medical practice. It is built on a culture of critically assessing and acting upon discrepancies, deviations and nuances. The good doctor copes with these uncertainties and gives holistic care, directed by her professional knowledge, skills and experiences, tailored to the individual patient. Good care only exists if the patient's voice and culture are at the centre of and in dialogue with the doctor's culture and professionalism. Donald Schön used the term 'Reflection in Action' or the 'conversation with the situation' to describe the artistry of practice where the certainty of technical-rational culture meets the uncertainty of real-life practice.

Intercultural dissonance in medical professionalism

The structuring of health care in society is increasingly a management controlled exercise, setting up cost-effective systems based on a professional culture dominated by the belief in generally applicable 'evidence-based' truths. A clash is unavoidable between the demand for uniform use of evidence-based guidelines and the individual doctor's use of professional judgements when the guidelines do not apply. The clash creates a dissonance of professional dilemmas. This dissonance can be devastating for order, but offers opportunities for creative developments. It is difficult, if not impossible, to describe doctors' experienced dissonance through traditional medical research methodology, but arts-based research methods allow dissonant life to unfold, transforming our understanding rather than just describing the differences.

The concept of dissonance has many meanings, but it always comprises some sort of conflict or incongruity. Psychologists would describe *cognitive dissonance* as the discomfort experienced by the individual who has beliefs, ideas or values that are contradictory. Cognitive dissonance can also occur if the individual is presented with knowledge or information that goes against existing values, beliefs or ideas (Festinger, 1957). The dissonance we found in this project comprised elements from cognitive dissonance with the added cultural elements arising from values belonging to the professional work of (GPs) in the Nordic countries. Researchers from ethnography and sociology have described a similar 'cultural dissonance' defined as the 'stresses, strains, and psychological processes associated with embodying and negotiating potentially competing or conflicting social norms . . . with dissonance referring both to the conflicts between cultural norms and to the emotional experience of such conflict and disequilibrium' (Snodgrass, Dengah, & Lacy, 2014, p. 16).

In this chapter we define *intercultural medical professional dissonance* as occurring when a doctor senses a conflict or contradiction between the culture of the technical-rational professional values and perceptions that exist concurrently within the medical profession and the culture of everyday practice. In Figure 18.1, a Danish GP used different media and symbols to illustrate the dissonance that he experienced in his work, a technical-rational illustration of a human being as measurable with fixed ratios between body parts, trapped by and perhaps also itself trapping modern life in all its diversity. The photo at the bottom of the illustration was found by the GP in a medical journal with the headline 'a time-bomb' and refers to the predicted explosion of health service needs for a specific group of immigrants having a high prevalence of diabetes. From his work as a GP, he knew that these men had come to Scandinavia to get a better life, and he was upset by the technical-rational interpretation of these people as a 'time-bomb'. Using different kinds of artistic expressions of human beings was the only way for him to express the medical professional dissonance he had experienced. Through drawings and poetry he found a pathway to make a description and clarification of different attitudes, perceptions of medical professionalism, and aesthetic and emotional approaches towards a human being.

Creating the space for dissonance to unfold through art in an intercultural arena

Sharing knowledge within the medical arena happens daily at staff meetings, in meetings with peers, and in the patient encounter. Sharing knowledge at the academic level demands a rigorous peer review mechanism, either as a journal article or at a conference, where your expert peers can enter into dialogue with you. A medical scientific conference has a format that in many ways reflects the medical scientific research process itself: characterised by a plan not to be deviated from (the conference programme); the scientific programme where the focus is on the

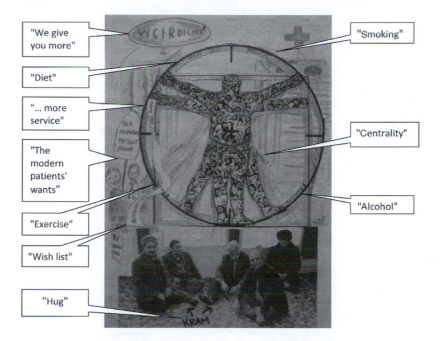

Figure 18.1 Drawing/collage with text, exhibited by a Danish GP to express his experience of medical professional dissonance in relation to healthcare structure and delivery (from Tulinius et al., 2013).

scrutiny of research for objectivity and stringency; and distinctly different social programming. This splits the conference programme into two options for interaction: the scientific programme or the social programme. Many medical conferences are also still sponsored by commercially interested companies. They support financially the social programme and the general costs of the conference to reduce the conference delegate fee. In return they have posters and hand out testers of their products located in an area of the conference hall labelled 'the exhibition'. With these labels a medical scientific conference is kept in a static format, with culturally known and accepted distinctly different content.

Many years of experience with these kind of conferences have created in us a wonder about the seeming narrowness of shared knowledge, mainly to be described as techno-rational evidence-based knowledge, and a worry that other types of knowledge were not shared and acknowledged, such as humanistic reflexive, emotional, creative and aesthetic knowledge. This feeling of unease was the start of our project, 'Being a GP in the Nordic Countries', that set out to describe what seemed to be absent in most of the knowledge production and sharing at these conferences: the subjective, perceived emotional and aesthetic knowledge about GPs' medical professionalism. Our project enabled us to gain access to unspoken knowledge, expressed in artistic and creative representations. Creating an 'artistic physical space' within an academic arena was challenging for researchers and for the participating doctors.

Recording the intercultural dissonance of medical professionalism

All biological systems include uncertainty. The attempt to reach certainty creates the dissonance for those who work with real-life biology. Through our arts-based research project, we enabled

the GPs to unveil and unfold the intercultural dissonance within medical professionalism. In this section, we describe the data that became available, the collection and analysis methods that made this happen, and the theoretical frames of reference that we used for the interpretation of the intercultural dissonance.

As part of the 2009 and 2011 Nordic General Practice Conferences, everyone working in general practice was invited to submit a contribution to an art exhibition exploring the work and lives of GPs in the Nordic countries. The contribution could be of any artistic/creative format. At both art exhibitions the audience, the conference delegates, had time to become acquainted with the artistic and creative contributions in different kinds of gallery walks. All contributors were interviewed during, before or after the workshop in a one-to-one interview (15–45 minutes). The themes coming up during these interviews were discussed with the conference delegates present at the workshops. Disposable cameras were handed out during the workshops for photo elicitation.

The art exhibition format as part of a research project design, built on elements of arts-based qualitative research (Jones, 2012; Leavy, 2009), allowing the experts on the topic (contributors as well as other conference participants) to direct and develop the themes of the project based on artistic and creative expressions. The interactive design elements were also inspired by the arts-based research methodology as described by Leavy (2009) and Jones (2012), advocating 'cross-pollination' through interdisciplinary collaboration and reflection through feedback during all phases of the research project. These elements of the project also built on participating engagement in research as described by Elliot (2007) and Jarvis (2002, 2006).

The design and methods were discussed with peer researchers at different academic meetings and conferences throughout the entire project. A website was set up to recruit as well as support participants in the study (see https://sites.google.com/site/nordicgp/home).

Contributions were received until spring/summer 2013. We used mixed qualitative research methods, including arts-based research methods, in an interactive participatory design (Creswell & Plano Clark, 2007; Elliot, 2007; Johnson & Onwuegbuzie, 2004; Jones, 2012; Pelias, 2004). These included exhibitions of artistic/creative representations, gallery walks, different kinds of interviews, peer group discussions and feedback on artistic and creative contributions, and photo elicitation methods. All interviews and debates were video or audio recorded and analysed. The data consisted of a ten-minute film, photos, sculptures, drawings, water colours, paintings, collages, poetry, short stories and choir singing. The data were submitted as contributions to the art exhibitions at and in between the conferences, and photos that were taken with disposable cameras were sent in by the participants from the workshops, and followed up by email interviews.

The thematic analysis of the different kinds of interviews and texts was inspired by Giorgi's psychological phenomenological method (Giorgi, 1985). After the 2009 exhibition and the first round of submitted photos, the data-led analysis was reframed using Swick's framework for medical professionalism (Swick, 2000). As a consequence of this analysis we changed the strategy after the 2011 exhibition. The analysis strategy returned to the data and participatory led method inspired by Pink's (2006) description of analysis in visual ethnography, with the focus on the context in which the image is produced and the meanings associated with the image as produced and expressed by the informants. This allowed the analysis to be data led across the type of data, predominantly guided by the contributors' intentions and descriptions. It also allowed for the description of the medical professional dissonance to be framed within an intercultural lens, in which we could discover how the art produced by the GPs illustrated and expressed unspoken parts of medical professionalism. The analysis was supported by the participatory interpretation of the data at workshops at the two Nordic GP conferences, ensuring an on-going interpretation of the analysis throughout the project. The technical side of the

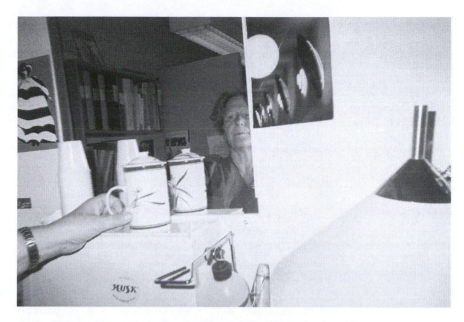

Figure 18.2 Photo sent in to the project by a Swedish GP, illustrating herself between patient
encounters (Tulinius et al., 2013, p. 124).

data analysis used NVIVO 9 with the video materials. The interpretation of the analysis was also
supported by the feedback received at other academic presentations of the material at different
stages in the project.

Artistic and creative expressions of dissonance

The GPs used many types of media and formats to express the experienced dissonance. A
few examples include: a landscape regulated by nature's overwhelming power – a place where
human interference would never be noticed; the reflection of a GP reaching out for the warmth
and strength of a cup of coffee or tea, surrounded by technical measuring instruments and clini-
cal cleanliness and rigour; and a wall of empty cigarette boxes, still promising death and disaster.
All the contributions we received, exhibited and discussed as part of this project can be seen in
the project book *Being a GP in the Nordic Countries* (Tulinius et al., 2013).

Voices from different cultures contributing to the dissonance

The demands from outside general practice, the discourse of evidence-based medicine, and
the focus on budget management all have the potential of creating dissonances in the profes-
sional work of a GP, giving a sensation of threatened values and professionalism and alienating
uncertainty as 'un-natural'. The GPs showed with their art how they, despite being from an
acknowledged medical specialty, were not sharing understanding or recognition of the impor-
tance of these issues with other specialty colleagues, among health politicians, and in the scien-
tific community.

Issues creating dissonance in GP professionalism were, among others, the discourse of risk
and risk management and what the GPs saw as the scientific poverty of mainstream research,

and not integrating breadth and depth into knowledge of the individual's experience in disease/illness/health. In the poem below, the voice of an Icelandic GP, representing the reflective culture, is addressing the consequences of the contemporary technical-rational risk management strategy:

Anxiety
Anxiety and worries
Come to you and me,
To worry for things You'll never see,
Destroy all your days to be.
 (Tulinius et al., 2013, p. 117)

Issues such as the different perceptions of risk create a 'dissonance', because they have a potentially negative effect or impact on some patients' health, if seen in the light of the contexts, the values and the characteristics of general practice life and work. Upholding professionalism in the context of general practice, challenging the discourse of these issues, the GPs found themselves at risk of being perceived as 'going against the stream', or even 'being unprofessional' by colleagues or other collaborators from the 'scientifically' based specialties.

The voices creating the dissonances can, therefore, be separated as belonging to both professional and lay choirs: the professional voices belonging to managers, budget holders, and the medical profession itself where there will be multiple voices, some from the culture of technical-rationality demanding evidence-based guidelines; and, the lay voices primarily giving the most important tone, the keynote, not always consistent from individual to individual, but the one the GPs will try to take the steer from. Still others are from the culture of reflection and reflexivity, like the GPs insisting that exceptions, deviations and differences should be closer to the fundamental note of each contact. One of the participants in our project expressed this, stating that by listening to the individual patient she became a better and a wiser doctor.

For some of the GPs the invitation to make an artistic or creative representation of their professional lives was the first time they had been able to express and debate the dissonance they experienced. Otherwise the dissonance seemed to be homeless in the scientific debate. In their professional settings, its absence threatens the very essence of what it means to be a Nordic GP and, in the end, it is impairing the patient encounter, treatment and relationships.

Listening to the dissonance: understanding the management of intercultural uncertainty

The public display and the interactive design of the project allowed the expression of different ways to manage the uncertainty. To understand the relation between uncertainty and medical professionalism, it was necessary to listen to the lived dissonance that these doctors presented. Uncertainty is the fundamental reasons that clients seek professional advice from human-facing professionals. The management of uncertainty is what the professional does by applying their expertise. It is expertise applied with integrity that is one of the planks of the social contract that enables the professional to practise.

Empirical science has made possible many advances in the human condition, in health and beyond. Technology is at its best when dealing with materials that behave according to definable and reliable laws. If an electrical voltage is applied across a suitable metal coil it will produce heat and light. The certainty we have when we throw the switch is such that if the light does not function, that is the surprise, not the wonder that it works. Biological systems work within

natural laws but with inherent variation, the degree of which is often predictable but the detail of which is uncertain. In the scientific experimental models, it is possible to eliminate many of the elements that might cause bias, but there is always a variation. At broader levels – for instance, immunisation programmes – it is possible to predict, within reasonable levels of certainty, uptake and outcomes.

Between the particles and the population is the individual. It is the variation at the individual level that creates the uncertainty that turns them to a medical professional. While the evidence-based guideline is working, confidence and certainty ride high and the routine expert can manage. When deviation occurs, the adaptive expert professional uses the knowledge built from integrated information and reflective practice, otherwise called experience. We can predict that deviation will occur but when and why in the individual is the uncertainty. The default setting for the technical-rational culture will be to follow the guideline and perceive deviation as 'noise'; the reflective practitioner will expect deviation as normality. In the blog below the GP explores the emotional reaction to something that within the technical-rational culture could just have been described as 'sudden death'.

Thin line

The ambulance came to the surgery today with a dead person.

The man had collapsed at the farm after he had been shopping.

Completely dead within a moment.

He came here because a doctor needs to confirm death.

I crept into the ambulance and sat next to the stretcher. I have met this man many times, and I was moved that he looked as neat as when we met last. I caressed his cheek, and swallowed my tears that came unexpected.

A very old man who died a natural death. Unreal for all involved.

(Tulinius et al., 2013, p. 39)

While uncertainty for the professional diminishes with experience and mastery, it never goes away and is often the reason why professionals continue to practise; they enjoy the variation and the intellectual or physical efforts required to solve problems. At times, solving the problems causes tension at the personal or political level. In novel situations professionals often lack the language to articulate the issue clearly, because of the emotional or affective dimension or because there is no acceptable forum. The choice is to put it aside, make a reductive analysis, or seek other ways of moving forward. Reductive analysis specifically strips away emotions as confounders; yet, they are the very reason for the feeling of uncertainty in the first place and the essential element of the human situation.

Performing intercultural dissonance of medical professionalism

Sharing uncertainty and professional dissonance

With uncertainty as an inherent part of work, many Scandinavian GPs will use peer supervision groups to share uncertainty and learn from each other. Often this will create a rationale or a logical reasoning for how uncertainties and dissonance are managed in a professional way (Tulinius, 2013). It is much more difficult to 'perform' dissonance with the aim of sharing with

others all the emotional and aesthetic elements of the uncomfortable sensation and feeling of contradictory values, beliefs, knowledge, or ideas, especially within the context of a culture of professionalism that values empirical absolutes, as the context of our project. Swick (2000, p. 614) described medical professionalism as having core humanistic values, dealing with high levels of uncertainty and reflecting upon actions.

Swick's model does not account for the intercultural professional dissonance we have described, a sensation of frustration and sadness among the GPs, and the sensation that under certain circumstances they were perceived by the remaining medical community as going against the mainstream of medical professionalism. We therefore applied the arts-based method that allowed the emotional side of the uncertainty in this intercultural meeting point to be expressed.

Challenging the traditional academic order, within and outside medicine

Many of the challenges we faced as researchers were because we stepped out of the expected frames of a 'normal' research project and a 'normal' contribution to a scientific conference. Our contribution was not seen to fit into the structure of being either 'scientific' *or* 'social'. This meant that at the basic level of labelling, the art exhibitions, that we called 'the workshops', could be labelled as belonging to the scientific part of the conference but were difficult for the organisers to place physically and logistically. The art exhibition was perceived by conference organisers and some of the delegates as decoration, with different activities happening in the room, including a workshop that was perceived as the more scientific part of our project. Labelling the activities 'workshops', however, created a seemingly common language between the technical-rational culture and the arts-based research exploration of aspects of aesthetics and emotions in medical professionalism.

Most of the academic audience treated the exhibition as a poster room, glancing quickly at the headings, moving on if nothing captured their interest. Some, however, displayed their uncertainty with bodily expressed wonder when understanding what was going on in the art exhibitions; looking quickly from one exhibited item to another with a puzzled expression; laughing a bit to themselves; shaking their heads; or going into an alerted freeze position with a strained facial expression as their eyes examined the art/creative expression before them.

To increase familiarity at the workshops, we chose a 'hot-chair interview' method, or we labelled the activities with concepts from the art and museum world, such as 'gallery walks' or 'Q&A sessions', all with audience interaction. The non-fitting status of this work was also felt and expressed by the GPs contributing to the exhibitions.

The fact that words on paper are normally exhibited at a conference means that the walls are seldom built to take any significant weight. As a consequence, we could not exhibit several pieces of heavy installation art. The assumption from conference organisers was also that nobody would ever steal a scientific conference poster, and therefore no insurance guaranties could be given in any of the conference rooms we used.

We chose to communicate the results of the project in a photo book, allowing as much space and originality as we could to the artistic and creative representations of the lived experiences. The underlying intention was to allow the individual readers to interpret, for themselves, the pieces of art illustrating the strong power of the artistic and creative expressions. All participants had expressed their pride of having contributed to this book. When we contacted editors to ask for a review of the book, we were again presented with the expectations towards 'real' research, 'true descriptions' of a profession. An editor for a national newspaper beautifully expresses the expectation of how 'true knowledge' is (not) supposed to be communicated with a lot of

pictures and sparse text, but: 'Incidentally, you are not writing a real textbook about general practice in the Nordic countries? Such a book I would still be interesting in reading' (from correspondence with a chief editor of a Nordic newspaper, 2013).

Re-interpreting the dissonance of medical professionalism, using an intercultural lens

The theoretical approach to our research question indicates that we see research as knowledge *production*. The production of research-based knowledge is a construction of knowledge between human beings: the researcher, the participant and those using the new knowledge. Research is now more commonly accepted as having subjective elements rather than being purely objective. When we do qualitative interviews we know the interviewee speaks from within the culture of which they are a part, and from the experiences life has given them. The interviewer might or might not be from the same culture, but will always have other individual experiences from life that will frame the words, the descriptions given by the interviewee. The researcher is therefore a co-producer of the insight that develops as a negotiated truth, produced by the interviewee and interviewer as the interview progresses (Hastrup, 1988). In this way the research methods we chose reflected the encounter between the patient and the doctor in general practice.

The interview is a mutual learning situation giving new knowledge and insights to both the interviewee and interviewer. The interviewee participates with the expectation that the researcher, by doing this interview, will learn and contribute to the production of new knowledge. The interviewee also gains new insight as the consequence of telling his or her story, being interviewed, and through this being challenged on the story she or he has told so far. Following the perception of research as a mutual learning process, research is not an objective transfer of knowledge that just needs to be found and described. This makes the subject interesting in a wider sense, and has an importance for the communication and interpretation of the research: if it is accepted that interviewee and researcher interpret and digest knowledge in the production of new insights, a logical consequence is, that those who receive the research results will also interpret and digest knowledge.

In the 1960s, Foucault and Barthes raised the philosophical question about the ownership of knowledge, with a description of how a written text always will have the meaning, and only the meaning and content that is attributed by the reader (Allen, 2003; Barthes, 1993; Foucault, 1991). The challenge for us as researchers in this project was not just how we could allow the unfolding of the emotional and aesthetic elements of medical professionalism within a setting often owned by the technical-rational culture, but also how we could communicate the insight we gained through this project, with the same contextual and cultural diversity, the same emotional richness, the same frame and freedom of interpretation for the ones with whom we are communicating. Our anticipation was that the results would decide the method of communication, just as the methods are decided by the research question.

Digestion and interpretation have more elements in common. In the interpretation of an interview, the researcher and interviewee will always include the context, emotions, sensed impressions, life history, body language, associations appearing in the situation, and . . . words. With traditional research communication methods such as journal articles, or even books like this, the main ingredient is a condensation of sensations in 'words'. With this condensation there is a risk for the communication to lose the emotional facets of the story, the interviewee's story, the researcher's own story, and the context the receiver of our research would have found authentic. We therefore chose to communicate the project in a book that would allow the

reader to interpret and synthesise meaning directly from the many artistic and creative representations of the GPs' professional lives.

Arts-based research is, according to Leavy, refining the work we already do as qualitative researchers as 'both artistic practice and qualitative research can be seen as crafts . . . Qualitative researchers do not simply gather and write; they *compose, orchestrate, and weave*' (Leavy, 2009, p. 10). The arts-based research methods used enabled us to draw the meaning-making processes to the front and through art and creativity to illustrate the intercultural dissonance between the technical-rational and the reflective medical practices. Through their own art and creative illustrations the GPs were allowed to express their lived experiences as professionals working in the tension between their own, their patients' and other medical professionals' values, ideas, knowledge and perceptions. It allowed the audiences to connect with the knowledge presented on a deeper emotional and aesthetic level, evoking compassion, empathy, sympathy and understanding, creating critical awareness and raising consciousness, exactly as described by Leavy (2009).

With the invitation to speak the unspoken, the intercultural arts-based approach succeeded in promoting dialogue within the public and professional arena, through creating spaces for dialogue (Leavy, 2009). The last words in this chapter are the beginning of a poem written by a Danish GP who brilliantly illustrates our understanding of what can be achieved by working with art and creativity in an intercultural setting of medical professionals. The entire poem can be found in the book, 'Being a GP in the Nordic Countries' (Tulinius et al., 2013).

> My consultation room exists somewhere
> approximately halfway between the ears.
> With visual runways intersecting in front and with wires
> out to the right and left.It is put there on purpose.
>
> *(Tulinius et al., 2013, pp. 79–80)*

References

Allen, G. (2003). *Roland Barthes*. London: Routledge.

Barthes, R. (1993). *Image music text*. Reissue edition. London: Fontana Press.

Creswell, J., & Plano Clark, V. L. (2007). *Designing and conducting mixed methods research*. Thousand Oaks, CA: Sage Publications.

Elliot, J. (2007). *Reflecting where the action is*. London: Routledge.

Festinger, J. (1957). *A theory of cognitive dissonance*. Stanford, CA: Stanford University Press.

Foucault, M. (1991). What is an author? In P. Rabinow (Ed.), *The Foucault reader: An introduction to Foucault's thoughts* (new ed.) (pp. 101–120). London: Penguin Books.

Gadamer, H. G. (1975). *Truth and method* (trans. J. Barden & G. Cumming). London: Sheed and Ward.

Gadamer, H. G. (2007). Gadamer's aesthetics quoted in *The Stanford Encyclopedia of Philosophy*. Retrieved February 23, 2015, from http://plato.stanford.edu/entries/gadamer-aesthetics/.

Giorgi, A. (1985). Sketch of a psychological phenomenological method. In A. Giorgi (Ed.), *Phenomenology and psychological research* (pp. 8–22). Pittsburgh, PA: Duquesne University Press.

Hastrup, K. (1988). Den tredie person. Køn og tid I det islandske landskab [The third person. Gender and time in the Icelandic landscape]. In K. Hastrup & K. Ramløv (Eds.), *Feltarbejde. Oplevelse og metode i ethnografien [Fieldwork. Experience and Methods in ethnography]* (pp. 199–225). Copenhagen: Akademisk Forlag.

Israel, L. (1982). *Decision-making, the modern doctor's dilemma: Reflections on the art of medicine* (trans. Mary Feeny). New York: Random House.

Jarvis, P. (2002). Practice-based and problem-based learning. In P. Jarvis (Ed.), *The theory and practice of teaching* (pp. 123–131). London: Kogan Page.

Jarvis, P. (2006). *Towards a comprehensive theory of human learning: Lifelong learning and the learning society*. London: Routledge.

Johnson, R. B., & Onwuegbuzie, A. J. (2004). Mixed methods research: A research paradigm whose time has come. *Educational Research, 33*(7), 14–26.

Jones, K. (2012). Connecting research with communities through performative social science. *The Qualitative Report, 17* (Review essay 18), 1–8.

Leavy, P. (2009). *Method meets art: Arts based research practice.* New York: The Guildford Press.

Pelias, R. J. (2004). *A methodology of the heart: Evoking academic and daily life.* Walnut Creek, CA: AltaMira Press.

Pink, S. (2006). *Doing visual ethnography: Images, media and representation in research* (2nd ed.). London: Sage.

Schön, D. (1983). *The reflective practitioner.* New York: Basic Books.

Schön, D. (1987). *Educating the reflective practitioner.* San Francisco, CA: Jossey-Bass.

Snodgrass, J. G., Dengah, H. J. F., & Lacy, M. G. (2014). 'I swear to God, I only want people here who are losers!' Cultural dissonance and the (problematic) allure of Azeroth. *Medical Anthropology Quarterly, 28,* 480–501.

Swick, H. M. (2000). Towards a normative definition of medical professionalism. *Academic Medicine, 75,* 612–616.

Tulinius, C. (2013). 'We're all in the same boat': Potentials and tensions when learning through sharing uncertainty in peer supervision groups. In L. S. Sommers, & J. Launer (Eds.), *Clinical uncertainty in primary care: The challenge of collaborative engagement* (pp. 241–270). New York: Springer.

Tulinius, C., Hibble, A., Stensland, P., & Rudebeck, C. E. (2013). *Being a GP in the Nordic countries.* Cambridge: Charlotte Tulinius Publishing. Retrieved from www.blurb.co.uk/b/4480717-being-a-gp-in-the-nordic-countries.

19

CALLING CRITICAL WORK INTO QUESTION

A case of arts-based performance as intercultural public pedagogy and participatory inquiry

Sue Uhlig, Lillian Lewis and B. Stephen Carpenter II

In 2011, Reservoir Studio initiated a participatory performance entitled Collaborative Creative Resistance with the intention to render the abstract notion of the global water crisis more tangible as a socio–environmental issue. The performances, which are between a few hours and an entire workday in duration, transfer the studio practices used for filter production into public spaces through participatory demonstrations of clay preparation, mixing, and filter production in collaboration with participants who happen upon the performance. These public pedagogy performances (Sandlin, Schultz, & Burdick, 2009) follow Nuñez, Konkol, and Schultz's (2014, p. 354) characterization of public pedagogy as "part of the tradition of social activism undertaken by public intellectuals . . . the 'translat[ion of] social issues for a public audience and the public good'." Similarly, Biesta (2014, p. 20), referencing Arendt (1958), suggests that a reduction in plurality leads to homogeneity in the public realm, "eradicat[ing] the very conditions under which action is possible and freedom can appear." In reflection of public pedagogy and social action defined in these ways, the Collaborative Creative Resistance performances by Reservoir Studio offer a rich space in which to consider intersections such as art and public pedagogy, artistic production, environmental politics, place-based education, cultural production, and artistic practice as social activism. The Collaborative Creative Resistance performances exemplify transdisciplinary educational and cultural work that occurs outside conventional studio settings, instructional practices, and educational institutions.

In this chapter we seek to problematize Collaborative Creative Resistance, a series of public pedagogy art-based performances. We take up our critical readings of Collaborative Creative Resistance through an intercultural lens. First, we describe these performances as public means to simultaneously respond to the global water crisis and promote the production, distribution, use, and health benefits derived from affordable point-of-use water filters produced from clay, sawdust, and colloidal silver. We provide a brief overview of the global water crisis as a context and impetus for the production and use of these colloidal silver enhanced filters. Next, through an intercultural approach, we describe and problematize the performances through narratives of public pedagogy, participatory inquiry, intervention and resistance. We also explore ways in which the performances promote a range of cross-cultural dialogue and public pedagogy engagements through intention,

process, and evidence. The chapter concludes with a set of possibilities and considerations for arts-based performances as intercultural public pedagogy.

The work of Reservoir Studio and the Collaborative Creative Resistance project has been described and documented previously (Carpenter et al., 2009, 2014; Carpenter, Muñoz, Muñoz, Arcak, Cornelius, & Boulanger, 2011; Carpenter & Muñoz, 2012) with the intention of presenting the project as a form of public pedagogy, collaborative interdisciplinary cultural work, and arts-based leadership. This chapter takes a more critical approach to this work in response to the call from curriculum theorists Jake Burdick, Jennifer A. Sandlin, and Michael P. O'Malley (2014) about the lack of theorizing and problematizing of self-declared public pedagogical work.

The performances have all occurred within the United States and are enacted by members of a society who have not experienced sustained direct effects of global water crisis to the life-threatening degree experienced by some people in this or other countries. This positionality inherently situates the performances as intercultural as they respond directly and in contrast to the lived experiences of the Collaborative Creative Resistance members and those of other people around the world who lack adequate access to clean water. Given this context, our work in this chapter is guided by a few key questions. For whom does Collaborative Creative Resistance speak and why? In what ways is the translation of the global water crisis through these public performances understood by participants? In what ways do the conceptual developments and Collaborative Creative Resistance performances serve as a warning of the likely future to a culture of excess consumption, a call for proactive prevention, or a reminder of luxurious comforts provided by seemingly unlimited access to potable water? The intercultural critical framework we use in this chapter attempts to make sense of these questions through reflective consideration of the performances through multiple cultural lenses.

In this chapter, we consider those in-between spaces of possibilities within the complex layers of expression, meaning making, and action by bringing awareness of the global water crisis through studio practices and dialogue. We frame our understanding of intercultural from interpretations of the writings of cultural theorist, feminist, and social activist bell hooks (2000) and feminist, philosopher, and literary critic Hélène Cixous (Sellers, 1994). As hooks (2000, p. 98) asserts, "When love is present the desire to dominate and exercise power cannot rule the day. All the great social movements for freedom and justice in our society have promoted a love ethic". Similarly, the philosophy of the Collaborative Creative Resistance performances echoes in the words of poet Estella Conwill Majozo (1995, p. 88), who wrote, "to search for the good and make it matter, not simply objects of matter: this is the real challenge for the artist. Not simply to transform ideas or revelations into matter, but to make those revelations actually matter". Simply, Collaborative Creative Resistance makes water filters, objects that matter, that espouse an ethic of care, love, and empathy for and of others. Throughout our analysis, we resist a singular hegemonic interpretation of Collaborative Creative Resistance. Rather, we embrace critically the name of the group as *collaborative*, *creative*, and *resistant*; we intentionally resist closure through a single perspective in order to view our actions through multiple lenses, understanding the strengths and limitations of each approach. In essence, this is how we approach interculturality in this chapter.

As a means to explicate and interpret, the chapter situates the public pedagogy performances within theoretical frameworks such as critical pedagogy and critical public pedagogy (Biesta, 2014; Burdick, Sandlin, & O'Malley, 2014; Gaztambide-Fernandez & Matute, 2014); participatory inquiry (Bishop, 2012; Heron & Reason, 1997; jagodzinski & Wallin, 2013); and interventionist practice and creative resistance pedagogy (Richardson, 2010). In summary, this chapter seeks to problematize the means and meanings generated by the Collaborative Creative

Resistance performances as public pedagogy through an intercultural critical framework that disrupts a singular interpretation of the performances.

We consider the range of these theoretical frameworks as well as those that encourage ethics of care, love, and empathy noted above to be cultural lenses, each informed by different experiences and practices. Therefore, this collection of lenses forms our intercultural critical framework. It is this framework that informs how we describe and problematize intercultural understandings of the performances as a means of mobilizing narratives of public pedagogy, participatory inquiry, intervention, and resistance.

Background

Water is central to life. Water scarcity and the global water crisis are life-threatening living conditions documented by groups such as water.org, the United Nations, and the World Water Council, among others. The centrality of water in the lives of the Earth's inhabitants is made explicit in the ten-year span between 2005 and 2015 through "Water for Life," the international decade for action as declared by the United Nations. "Water-related diseases cause millions of deaths annually around the world, and these grim living conditions due to a lack of safe drinking water, pervasive disease, and substandard sanitation are known as the global water crisis" (Carpenter, 2014, p. 310). Implications of the global water crisis are far reaching, and include concerns related to education, economics, politics, health, gender equality, and human rights. Among the most active means of responding to the global water crisis are efforts by non-governmental organizations (NGOs), not-for-profit groups, concerned independent citizens, social activists, and artists. The work of the TAMU (Texas A&M University) Water Project and Reservoir Studio are small-scale groups that function within large research universities. One such not-for-profit group is Potters Water Action Group, based in Pittsburgh, Pennsylvania. Potters Water Action Group is the lead organization of a confederation of domestic and international organizations to establish filter manufacturing sites in the developing world. Partnering organizations include universities, church missions, service clubs, private philanthropic organizations, governments, and NGOs (Potters Water Action Group, 2015). The TAMU Water Project and Reservoir Studio are two small-scale organizations in this confederation, both of which function within large research universities in the United States. Reservoir Studio produces the Collaborative Creative Resistance performances.

Accounts of the histories, intentions, work, and implications of the TAMU Water Project, Reservoir Studio, and the Collaborative Creative Resistance performances have been documented elsewhere (Carpenter, 2010, 2014; Carpenter et al., 2011; Carpenter & Muñoz, 2012). These accounts have been concerned primarily with ways in which this work functions as public pedagogy (Carpenter, 2010, 2014), collaborative interdisciplinary cultural work (Carpenter et al., 2011; Carpenter & Muñoz, 2012; Carpenter, 2014), arts-based practice (Carpenter & Muñoz, 2012; Carpenter, 2014), and collaborative leadership (Carpenter, 2014). The public performances, which originated in 2007 under the auspices of the TAMU Water Project, perform the practice of production of ceramic water filters with materials and equipment used in the production facility or studio. In essence, a production facility is constructed temporarily in a public or studio space to demonstrate the process of creating hydraulic press-molded water filters from dry materials. Artists, faculty members, and students work with attendees during the performance to mix clay, produce filters, share information about the global water crisis, distribute handouts, and discuss ways to extend the project (Carpenter, 2010).

In 2011, after B. Stephen Carpenter II, relocated from TAMU to The Pennsylvania State University, the performances adopted the title "Collaborative Creative Resistance" through

the support of Reservoir Studio, the interdisciplinary collective for which he serves as chief executive artist.[1] The Pennsylvania State University, also referred to as Penn State, is a large public research university located in the eastern part of the United States. The main campus, located in the center of the state in a rural town, is one of 24 campuses that serve over 100,000 students across the state in urban, suburban, and rural communities. With this change came a wider range in duration for the performances, which can last a few hours, an entire workday, or multiple days. The performances transfer the studio practices for filter production into public spaces through participatory demonstrations of clay preparation, mixing, and filter production in collaboration with participants who happen upon the performance. Since their inception at TAMU, the Collaborative Creative Resistance public performances have occurred in public spaces, schools, studios, and other sites.

The work at TAMU and at Penn State through Reservoir Studio echoes and embodies the concept of a collective. Collaborative work in the studio seeks to take form through partnerships and non-hierarchical relationships (Carpenter & Muñoz, 2012) and consideration of studio space as a community. As such, a collective seems to describe adequately the nature of the collaborative network of people who pass through, linger, and revisit each of these sites.

The name "Reservoir Studio" functions on at least three levels. First, it speaks to the notion of an "underground collective" as a specific location in which water gathers to be saved and used later. Second, the physical location of Reservoir Studio is in the basement of one of the oldest buildings on campus and therefore is literally an underground space. Third, the studio engages in a research practice and arts-based scholarship that exists within an "underground" or "hidden" culture of a research university focused on conventional approaches, definitions, and purposes for research and scholarly production. In these ways, the Reservoir Studio is both literally and figuratively below the surface, hidden, and stashed away. Much like the global water crisis and its impact on the lives of most U.S. citizens and other members of first world and developing countries, the studio practices taken up by Reservoir Studio are at present below the surface, hidden, and out of sight and therefore by association, out of mind. By its very existence, Reservoir Studio functions as a site of intercultural engagement as its underground and hidden practices exist in conflict with the conventional practices of the research institution in which it exists and the traditions of utilitarian pottery to which it is connected directly through the materiality of the clay used to create the filters.

Critical analysis

How can we approach a critical understanding of the Collaborative Creative Resistance performances and Reservoir Studio? How might we respond to the questions that guide our present inquiry? The aforementioned notion of a studio practice working below the surface in relation to the works emerging from Reservoir Studio calls to mind artistic predecessors and antecedents, such as performance artist Joseph Beuys' efforts to challenge the role of curriculum and participation in art and learning as he merged his artistic practice with his approach to teaching, rendering them difficult to separate. We are also reminded of the initial design/build architectural work of the late architect and professor Samuel Mockbee, his colleagues, and their second- and fifth-year architecture students through Auburn University's Rural Studio. Auburn University, located in the state of Alabama in the southern part of the United States, is among the largest universities in the state. Rural Studio merges the curricular and pedagogical elements of architecture with the lived experiences and needs of the clients with whom they work. While Reservoir Studio might bear some similarities to the work of Beuys and Mockbee, there are key differences that distinguish the methods and functions of Reservoir Studio. Likewise, the processes of scientific

and artistic preparatory research, public performance, collaboration, and adaptive practice that emerge from reflection share similar characteristics to participatory and arts-based inquiry.

Collaborative creative resistance as public pedagogy

Collaborative Creative Resistance raises issues of the global water crisis while performing an embodied practice of making ceramic water filters as a form of public pedagogy.

According to Carpenter the project:

> transfers studio practices for filter production . . . to public spaces through participatory demonstrations that actively include those who attend the events. These public performances are also forms of advocacy and activism that mobilize narratives of public pedagogy, participatory enquiry, intervention and resistance.
>
> *(2014, p. 312)*

Such accounts of these events have framed the performances as intentionally pedagogical events in public spaces, but have steered clear of critical reflections about key concepts such as *public* and *pedagogy*. Burdick et al. (2014, p. 3) call into question the ways in which *public pedagogy* is defined since "its meaning, context or location" is rarely fully explicated. Who is the public with whom the Collaborative Creative Resistance seeks to engage, collaborate, and inform? This question promotes an intercultural interpretation of Collaborative Creative Resistance as it seeks responses informed by different cultural perspectives about the meanings of what constitutes public, collaboration, performance, knowledge, and dialogue. In this section, we address the terms *public* and *pedagogy* in correspondence with the interculturality of Collaborative Creative Resistance performances informed by the collection of lenses that inform our intercultural critical framework as described previously.

Performing in public spaces like a plaza in front of an art museum or the sidewalk outside a community library enables Collaborative Creative Resistance performances to make intercultural connections with people in the area who enter into these institutions or as they walk past but decide to "stay and participate in the educational experience" (Carpenter, 2010, p. 340). In order for Collaborative Creative Resistance to be considered public pedagogy, Glenn Savage (2014) cautions, it must specify with what and whose public the performance engages since the public is the framework for its pedagogy. Public does not imply a physical space but rather a social space of human interaction (Biesta, 2014). Education policy scholar Glenn Savage (2014, p. 80) argues, "it is through this *act of framing* that a particular public is evoked, and this 'evoked public' is that which is ostensibly educated".

Education scholar Gert Biesta (2012, 2014) postulates three forms of public pedagogy. Biesta distinguishes among pedagogy *for the public*, pedagogy *of the public*, and a pedagogy *enacting publicness*. Pedagogies for the public are top-down and didactic where the educator generates content for the learner. In pedagogies of the public, the educator acts as facilitator for the public to generate content where learning is collective. An example of a pedagogy of the public is one advocated by educator and cultural pedagogy scholar Paulo Freire (2000), where learners reach a critical consciousness through reflection that leads to praxis. In this notion of enacting publicness, pedagogical content is "more activist, more experimental, and more demonstrative" (Biesta, 2014, p. 23). This human concern for publicness implies human togetherness, fosters action, and leads to freedom insofar as one cannot act in isolation, and isolation implies the inability to act (Arendt, 1958; Biesta, 2012, 2014). Moreover Biesta (2012, p. 688), contends "action is never possible without plurality" or the ability for all to have the facility to act.

While Biesta (2012, 2014) suggests neither a multiplicity nor overlapping of these three forms, Collaborative Creative Resistance does appeal to each of these forms of public pedagogy. As a pedagogy *for* the public, Collaborative Creative Resistance brings a specific curriculum into public spaces for its audience that demonstrates the making of water filters using clay and colloidal silver, the process of how the filter works, proper procedure for daily use and maintenance, and rationale for why they are needed. As a pedagogy *of* the public, the water filter performance demonstrations engage the audience physically and cognitively in the process, where the educators facilitate content and collaborate with the public to disrupt notions of global availability of clean water and elicit reflection, leading ideally to action on the part of the public audience member. Last, as a pedagogy for enacting publicness, Collaborative Creative Resistance works alongside the public in a non-hierarchical performance, where volunteers in the collaborative generate their own content and direction as long as it follows the group's mission to promote, make, and facilitate the distribution of point-of-use water filters to communities in need. All members of the collaborative have the ability to act, and the actions of the collaborative are not in isolation, embodying the notion of interculturality. As hooks (2000, p. 141) notes, "Moving from solitude into community heightens our capacity for fellowship with one another. Through fellowship we learn how to serve one another. Service is another dimension of communal love". Members of Reservoir Studio work with and alongside people who enter the performance area as active observers and participants to foster a collaborative space where the influence of the pedagogical push (Gaztambide-Fernandez & Matute, 2014) facilitates a shift from potential apathy to solidarity.

Collaborative creative resistance as participatory practice

Post-studio artists are those who engage in participatory practice, meaning they stage their studio art, spectacle, and criticism of society through creative practice from positions outside a traditional studio environment. Post-studio artists seek to remove the conceptual distance between the production of the artwork and the spaces and practices of display. During the beginnings of post-studio production in the mid-1900s, artists were still tied to working as artist/critics within institutions. Once post-studio artists were able to break free from the confines of institutions, the forms and methods of artistic production varied greatly. That is, this shift to post-studio art practice served as a liberation from the conventional and private culture of institutional art to new definitions and enactments of artmaking within a broader scope of a public culture of contemporary art. For example, conceptual artist Joseph Beuys created works that included public talks, daylong performative critiques of student works, and the planting of trees. Additionally, Beuys founded the Free International University for Creativity and Interdisciplinary Research (Bishop, 2012). Due in part to Beuys's post-studio art practice, speech and teaching can be considered artistic media today (Bishop, 2012). Another example of variety in post-studio participatory practice is playwright Paul Chan's staged performance, *Waiting for Godot in New Orleans* (2007). Chan's work arose from a visit in 2006 to New Orleans, an historic and culturally diverse southern city in the United States situated near the Gulf of Mexico. As Chan reflected on the devastation caused by Hurricane Katrina in August 2005, he was reminded of Irish playwright Samuel Beckett's play *Waiting for Godot*. Chan developed a production of the play staged by the Classical Theater of Harlem. Chan's play was performed five times in various locations in the Lower Ninth Ward and Gentilly areas of New Orleans. Chan's linking of Samuel Beckett's work with the lives of the people of New Orleans was an intercultural and post-studio effort to perform the play "as the departure point for inaugurating a series of causes and effects that would bind the artists, the people in New Orleans, and the city together in a relationship that

would make them each responsible for the other" (Chan, as quoted in Bishop, 2012, p. 251). Chan also engaged in eight months of workshops and teaching as well as a fundraising campaign to support local organizations involved in post-hurricane rebuilding efforts.

Collaborative Creative Resistance shares characteristics with the post-studio projects, like those of both Joseph Beuys and Paul Chan, in that the projects are intercultural post-studio responses to social or environmental conditions that the artists found troubling. These works also engage a post-studio practice of working with and for the public in order to provoke social change. As participatory and post-studio practice, Collaborative Creative Resistance involves participants who enact a demonstration of the creation of practical-use objects used for survival. Additionally, while Collaborative Creative Resistance is coordinated by a single individual, the performances themselves do not rely on the artistic or pedagogical vision of a single creator; rather they are distributed creative performances with participants and have outcomes that shift with each iteration. As such, these performances rely on the intercultural dialogues that take place among the artists, participants, and audience who attend and enact them.

Due to its existence outside conventional institutions of art exhibition and conventional cultures of artmaking, post-studio participatory practice, like Collaborative Creative Resistance, is in tension with more traditional forms of artistic practice. Yet, as performance artist Andrea Fraser (2005) argues, art is unable to escape the boundaries established by the institution. Fraser characterizes analysis of the transformation of institutions as reductive and binary. This transformation revolves around binaries such as inside and outside, public and private, or elitism and populism, yet fails to account for the underlying distributions of power that are reproduced even as conditions change. Thus, the institutional transformation ends up serving to legitimate such reproduction (Fraser, 2005). While Collaborative Creative Resistance is a performance-based educational project, it does not seek to critique the institutions of art as its singular or primary focus. The educational focus and fluidity of contributing educators and performers these performances attract, support the importance of broadening the intercultural critical examination of Collaborative Creative Resistance to include, among others, participatory inquiry and interventionist practice.

Collaborative Creative Resistance as participatory inquiry

Cooperative inquiry is a process wherein participants collaborate to define questions they wish to explore and a methodology for that exploration (Heron & Reason, 1997). The participants work together or separately to enact the methodology as it relates to their practice with the intention of leading to new encounters within their field of exploration. Through this process, participants find ways to represent experiences in significant patterns that feed into revised understandings of their questions. In John Heron and Peter Reason's (1997, p. 283) conception of cooperative inquiry, co-researchers engage together in multiple iterations of these forms of knowing in an effort to build what they term "congruence". Congruence is a means for participants to refine the ways events are consummated and to deepen how such events are grounded in each other. Political and epistemic participation are two key participatory principles that guide cooperative inquiry. Political participation in research means that research subjects have a basic human right to participate fully in designing the research that intends to gather knowledge about them. Epistemic participation means that any knowledge that emerges from cooperative inquiry is grounded in the lived experiences of the researchers and participants. For example, Heron and Reason (1997) point out that qualitative research is a social science that studies people in their own social setting. In comparison, cooperative inquiry is a wide-ranging process that may include any aspect of the human condition that a group of co-researchers choose

to explore through the instrumentality of their own experience. Considered through the lens of participatory inquiry, Collaborative Creative Resistance might again be considered both a subject and process of inquiry. Participatory inquiry through artmaking enables investigations of art as a mode of knowledge, participative knowledge of organic and inorganic forms, and altered states of consciousness (Heron & Reason, 1997, p. 286). Participatory inquiry through artmaking is transformative as knowledge of the world is consummated as action in the world. Heron and Reason (1997) argue that the traditional Western worldview is coming to the end of its useful life and has left the Earth with a legacy of human alienation and ecological devastation. They caution:

> The shadow face of authority is authoritarianism; that of collaboration, peer pressure, and conformity; that of autonomy narcissism, willfulness, and isolation. The challenge is to design institutions that manifest valid forms of these principles, and to finds ways in which they can be maintained in self-correcting and creative tension.
>
> *(Heron & Reason, 1997, p. 287)*

Heron and Reason's phenomenological view of participatory inquiry runs counter to some proposals for participatory inquiry. For example, art education and psychoanalytic theorists jan jagodzinski and Jason Wallin (2013) are critical of traditional views of arts-based research, as they assert art is neither research nor knowledge but rather an event or encounter.

Many incarnations of arts-based research indirectly reflect a neoliberal view of research wherein boundaries between art and technology blur. Rather than moving beyond it, arts-based research that emphasizes artistic products as representations of knowledge succumbs to the modernist hierarchy of knowledge. Arts-based research that generates products as the final outcome becomes "inconsequential and dangerously isolated from historical and political memory" (jagodzinski & Wallin, 2013, p. 193). Collaborative Creative Resistance differs from the kind of arts-based research jagodzinski and Wallin critically discuss as it is not intended to function as either a subject or product of research. While Collaborative Creative Resistance can function as a subject of research under Heron and Reason's (1997) notion of participatory inquiry, the performances are predominantly pedagogical in nature.

Collaborative Creative Resistance as interventionist practice

Art education and curriculum theorists B. Stephen Carpenter, II and Marisa Muñoz (2012) argue that the water filtration performances echo the Freirean concept of *conscientization*, which Paulo Freire (2000, p. 109) defines as "the deepening of the attitude of awareness characteristic of all emergence". Carpenter and Muñoz (2012, p. 126) note this critical consciousness is transformative in the water filter performances as the collaborators shift "from passive observers into active agents who create real-world critical interventions," eschewing and disrupting dominant cultural narratives of passivity and enacting the care of interculturality. The collective of artists, educators, and passers-by learn from, with, and alongside one another from a model of "doing, responding, interacting, interrupting, and resisting" (Carpenter & Muñoz, 2012, p. 126). Furthermore, in reflecting upon the performances and issues related to the global water crisis, collaborators may experience a praxis, or call to action, in order to better the world (Carpenter & Muñoz, 2012). Freire (2000, p. 66) suggests the "action will constitute an authentic praxis only if the consequences become the object of critical reflection". It is important to note not all locations in which the water filter performances occur are communities who have difficulty accessing potable water. For example, Collaborative Creative Resistance performances have occurred in

Pennsylvania on or near university campuses, where access to clean water is abundant and water quality is rarely questioned. However, key points of the global water crisis and the process of making and using ceramic water filters are addressed through printed material, interactive dialogue, and participant demonstrations. These elements disrupt the ways in which water and the availability of clean water are perceived. The engagement and interaction of the Collaborative Creative Resistance performances opens up the potential for the immediacy of active social participation during the performance demonstrations, prompting reflection that may lead to praxis and a call for social change.

Drawing from theories and practices in community-based artwork, specifically citing the work of contemporary art curator Nato Thompson (2004), art education scholar Jack Richardson (2010, p. 20) uses the term *interventionist practice* to define work that "provokes solid dialogue and collaboration and produces an art form that can function as the basis for intellectual investigation into the social environment". Seen in this way, interventionist practice provides an "opportunity for reflection and the potential for active social participation" (Richardson, 2010, p. 19), echoing the Freirean concepts of conscientization and a call for praxis. This intervention can also be seen as the pedagogical push against another in order to exert influence (Gaztambide-Fernandez and Matute, 2014). As interventionist practice, the work of Collaborative Creative Resistance is intercultural because it embraces change by supporting what hooks (2000) considers a "love ethic" across cultural boundaries. The educators involved in the Collaborative Creative Resistance performances interrupt and disrupt a capitalist status quo as they challenge how the global water crisis is perceived and received in order to elicit reflection, foster affect, and enact positive social action.

Re-reading Collaborative Creative Resistance: intercultural analysis in context

In this chapter, we have explored ways in which the Collaborative Creative Resistance performances of Reservoir Studio promote intercultural dialogue through the lenses of participatory practice, participatory inquiry, public pedagogy, and interventionist practice. This intercultural dialogue is evidenced with and by the public through the participation of the passers-by who bring their own disciplinary, personal, and cultural knowledge to a conversation about the global water crisis already in progress, and how this particular conversation in which they are engaged overlaps conversations elsewhere. For example, at a recent Collaborative Creative Resistance performance, a graduate student in life sciences watched the performance with an enthusiastic academic and personal curiosity. Her conversation with members of Reservoir Studio led to a pedagogical dialogue on the effectiveness of the point-of-use water filter against waterborne disease. As the conversation continued, she shared the names and research expertise of colleagues with whom she works as potential collaborators on future research to increase the effectiveness of the water filters. The disciplinary knowledge this graduate student brought to the dialogue was an example of *participatory engagement* through shared dialogue and *interventionist* through considerations of future action and collaboration. As an intercultural exchange, Reservoir Studio members embraced seamlessly the graduate student as a collaborator; each participant in this conversation shared a love for objects that matter to help provide clean water for those without access.

We described and problematized ways in which the Reservoir Studio performances seek to mobilize various narratives as a means to explore cross-cultural dialogue. As one example, we considered the performances within the framework of other post-studio artists whose work and intentions seek to challenge, escape, and critique the confines of conventional art institutions. As such, post-studio practices engage a critical dialogue with cultural practices of institutional

art conventions and encourage a broader critical scope of artistic practice within a contemporary public culture of art and social responsibility. When considered at a global scale, the intercultural dialogues that emerge from post-studio practice grounded in social issues become even more complex. We are encouraged by the richness, complexity, and participatory nature of such intercultural dialogues.

Finally, as intentional public pedagogical projects, the Collaborative Creative Resistance performances connect with and engage different publics—a pedagogy *for the public*, a pedagogy *of the public*, and a pedagogy of *enacting publicness*. That is, these three conceptions of *public* facilitate and encourage critical explorations among participants, artists, and observers who bring personal and cultural knowledge and experiences to these works. In order to function as meaningful intercultural spaces, these conceptions of *public* demand intercultural dialogue in the ways we have discussed above, particularly when considered in relationship to participatory art practices such as the Collaborative Creative Resistance performances. Further, our exploration of the performances revealed the centrality of participatory post-studio practice as complex, contextualized, and relational. It is the complexity, overlapping contexts, and relationships among cultures that are the essence of the pedagogical possibilities, the ways that this thing functions as instructive, informative, that people learn from each other and teach one another about water, cooperation, collaboration, human rights, ethical decisions and actions, and local and global politics. Overall, we intended our inquiry as a way to begin a dialogue of possibilities for consideration by educators, artists, and others who conceive and enact arts-based performances as intercultural public pedagogy.

Note

1 For more information on Reservoir Studio, visit sites.psu.edu/reservoirstudio.

References

Arendt, H. (1958). *The human condition*. Chicago: The University of Chicago Press.

Biesta, G. (2012). Becoming public: Public pedagogy, citizenship and the public sphere. *Social & Cultural Geography, 13*(7), 683–697.

Biesta, G. (2014). Making pedagogy public: For the public, of the public, or in the interest of the publicness? In J. Burdick, J. A. Sandlin & M. P. O'Malley (Eds.), *Problematizing public pedagogy* (pp. 15–25). New York: Routledge.

Bishop, C. (2012). *Artificial hells: Participatory art and the politics of spectatorship*. London: Verso Books.

Burdick, J., Sandlin, J. A., & O'Malley, M. P. (Eds.) (2014). *Problematizing public pedagogy*. New York: Routledge.

Carpenter, B. S. (2010). Embodied social justice: Water filter workshops as public pedagogy. In J. Sandlin, B. Schultz, & J. Burdick (Eds.), *Handbook of public pedagogy: Education and learning beyond schooling pedagogy* (pp. 337–340). New York: Routledge.

Carpenter, B. S. (2014). Leading through giving and collaborating: Considerations for socially engaged arts-based practice and collaborative leadership. *Visual Inquiry: Learning and Teaching Art, 3*(3), 309–322.

Carpenter, B. S., Cornelius, A., Muñoz, M., & Sherow, E. (2011). Engaging social justice and place-based education. *Trends*, 31–36.

Carpenter, B. S., Muñoz, O., Muñoz, M., Arcak, C., Cornelius, A., & Boulanger, B. (2011). Re/searching for clean water: Artists, community workers and engineers in partnership for positive community change. In C. McLean (Ed.), *Creative arts in research for community and cultural change* (pp. 41–64). Calgary: Detselig/Temeron Press.

Carpenter, B.S., & Muñoz, M. (2012). In search of environmental justice and clean water: Encouraging artistic and collaborative responses through the possibilities of sustainable appropriate technologies. In L. Hochtritt, T. Quinn, & J. Ploof (Eds.), *Art and social justice education: Culture as commons* (pp. 124–130). New York: Routledge.

Fraser, A. (2005). From the critique of institutions to an institution of critique. *Artforum International, 44*(1), 278–285.

Freire, P. (2000). *Pedagogy of the oppressed: 30th anniversary edition*. New York: Continuum International Publishing Group.

Gaztambide-Fernandez, R. A. & Matute, A. A. (2014). Pushing against: Relationality, intentionality, and the ethical imperative of pedagogy. In J. Burdick, J. A. Sandlin, & M. P. O'Malley, *Problematizing public pedagogy* (pp. 52–64). New York: Routledge.

Heron, J. & Reason, P. (1997). A participatory inquiry paradigm. *Qualitative Inquiry, 3*(3), 274–294.

Hooks, B.(2000). *All about love: New visions*. New York: Perennial.

Jagodzinski, J., & Wallin, J. (2013). *Arts-based research: A critique and a proposal*. Rotterdam: Sense Publishers.

Majozo, E. C. (1995). To search for the good and make it matter. In S. Lacy (Ed.), *Mapping the terrain: New genre public art* (pp. 88–93). Seattle, WA: Bay Press.

Nuñez, I., Konkol, P., & Schultz, B. D. (2014). 3,417 footnotes:Troubling the public pedagogy of CReATE. In J. Burdick, J. A. Sandlin, & M. P. O'Malley (Eds.), *Problematizing public pedagogy* (pp. 161–172). New York: Routledge.

Potters Water Action Group. (2015). Online. http://www.potterswateractiongroup.org/ (accessed 4 March 2015).

Richardson, J. (2010). Interventionist art education: Contingent communities, social dialogue, and public collaboration. *Studies in Art Education, 52*(1), 18–33.

Sandlin, J., Schultz, B., & Burdick, J. (Eds.) (2009). *Handbook of public pedagogy: Education and learning beyond schooling*. New York: Routledge.

Savage, G. C. (2014). Chasing the phantoms of public pedagogy: Political, popular, and concrete publics. In J. Burdick, J. A. Sandlin, & M. P. O'Malley (Eds.), *Problematizing public pedagogy* (pp. 79–90). New York: Routledge.

Sellers, S. (Ed.) (1994). *The Hélène Cixous reader*. New York: Routledge.

Thompson, N. (2004). Trespassing toward relevance. In N. Thompson & G. Sholette (Eds.), *The interventionists: Users' manual for the creative disruption of everyday life* (pp. 97–108). Cambridge, MA: Mass MoCA.

20

A DIALOGIC APPROACH FOR THE ARTIST AS AN INTERFACE IN AN INTERCULTURAL SOCIETY

Elena Cologni

to listen to oneself listening . . .

(Dolci, 1988, p. 144)

Remembering is a realization of belonging, even a social obligation.
(Assmann, 2008, p. 114)

Can we learn to listen? Or to allow silence to speak to us? Can we visualize the space among us and inhabit it with our memories? These are among the questions raised by, and embedded in, my recent participatory art project "lo scarto," which evolved through the relational dynamics within the group. It was informed by the Reciprocal Maieutics Approach (RMA; Dolci, 1973), a pedagogic process based on collective exploration of individuals' experience and intuition. This enabled inter-subjective exchange, the activation of history and memories, and the construction of a narrative related to the current intercultural process taking place in Italy. My creative process is here discussed as research as art practice, in relation to socially engaged and dialogic art and communicative memory, to act as an interface in an intercultural society.

Research as art practice in context

As an artist and a researcher, my creative process can be defined as "research as art practice." According to Busch (2009) contemporary art is often characterized by an explicit recourse to philosophical or sociological theories, and scientific research and process that "critically analyses both the commodity aspect of artworks and their purely aesthetic impact, as well as the power structures of the art world" (Busch, 2009, p. 1) resulting in interdisciplinary and socially engaged artistic research. My ongoing investigation into the "interchange" (Cologni, 2004) of artist and audience/participant, based on the co-functioning of self and other (Merleau-Ponty, 1962), and the perceptual, psychological and social dynamics within it, is manifested in participatory and collaborative events, sculptures, drawings and workshops. The live encounter in the form of dialogue is central to the construction of meaning. In particular, in my production platform

Rockfluid,[1] my approach was also *in-disciplinary* in that it was "not only a matter of going besides the disciplines but of breaking them" (Baronian, Rancière & Rosello, 2008, p. 2). I have recently focused on processes of memorization in the present and in relation to space/place, through, for example, "Spa(e)cious" and "lo scarto" discussed below. Research as art practice is a natural development from the art practice as research paradigm that emerged in the 1990s, defined as the context where the produced artworks also produced (often critical) knowledge (Busch, 2009), of which my piece "Diagrammi" (Cologni, 2000 (Venice Biennale 1999)) is an example. The art research debate grew and intertwined with movements in contemporary art, allowing research in the arts and an evolution of the relationship between theory and practice (Busch, 2009; Sullivan, 2005). These are interwoven in research as art practice, which through different manifestations acts through many registers, and has a wider impact in society because it talks to—while engaging with—different audiences to share the transformation taking place from ideas to artworks, from raw matter to specific constructs, from subjective needs to shared meaningful actions.

My artistic research within the Anti Ocularcentric Discourse (Cologni, 2004; Jay, 1993), a critique of the vision-centered western cultural context, is filtered through my own experience as a transnational artist within a now rapidly changing multi-ethnic European continent (Checkel & Katzenstein, 2009; Herrmann & Risse, 2004). The Council of Europe issued the following statement about diversity in Europe: "Over the past few years, cities across Europe have become increasingly diverse in ethnic, cultural and religious terms. Diversity challenges the ability to establish and maintain peaceful and productive relations between different segments of the population" (Council of Europe, 2008), but this also presents the opportunity to debate the meaning of "European" and "transnational" identities, and indeed of a shared cultural identity. The rapid social transformations provoked by globalization and migration impose new settings in which people, communities and cultures mix, creating a new organic intercultural context in which national identities are undergoing a real crisis (Petkova & Lehtonen, 2005). Europe thus is no longer a static monolithic construct with its traditions and certainties, but a more open and organic, albeit unstable, context in which different cultures are constantly assimilated, and artists, who today work more and more beyond their studios' closed doors, have the responsibility to respond to this situation.

Socially engaged art

Socially engaged practices can enhance dialogue and intercultural exchange among participants and more widely in culture and society, for example what is defined as Littoral Art (Kester, 2004) indicates a "spatial" shifting of boundaries of knowledge and contexts, to locate meaning among the subjects involved—artist, participants, collaborators—significant beyond the art context. This implies dynamic relations typical of intercultural engagement as well, which are "constituted by the intersections of time, place, distance, different systems of thought, competing and contesting discourses within and between different knowledge traditions" (Nakata, 2007, p. 10).

Since postmodernism in the 1980s, structures of knowledge hierarchies collapsed within a growing pluralist and multicultural society while visual artists' voices became a form of social critique. It is this urgency to address the social role and meaning of art that resulted in a participatory approach (Bishop, 2006) to become the imperative from then onwards: the social turn. In the book *Relational Aesthetics*, Nicholas Bourriaud (2002) defined an art which took as the theoretical and practical point of departure the whole of human relations and their social context, resulting in artworks producing inter-subjective encounters for the construction of

meaning. Contemporary art projects have since assumed more and more social, pedagogic and political roles to impact a changed society, while also adopting research-like language (field-work, research, interviews) and methods. Grant Kester (2004) defined this tendency typical of Littoral Art (a term borrowed from artist Ian Hunter, the littoral zone is the part of a sea, lake or river that is close to the shore) to indicate a shifting of boundaries of knowledge and contexts. Socially engaged art practice is indicated by Kester to be rooted in the art of the 1960s and 70s (the gradual movement away from object-based practices, the interest in interaction with the viewer, and a shift towards a durational experience (Kester, 2004, pp. 13, 50). The discussion on the ethical implications of this participatory art for the communities involved, the artists and the facilitators is very lively (Bishop, 2012; Kester, 2004), but it is well accepted that this art practice has shifted the attention "from galleries to 'real' places with 'real' people addressing 'everyday' issues" (Kwon, 2002, p. 107) and focused on active participation. Of course, such an approach presents challenges; for example the assimilation of certain method-ological strategies from anthropology (Foster, 1996), or the rhetoric of the "community art-ists as the vehicle for an unmediated expressivity on the part of a given community" (Kester, 1995). However, artists might feel under pressure by institutional intervention, as projects of a collaborative nature develop in dialogue with all parties involved: artist, curator, institu-tion and community groups (Kwon, 2002). These very dialogues become assimilated into memory-construction processes, thus impacting in society. Within this context the subject is produced in and through dialogical exchange (Kester, 2004, p. 4), hence the related and more specific definition of dialogic art.

UK artist Stephen Willats, one of the pioneers of socially engaged art, worked with open structures of participation since the late 1960s. The book *The Artist as an Instigator of Changes in Social Cognition and Behaviour* was first published to coincide with the exhibition of the same name staged at Gallery House in 1973, as "an externalisation of the Centre for Behavioural Art's discussions and research" (Willats, 2010, p. 10). In it, Willats discusses the notion of an artwork as a "social phenomenon in which the audience is all important in giving its meaning and valid-ity" (Willats, 2010, p. 11) and which was at the basis of the conception of an artwork. The idea of "agreement," represented a perceptual recognition of mutuality through a complex series of exchanges, a social state between people (Pethick, 2011).

Further afield in the south of Italy a very different scenario unfolded: on 15 January 1968, an earthquake destroyed many villages of the Belice Valley in Sicily, including Gibellina. As a con-sequence of the destruction numerous people emigrated, while at the same time in response to the government's lack of support an extraordinary effort went into the reconstruction by those who stayed behind. This was led by townspeople and their mayor, Ludovico Corrao (Carollo & Corrao, 2010), together with activist Lorenzo Barbera, urbanists, architects and artists, who all worked at building Gibellina Nuova, a new utopian town not far from the debris of the original village. Poet and pedagogist Danilo Dolci also conducted an important political and social cam-paign, and within this scenario artists felt art could help in the healing process as well as offer-ing a future for the community (Camarrone, 2011). This historical process is still visible in the traces left to form the open air museum Fondazione Orestiadi. As part of this, Enzo Fiammetta's program "trame del mediterraneo" (Mediterranean threads) aims at supporting the role of art impacting on society, by continuing a transnational dialogue in the Mediterranean region. My art project in the Belice Valley "lo scarto," as described below, developed with a careful con-sideration of this recent past, and in relation to Dolci's Reciprocal Maieutic Approach and Corrao's vision of art for change. These positions set important examples of how dialogic and artistic tools can, together, interface in society, to inform possible interventions within the rap-idly changing social landscape due to mass migration.

The dialogic approach

The approach adopted in the art projects described below has evolved from my interest in the interchange of artist and participant in the live encounter underpinned by perceptual dynamics (Cologni, 2010), and is here discussed in relation to dialogism and, in particular, to Reciprocal Maieutics.

Dialogical Art, created through interaction between the artist and a community, belongs to the wider philosophical context of dialogism, more specifically to Russian theorist Mikhail Bakhtin (Holquist, 1990/2002). According to Bakhtin there are no limits to the dialogic context; it extends into the boundless past and the boundless future, and there is neither a first nor a last word (Bakhtin, 1986). Even meanings defined in the past can never be stable and finalized—they will always change in the process of subsequent development of the dialogue. In this sense his view of culture as a network of overlapping discussions and tendencies, attitudes and ideas, changing over time, emergent and dynamic, rather than as stable and given, also foregrounds intercultural processes. Since 1997, when I left my home country, I have adopted dialogic strategies in my art projects,[2] either using spoken language or through body movement with a pre-linguistic approach, or a combination of both. Among Bakhtin's phenomenological roots is Maurice Merleau-Ponty's notion of embodiment (Bostad, Brandist, Evensen, & Faber, 2004). The two philosophers were contemporaries, and similarities in their thought can be attributed to some common sources, including continental philosophy, phenomenology, pre-structuralist views on language, Gestalt psychology, and the work of Henri Bergson (Bell & Gardiner, 1998). Both Bakhtin and Merleau-Ponty contribute to the contemporary discussion on cognition and

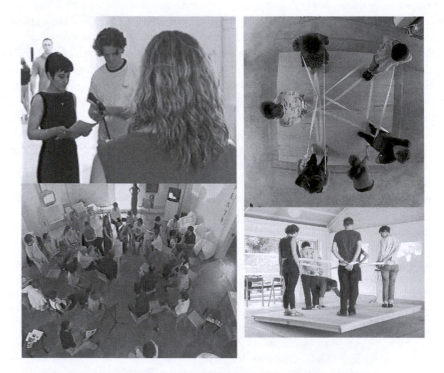

Figure 20.1 "Diagrammi," Venice Biennale (performance, 1999), videostills. "Spa(e)cious" (live installation, 2012), Wysing Arts Centre, Bourn, UK, videostills.

adopt a non-Cartesian position, as well as the situatedness of cognitive and linguistic experiences. In particular, Merleau-Ponty's position partially informed my work described below.

"Spa(e)cious"[3] aimed at creating the physical and psychological conditions to enhance an awareness of the illusory nature of the perception and memorization of time and space in the present. Through a strategy of spatial relations of bodies, I devised a participatory and performative activity for five people. This was based on the observation that the body experiences time and space while moving through and in space, since before we learn to speak (Plumert & Spencer, 2007), and in this sense we build our spatial relations with the world and others through our body first, before language develops. The piece is underpinned by elements of cognitive psychology and philosophy, in particular the Memory–Time–Perception relation: the definition of *specious present* (a present moment in which perception and memory are indistinguishable from each other; James, 1890, p. 608); the notion of the present within duration (Bergson, 1939); and, the notion of Praktognosia, experience of movement "as original and perhaps as primary" (Merleau-Ponty, 1962, p. 140). "Spa(e)cious" is performed through stages on a horizontally pivoted platform which interferes with our experience of the actual, and which prompts the participants to react by establishing physical and social relations in space with each other. The dynamics that took place among people on the unstable platform included: pulling each other as they are joined together with elastic string; avoiding each other as they walk on a marked path; and balancing each other. Most of these happened with very few or no words exchanged. Mainly through looking, moving arms and gripping, a pre-linguistic communication system was established. While restaging this work I became more interested in how the social and cognitive dynamics among the participants on the platform translated into different movements and shapes in the defined place. I then started investigating different related strategies through dialogic site-specific interventions[4] including maieutics, the Socratic pedagogic method in which the master facilitates the surfacing of knowledge in the pupil (Plato, 2005). In the most recent project I specifically referred to Danilo Dolci's reading of it.

Italian poet and educator, Dolci, worked in Sicily, developing the pedagogic Reciprocal Maieutics Approach (RMA; Dolci, 1973), which is based on a dialogic exchange between at least two persons, and inside a group, to support each participant's creativity and self-determination. Reciprocity is also a constant element in my work (Cologni, 2004), and is seen as characterized by interactions as a "two-way flow . . . essential to genuine dialogue and to free, full, and equal participation in society" (Anderson, 2010, p. 6). In the context of Sicily, a complex social and political situation in the 1950s, Dolci was able to adopt this non-violent revolutionary approach to stimulate dialogue. His method, based on empathy (Novara, 1998, 2000), became an instrument for change and "nonviolent communication" (Rosenberg, 2001) as Dolci was effectively "giving voice to the people"—I was told by Pino Lombardo (who collaborated with him)—and his method had a profound effect on those involved. According to pedagogist Novara (1998), "the question" was the metaphor characterizing Dolci's experience, to explore, discover, and go beyond what is apparent. Novara states that, epistemologically, Dolci's position is among that of Gardner, Goleman, and complexity theory. Danilo Dolci finds excitement in discovery and unpredictability that is often typical in dialogue. Learning, in Dolci's view, was part of a creative process, and was stimulated through creativity. He stated "to find all together those creative relationships allow us to enrich each other" (Dolci, 1988, p. 57).

Lo scarto

In my most recent participatory project "lo scarto," I wanted to relate to Dolci's process of knowledge formation through a genuine dialogic exchange, which would stimulate the surfacing

of a narrative to be embedded therein. In particular, I wanted to allow myself/the artist to be challenged, and "changed" though the dialogue in a shared conceptual space where we in the group would be free to communicate, and our subjectivity could be activated through personal input. This empathic approach puts the participants' own responses to carefully posed "questions" at its core. The site-specific project was both in relation to a tangible physical location, the Belice region of Sicily,[5] as well as its immaterial cultural heritage, Dolci's work. In particular, the process of knowledge exchange defined by considering the gap between what is not yet known and newly acquired knowledge (Novara, 1988): "lo scarto." This could be translated as the discarded, or the scrap, leaving a gap to be overcome during the exchange. This gives the Italian word a positive connotation: it points to the possibility of transpassing that gap. However, as the work progressed "lo scarto" acquired new meanings. I had worked on time gaps in perceptual dynamics before (Cologni, 2009), and in this case I understood it in spatial terms, developing drawings and sculptures (spaces between hands) first, and then in social terms, through workshops and a performance (space and distance among people) in relation to architecture. The latter is a bearer of local history where religion and nature, myth and science intertwined, still embedded in people's lives. The project tried to offer an opportunity to nurture the relationship we have with places, even if we inhabit them only for a short amount of time (as an artist through the exchange with the locals), and how this impacts on the construction of our memories and identity, thus posing as a possible dialogic model within the current worldview.

The participatory (and maieutic) nature of the project was embedded in its development in response to a number of formal and informal inputs. Some of the steps in the process caused me to define important elements, such as: (a) location (the Sistema delle Piazze in the city—System of Squares—was suggested by the artisan Leonardo, who said that the place is not as lively as it used to be); (b) scale (the idea of the "sculptures for hands" evolved from a drawing session of the Greek vases at the Museo Civico Selinuntino, and in discussion with its staff); (c) historical perspective (I read about Frederick II's castle, now barely visible in the mainly baroque square, in a locally published book by Calamia, La Barbera and Salluzzo (2004)); (d) the role of silence (discussed at Belice/Museo della Memoria Viva, Gibellina); and (e) participants[6] (including students from the local Liceo Pantaleo, and the Selinus Theatre Drama School, led by Giacomo Bonagiuso).

The workshops took place in the square with participants positioned in a circle, and with a consideration of citations from Dolci's work as a means to underlie movement-based activities and narrative construction. These would include the number of stages briefly summarized here. Workshop one was titled "Waiting for a unique/scarce moment of synchronicity on the part of the other" (Dolci, 1988, p. 159), and it aimed at understanding "lo scarto" in terms of space among us through devising movements in pairs. The participants were then prompted to perform the sculptures for hands. This moment is called "pollination"[7]: like bees collecting and spreading pollen, each person in the group engaged with some of the spectators in the square, through interfacing with one of the sculptures thus activated. The wooden objects are the result of a process of deduction and materialization of the space between two hands, whose impressions soften the straight edges into quasi-geometric shapes. The workshop ended with the agreement that "l'ascolto" (listening) was essential in the process, as Dolci puts it "to listen to oneself listening" (Dolci, 1988, p. 144). Workshop two was titled "The structure of silence (physical as well as temporary spaces)" (Salluzzo, G., notes from a workshop with Danilo Dolci, 1990s) and was aimed at visualizing the space among us and the architecture through silence, inhabiting and measuring the space in the system of squares, and defining "offcuts" of space between bodies. Aspects from both workshops were included in a final public performance in the square, which retained the quality of being open and unfinished.

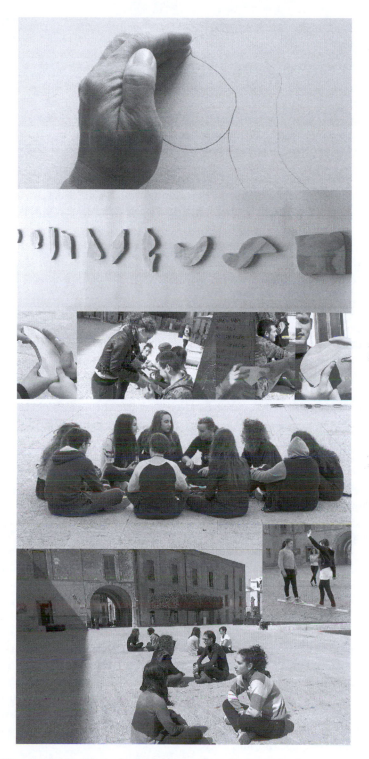

Figure 20.2 "Lo scarto" (drawing, sculptures, site–specific performance 2015), Convento San Francesco di Paola Castelvetrano, Sicily (*IArt residency*), stills from documentation.

During the workshops participants suggested new meanings for "lo scarto." Gabriele said that in social dynamics it might mean to push aside someone, marginalizing them. Alessandra referred to the discarded, not chosen ideas; Francesca to tangible scraps, discarded objects; while Enza did not like "this notion of elimination, instead lo scarto could be understood in terms of overcoming something, to progress, to move forward." The discussion continued, allowing the narrative to unfold.

The feedback I had from the participants confirmed that, through RMA, our community was now sharing newly constructed memories and developing a more open attitude towards others. Roberta, for instance, sent me her feedback after the final performance in which she stated:

> A completely new approach which has made me grow both personally and culturally. The group helped me a lot, really feeling others working with me, and, by looking at each other, I noticed that we could often communicate without too many words, and to find silence again, and focus . . . my first word used when we had to describe ourselves was "cold" . . . Then, through talking and working, that "cold" person left to make room for a more open and receptive one. A new way of working and a new way of learning, taking from giving.

The final performance proved quite challenging, and, as this was a city not used to contemporary art, a number of interferences presented themselves: loud gangs of youngsters; tourists looking for monuments; even police cars in the pedestrian area. So, how did the participants deal with all of these challenges? Some dealt with them by shifting the focus, like Enza, who said:

> It has been very useful to think about silence, as we did when we were laying down as part of the workshop . . . in the end interferences have been integrated in the work, and every sound, voice became part of the background.

Others learned to adapt to open spaces and to the various glitches that working with people may entail. Moreover, the participants found themselves in the position of offering an art experience to others through each one of the small sculptures. Roberta said:

> I liked to work outdoors, feel people's eyes, voices, and their hands which wanted to touch the works we were holding. I particularly liked the "pollination" moment, I saw people very curious and engaged, and this was very surprising for me, I did not think they could have such a positive reaction.

The participants in the workshops were all local and it became clear that the work done together allowed them to break preconceptions which would perpetuate existing social patterns among different local groups. One of the spectators, Pino Lombardo, stated that he "liked this particularly because it took the group to relate to the outside," furthermore that the way in which the youngsters presented themselves implied a certain maturity which a maieutics approach can support in achieving. The whole project was appreciated through this lens, and seen as operating "by connecting craft, local history, architecture, students and people passing by, thus producing relational spaces" as one of the collaborators said, adding that I have "worked as Danilo Dolci would have, through sharing at various levels."

One of the aspects I cherished the most was the arising of personal narrative, which gave the work a real sense of purpose, and inevitably linked it to the current social context in Sicily.

Alessandra, one of the participants, shared her worries and fears for the future, as our activity was just after the tragedy on 19 April 2015, when some 700 migrants died a few miles away in the Mediterranean sea while looking for a better life. Alessandra also shared her moment of realization: "Only through knowing the unknown (transpassing the gap/lo scarto) we can overcome fear together." This was embedded into one of the actions of the final performance, where she was balancing on one of the provided wooden boards, while looking for support from her work partner Francesca.

These genuine responses surfaced within a context where mutual trust was enhanced by the maieutics approach. The group was formed mainly of young students, a generation who will have a role within a changing society, and for whom learning to listen and interact with people from other cultures is now a necessity. Through the work done, it has become apparent how dialogic-based art is an important tool in the current intercultural landscape, within which it can support and enhance communication.

To physically relate to space in the square took an important role in building memories through our bodies moving through it—a connoted place as opposed to the conceptual one in "Spa(e)cious." Enza felt the need to cross it all and said "as if I wanted to inhabit it. . . . I wanted to 'know' it." Even if all the participants were local, the engagement with the square was a new experience for them, to gain awareness of their own identity in relation to it. It suggested that the process of attachment to (or separation from) a place, its history and people, and memory have a crucial role in identity formation.

High numbers of people have emigrated from Sicily at different phases in history, and in a particularly traumatic way after the 1968 earthquake; but in the current global migration map, the island sits in a somewhat strategic position in the Mediterranean. Sicilians now find themselves welcoming others crossing the sea, with generosity, courage and empathy coming from their own experience of being at one time those very others.

The role of memory within intercultural dialogue

The RMA can be interpreted and adopted in many different ways (including "Lo scarto") and contexts, aiming at building a shared experience as communities and groups through dialogue; that is also how communicative memory is created. The process is crucial for an awareness of selfhood (identity) both on the personal and on the collective level, which Jan Assmann (2008) states can lead to a sense of belonging to a community. Assmann introduced the concepts "communicative memory" and "cultural memory" as almost binary—as immaterial and material. Cultural memory (the monument, artifacts) is a kind of institution, exteriorized and objectified (Assmann, 2008), helping groups which do not "have" memories to "make" them, as it happened in the site-specific artworks in Gibellina. On the other hand, communicative memory is not formalized and lives in everyday interaction (dialogic, unfinished and unstable), and for this reason has only limited time depth, with what frames Assmann calls "communicative genres"—ties that bind together families, groups and generations. Assmann (2008) states that "remembering is a realization of belonging, even a social obligation" (p. 114), and that memory is local, egocentric to a group; however, he also states that the process of a specific memory to be integrated in the culture of a different group, called *assimilation*, is usually accompanied by the necessity to forget the memories connected with the original identity.

The moment of the present becoming memory, the mnemonic present (Cologni, 2009[8]), holds a particular fascination for me, because it is where its unstable and fragile nature is made apparent. When this takes place in dialogic exchange, others witness and participate in the filtering of memories through recollection, which also generates a removal and loss of the

discarded ones.[9] These concepts, which I experience on a daily basis as a migrant, are integrated in my projects through the activation of subjectivities based on communicative memory. In particular, site-specific participatory interventions become attempts to create ties and belong, inevitably followed by a process of separation. Within this process, transnationalism arises as a site for the artist's condition of non-belonging (Svasek, 2012), inter-subjective and inbetween, where my identity opens up to that of participants from different cultures and backgrounds, thus providing a model for intercultural exchange. At the end of the workshops in Sicily, I wrote: "Synchronicity. To tend towards synchronicity. Through the exchange." Simultaneity as a never-realized possibility in communication (Cologni, 2006), which prompts more dialogue within a continuous process of change and integration.

Conclusions

I moved away from my country of origin years ago and I have yet to call another place home; nonetheless, I find this transitional position a somewhat "stable" one, in which I am allowed to expose the vulnerability it implies in order to continually re-negotiate my identity in the encounter with others. This is based on trust in validating each other's position and role within the artwork, and society. Being able to relate to Dolci's RMA in a creative way has been a transformative experience, as I was challenged within the encounters, allowing myself to follow the lead I was shown by participants and collaborators. Through this I inhabited physically and conceptually a new space/place, and have become part of its memory, which also still lives in me. I developed a deep sense of attachment because of the genuine connections established, and feel the difficulty in leaving it behind, unable this time to re-enact the process of separation I experienced so many times before (Cologni, 2009). I was able to work with youngsters in a rapidly changing Italian multicultural society, and could see the effect that dialogue through art had on them as well, on the way they may approach this unknown future. Dialogic Art can train participants to develop an open predisposition towards others, to break social barriers and thus open up to interculturality as it is dynamic, vibrant and evolutionary, and open to the unexpected. The artist's role is thus to transform "existing values and provide a vision of the future, a different perception of the world and a language for that" (Pethick, 2011). RMA can be an important instrument for pursuing intercultural art practices based on an "open and respectful exchange of views between individuals and groups belonging to different cultures that leads to a deeper understanding of the other" (Council of Europe, 2003, Opatija Declaration).

The strategy we shared has proved that we can learn to listen, and allow silence to speak to us. Communication and exchange can happen with and without words, and within spaces of silence where listening, "l'ascolto," is at the core of these dynamics: a gap that can never be fully filled to continually perform its function. Throughout the project I had to learn to understand and decode the role of silence in the exchanges: as a conscious omission (aspects of history, traumatic memories or experiences); or an empty space created to welcome input; or, indeed, a need for a rest (to be left empty). My response was based on considering and respecting those possibilities and acting accordingly. As Dolci says: "one has to switch off oneself in order to get to know" (1988, p. 46). To respect others' silences, or indeed opinions and customs, we have to place aside our own. Dialogic Art can allow us to inhabit the space among and around us, by supporting the formation of communicative memory through the integration of different traditions, an aspect of which will be lost or discarded along the way. This is "lo scarto"—offcut, scrap, residue of culture—which might be picked up in the future to be reactivated again in a changed society.

Notes

1 Rockfluid (rockfluid.com 2011/13–2014/15), outcome of a residency at the University of Cambridge, Faculty of Experimental Psychology (two Grant of the Arts, Arts Council England: Escalator Visual Art Retreat at Wysing Arts Centre, Escalator live art, Colchester Arts Centre).

2 "Communication" (1997, West Bretton), "Diagrammi" (1999, Venice Biennale, Figure 20.1), "In Bilico, experience of aesthetic pain" (2001, London), "Geomemos" (2009, Yorkshire Sculpture Park), "Spa(e)cious" (2012/2013, Figure 20.1).

3 Presented at: *How Performance Thinks*, Conference PSi Performance and Philosophy working group and Kingston University's Practice Research Unit 2012, The London Studio Centre, London; *Re-Collect*, curator Ellie Morgan group show Wysing Arts Centre, Bourn, UK; IKF Institut für künstlerische Forschung Berlin, Germany; *Cose Cosmiche*, Artra Gallery, Milan; MK Gallery, Milton Keynes, UK (2012); Lincoln University, May; PSi #19, Stanford University; Bergamo Scienza, Bergamo, Italy, with Caterina Albano (2013); Cognitive Futures Conference, Oxford University (2015).

4 "Navigation Diagrams" (MK Gallery, Milton Keynes UK 2013, curator Simon Wright), "L'elastico" (Ruskin Gallery, Cambridge, UK, curator Bronac Ferran, 2012) and "Balancing" (Radio Materiality, Athens Biennale in 2013, curator Vessel, Doppelgaenger Gallery, Bari, Italy 2014).

5 Through an art residency run by *I*Art and Clac, with Arts Council England, UNESCO and European funding.

6 Francesca Bianco, Marilyn Buscemi, Vito Cafiso, Valentina Cangemi, Enza Valentina Di Piazza, Roberta Marchese, Gabriele Marchica, Irene Moceri, Federica Passanante, Alessandra Sparacia, Aurora Taormina.

7 Also in an activity I led, Circuit Cambridge (Tate), 2013, https://circuit.tate.org.uk/2014/02/mosaic3dx/

8 In my "Mnemonic Present, Un-Folding" (2005 performance series).

9 *Re-Moved*, Centre for Contemporary Arts Glasgow, Gi08, Francis McKee.

References

Anderson, J. (2010). *Intercultural dialogue & free, full, and equal participation: Towards a new agenda for an intercultural Europe*. Utrecht, the Netherlands: Utrecht University. http://www.kunstoginterkultur.dk/assets/files/pdf/PIE-disc-paper_J-Anderson.pdf (accessed 30 May 2015).

Assmann, J. (2008). Originalveröffentlichung. In A. Erll, and A. Nünning (Eds.), *Cultural memory studies: An international and interdisciplinary handbook* (pp. 109–118). Berlin, New York: de Gruyter.

Bakhtin, M. (1986). *Speech genres and other late essays*. Austin: University of Texas Press.

Baronian, M.-A., Rancière, J., & Rosello, M. (2008). *Jacques Rancière and indisciplinarity* (G. Elliot trans.). *Arts & Research, 2* (1), available online at http://www.artandresearch.org.uk/v2n1/jrinterview.html (accessed 24 March 2015).

Bell, M., & Gardiner, M. E. (1998). *Bakhtin and the human sciences: No last words*. London: Sage.

Bishop, C. (2006). The social turn: Collaboration and its discontents. *Artforum, 44*(6), 179–185.

Bishop, C. (2012). *Artificial hells: Participatory art and the politics of spectatorship*. London: Verso.

Bostad, F., Brandist, G., Evensen, L. S., & Faber, H. C. (Eds.) (2004). *Bakhtinian perspectives on language and culture*. New York: Palgrave Macmillan.

Bourriaud, N. (2002). *Relational aesthetics*. Paris: Les Presses du Réel.

Busch, K. (2009). Artistic research and the poetics of knowledge. *ART&RESEARCH: A Journal of Ideas, Contexts and Methods, 2*(2), available online at http://www.artandresearch.org.uk/v2n2/busch.html (accessed 10 February 2015).

Calamia, P., La Barbera, M., & Salluzzo, G. (2004). *Bellumvider La Reggia Di Federico II Di Svevia A Castelvetrano*, quaderni 4. Castelvretrano: Grafill.

Camarrone, D. (2011). *I Maestri di Gibellina*. Palermo: Sellerio.

Carollo, B., & Corrao, L. (2010). *Il sogno mediterraneo*. Palermo: E. Di Lorenzo.

Checkel, J. T., & Katzenstein, P. J. (Eds.) (2009). *European identity (Contemporary European politics)*. Cambridge: Cambridge University Press.

Cologni, E. (2000). Institutions in Great Britain: Artist as researcher. Diagrams. In *Oreste at the Venice Biennale* (pp. 57–59), Milan: Charta.

Cologni, E. (2004). *The artist performative practice within the Anti-Ocularcentric discourse*. Unpublished PhD Thesis. London: University of the Arts London.

Cologni, E. (2006). Present-memory: Liveness versus documentation and the audience's memory archive in performance art. In D. Meyer-Dynkgraphe (Ed.), *International conference consciousness, literature and the arts* (pp. 368–386). Newcastle: Cambridge Scholars Press.

Cologni, E. (Ed.) (2009). *Mnemonic present, shifting meaning.* Vercelli: Mercurio Edizioni.

Cologni, E. (2010). That spot in the "moving picture" is you (Perception in time-based art). In J. Freeman (Ed.), *Blood, sweat & theory: Research through practice in performance* (pp. 83–107). London: Libri Publishing.

Council of Europe. (2003). Opatija Declaration. http://www.coe.int/T/E/Com/Files/Ministerial-Conferences/2003-Culture/declaration.asp (accessed January 2015).

Council of Europe. (2008). *White Paper on Intercultural Dialogue: Living together as equals in dignity.* Strasbourg.

Dolci, D. (1988). *Dal trasmettere al comunicare: Non esiste comunicazione senza reciproco adattamento creativo.* Casale Monferrato: Ed Sonda.

Dolci, D. (1973). The Maieutic Approach: The plan of a new educational centre at Partinico. *Prospects, 3*(2), 137–146.

Foster, H. (1996). The artist as ethnographer. In *The return of the real: The advant-garde at the end of the century.* Cambridge, MA: MIT Press.

Herrmann, R. K., & Risse, T. (Eds.) (2004). *Transnational identities: Becoming European in the EU* (Governance in Europe Series). New York: Rowman & Littlefield Publishers.

Holquist, M. (1990/2002). *Dialogism: Bakhtin and his world.* London, New York: Routledge.

James, W. (1890). *Principles of psychology* (2 vols). New York: Henry Holt.

Jay, M. (1993). *Downcast eyes: The denigration of vision in twentieth-century French thought.* Berkeley and Los Angeles, CA: University of California Press.

Kester, G. (1995). Aesthetic evangelists: Conversion and empowerment in contemporary community art. *Afterimage*, January: 5–11.

Kester, G. (2004). *Conversation pieces: Community and communication in modern art.* Berkeley, CA: University of California Press.

Kwon, M. (2002). *One place after another: Site specific art and locational identity.* Cambridge, MA: MIT Press.

Merleau-Ponty, M. (1962). *The phenomenology of perception* (C. Smith, trans.). London: Routledge and Kegan Paul.

Nakata, M. (2007). *Disciplining the savages: Savaging the disciplines.* Canberra, Australia: Aboriginal Studies Press.

Novara, D. (1988). Una Pedagogia Liberante. In D. Dolci (Ed.), *Dal trasmettere al comunicare*: *Non esiste comunicazione senza reciproco adattamento creativo* (pp. 11–30). Casale Monferrato: Ed Sonda.

Novara, D. (1998). *Scegliere la pace. Guida metodologica.* Torino: Edizioni Gruppo Abele.

Novara, D. (2000). *L'ascolto si impara.* Torino: Edizioni Gruppo Abele.

Pethick, E. (2011). Stephen Willats Art Society feedback. *Mousse Magazine, 27* (January). http://moussemagazine.it/articolo.mm?id=645 (accessed 15 December 2014).

Petkova, D., & Lehtonen, J. (2005). *Cultural identities in an intercultural context.* Department of Communication, No. 27. Jyväskylä, Finland: Jyväskylä University.

Plato. (2005). *The Collected Dialogues of Plato* (Ed. E. Hamilton & C. Huntington, trans. L. Cooper). Bollingen Series. Princeton, NJ: Princeton University Press.

Plumert, J. M., & Spencer, J. P. (Eds.) (2007). *The emerging spatial mind.* Oxford: Oxford University Press.

Rosenberg, M. (2001). *Nonviolent communication: A language of life.* Encinitas, CA: Puddle Dancer Press.

Sullivan, G. (2005). *Art practice as research: Inquiry in the visual arts.* Thousand Oaks, CA: Sage.

Svasek, M. (2012). *Moving subjects, moving objects: Transnationalism, cultural production and transformations.* Oxford, New York: Berghahn Books.

Willats, S. (2013). *The artist as an instigator of changes in social cognition and behavior.* London: Occasional Paper.

21

AN ART RESEARCH OF URBAN SPATIAL PRACTICES AND MOBILIZING IMAGES

Emancipating bodies and signs at Montevideo's Espacio de Arte Contemporáneo

Laura Trafí-Prats

Introduction

Despite their different geographies and socio–political histories, all cities share transversal charac-teristics that define life in urban conditions, which include being complex and incomplete sys-tems that deploy "the possibility of making—making the urban, the politic, the civic" (Sassen, 2013, p. 209). Contemporary global cities are affected by extensive institutionalization, sur-veillance and commercialization that put under attack such possibility of making and political transformation (Lefebvre, 2003; Sassen, 2013).

This chapter is about a pedagogical experiment for which I traveled from the city of Milwaukee in the United States where I currently live, to a city where I had never been before, Montevideo in Uruguay. I went there with the expectation of using research experiences and theoretical engagements with the city in the transversal way anticipated by Sassen (2013): to use shared characteristics of the urban condition to set a dialog with other art practitioners living in Montevideo who had the interest to collectively rethink the uses, stories and possibilities con-nected to Espacio de Arte Contemporáneo (hereafter, referred to as EAC), a recently established contemporary art museum.

In this project, art research functioned interculturally through a vitalist, non-fixed approach to thinking about art and the city. This is a type of thinking that forms and reforms in a perma-nent encounter with a world made of human and non-human others (Braidotti, 2013). Felix Guattari (1995) argues that art research has the power to unframe and rarefy fixed models of theory and cultural practice, enabling new and unexpected connections. It situates institution-alized theories in a state of bifurcation and alteration that is in sync with the transformations of life itself. As will be discussed in detail through the chapter, the approach to intercultural-ity that I propose connects Guattari's ideas on art research mentioned above with theories of posthumanism (Braidotti, 2013; jagodzinsky & Wallin, 2013) and new materialisms (Alaimo & Hekman, 2008; Bennett, 2010), to suggest an understanding of urban culture as an embodied, improvisational, artful practice seeking for moments of interrelatedness and distributed agency

between bodies and spaces, bodies and non-human phenomena, perceptions and sensations, representations and fluid images. In this non-dualistic view of urban culture, interculturality is the outcome of the multiple connections that we form, deform and reform in our peripatetic, perceived, inquired relations with the palimpsest of histories constituting the global city and its differing states of materiality.

From prison to museum

EAC is the first art center in Uruguay exclusively dedicated to contemporary art. As expressed in its institutional mission statement, EAC aims to play a role in the circuits of the art system by "becoming an influential organization, both locally and internationally, with regards the development, research, production, and exhibition of contemporary art." At the same time EAC operates as a space for dialog and possibility, "as a meeting point for artists, theoreticians and various types of audiences" (http://www.eac.gub.uy/eac_files/eac_pdf /eac_institucional.pdf).

Our pedagogical experiment started as an initiative of art education professor Fernando Miranda at Universidad de la República, whose research centers on collective art practices. Being acquainted with other pedagogical projects that I had previously developed in connection with contemporary art museums (Trafí-Prats, 2009, 2015), he invited me to work with EAC as a territory that could potentially be re-territorialized (Deleuze & Guattari, 2005) beyond, and despite, the distribution and separation of tasks in the above-mentioned mission statement by engaging in creative practices of spatial production and movement. Towards this goal, I collaborated with an intergenerational group of 18 members, all of them practitioners (students/ teachers/artists) in the fields of visual arts, architecture, dance and theater.

This call for a re-territorialization of EAC made more sense when I became acquainted with the history of its formation. EAC was built in one of the five wings of the former Miguelete Penitentiary, the first prison constructed in Uruguay. Miguelete opened on May 25, 1888 with a panoptic architecture, very similar to the prison of Pentonville in England. During the military dictatorship of 1973–1985, Miguelete was used to lock up political dissidents. In 1986, it became a prison for minors and functioned that way until 1990, when its uses as a penitentiary ended. It was not until 2009 that the Uruguayan government announced the restoration of one of the five wings to erect the EAC, in an effort—in words of its artistic director Fernando Sicco—"to re-signify the space . . . as a space of freedom" (http://www.eluniversal.com.mx/ articulos/54859.html).

For this renovation, the structure of the third story of the building and the surveillance tower were left intact. While physical access to these structures was not permitted, visitors could see such historical fragments of the building from the main museum floor. Substantial changes occurred in the second and first floor. One of them was the covering of stonewalls with white drywall. Another was the construction of a floor that extended from side to side in the second level of the building. These two changes dramatically altered the architecture of the panoptic, in which the central space of the wing remains open for surveillance purposes with only a narrow corridor connecting the linear rows of cells to the central tower. While cell spaces were preserved in order to be used as exhibition rooms, the aforementioned interventions fully immersed the visitor in the time-space of a gallery experience. The experience outside the building was qualitatively different because the reconstruction process was at a more intermediary stage. The jail courtyard, additional wings of the panoptic, and an adjoining building used for prisoners' visits, which are now the museum's conference room, were still fully or partly abandoned.

In addition to all this, EAC had been a top-down governmental initiative, in which the participation of civil society was nothing but tenuous. Educational activities tended to reproduce

linear models of instruction, like the guided tour, leaving little room for counter-stories or differencing experiences. This lack of space for a collective re-imagination of EAC/Miguelete seemed even more concerning after learning about the repressive scope of the military dictatorship (1973–1985) and its connections with *Operation Condor*, which meant the involvement of right-wing dictatorships in the south cone of South America including Chile, Argentina, Brazil, Paraguay and Uruguay in practices of state terrorism including kidnapping, incarceration, torture, and assassination of individuals associated with left-wing ideologies (Klein, 2007). Operation Condor resulted in more than 33,000 deaths, 300 involving Uruguayan citizens (del Pozo, 2002). When I visited Montevideo, my host Professor Miranda from Universidad de la República, noted that some victims of torture, as well as family members of those who were assassinated, were still alive, including President Pedro Mújica and his wife, senator Lucía Topolansky, who both spent almost two decades in confinement cells. I also learned that many *desaparecidos* (missing) bodies had still not been found (GIAF, 2006). Despite government initiatives to research the scope of the repression, there has been a lack of cultural and participatory work centered on memory, difficult knowledge and trauma (del Pozo, 2002). For all these reasons, the idea of presenting EAC/Miguelete as a site for instantaneous freedom appeared to many as a superficial measure to lock down the past instead of engaging in its complexities.

Urban space production

A couple of weeks before I traveled to Montevideo to meet with the group, I emailed and asked them to bring a personal or found image of a public space in the city along with a narrative on how the image connected with a concrete, non-fixed understanding of space—space as usage, movement, occupation, co-existence of different things at once (Massey, 2005). Besides having the group teach me about a city that was new to me, the goal was to see what were the participants' initial understandings of urban space. This is the narrative that participant Mariana Percovich, an independent theater director and professor at Universidad de la República, wrote:

Colón Train Station

Colón Station, built in 1912, is situated at 6 miles from Central Station. It is one of the semi-abandoned stations in Uruguay due to a lack of passengers. It is linked to a network of British style stations that extend throughout the country that nobody maintains. It is in a zone far from the downtown by a traditional and popular barrio.

Passenger trains stopped their normal activity in the 1980s, when the system entered into crisis and the government dismantled it. . . . In my childhood of divorced parents, my father, who was a journalist and an intellectual, gathered his five children from different mothers and pulled us hiking in Montevideo. He was penniless, and sought for cheaper ways to entertain his children. One of my favorite walks was to go to Central Station, which at that time (late 70s) was active, purchase tickets, small, pink or green, and board the rattling trains. We traveled the 6 miles to Colón Station. When we got off, we would go up and down the structure of the English bridge, and snacked coffee and a yellow, big, rich biscuit in the bar on the corner of Plaza Vidella. In the 90s, when I was doing theater and I used to do shows in real spaces, I chose Colón Station for one. Trains no longer functioned normally, only some few passengers lines were left passing through Colón. I asked and got permission. I traveled to rehearse with any of the objects of the show (a couple of giant dragonfly wings designed by

Carlos Musso, a Uruguayan artist) in the increasingly rattling trains with no light. We rehearsed in the station, we illuminated it and put speakers and music. The opening night I had the magic experience of meeting numerous young people in the audience who did not know about the trains. . . . It was like recovering Colón Station from another perspective.

I chose this narrative among the few that were read aloud in our first meeting due to its emphasis in usage of space, in the capacity of the street to be unpredictable, ludic and symbolically productive, a resource for creativity and freedom. Mariana's narrative was indicative of Lefebvre's (2003) differentiation between the city and the urban. For Lefebvre the city is the planned and constructed physical environment for power and exchange to be deployed, while the urban is an unfinished reality, which does not exist except in the form of potential, or utopian horizon.

Additionally, Mariana's aforementioned narrative alluded as well to what Lefebvre describes as obstacles of the urban, such us the drive of the global city towards surveillance, urban planning and commercialization. Rather than a meeting point, the street is a passageway where movements between work and programmed leisure become regulated, where contemplation of goods takes over action. In this change, monumentalization, either via the suppression of train stations—to follow Mariana's narrative—or through the drive towards musealization, of which EAC/Miguelete may be an example, colonizes and controls the street, neutralizing the potential of the street to produce other forms of order (Lefebvre, 2003).

Considering an intercultural perspective, I suggest that Lefebvre's (2003) understanding of the urban as a potential for this other kind of order can be extended and reimagined via Deleuze and Guattari's (2005) concepts of de-territorialization/re-territorialization. These concepts provide a critical view on how capitalism homogenizes the spaces where urban practices take place (territorialization), while at the same time bringing forward possibilities of resistance, re-appropriation, reactivation of urban spaces, subjectivities and cultural practices in the city (re-territorialization). As I mentioned earlier, these re-territorialized spatial and cultural practices link with ideas of interculturality that center on situations of connectivity, and distributed agency between bodies and spaces. Deleuze and Guattari describe these practices of re-territorialization as existing in the *smooth spaces* created by nomadic subjects.

One of the ways the nomadic subject defies conventional conceptions of space-time is through virtual relations. The virtual refers to the unrepresentable aspects of the real. It alludes to a field of relations beyond the constraints presented by actual subjects and objects. In connection to this, jagodzinski and Wallin (2013) invoke the will that the nomad has for the unthinkable, which is "a break in the habit of sense and representation, bending the geometrical organization of both space and time through a molecular approach to urban movement" (p. 164). jagodzinski and Wallin see this in the psychogeographies and drifting processes (*dérive*) developed by the International Situationists in the 1960s and 1970s. In sync with these ideas, our project intended to experiment with the possibilities of molecularizing EAC/Miguelete with a special emphasis on those spaces left in its precinct that still offered a potential to explore, following Lefebvre's (2003) other forms of order beyond the orders offered by the museum map. In this respect, the project aligned with a long tradition of philosophical and artistic anti-representational practices connecting thinking with moving and exteriority. Some of these anti-representational practices were invoked through the three premises of space production that we discussed and experimented with as a group. These are: Premise #1, Walking as a form of thinking; Premise #2, Going beyond perceptual habits; and Premise #3, Immersing in *terrain vagues*.

Premise #1: walking as a form of thinking—no expectations— no destinations

Contemporary artists and scholars have been interested in how walking opens possibilities for rethinking how moving bodies are affected by spaces. For instance, ethnographer Manuel Delgado (2014) describes walking as an act of thinking that permanently occurs in movement and therefore remains unformalized. Urban historian Francesco Careri (2009) refers to the Latin verb *discurrere*, which means both moving through and the process of thinking. As one moves, spaces remain open.

During our working sessions, we looked at and talked about the work of contemporary artists like Francis Alÿs, Richard Long, Robert Smithson, Sandra de la Loza, Viviam Maier and others, who have used walking as a practice of art research. This led the participants to initiate a discussion on what art does when art involves moving in/through/for the urban landscape. Do the performances, maps, drawings and textworks created by these artists succumb eventually to representation and the formalization of what moves and resists fixation? With these questions and other questions that emerged, we intended to discern whether the spatial practices of EAC/Miguelete, which the group was going to engage with eventually, had to seek the production of an artwork or if they had to be left as a thinking process, henceforth resisting formalization? This dilemma led to a discussion on the connections of perception with movement, and the production of images as something machinistic (Colebrook, 2006; Deleuze, 2010; jagodzinsky & Wallin, 2013) and therefore non-human, which constituted the second premise for our project.

Premise #2: going beyond perceptual habits—mobilizing images

Cinema and the digital image have brought a new understanding of the image. In the philosophy of the time-image (Colebrook, 2001; Colman, 2011; Deleuze, 2010; Rushton, 2012), images are not understood as reflection of a world that we pre-know, but something that can "estrange perception" (jagodzinski & Wallin, 2013, p. 46). The time-image is an image that occurs in a situation of discontinuity or shock within a cause-logic narrative. It reveals "how time is a process of becoming which affords a temporal perspective of images that problematizes classical philosophy's categorizations of 'truth' and the 'reality' of the world" (Colman, 2011, p. 180).

Within this perspective, as jagodsinski & Wallin (2013) suggest, images neither recognize nor represent, but encounter, the world. In this respect subjectivity does not precede perception but results from it. Perception is subjectivity in process, a form of looking, which always entails a double movement of thinking and rethinking what and how we perceive in the unfolding and durational act of looking. Therefore, perceiving is "*incorporeal*" (p. 47) because it occurs in interrelation with the world, coming to us from the outside.

Deleuze (1986, 2010) describes the knowledge that comes from this "absolute exteriority" as machinistic. It relates to the power of the camera and its post-production devices to deploy a world that is beyond human perception. For Deleuze, images can think in differencing terms, and consequently they make us rethink how we organize the world. They force us "to confront the very becoming and dynamism of life" (Colebrook, 2001, p. 30).

We projected this notion of a machinistic production of subjectivity and images that estrange our habitual perceptions into a discussion of the recently discovered work by amateur photographer Vivian Maier. I selected Maier's work to be discussed with the group of participants as an example of the practice of perception, and therefore subjectivity as movement, process

and engagement with an exteriority discussed above. I focused on her broad collection of self-portraits in urban spaces and domestic sites because of their layered materiality, their heterogeneous arrangements, and their instantiation that a body only exists and can be perceived in interrelation with its surrounding world. In these self-portraits, Maier's body appears interfered, permanently altered, as something that is ungraspable by a holistic image, being infiltrated by objects, people, spaces (see, www.vivianmaier.com).

Sometimes her body is just a part-reflection in a window that frames other actions/stories/ images going on. Other times her body appears as a reflected shadow projected in the bodies of other people and objects in both a disturbing and unnoticed closeness, nearing the behavior of a stalker who follows others' lives and traverses. The radical, unexpected angles of some of these pictures speak of these momentary encounters between extraneous bodies forming a new and hybrid reality. There is a clear example of this in Maier's composition featuring the behind of a street worker's dirty pants covered with a thick layer of dirt. The silhouetted body of Maier taking the picture appears abstractly reflected in this unusual surface in a shocking intimacy.

Maier's image-making engages with what Deleuze (2003) calls sensation. Prior to the recognition of a muddy worker's behind, the artwork is sensed as matter: What first traverses our bodies in this photograph is the sharp midday light and contrast, the thickness and freshness of the mud, the striking viewing angle, the collapse between two bodies. Colebrook (2006) affirms that sensation is a vibrating quality beyond any generality. As a result sensation is re-territorialization, "a perceptual power or potential from which a world of perceived things emerges" (p. 107). Deleuze (2003) states it this way: "Sensation is what passes from one order to another, from one level to another, from one area to another. This is why sensation is the master of deformations, the agent of bodily deformations" (p. 36), and these bodily deformations are clear and abundant in Maier's self-portraits.

For Deleuze (2003), sensation functions like an arrest of motion in which movement decomposes and recomposes through new arrangements and intensities. It is not that movement is a displacement, but "an amoeba-like exploration that the Figure is engaged inside the contour" (p. 41). The clear and sharp contours of Maier's bodies are extensive and porous. Other worlds emerge within the enclosed and echoing rectangles (sometimes circles) of windows and mirrors against which Maier constantly shoots herself.

Following all these ideas, the aim of our second premise was to understand image-making and practices of space at EAC/Miguelete as something that connects through perception, and not as something in opposition. It is in this sense that Maier's work and its connections with Deleuze's (2003) theory of sensation can inform an understanding in which culture emerges from relational encounters in the spaces in-between; in-between the body and the street, the corporeal and the incorporeal, people and objects/images. Maier's work causes us to think about the cultural ways our bodies inhabit cities, and therefore creates an intercultural space of ambiguity, interrogation and possibility.

In the philosophical framework that the time-image offers, images are something that heterogenizes space-time. They form perception not to recognize but to encounter. Perception comes from our engagement with the outside, not the inside. This type of image requires movement, and fits with Massey's (2005) call for a new imagination of space. To imagine space is not necessarily to spatialize, represent, or stabilize, but to engage in aspects of freedom, dislocation, surprise, that open space up to the political. This is space understood not as a physical location— EAC as institution—but as a movement where multiplicity, encounter and duration take place. It takes place through matter, sensation and the image. In continuity with these ideas, I introduced to the group of participants a third and final premise connected to the EAC/Miguelete as a space between abandonment and possibility.

Premise #3: immersing in *terrain vagues*—engaging with vibrant matter

As mentioned earlier, there were different areas in the EAC/Miguelete's precinct that were still part of the original prison building. Many spaces were in a state of semi-abandonment, contrasting with the highly formalized interior of the museum. In these spaces, debris, weeds, and other manifestations of wilderness had partly taken over human construction. When walking in the museum/prison precinct we would pass by scaffolds, discarded materials, and workers. Our project took place in a transitional moment, when there was still a material presence to consider EAC/Miguelete through what architect Solà-Morales (1995) describes as a *terrain vague*. A *terrain vague* consists of an indeterminate space that seems forgotten, unproductive, conveying a tension between an absence of utilization and the openness of possibility.

Following this idea of possibility within a place that is transitioning to higher formalization and less indeterminacy (musealization), the discussion with the participants concentrated on artist Robert Smithson's *investigation-sites*. These documentary works focused on urban spaces transformed by industry, construction and abandonment where the city escaped its representation, manifesting dynamic aspects of entropy and self-dissolution. These investigation-sites included going to these spaces, traversing, photographing and filming them, while keeping the artistic process as something multiple in nature—merging with everyday life and other disciplines like archeology, biology, science, maintaining a sense of open-endedness and experimentation.

We discussed how Smithson's site investigations connected with new materialisms' idea that all types of bodies (human and non-human) project "peculiar forms of vitality . . . appropriate to [their] material configuration" (Bennett, 2010, p. 2). Precisely, the aim of this third premise was to immerse in the *terrain vagues* of EAC/Miguelete, give up our assumed priority as knowing agents, and encounter through movement, perception and the image (premises 1 and 2) its vibrant matter; that is, to encounter the powerful forces towards sense and sensation, and to see matter not as passive and inert but as an *actant* affecting the capacities of our bodies to act-in-the-world. New materialisms' ideas connect with the view of interculturality that I am putting forth in this chapter because they understand that cultural phenomena are not limited to representation, but emerge from realities made of materiality and sensation. New materialist concepts see culture not in a dualistic structure functioning in opposition to nature and the environment, but situated in interrelation with a world that is more-than-human (Alaimo & Hekman, 2008).

Practices of space production

In the second and third day of our project, participants engaged in their own practices of space and site investigations of EAC/Miguelete. Some worked individually and others in groups, using portable devices such as phones, tablets and compact cameras to visually document their movements with photos, sound and video. These processes were interfaced with group discussions that led to the exploration of new practices, itineraries and images. In the two sections that follow, I discuss two cases of space production. The first case presents an investigation of the pentagon as a *terrain vague* in the city. It also connects drawing with walking and image-production as strategies for spatial reconstruction and critique. The second case addresses practices of mobility stimulated by non-human material elements located in EAC/Miguelete's courtyard. Both cases function as possible experiments for an intercultural pedagogy centered on practices of mobility, re-territorialization, nomadism and distributed agency between bodies, images and urban spaces.

Re-territorialization #1: searching for the diagonal—
walking the void

During our discussion of ideas and practical premises, participant Andrés Santangelo had been inspired by the walking art of Richard Long and the idea that traversing space was a form of drawing lines while abstractly evoking a space that was impossible to be perceived in its wholeness. This approach did not come as a surprise because Andrés had introduced himself as an artist and professor of drawing and geometry in the school of architecture. He described his space practice in EAC/Miguelete as "an experiment intending to retrace the pentagon of the panoptic plant by locating and following the diagonal(s). A pentagon always generates diagonals" (Santangelo, in Trafi-Prats, 2014). This retracing was motivated by his experience in the museum galleries, where the sense of being inside a pentagonal structure became lost. "I was curious to see if I could still locate those spaces of disturbance, spaces where the city does not quite fit" (Santangelo, in Trafi-Prats, 2014). By looking through the windows and walking EAC/Miguelete's external perimeter, Andrés found many odd-shaped spaces that functioned as external resonances of the pentagon. "I thought that no matter how much EAC got rehabilitated, there always would be *terrain vagues* in its surroundings. It is just what a pentagon produces when placed inside a grid" (Santangelo, in Trafi-Prats, 2014).

Andrés' walking practice of retracing the apparently imperceptible shape of the pentagon from the museum interior inspired a discussion about the other movements that were possible in EAC/Miguelete—movements not necessarily developed on its solid constructed spaces but movements through its voids. Andrés' walking privileged drawing instead of contemplation of goods. This displacement allowed the group to start speculating about the multiple itineraries of movement, of crossing lines, for example, instead of orthogonal movements, and the states of vagueness that the given figure of the Pentagon offered.

Re-territorialization #2: images that renew our relations
with the world

Alejandra Prieto Porta and Pamela González Almeida collaborated together expressing a shared interest in exploring the materiality of the EAC/Miguelete, looking for things that vibrated, while using play and externally set rules to bring a non-human character to their movements. They had noticed that in the ground that we transited every day from the precinct's entrance to the museum and the conference room, there were islands of gravel that spread around, moving unevenly in different directions. They started throwing pebbles randomly, and moving to the places where the pebbles fell, re-engaging again and again with the material environment from the perspective of each new location. An additional spatial practice followed this, which consisted in chasing the minimal and intermittent lines of gravel, meandering with them into

Figure 21.1 In search of diagonals (courtesy of Andrés Santangelo).

hidden corners. Alejandra and Pamela set the rule of following the gravel until they found a limit that did not allow them to move further. In one of these drifts, they ended in a wall situated in one of the prison courtyards, which contained a deteriorated group of square mirror tiles layered with dirt and cracks. Pamela photographed herself against this surface made of different wall textures: the tiles, a reddish wood panel, and a lower layer of concrete. As occurring in the photos of Vivian Maier, Pamela's body reflection interferes/merges with the many incidents of this wall. A part of her face renders itself invisible, implicitly situated in the empty space between two mirror tiles. In the adjacent tiles we glimpse the faded reflection of two wings of the panoptic building. The composition unfolded a contradictory sense between presence and abandonment vibrating through the wall as Pamela encountered it, perceived it, and photographed it. In a post-production moment, Alejandra and Pamela selected this specific photograph from the many they had taken in their drifting. Using Photoshop they digitally inscribed the letters and words, "UNA PARE," an invented term with the potential to refer to different words: *una* (one), *par* (two); *pared* (wall); and the verb *parar*, more specifically the conjugation *pare*, which expresses the obligation to stop. Some palpable dislocations, both in the placement of the letters as well as in the composition and spelling of the words, echo the fragmentation already present in the mirror tiles.

In our group discussion of this image we invoked again the theory of the time-image, and its defense of a montage that was not lineal and cause-logical, but one that made complex our access to history, time, space and allowed us to access the singularities of space-time through a multiplicity made of bifurcations and evocations. Alejandra and Pamela's image was neither single nor simple. As Godard and Ishaghpour (2005) put it, in such montages words collide and multiply so the image can emerge. This image mobilized our ideas of the world (EAC/ Miguelete) as it was initially given to us—a museum, a place under rehabilitation, a space of freedom (jagodzinsky & Wallin, 2013).

Figure 21.2 Una pare (courtesy of Alejandra Prieto Porta and Pamela González Almeida).

The visualization of this and other images prompted Valeria, another participant, to explain the story of how the room where we had met for four days was the same room where she visited her own brother who had been imprisoned in Miguelete during the years of the dictatorship. Despite the invitation that our project offered to think of EAC/Miguelete in new ways, she shared how she had felt immobilized to say anything different during our conversations, disconnected because of her haunting memories. She explained that most of the images that she captured in her spatial practices continued her desire to seek the places in her memory, as she tried to imagine where her brother was, which window cell was his, and how his cell looked. Despite all of our dialogs of how the prison space was being rehabilitated and renovated, she shared how difficult it was for her to see the place as anything other than a prison. However, Valeria also acknowledged that the practices of space presented by the younger generation of participants had helped to mobilize her own experience in other directions.

As a type of image that emerges in the context of post-war experiences of trauma, the time-image has the power to renew a belief in life in the shadows of disaster, war, violence (Deleuze, 2010). In this respect, the films of the time-image bring an understanding of the world as shocking, confusing and, often, unbearable (Rushton, 2012). Valeria described this as the inability to say/see anything new about EAC/Miguelete's space. However, the characters in these films emerge from such unbalancing and disorienting situations with a renewed way of seeing the world, as happened as well to Valeria.

Conclusions

Culture/art as a museum institution relies on ideas of human initiative, exceptionalism, intelligibility, representation and art as separated from life. In this chapter, I have argued that culture/art as interculturality, as an encounter, as interrelatedness with an outside, and as materiality is an assemblage of human and other non-human entities that, as Bennett (2010) explains, "share powers and operate in dissonant conjunction with each other" (p. 34).

If EAC/Miguelete aspires to deploy an affirming transition from control to freedom that is more than an image of thought, then EAC/Miguelete should work towards an understanding of art/research less as an object of meaning-making (to be thought in a separated individualistic realm of aesthetic autonomy), and more as an event through which sense emerges—not because we are detached from the world but because we are located in it (Kirby, 2007). From a Deleuzian perspective, sense-making is not equal to meaning-making. As a matter of fact, sense is not intentional and individual but indirect and distributed. Sense is a space where the known and the unknown exist together, and knowledge resists closure and representation (jagodzinski & Wallin, 2013).

Based upon these ideas, urban and spatial experimentation, thinking as movement, and the time-image appear as key concepts for EAC/Miguelete to reconsider where the locus of agency resides. As we have seen, through our premises and practices, freedom of the body (a body that is a human–non-human material assemblage) does not really occur if this is not accompanied by a freedom of the sign-art towards other forms of sense-making not limited to its institutionalization. This entails making art to work for the multiplicity of sense (Colebrook, 2006; Deleuze, 2003), "assaulting a kind of representational lethargy by which signs are always-already distributed within a semiotic field" (jagodzinsky & Wallin, 2013, p. 9), such as the exhibition as a spatial arrangement, the gallery tour, the art catalog. If this emancipation of bodies and signs is not put at the center of EAC/Miguelete, cultural action, the aspiration for freedom described earlier by EAC's artistic director Fernando Sicco would become a dogmatic image of thought upon which a given group has agreed upon.

In the tension between formalization and *terrain vague* in which EAC/Miguelete was immersed at the time of this project (June 2014), we performed an intercultural pedagogy as an experiment of re-territorialization and nomadism, a movement towards virtuality and smooth space where the perceptions and sensations configuring our shared world were reconsidered (Braidotti, 2013).

References

Alaimo, S., & Hekman, S. (2008). *Material feminisms*. Bloomington, IN: Indiana University Press.

Bennett, J. (2010). *Vibrant matter: A political ecology of things*. Durnham, NC: Duke University Press.

Braidotti, R. (2013). *The posthuman*. Cambridge, UK: Polity Press.

Careri, F. (2009). *Walkscapes: Walking as an aesthetic practice*. Barcelona: Gustavo Gili.

Colebrook, C. (2001). *Guilles Deleuze: Essential guides for literary studies*. London: Routledge.

Colebrook, C. (2006). *Deleuze: A guide for the perplexed*. London: Continuum.

Colman, F. (2011). *Deleuze and cinema: The film concepts*. Oxford, UK: Berg.

Deleuze, G. (1986). *Cinéma I: The movement-image*. Athlone: London.

Deleuze, G. (2003). *Francis Bacon: The logic of sensation*. London & New York: Continuum.

Deleuze, G. (2010). *Cinéma II: The time-image*. 9th ed. Minneapolis, MN: University of Minnesota Press.

Deleuze, G., & Guattari, F. (2005). *A thousand plateaus: Capitalism and schizophrenia*. 11th ed. Minneapolis, MN: University of Minnesota Press.

Delgado, M. (2014, June 5). *Notas para una etnografía peripatética y de los merodeos. Apuntes para Caterina Borelli y su tesis doctoral sobre el urbanismo postsocialista en Sarajevo* [Notes for a peripatetic and wandering ethnography. Comments for Caterina Borelli and her doctoral dissertation on post-socialist urbanism in Sarajevo] [Web Log post]. Available from http://manueldelgadoruiz.blogspot.com/2014/06/notas-para-una-etnografia-peripatetica.html.

del Pozo, J. (2002). *Historia de América Latina: 1825–2001* [History of Latin America: 1825–2001]. LOM Ediciones: Santiago de Chile.

GIAF (2006). *Informe final 2005–2006: Investigaciones arqueológicas sobre detenidos-desaparecidos en la Dictadura Cívico-Militar* [Final report 2005–2006: Archeological investigations about the detained-disappeared during the Civic-Military Dictatorship]. Available from http://archivo.presidencia.gub.uy/_web/noticias/2007/06/tomo5.pdf.

Godard, J. L., & Ishaghpour, Y. (2005). *Cinema: The archeology of film and the memory of a century*. Oxford & New York: Berg.

Guattari, F. (1995). *Chaosmosis: An ethico-aesthetic paradigm*. Sydney: Power Publications.

jagodzinski, j., & Wallin, J. (2013). *Arts-based research: A critique and a proposal*. Rotterdam: Sense Publishers.

Kirby, V. (2007). Natural convers(at)ions: Or what if culture was really nature all along? In S. Alaimo & S. Hekman (Eds.), *Material feminisms* (pp. 157–187). Bloomington, IN: Indiana University Press.

Klein, N. (2007). *Shock doctrine*. New York: Picador.

Lefebvre, H. (2003). *The urban revolution*. Minneapolis: University of Minnesota Press.

Massey, D. (2005). *For space*. London: Sage.

MZR (2009, June, 29). De prisión a espacio cultural en Montevideo. *El Universal*. Available from www.eluniversal.com.mx/articulos/54859.html.

Rushton, R. (2012). *Cinema after Deleuze*. London and New York: Continuum.

Sassen, S. (2013). Does the city have a speech? *Public Culture, 25*(2), 209–222.

Solà-Morales, I. (1995). Urbanité interticielle [Intersticial urbanity]. *Inter Actuel, 61*, 27–28.

Trafí-Prats, L. (2009). Destination Raval Sud: A case study on pedagogy, aesthetics, and the spatial experience of growing up urban. *Studies in Art Education, 51*(1), 6–20.

Trafí-Prats, L. (2014). [Transcriptions of participants individual interventions and dialogs in the seminar Cartographies of Montevideo, Espacio de Arte Contemporáneo]. Unpublished raw data.

Trafí-Prats, L. (2015). Reactivating ARTIUM's Collection: The time-image and its mode of address as prosthetic pedagogy in museums. Manuscript submitted for publication.

22

"RADICAL HOSPITALITY"

Food and drink as intercultural exchange

Kimberly Powell and Christopher Schulte

Coffee pedagogy

We had become quite fond of our Friday morning meetings. It was a dedicated moment in an otherwise hectic week, affording each of us the reflective space of exchange that we needed. We sat together, scattered around a small cluster of tables inside the gallery café, and between sips of coffee shared stories about our weekly experiences in teaching, researching, and making art with children. As part of an experimental program designed to mentor undergraduate students toward a practice of teaching and research in early childhood art education, our Friday café gatherings, which had become central to the experience itself, served as a watershed for our thinking about how to live with and alongside of young people in education and art. Our Friday interactions, which continued throughout the academic year, eventually came to a close in 2012. As I worked in my office during those first few weeks, and in the months that followed, I found myself longing for the café. In many ways, those café gatherings constituted an unofficial degree program, one that allowed the students and myself to relinquish our traditional roles and to abandon as well the idea that our discussions should reflect what was already seen to matter. Instead, we talked about what we felt to be important or remarkable in the moment, that which demanded our attention. The café permitted us to do something different with our education and educational experiences. It allowed us to become something different, too. What was it about those gatherings that made this possible? Was it us? The program? The quaint space of the café? Me? The slow sips of coffee that we shared with each other?

Tea pedagogy

Water boils, water pours, teapots heat, tea leaves unfold. Water pours again. Our hosts gaze, listen, and sniff at the aromatic leaves. Gazing at the tea pot, we take in the arrangement slowly, sweeping our eyes over the carefully situated objects of Chinese tea ceremony. A tea offering is poured on the cast iron turtle pet, a gift that might bring luck. We sit around a cluster of tables that are placed together to create one whole surface that we can share. It is close to the end of the semester, and my students and I have had some time together creating, and often participating in, each other's sensory field experiences. This is not our

typical weekly seminar room, and the place is new to all of us. We sit quietly, listening to our hosts—students who are part of the on-campus tea institute—explain and demonstrate a Chinese tea ceremony. We are instructed to hover over our cups and inhale deeply, slurping the tea to mix air with water and leaves, and to exhale through our mouths in order to taste the sweet qualities of the tea. Water boils and is poured five times, at varying speeds, over the same leaves during the course of our ceremony. Each time we are instructed to taste, we comment on the differences in taste with each pour—floral, tanic, bright, bitter, and smoky are just a few of the words we exchange. After nearly ninety minutes, we start noticing that the taste of tea has infused our senses even when we are not drinking it. I can taste it when I breathe in the air around me. I have watched the infusion of water and tea, and now I feel infused as well. This is pedagogy in the sensing, in the making.

Culture has often been defined as a way of life embodying behaviors, beliefs, values, conventions, and activities. This concept of culture, however, has been widely critiqued, contested and revisited (e.g., González, 2004) in ways that suggest that culture is not just something that we are born into and tacitly embody but is also something we improvise, create, and envision through the everyday practices in which we engage (e.g., Holland, Lachicotte, Skinner & Cain, 2001; Varenne & McDermott, 1998). The term "intercultural" acknowledges that the location of culture is not fixed or place-bound but, rather, exists in and across sites, identities, practices, and communication in a global world: it connotes a kind of space and movement characterized by the slippage between categories, "an operation of displacement" (Hay, 1999, p. 8).

In our chapter, we draw from our own pedagogical experiences with the act of sharing food and drink as an intercultural artistic, pedagogical, and research practice. In doing so, we open up the concept of interculturality to the sensorial, the material, and the hospitable, examining intercultural practice as a state of in-betweenness that remains open and dynamic to reciprocity (Bouchard, 2011) as well as to difference. We underscore the ways in which practices are entangled with and by a diverse range of actants such as activities, people, objects, discourse, ephemera, memory, non-discursivity, the senses, and the immediate environment. The above vignettes are from our teaching contexts—a preservice teacher education course and a graduate research seminar in sensory ethnography, respectively. We draw our inspiration, and part of our chapter title, from an art exhibit that explicitly pursued hospitality as a theme, and is more fully described in the following section. Following this section, we each present our pedagogical and/or research encounters with meal sharing, theorizing radical hospitality as a form of intercultural practice.

Food and drink rituals as art practice

Food and drink as artistic practice has enjoyed a long history involving relational encounters. For the purposes of our chapter, we draw attention to one exhibit in particular. *Feast: Radical Hospitality in Contemporary Art* (2012), an exhibit held at the Smart Museum of Art in Chicago, IL (United States), featured a survey of artistic practices from over 30 artists and artist groups who have deliberately transformed the act of sharing a meal into an artistic medium. The exhibit's website states that "[t]hese artist-orchestrated meals can offer a radical form of hospitality that punctures everyday experience, using the meal as a means to shift perceptions and spark encounters that aren't always possible in a fast-moving and segmented society" (http://smartmuseum.uchicago.edu/exhibitions/feast/, 2014). The exhibition examined the history of artist-orchestrated meals from early twentieth-century European avant garde to its current global practice, and addressed social, commercial, and political structures that contextualize the

experience of eating together. As part of the exhibit, there were many participatory projects, meals and salons that took place in the museum and throughout the city of Chicago. Some of the highlights featured by the museum included Tom Marioni's *The Act of Drinking Beer with Friends Is the Highest Form of Art* (an exhibit first created in 1970), Mella Jaarsma's (2002) *I Eat You Eat Me*, the *Enemy Kitchen Food Truck* (Iraqi cuisine), a series of one-on-one meals with artist Lee Mingwei, and *Soul Food Pavilion*, a participatory dinner series by Chicago-based artist Theaster Gates. Here, we focus on the work of Theaster Gates, specifically his project *Soul Food Pavilion*.

Located at a home at 69th Street and Dorchester Avenue on Chicago's South side, an area in which economic disadvantage is well documented, *Soul Food Pavilion* leverages the ritual of sharing a meal as a means to occasion conversations around difficult topics such "the ethical, social and economic realities of black neighbourhoods in the United States" (McGraw, 2012, p. 89). The home, which Gates refers to as *Dorchester Projects*, not only provided a conceptual framework for thinking about and approaching a series of revitalization projects, it also hinted at the underlying intent that he desired to mobilize in his work. Since the inception of *Dorchester Projects*, Gates has transformed both modest ideas and grand ambitions into a $20 million redevelopment scheme for the city of Chicago, which includes a cultural center, arts incubator, and artist housing collaborative. More importantly, it was this scheme that gave Gates the "right to re-imagine place [. . .] not just as an art project, but as a way of living" (McGraw, 2012, p. 93). For Gates, it is also a scheme that turns on its head the stigma that businesses, musicians, and artists cannot succeed in neighborhoods where cultural amenities are scarce. The issue, as Gates points out, is that "the rubric for somethingness [is simply] different from the somethingness happening in that place" (Life + Times, 2011). What Gates initiates then, is a new rubric, one that transforms this stigma by producing a narrative of work that reanimates the cultural and material practices of black neighborhoods in the United States.

In its most generic form, hospitality refers to the friendly or generous treatment (i.e., the practices of reception and entertainment) that one extends to his or her invitees, guests or strangers. To be friendly or generous then, is to exercise a critical yet caring pedagogy, one that moves those in attendance to always be in a process of hosting and being hosted. Further, to be hospitable is to invite, receive, and accommodate the somethingness—no matter how strange, difficult, or different—that others bring to a particular situation. Central to the artistic practice of food and drink, hospitality serves as a critical relation of being and becoming knowledgeable to others, places, and events—a foundation of possible agencies. This is especially true of *Soul Food Pavilion*, the participatory dinner series that is periodically hosted by Gates at Dorchester Projects. The communal space of the dinner table serves not only as an invitation to consume soul food, but also as a forum to discuss issues of race and inequality. Guests in attendance come from different places and perspectives, and bring with them a range of cultural backgrounds as well. This difference; along with the food, its histories and narratives, and the memories and performances of those who share it; is consumed and exchanged, accommodated, and cared for.

Coffee exchanges: Chris

I had finally come to recognize the connection between those Friday café conversations and my work and current dilemma as a faculty member. I was aided in discovering this connection by the work of Theaster Gates, in particular his project *Soul Food Pavilion*. What Gates' work helped me to see was the creative value in having coffee with others. The act of sharing coffee with others makes visible a reciprocity of attentions and the exchange of both curiosity and expertise. Our café gatherings made it possible to articulate difficult questions about things that

were not usually discussed, and in ways that were often unexpected. The discussions that we shared, similar to those that Gates and his guests entered into, were complicated, often difficult to negotiate. However, the quaintness of the café and the conviviality of sharing coffee helped to foster a space that was hospitable to the tensions of such work, making it possible to linger on topics that were in and across identities, materials, and modes of communication.

It was with this connection in mind that I began to devise a plan for a new project, *coffee pedagogy*, which aimed to purpose my office as a site for critical and creative collaboration. The aim of the project was simple: to use the ritual and material of having coffee with others as a means to generate discussion of and about art pedagogy and research, especially those elements that were difficult to engage in a typical classroom setting. As a graduate student, the café was my office, so when I arrived on campus as a new faculty member, I didn't really realize how isolating it would be to work in my office. In fact, unless I was engaged in advisement or providing feedback on a project, students never came by. Not once had a student ever popped in to discuss an idea or issue that they were interested in. It simply didn't happen.

And so *coffee pedagogy* became part of my everyday routine. I made a point to schedule it into my day, about an hour before my first class. It served as a creative, critical, and collaborative intervention into the typical life of my office, and I hoped, a challenge to what had become acceptable decorum for office interactions. The coffee maker, which was given to me by my spouse as an office-warming gift, was used to brew the coffee. The mugs, which were hand-made, each had a personal story that reflected a particular relationship, memory, or experience in my educational journey. I placed napkins, creamer, sugar, and stirring sticks on a large silver platter that I had found in one of the classrooms. Also on that platter, I routinely placed a small folded card with the words *Pedagogical Gesture* carefully written in cursive. I hoped that the card would move those in attendance to speculate on its meaning and to begin questioning their relationship to the office, the coffee, me, the card, the provocation that was written on the card, and to the other visitors in attendance. For me, everything was a kind of pedagogical gesture, a move or strategy that was initiated as a means to open those in attendance to recognize the power of exchange. But it wasn't until the end of the first semester that I really began to understand the value of what I had so carefully written on that card.

On a morning that was busier than most, I had made a casual comment to those in attendance about how quickly we had managed to go through the coffee. "Either I need a larger coffee maker, or I had better invest in smaller mugs." To be honest, I didn't give much thought to the comment, and I certainly didn't expect anything to come of it. However, a few weeks after making the comment, just before the semester came to close, a student who was in attendance that day, stopped by my office with a small box in hand. Inside the box was a miniature handmade ceramic coffee mug. As I opened the box, the student stood there, smiling politely. It nearly brought me to tears, looking at the tiny handcrafted mug and thinking about the sincerity of the gesture that was being made. Until this moment, I don't think that I fully understood how the act of sharing coffee with others was indeed an art practice, nor did I fully grasp what the practice made possible, what it produced through its processes. What I realized in this moment was that the act of sharing coffee with others, as an art practice, made it possible to live, think, and be more hospitable in the world. I began to recognize that the materiality of this practice afforded new relations, engagements, and opportunities for creative production—not just for me, but for everyone and everything involved.

Karen Barad (2007) writes, "Discourse is not what is said; it is that which constrains and enables what can be said" (p. 146). Every cultural space; a neighborhood, home, classroom, café, or even one's office; runs through a discourse of possibility that both constrains and enables what can be said. For me, having coffee with students shifted the discourse of the office,

making it possible for new things to be said and new experiences to be heard. The practice of having coffee with others promotes what Jane Bennett (2010) calls, "more attentive encounters between people-materialities and thing-materialities" (p. viii). Part of what Bennett promotes is the value of non-human objects and things; for example, tables, chairs, coffee, and mugs; in our engagements with others, especially if and when those thing-materialities are imbued with cultural significance. Bennett's acknowledgment that encounters consist of both people- and thing-materialities, and that these materialities are equally effective, transforms how we enter into compositions with the materiality of the world and the different events that emerge through it. The act of giving "the force of things more due," as Bennett says, is a gesture that recognizes in things the capacity "to make a difference, produce effects, and alter the course of events" (Bennett, 2010, p. vii).

In *Soul Food Pavilion*, everything—the people in attendance, the architectural space of *Dorchester Projects*, the recycled boards that were used to design it, the table and chairs, the wares that the food was served on, the food itself, the performances and personal offerings, the clattering of utensils and glasses, the pouring of wine, the shifts in attention, a lingering gaze, and the constant flickering of light—is a source of action that has the power to alter, redirect, even bring to a halt human intention. But it is also a source capable of activating its own intention to purpose or plan a course of action. *Soul Food Pavilion*—like those Friday café gatherings and the coffee encounters that were based in my office—is a vital encounter, in which cultural matter (whatever that might be) remains susceptible to change—improvised, created and envisioned through the hospitable turns of everyday practices of exchange.

Sensory practices with food: Kim

My connection with the work of Theaster Gates and the concept of radical hospitality came in the form of a graduate course that I designed and taught, entitled "Sensory Ethnography." Aimed at graduate students in the arts and in education, a significant part of the course included art practices in and as research. Art and research share similar practices: both require, for example, the development of attentiveness and the need to render the familiar strange. Throughout the course, this relationship between art and research was underscored and blurred.

As part of the course, I had designed regularly occurring sensory explorations that might halt the taken-for-granted in everyday practices in order to produce and encounter new relations with different sensory experiences (e.g., vision, audiation, touch). For experiences pertaining to taste and olfaction, several of the students developed compelling intercultural research practices that hinged upon the idea of radical hospitality as a sensory, material encounter. As a class, we participated in a tea ceremony (described above), shared a meal that involved favorite foods and associated stories from childhood, attended a presentation by a food scientist, and viewed art practices related to food, eating, and meal sharing, such as those found in *Feast*.

We explored several theories and ethnographies pertaining to sensory ethnography. Crosscultural readings of the senses and perception underscored the senses as culturally constructed categories that are imbued with social values (e.g., Howes, 2005; Stoller, 1989). We worked with the idea of sensory ethnography as an embodied practice of being *with*—in participation, or in shared or imaginative empathy with others—which calls for engagement with the practices of everyday life (Pink, 2011). Evoking Michel de Certeau's study of (1984) everyday practices such as walking, talking, and eating together with participants, anthropologist Sarah Pink advocates these as a means of ethnographic engagement to evoke sensory and affective dimensions of experiences (Pink, 2009) that could serve to attune researchers and participants. While noting Pink's emphasis on attunement and emplacement (the interrelationship of

body–mind–environment), we also discussed Paul Stoller's (1989) argument for the centrality of the senses in ethnographic fieldwork, in which he proposed sensuous methodology as a means to encourage participation in a variety of cultural practices and render more vividly the worlds of others. We worked with theories of intersensoriality and synesthesia, which suggest the connections and resonances inherent in multiple sources of sensations that link bodily experiences to thought and action as perceiver and perceived blur (e.g., Connor, 2004; Feld, 2005). Relatedly, we encountered theories from posthumanism and new materialism that hold views of sensation as something unfolding and vague rather than constituted by a particular form (e.g., Massumi, 2011) and emphasize the agency and materiality of human and non-human actants. All of these concepts emphasized intercultural practices as comprised of intersensorial and material relations.

Individual student projects, conducted outside of class and then shared through writings, media, materials, and reflections during class hours, ranged from studied practices of new cultural experiences with food and drink, such as when a student from Lebanon participated in the practice of the North American "potluck" hosted by an academic department, to the creation of meals to be shared with friends as a form of artful practice involving attentiveness and attunement. I describe two of these projects here as examples of intercultural exchanges.

Over the course of the semester, Sue, a graduate student in art education, created an artist series of sensory boxes. Inside each partitioned box were materials she had collected pertaining to a particular sensory experience, several photocards she created that contained a photograph of relevant material (e.g., a meal) on one side of a card with a description pertaining to the image on the other, and a transparent map that she had drawn of the place in which the event had occurred, marking with the places and paths she moved through, so that the contents of each box could be seen peeking through the transparent parts of each visual map, emphasizing the material and emplaced nature of her experiences. For her sensory encounters regarding taste, food and drink, she decided to conduct field research while visiting New Orleans, LA (United States), a city known internationally for its Cajun and French creole-based cuisine and experimental dishes, and known also for its hospitality. On one of her photocards, she wrote the following description of her intent with the project, situating it within the context of a class reading pertaining to a cultural critique of authenticity:

> In reading Lisa Heldke's chapter on "But is it Authentic?," I contemplate the idea of eating as "a kind of conversation" in which the food, the preparer, and the eater engage in a dialogue, each bringing unique contributions, perspectives, and experiences. The conversation shifts when the patron is a cultural outsider. Heldke writes, "the work of cuisine is a different work for the cultural insider than it is for the cultural tourist" (2005, p. 389). As cultural outsiders, what is the authentic New Orleans experience? What should it be?

Sue eventually engaged in experiences with taste and smell at seven restaurants and shops, prompted by what she referred to as "relational dialogue": crowdsourcing suggestions on Facebook for where to eat; looking up "best food" on Tripadvisor; and, importantly, asking local residents for their recommendations of favorite places to eat and drink along with explanations and stories pertaining to those places. Once in these locations, she asked waitstaff and store employees for their recommendations and held several conversations. Much of what Sue engaged in is done by many of those who travel and want to experience local cuisine. But Sue pursued this engagement in a deliberate, attentive way by attending to food and eating as artful practice and research. In her reflection on the back of one of her photocards (and as part of her sensory box), she wrote that the experiences were not just about taste and smell:

My experiences are enhanced by my relationships with others around me, of people who inform my awareness and mindfulness of my relationship with those experiences The environment also enters into this dialogic and communal space as an important relational contributor. The best restaurants are those that understand the importance of place and how it enhances dialogue of people to place, with each other, and with the food. Eating a meal should be a multisensory event, one that fosters an uninterrupted intermingling with the material culture of food through smell, touch, movement, sight, sound, and of course taste.

Yet, Sue was also concerned about the ways that Western culinary travel, especially in a city like New Orleans which is a popular tourist destination, led to intercultural exchanges that reified cultural stereotypes. She cited Heldke once again in her written notes:

"We leave the familiar in order to encounter the unusual, the unfamiliar, strange exotic Other and to reflect on how this particular Other transforms our own identities" (2005, p. 385). I consider [that] the concept of Otherness . . . , in this case New Orleans, is purposefully and deliberately exoticized to create a narrative of sensory pleasures, including one of taste.

Sue existed in a differential space of hospitality, of wanting to participate in the many culinary offerings of the city while realizing her complicity as a participant in culinary tourism.

Tim, a graduate student whose plan of study included English language acquisition, conducted two separate sensory practices pertaining to meal sharing. Passionate about cooking, his first experience was to create a three-course meal for two of his friends that involved taste and reflection on the sensory experience of the meal. Tim soon found himself reflecting on the discussion that the meal prompted: "[T]o be able to discuss everything from our research, to stresses of grad school, to personal relationships. Food has an uncanny way of bringing us together in that way." His final project for the course again focused on meal sharing, inspired by his first experience, but in a very different way. Tim invited Adeline, a French graduate student in the course, to breakfast so that he might engage in conversational French, his second language, with her. He had intended on examining the ways in which the sensory context of the conversation influenced their conversation, but he reported that more emerged from their conversations than he had anticipated:

We did not merely engage in conversations on what we were eating, or how speaking French made me feel on a personal level. Instead, it became obvious to me that our meal, and the American restaurant context where we found ourselves, influenced our interaction in numerous discernible and indiscernible ways.

His written and audio-recorded accounts of the shared meal revealed the tensions he felt with such an intercultural experience. Noting his uneasiness with speaking French in an American restaurant, as well as his struggle to speak and comprehend French, he discussed the feeling of being "other," an experience of feeling disconnected from body and sense, and noted the ways in which sensory perception was heightened only if it pertained to their conversation; otherwise, they were suppressed so that he could focus on "native speaker norms and bodily behavior such as gestures and facial expressions" and his own communication challenges. This attentiveness caused him to note the ways in which "sensory-drenched contexts imbue the language we speak with years of socio-historical re-appropriation of transcultural flows. I contend that

syntactical structures operate under culturally created and bound rules of engagement rather than through the application of a universal, overarching linguistic structure." Referring to intersensoriality and emplacement—a concept that integrates body–mind–environment (e.g., Ingold, 2007), Tim noted that these culturally constructed rules sometimes operated at explicit levels, as when French-speaking Adeline did not understand the server's reference to buffet service v. menu ordering, and sometimes at the implicit level, as when he recognized that the interactions with their environmental context is embodied and affected intercultural communication. Tim referred to Pink's contention that "the self emerges from processes of sensory learning, being shaped through a person's engagement with the social, sensory and material environment of which she or he is a part" (Pink, 2009, p. 40).

In taking up a meal, Sue and Tim also took up intercultural encounters with the "Other" through material engagements that were entangled with dialogue, food, place, memory, and sensation. They were transactions that were open to difference and surprise (e.g., understanding of the self as other). It was only after we had reflected upon their projects in class that I realized the material, sensory ways in which hospitality was at play. Eating, as Carolyn Korsmeyer has written (Korsmeyer, 1999, cited in Heldke, 2005), is an intimate material encounter, requiring that objects become part of one's self; as such, it requires risk and trust. Heldke has argued that all works of cuisine involve transactions between the cook, food, and eater that are inherently crosscultural and relational, and that cultural markers found in food (a certain spice, for example) are a type of dialogic material (2005, p. 392) that can spark new transactions. Barad (2007) developed the concept of agentic realism from Niels Bohr's concept of the apparatus and how it functions in relation to scientific endeavors. Apparatuses, she argues, are material-discursive practices. More than just embodied by humans as laboratory setups, they produce differences that matter; that is, they constitute and are reconstituted in ongoing entanglement within a field of relations, and have the potential to reconfigure spatial and temporal dynamics (Barad, 2007). Sue and Tim were engaged in hospitable dialogic encounters. As Chris Schulte noted previously, Barad's view of discursive materiality does not refer to grammar, speech acts, or conversation per se but, rather, to that which constrains and affords what is said, opening new relations and opportunities for creative production.

Kim, Chris, coffee, and conversation

Kim: (Holds pitcher, poised to pour): Do you want cream in your coffee? I forget how you take it.

Chris: No, thank you, I take it black.

Kim: So, food as an intercultural art practice. What do you think of what we have written here?

Chris: I suspect that it is a stretch for most people to entertain the notion that food and drink rituals could be art practice. It is an idea that shifts what people understand to be "true" regarding what counts as art material. Suddenly, in place of paint or clay, for example, you have coffee, creamer, a mug or two, the people involved, a table, some chairs, etc. In other words, the materiality of the art practice expands in such a way that it fails to register to most as intelligible, as recognizable.

Kim: I think that might be a necessary consequence of concepts that are inherently fluid and unstable. Here, we have opened up the term "intercultural"—connotative of displacement and movement—to other theoretical concepts equally connotative of displacement and movement: materiality, embodiment, the senses. So, let's review for our readers what we have attempted to perform in this chapter. And, please pass me a cookie.

Chris: Sure, and I think we can add more theoretical discussion here, too. In this chapter, we have offered ways of considering food and drink as an intercultural practice that is living, relational, artful, and pedagogical. We have focused on the act of eating and drinking together as an assemblage in which conversations emerged that were open to difference, caring, deliberation, and generosity—a hospitable reconfiguration in which teaching and research as an art practice is in an entangled relation with food and drink as art practice.

Kim: (Sips coffee). In this way, we are not privileging art as object but conceive of it as an event that is shared and participatory. A shared experience, Brian Massumi (2011) writes, has an orchestration; two people do not so much share the same experience when they are involved in an event such as coffee and conversation, but rather are in *differential* involvement of the same event. There are "cross embodied attunements" (p. 112), an affective singularity that marks an event as shared and recognized as such. But any singular event also belongs to a larger category in which an event is recognizable as belonging to something larger than itself, to a grouping.

Chris: Right. He writes that, in the liminal space of the "just so" and "more than itself" (Massumi, 2011, p. 112), slippage can occur wherein potential new directions can emerge. In this view, we emerge, always entangled within a broader field of relations, be it constituted of coffee, food, memories, discourse, people, and/or new thoughts.

Kim: I'm struck by the very slippage that occurs both within and across the food and drink exchanges that we have written about in our chapter. Hospitality is explicitly at play in your coffee conversations, where you are hosting the event. It is at play with Tim's creation of a meal that he hosted for his friends, an event which I only briefly touch upon in this chapter. Sue's culinary travels and Tim's breakfast highlight the ways in which place—an urban center like New Orleans, or a restaurant, offers occasion for hospitable events and the ways in which the environment becomes part of that material encounter.

Chris: I think one of the points we want to underscore is that, when we discuss the idea of hospitality as an intercultural practice, we recognize its potential to always be in differential involvement.

Kim: That sounds like a great way to end our chapter, Chris.

References

Barad, K. (2007). *Meeting the universe halfway: Quantum physics and the entanglement of matter and meaning.* Durham, NC: Duke University Press.

Bennett, J. (2010). *Vibrant matter: A political ecology of things.* Durham, NC: Duke University Press.

Bouchard, G. (2011). What is interculturalism?/Qu'est ce que l'interculturalisme? *McGill Law Journal, 56*(2), 435–469.

Connor, S. (2004). Edison's teeth: Touching hearing. In *Hearing cultures: Essays on sound, listening and modernity* (pp. 153–172). Oxford: Berg Publishers.

de Certeau, M. (1984). *The practice of everyday life.* Berkeley, CA: University of California Press.

Feld, S. (2005). Places sensed, senses placed: Towards a sensuous epistemology of space. In D. Howes (Ed.), *Empire of the senses: The sensual culture reader* (pp. 179–190). Oxford: Berg.

González, N. (2004). Disciplining the discipline: Anthropology and the pursuit of quality education. *Educational Researcher, 33*(5): 17–25.

Hay, J. (1999). Toward a theory of the intercultural. *RES: Anthropology and Aesthetics, 35*(Spring): 5–9.

Heldke, L. (2005). But is it authentic? Culinary travel and the search for the "Genuine Article." In C. Korsmeyer (Ed.), *The taste culture reader* (pp. 385–397). New York: Berg.

Holland, D., Lachicotte, W., Skinner, D., & Cain, C. (2001). *Identity and agency in cultural worlds.* Cambridge, MA: Harvard University Press.

Howes, D. (2005). Introduction: Empires of the senses. In D. Howes (Ed.), *Empire of the senses: The sensual culture reader* (pp. 1–17). Oxford: Berg.

Ingold, T. (2007). *Lines: A brief history*. London: Routledge.

Life + Times (2011). Try a little tenderness. Retrieved December 2, 2014 from http://lifeandtimes.com/try-a-little-tenderness#.T0vR0JB4TEY.tumblr

Massumi, B. (2011). *Semblance and event: Activist philosophy and the occurrent arts*. Cambridge, MA: MIT Press.

McGraw, H. (2012). Theaster Gates: Radical reform with everyday tools. *A Journal of Art, Context, and Enquiry, 30*, 86–99.

Pink, S. (2009). *Doing sensory ethnography*. Thousand Oaks, CA: Sage Publications.

Pink, S. (2011). Multimodality, multisensoriality and ethnographic knowing: Social semiotics and the phenomenology of perception. *Qualitative Research, 11*(3), 261–276.

Smart Museum of Art: The University of Chicago (2012). Feast: Radical hospitality in contemporary art. Retrieved December 2, 2014 from http://smartmuseum.uchicago.edu/exhibitions/feast/

Stoller, P. (1989). *The taste of ethnographic things: The senses in anthropology*. Philadelphia: University of Pennsylvania Press.

Varenne, H., & McDermott, R. (1998). *Successful failure: The school that American builds*. Boulder, CO: Westview Press.

23

INTERCULTURAL EXCHANGE

The interventions and intraventions of practice-based research

Adrienne Boulton-Funke, Rita L. Irwin,
Natalie LeBlanc and Heidi May

Introduction

In this chapter we discuss how a pedagogical intervention became a site for intense engagement among faculty members, graduate teaching and research assistants, and visiting artists. This engagement acted as a site for intercultural exchange where we questioned assumptions about art and education, with the intention of disrupting and examining these assumptions before positing potentialities for what art and education could become and how it might move in such directions. The intervention led to ongoing processes of intravention—those self-reflexive practices that purposefully make connections between and among research projects. The inter-cultural nature of our work is evident in our diverse cultural, educational, philosophical, and artistic backgrounds situated within our varied histories and socio-cultural contexts.

In this chapter, it is the very act of our ongoing engagement in our diverse roles with one another that stretches our intercultural understandings of ontology. To do so, we focus on the intraventions of three graduate teaching and research assistants and a faculty member who were integrally involved in a specific artistic and pedagogical intervention and the resulting discussions we held on ontology. Throughout this chapter, we attempt to capture some of the intra-ventions that emerged and which continue to inform our research. Rita L. Irwin will open the chapter with a brief introduction to the intervention and introduce the notion of a "pedagogy of ontology." Disrupting a structured teacher education program with an artistic and pedagogical intervention opened the way for discussions and activities to examine pedagogies of ontology. Adrienne Boulton-Funke extends the pedagogy of ontology by discussing her involvement in the intervention and how it led to new understandings about the "duration of ontology" that ultimately impacted her dissertation research. Examining her own initial resistance to, and subsequent embrace of, the intervention, she explores the duration of ontology as one's intu-ition begins to perceive the potentials of practice in and through time. Heidi May extends the pedagogy of ontology and the duration of ontology by discussing the "medium of ontology." Becoming medium is a phrase used to describe the personal recognition that one's practice can actually be the medium of art and the medium of learning. Situated within a community of practice, the medium of ontology is a powerful descriptor of being and becoming artists and educators. Natalie LeBlanc extends the pedagogy of ontology, the duration of ontology and the medium of ontology and describes how these interpretations of the intervention illustrate how

each individual has experienced an intravention as a "wake of ontology." Looking back in the wake of the intervention, she describes a pivot point where we can see traces of our journey left behind while perpetual movement pulls us forward. We end the chapter commenting on ontology's eternal return (Deleuze, 1990). We suggest that the concepts of intervention and intravention (self-reflexive practices that link engagements) formed a contiguous and generative relationship that provoked new understandings and intercultural exchanges about ontological processes in practice-based research.

Rita: the pedagogy of ontology

Becoming pedagogical[1] is a phrase from my research[2] and teaching colleagues, which I have used to connote a state of embodied living inquiry whereby the learner reflectively and reflexively questions his/her intentions/actions as they relate to contextual artefacts and experiences. By conceptualizing the identity of the teacher candidate as a researcher, living inquiry becomes a place for the teacher candidate to learn skills of observation, questioning, analysis and interpretation. Teacher candidates acquire those skills as they move from desiring to "be" a teacher as expert to "becoming" a teacher as inquirer (Britzman, 2003). A/r/tography is a form of practice-based research that inquires into phenomena using artistic and educational means to offer a materiality and physicality to our work (Springgay, Irwin, Leggo, & Gouzouasis, 2008). Using a/r/tography in the *becoming pedagogical* project encouraged our teacher candidates to shift from desiring to "be" an artist as expert to "becoming" an artist as inquirer, and moreover, from desiring to "be" an educator/learner as expert to "becoming" an educator/learner as inquirer. Thus the complexity of *becoming pedagogical* includes an examination of one's ontology as an artist and as an educator.

The *becoming pedagogical* study offered us an opportunity to create an intervention into our art teacher education program. Concerned that new teacher candidates have limited knowledge of contemporary art practices (Adams, Worwood, Atkinson, Dash, Herne, & Page, 2008; Atkinson, 2011), we decided to intervene and create a space in the program when the teacher candidates would be immersed in a three-week experience with two visiting artists committed to socially engaged practices (Irwin & O'Donoghue, 2012; May, O'Donoghue, & Irwin 2014). The artists used pedagogical strategies within their artistic engagement. For example, they focused on the out-of-print text entitled *Summerhill: A Radical Approach to Child Rearing* by A. S. Neill (1960). Finding enough copies for everyone, they studied the alternative approaches Neill advanced. They also examined the marginalia in these used books and created their own marginalia in artistic ways (Jackson, 2002). In rhizomatic form (Deleuze & Guattari, 2004), they searched for local places with the name of Summerhill and eventually took a field trip to a Summerhill Retirement Centre. Most of the artist residency was punctuated with questions surrounding traditional and alternative practices in the arts, arts education, and education in general. Teacher candidates were experiencing *becoming pedagogical* through processes of living inquiry. In time, the community of teacher candidates, instructors, and artists created a new edition of the Summerhill text entitled "Summerhill, revised: A radical approach to child/teacher rearing," an artistic product that was later exhibited by the two artists.

Hoping to disrupt stereotypical ideas about art, teaching, and learning, particularly in contemporary visual arts, teacher candidates ultimately embraced *and* resisted alternate forms of art and pedagogy. The intervention created the conditions for questioning pedagogical practices within visual arts, which in turn, offered the conditions for questioning artistic practices within education. The intervention was initially conceptualized within a specific time frame, yet has endured in and through time for many of the teacher candidates, instructors, and researchers.

As such, there have been two unforeseen results of the research. The first is the realization that, in addition to the three–week visiting artist residency, regular discussions held over the remainder of the teacher education program also became interventions. These discussions not only reminded teacher candidates of the intention of the initial intervention, they also provided them with the time and space to collectively question what unfolded. Without these interventions interspersed in their program, individuals might not have taken up personalized forms of inquiry related to contemporary art and education practices (Garoian, 2013; Sullivan, 2010). The second result is the impact upon the multiple identities of the instructors, researchers, graduate research assistants, and/or artist–educators as we inquired into the project in and through time. A complex assemblage of identities emerged. While we envisioned the teacher candidate assuming the multiple identities of artist, inquirer, and educator, the graduate research assistants who were also instructors in the program experienced their own form of intervention as they dealt with the impact of the visiting artists on their own practices. Furthermore, over the next three years each graduate student began to interpret her experiences within the project *and* in her own professional practices. It was here that we conceptualized intraventions as those practices that purposefully make connections between and among research projects, linking concepts that influence forms of inquiry and substantive engagements.

Adrienne: the duration of ontology

The *becoming pedagogical* artistic intervention described by Rita Irwin was implemented in the secondary visual art methods course that I taught. In this section, I take up the processes of inquiry provoked through this intervention as I examine how re-conceptualizing time through Deleuze's (1991) concept of duration created the opportunity for my own disruption to perceptions of teaching and research practices and the inherence of this disruption in my capacities to act as both a teacher and a researcher. I argue that rather than an epistemological form of research focused on what is *known* about teaching; *the intervention* provoked an ontological form of research into the yet unknowable. This shift is unique in that, rather than utilizing processes of reflection to learn from experiences as past, this research explored learning *through* experience to create new potentials. This shift displaces the discrete compartmentalization of time as past, present, and future, instead favoring attentiveness to the embodied, affective dimension of experience that draws both memories and future desires into the present.

Drawing from the works of Deleuze (1991), Garoian (2013) and my doctoral research (Boulton-Funke, 2014), I suggest that to enact and explore these types of experiences, ontological research conceptualizes time as non-linear simultaneity of past, present, and future as duration (Deleuze, 1991). Duration disrupts processes that are used to make sense of experience, primarily acts of reflection, favoring practices that form generative connections for the potential for new thought. For me, this process emerged through this artistic intervention as it created the conditions to disrupt my own perceptions of practices associated with researching and teaching, which included seeking what is unknown as a potential of teacher practice and research rather than what is known. Through my experiences within the intervention and resultant research practices, my perceptions about what is possible in both teaching and researching became amenable to change. This shifted *becoming pedagogical* as a practice external to my experience to an intravention, which implicated my own perceptions of teacher education and inhered in my potential to act in my own research and teaching practices. As such, I argue that through the concept of duration, we might explore experience as that which destabilizes perceptions, memory, and future desires in the present rather than affirming normative understandings, creating the conditions for new and creative thought.

My encounter with my perceptions of teacher practice began with the simultaneous embodiment of the roles of instructor, graduate student, researcher, and participant, which surfaced my own tacit perceptions of hierarchical power structures and normative understandings of the purposes of art education and teacher education, including the importance of classroom management and planning. In these moments, I became resistant to the alternate ways of conceptualizing art and teacher education that came as the artists made changes to the course I was teaching. I attempted to learn from both my experience of the research process as well as my resistance to the changes made by the artists, by reflecting on my experiences as though they existed as an object in time distinct from the time of reflection. What I realized as I began my own doctoral research was that this type of reflective process suggests that the experience, and the perceptions of it, remain static and intact and available for reflection in their unchanged form. During this reflection, rather than considering the potential of the artistic intervention under way, I tended to only consider my perceptions of institutional, personal, and student expectations for the course and, in doing so, I reified my static perceptions of pedagogical and research practices.

My processes of reflection sustained my perceptions, so the experience of the intervention did little to disrupt my ways of thinking as they affirmed that which I already knew about teacher education. Deleuze (1991) argues that experience is constituted by the composites of memory and perception and that for experience to disrupt or to create the conditions for creative thought, it must create the opportunity to unsettle or make our perceptions unrecognizable so that we make new meanings. I found that instead of creating the conditions for my perceptions to become amenable to change, the intervention made more visible my perceptions of the structures within academia and teacher education, which included my perceptions of teacher candidates' expectations of course work, tools of instructor surveillance and assessment, and the hierarchical power structures of the research and graduate student/faculty relationships. The intervention pointed to the constructed nature of my perceptions and reified these perceptions that what was *known* about teacher practice was to be sustained.

My experiences in the intervention suggest that while ontological research can create opportunities to disrupt normative understandings, the primary practices of reflection utilized to make meaning through these experiences might serve to rigidify rather than destabilize perceptions. As such I argue that rather than reflecting on experience as an object separate and outside of the time of reflecting, experience must be considered as provocative. Experience is then explored through duration and the potential of affective intensity that potentially destabilizes tacit and normative understandings.

As the *becoming pedagogical* concluded and the methods course was completed, I began my doctoral research with secondary visual art teacher candidates and I found that rather than remaining reified, my perceptions of various practices stemming from the *becoming pedagogical* project shifted through a process of intravention. The intravention, as a process of disrupting perceptions of practice as well as a shifting of my capacities to act, flattened the distinctions I had initially solidified between the identities of student, teacher, researcher, and participant. As I began to pursue my own doctoral research related to arts-based educational research methodologies and teacher education, I found that my own inquiry created conditions for new understandings as an intravention about *becoming pedagogical*. It created opportunities to engage in embodied practice to tease out my own understandings of the artistic intervention. The intravention began not through reflecting on the object of experience, but through processes of *looking away* that Garoian (2013) describes as "slippages of meaning and understandings between and among perceived and conceived images and ideas" (pp. 9–10) that create delays in the body and a postponement of meaning making and action. Duration, as an embodied experience of

time, suggests that these delays allow alternate processes of learning to emerge. While reflection requires that we look directly at experience as an object, creative acts including art practice and research create the potential to form generative connections, creating an opportunity to inhere new and creative understandings in our capacities to act in teaching and research.

This intravention in the composites of my memory and perceptions of both research and pedagogy with teacher candidates shifted my research interests from epistemology and knowledge to the conditions for the provocation to new knowledge. Rather than reflecting on the meaning of the intervention as past, the intravention lives in the present, inhering in my capacity to act as both a teacher and a researcher that looks to processes to support the disposition of inquirer rather than those practices that support already known capacities to act as a teacher. The duration of ontology is understood as experience, not as an object of reflection, as lived and embodied, creating new ideas and concepts within teaching and researching to provoke the yet unknowable rather than sustaining what is already known. Becoming as an intercultural exchange within duration draws the experience of the intervention into the present to achieve alternate meanings and with new meanings, new performances of teaching and researching are made possible.

Heidi: the medium of ontology

The intervention previously discussed enabled teacher candidates to question their identities as teachers and artists, by challenging the fixity and individuation of these identities. They collaborated with the visiting artists on *Summerhill*, which blurred the line between art and education. In group interviews, teacher candidates discussed how the intervention produced art as processes of learning and art as social practice, including one teacher candidate who wrote that they were the *medium* for learning through social practice as art (Irwin and O'Donoghue, 2012). In the early stages of the project, teacher candidates often felt they were co-artists; however, after an exhibition of the collaborative work where the visiting artists were given primary credit, some teacher candidates began to question their identities in the project. They recognized they were collaborative artists yet they were also the medium through which the visiting artists worked. Embracing our own multiple identities as instructors, researchers, graduate research assistants, and artist-educators, I began to question what "artist-as-medium" might mean for "becoming pedagogical," and more specifically the notion of "becoming medium."

As an interdisciplinary artist, educator, and researcher, I work and move across these categories, adopting various identities for different projects. I choose to adjust my methods depending on the project at hand (video narrative at http://vimeo.com/heidimay/intraventions). These projects can be understood as interconnected a/r/tographical renderings realized through relational inquiry with others (Boulton-Funke, LeBlanc, May, Irwin, & O'Donoghue, 2012; Irwin & Springgay, 2008). Similar to Adrienne, the intervention led me to a process of intravention that deepened my understandings of *becoming pedagogical* which ultimately impacted my doctoral research of artists teaching at universities (May, 2013). For me, the intravention process occurred as I found meaningful connections between the various art and research projects I worked on, such as the notion of one's practice becoming the medium of art and the medium of learning. Below I examine the art and pedagogical practices of one of the artist pedagogues from my doctoral research who constantly becomes the medium of his work. I argue for a temporal epistemology in which knowledge is understood as performative learning, which involves an ontological process of learning from within the experience. Following on Adrienne's discussion of the ontological event of becoming, I propose that "becoming medium" be extended to understandings of pedagogy, and ultimately to intercultural arts practices. Becoming the

medium of our art and pedagogy can include intraventions, in which connections are created between different areas of one's research, and can lead to *becoming intercultural*.

Mark Amerika is an artist with multiple personas who moves in and between his art, writing, research and teaching in a networked way[3] (May, 2013). His practice is complex and difficult to define, as it includes internet art, digital video installations, live audio-visual remix performances, fiction and non-fiction books, and feature-length films. A professor in interdisciplinary media arts practices at the University of Colorado located in Boulder (United States), his individual works can be understood differently, perhaps with more meaning, when understood within the context of his larger performative and interdisciplinary art practice (see May, 2013). Within current "performative" art works:

> [S]omething is not performative in itself, but rather *becomes performative* by being enacted and experienced within a specific framework . . . Thereby, to speak of a performative artistic work means to claim that the process of being realized and experienced make something art, rather than, e.g., its object qualities.
>
> *(Networked_Performance, http://turbulence.*
> *org/blog/about/)*

To understand Amerika's work as performative, one must understand him not necessarily as a performer but, rather, that he is the *medium* becoming performed in and through the work. As an artist, he uses himself and his practice as the medium of his art and of his learning.

Amerika (2007, 2008) describes how he works as an artist through the notion of artist-as-medium or artist-medium. Influenced by the writings of video and performance artist Vito Acconci (1979/1996), Amerika states that "it's the artist that is the medium or instrument most capable of conducting radical experiments in subjective thought and experience" (2008, p. 75). Amerika is inspired by Acconci's desire to shift attention away from specific media and disciplines, and instead to focus on *becoming* the instrument that acts on whatever ground is available. A common theme in Amerika's work is persona transformations in a state of "becoming." The persona is often a fictional character searching for something in an unknown world while simultaneously becoming other characters. In his film *Immobilité*, two artists explore a landscape in a future world while continuously losing and finding personal identities (see http://immobilite. com/film/).

Amerika's work lives on the internet in addition to the gallery exhibition format. He embraces what artist Allan Kaprow[4] described as *"nontheatrical performance . . . an art of living that* effectively takes the art world out of the museums and galleries and blurs all human action and social behavior into a kind of artistically generated 'Life Style Practice'" (Amerika, 2007, p. 61). Amerika's teaching is not only similar to his ways of making art, it actually stems from the same methods employed within his networking life style practice. Digital and internet art methods, such as tagging and remixing, become performative strategies employed in his classroom:

> This unique style of experientially tagging the data is what an evolving digital poetics is all about. . . . [I]t's teaching through example how to enter a space of mind where the artist-as-medium improvisationally composes their work on and in the open playing field of potential artist development.
>
> *(Amerika, 2008, p. 82)*

In an interview I conducted with Amerika (May, 2013), he described his teaching as a performance and acknowledged the process in the classroom as "inter-subjective jamming" which

requires one "(t)o be able to not only listen but process and contribute, almost at the same time—like you would if you were in an improv jazz band." The collaborative and relational aspects of the jamming experience are what contribute to Amerika's understanding of the teacher as a "network conductor" (May, 2013, p. 148).

Becoming medium requires a willingness to move in and between disciplinary boundaries and genres, while engaging in relational, dialogical, and collaborative processes. These processes may lead to learning experiences in which knowledge emerges through acts of performance. Performative learning requires a "temporal epistemology" (Osberg, Biesta, & Cilliers, 2008)—an understanding of knowledge that is not representational and spatial, but emergent and ongoing: Knowledge being something to locate oneself *within* rather than something to acquire. Performative learning occurs when one is not necessarily looking to learn (or become), but instead emerges within a non-linear and sometimes delayed experience. Osberg, Biesta, and Cilliers (2008) suggest that we construct knowledge through our experiences within environments and through our participatory actions, arguing "(t)he epistemology of emergence therefore calls for a switch in focus for curricular thinking, away from questions about presentation and representation and towards questions about engagement and response" (Osberg et al., 2008, p. 213). If we are to understand art pedagogy through a temporal epistemology, we must consider how learning can be actively generated and performed by students. Amerika's intersubjective jamming is just one way of generating potential moments of performative learning and reconsidering the role of the teacher as a network conductor.

Becoming medium leads to networked moments of performative pedagogy and learning, and encounters with an ephemeral self. Becoming the medium of our intercultural arts practices allows for an opening up of the spaces that exist between the various ways we work and live. One must be willing to move in and between identities of teacher, artist, and learner and be open to becoming collaborator, performer, writer, and networker. Deleuze and Guattari (2004) describe becoming as the in-between, further emphasizing: "Becoming is the movement by which the line frees itself from the point, and renders points indiscernible" (pp. 293–294), suggesting the self exists with/in a network of identities, in a state of constant flux. As the interdisciplinary artist pedagogue adapts to a networking practice of becoming medium, the potential emerges for intraventions to occur that create connections between and among research projects. Embracing an experience of performative learning, the artist-medium engages in intercultural exchanges within an ongoing process of becoming intercultural.

Natalie: the wake of ontology

Becoming pedagogical re-contextualized the familiar and disrupted assumptions that I had about art, education, pedagogy, and inquiry. As a researcher, graduate student, artist, and teacher-educator participating in the study, the intervention brought forth the notion that a participatory, self-reflexive, and performative practice operating within a living and shared inquiry is not always a comfortable place. In re-visiting the intervention as an intercultural dialogical and collaborative practice of intravention, I have become part of a creative force, dependent on movement and on the production of the new. In this section, I draw on the work of Ellsworth (2005) and Massumi (2011), bringing forth the concept of the wake as a way of extending the pedagogy of ontology, the duration of ontology, and the medium of ontology, ultimately describing the intravention as a "wake of ontology."

Over the last few years, I have been studying the concept of the wake through various media including video, digital photography, installation (see http://www.natalieleblanc.com/n/wake.

html) and, more recently, oil paint (see http://www.natalieleblanc.com/n/bodies.html). In all of these works, the focal point of the composition remains a trail left on the water's surface made by a moving vessel, an organic path that disappears into the horizon while a trace of movement spills out from the center. The production of this series has helped me conceptualize becoming and the wake of my own becoming through *becoming pedagogical*.

The research project, modeled after artistic interventions, took shape as an event in which participant interactions and performances were brought into the meaning of the work. Interventions are a re-territorialization of space, drawing attention to cavities in the economy, academia, socio-cultural/political developments, and other places in which flows of capital and/or information are made inaccessible to the public (Smith, 2010). Interventions, as situational provocations, produce social, cultural, and political *voids*, opening interstices in human relations and finding places within current system as actual "ways of living" and "models of action within the existing real" (Bourriaud, 2002, p. 13).

The origin of the word intervention comes from the Latin word *interventiōn*, which means *a coming between*. To intervene means to appear, to lie, or to be situated between two things, two periods in time, or two events. As a graduate teaching and research assistant participating in the intervention, I was positioned between two endeavors: teaching a course coordinated by the professor of my doctoral seminar at the time, and participating in the research project led by my graduate supervisor as the principal investigator. During this time, I took both perspectives into consideration as I planned, strategized, and implemented my curriculum with the awareness that the teacher candidates involved in the study would also be formally evaluating my performance as their instructor. This space was unsettling and fraught with tension. It demanded that I navigate emerging contradictions between course objectives, the research design, and my conflicting roles as a teacher/researcher and student/teacher. These emergent learning encounters revealed a constant process of becoming that, based on my desire to learn, also required performing living inquiry. As an event, I experienced a shift and a re-contextualization of ideas within relational situations that heightened my awareness of the structures, relationships, and modes of accountability in education and research.

Ellsworth (2005) argues that the occurrent arts, inclusive of artistic interventions, transform ways of knowing because spatio-temporal (re)configurations that engage the body disrupt habitual ways the body inhabits space. The intervention, provoking an experience that was immediate and palpable, produced an embodied sensitivity where emotional response, affections, reflections, stimuli, and aversions (De Brabandere, 2014) formed a clamorous heterogeneity, best described as an information overload (Nechvatal, 2011). Held in this immersive position, the instructional team conceptualized the term intravention where, as artists and researchers, we could come together to create new cultural relations, potentials for self-(re)formation.

The intravention is where we feel our own *becoming* within an aesthetic dimension that is networked and distributed in time and space. As the wake implies, this stance requires surrender, a pivot to becoming conscious of how our movements are affected by change. The intravention as the wake, is the semblance of an event, a lived abstraction of the event that makes it qualitatively more intense (Massumi, 2011). As an awakening, it is a cultural formation that operates on multiple registers of sensation in combination with a continuity of movement that is not measurable or easily defined, a series of qualitative changes that are the effects of a passing event. The wake, as semblance, is the emergent space where artists, audiences, cultural relations and a multitude of other factors converge as potential. In a collaborative endeavor, Rita, Adrienne, Heidi, and myself have come together to present our learning encounters from this project on several occasions. These opportunities, as the wake, allow us to recognize how our processes of perception endure a constant change, a retrospective and introspective awareness

that requires movement. The wake, protruding from a distance and disappearing out of sight beyond the foreground renders the past in continuity with the future. This is a future–past that Massumi (2011) recounts, which is continually moving through the present. A thing-in-the-making (Massumi, 2011), it is a process that does not bring thinking to an end, but an event that provokes us to keep thinking (Ellsworth, 2005). Instead of marching "habitually and half-consciously from one drop of life to the next" (Massumi, 2011, p. 51), it asks that we attend to the ripples and recognize the semblance of the event as a force.

For Massumi (2011), to experience the event is to experience its passing, thereby producing a processual series of events that are unending. In the wake of *becoming pedagogical*, I have conceptualized my doctoral research as an intervention artwork, a practice-based form of research into relations between the self and an abandoned school building in which qualities of a de-institutionalized place are embodied and perceptually felt. This relation creates a unity between the past and the future that as semblance becomes a lived expression of time, prompting a mode of being in which the *in* and the *through* become necessary conditions for the production of the new (De Brabandere, 2014). It is through movement, conceived here as a pivot from the intervention to the intravention that the work continues to endure a constant change, as do we, its medium: *The work changes us and we change the work, because we are the work.*

Becoming pedagogical sought how artistic and pedagogical potentialities could materialize, not in form but in moments of interaction and connection. The research began in the middle with a simple gesture, "from something doing to the bare fact of activity; from there to event and change; then on to potential and the production of the new; coming to process as becoming" (Massumi, 2011, p. 2). Like the rhizome, which "is composed not of units but of dimensions [and] directions in motion" (Deleuze & Guattari, 2004, p. 21), the wake "has neither beginning nor end, but always a middle (milieu) from which it grows and which it overspills" (ibid.). The wake depicts a journey towards a destination that remains unknown. Although we can see a semblance of the route that our wake has taken, we cannot see the direction in which we are headed. This stance not only renders a potential with which interventions are unprescribed and emergent, it holds us in a reality of relations so that the intravention, as an intercultural dialogical and collaborative practice, may unfold.

Conclusion

The nature of becoming pedagogical allowed for the experience of the intervention to become highly individuated through an intercultural exchange of ideas, memories, perceptions, and experiences. In doing so, the graduate researchers and teachers were able to draw from the intervention to form an intravention with their own perceptions and beliefs related to their teaching and research practices. The pedagogy of ontology pursues the conditions of experience that allow for this type of new and creative thought and exchange to occur. The time of ontology expresses the confluence of the virtual past, present, and future in the present moment, rendering memory and perceptions amenable to change, destabilizing the time of research, suggesting the intercultural as a temporal and relational practice. The medium of ontology expresses the capacity of knowing and becoming as inhering in a body's capacity to act; the wake of ontology is the performance of creative acts as indeterminable, untimely, and relational, emerging from the middle and growing at the edges. In these moments, an intercultural exchange, both material and immaterial, expands our understandings of the capacities and potentials of research that aims to provoke new and creative thought where old ideas once existed.

Notes

1 I want to thank Donal O'Donoghue and Stephanie Springgay (co-investigators) for their generous and significant contributions to this particular *Becoming pedagogical* project. I also wish to express my deep gratitude to the teacher candidates involved in this project.
2 I wish to thank the Social Sciences and Humanities Research Council of Canada for their generous support of these research studies.
3 In my research with Mark Amerika and other artist pedagogues (May, 2013), I theorize a network and performative approach to art pedagogy, influenced by relational and experiential understandings of the notion of network/ed/ing as "a process or state of ongoing relations in flux" (p. 21).
4 Kaprow was a pivotal artist in the 1960s who is most known for his "happenings" which replaced the art object with spontaneous, open-ended events that just happened.

References

Acconci, V. (1979/1996). Steps into performance (and out) (1979). In K. Stiles & P. Selz (Eds.), *Theories and documents of contemporary art: A sourcebook of artists' writings* (pp. 759–765). Berkeley, CA: University of California Press.

Adams, J., Worwood, K., Atkinson, D., Dash, P., Herne, S., & Page, T. (2008). *Teaching through contemporary art*. London: Tate Publishing.

Amerika, M. (2007). *Meta/data: A digital poetics*. Cambridge, MA: MIT Press.

Amerika, M. (2008). Making space for the artist. In M. Alexenberg (Ed.), *Educating artists for the future: Learning at the intersections of art, science, technology and culture* (pp. 75–82). Chicago: Intellect Books, The University of Chicago Press.

Atkinson, D. (2011). *Art, equality and learning pedagogies: Against the state*. Rotterdam: Sense Publications.

Boulton-Funke, A. (2014). A critique and a proposal: A/r/tography and arts-based research as a methodology of intuition. *Visual Inquiry, 3*(2), 207–221.

Boulton-Funke, A., LeBlanc, N., May, H., Irwin, R. L., & O'Donoghue, D. (2012). Intraventions: Pedagogy and democratic participatory research with visual art teacher candidates. Presentation given at the *National Art Education Association* conference, New York City, March 3. Video narrative component available at: http://vimeo.com/heidimay/intraventions.

Bourriaud, N. (2002). *Relational aesthetics* (trans. S. Pleasance, F. Woods, & M. Copeland). Dijon, France: Les presses du réel.

Britzman, D. (2003). *Practice makes practice: A critical study of learning to teach*. New York: SUNY Press.

De Brabandere, N. (2014). Performing surfaces: Designing research-creation for agentive embodiment. *Cultural Studies Review, 20*(2), 223–249.

Deleuze, G. (1990). *The logic of sense* (ed. C. V. Boundas; trans. M. Lester & C. Stivale). New York: Columbia University Press.

Deleuze, G. (1991). *Bergsonism* (trans. H. Tomlinson & B. Habberjam). New York: Zone Books.

Deleuze, G., & Guattari, F. (2004). *A thousand plateaus: Capitalism and schizophrenia* (trans. B. Massumi). Minneapolis, MN: Minnesota Press.

Ellsworth, E. (2005). *Places of learning: Media, architecture, pedagogy*. New York: Routledge.

Garoian, C.R. (2013). *The prosthetic pedagogy of art: Embodied research and practice*. New York: SUNY Press.

Irwin, R. L., & O'Donoghue, D. (2012). Encountering pedagogy through relational art practices. *International Journal of Art and Design Education, 31*(3), 221–236.

Irwin, R. L., & Springgay, S. (2008). A/r/tography as practice-based research. In S. Springgay, R. Irwin, C. Leggo, & P. Gouzouasis (Eds.), *Being with a/r/tography* (pp. xix–xxxiii). Rotterdam, the Netherlands: Sense.

Jackson, H. J. (2002). *Marginalia: Readers writing in books*. New Haven, CT: Yale University Press.

Massumi, B. (2011). *Semblance and event: Activist philosophy and the occurrent arts*. Cambridge, MA & London: MIT Press.

May, H. (2013). Educating artists beyond digital: Understanding network art and relational learning as contemporary pedagogy. Ph.D. dissertation, Vancouver: University of British Columbia. Retrieved August 30, 2014 from: https://circle.ubc.ca/handle/2429/45179.

May, H., O'Donoghue, D., & Irwin, R. L. (2014). Performing an intervention in the space between art and education. *International Journal of Education through Art, 10*(2), 163–177.

Nechvatal, J. (2011). *Immersion into noise.* Ann Arbor, MI: Open Humanity Press.

Neill, A. S. (1960). *Summerhill: A radical approach to child rearing.* New York: Hart Publishing.

Networked_Performance. (2004). Retrieved August 30, 2014 from: http://turbulence.org/blog/about/

Osberg, D., Biesta, G., & Cilliers, P. (2008). From representation to emergence: Complexity's challenge to the epistemology of schooling. *Educational Philosophy and Theory, 40*(1), 213–227.

Smith, P. (2010). The contemporary dérive: A partial review of issues concerning the contemporary practice of psychogeography. *Cultural Geographies, 17*(1), 103–122.

Springgay, S., Irwin, R., Leggo, C., & Gouzouasis, P. (Eds.) (2008). *Being with a/r/tography.* Rotterdam, the Netherlands: Sense.

Sullivan, G. (2010). *Art practice as research: Inquiry in visual art* (2nd ed). Thousand Oaks, CA: Sage.

24

PROPOSITIONS FOR WALKING RESEARCH

Sarah E. Truman and Stephanie Springgay

Walking as an artistic and participatory practice is re-emerging in various disciplines, including its intersections with social science and humanities research methods and methodologies (see walkinglab.org). Some of this interest stems from the fact that walking can be an embodied and sensory way of enacting research. In this chapter we discuss how walking as research also begs the question of the "*how* of research"; we speculate on how rather than simply a mode of moving from place to place, walking engenders what Alfred North Whitehead (1978) refers to as propositions.

We use the concept of propositions to examine the productive potential of walking research within two artist groups: a community arts walking practice in Canada organized by the Hamilton Perambulatory Unit (HPU), and a contemporary art walking project in the United Kingdom facilitated by Barbara Steveni, founder of the former art collective the Artist Placement Group (APG). When walking is understood as a proposition, subjects are not given to experiencing movement, space, walking, etc. in any pre-determined or already realized way. Walking becomes stripped of its own assumptions.

Whitehead (1978) states, "A proposition is a new kind of entity. It is a hybrid between pure potentialities and actualities" (pp. 185–186). Propositions draw from actuality as well as propose what *could* be, they are "tales that perhaps might be told about particular actualities" (p. 256); in that regard a proposition can be seen as both actual and speculative. According to Whitehead, propositions are either true or false—they either conform to the world order or do not conform (he was, after all, a logician and mathematician). But unlike classical philosophers' views of propositions, in Whitehead's work, *Process and Reality* (1978), he asserts that even *false* (non-conforming) propositions offer "novelty" that can "promote or destroy order" (pp. 186–187) and provide alternative potentialities for those who prehend and feel them; as Whitehead states, "it is more important for a proposition to be interesting than it to be true" (p. 259). Even a non-conformal proposition's "primary role" is to "pave the way along which the world advances into novelty" (p. 187). Propositions do not give information as to how they function in concrete instances but gesture to how they could potentialize; allow us to feel what may be; in that regard, propositions are "lures for feeling" (p. 25).

The chapter unfolds with an exploration of propositional thinking related to walking research and questions about the compatibility of the notions of intercultural arts and non-binary thinking. Following this, we use propositions in two ways in this chapter. First,

259

as linguistic statements about what walking as a research practice *can do*, along with a discussion of the two contemporary walking groups. Second, we envision the act of walking as a proposition—a hybrid movement and *lure for feeling* that can *pave the way along which the world advances into novelty*.

Proposition 1: open space for novelty

Erin Manning (2013) discusses that a proposition is immanent to the event, not external or separate from the event, but co-constitutive. As Whitehead (1978) shows, a proposition's "'lure for feeling' is the final cause guiding the concrescence of feelings" (p. 185). Accordingly, propositions describe how events occur—it is through "feeling" that new potentialities are actualized within an inherited context. Once these potentials are actualized (in an event) new propositions immediately emerge (creating a new hybrid between actual and speculative), and the pattern continues: "[e]vidently new propositions come into being with the creative advance of the world" (p. 259). Propositions follow propositions follow propositions. But not in any linear or causal way. Although propositions follow propositions, this following is not pre-planned or determined.

Manning (2013) asks how techniques become propositional (as opposed to instructional). Walking the streets of Hamilton Ontario "becomes a proposition when it begins to exceed the technical, making operable a kind of bodying that is unforeseen (unpracticed) but available from within the register of the movement that will have preceded and followed it" (p. 78). This shifts walking's relationship to research. Walking, we will argue, is not a habit of movement external to the event of research, nor simply an embodied way to feel in space; rather, it is the event's becoming. In a Whiteheadian sense, feeling is not a reflective act but an "intensive felt interval of the between" (Manning, 2013, p. 79).

While the central arguments of our chapter are concerned with the implications of propositional thinking for walking research methods, we also want to address a tension between our approach to propositional thought and interculturality—the theme of this book. Interculturality seems rather paradoxical given that most arts practices are contributed to by varied sources. Jonathan Hay (1999) offers three definitions of intercultural: contact between cultures; what happens in the space between cultures; and the hybrid nature of any given culture. He notes however, that when culture is approached as a noun, rather than an adjective, it reifies binaries and thereby reinforces issues of power and privilege. Similarly, art scholar Laura Marks (2000) conceptualizes intercultural cinema as that which is produced in the interstitial space between belonging—a kind of transnational, diasporic, nomadic art practice. Her scholarship is Deleuzian and speaks to the visceral and haptic materiality of film, and thus resonates with our approach to walking. However, interculturality, it would seem is a complex if not problematic concept. In thinking propositionally, we want to open up the concept of interculturality to *difference*—not as occurring between entities but emerging through *events*. Another way of thinking about this is through Karen Barad's (2007) work on entanglements. According to Karen Barad (2007) "[e]xistence is not an individual affair. Individuals do not pre-exist their interactions; rather, individuals emerge through and as part of their entangled intra-relating" (p. ix). Rather than inter-action, Barad speaks of "intra-action" which, "*signifies the mutual constitution of entangled agencies*" and asserts that agency is not something that someone (usually human) possesses, but emerges through mutual entanglement (2007, p. 33). As such, entangled practices are *productive*: "different intra-actions produce different phenomena" (p. 58). When discussing propositional thought, Whitehead (1978) states:

The true method of discovery is like the flight of an aeroplane. It starts from the ground of particular observation; it takes flight in the thin air of imaginative general-ization; and it again lands for renewed observation rendered acute by rational inter-pretation . . . Such thought supplies the differences which the direct observation lacks.

(Whitehead, 1978, p. 5)

In thinking-walking propositionally, we posit how walking research *could be* and what it *could do* by taking a speculative "flight of an aeroplane," through propositions and then viewing walking events with different perspectives and of course new propositions. If thinking-walking research is intra-active, then propositional relations precede relata, which then alter and change phenom-ena. Propositionally, properties are no longer embedded in individuals but are emergent features of entangled productions.

Proposition 2: de-familiarize your body

Walking has been a staple of art practices since the 1960s in sculpture, conceptual art, per-formance and social practice. Contemporary examples include work by Simon Pope, Diane Borsato, Jess Dobkin, Rebecca Belmore, Terrance Houle and Marlon Griffin who deploy movement as an embodied critique of spatial conditions in which walking is an evocation of memory and political action (Springgay, 2011). Similarly, throughout history countless writ-ers and philosophers, from Friedrich Nietzsche to Virginia Woolf to Matsuo Basho, have used walking to explore the relationship between movement and thought. A current example of walking and writing is work by American poet and professor Harryette Mullen who recently published *Urban Tumbleweed* (2013) wherein her 366 Tanka poems represent "a year and a day of walking and writing" in Los Angeles (Mullen, 2013, p. viii). Walking also provides a way to open up the non-visual senses, finding ways of knowing and communicating through movement, and helps to de-familiarize everyday actions. Many current walking groups draw from walking practices developed by psychogeographic artists, theorists and writers who have experimented with walking and various forms of de-familiarization since the 1950s–1960s. Guy Debord (1955) explains that psychogeographic walking practices can help "express not subordination to randomness but total *insubordination* to habitual influences" (p. 17). While practices of de-familiarization through walking vary—from the Situationist International prac-tice of "derive," to urban foraging, to sensory mash-ups like synesthesia walks—many walking aesthetic projects possess the common theme of using the situated, affective responses of par-ticipants when walking to de-familiarize the habitual.

According to Rosi Braidotti (2013), de-familiarization occurs through "experiment[ing] with new practices that allow for a multiplicity of possible instances—actualizations and coun-teractualizations . . . different lines of becoming" (p. 140). De-familiarization requires us to rethink and re/move what has become habitual, and to re-evaluate or upset common opinion; de-familiarization is similar to what Deleuze and Guattari would call "de-territorialization" (Deleuze & Guattari, 1987, p. 356). In literary theory, de-familiarization is the act of presenting common or familiar tropes in new or unfamiliar ways in order to broaden a reader's perspec-tive. The notion of pedagogy is implicit in de-familiarization in that there is an active effort to change a perspective. This can be as basic as wanting to enhance perception of a familiar situation, or it can have more radical aims. For example, many social movements based around walking, such as the *slut walk*, have used de-familiarization to destabilize both walkers' and onlookers' perspectives and draw attention to social injustices that have been normalized by prevailing social discourses. Jack Halberstam's (2011) work on failure and refusal is another

way to think about de-familiarization beyond simply moving outside of conditioned habits. De-familiarization as a refusal entails a form of performative disengagement. By disengagement we do not mean the typical use of the term in education, whereby students become disinterested or lack attention. Rather, as a practice of failure, disengagement is an act of unwillingness or a willfulness to refuse the choice between refusal and affirmation (Ahmed, 2014). In the slut walk example, intra-active difference shifts our understanding of the walk as that which celebrates, reclaims and embraces "slut," and "threatens the male viewer with the horrifying spectacle of the 'uncastrated' woman and challenges the straight female viewer because she refuses to participate in the conventional masquerade of hetero-femininity as weak, unskilled, and unthreatening" (Halberstam, 2011, pp. 95–96). While there is an ethos guiding propositional attempts at de-familiarization, it is impossible to predict what the outcome of de-familiarization will be other than proposing that eventually what is de-familiarized will too become "familiar," and require de-familiarizing interventions, or become re-territorialized and require further de-territorialization (Ahmed, 2006; Guattari, 2013).

Proposition 3: mix the senses—use touch to describe smell

An urban art collective, the Hamilton Perambulatory Unit (HPU) hosts public walks in Hamilton, Ontario, Canada, an old steel and manufacturing city that is currently undergoing an artistic revitalization (http://hamiltonperambulatoryunit.org). Members of the HPU meet regularly to walk through alleys, along the Bruce Trail to waterfalls, through graveyards, and around the city's gentrifying downtown. The HPU's oldest member is 70 and the youngest is 9. The HPU's walks generally include some kind of enabling constraint (Manning, 2013), where participants confine their perambulations to a designated neighborhood and/or explore a specific artistic notion, proposition, or sensory investigation while walking. The enabling constraints act as pedagogical prompts; for example, during the synesthesia walk offered in the Hamilton Farmer's Market, participants mapped their experience on an existing blueprint of the market by using the literary device synesthesia. Synesthesia is a literary device wherein the writer uses words associated with one sense modality to describe another, for example "piercing warmth." On the HPU walk participants were instructed to note the affective experience of what they "smelled" by using a linguistic descriptor from a different sense modality.

Literary synesthesia is a kind of de-territorialization of both the senses and language and is often employed by poets who wish to convey an affective experience. According to Brian Massumi (2002) affects differ from emotions and are pre-linguistic. He states, "the skin is faster than the word" (p. 25), yet also discusses how language can amplify or dampen the intensity of an affect through articulation or writing. Such a viewpoint does not reduce linguistic communication to a representation of affects, but recognizes words as vectors in the affective encounter, or as another part of the feeling-event across bodies from which material experience arises. In the case of the synesthesia mapping, the linguistic merging of sensory experiences enacted a de-territorialized map of the Hamilton Farmer's Market, or de-familiarized "sensory ethnography."

Sarah Pink (2009) understands sensory ethnography as practices in which the ethnographer "attends to the question of experience by accounting for the relationships between bodies, minds, materiality and sensoriality of the environment . . . multisensorial embodied engagements with others [and] with their social, material, discursive and sensory environments" (Pink, 2009, pp. 24–25). Although it is called "sensory" ethnography, Tim Ingold (2000) troubles the five-sense sensorium as the basis for a universal system of codification and proposes, that eyes, ears and noses "should not be understood as separate keyboards for the registration of sensation

but as organs of the body as a whole, in whose movement, within an environment, the activity of perception consists" (p. 268). In such a view, the senses also form a zone of indiscernibility. The HPU's Synesthesia Market Walk deliberately ruptured the five-sense sensorium by employing synesthesia to "record" affective experiences during the walk. The ensuing "data" from the process, rather than reproducing the market as forming boundaries based on pre-existing spatial attributes, generated maps based on scents—which were more than scents. They were "more than" (Manning, 2013) scents in that they were not isolated smells such as "grass" or "lemon" but rather the synesthetic entanglement or coupling between affective sensation, moving body, language, and space.

Writing about the relationship between water and place in the context of Australia and while working with Indigenous communities and collaborators, Margaret Somerville (2013) notes that traditional points on a map confine space because "they are contrary to a sense of local country defined from within experiential and relational knowing" (p. 75). In her research a collaborator noted that lines on a map "hem people in" (p. 75). Synesthesia as de-familiarization "involves the loss of familiar habits of thought and representation in order to pave the way for creative alternatives" (Braidotti, 2013, pp. 88–89). De-familiarization shifts the practice of walking from humanist ethnographic orientations—such as lines, points, place names—to one in which the categorical divide between body/place, human/nature is displaced with a new kind of radical transversal relation that generates new modes of subjectivity. De-familiarization becomes a "crucial method" in learning to think differently (Braidotti, 2013, p. 93). As a practice of de-familiarization, the HPU's peripatetic meditations question how to enact a sense of territorial vitality without drawing boundaries between points.

De-familiarization as a proposition of walking enacts what Deleuze and Guattari (1994) call "geophilosophy." According to Deleuze and Guattari, thinking takes place in relation to the earth, which means that thought is always a process of "becoming-earth." Geophilosophy emphasizes that the assemblages, connections, and multiplicities between phenomena (human and non-human) take place on a "plane of immanence," which is open to ceaseless transformations and experimentations. Geophilosophy emphasizes the ontology of the earth as complex processes of stratification, of flows and folds, of the "now here" of matter. To emphasize the interaction of the human and non-human in terms of immanence, Deleuze and Guattari's concept of "milieu" plays an important role. A milieu is the site, habitat, or medium of ecological interaction and encounter; akin to their notion of multiplicity, a milieu is open to transformation on the basis of its supple boundaries and alterable relationships. Milieu develop, grow and change together within continuous intersecting processes of becoming, which are constituted through relations of alliance that are articulated in terms of particular milieu overlapping with other milieu. For example, Deleuze and Guattari (1994) suggest an analogy between artistic monuments and the territory marked out by birdsong. A bird's territory, or milieu, cuts across the territories of other birds and other species. Its song, resounding beyond apparent boundaries, generates "interspecies junction points" (p. 185). The HPU's synesthetic walk abandons reductionist and universalist approaches to creating and representing space, and allows for unending variables (of subjectivity and place) to arise in relation to the human, non-human and various other components in a given instance. Urban psychogeographer Tina Richardson (2014) uses the term *schizocartography*, which she draws from Guattari, and states that it "enables alternative existential modes for individuals to challenge dominant representations and power structures" as they walk through urban space (p. 140, emphasis added). Because Guattari spends most of his book trying to "minimize the use of notions like *subjectivity*" . . . as a "transcendental" entity that is "impermeable to concrete situations," and in keeping with a post-human and new material perspective, in our use of schizo-geography, individuals, and their subjectivities

do not pre-exist spaces/places and affective intra-action but are produced through intra-action in a zone of indiscernibility (p. 23). From an affective perspective, space is produced socially and bodily, in conjunction with other bodies, objects, social conventions, smells, sounds, texts and relations that are "always in excess of a transpersonal capacity" (Thrift, 2004, as cited in Beyes & Steyaert, 2011, p. 52). In the case of the synesthesia market walk, the market's territory is remade through attending to scents. Myriad scents cut across the territories of other scents—non-human objects, the word, the map, and the walkers are de-territorialized and the space or place of the "market" is produced through affective engagement. Guattari (2013) views affect as a "hyper-complex object, rich with all the fields of potentiality that it can open up . . . loaded with the unknown worlds at the crossroads of which it places us" (p. 186). For Guattari (2013), rather than affect being a raw feeling; it is a kind of hyperlink to new possibilities and always already in excess of personal capacity. As Timon Beyes and Chris Steyaert (2011, p. 53) state:

> Instead of returning to a phenomenological stance that sees the corporeal as a stable basis of human experience, affect instigates us not so much to look at representations and significations as to engage with the intensities and the forces of organizational life, an event across bodies from which sensible experience emerges.

This returns us to Whitehead's propositions where we feel first and cognize afterwards. Affects are contingent on a variety of human and non-human actors. In such a view, bodies of participants and researchers are not fixed, but partially materialized through environmental factors—and also have the potential to affect their surrounding environment. Springgay's (2008) research into the potential of inter-embodiment, materiality and arts education, Anna Hickey-Moody's (2013) approaches to pedagogy that "mobilize a being [or bloc] of sensation to interrogate the affective forces produced by art" (p. 92), and Elizabeth Ellsworth's (2005) discussion of a "moment's hinge" (p. 8) for transitioning between "movement/sensation and thought," offer further examples of how the affective intensities in pedagogical encounters are complex, relational and likely felt before being cognized and named. Accordingly, the HPU's synesthesia exploration was a practice of "de-territorialization" of both language and place; the deliberate mixing of sense modalities disrupted the habitual use of language to describe smell, taste, touch, sight and sound and provided an affective, schizogeographic production of the Hamilton Farmer's Market.

Proposition 4: walk like an archive

Although the humanist ideal views human subjectivity and bodies as ontologically distinct and fixed, several theorists of walking and other forms of movement discuss how subjectivity (and the "body") is produced through movement, and as such is constantly in flux. Frederic Gros states, "the walking body has no history, it is just an eddy in the stream of immemorial life . . . a moving two-legged beast, just a pure force" (Gros, 2014, p. 7). Similarly, Erin Manning views the body: as "a field of relations rather than a stability, a force taking-form rather than simply a form" (Manning, 2013, p. 31). Thus a walking body is not a material form that moves through space, but body-space-matter "created through movement, differentiating endlessly. This movement is intensive, flowing, and affective" (Truman & Springgay, 2015). We view the walking body as enacting what Deleuze and Guattari (1987) call a "zone of indiscernibility," and what Brian Massumi refers to as the "included middle" (2014, p. 6). According to Brian Massumi (2014) the included middle packs two different logics into a

given situation, and by bringing them together creates a third, which is productive: "There is one, and the other—and the *included middle* of their mutual influence. The zone of indiscernibility that is the included middle does not observe the sanctity of the separation of categories, nor respect the rigid segregation of arenas of activity" (p. 6). In recognizing the included middle, instead of reifying binaries we begin to see how different gestures, or entities can paradoxically become performatively fused (in a *zone of indiscernibility*) while still retaining difference (Massumi, 2014, p. 6). This process is productive of newness, emergent differentiation and becoming. In thinking about this conceptually we contend that the productivity and propositionality of "open brief," an art practice deployed by the Artist Placement Group (APG), might serve as an example.

The APG, created in 1965 by Barbara Steveni and founded a year later by Steveni and her former partner John Latham, influenced the shift in artistic practice away from solitary studio production (Hudeck & Sainsbury, 2012). The APG placed artists in industry and later in government departments, as a way for artists to relocate their practices away from the studio and gallery, and to redefine the role of artists in society. The radical premise behind the placements was what the APG called the "open brief": the placements were not directed by the host organization, there was no obligation or expectation of services rendered by the artists, outcomes were not determined in advance, and the artists were to be paid a wage by the host organization. Developing an art practice beyond the studio and exhibition space, the "artist assumes the role of facilitating creativity among 'everyday' people" (Bishop, 2012, p. 163). The APG fostered the belief that artists have a "useful contribution to make to the world, and that artists can serve society—not by making works of art, but through their verbal interactions in the context of institutions and organizations" (p. 164). The model developed by Steveni shifted the typical patronage or commercial ties between industry and artists, insisting that art was a valuable research and educational practice for these organizations. The "open brief," Steveni argues, is a process of "not knowing" which becomes "the basis of action moving forward," and which engenders a relational, aberrant and ecological re-formation of matter.

The placements ideally occurred in two phases: a feasibility study which might last one or two months, followed by a longer engagement (Hudek & Sainsbury, 2012). APG's emphasis on "placement," "context" and the "artist as cultural worker" sought to foster links between art and other disciplines whereby the "artist moves out of the closed art world into the domain of decision making and recognized areas of large scale problem handling" (APG, nd). In an undated memo the APG describes the procedure for a placement to consist of a brief feasibility study followed by a longer "fellowship" period. The main feature of the placement was that the organization paid the artist but there was no commitment by the artist to produce a work of art with such funds. In the feasibility period the artist would spend time at the host organization, to learn about the context of the placement, often using methods similar to ethnographic fieldwork—participation, observation, research design, objectives, problem posing, etc. As opposed to asking industry to fund one-off projects by artists, or to provide resources and materials for artists to create art, the APG model emphasized that "context is half the work." The APG's aim was to make a contribution to society by bringing creative practices to bear on problems within a selected area of society. The host organization did not pre-determine a problem, but rather through the open brief or a period of "not knowing" the artist moved through the day-to-day operations of the organization in order to focus on an area of interest. The artist—or what was to be later called the "Incidental Person" (Hudek & Sainsbury, 2012)—was free to function as he or she wished and to discover relationships between previously unrelated areas.

Steveni's current enactment of an "open brief" methodology is her project, "I am an archive," a series of participatory walks taking place on the site of original APG placements. The walks include a conversation or exchange of ideas between Steveni and other artists, while cooking food, hanging out, socializing, and making art, in order to explore the potential to reactivate the APG methodology. "I am an archive" does not function in the same way as the more historical APG archives, now located in the Tate Gallery, but is an active, live/d, performed, reworking of APG material; an anarchive, a *zone of indiscernibility*.

"I am an archive" as a proposition creates conditions of intensity. "It inflects the occasion," Manning (2008) would argue, thereby "creating a relational matrix that transforms the singular elements into a network of potential. It creates an appetite for experience within the event itself. It is neither true nor false. It is absolutely what it becomes" (p. 8).

Proposition 5: propose!

Walking should not conform to traditional understandings of qualitative research methods. What we are proposing for walking, by way of propositions, e/affects an orientation shift. Manning (2008) suggests that "what the proposition calls for is not a newness as something never before invented, but a set of conditions that tweak experience in the making" (p. 6). Walking as propositions triggers conditions of emergence activating self-organizing potential that invents its own parameters (Manning, 2013). Methodologically, this is quite different from giving directions, collecting data or establishing pre-determined methods. Walking proposition-ally demands that we conceive of research happening in the now. Research thus becomes "an occasion for experience [that] holds within its potential the dynamics of singularity" (Manning, 2008, p. 6). Walking sets in motion a variety of bodily movements, intensities, and affects that unfold and extend new variations. We are obligated, rather, as Massumi (2011) via Whitehead (1967) contends, to let go of cognitivist approaches that ask what we can know of the world, in order to begin with an event-activity in and of the milieu.

> There is no "the" subject. There is no subject separate from the event. There is only the event as subject to its occurring to itself. The event itself is a subjective self-creation: the how-now of this singular self-enjoyment of change taking place.
>
> *(Massumi, 2011, p. 8)*

Steveni's "I am an archive," is not merely a reactive representation or a monument to the APG. Her walks do not simply recall past experiences and sentiments, but rather as Steveni moves through and engages with sites, she actively embarks on de-territorializing what might be thought about not only the APG, but the sites themselves "in the now here." By render-ing the sites visible "in the now," Steveni implicitly calls for the proliferation of new becom-ings. Similarly, the HPU's walk de-territorialized language, place, and sensory categorization. Their de-familiarized use of sensory descriptors amplified affective responses in new ways cre-ating a schizogeographic "mapping" of the Farmers' Market. Walking in these actualizations is no longer a "tool" for "collecting data" or moving from one data location to another but, rather, exists as a conjunction, in and of the milieu, where bringing one type of organization near another causes changes in both that are thick with "indirectness or within the operative clutches of scattered and often not findable action" (Gins & Arakawa, 2006, p. 65). For the concept intercultural—we propose an expanded, propositional, inventive, prehended approach to research. Walking holds open a set of dynamics, or technicities of activation that propel us forward to another dynamic movement.

References

Ahmed, S. (2006). *Queer phenomenology: Orientations, objects, others*. Durham, NC: Duke University Press.

Ahmed, S. (2014). *Willful subjects*. Durham, NC: Duke University Press.

Barad, K. (2007). *Meeting the universe halfway: Quantum physics and the entanglement of matter and meaning*. Durham, NC: Duke University Press.

Beyes, S., & Steyaert, C. (2011). Spacing organization: Non-representational theory and performing organizational space. *Sage Publications Online*. Retrieved February 3, 2013, from http://org.sagepub.com/content/19/1/45.

Bishop, C. (2012). *Artificial hells: Participatory art and the politics of spectatorship*. New York: Verso.

Braidotti, R. (2013). *The posthuman*. Cambridge, MA: Polity.

Debord, G. (1955). *Introduction to a critique of urban geography*. Retrieved March 5, 2104, from: http://library.nothingness.org/articles/SI/en/display/2.

Deleuze, G., & Guattari, F. (1987). *A thousand plateaus*. Minneapolis, MN: University of Minnesota Press.

Deleuze, G., & Guattari, F. (1994). *What is philosophy?* London: Verso.

Ellsworth, E. (2005). *Places of learning: Media, architecture, pedagogy*. New York: Routledge.

Gins, M., & Arakawa, S. (2006). *Making dying illegal*. New York: Roof Books.

Gros, F. (2014). *A philosophy of walking* (trans. J. Howe). London: Verso.

Guattari, F. (2013). *Schizoanalytic cartographies*. New York: Bloomsbury.

Halberstam, J. (2011). *The queer art of failure*. Durham, NC: Duke University Press.

Hay, J. (1999). Toward a theory of the intercultural. *RES: Anthropology and Aesthetics, 35*, 5–9.

Hickey-Moody, A. (2013). Affect as method: Feelings, aesthetics and affective pedagogy. In R. Coleman & J. Ringrose (Eds.), *Deleuze and research methodologies* (pp. 79–95). Edinburgh: Edinburgh University Press.

Hudek, A., & Sainsbury, A. (2012). *The APG approach*. Catalogue essay. Raven Row, London.

Ingold, T. (2000). *The perception of the environment*. London: Routledge.

Manning, E. (2008). Propositions for the verge: William Forsythe's choreographic objects. *Inflexions: A Journal for Research-Creation, 2*.

Manning, E. (2013). *Always more than one: Individuation's dance*. Durham, NC: Duke University Press.

Marks, L. U. (2000). *The skin of the film: Intercultural cinema, embodiment, and the senses*. Durham, NC: Duke University Press.

Massumi, B. (2002). *Parables for the virtual: Movement, affect, sensation*. Durham, NC: Duke University Press.

Massumi, B. (2011). *Semblance and event: Activist philosophy and the occurrent arts*. Cambridge, MA: MIT Press.

Massumi, B. (2014). *What animals teach us about politics*. Durham, NC: Duke University Press.

Mullen, H. R. (2014). *Urban tumbleweed: Notes from a tanka diary*. Minneapolis, MN: Gray Wolf Press.

Pink, S. (2009). *Doing sensory ethnography*. London: Sage.

Richardson, T. (2014). A schizocartography of the University of Leeds: Cognitively mapping the campus. *Journal of Social Theory, 23*(10), 140–162.

Somerville, M. (2013). *Water in a dry land: Place-learning through art and story*. New York: Routledge.

Springgay, S. (2008). *Body knowledge and curriculum: Pedagogies of touch in youth and visual culture*. New York: Peter Lang.

Springgay, S. (2011). "The Chinatown Foray" as sensational pedagogy. *Curriculum Inquiry, 41*, 636–656.

Truman, S. E., & Springgay, S. (In press). The primacy of movement in research-creation: New materialist approaches to art research and pedagogy. In M. Laverty & T. Lewis (Eds.), *Art's teachings, teaching's art: Philosophical, critical, and educational musings*. New York: Springer.

Whitehead, A. N. (1967). *Adventures of ideas*. New York: Free Press.

Whitehead, A. N. (1978). *Process and reality*. New York: Free Press.

25

PERFORMING RESEARCH AS SWIMMING IN PERPETUAL DIFFERENCE

Charles R. Garoian

Learning is essentially concerned with *signs* . . . everything that teaches us something emits signs; every act of learning is an interpretation of signs or hieroglyphs.

Gilles Deleuze, 2000, p. 4

Performativity is properly understood as a contestation of the unexamined habits of mind that grant language and other forms of representation more power in determining our ontologies than they deserve.

Karen Barad, 2007, p. 133

If you want to learn to swim jump into the water. On dry land no frame of mind is ever going to help you.

Bruce Lee n.d.

Apprenticing sensuous signs

Touch it, feel this page, touch it, feel the texture of its words, touch its phrases, listen to the rhythms of their encounters and alliances, *see* their entangled betweenness, such *signs,* such *sensuous signs* . . . Gilles Deleuze (2000), in his characterization of learning based on Marcel Proust's *In Search of Lost Time*, contends that searching for what emerges, as the real, the truth from any experience is constituted by a *temporal apprenticeship*; a learning *with* sensuous signs. The experience of an unexpected smell, texture, sound, taste, sight, a sensation brings to mind a fragment of memory from the past, a fragment that repeats differently in the present and, in doing so, casts chronological time out-of-joint, which, according to Deleuze, constitutes a paradoxical temporality from which yet unknown ways of thinking and learning emerge.

In this chapter, I discuss *Confluence*, a live assemblage that I performed several years ago, in terms of its out-of-joint adjacency and temporality with its voice-over narrative *Becoming-water*. In doing so, I explore their disparate and disjunctive encounters, alliances, and entanglements with reference to a Deleuzian apprenticeship of sensuous signs that constitutes *swimming* in art research and practice. The fluid and flowing movements of swimming, for Deleuze, serve as a dynamic cultural metaphor, one that suggests real learning occurs through transversal ideational movements (lines of flight). Real learning is contingent. It emerges from an inchoate ideational multiplicity that unsettles and casts rarefied cultural assumptions and representations

into a predicament, an anomalous sea of complex and contradictory signs. Swimming in such a predicament, the swimmer learns to swim not according to pre-existing understandings of wave action or the teachings of a swimming instructor, but by being in relation and doing *with the actions of the wave*. The swimmer, in responding to the contingent signs of the wave, repeats them differently rather than resembling and reproducing them as previously understood (Deleuze, 1994, p. 23).

The repetition of difference that occurs as the swimmer learns to swim by swimming with the contingent emissions of the wave corresponds with Deleuze and Guattari's three aspects of a cultural assemblage that is "The Refrain" (1987, p. 310): *infra*-assemblage, *intra*-assemblage, and *inter*-assemblage. As navigational coordinates, the three aspects of The Refrain constitute the performativity of *Confluence* as *infra-cultural assemblage*, an apprehensive yet exploratory swimming of its anomalous predicament of cultural signs; as swimming with *intra-cultural assemblage*, the sensing and making sense of its anomalous predicament through experimentation; and, as swimming with *inter-cultural assemblage* by opening up to new and different ways of thinking through improvisation. In doing so, these three aspects of The Refrain constitute the research and practice of *Confluence* as swimming in cultural difference, thus suggesting ways in which encounters and alliances between and among the arts and other cultural knowing enable new and different ways of thinking.

The Latin for the prefix *infra-* is "below, underneath, beneath" (OED: Online), suggesting that the infra-assemblage aspect of The Refrain is an apprehensive receptiveness to explore an incomprehensible chaos of disjunctive signs for some semblance of order. Such receptiveness to being "in-over-one's head" with the incompossible cultural signs of my performance of *Confluence* constitutes infra-assemblage as swimming-from-beneath to stabilize the overwhelming difference of the performance. The Latin for *intra-* is "on the inside, within" (OED: Online), that in Deleuze and Guattari's intra-assemblage constitutes another aspect of The Refrain, which suggests the making of sense of the performance *Confluence* through experimentation by selecting, eliminating, and extracting from within its chaotic cultural signs to create a center, a space of stability, and from which to resist and prevent chaos from recurring. And, the Latin for the prefix *inter-* constitutes the "between, among, amid, in between, in the midst" (OED: Online). Deleuze and Guattari conceptualize the inter-assemblage of The Refrain as the unfolding and launching of transversal lines of flight that hazard improvisational encounters and alliances in-between *Confluence* and among multiple other signs.

Comprised of disjunctive memory fragments, the refrain that is *Confluence* emerged and agglomerated during an exploratory, experimental, and improvisational apprenticeship in my studio with words, actions, images, materials, objects, and sounds; a research into sensuous signs from my cultural history. Michel de Certeau refers to the performativity of such fragmentations in storytelling as

> the *verbal relics* of which the story is composed, being tied to lost stories and opaque acts, [that] are juxtaposed in a collage where their relations are not thought, and for this reason they form a symbolic whole. They are *articulated by lacunae*. Within the structured space of the text, they thus produce *anti-texts*, effects of dissimulation and escape, possibilities of moving into other landscapes, like cellars and bushes.
>
> *(de Certeau, 1984, p. 107; emphasis added)*

The verbal relics, lacunae, and anti-texts to which de Certeau refers constituted the contextual shifts and in-between movements of my apprenticeship of signs in performing *Confluence*; an apprenticeship that also resonates with Deleuze's (1997) conceptualization of writing as

a stuttering performance. A performative apprenticeship that occurs through storytelling, according to Walter Benjamin, offers "counsel" for learners; "counsel [that] is less an answer to a question than a proposal concerning the continuation of a story which is just unfolding" (1968, p. 86). A proposal such as *Confluence* is performative insofar as its unfolding encourages a play of contradictions—that is, a doing.

The memory signs of *Confluence* emerged from my youth growing up, playing, and working on my parents' vineyard in Fresno, California; serving as an acolyte in the Armenian Apostolic Church; and, living among a diasporic community of Armenian refugees who survived the genocide of 1915. The temporal dislocations that constitute Deleuze's "involuntary memory," which I will elaborate on later, characterize the ways in which several iterations of the performance materialized; first, as previously mentioned, when I began my apprenticeship of signs in the studio; second, as I continued the apprenticeship while performing four permutations at the University of California, Irvine Department of Art; a third apprenticeship occurred when I performed it in the auditorium of The Lowie Museum of Anthropology at the University of California, Berkeley campus; a fourth permutation that I performed at the Cleveland Performance Art Festival; and, this performative writing constitutes my fifth apprenticeship of signs in terms of what I remember of *Confluence* as it was performed in my past. Each of these performances, in riffing off the refrain of the former, constitutes what Peggy Phelan refers to as the contingent and ephemeral characteristics of live performance:

> Performance occurs over a time which will not be repeated. It can be performed again, but this repetition itself marks it as "different." The document of a performance then is only *a spur to memory, an encouragement of memory to become present.*
>
> *(Phelan, 1993, p. 146; emphasis added)*

Such "spurring and encouragement of memory" to presence will be discussed in terms of Deleuze's apprenticeship of signs, involuntary memory, and their relationship to art research and practice.

What is "apprenticeship" according to Deleuze? What does it do? How does its performance affect research and learning differently? What are "sensuous signs"? What do they do and how do they affect apprenticeship? What is "involuntary memory" and how do sensuous signs affect it? And, how do such occurrences constitute swimming? These are but a few questions that I address in what follows by positioning the performative assemblage that constitutes *Confluence* adjacent with Deleuze's concept of "swimming in signs," with Michel Foucault's "effective history," and with Karen Barad's "diffractive performativity" to explore and experiment with their betweenness; their transversal lines of flight; and, their accidental encounters for potential unforeseen and unknown alliances as they are read and understood through one another. Before delving further into theory, however, I begin the next section of this chapter with the list of incongruent artifacts and materials with which I performed *Confluence*; followed by a characterization of my movements and entanglements with them during the performance; then followed by the incongruent entanglements between *Confluence* and *Becoming-water*, the latter, a voice-over narrative that began emitting from speakers halfway through the former, and until their mutual, out-of-joint ending. In performance, these disparate and disjunctive entanglements constituted the infra-, intra-, and inter-cultural performativity of *Confluence*—its exploratory, experimental, and improvisational coordinates.

About the precarious, indeterminate characteristics of such entanglements, Elin Diamond writes:

when *performativity* materializes as *performance* in that risky and dangerous negotiation between *a doing* (a reiteration of norms) and *a thing done* (discursive conventions that frame our interpretations), between someone's body and the conventions of embodiment, we have access to cultural meanings and critique.

(Diamond, 1996, p. 5; emphasis added)

In terms of what Diamond is suggesting, the reiterative performativity of *Confluence*, a doing, constitutes a doubling that mirrors, disorients, and disrupts prior understandings and representations of performance, of things done in the past. In-between such doing in the present, and what has been done previously, new ways of thinking and learning are immanent.

Consider the disparate and disjunctive artifacts and materials in *Confluence*, listed in the next section, performed in close proximity with one another as swimming in signs; that is, swimming an archeological agglomeration in search of a taxonomy, an alternative to the universalizing taxonomies of the Enlightenment: an alternative similar to a fictitious taxonomy from an ancient Chinese encyclopedia entitled *Celestial Emporium of Benevolent Knowledge* that Jorge Luis Borges cites in his essay *The Analytic Language of John Wilkins* (Borges, 1993, p. 103). In *The Order of Things: An Archeology of the Human Sciences*, Michel Foucault (1973) characterizes Borges' citation and use of the taxonomy as

another system of thought . . . breaking up all the ordered surfaces and all the planes with which we are accustomed to tame the wild profusion of existing things, and continuing long afterwards to disturb and threaten with collapse our age-old distinction between the Same and the Other.

(Foucault, 1973, p. xv)

Accordingly, the following artifacts and materials were performed in *Confluence* as a means of extracting and re-wilding images, words, ideas, and actions of memory and cultural history that "we are accustomed to tame," to instead enable "another system of thought."

Confluence: performing another system of thought

- Two—twenty gallon clear plastic bags, bladders filled with five gallons water in each, tied at the top and placed adjacent to each other on the floor.
- One—four feet wide by four feet high flight of four stairs with steps that are twelve inches deep placed behind the water–filled plastic bags.
- One—eight feet, six inches long, crooked V-shaped tree branch with a metal spike affixed at its joint, leaning against the flight of stairs.
- Two—stainless steel bowls placed on the floor below the highest step of the stairs.
- One—roll of black duct tape placed next to the two bladders of water.
- Two—speakers placed on either side of performance space, a CD player, and a CD of the voice-over narrative *Becoming-water*.
- The clothes on my body.
- My body and the bodies of those who assisted and observed the performance.

After having entered the performance space, and approached the translucent bladders of water, I removed my shoes and socks, unbuckled my belt, and took off my pants, rolled them up and placed them to one side on the floor . . . I untied and opened the top of one bladder, placed one of my naked legs into its cold water, grabbed the roll of black duct tape with one hand, and

with the other hand I gathered together and held the opening of the bladder tightly around the calf of my leg, then wound the tape several times to seal it (Figure 25.1a) . . . after repeating the same with the other leg, I placed the roll of tape on the floor and began an imperfect *walking-on-water*, and as I lifted each leg, one at a time (Figure 25.1b), gravity pulled on the weight of the bladders' five gallons of water straining my legs, hampering my stride, and slowing my awkward circuitous movement around the flight of stairs . . .

. . . rhythm emerged from the oscillating sights and sounds of the churning wave action in each of the bladders as I stepped, a syncopation on which I began riffing an absurd, nonsensical rant while slogging around the performance space: "ba-pacho, attai-dunda, shadeha-kimbaella, gotolo-dateh, shataeela, taambucca-dunda, tagliatabu-dunda, coboku, yaphe-zandacala, ashateh-chocoashe, kekionga, dunda-dunda, motivaheh, dunda-cadada, dunda-cadada, cadada" Then, then the telling of a water dream followed, a dream in which I dreamt that "the river spoke to me, though, a message that I couldn't understand, I considered the puddles I used to play in as a child that have long since dried up, about the rivers I once fished that are now *dammed*, I suddenly awakened" About the materiality of water and dreams, Gaston Bachelard writes, "One cannot bathe twice in the same river because already, in his[her] inmost recesses, the human being shares the destiny of flowing water. Water is truly the transitory element" (1994, p. 6), always incipient, always becoming other than what we've already learned, what we know . . .

. . . as the *Becoming-water* voice-over (text forthcoming) began sounding through loud speakers, I lifted the absurd V-shaped tree branch (Figure 25.2a) leaning against the flight of stairs, cantilevered its awkward six foot reach against and out from my body, then resumed walking-on-water (Figure 25.2b), a peripatetic pilgrimage to nowhere and everywhere, "a state of being between . . . [my] past and future identities . . . outside the established order, in a state of possibility" (Solnit, 2000, p. 51), my pretentious walking-on-water while bearing the extended weight of that clumsy "stick," its crooked materiality, an inflated divining rod, its shiny metal spike quivering, quaking, divining for a sea, in search of what was afoot yet oblivious, an imperceptible sea of signs . . . that ungainly stick mocking my every movement, my thoughts, as I resisted gravity's pull . . . slosh, slosh, sloshing to matter that "stick" jutting from my body, to matter the waters' persistent sloshing still heard as I shuffled precariously about and around, in-migration to the back side of the stairs, then leaning on the stick for balance and climbing its steps, carefully lifting one leg at a time, step, step, stepping until I reached the top . . . there, where I raised the stick vertically and push it downward several times, its metal tip puncturing, punctured each translucent bladder, their contents then spurting and draining from multiple streams (Figure 25.2c), then sounding their diffractive landings in the stainless steel bowls on the floor below—all this *in confluence* with the coincidental ending of the voice-over: *The classroom*

Figure 25.1 *Confluence*, performance video stills (courtesy Charles R. Garoian).

Figure 25.2 Confluence, performance video stills (courtesy Charles R. Garoian).

was empty by comparison. It was merely a site from which to experience the confluence, thus suggesting an ending that rouses new beginnings.

"The end is where we start from," writes T. S. Eliot (1943, p. 38). That is, the end, a temporary concordance, generates endless new beginnings that Friedrich Nietzsche refers to as a monstrous energy of "forces and waves of forces . . . a sea of forces flowing and rushing together, eternally changing . . . [the] ebb and flood of its forms . . . [its] play of contradictions," and its eternal return of difference (Nietzsche, 1968, pp. 549–550, entry 1060). Such extraordinary forces are consistent with the affects, movements, and sensations that Deleuze (1994) describes about learning as swimming in signs; an example of which is the alternative learning that emerges from swimming in the infra-, intra-, and inter-cultural assemblage that is *Confluence*; a learning that occurs between and among its bladders of water, unbuckled belt, naked legs, walking-on-water, churning waves, river that spoke, V-shaped tree branch, water dream, divining rod, slosh-sloshing, and their transversal encounters and alliances with the other signs of *Confluence* in conjunction with the signs of the voice-over *Becoming-water*.

Intermezzo: a monstrous energy

Hear, where *Becoming-water* encounters *Confluence* endlessly; *hear* where "history," according to Michel Foucault,

> becomes "effective" to the degree that it introduces discontinuity into our very being—
> as it divides our emotions, dramatizes our instincts, multiplies our body and sets it against
> itself . . . This because *knowledge is not made for understanding; it is made for cutting.*
> (*Foucault, 1977, p. 154; emphasis added*)

Hear it, hear the voice-over *Becoming-water* that is forthcoming, hear it sounding concurrently with *Confluence*, and constituting Foucault's notion of "effective history" insofar as it is comprised of "cuttings" from memory, fragments that emerged and were extracted from my past to resist performing subjectivity as self-indulgence and narcissism, that, according to

Foucault, "deprives the self of . . . reassuring stability," to instead constitute the cutting of double-negativity: "The old man pulled his faded blue pants up and over his naked legs," is not me, but not-not me, not you, but not-not you. Such disavowed affirmation of the "not-not" constitutes a doubling repetition; a reflexive way of thinking through art research and practice that resists intellectual closure and representational understandings by setting the body against itself in order to open spaces for differential ways of knowing.

Becoming-water: **an effective history**

(A recording of the following narrative, recited in my own voice as a doubling repetition, was emitted from overhead speakers in conjunction with my live performance of *Confluence*.)

> *It was dawn and he hadn't slept for days. The sun was rising, flooding each row with the light of morning. The old man pulled his faded blue pants up and over his naked legs. He had just finished irrigating his vineyard. During the day, he worked at Gallo. At night he tended his vines. He had no family, only a few friends. He lived alone. I heard about the incident a week after it occurred. After a day's work at the winery, he drove home in his 52 Chevrolet flatbed. By the time he approached his destination the afternoon sun had set. No time for dinner, no sleep, no drink—only work. The quarter-mile rows of his forty-acre vineyard were parched—in need of water. With his Ford tractor, he had double furrowed each row a couple of evenings before. Having had no sleep, he was exhausted. Drowsy eyed, he pulled the old Chevy up to the pump house. Illuminated by its headlights, he unlocked the weathered wooden doors and entered the darkness inside. Feeling his way around, he flipped the lever on the fuse box. Then he pushed the lowest button to start the twenty horsepower motor. Cool water began to pump out the aquifer. It flowed underground along a concrete pipeline then spilled out of sluice gates into each furrow at the west end of the vineyard. Wearing his irrigation boots and wielding a shovel he set out to disperse the waters evenly by adjusting each gate and to mend any broken furrows along the way. The entire forty acres of Thompson Seedless grape vines were now under irrigation. The musical trickle of water could be heard along the frontage road—Valentine Avenue. Inhaling a deep breath as if to yawn, he gazed up at the clear night's sky lit by a full moon and stars. The smell of newly wetted soil permeated his nostrils. In his weary state, he slowly walked the quarter-mile to the opposite end of the vineyard where the furrows ended. There, he stuck his shovel into the ground and hung his khaki fedora on the handle. He slipped off his irrigation boots and stuffed his socks. Gently, he sat on the ground, took off his pants, rolled them into a pillow, laid back, and wedged his head. Adjusting his body like a gauge, he lifted each of his naked legs into the air and plopped them down into the dry earth of the two adjacent furrows. Within minutes, he dozed off. He slept peacefully into the night. At dawn he was awakened with a startle. The cold irrigation waters, having flowed all night, finally reached his feet and soaked his legs at the end of the vineyard row—a signal that it was time to turn off the pump and to repeat the cycle of labor. I'm not certain why, but the old man's strange ways always kept me stirring and awake at night and my mind wandering, dreaming during the day at school. The classroom was empty by comparison. It was merely a site from which to experience the confluence.*

Swimming *in* and *with* contingencies of memory

Consider the multiplicity of signs in the above writings of *Confluence* and *Becoming-water* as performative insofar as their linguistic elements are made to *stutter*; a disjunctive process of writing in which words, phrases, and actions are being used in ways that challenge their representational

understandings; that is, stuttering as "an affective and intensive language, and no longer an affectation of the one who speaks" (Deleuze, 1997, p. 107). Consider such stuttering in terms of Della Pollock's six excursions of performative writing: with *evocative* linguistic elements and usage suggesting images and ideas that are otherwise intangible; *metonymic* writing that resonates with contiguous difference rather than dualistic, representational sameness; *subjective* writing that enfolds the writer within a larger context of cultural phenomena; *nervous* writing that is restless, non–linear, and non–representational in its use of language; *citational* writing with images and ideas that *repeat* differently rather than the same as in the past; and, *consequential* writing that takes "up the performativity in language . . . to make a difference, 'to make things happen' . . . [to throw] off the norms of conventional scholarship for an explicit, alternative normativity" (Pollock, 1998, pp. 94–95).

Finally, consider the writings of *Confluence* and *Becoming-water* in terms of *diffraction*, Karen Barad's theorization of wave behavior and its contestation of linear and representational uses of language as stated in the second epigraph at the beginning of this chapter. Consider their agglomerating contingencies, wherein the ebb and flow of their movements constitute learning through art research and practice as swimming in a multiplicity that is a liminal sea of *sensuous* images and ideas. Such learning that is contingent and differential, Deleuze contends, "takes place not in the relation between a representation and an action (reproduction of the same) but in the relation between a sign and a response (encounter with the other)" (1994, p. 22). Given their heterogeneity and dissimilarity, signs encounter and respond to one another in ways that constitute swimming in perpetual difference. Swimming in heterogeneity is suggested, for example, in the multiple encounters, alliances, and entangled images and ideas occurring between *Confluence* and *Becoming-water*; between the disparate encounters and alliances enfolded within their separate milieus; and in our responses to their differential movements. To elaborate on Deleuze's concept of swimming in signs mentioned earlier:

> When a body combines some of its own distinctive points with those of a wave, it espouses the principle of a repetition which is no longer that of the Same, but involves the Other—involves difference, from one wave and one gesture to another, and carries that difference through the repetitive space thereby constituted. To learn is indeed to constitute this space of an encounter with signs, in which the distinctive points renew themselves in each other, and repetition takes shape while disguising itself.
>
> *(Deleuze, 1994, p. 23)*

What Deleuze is conceptualizing here is the double problematic of learning as navigating the heterogeneous modulations of a wave: the *swimmer learning to swim by swimming with the wave* (Garoian, 2013). Consider the differential encounters, alliances, and movements of *Becoming-water* as learning by swimming *in* and *with* sensuous signs: See, hear, touch, smell, taste . . . *sense* the dawn, *look* at the rising sun, *feel* the lack of sleep, *see* the old man, *touch* his faded blue pants, *touch* his naked legs, *listen* to the irrigation, *hear* its running water, *smell* the vineyard, *feel* its hot, clammy air, *taste* the winery, *smell* its nose, *see* the 52 Chevy flatbed, *touch* the parched land, *hear* the Ford tractor, *smell* the pump house, *see* its fuse box, *hear* the twenty horsepower motor, *taste* the aquifer, *see* the concrete pipeline, *touch* its sluice gates, then *touch* the irrigation boots, *feel* their mud encrusted rubber, *walk along* Valentine Avenue, *hold* the shovel, *smell* the khaki fedora, *whiff* its sweaty band, *feel* his soaked legs, *feel* the cycle of labor, *the* classroom, *the* confluence

> The *swimmer learning to swim by swimming with the wave* is to conjugate the distinctive points of our bodies with the singular points of the objective Idea [of becoming–wave,

Charles R. Garoian

Becoming-water] in order to form a problematic field. This conjugation [a contiguous, disjunctive assemblage] determines for us a threshold of consciousness at which our real acts are adjusted to our perceptions of the real relations, thereby providing a solution to the problem.

(Deleuze, 1994, p. 165)

Conjugating signs within and between *Confluence* and *Becoming-water* suggests the forming of problematic fields, "threshold[s] of consciousness," where unanticipated, imperceptible encounters and alliances are constituted as real relations rather than those that are representational and predetermined, and that necessitate "real acts" rather than representational and predetermined modes of address. The existential real to which Deleuze refers is incipient, that which emerges unexpectedly and necessitates being addressed according to its particular, contingent circumstances. In doing so, real relations and real acts of contingency constitute swimming *with* the wave; learning *with* the contingencies of *Confluence* and *Becoming-water*.

Sensuous signs are the "raw materials, the lines of an apprenticeship" that constitute teaching and learning as an exploratory process that Deleuze (2000, p. 3) refers to as The Search: "The exploration of different worlds of signs that are organized in circles and intersect at certain points, for the signs are specific and constitute the substance of one world or another" (2000, p. 4). According to Deleuze, The Search is comprised of three worlds of signs: worldly, love, and sensuous impressions. The *worldly* sign stands for something: the valorizing of institutionalized assumptions, principles and representations. "It anticipates action as it does thought, annuls thought as it does action, and declares itself adequate: whence its stereotyped aspect and its vacuity" (2000, pp. 6–7). The second world of signs is that of *love*. Unlike the vacuous, empty signs of worldliness that stand for pre-existing thoughts and actions, love is subjective and its signs deceptive; "they can be addressed to us only by concealing what they express; the origin of unknown worlds, of unknown actions and thoughts that give them meaning" (2000, p. 9). It is on the third world of signs that Deleuze focuses attention: those of *sensuous impressions*.

Sensuous signs, according to Deleuze, have an immediate effect on thinking. They evoke a necessity to search their meanings that then "yield to us the concealed object" (2000, p. 12), a fragment of memory from the past: a nose of wine yields for me the old man's ways, his work at Gallo Winery, his awkward tending of the vineyard, his naked legs stretched out in furrows, gauging irrigation; the sounds of falling water reminding of pumping the aquifer; the taste of grapes allowing my proximity with living on Valentine Avenue; and, the adjacency of sounds and smell from fresh rain in my garden remembering working with soil in the past . . . such sensuous experiences, according to Deleuze, "are already distinguished from preceding ones by their immediate effect" in the present (2000, p. 12).

A sensuous sign experienced in the present evokes a concealed object, involuntarily, a sign from the past that repeats not in the same way but differently. Deleuze writes: "Involuntary memory seems to be based first of all upon the resemblance between two sensations, between two moments," that is, two moments of time out-of-joint with each other (2000, p. 59). In doing so, it appears as though the nose of wine sensation that is experienced in the present "contains a volume of duration that extends it through two moments at once. But, in its turn, the sensation, the identical quality, implies a relation with something different" (2000, p. 59). In other words, a nose of wine has, in its capacity, enfolded the vineyard of my youth on Valentine Avenue. Its sensation in the present is constituted disjunctively in an external relation of contiguity with the vineyard. Conversely, the vineyard is situated external to the nose of wine, as the disjunctive context of the past sensation. Nevertheless, both are enfolded in one another. "*But this is the characteristic of involuntary memory: it internalizes [enfolds] the context, it makes the past context*

inseparable from the present sensation" (Deleuze, 2000, pp. 59–60; emphasis added). Accordingly, the convergence, and contiguous adjacency of the signs' two contexts in the present, renders their measured, chronological time out-of-joint, and in doing so results in "extraordinary joy" (2000, p. 13).

Such affirmation of the two signs' paradoxical adjacency is partial and inadequate, however, insofar as their originary, material displacements have yet to realize a greater potential and transformation considering, Deleuze argues, that they "do not rise up as the product of a [complex and compelling] association of ideas," but are limited by their particular "hieroglyphic" essence (2000, p. 13). Given their inadequacy, Deleuze is seeking an incipient potential from the signs' adjacency, a robust emission of transversal lines of flight, multiple convergences, and the fulfillment of an ultimate essence, which he associates with the problem of art. In other words, the problem of art *is* the problem of signs.

> The world of art is the ultimate world of signs, and these signs, as though *dematerialized*, find their meaning in an ideal essence . . . all the signs converge upon art; all apprenticeships, by the most diverse paths, are already unconscious apprenticeships to art itself. At the deepest level, the essential is in the signs of art . . . signs constitute different worlds, worldly signs, empty signs, deceptive signs of love, sensuous material signs, and lastly the essential signs of art (which transform all the others).
>
> *(Deleuze, 2000, pp. 13–14; emphasis in original)*

The essence that Deleuze associates with a work of art is that which is emergent within its robust multiplicity of signs; an entangled multiplicity that constitutes learning as swimming in and with signs. The essential signs of a work of art, unlike the inadequate worlds of signs, are enfolded and entangled within itself and upon itself, thus engendering seeing and thinking differently as linguistic conventions are rendered out-of-joint (Deleuze, 2000, pp. 154–156). It is within such problematic conditions of works of art that the "significant contents and ideal significations" of memory and history collapse and give way to an entangled "multiplicity of fragments, to chaos"; that is, the performative functions of a work of art, its sensations, affects, and movements, thus evoking what it does and is doing that "the artist, and the reader in his [her] wake . . . 'disentangles' and 're-embodies'" (Deleuze, 2000, p. 156).

Swimming *in* and *with* signs as diffractive learning

The aforementioned entanglements and disentanglements of swimming in and with signs that Deleuze conceptualizes as the incipient and immanent performativity of works of art, resonate with Karen Barad's theory of diffraction, the performative interference of wave phenomena through which she calls "into question the basic premises of representationalism" (2007, p. 28). Wave behavior is constituted as a "combination of disturbances" (2007, p. 76), a process of *superposition* through which they interfere with each other contiguously and, in doing so, create non-homologous and non-representational diffraction patterns that attend "to specific material entanglements" (2007, p. 88). Given its differential conditions and circumstances, diffraction is constituted through *intra-action* rather than *interaction* between and among wave patterns. Whereas, interaction constitutes wave phenomena as the engagement of absolute separate agencies, intra-action is constituted as difference from within waves. As such, Barad's characterization of intra-action as the enfolded behavior of waves corresponds with the repetition of difference in Deleuze and Guattari's intra-assemblage, and with the intra-cultural assemblage of my performance *Confluence* discussed previously.

The neologism "intra-action" *signifies the mutual constitution of entangled agencies.* That is, in contrast to the usual "interaction," which assumes that there are separate individual agencies that precede their interaction, the notion of intra-action recognizes that distinct agencies do not precede, but rather emerge through, their intra-action. It is important to note that the "distinct" agencies are only distinct in a relational, not an absolute, sense, that is, *agencies are only distinct in relations to their mutual entanglement; they don't exist as individual elements.*

(Barad, 2007, p. 33; emphasis in original)

Consider all things in performance. *Confluence* and *Becoming-water*—their actions, materials, instruments, objects, words, images, and bodies—are thus entangled in an intra-active, material–discursive relationship as compared with the separate individual relations of subject/object binaries and dualisms of interaction. Such intra-active entanglements are performative insofar as they constitute Deleuzian repetition and difference through complex iterative and citational processes. Accordingly, Barad characterizes the significance of the physical phenomenon of diffractive iteration as "mark[ing] the kinds of shifts that are at issue in moving away from the familiar habits and seductions of representationalism (reflecting on the world from outside) to a way of understanding the world from within and as part of it" (2007, p. 88).

Barad's characterization of diffractive oscillation and superposition, the contiguous intra-activity that constitutes wave phenomena, corresponds with the entanglements of Deleuze's swimming in and with signs mentioned previously as "the exploration of different worlds of signs that are organized in circles and intersect at certain points" (Deleuze, 2000, p. 4). What emerges through diffractive intra-action as distinct yet relational agencies for Barad corresponds with Deleuze's concept of incipience and immanence: thought that is immanent emerges from entangled encounters and alliances of signs; such thought that is yet imperceptible and non-representational, according to Deleuze, "yield[s] to us the concealed object," the perception of truth, the real relations from which seeing and thinking differently emerges. The "real acts [that] are adjusted to our perceptions of the real relations," that Deleuze contends about swimming in signs, Barad refers to as "agential realism," an account of discursive practices where "matter does not refer to a fixed substance; rather, matter is substance in its *intra-active becoming*—not a thing but a doing, a congealing [materialization] of agency. Matter is a stabilizing and destabilizing process of iterative intra-activity . . . materiality and discursivity are mutually implicated in the dynamics of intra-activity" (Barad, 2007, p. 336; emphasis added).

Thus, the agential realism that emerges from the intra-activity of Barad's diffractive wave patterns finds its complement in Deleuze's conjugation of signs—the real relations and real acts that constitute the swimmer learning to swim by swimming with the wave. In doing so, Deleuze's logic of conjugation and Barad's diffractive intra-activity constitute the process of learning as *Confluence* and *Becoming-water*. Consistent with Deleuze and Guattari's intra-assemblage of The Refrain, such relational learning occurs by exploring, experimenting, and improvising the betweenness of differing cultural signs; their transversal ideational movements; and, their accidental encounters for potential unforeseen and unknown alliances as they are read and understood through one another . . .

(Voice-over) *And again . . . he laid gently on the ground . . . his body like a gauge . . . naked legs plopped into the dry earth . . . having slept peacefully into the night . . . at dawn, the cold irrigation waters reached his feet and awakened him with a startle . . . the old man's strange ways always kept me stirring . . . the classroom was empty by comparison . . . it was merely a site from which to experience the confluence.*

References

Bachelard, G. (1994). *Water and dreams: An essay on the imagination of matter.* Dallas, TX: The Pegasus Foundation.

Barad, K. (2007). *Meeting the universe halfway: Quantum physics and the entanglement of matter and meaning.* Durham, NC: Duke University.

Benjamin, W. (1968). *Illuminations* (trans. H. Zohn). H. Arendt (Ed.). New York: Schocken.

Borges, J. L. (1993). The analytical language of John Wilkins. In *Other inquisitions 1937–1952* (pp. 101–105) (trans. R. L. C. Simms). Austin, TX: University of Texas.

de Certeau, M. (1984). *The practice of everyday life* (trans. S. Rendall). Berkeley: University of California.

Deleuze, G. (1994). *Difference and repetition* (trans. P. Patton). New York: Columbia University.

Deleuze, G. (1997). *Gilles Deleuze: Essays critical and clinical* (trans. D. W. Smith & M. A. Greco). Minneapolis, MN: University of Minnesota.

Deleuze, G. (2000). *Proust & signs: The complete text* (trans. R. Howard). Minneapolis, MN: University of Minnesota.

Deleuze, G., & Guattari, F. (1987). *A thousand plateaus: Capitalism and schizophrenia* (trans. B. Massumi). Minneapolis: University of Minnesota.

Diamond, E. (1996). *Performance & cultural politics.* London: Routledge.

Eliot, T. S. (1943). *Four quartets.* New York: Harcourt, Brace and Company.

Foucault, M. (1973). *The order of things: An archeology of the human sciences* (trans. Les Mots et les choses). New York: Vintage.

Foucault, M. (1977). Nietzsche, genealogy, history. In D. F. Bouchard (Ed.), *Language, counter-memory, practice: Selected writings and interviews* (pp. 139–164). Ithaca, NY: Cornell University.

Garoian, C. R. (2013). Learning by swimming in signs. Unpublished manuscript. The Pennsylvania State University.

Lee, B., n.d., *Who is Bruce Lee: Bruce Lee facts, motivation, and inspiration.* Available from: <http://whowasbrucelee.com/> (accessed 1 November 2014).

Nietzsche, F. (1968). *The will to power.* Ed. W. Kaufmann. New York: Vintage.

Oxford English Dictionary. Available from: <http://www.oed.com/> (accessed 2 February 2015).

Phelan, P. (1993). *Unmarked: The politics of performance.* New York: Routledge.

Pollock, D. (1998). Performing writing. In P. Phelan and J. Lane (Eds.), *The ends of performance* (pp. 73–103). New York: New York University.

Solnit, R. (2000). *Wanderlust: A history of walking.* New York: Penguin.

PART III

Research

26

RESEARCHING 'VOICE' IN INTERCULTURAL ARTS PRACTICES AND CONTEXTS

Pat Thomson

The term 'voice' is not as straightforward as it might first appear. Commonly used in relation to a number of art forms, it is highly ambiguous and slippery. Take its application in writing research for instance. Peter Elbow, the veteran writing researcher, argues that the notion of a writing 'voice' can be used variously to describe: the sense that readers have of hearing the words on the page as they are reading them (audible voice); the way in which the audible voice is more or less full of character (dramatic voice); the way in which a distinctive authorial style can be recognised by its deployment of language, syntax, speech, metaphor and so on (distinctive voice); and the degree of confidence and expertise that the writer asserts (authoritative voice) (Elbow, 1994).

Elbow also points to voice as a 'presence' in writing. 'Presence' is a much more murky idea, he contends, because it assumes that the writing is a sincere and authentic representation of the writer. As Elbow puts it, '[a] discourse can never fully express or articulate a whole person. A person is usually too complex and has too many facets, parts, roles, voices, identities' (Elbow, 1994, p. 12).

The very idea that a writer's text is a manifestation of a person's artistic vision, intention and voice is deeply problematic, according to Elbow. In fact, he suggests, the notion of mimesis – the duplication of the real by a text – actually opens the door to its other. 'Authentic' presence allows for irony, fiction, lying and games and other forms of polyvocality and disjointedness in texts. Rather than seeing writing as having a 'voice' Elbow argues, in tune with much contemporary literary theory (e.g., Eagleton, 1996; Makaryk, 1993), writing should be understood as a place where writers 'try out' parts of the self, where they experiment and play (see also Elbow, 2012).

This chapter considers how these kinds of understandings relate to a more general notion of an artist's 'voice' and how an examination of the notion of artist 'voice' might contribute to thinking about researching artistic practices in intercultural contexts. First, I consider the common sense narrative of an artist's 'voice' as 'personal expression', arguing that this is a notion that researchers need to question. I then canvass some scholarly literatures where research and political understandings are used to make the case for artists' voices which are multiple, discursive and fluid. In conclusion I turn to contemporary arts practices which both trouble the notion of 'personal expression' and raise further questions about researching intercultural arts practices and contexts. My aim in the chapter is to raise questions useful to researchers, not to provide easy answers.

The artist 'voice' as 'personal expression'

In 1962, the art historian and curator Katherine Kuh produced a (now seminal and much reprinted) book of interviews she had conducted with seventeen modern artists – sixteen men and one woman. Her rationale was that, while many critics spoke about modern art and artists, the 'voice' of the artists themselves was less often heard. Kuh set out to redress this imbalance. Kuh's purpose in publishing was thus like that of any researcher who seeks to fill a 'gap' in scholarly knowledge. She focused on perspectives that had had, in her view, inadequate attention.

In the introduction to her book Kuh explains that what artists said in their interviews would help readers understand why their work was important and significant. She brings together – and equates – three different meanings of artist's voice:

1 *Voice as knowledge.* The artists' perspectives would add to general understandings about modern art. Kuh adopts an implicit metaphor of knowledge as a public conversation.
2 *Voice as speech.* Kuh uses an interview format – voice as an actual conversation which was recorded, transcribed, edited and then published in the format of answers to interviewer questions.
3 *Voice as a mimetic presentation of the artist's practice and the work itself.* Both the individual artist's voice and their art work are taken to be a 'personal expression'. Talking about the art and the art itself together constitute the artist's voice which is individual and unique.

This is Kuh's implicit conceptual framework. As such, it might be of interest to researchers seeking to understand practices in intercultural contexts. However, the way in which these concepts are framed matters a great deal.

The extract below, taken from Kuh's introduction to the book, contains a number of additional ideas key to her understanding of artist 'voice'.

> [T]he work of individual artists has significance chiefly in relation to that *ephemeral quality* we *call 'personal expression'*. The theory that whatever an *authentic artist* produces is art (*though the same methods in the hands of another man can become merely tedious*) is an extension of this idea. For the artist as well as the *layman*, there are *no concrete signposts* pointing the way. It is only through *arduous trial and error* stiffened by *unwavering convictions* that *his brand* of personal expression is *refined and forged*.
>
> *(Kuh, 1962, p. 6; my emphases)*

According to Kuh, what is found to be significant in an artist's work is elusive, hard to pin down, not easily amenable to the application of rational criteria – it is *ephemeral*. It emanates from a unique individual unlike any other; it is an *expression*, a communication of that particular person, perhaps of their very essence, their soul, their innermost being. The art they produce is beyond technique, not *merely tedious*, something more, something ineffable. Artists are *authentic*, genuine, sincere, there is no pretence about what they are trying to achieve – they are true to themselves and their *unwavering convictions*. They are not the same as lay people; their difference is due to their singular pursuit of a vision, an important innovation. They work through *trial and error* – there is no recipe, they are at the frontier, breaking new ground, going forward no matter what it takes. What they achieve through this single-minded pursuit is their brand, the work can be recognised as theirs alone, it is as distinctive as a handwritten signature. This way of working is far from easy – it is *arduous*, and the artwork is hard won. It takes time and much repetition

before it is *refined and forged*; the metaphors of distillation and smithery bring with them images of fire, sweat and physical demand.

Kuh presents artist's work and the articulation of artistic voice as a quasi–religious pursuit, a kind of Pilgrim's Progress of ongoing hardship and near obsessive solitary effort. Kuh is not alone in this view. A search of online materials using the notion of 'artist voice' produces thousands of websites – many of these offer advice about how to achieve 'voice' (see Figure 26.1).

The ongoing nature of these sentiments suggests a popularly held view about the work of artists, as expressed through the concept of 'voice'. This narrative of artist 'voice' holds that:

- it is the moral responsibility of an individual artist to formulate a view and practice unlike any other;
- novelty and authenticity are the prime values of the artist's work;
- an artist's practice necessitates the adoption of a Protestant work ethic. Getting beyond the mastery of technique to a distinctive artistic practice requires long hours of application; and
- the artist is a self-managed and self-disciplined auto–didact.

It is not too far a stretch to suggest that the 'personal expression' version of artist voice can be understood as a relatively robust social narrative. Because a social narrative is taken both as a truth and as a rationalisation for action, it can have considerable sway in social events and practices. It can be seen in action in people's lives, in education and other institutional systems. It acts as both a motivation for and a legitimation of actions (Bal, 1997; Berger, 1997).[1] It may have influence on what both artists and researchers do.

Researchers keen to investigate intercultural practices may need to subject the 'personal expression' narrative to critical scrutiny. On the one hand, researchers might examine how much this narrative influences practices in intercultural contexts, making it the object of their inquiry. But equally, researchers might need to guard against the ways in which the ongoing and pervasive nature of the 'personal expression' narrative might influence their own data generation and analytic processes. However, these are not the focus of this chapter. This chapter assumes

Voice:

- cannot be taught – 'It requires you to pull from deep inside yourself to find what moves you and to express that through what you create' (http://www.jonathanfields.com/finding-your-voice/)
- is not about copying what others have done – 'How does one find their unique voice? Well, one won't find it in most educational environments. It requires experimentation, personal meditation and assessment and can only be discovered by the artist themselves' (http://blog.entrepreneurthearts.com/2009/08/26/ten-steps-to-finding-your-artistic-voice/)
- is about 'reflecting your unique creative spirit' (http://www.peachpit.com/articles/article.aspx?p=2044275)
- finding your voice will lead to recognition and success (http://blog.songtrust.com/songwriting-tips/4-ways-to-find-your-musical-voice/)
- voice does not happen for everyone – 'Artists may work for a very long time, even a lifetime, and never quite find their artistic voice. They may know that their work isn't really that fresh or interesting but not seem to possess the wherewithal to break through into deeply felt, personalized work.' (http://artbistro.monster.com/benefits/articles/12710-finding-your-own-artistic-voice)

Figure 26.1 Web examples of a contemporary 'personal expression' narrative.

that researchers are interested in learning how 'voice' is produced in and through intercultural arts practices and that researchers might go first of all to their own traditions to see what these have to offer the project of researching intercultural arts practices.

Researching 'voice': the scholarly literatures

In this section I address three fields of study that speak to the notion of artistic 'voice'. These are academic literatures on (1) research methods, (2) the production and interpretation of texts, and (3) political action. In each of the three I discuss the general first and conclude with some italicised comments and questions about some implications for researching intercultural arts practices and contexts.

Research methods

In writings about research, 'voice' can refer to the efforts that a researcher takes to represent informants' speech as vernacular language, laughs and silences. It can alternatively, or in addition, refer to the researcher's commitment to present views and perspectives that have hitherto been ignored.

Working with 'voiced research' means dealing not only with informants who have heterogeneous views, but also with theoretically informed perspectives which suggest that: an individual can have multiple and sometimes conflicting perspectives; that their perspectives are not fixed but change over time and in different contexts; and that what is said to a researcher is always shaped by broader social, political, economic and cultural relations and practices. 'Voiced research' is inevitably particular and situated and the researcher must therefore look for singularities as well as patterns across people, time and space (e.g., Arnot & Reay, 2007; Lather, 2007; Smyth & Hattam, 2001; Thomson, 2011).

Researchers who work with 'voiced research' begin with the understanding that they speak from somewhere, as do their research participants. They think carefully and continuously about the ways in which they are producing particular interpretations and categorisations. They are mindful of the ways in which conversations are always imbued with power relations and that particular care must be exercised by those with cultural/generational/positional power – they must not assume that everyone feels equally able to participate and contribute (Allan & Slee, 2008; Nind, 2014; Thomson, 2008). Researchers who aim to be participatory and collaborative go further than this – they seek to create a space/time in which there is a more reciprocal determination of research projects and more equal exchange of views, analysis and interpretations. In such circumstances high degrees of reflexivity are required on the part of all involved (Gallagher, 2008; Lassiter, 2005; McIntyre, 2008).

The methods literatures suggest that researching intercultural contexts and practices will entail high degrees of researcher reflexivity, and the use of data generation methods which focus on multiple perspectives. Analysis will necessitate refusing a naive notion of 'authenticity' and instead supports the development of understandings of commonalities, points of tension, discursive framings and liminal possibilities.

The production and interpretation of texts

Contemporary scholarship about the production and interpretation of written, visual and performed texts rejects a notion of 'voice' which implies that there is an equivalence between the text/art work and its maker (Barthes, 1967; cf. Elbow, 1994 at the beginning of this chapter). A text is understood as malleable, not fixed, and open to many interpretations (Derrida, 1978;

Holub, 1984); the author's intentions are not the key to understanding (Wimsatt & Beardsley, 1946). The production of any text occurs within a particular institutional and socio-cultural context which frames its logics – both what it can be and do and how it is understood (Sauvagnargues, 2013). What matters is the way in which the text steers interpretation and the diverse meanings made by the reader/viewer/audience (Mitchell, 2005). This stance towards text positions the narrative of artistic 'voice' as 'personal expression' as a particular cultural and intercultural artefact, situated in a specific time/space and, as such, available for de- and re-construction.

In thinking about how art and intercultural art practices, contexts and works might be understood differently, researchers might call on all or some of the following key understandings:

- *An art work (text) can be understood as multi-vocal, and artists as practising multivocality rather than speaking with a singular 'voice' (Bakhtin, 1981; Shusterman, 2000).*
- *Individual art works (texts) refer to other art works and to broader socio-cultural practices and relations (intertextuality) (Kristeva, 1980).*
- *The artist is not a fixed and unitary subject, but is fluid, contradictory and changing (Foucault, 2006; Lacan, 1968). An art work is a partial expression of the artist's being and becoming.*
- *Art works can be deliberately playful, transgressive, disruptive and/or experimental rather than a unitary 'authentic' expression (Becker, 1994; de Certeau, 1988; Fisher & Fortnum, 2014).*
- *The interpretation of an art work occurs in and as an inter-subjective and non-linear 'event' in which both the object/text and the viewer/reader/audience are involved (Badiou, 2013; Dezeuze, 2010).*

Thus, rather than thinking about an artist's 'voice' and their personal vision, as Kuh (1962) does, intercultural arts researchers might: look for frames, interpretive resources and possibilities; focus on the proliferation of possible meanings, rather than singular visions; and hear polyvocality within and between individuals and texts/works.

Political action

Arts researchers in particular have been keen to investigate and support political change in the operations of arts institutions. For example, Peter Renshaw, a British creative learning consultant and researcher with a special interest in institutional change and lifelong learning, argues that:

> [e]ngagement in . . . critical dialogue is the life-blood of a cultural democracy and it should constitute the basis of any reordering of priorities in higher arts education institutions. For such dialogues to have any resonance with the diversity of voices in the real world, these 'growing circles of conversation' should include cross-disciplinary, cross-cultural and cross-sector perspectives. They should also be rooted in partnerships that bring together performers, composers, writers, directors, visual artists, business people, teachers, school children and young people. *Each person has a voice that needs to be heard and respected.*
>
> (Renshaw, 2004, pp. 103–104; my emphasis)

Here we see the notion of political 'voices'– each one from a unitary subject – and the need for 'conversation' across differences. Renshaw also advocates what Gayatri Spivak (1993) once called 'strategic essentialism' (a term she has since retracted) – a unified 'voice' assumed in order to assert a political position. Such unity papers over differences within groups, and often falls apart, as the history of social movements and identity politics attests (Maffesoli, 1995). An 'arts

sector voice' might be directed to politicians. As Renshaw has it, 'It is imperative that the whole arts community begins to engage in a local and global dialogue about who we are and what we can achieve together' (Renshaw, 2004, p. 101).

The difficulties of speaking with one voice are significant and raise questions about the hierarchical and marketised nature of the arts, with organisations, groups and individuals in very different economic and social circumstances having different needs, contexts, desires and views.

In political scholarship, the notion of 'voice' generally raises discussions of recognition, reciprocity and the preparedness of participants to negotiate a position beyond that of any one person. In scholarly writings about democracy and rights, 'voice' might mean the opportunity to speak and be heard, the competences necessary to take part in discussions and debates and/or the right to influence events that affect the speaker(s). A democratic discussion is generally also taken to mean that there will be a multiplicity of voices that may not be in agreement (e.g., Benhabib, 1996; Bhaba, 1994; Fraser, 1993). Political pedagogical writing (e.g., Ellsworth, 1989; Joshee, 2012) also highlights the possibility of reproducing via public conversation the very dominant discourses that are being critiqued. These writings suggest that 'conversations' and 'an arts sector' voice, as proposed by Renshaw might be easier to advocate than to achieve.

Arts researchers have sometimes understood arts events as the production of small democracies; they have analysed and theorised the citizenship potential of the arts, and their power to allow previously subjugated groups to express and communicate their ideas/opinions/perspectives (Hickey-Moody, 2012; Nicholson, 2005). They often draw on political theory (e.g., Gutmann, 2003; Mouffe, 1993). Scholars concerned with political action in and through the arts direct their critical attention towards: the ways in which taken-for-granted truths and practices can inhibit democratic artistic practices; the power relations that exist between groups and individuals undertaking artistic/political action; the difficulties of achieving reciprocity and collaboration; the complex practices of recognition of difference; and the capacity for arts practices to transform relations of domination and oppression (e.g., Schmidt-Campbell & Martin, 2006; J. Thompson, 2009; N. Thompson, 2012). In this body of scholarship, the ways in which 'voices' come together as a practice is at once full of possibilities and potential problems.

Intercultural arts researchers might take from this work a focus on both intentions and processes. While they might understand arts events differently, the political focus – on power relations that saturate interactions and also artistic forms – could be very helpful. It moves the researcher beyond the notion of context to consider what kinds of polis is being brought into being through intercultural arts practices and to what ends. It asks how this might be different from other arts events and practices and what the wider implications of this might be. Furthermore, the attention to institutional policies and dialogues offers intercultural arts researchers an opportunity to consider how they might wish to communicate their research and to whom. Is the research to have an impact of any kind? Is it to be in dialogue with taken-for-granted truths? If so, how are the voice(s) of the artists implicated and what can the researcher do about it? Is the arts practice an attempt to challenge the (cultural) status quo, to advocate for new kinds of arts practice and, if so, what is the responsibility of the researcher in relation to this desire?

In sum

The scholarly literatures alert us to some of the key challenges of researching intercultural practices:

* the recognition of difference requires decentring one's own norms, narratives and truths – it means allowing multiple 'voices' to speak and be heard;

- 'voices'/people are not fixed, but have many roles/views/perspectives – they are more than they say, more than their representations, and they are always both beings and becomings;
- some knowledges and practices can be held in common, so dealing with difference does not come at the expense of sacrificing traditional knowledges and beliefs;
- 'voices' are formed and framed within their specific locations and by the continuing presence of power relationships that are manifest in knowledges, social relations and everyday practices;
- there are many kinds of possible cross-cultural conversations – serious, playful, ironic, satirical, transgressive and so on – all of which can be explicitly polyvocal rather than differences being smoothed over or homogenized;
- attention to process is vital if there is to be collaboration and/or the building of democratic 'polis'.

The research methods literatures in particular contribute to understandings about what might be involved in intercultural arts practices and processes. For example: participant and event organisers' reflexivity is crucial; there must be ongoing attention paid to material arrangements and negotations of site, space, time; and collaborative engagement can start at the very beginning of a project.

However, a researcher interested in intercultural arts practices might do more than examine their own traditions of work. They might also go to contemporary art practices for other insights.

Researching intercultural arts and 'voice': insights from arts practices

Within arts communities various aspects of voice as 'personal expression' have been challenged. While the personal expression narrative is alive and well, it is not a lone and all-encompassing story. Here I signal some key examples arising from everyday practices. After each example I raise some italicised questions that those researching intercultural arts practices might consider.

Challenges to the equation of 'voice' with a unique art work

Marcel Duchamp, one of the very artists whose 'voice' Katherine Kuh included in her seminal book, used duplicates and Ready-Mades. These 'avant-garde' works were intended to confront ideas of an art work as hand-made and one-off. Duchamp's use of 'the accidental' as a prompt to begin a work was also somewhat contrary to the notion of an artist working away for a lifetime on a particular idea. Of course, as Duchamp acknowledges in his interview with Kuh, the use of duplicates and Ready-Mades could be seen as his particular vision and taste, and indeed that is exactly how Kuh presented it. The thing can be (mis)taken for its other. Some contemporary visual artists have taken the challenge to uniqueness much further than Duchamp – for example, Jeff Koons has elevated 'kitsch' to literally mammoth proportions; Damien Hirst's multiples, the spot paintings, are mostly produced by assistants, and now number well over 1,000. While these works are at once a personal artistic expression, they are also simultaneously its antithesis (Van Winkel, 2007).

This example raises questions about the assumptions made about the nature of the intercultural art practice being researched. Do the practitioners and/or the researcher see that 'voice' can only be produced from a 'new' practice? Do they use 'ready-mades' in any form? Do they re-enact, remix and/or re-perform? What was the basis on which these pre-existing works were selected? How is their use rationalised? What happens when old becomes new?

The presence of collaborative art forms

Some art practices stand diametrically opposed to the notion of a singular personal expression. For instance, while theatres have become subject to the cult of the director, there is also a strong theatrical tradition of ensemble work in which it is the group vision and voice which counts (Williams, 2005). The group is greater than, and different from any of the individual members; it sometimes also functions as a democratic polis (Neelands, 2009). Ensembles are not only found in theatre, but are also a feature of musical practice where they contrast with the conductor-led orchestra or choir. In both theatre and music, ensemble work demands sustained aesthetic, haptic, emotional and intellectual engagement of and between participants.

This example raises questions about where 'voice' is to be found. Is the researcher looking for diverse individual 'voices' or a collectively produced and/or distributed 'voice'? The example also points to the importance of process. What artistic processes indicate collective 'voice'? What methods allow the researcher to 'see' the process of producing or co-producing intercultural voice(s)?

Pedagogies which are productive of artist 'voice and vision'

The personal expression narrative has produced particular kinds of counter-pedagogies as a response to the 'truth' that personal expression cannot be taught. Artist Judy Chicago, for example, engages her students in a form of collective feminist consciousness raising, systematic research and a strong focus on 'quality content' which speaks to the everyday concerns of women. Chicago is highly critical of art school pedagogies which simply focus on process (Chicago, 2014).

This example raises a set of questions about the degree to which the researcher focuses on the intercultural arts practice as a pedagogical event? What is the researcher to look for as pedagogy – words, images, actions, networks, discourses, content and/or process? And who is learning what, and is there a 'teacher' or 'curriculum' present? How is this pedagogy to be theorised?

The pedagogies and practices of the art market

In his exegesis of the history of art schools and university art departments, Howard Singerman (1999) argues that there is a fundamental tension between the nineteenth-century view of the 'driven, alienated and silent individual' artist and the university trained professional artist. He suggests that university trained artists are not positioned to follow the 'personal expression' narrative. However, as Thornton (2008, chapter 2) notes, art schools promote notions of pioneering, being at the frontier and being an 'avant-garde' able to put in the long hours necessary to be an artist alongside the notion of a community of critical peers. But, according to Singerman (1999), pedagogies such as 'the crit' not only create young artists able to deconstruct the 'personal expression' narrative but artists who are also ready to engage with the art market.

While the university art schools may be geared to deconstructing the personal expression narrative, art dealers and curators deal in it. The artistic irony of Hirst and Koons is marketed and sold as a 'personal expression'; the social narrative is a highly successful marketing strategy. Indeed, both Koons and Hirst are highly entrepreneurial and the personal expression narrative is something they take up in order to sell their work (Harris, 2013). They deal with, in and through the narrative, and profit from it even as they parody it in the work itself.

Many artists, of course, eschew the market and reject the art 'industry' – however, they cannot escape it, even in opposition. As Povall argues, while rebellious artists might

challenge the status quo, (they do so) in a way that entirely supports an 'alternative' status quo – that world of museums and alternative galleries where artists are underpaid and exploited as shamefully and as arrogantly as were the workers in 19th-century factories.

(Povall, 1997, p. 12)

Resistance as 'personal expression' does not get very far in changing the way that the art world operates.

Nevertheless, while the market works for a chosen few, it creates tensions for the many as they attempt to make a living. Here is one example. Writing in *The Atlantic* magazine Noah Berlatsky (2014) describes the aspirations he once had to write in his own 'voice'. Writing for obscure literary magazines did not provide a living wage so he turned to work-for-hire, writing text-book entries and websites. Here, he says, the object was not to have a voice but to reproduce 'house style'.

> For the vast majority of working scribblers, writing is less about finding your own voice than about figuring out how to say something to someone, somewhere will pay you for, or at least listen to. If there's a voice, it's always an adjusted and negotiated voice, rather than a pure effusion of individuality.

However, he goes on, this is fine with him. Not everything that matters is about the personal.

> Writing is partly about individual expression. But it's also about communication and community. Language is a social thing; it exists between people. The voice you hear in your head, the language you speak to yourself – that's not just your voice or your language. It belongs, to some degree, to everybody. Which is what's so magical about language. It connects you to other people. You speak through them, and they speak through you, which is how, with unexpected familiarity, we understand each other.

Here is an assertion of the importance of the social as well as the individual, and the importance of communication over the singular artistic 'voice'. Berlatsky proposes that his art form – in this case language – is a public good *commonly owned*, not the prerogative of an artist who makes art for laypersons. We see in his commentary a competing set of values to that of the self-determining individual, and its contemporary incarnation of the professionally trained entrepreneur.

This example raises a further set of questions about the contexts in which intercultural arts are practised, as well as their purposes – and equally research into these practices. How will the researcher investigate the economic connections with the intercultural arts practice being researched? Is what people say sufficient to understand this or is it necessary for the researcher to take a broader view, and if so, how will they get this? And what of the researcher's own economic context – how much does funding and the quest for research 'distinction' play out in their inquiries of intercultural arts practices? Where do the researcher and the intercultural artist stand in relation to the idea of art as common language and a public good?

Collectively produced art

The market and 'personal expression' narrative is also challenged by artists who work collectively. Australian Aboriginal artists, for example, often tell of their Dreaming using images or stories belonging to members of a particular 'skin' group. An individual artwork might be materially produced by a single artist, by a group, or by a person other than the senior figure

authorised as the custodian of the images and narrative. However, the art work itself does not emanate from an individual voice; it is an articulation and transmission of commonly held traditional knowledges and beliefs (Coleman, 2005; Myers, 2002).

Accustomed to selling work on the basis of a unique artist voice, vision and production process, the art market has found it particularly difficult to manage Aboriginal collective artworks. While they can be sold as 'authentic' and 'exotic' the usual processes of artistic attributions fall short – who/what should customers be told about the actual artist? Art dealers are further challenged by changing Aboriginal artistic practices, as artists innovate, refusing to be frozen in an easily marketable 'primitive' style (Errington, 1998). To add to the complexity of the situation, Aboriginal art is big business and there are unauthorised copies and forgeries of both individual and collective works on the market. The simultaneous presence of legitimate collective productions and forgeries creates a mix that dealers and Eurocentric legal practices alike find difficult to manage (Janke & Quiggin, 2006). But there is perhaps a growing awareness that the narrative of art as a unique 'personal expression' is a white Western construct.

This example raises important questions about the adequacy of the researchers' cultural frames and their own traditions in understanding the intercultural arts practices they are researching. Are they, like Western legal administrators, simply unable to stretch their existing frames of reference and their familiar methods and analytic processes to fit intercultural arts practices? Does there need to be a way for the researcher to problematise, together with intercultural arts practitioners, the processes and analytic categories that they use themselves?

Socially engaged art practices

A different kind of challenge to the status quo is presented via socially engaged art practices and community arts. Collaborative art forms often place strong emphasis on process and on the development of a shared political vision and action (Van Erven, 2001). Rather than a work of art being conceived by the artist beforehand, a product of their 'aesthetic autonomy' to be placed before an audience with an intent to shock and disrupt (Bishop, 2012), collaborative art practices seek to dissolve the artist/audience binary through protracted interaction and mutual artistic endeavour (Kester, 2011).

This example raises further difficult questions for the researcher. When working with intercultural arts practices, how much does the researcher seek to dissolve the researcher/researched binary? How much does the research become co-constructed, participatory and collaborative? How much does the researcher 'voice' merge with that of the intercultural arts practitioners?

Conclusion: still more to think about

Using the lens of 'voice' to consider researching intercultural arts practices highlights the need for researchers to ask new questions, behave in particular and different ways and develop new understandings. But it also suggests that the task of researching interculturally is not simply about methods, or about epistemology. It is also about ontology. Why ontology? Ontology is the term used to describe the ways in which we understand what it is to exist, to live in the world, to be with ourselves and others. It is not knowledge per se, but about the way we are and exist in the world.

The examples that I have considered all imply that working with difference requires people – researchers and artists – to be open to acknowledging their own social and cultural frames, to be vulnerable and to take risks in conversing when there is a risk of setting a foot wrong, to be encouraging so that others can participate, to be respectful of other points of view, values,

practices, languages, emotions and pedagogies, and to be generous and affirming of all voices, even when they are hard to hear, angry or contrary. Such an ontological position is profoundly about an attitude to living and a disposition towards learning, changing and improvising new ways to be and become. It is, as artists often suggest, much more about the not knowing than knowing. It is about playing, trying things out, being open to experimentation (Fisher & Fortnum, 2014).

We can perhaps take a lead here from collaborative and socially engaged arts practitioners and researchers who work with these understandings, seeing conversation and art making as the creation of a space of collective meaning making. This space is not only social and relational but also highly productive of new forms of the social and relational. The exchange that happens in the intercultural arts space can operate in the interstices of dominant discourses but, in order for this to happen, all participants, including researchers, must be motivated by more than narrow economic and utilitarian ends (cf. Bourriaud, 1998). They must want to learn to practise in different ways – and encourage and teach others to do so too.

Note

1 The notion of social narrative has strong connections to Foucault's 'regime of truth' and Bourdieu's notion of 'doxa'.

References

Allan, J., & Slee, R. (2008). *Doing inclusive education research*. Rotterdam: Sense Publishers.

Arnot, M., & Reay, D. (2007). A sociology of pedagogic voice. *Discourse, 28*(3), 327–342.

Badiou, A. (2013). *Philosophy and the event* (trans. F. Tarby). Cambridge: Polity.

Bakhtin, M. (1981). *The dialogic imagination: Four essays* (trans. C. Emerson & M. Holquist). Austin, TX: University of Texas Press.

Bal, M. (1997). *Narratology: Introduction to the theory of the narrative* (2nd ed.). Toronto: University of Toronto Press.

Barthes, R. (1967). The death of the author. *Aspen, 5/6* (Fall Winter), http://www.ubu.com/aspen/aspen5and6/threeEssays.html.

Becker, C. (Ed.). (1994). *The subversive imagination: Artists, society and social responsibility*. New York: Routledge.

Benhabib, S. (1996). *Democracy and difference*. Princeton, NJ: Princeton University Press.

Berger, A. A. (1997). *Narratives in popular culture, media and everyday life*. London: Sage.

Berlatsky, N. (2014, 29 November). 'Voice' isn't the point of writing. *The Atlantic*.

Bhaba, H. (1994). *The location of culture*. London, New York: Routledge.

Bishop, C. (2012). *Artificial hells: Participatory art and the politics of spectatorship*. London: Verso.

Bourriaud, N. (1998). *Relational aesthetics*. Paris: Les Presses du Réel.

Chicago, J. (2014). *Institutional time: A critique of studio art education*. New York: The Monacelli Press.

Coleman, E. (2005). *Aboriginal art, identity and appropriation*. Aldershot, UK: Ashgate.

de Certeau, M. (1988). *The practice of everyday life* (trans. S. Randall). Los Angeles: University of California Press.

Derrida, J. (1978). *Writing and difference* (trans. A. Bass, 1995 ed.). London: Routledge.

Dezeuze, A. (Ed.). (2010). *The 'do-it-yourself' artwork: Participation from Fluxus to new media*. Manchester: University of Manchester Press.

Eagleton, T. (1996). *Literary theory: An introduction*. Minneapolis, MN: University of Minnesota Press.

Elbow, P. (1994). What do we mean when we talk about voice in writing? In K. Yancey (Ed.), *Voices on voice: Perspectives, definition, inquiry* (pp. 1–35). Urbana, IL: National Council of Teachers of English.

Elbow, P. (2012). *Vernacular eloquence: What speech can bring to writing*. Oxford: Oxford University Press.

Ellsworth, E. (1989). Why doesn't this feel empowering? Working through the repressive myths of critical pedagogy. *Harvard Education Review, 59*(3), 297–324.

Errington, S. (1998). *The death of authentic primitive art and other tales of progress*. Los Angeles, CA: University of California Press.

Fisher, E., & Fortnum, R. (2014). *On not knowing: How artists think*. London: Black Dog Publishing.

Foucault, M. (2006). *The hermeneutics of the subject: Lectures at the Collège de France, 1981–1982*. New York: Picador.

Fraser, N. (1993). Rethinking the public sphere: A contribution to the critique of actually existing democracy. In B. Robbins (Ed.), *The phantom public sphere* (pp. 1–32). Minneapolis, MN: The University of Minnesota Press.

Gallagher, K. (Ed.). (2008). *The methodological dilemma: Creative, critical and collaborative approaches to qualitative research*. New York: Routledge.

Gutmann, A. (2003). *Identity in democracy*. Princeton, NJ: Princeton University Press.

Harris, A. (2013). Financial artscapes: Damien Hirst, crisis and the City of London. *Cities, 33*(August), 29–35.

Hickey-Moody, A. (2012). *Youth, arts and education: Reassembling subjectivity through affect*. London: Routledge.

Holub, R. (1984). *Reception theory: A critical introduction*. London: Methuen.

Janke, T., & Quiggin, R. (2006). *Indigenous cultural and intellectual property: The main issues for the Indigenous arts industry in 2006*. Canberra: Aboriginal and Torres Strait Islander Arts Board, Australia Council.

Joshee, R. (2012). Challenging neoliberalism through Ghandian trusteeship. *Critical Studies in Education, 53*(1), 71–82.

Kester, G. (2011). *The one and the many: Contemporary collaborative art and the many*. Durham, NC: Duke University Press.

Kristeva, J. (1980). *Desire in language: A semiotic approach to literature and art*. New York: Columbia University Press.

Kuh, K. (1962). *The artist's voice: Talks with seventeen modern artists* (2000 reproduction of original ed.). New York: First Da Capo Press.

Lacan, J. (1968). *The language of the self: The function of language in psychoanalysis*. Baltimore, MD: Johns Hopkins University Press.

Lassiter, L. E. (2005). *The Chicago guide to collaborative ethnography*. Chicago: University of Chicago Press.

Lather, P. (2007). *Getting lost: Feminist efforts toward a double(d) science*. New York: State University of New York Press.

Maffesoli, M. (1995). *The time of the tribes: The decline of individualism in mass societies* (trans. D. Smith). Thousand Oaks, CA: Sage.

Makaryk, I. R. (Ed.). (1993). *Encyclopedia of contemporary literary theory: Approaches, scholars, terms*. Toronto: University of Toronto Press.

McIntyre, A. (2008). *Participatory action research*. Thousand Oaks, CA: Sage.

Mitchell, W. J. T. (2005). *What do pictures want? The lives and loves of images*. Chicago, IL: University of Chicago Press.

Mouffe, C. (1993). *The return of the political*. London: Verso.

Myers, F. R. (2002). *Painting culture: The making of an aboriginal high art*. Durham, NC: Duke University Press.

Neelands, J. (2009). Acting together: Ensemble as a democratic process in art and life. *Research in Drama Education, 14*(2), 173–189.

Nicholson, H. (2005). *Applied drama*. Basingstoke: Palgrave.

Nind, M. (2014). *What is inclusive research?* London: Bloomsbury.

Povall, R. (1997). Sociological, artistic and pedagogical frameworks for electronic art. *Computer Music Journal, 21*(1), 18–25.

Renshaw, P. (2004). Connecting conversations: The changing voice of the artist. In M. Miles (Ed.), *New paradigms new pedagogies: A reader* (pp. 99–116). Amsterdam: European League of Institutes of the Arts, Swets & Zeitlinger.

Sauvagnargues, A. (2013). *Deleuze and art* (trans. S. Bankston). London: Bloomsbury.

Schmidt-Campbell, M., & Martin, R. (Eds.). (2006). *Artistic citizenship: A public voice for the arts*. New York: Routledge.

Shusterman, R. (2000). *Pragmatist aesthetics: Living beauty, rethinking art*. Lanham, MD: Rowman & Littlefield.

Singerman, H. (1999). *Art subjects: Making artists in the American university*. Berkeley, CA: University of California Press.

Smyth, J., & Hattam, R. (2001). 'Voiced' research as a sociology for understanding 'dropping out' of school. *British Journal of Sociology of Education, 22*(3), 401–415.

Spivak, G. C. (1993). *Outside in the teaching machine.* New York: Routledge.

Thompson, J. (2009). *Performance affects: Applied theatre and the end of effect.* Basingstoke: Palgrave Macmillan.

Thompson, N. (Ed.). (2012). *Living as form: Socially engaged art from 1991–2011.* Cambridge, MA: MIT Press.

Thomson, P. (2011). Coming to terms with 'voice'. In G. Czerniawski & W. Kidd (Eds.), *The international handbook of student voice* (Vol. 19–30). London: Emerald.

Thomson, P. (Ed.). (2008). *Doing visual research with children and young people.* London: Routledge.

Thornton, S. (2008). *Seven days in the art world.* London: Granta.

Van Erven, E. (Ed.). (2001). *Community theatre: Global perspectives.* London: Routledge.

Van Winkel, C. (2007). *The myth of artisthood.* Amsterdam: BKVB.

Williams, D. (Ed.). (2005). *Collaborative theatre: Le Theatre Du Soleil.* New York: Routledge.

Wimsatt, W., & Beardsley, M. C. (1946). The intentional fallacy. *Sewanee Review, 54*, 468–488.

27

WHEN DIALOGUE FAILS

An art educator's autoethnographical journey towards intercultural awareness

Eeva Anttila

In this chapter, the author investigates her professional practice in the context of arts education and revisits her doctoral study (Anttila, 2003) on dialogical dance pedagogy. She connects Martin Buber's ideas about dialogue with Homi Bhabha's (1994) notion of cultural hybridities, and presents the notion of intercultural awareness. She suggests that this notion, theoretically inspired by Buber's dialogical philosophy and Bhabha's post-colonialism, might be helpful in understanding and fostering social change. Moreover, she wonders if educators and researchers aiming for social change should examine their professional practice from the viewpoint of inter-cultural awareness. She then turns her focus towards her own professional practice. Utilizing autoethnographical and performative writing she explores ways to research "in-betweenness." In conclusion, she proposes that arts educators and researchers interested in fostering social change through heightened intercultural awareness need to give up the search for coherence and cherish the emergence of hybrid spaces where difference may be performed and mutated. Being open for constant transformation is risky but might open new possibilities to live together.

Orientation

Academic and artistic practices embrace excellence and celebrate achievement. Writing about failure seems absurd and risky. Scholarly work calls for clear conclusions but the clarity may be deceiving when it smooths out the complexity of the social reality. I often find myself contemplating the notion of history repeating itself: have we not learned anything? Why do we keep repeating the same mistakes over and over again? Often these thoughts arise in connection to disturbing news, local and global, but, increasingly, in connection to professional life. I have begun to wonder if a tendency to give an enhanced impression of our own professional practice is one part of the problem. Might it be a place to begin the search for better practice, and even for a better world; a world where difference is cherished and where intercultural awareness empowers individuals and strengthens communities? The recurrence of conflicts of all sorts makes me question why even the most developed societies keep failing in their efforts to gener-ate well-being, equality and peace. Why does all this research on social justice not seem to have impact? What if we who do such research are part of the problem? Could an investigation into our own failures generate intercultural understanding that could be transferred to other contexts and make sense of social turmoil outside academia? In other words, how could we as artists,

educators and scholars allow intercultural ruptures to be present in our writing, and how can such writing evoke intercultural awareness? For me, aiming for this kind of awareness means letting go of the desire to make sense, know better, and arrive at conclusions. Accepting not-knowing, confusion, loose ends, false starts, and messy outcomes in research and in professional practice might be a crucial step towards heightened intercultural awareness.

Through this writing project, I am unraveling my experiences of failure in the context of collaborative artistic–pedagogical projects where my intention has been to enhance dialogical encounters among the participants. Through these encounters I have hoped to foster shared meaning-making processes. Such processes involve venturing into unknown territories, facing otherness, accepting difference, and giving up the notion of the artist as an individual author. These aims are related to interculturality, even in a homogenous cultural context where the need to enhance intercultural awareness might seem less urgent. My experiences of failure "at home" might shed some light on the formidable challenges we, privileged academics, face in understanding difference and practicing interculturality.

Otherness that emerges in collaborative artistic work is of a special kind: it is co-created, imagined, performed and often temporal. However, the creative process that generates these imagined, alternative realities is corporeal and tightly connected to the complexities of social reality. The power of imagination is great, but can lose its thrust in social life where ownership, personal needs and interests are at stake. Along with Maxine Greene, I have wondered, "Is it not imagination that allows us to encounter the other as disclosed through the image of that other's face?" (1995, p. 37). Greene contemplates this further:

> [I]magination is what, above all, makes empathy possible. It is what enables us to cross the empty spaces between ourselves and those we teachers have called "other" over the years. If those others are willing to give us clues, we can look in some manner through strangers' eyes and hear through their ears.
>
> *(1995, p. 3)*

Crossing over these "empty spaces" is a phenomenon that has intrigued and puzzled me for a long time. How to build a bridge when the breaking just begins, or even before? How to stop the gap from widening? On a deeper level I have found myself contemplating foundational questions concerning the human condition. How to deal with the feelings of hollowness, of being deserted? Could understanding the destructive impact of being abandoned generate understanding about social justice? And then, coming back to the arts, professional practices and research, I am eager to learn to appreciate these gaps and failures as possibilities for developing intercultural awareness.

Arts educator, a colonizer?

Upon entering "the field," so to say, I have considered myself as a do-gooder, sensitive to others' needs, willing to defend the weak. Like a missionary I have chased the artist, the dancer in everyone, substituting faith with art. This commitment has shaped my artistic–pedagogical endeavors and research interests, and taken me to various communities, mostly public schools, as a "dance specialist."

The lack of artistic activity in public schools has been a topic that I have spent a lot of time contemplating. I have considered this lack as a kind of deprivation and thus, oppressive, since it prevents children from exercising all their faculties (see Freire, 1972, p. 51). My mission has been to foster possibilities to develop and use imagination and creativity in school and help children to

become the kind of persons they would want to become, and learn to live together (Anttila, 2003, p. 260). This has repeatedly taken me to communities where art seems to be devalued. My own experiences on how dance has changed my life play a significant part in solidifying my commitment but, also, this faith has generated blind spots and obscured my vision.

Another belief that I have committed to, has been dialogue.

Today, I feel a compelling need to return to Martin Buber's writings and contest his views on dialogue in relation to the notion of interculturality. With this writing project I am revisiting "the land of dialogue" that I explored through my doctoral study (Anttila, 2003). The basic premise that I have adopted from Buber is that a human being becomes a person through relationships to the other and to the world. Becoming a person happens through relating and associating; in contrast, becoming an ego happens through separation from others (Buber, 1937/1970, p. 112). Buber explains how dialogue emerges as *reciprocal movement*: "The basic movement of the life of dialogue is the turning towards the other . . . no man is without strength for expression, and our turning towards him brings a reply, however imperceptible, however quickly smothered" (1947, p. 22).

Using the metaphor of a journey where dialogue would be the destination, I contemplated that "the land of dialogue peculiar is in itself. It is possible to arrive there and in an instant, notice that it is not there anymore. As such, it is like a dream, true and ephemeral at the same time" (Anttila, 2003, p. 295). The fleeting quality of dialogue combined with post-foundational questioning of liberatory praxis, by for example, Elizabeth Ellsworth (1992) still rings very true today. Ellsworth notes that she, as a critical educator, can never "participate unproblematically in the collective process of self-definition, naming of oppression, and struggles for visibility in the face on marginalization engaged in by students whose class, race, gender and positions I do not share" (Ellsworth, 1992, p. 101).

The need to understand my experiences of failure are related to the gradual recognition of how my benevolent intentions have at times become tangled with "knowing better." This tacit colonizing thrust seems to easily transform the dynamics of social life from collaboration and trust towards hostility and mistrust. Here, "art" and "school" are equated with nations with borders, cultures, norms and habits. The artist travels to school and begins a project there, aiming at a transformation of school culture through art, or claiming new territory for art. Art, indeed, takes the place of religion, and the artist is the colonizer, the missionary, the savior. The conventional school culture becomes juxtaposed with the liberal art culture, and a fertile ground for an intercultural clash has been created. The blurring of disciplinary boundaries between art and education generates tension. The gap emerges, but is it a problem, or possibility?

I have often anticipated and even welcomed some kind of friction, and it has intrigued me as a possibility for transformation, learning, and social change. I recognize familiarity in Homi Bhabha's (1994) musings on cultural hybridities that may emerge where different cultures (or nations, races, genders) meet, and where "the boundary becomes the place from which *something begins its presencing*" (1994, p. 5). Bhabha (following Martin Heidegger), refers to bridges that escort "men to and fro, so that they may get to other banks" (1994, p. 5) and "the emergence of the interstices," or gaps, as overlaps and displacements of domains of difference (1994, p. 2). In this liminal space, or hybrid site, new cultural meanings may be produced, and the colonizer and the colonized can negotiate. For Bhabha, this negotiation is a performative act, that is, difference is being performed and, simultaneously, transformed and mutated. This performance may involve a mutual recognition of cultural difference and its transformation. Bhabha (1994, p. 2) encourages us to "think beyond narratives of originary and initial subjectivities and to focus on those moments and processes that are produced in the articulation of cultural differences." These performative acts are, in my view, possibilities for enhancing intercultural awareness.

In my experience, however, the gap has often appeared to be too wide. The hybrid space, if it ever emerges, is virtual, temporary at most. The moment when the awareness about the totality of the difference hits you is terrifying. You realize that you imagined the connection, and you ask yourself, was it all forged?

Bhabha's notion of "unhomely lives" resonates in me, and I recognize this as a feeling of being a stranger in my own home. It is not about homelessness, but "an estranging sense of the relocation of the home and the world – the unhomeliness – that is the condition of extra-territorial and cross–cultural initiations" (1994, p. 13). Bhabha continues:

> The unhomely moment creeps up on you stealthily as your own shadow and suddenly you find yourself . . . taking a measure of your dwelling in a state of "incredulous terror" . . . The recesses of the domestic space become sites of history's most intricate invasions.
>
> *(1994, p. 13)*

These situations have created intense embodied sensations, emotions and feelings that are quite difficult to deal with and articulate. These experiences are characterized by a sense of alienation, otherness, or a state of perplexity where a feeling of not-knowing becomes prevalent. They have generated disruptions in the ways I view myself and my work as a practitioner-researcher interested in dialogical life and social change through the arts and compelled me to revisit and reconfigure the notion of dialogue from the viewpoint of intercultural awareness.

How to research one's own experiences of failure and loss, of not-knowing?

On autoethnography

Making sense out of not-knowing and exposing one's vulnerability might seem anomalous, but seem to be, indeed, the very heart of intercultural research practices. A traditionally oriented scholar might turn away from these frightening episodes, to bypass them as glitches, phantoms, instead of ubiquitous phenomena that warrant researchers' attention. These ghostly encounters have begun to preoccupy me and signify something meaningful. This budding need to seek meanings that may be embedded in these experiences has driven me towards taking on this challenging journey towards heightened intercultural awareness. Thus, I am revisiting not only my journey towards dialogue, but also towards research, and especially, towards autoethnography. I have felt a need to adjust and enhance my lenses in using this autobiographical genre of research that has supported me in investigating the possibilities of dialogical life. As I have learned, autoethnographical texts are composed of concrete action, dialogue, emotion and embodiment (Ellis & Bochner, 2000). Is it possible to build a bridge from personal, lived, embodied experiences of a "self," towards hybrid encounters where the researcher as a subject, as a knower, ceases to exist as one, but becomes many? How does autoethnography bend towards researching "in-betweenness"?

According to Carolyn Ellis and Arthur Bochner (2000) autoethnography displays multiple layers of consciousness as the researcher looks both outward on social and cultural aspects of their personal experience, and inward, exposing a vulnerable self. Here, I am intrigued about seeing how the shift of focus from personal to cultural may blur distinctions between these areas, and create another liminal, or hybrid space, that is, an intercultural space – the gap that may be a possibility for something new to emerge. Thus, I am trying not only to make sense of the past

but, increasingly, to imagine the future; I am trying to let go instead of to grasp; I am trying not to resolve, but to learn to live with not-knowing.

On embodiment

For me, as for many dance practitioners and scholars, embodied, or pre-reflective experiences constitute a significant element of consciousness. In phenomenological terms, we are in the world as bodily subjects, and our reflections are always situated in and mediated through the body (Merleau–Ponty, 1995/1962). In terms of cognitive science, our bodies shape the way we think (Pfeifer & Bongard, 2007). In my previous research on body memories and intro-spection (Anttila, 2004; 2007) I have explored how attending to pre-reflective, bodily sensa-tions and states transforms them into contents of our reflective consciousness, translatable to language (see also Damasio, 1999). Thus, bodily presence is always tied to bodily consciousness and our historicity. However, if we are to shift our focus from our own lived body towards "in-betweenness," how should we deal with subjective embodied experiences and the inter-pretations and reflections that they give rise to? Is it possible to escape the positionality of an embodied subject, and if so, how?

On performative writing

I have found the notion of performative writing helpful in reconstructing my position as a scholar, a writer, a knowing subject. As Ronald Pelias (2005, p. 418) puts it, performative writing features lived experience and "iconic moments that call forth the complexities of human life." Such writing does not separate the mind from the body, and "attempts to keep the complexities of human life intact" while acknowledging that everyday experience does not equal scholarship. Performative writing is an approach to research that seeks to engage and evoke, instead of report and describe; thus, the performative writer, as an artist, shapes experiences into texts that move and matter. Performative writers see the world not as given, but composed of multiple realities. They privilege dialogue, the fragmentary, the uncertain, and "do not believe that argument is an opportunity to win, to impose their logic on others, to colonize . . . [performative writing] creates a space where others might see themselves" (Pelias, 2005, p. 419). The "I" of the writer is plural, as it invites to take another's perspec-tive. Performative writing seeks to create resonance through words performing, dancing on pages, and through constructing stories that can be trusted and used, rather than posing truths. The criteria of validity for this kind of research stem from, for example, verisimilitude, resonance, and aesthetic merit instead of correspondence to truth and reality (Ellis, 2004; Richardson, 2000).

To sum up, I am seeking writing that is rooted in my subjective embodied experiences, but does not end there. I expose my vulnerable self not for the sake of personal closure but for the sake of inciting dialogue about failure and vulnerability as something that human beings inevitably face, but that is difficult to share. I trouble myself by questioning my expertise and my choices. I can take this risk because I trust that I am not alone with my experiences. From this privileged position where I have the means for speaking about my experiences, I wish to embrace otherness and imagine how my experiences might resonate in other contexts, other cultures, and reach towards the future. I believe that these connections are crucial in developing intercultural awareness and in intercultural research practices.

Next, I will present three incidents that have taken place in artistic-pedagogical contexts where I have strived for dialogue and intercultural awareness. These incidents stand out in my

consciousness, as treacherous moments, as embodied memories. These moments have thrown me onto this remote orbit, in search for a deeper understanding of failing dialogue. When revisiting these incidents I have focused on my embodied experiences and on the images that stand out, and let words arise in an unchained manner, one after another, like a pearl necklace. I have edited the accounts, however, for coherency and aesthetic appeal. After writing the accounts, I have revisited Martin Buber's writings. Looking back now, I realize that he is, in many measures, one of the most progressive thinkers on interculturality, speaking for the possibility of the land of two peoples (Buber, 2005). His dreams, as we painfully well know today, did not come true, but maybe it is possible to find new insights, comfort, and hope from his words.

Confronting failure: three critical incidents

I: Rehearsal

This morning the atmosphere seems odd. We gather in a circle and one dancer presents a sketch that some ideas that her group has worked as assigned. I do not comment yet, although I immediately think that the plan is complicated and would be difficult to realize with the resources we have.

Ahah, don't you see how you suppressed the "I-know-better" urge – oh how familiar it feels . . . let them find the right answer themselves, although I know it already!

A dancer from the other group voices my thoughts. I am relieved –

> *Here it comes!*

. . . hoping that peer feedback will work and we can sustain the non-hierarchical approach that I have strived for. But another dancer insists on keeping the plan. The voices become tense.

I ask everyone to say what is most important to them in this process. My intention is to clarify our aims.

> *Now, you sound too confident.*

The dancers seem detached and disinterested. Their responses arouse feelings of disappointment in me. Is this all we have accomplished together?

One dancer cries, saying she can't bear this state of not-knowing any longer. I agree I talk to myself I convince myself this is the right way to proceed they need a push! "We have enough ideas, enough material, it is time to sort it out" the inner teacher that I have tried to extinguish or at least hide for now keeps nagging but swallows the words.

I make a straightforward suggestion on what to keep from the plan, and what to cut. A mistake! Another dancer cries: the whole process has been in vain, she does not want to have anything to do with this project anymore.

I feel the ground below me shifting as in an earthquake. The voices seem to come from a distance now. They seem to be drifting away. The gap between us grows and deepens. The break just happened and feels absolute, irreversible. It is like a nightmare where you want to move your arms, reach out, touch, but you are paralyzed. Events unfold before you, and there is nothing you can do. It is an avalanche, no human force can stop it. I feel like sinking, disappearing.

The context of this incident was not a public school, but higher education, where I worked with a group of arts education students. When I think back about this incident today my

breathing gets stuck in my throat; it becomes superficial and hollow. I close my eyes and my fingers slow down, the typing stops. I see the incident as images, as film, a nonverbal narrative (Damasio, 1999). I see the space, the dark walls, the persons sitting in the circle, many details. Images of an earthquake, avalanche, or eruption of a volcano merge with the picture. It is very dramatic, and yet, it is just a group of people sitting on the floor and talking. There is no outer threat, no violence, hardly any physical action. We see each other, I see them but I do not see what they feel, why they feel the way they feel. I fail in *experiencing the other side* because I think I know better, or I think I must know better.

Experiencing the other side, or *inclusion* is a central concept in Buber's philosophy (Buber, 1947 p. 96). Inclusion makes the other person present to the other. For Buber, not all dialogical relationships consist of *mutual inclusion*. He confirms that relationships that are characterized by *one-sided inclusion* have not lost anything of their dialogical character, and that there are many I–You relationships, like the relationship between the teacher and the student, that "by their very nature may never unfold into complete mutuality if they are to remain faithful to their nature" (Buber, 1937/1970, p. 178). *One-sided inclusion*, or embracing, means that the educator "experiences the pupil's being educated, but the pupil cannot experience the educating of the educator" (Buber, 1947, p. 100). By practicing embracing, the teacher might awaken capability for inclusion in students but cannot prescribe how and when, if ever, this will happen.

I must have desired to witness my students practice inclusion towards each other and even towards myself. Meanwhile, I was holding onto my position as a teacher, knower, unable to abolish my urge to colonize, to teach how to live dialogically, and how to work collaboratively. I thought I knew how it works, how it is supposed to be, and failed to endure the state of not-knowing when some students cried for resolutions. Difference was performed, but I failed to read this performance as an emerging hybrid space, and panicked. As Bhabha (1994) affirms, performing difference might be the key for creating the hybrid space, or a Third space, an intercultural territory for everyone. When this new territory emerges, it may be shared – it is no man's land, so to say. Researchers and teachers alike have to learn to live in these hybrid spaces, give up their urge to control, know better, teach, resolve – live with the participants, endure, comfort, trust.

Why don't you just trust us?

A tired voice I hear it yes but do I listen?

Of course I trust but see I must take responsibility here because not everybody has voiced their desires what if someone else feels the opposite what if someone else wants me to help you?

I would so much like to know how to help you and everyone.

II: Message

Finally, at the airport. It is close to midnight, my overnight flight is about to depart. I find a seat by the gate, close my eyes for a moment, and take a deep breath. It has been a hectic day, and a hectic week. Over the long flight I cannot do anything but be still.

I decide to check my inbox once more before boarding. I see a message from a colleague regarding a recent meeting. The memory of that meeting makes me anxious. It was a difficult meeting and something about it has bothered me ever since. Should I open the message? If I don't read it I may be wondering about it during the flight.

I read it first with a quick glance. I start to feel queasy. A heavy sensation seeps into my chest and it grows. I feel like the ground is sinking below me. I read it again, slowly. The message is directed to everyone in the group, but I am being referred to in third person.

> *THIRD PERSON! What does s/he think s/he's doing, ignoring ME! I have always been polite my words never hurt – right? I am a very good, very very competent project leader. This must be a grave misunderstanding, a MISTAKE!*

Ok, if I think calmly and honestly I did notice a moment of lost connection during the meeting but did not read this fleeting moment of misunderstanding was so fundamental that the colleague decided to withdraw from this project.

> *WITHDRAW?? Just a minor bump and s/he is running away! What now – how can I save the project now, MY project?*

I realize that I have to bear this heavy sensation with me over the entire flight, and maybe much longer (What is this sensation? Could it be guilt?) I can't reach to my colleague by any means now. S/he is somewhere out there in this world and I am here and now, with this heaviness that wraps around me and creeps inside me. I can't shake it off. Sticky murky guilty feeling.

This incident took place three years ago, and it kept troubling me for months, even years. The context of the meeting from which this incident stemmed was a public school, where I was leading an arts education project as a guest artist. I was in the position of the project leader. I was in a foreign territory, trying to sort out something that had created anxiety among the "locals." I interfered with a good intention to help.

I encountered the feeling of helplessness again, as well as anger towards myself, my inability to read my colleague's experiences and expressions at the meeting. Misunderstanding was created by just a few words, gestures, and expressions.

Did I believe that my good intentions and my ability to use a dialogical approach as a leader gave me superior skills with which to prevent, detect and resolve all misunderstandings? Or, had I become blind about the limits of dialogue? Buber writes that the moments of dialogue appear to us as "lyric–dramatic episodes," whose spell is seductive but dangerous, because "they pull us dangerously to extremes, loosening the well–tried structure" (1937/1970, pp. 84–85). Life in the It–world, that is, the world where we see others as objects, does not burn; it is structured, ordered and predetermined. You–moments stir up this order, seduce and confuse. He asks, why do we need those moments, because we must return to the It–world, anyway? The loss of connection hurts, why then risk and strive for dialogue?

Buber (1937/1970, p. 92) writes about the paradox of what usually happens when people learn to "experience and use," stating that it generally causes a decrease in their power to relate. He goes on, explaining that:

> Standing under the basic word of separation which keeps apart I and It, he has divided his life with his fellow men into two neatly defined districts: institutions and feelings. It–district and I–district. Institutions are what is "out there" where for all kinds of purposes one spends time, where one works, negotiates, influences, undertakes, competes, organizes, administers, officiates, preaches . . . Feelings are what is "in here" where one lives and recovers from the institutions.
>
> *(1937/1970, p. 93)*

Buber says that the borderline between institutions and feelings is continually endangered, as feelings break into the institutions. Buber describes how a remedy has been thought of for this

problem: institutions should be renewed by bringing feelings into institutions, by opening them up by feelings. Buber doubts this, suggesting that:

> True public and true personal lives are two forms of association . . . but even the combination of both still does not create human life which is created only by a third element: the central presence of the You or . . . the central You that is received in the present.
>
> *(1937/1970, pp. 94–95)*

The living center, or the central you, resembles, to me, Bhabha's notion of the hybrid space, or the Third space. Bhabha, interestingly uses the words "I" and "You," and writes: "The pact of interpretation is never simply an act of communication between the I and You designated in the statement. The production of meaning requires that these two places be mobilized in the passage through a Third Space" (1994, p. 36).

This liminal space might seem and remain unintelligible, a space of not-knowing. I understand now that this space needs to be cherished, not broken apart by attempting to resolve differences too hastily. I must be present, listen and only then, maybe, the Third space emerges. Giving up predetermined ends is stepping into the world of relation within its ethical limits. I must stop knowing, forget my desire to excel.

III: Face-to-face

We meet in my office. I feel relief, hope. This is good, I think – we have a possibility to encounter each other, to figure out what is going on, to understand each other. I look at her, I feel soft, open and vulnerable.

> *Now that she's here, just the two of us. I can make her understand. And I can forgive her since she came! She will learn and everything will be fine.*

She looks at me but strangely, we do not seem to see each other. I see her eyes, I see her, but I do not reach her. She is far away. The difference, the distance is greater than ever. The gap grows, I feel my words disappearing into an empty space around me. I am in darkness, trying to grasp onto anything that would connect us. (Where is your optimism now? The power of words? The magnificent encounter where you can put to work the beauty of face-to-face meeting that no one can resist?)

I find nothing. There is nothing.

I feel like plunging into a deep hole that has no bottom.

When she leaves I breathe heavily into the deep, dark, hollow space inside me. It feels like something from inside me was just ripped off. This feeling of emptiness touches me on a deep, ontological level. It is about the totality of Otherness, the recognition of complete separation when facing the other that creates hopelessness.

This incident, again in the context of higher education, makes me reflect on what it means to be rejected in personal life. If I, an adult with all the physical security and safety that I can ask for, feel so overwhelmed when losing connection to a student, I cannot begin to understand what denial of love does to a child. It must be much more profound, devastating. Soliciting care and longing for relation is deeply inherent in humanity. When this reciprocity becomes smothered, loneliness hits you. This experience of failing dialogue revealed to me that I know nothing about such rejection.

Buber writes that the prenatal life of a child is pure natural association, a bodily reciprocity. Longing towards unity is based on this association: "The innateness of the longing for relation is apparent even in the earliest and dimmest stage" (1937/1970, p. 77). The longing for relation is primary: "In the beginning is the relation . . . *the innate You*" (Buber, 1937/1970, p. 79) that manifests itself as a drive for contact.

> The development of the child's soul is connected indissolubly with his craving for the You, with the fulfillments and disappointments of this craving, with the play of his experiments and his tragic seriousness when he feels at a total loss.
>
> *(1937/1970, p. 79)*

There are too many rejected children and lonely human beings in this world. Rejection turns into shame and hatred, accumulating over time, and resurfaces as social conflicts of all sorts. I think now that the path towards dialogue, towards community and peace starts with the face-to-face encounter, the eyes meeting, the deep connection that says: I see you.

Embracing

Three years have passed since the night at the airport. I still remember the feeble sensations in my knees and elbows, the heavy lump in my chest, the sinking ground, and the feeling as if the blood flow in my veins would stop.

One Sunday, in the midst of some garden work, I see another message from the colleague. I startle. Maybe I should not attend to this now. The whole project has ended a long time ago. What now? Maybe my report has instigated another misunderstanding. I cannot resist, and open the message. This time, the message is to me personally. I am being addressed directly, politely. The tone is still formal. This is an invitation to attend an event that is related to the project. I reply politely, I will attend.

A week later, I attend the event. The colleague meets me at the entrance, by chance, I think. S/he smiles and welcomes me with a handshake. Then, s/he says: "I think it is time for a hug." I say, yes, and we hug each other. The restored connection feels like balsam inside me: warm and soft, a melting sensation.

Maybe I just imagine, how would I know? Anyhow, I am grateful that my belief in the power of dialogue gets another chance today, here. It is a mystery, however, when and how the gap fades, and how to make it happen. I still don't know — I trust.

This episode, where the connection became re-established between my colleague and me, reminds me of an incident that Buber writes about. He refers to it as a "broken-off conversation" with Christians and Jews in 1914:

> [O]ne of us, a man of passionate concentration and judicial power of love, raised the consideration that too many Jews had been nominated . . . Obstinate Jew that I am, I protested against the protest . . . so I directly addressed the former clergyman. He stood up, I too stood, we looked into the heart of another's eyes. "It is gone," he said, and before everyone we gave another the kiss of brotherhood. The discussion of the situation between Jews and Christians had been transformed into a bond between the

Christian and the Jew. In this transformation dialogue was fulfilled. Opinions were gone, in a bodily way the factual took place.

(1947, pp. 5–6)

Dialogue becomes manifested through embodiment. Touch may lead to an embodied act of inclusion, experiencing from the other side, a concrete act of embracing. In touch, feeling the contact from two sides is possible, with "the palm of one's own skin," and also with the other's skin, as Buber describes:

> For the space of the moment he experiences the situation from the other side. Reality imposes itself on him . . . The twofold nature of this gesture . . . thrills through the depth of enjoyment in his heart and stirs it.
>
> *(1947, p. 96)*

Hope may be kindled through a simple gesture, the connection restored through a fleeting moment of recognition when the eyes meet, and peace can be restored through an embrace. Prior knowledge means little here.

Through this writing process I have learned about the gap, the difference, and the ephemeral nature of the movement across this space that separates I and You. For Bhabha,

> [t]hese "in-between" spaces provide the terrain for elaborating strategies of selfhood – singular or communal – that initiate new signs of identity, and innovative spaces of collaboration, and contestation, in the act of defining the idea of society itself.
>
> *(Bhabha, 1994, p. 2)*

I have learned to appreciate this space as a possibility; as a Third space that I cannot know, that I cannot make happen, I cannot control. Once more, I turn towards Buber:

> Between you and it there is reciprocity of giving: you say You to it and give yourself to it; it says You to you and gives itself to you. You cannot come to an understanding *about* it with others; you are lonely with it; but it teaches you to encounter others and to stand your ground in such encounters; and through the grace of its advents and the melancholy of its departures it leads you to that You in which the lines of relation, though parallel, intersect.
>
> *(1937/1970, p. 84)*

Today I see the land of dialogue as a hybrid space, a possibility for unprompted transformation. Arts educators and researchers willing to foster such transformation and, at the same time, enhance intercultural awareness may find themselves in unknown territories. While these territories are intriguing possibilities for something new to emerge, they are also sites where borders, differences, and even hostility can appear. An unwelcoming gesture might be, however, a reflection of fear, a memory of rejection, or a reminder about boundaries that cannot be moved by force. Reading these gestures not as anomalies, but as meaningful signposts, might be a worthy option and a moment to give up the need to control. Thus, the land of dialogue is a messy place. Here, hope emerges when people move towards possibilities and embrace difference.

References

Anttila, E. (2003). *A dream journey to the unknown: Searching for dialogue in dance education*. Theatre Academy Helsinki, Finland: Acta Scenica 14.

Anttila, E. (2004). Dance learning as practice of freedom. In L. Rouhiainen, E. Anttila, S. Hämäläinen & T. Löytönen, *The same difference? Ethical and political perspectives on dance* (pp. 19–62). Theatre Academy Helsinki, Finland: Acta Scenica 17.

Anttila, E. (2007). Mind the body: unearthing the affiliation between the conscious body and the reflective mind. In L. Rouhiainen, E. Anttila, K. Heimonen, S. Hämäläinen, H. Kauppila & P. Salosaari, *Ways of knowing in dance and art* (pp. 79–99). Theatre Academy Helsinki, Finland: Acta Scenica 19.

Bhabha, H. (1994). *The location of culture*. New York: Routledge.

Buber, M. (1937/1970). *I and Thou* (trans. W. Kaufman). Edinburgh: T.&T. Clark.

Buber, M. (1947). *Between man and man* (trans. R.G. Smith). London: Kegan Paul.

Buber, M. (2005). *A land of two peoples: Martin Buber on Jews and Arabs*. Chigaco, IL: University of Chicago Press.

Damasio, A. (1999). *The feeling of what happens: Body and emotion in the making of consciousness*. New York: Harcourt Brace & Company.

Ellis, C. (2004). *The ethnographic I: A methodological novel about autoethnography*. Walnut Creek, CA: AltaMira Press.

Ellis, C., & Bochner, A. P. (2000). Autoethnography, personal narrative, reflexivity: Researcher as subject. In N. Denzin & Y. Lincoln, *The handbook of qualitative research* (pp. 733–768). Thousand Oaks, CA: Sage Publications.

Ellsworth, E. (1992). Why doesn't this feel empowering? Working through the repressive myths of critical pedagogy. In C. Luke & J. Gore, *Feminisms and critical pedagogy* (pp. 90–119). New York: Routledge.

Freire, P. (1972). Pedagogy of the oppressed (trans. M.B. Ramos). Harmondsworth: Penguin Education.

Greene, M. (1995). *Releasing the imagination: Essays on education, the arts, and social change*. San Francisco: Jossey-Bass.

Merleau-Ponty, M. (1995/1962). *Phenomenology of perception* (trans. C. Smith). New York: Routledge.

Pelias, R. (2005). Performative writing as scholarship: An apology, an argument, an anecdote. *Cultural Studies – Critical Methodologies, 5*(4), 415–424.

Pfeifer, R., & Bongard, J. (2007). *How the body shapes the way we think: A new view of intelligence*. Cambridge, MA: MIT Press.

Richardson, L. (2000). Evaluating ethnography. *Qualitative Inquiry, 6*(2), 253–255.

28

USING INTERCULTURAL-HISTORICAL AUTOETHNOGRAPHIC WRITING TO RESEARCH A COMPOSER'S STORY WITHIN AN AUSTRALIAN-ASIAN COMPOSITIONAL AESTHETIC

Diana Blom

Introduction

I have been composing music since I was about 12 years old. On moving to Sydney in 1969 for postgraduate music study at the University of Sydney, I met Australian composer and teacher Peter Sculthorpe who introduced me, and fellow students, to music of Asian countries. This, looking back, was the basis for what Roth (2005, p. 4) calls the 'concrete realization of cultural-historical possibilities' where the actions of the individual autobiographer, in this chapter my place as composer within the history of an Australian compositional aesthetic influenced by Asian cultures, are realised through the action of writing. This chapter seeks to present and develop an autoethnographic approach to this intercultural meeting of an Australian non-Asian composer with Asian cultural influences which, in turn, intersects further with a historical context.

Intercultural autoethnography as reflexive writing

Autoethnography is one of several methodological approaches involving reflexive research enquiry (see Denzin, 2014). My own experience has been largely focused on practice-led research as a pianist and composer (for example, Blom, 2006). Sarah Rubidge, a dancer, describes practice-led research as being where 'the research is initiated by an artistic hunch, intuition, or question, or an artistic or technical concern generated by the researcher's own practice which it has become important to pursue in order to continue that practice' (Rubidge, 2004, no page number). The ability to explore the self through one's own arts practice moved me from other qualitative research methodologies, where I could largely stand aside, to a reflec-tive/reflexive mode.

Revisiting de Vries's[1] (2000) case study on learning how to be a music teacher, I felt that the descriptions of his experiences – pre-service training, books, his mother a music teacher – all tended towards autoethnography, with aspects of autobiography plus analysis of many of the experiences. These thoughts were confirmed on reading de Vries's later (2012) writing in which he has a conversation with himself. Peter 1996 asks, is autoethnography like autobiography? Peter 2010 replies, 'Kind of. Well not really, actually, because it's also about connecting the self to the culture you live in' (de Vries, 2012, p. 355). This sums up an underlying difference between autobiography and autoethnography – one is focused on the individual life, the other deliberately connects one's lived life to its society and culture. Definitions of autoethnography emphasise this connection, finding it 'helps undercut conventions of writing that foster hierarchy and division' (Ellis & Bochner, 2006, p. 436). Autoethnography has been described as 'the use of personal experience to examine and/or critique cultural experience' (Jones, Adams & Ellis, 2013, p. 22) with the following characteristics distinguishing it from other kinds of personal writing: '(1) purposefully commenting on/critiquing of culture and cultural practices, (2) making contributions to existing research, (3) embracing vulnerability with purpose, and (4) creating a reciprocal relationship with audiences in order to compel a response'. There are many approaches to autoethnography with several writers describing them and tracing their origins (Ellis, 2004; Spry, 2011; Jones et al., 2013; Chang, 2013; Bartleet, 2013). To write about my place in the history of a recognised and documented Australian intercultural compositional aesthetic, I focused on autoethnographic approaches which would draw out and elaborate the 'intercultural' and 'music creativity' aspects of my story. And I also wanted to satisfy my 'so what? Where's the new knowledge?' research background.

Indigenous or native ethnography is written by researchers with 'a history of colonialism or economic subordination . . . raising questions of power relations' (Ellis, 2004, p. 46) and Kok's (2011) evocative autoethnographic telling of life as a Malaysian musician undertaking the British music exam system of the Associated Board of the Royal Schools of Music (ABRSM) with 'postcolonial theory as a mode of cultural analysis' (p. 74), is an example of this approach. For Green (2011), Kok's essay is autobiographical with a focus on 'the formation of a mixed and complex ethnic identity' (p. 5) yet the power relationships and connections with 'ethnicity, local culture, and colonial history' (p. 5), plus the story-teller's interactions with family and society are, to me, strongly autoethnographic. Four aspects resonated with me: I found it very evocative and a 'good read'; its focus on her experiences with an exam system with which I was also deeply involved as a young pianist in New Zealand, made me consider my role as an 'antipodean' (literally, opposite foot – the part of the earth's surface directly opposite one point) a name I, and others, as New Zealanders/Australians, have experienced at times in England, in the same system; I lived in Malaysia for three years; and her discussion of working with another's culture, trying to reconcile a fit 'interculturally', is the opposite angle to mine as a Western musician drawing on Asian aesthetics.

Anderson (2006) argues for the relevance of an analytic autoethnography paradigm. To come to theoretical understandings, 'the resulting analysis recursively draws upon our personal experiences and perceptions to inform our broader social understandings and upon our broader social understandings to enrich our self-understandings' (p. 390). He compares analytic autoethnography to 'evocative or emotional autoethnography' (p. 374). Finding that the former is 'grounded in self-experience but reaches beyond it as well' (p. 386) through adoption of a formal and identifiable analytic process, Anderson recognises that the latter 'seeks narrative fidelity only to the researcher's subjective experience' (p. 386). Adopting an autoethnographic writing style, Ellis and Bochner (2006) conduct an invigorating autopsy on Anderson's article. They feel Anderson is trying to use analysis to bring control through reason and logic – a destination,

instead of ethnography as a journey. At the same time both Ellis and Bochner acknowledge theoretical writing and traditional analysis in some of their own writing, sometimes resorting to 'the usual, "one-two punch", traditional argumentative style' (p. 443). This frank dialogue between the three researchers outlines the pros and cons of the approaches from both sides for a researcher. By adopting an analytic autoethnographic approach, I could indulge my research background and treat stories as data for analysis – 'thematic analysis of narrative', one of Ellis's (2004, p. 196) approaches to analysis of narrative.

My approach to intercultural-autoethnographic writing

Why did I choose an autoethnographic approach? I am not writing about negative issues or trauma, although Ellis (2004) and Clough (2000) note this is where much autoethnographic writing comes from. Several autoethnographic writings by other musicians had an impact on me. De Vries's 2000 paper on learning to be a music teacher was one of my earliest encounters with this type of reflexive writing and it had a refreshing balance of self and context. In her PhD, Brown (2011) devoted one volume to writing autoethnographically about her experience as a piano accompanist, and a second analysed the first in relation to Csikszentmihalyi's 'flow theory'. As a pianist, I related to her recalled moments of embarrassment, hesitation, doubt and triumph in her accompanying career. Kok's (2011) relationship with the British music exam system interested me on a personal and scholarly level. Wang's (2009) journey to becoming a professional percussionist 'documents' her story through social-historical commentary about the background of her family members, school environment and influential people, raising issues of discrimination, encouragement and discouragement. Wang's chapter is one of many in a book of music autoethnographies by musicians across a spectrum of musical backgrounds and activities who investigate within a range of clearly defined (although not narrow) social/cultural contexts. Each chapter moves the reader through the story accompanied by relevant literature and most end with an identifiable analysis section, although never so named. I was interested in what these sections were called – 'Going out (a way of knowing)'; Conclusion: autoethnography as life style; and June 2009. Coda and 'Dead'-ication – and how analysis is embedded within autoethnographic writing. I had read, several years ago, Scott-Hoy's (2009) moving story of writing lyrics for her son's metal band after the deaths of members of a local band. The story is about much more than that and I found myself, a mother of young adults, emotionally moved by it. But then the researcher in me kicked in – the 'so what' factor: it's just a story – where is the analysis? On rereading the chapter I can now see Scott-Hoy moving, gliding, between story and reflective analysis over and over with the 'coda' as a way of drawing all to a close, and the pages are now full of my pencilled underlinings – my analysis. When I read Ellis's *A Methodological Novel about Autoethnography* (2004) I was prepared for this constant gliding forward, circling back, and the library's copy is full of pencilled and green ballpoint(!) underlinings of key points – other readers' analyses. This is a good example, in practice, of Ellis and Bochner's (2006) description of the difference between traditional analysis and narrative inquiry – 'between closing down interpretation and staying open to other meanings, between having the last word and sharing the platform' (p. 438).

Tackling the double journey of autoethnographic writing and my place in an intercultural compositional aesthetic seemed daunting but then I realised I have already started and that 'dichotomies [art-science, personal-political] present as opposites what are actually interdependent' (Ellingson & Ellis, 2008, p. 447). And there is one valuable music model. Music conductor Brydie-Leigh Bartleet's (2009) journey seeks to discover why she conducts music, at the same

time overtly exploring the autoethnographic mode of writing. Like me, she was guided by many writers on issues of approaches, styles and techniques in this writing. Here is one model. In this case, the musical topic is different and so the recursive shapes end up in a different place.

Intercultural-historical autoethnographic writing

I am ready to start the self-reflective writing about being a composer who often draws intercultural influences into her music. Not famous (or rich) but through circumstance and then interest, response and opportunities to live in Hong Kong and Malaysia, I am part of an identified and oft discussed (Covell, 1967; Hannan, 1982; Sculthorpe, 1999; Atherton & Crossman, 2008; Kerry, 2009) history of Australian compositional aesthetic. I find historians are also grappling with notions of objectivity and subjectivity within their discipline. Barber and Peniston-Bird (2009) ask how, as historians, 'can we ever detach emotion from less subjective forms of human expression and should we try? . . . a piece of music is seldom composed without an intention of stirring some emotion in its hearer' (p. 4). I am reminded of living in Hong Kong during the 1980s and hearing Cantonese pop music sounding from buildings and shops when walking through the crowded streets; and on my return to Sydney in 1989, hearing the same sounds flowing over the fence from my elderly neighbour's Chinese television soap operas. Percy Grainger had a similar experience growing up in Melbourne, visiting the Chinatown precinct, and wrote his *Eastern Intermezzo* of 1898 which reflects these boyhood sounds. Stanford (1994) makes a distinction in history between 'something coming about because of a preceding event and its coming about because of some envisaged future' (p. 206). This resonates strongly with Australia's relationship with Asia from the 1970s which set the stage for an envisaged future in politics and music. Asian people, especially the Chinese, have been some of Australia's earliest inhabitants, from whaling and gold rush times. However, Australia's relationship with Asia was heightened and defined by the Vietnam War in the 1960s and non-white immigration to Australia in the early 1970s. Socially, the 1960s saw Asian countries become places where young Australians chose to travel, rather than ports visited en route from Australia to England. These encounters helped change Australian attitudes to Asian peoples and their cultures and Australia's creative relationships with Asia in the 1960s and early 1970s, through painters and potters, were warmer and more fruitful than its political relationships. Broinowski (1992, p. 91) identifies 'the folk tradition and the aesthetic of Japanese farmhouses' as inspiration for the 'nuts and berries' school of architects of the 1960s in Sydney, and my house in Sydney is of this school.

Composer Peter Sculthorpe began teaching in the Music Department at the University of Sydney in 1963 and, shortly after, introduced a subject called 'Ethnomusicology', basing much of his knowledge, at first, on books and LPs about music of SE Asia. In 1968, the year before I arrived in Sydney, Sculthorpe met and befriended ethnomusicologist William Malm in Japan and from these meetings Sculthorpe developed a strong interest in the whole culture and the sounds of this country. Cook (1998, pp. 126–127) finds

> composers like Peter Sculthorpe have drawn on native Australian and East Asian musics in such a way as to contribute towards the broader cultural and political repositioning of Australia as an integral part of the emerging region of the Pacific Rim, rather than a European culture on the wrong side of the world.

Leon Trotsky, someone who made history and wrote it, is for Tuchman (1983) 'the nearest anyone has come to explaining history' (p. 22). She notes that 'the contemporary, especially if he is a participant, is inside his events, which is not an entirely unmixed advantage. What he

gains in intimacy through personal acquaintance – which we can never achieve – he sacrifices in detachment' (p. 28). This sounds like historical autoethnography.

These dialogues between composers, architects, painters, politicians, historians, sociologists and cultures other than their own, through influences, cross-fertilisation (largely one way) and insider/outsider views, develop new aesthetics, new ways of thinking and build an intercultural nexus.

Writing intercultural-historical autoethnography

When first starting autoethnographic writing, Ellis (2004) is a great help. She suggests putting down one's story 'as field notes organized chronologically' (p. 113). I put my notes into a chronological table and found myself adding and changing things as new artefacts were found, thoughts emerged and discussions took place, during an extended preparation phase. Composer Michael Hannan, a University of Sydney music graduate, and I talked about early memories, experiences and influences of Peter Sculthorpe's ethnomusicological teaching.[2]

DB: My postgraduate ethno class was held in Peter's south-facing room. Composition teaching was one-on-one but ethnomusicology was a small group. I remember the large window which provided good light for the music teaching and discussion.

MH: Ah – I was an undergraduate and so our larger numbers were taught in the Lecture room, an internal auditorium. Peter introduced me to the music of several Asian cultures, in particular Japanese, Balinese and Tibetan.

DB: Peter introduced us to the sounds of the Balinese gamelan, ketjak and rice pounding music, and the Japanese traditions, drawn from recordings and books, but all filtered through his own interest in these musics and their influence on his own compositions.

MH: The things about Japanese music that stick in my mind from Peter's teaching are: firstly, extreme forms of heterophony. In gagaku, for example, the melodic lines of the hichiriki (oboe) and the ryuteki (flute) are essentially the same but vary greatly in rhythm and pitch detail, creating a sound that to the Western ear is very dissonant. Peter maintained that the Japanese performers and listeners did not hear these pitch clashes as dissonant.

DB: I was left with a lasting interest in heterophony from the Japanese shamisen and voice combination with one leading the other, creating dissonances, yet playing very similar melodic lines.

MH: Another Japanese trait which Peter pointed out and which I've retained is accelerating tempo and rhythmic motifs. Unlike most Western music the tempi of Japanese pieces of music tended to increase in tempo throughout the performance. There were also distinctive accelerating rhythmic motifs, for example in the kakko drum patterns of gagaku and I've used that idea in Resonances II (Mercurial Orbits) for solo piano.

DB: So have I and elsewhere in this chapter I've described this figure being used in Genji for violin and piano. The pianist has to learn to play an evenly accelerating rhythmic motive on one note!

Because of Australia's proximity to south-east Asia, Sculthorpe felt this should be where an Australian composer could draw ideas, rather than Europe (Hannan, 1982). On his first visit to Japan in 1968, Sculthorpe heard *Etenraku*, a *gagaku* piece, live and 'became aware of the basic difference between Western and Japanese music. In Western music we're very concerned with the blending of tone colours . . . In Japan, the ideal is separation of sound, with no attempt to blend colours' (p. 132). He introduced me to a Sydney-based Japanese koto player in 1970 who

I heard play the music of Michio Miyagi (1894–1956), a blind koto player and composer who brought contemporary composition techniques into the largely traditional Japanese koto repertoire. A 2008 exhibition of *The Tale of Genji*, the novel by Murasaki Shikibu, a lady of the Heian court of 11th-century Japan, showed how *Genji* has remained popular through movies, plays, dance, Kabuki, opera and *manga* (comic books). My 2009 piece for violin and piano, *Genji, the shining prince, and the koto player* (2010) via three joined sections, moves through influences of traditional Japanese koto and *kakko* figures, Miyagi's stylistic koto compositional traits, to the visual dynamism of *manga* (Musical example 28.1). None of the sections are literal but there are recognisable stylistic traits plus exploration of transformed Japanese scales in the third section.

Ellis (2004) says, 'It's amazing the details you recall, and for how long, if the event was emotionally evocative' (p. 117). Michael Hannan and I have held onto, and embodied in our composing, the emotionally evocative sounds and ideas which attracted us, an intercultural connection which both of us still draw on in our compositions. Through his own understanding of

Musical example 28.1 Genji, the shining prince, and the koto player (Diana Blom) showing the move from section 2 to section 3, mm. 67–75 – with permission, Wirripang Pty. Ltd.

these musical cultures, Peter Sculthorpe was our cross-cultural communicator, fusing different musical elements from his own and Asian cultures and passing these on to his students. This, in turn, has brought into being for the three of us, a new compositional aesthetic, each composer taking techniques and sounds which interest him/her and creating new sound worlds.

On rereading the chapter, I notice an increasing array of artefacts or memory-data (Bartleet, 2009; Giorgio, 2013) being referred to, each bringing with it more memories and thoughts, all insisting on having a place in the story, an 'archaeological effort . . . [which] is what lets the self unfold, discover itself, and put itself on display' (Pelias, 2013, p. 387). Moving to Malaysia in 1987 I immediately joined a group learning the Terengganu gamelan. Ellis (2004) suggests concentrating on 'emotions and dialogue . . . [and] to describe places, colors, sounds and movements' (p. 117). I will concentrate on being in a Terengganu gamelan lesson as it is a strong memory, albeit an amalgamation of many lessons so descriptions 'collapse stories into one another' (Bartleet, 2009, p. 728).

> The room is fairly dark and the gamelan instruments are set up facing a white board on which numbers are written. This is a smaller, less complex ensemble than the Balinese gamelan. My fellow musicians are all expatriates – Japanese, English, Australian – and we choose an instrument to sit at – Sarong Peking, Sarong Barong, Gambang, Bonang, Kenong, Gong Kecil, Gong Besar, Gendang. I like the Bonang, the lead instrument which sets the tempo, dynamics and follows the dancers or action to determine the length and therefore number of repetitions in the piece. The Malay teacher, male, holds a long stick and as we play loudly taps each number on the whiteboard: – 55-5555 3565 3565 – the opening of Lagu Perang, a piece performed when people are entering and taking their seats for an occasion. He shows me how to play subtle variations on the Bonang melody. We finish then change to another instrument. I like them all, and receive great pleasure being inside this largely metallophone world of sound, each instrument offering a new sound perspective – truly swimming in the music.

The sound characteristics of the gamelan, plus Orff and Terry Riley influences, permeate *The Golden Bird* (in press) a children's opera from 1987 written for performance by upper-primary age students at a Hong Kong school, the libretto based on a story by Sri Lankanese-Australian writer, Chitra Fernando – pan-Asian!

Autoethnography is said to benefit from "its acquaintance with the personal, poetic, and performative" (Pelias, 2013, p. 401). Writing from a nursing perspective, Kidd and Finlayson (2009) find these three approaches 'convey meaning and shared humanity' (p. 982). The personal is certainly present in the chapter. I have had several children's poems published so wanted to capture, in a haiku, my first visit to the White Rabbit Gallery in Sydney and its collection of 21st-century Chinese contemporary art – a dazzling feast of strongly flavoured paintings, installations and other artworks.

> Splash! Bam! Colour,
>
> fine line, texture -
>
> ah! hear the music.

The incongruences present in many of the artworks' subject matter spilled over into the title and musical material of *White Rabbit Climbs Mt. Kosciusko* (2012) for piano, the score cover featuring *Apple in Love*, a painting by He Jia, celebrating this juxtaposition perfectly.

Figure 28.1 Apple in Love, by He Jia (with permission of the White Rabbit Gallery, Sydney).

Performative autoethnography is 'the convergence of the "autobiographic impulse" and the "ethnographic moment" represented through movement and critical self-reflexive discourse in performance, articulating the intersections of peoples and culture through the inner sanctions of the always migratory identity' (Spry, 2001, p. 706). It is an approach I have not explored, although there is an argument to be made for my own 2009 harpsichord performance of *Lady Huang's Album* (published 2010, composed 1984/2007) as a form of performative autoethnography because of its dedication and musical influences from my years living in Hong Kong.

Like Mendelssohn, and many of my fellow Australian composers, I am a musical tourist, picking up sounds, ideas from images, locations, cultures, instruments and drawing them into my works. But autoethnography, as a mode of enquiry, can be 'unruly, dangerous, vulnerable, rebellious, and creative' (Ellis & Bochner, 2006, p. 433) and detractors have referred to the gender wayang section of Sculthorpe's *Sun Music III* as 'Suzie Wong music' (Sculthorpe, 1999, p. 101). Other terms used to describe this Australian–Asian aesthetic have been '*Chinoiserie* of the West' (Hannan, 1982, p. 70); and 'travelogue music' (Kerry, 2009, p. 62). For Said (1978–2003), 'the real issue is whether . . . there can be a true representation of anything' (p. 272). 'The Orient that appears in Orientalism [Said says] . . . is a system of representations framed by a whole set of forces that brought the Orient into Western learning, Western consciousness, and later, Western empire' (p. 203).

'Cosmopolitanism' is the term Khoo (2000) sees 'as a travelling trope [which] suggests how we can be connected to all sorts of places to which we have never travelled, except through watching movies or reading novels and magazines' (p. 3), and hearing music. Using two forms of Chinese box as representations – the Russian doll-like version, 'where a box contains within it a smaller box' and 'the Chinese take-away box' – Khoo discusses how 'the Asian exotic travels in a form that folds . . . between notions of time and space, representing both the new Asian modernities and economies, as well as being outside time . . . ahistorical and traditional' (p. 1).

Anne Boyd has been described as an orientalist (Tokita, 1996, p. 185) because, 'despite her love of Asian music and philosophy, she seems uninterested in contemporary Asia'. This is unfair to a composer who wrote *Black Sun* in 1989 while living in Hong Kong, and dedicated it

'to the Beijing student martyrs' (composer, front of score). Fragments of a Chinese song, 'The Ancestor of the Dragon', 'used during the student democracy movement . . . [and drawn into the work] . . . summon the sound of sobbing', according to the composer (Macarthur, 2006, p. 23). Here, Khoo's (2000) idea of folds between 'notions of time and space' are certainly representing both the new Asian modernities and old traditions.

Analysis – reflections

Sculthorpe's 'Balinese borrowings' (Gerster and Bassett, 1991, p. 126) are seen by the composer (Sculthorpe, 1999) as the first of three successive stages in his work – imitation of the sound; employment of 'Balinese compositional techniques, with no attempt at recreating the sound' (p. 171); and 'the final stage when something of the essence of Bali, not only its music, entered my work almost without my noticing it' (p. 172). Here the composer is describing a spectrum of ways an Asian culture can influence a composer.

To shape the spectrum I have adapted Johnson's (1994) three definitions applied to minimalism in music – 'an aesthetic, a style, and a technique' (p. 742) and found Asian influences ranging from direct borrowing to capturing a cultural essence (Table 28.1). Johnson's label 'aesthetic' can apply to Asian culture 'in toto' and to all of the influence possibilities because of the need for the 'development of new listening strategies in order to fully appreciate [the aesthetic]' (p. 745).

Conclusions: intercultural-historical autoethnography

This chapter is drawing to an end so the final section headings of authors in Bartleet and Ellis's (2009) book return to my mind. I want nothing too cute but something which wraps the intercultural music history aspect in with the autoethnographic focus. On rereading the chapter, I notice I have borrowed, imitated and drawn techniques (to use my own spectrum of influence possibilities) from fellow (music and other) autoethnographers: Kok's way of blending an interesting story (I hope) with analytic circles and questioning; at the chapter end, giving a separate, more formal analytical wrap-up like Brown's thesis, and, in doing so, adopting Ellis's thematic analysis of narrative, yet also trying to let the story-telling be from 'my own place in the world' (Kidd & Finlayson, 2009, p. 986); describing the influences of teachers, significant others and experiences with Asian cultures, something that permeates both de Vries' and Wang's articles; and from Bartleet, trying to capture the braiding of two topics within one chapter, saying something new at the end, as she achieved.

Table 28.1 A spectrum of influence possibilities in relation to an Asian aesthetic

Borrowing	Aesthetic – requiring the development of new listening strategies (Johnson)
Imitation/recreation (Sculthorpe)	Aesthetic – requiring the development of new listening strategies (Johnson)
A style – a school of compositional thought and influence (Johnson)	Aesthetic – requiring the development of new listening strategies (Johnson)
Techniques (Johnson; Sculthorpe)	Aesthetic – requiring the development of new listening strategies (Johnson)
The essence of a culture and its music (Sculthorpe)	Aesthetic – requiring the development of new listening strategies (Johnson)

I find I am proposing another approach to autoethnography, a little different from the others I have read about. Roth uses the term 'cultural-historical'; Wang adopts 'social-historical'; Soviet historian, Sheila Fitzpatrick was recently described as 'historian-cum-autobiographer';[3] and Italian historian, Carlo Ginzburg describes his approach as 'halfway between history and anthropology' (in Schutte, 1976, p. 315). I am halfway between music history and autoethnography. I am not a historian so historical autoethnography is too bold, coming from a composer, but intercultural-historical autoethnography might do well. And the intercultural aspect is fundamental to my autoethnographic story and my compositional development.

Looking back over the chapter, a chain of intercultural notions emerges (see Table 28.2) with two ideas from different cultures moving, over time, to become merged. One beginning is the change in Australian political and social attitudes to Asian countries which result in a broader cultural and political repositioning, plus intercultural relationships with intercultural dialogue. From this, books and LPs of Asian music are published, travel to and from Asia by artists brings cross-fertilisation, insider/outsider perspectives, and forms an intercultural nexus. This, in turn, intrigues one composer's compositional instincts, forming the beginning

Table 28.2 A chain of intercultural notions drawn from autoethnographic writing

Events	Intercultural notions
Changing Australian political/social attitudes to Asia	Broader cultural and political positioning; Intercultural relationships; Intercultural dialogue.
Publication of LPs and books on Asian music	Cross-fertilisation; Insider/outsider views; Intercultural nexus.
The composer draws on Asian musical sounds and techniques in his work	Musical intersection; Fusion of different cultural musical forms; Folds between notions of time and space.
The composer teaches his fusion and the original sources to students	Cross-cultural dialogue between young composers and Asian influences; Intercultural connections; Cross-cultural communicator.
Over 50 years of influences from the transplanted Asian aesthetic	Transplanted culture; Development of a new, identifiable, discussed Australian-Asian compositional aesthetic; Spectrum of intercultural influence possibilities.
My own pieces with an Australian–Asian compositional aesthetic	Juxtaposition, incongruence, pan-Asian, borrowing, imitation, transforming, style, techniques, essence; Orientalism, Chinoiserie, musical tourism, cosmopolitanism, travelogue music.
Autoethnography (personal, poetic, performative), practice-led research, historical research;	Blurring of boundaries between reflexive research paradigms; Braiding;
Braiding autoethnographic writing and my place in an intercultural compositional aesthetic	Convergence; Intercultural autoethnography; Intercultural-historical autoethnography.
Intercultural brings interpersonal	Changing attitudes; Seeking similarities and mutual interests; Intercultural identification with the other.

of a musical intersection through folds between notions of time and space. As teacher, the composer's interest in, and fusion within his own composition of, Asian sounds and techniques creates a cross-cultural dialogue with students, bringing intercultural connections with the composer as a cross-cultural communicator. From the 1960s, an increasing number of composers engaged with, and built, an identifiable Australian–Asian compositional aesthetic from what Covell (1967) calls 'a transplanted culture' (p. xi), with a spectrum of intercultural influence possibilities. My own compositions engage with an Australian–Asian compositional aesthetic in several ways – juxtaposition, incongruence, pan-Asian, borrowing, transforming and perhaps Orientalism, Chinoiserie, musical tourism, cosmopolitanism, travelogue music. And through my autoethnographic writing in telling this story, there is a blurring of boundaries between a range of reflexive and creative research paradigms – personal, poetic and performative auto-ethnography, practice-led and historical research, poetry and composition. This braiding of autoethnographic writing and my place in an intercultural compositional aesthetic is a convergence, creating intercultural autoethnography and intercultural-historical autoethnography. Finally, on an important interpersonal level, these events have brought about changing attitudes and a better understanding of the other. Donald Horne captured this in the mid-1960s in *The Lucky Country* (1964/1984), urging Australians 'to seek similarities in Asians and mutual interests [which] could lead to creative awakening among Australians' (p. 120). This intercultural interface and the interest it generates forms an identification with the other resulting, in the view of some young people, in the belief that 'we're all Asians now' (p. 120). And Horne said he took that view himself.

Telling one's history is baring one's soul, and that takes fortitude, but Anderson (2006) had warned that 'the researcher is a highly visible social actor within the written text' (p. 384) so I knew what was coming. And the practice-led writing previously undertaken was autoethnographic within the environment of learning a piece of music. I am reminded that writing about music is not unlike composing music – 'cycles of creation, reflection, refinement, and, ultimately, performance for an audience' (Bartleet, 2013, p. 451) which define autoethnography and the composing process too. My story is certainly not about trauma, not even a crisis of musical purpose, as in Bartleet's story, but writing the chapter autoethnographically has helped me discover threads and themes influencing my compositional cosmology and see my place in the larger intercultural history of the influence of Asian cultures on an Australian compositional aesthetic.

Notes

1 de Vries is also spelled Devries.
2 Email conversation 14 November, 2014, used with permission.
3 Email received 26 March, 2014, 10:25 am from Department of History, School of Philosophical and Historical Inquiry Sydney Ideas.

References

Anderson, L. (2006). Analytic autoethnography. *Journal of Contemporary Ethnography, 35*, 373–395.
Atherton, M., & Crossman, B. (2008). Introduction. In M. Atherton & B. Crossman, *Music of the spirit: Asian-Pacific musical identity* (pp. 8–11). Sydney: Australian Music Centre.
Barber, S., & Peniston-Bird, C. M. (2009). Introduction. In S. Barber and C. M. Peniston-Bird, *History beyond the text: A student's guide to approaching alternative sources* (pp. 1–14). London: Routledge.
Bartleet, B. L. (2009). Behind the baton: Exploring autoethnographic writing in a musical context. *Journal of Contemporary Ethnography, 38*, 713–733.
Bartleet, B. L. (2013). Methods, modes of inquiry, and forms of representation. In S. H. Jones, T. Adams & C. Ellis (Eds.), *Handbook of autoethnography* (pp. 443–464). Walnut Creek, CA: Left Coast Press Inc.

Bartleet, B. L., & Ellis, C. (2009). *Music autoethnographies: Making autoethnography sing/making music personal*. Bowen Hills, Queensland: Australian Academic Press.

Blom, D. interacting with Edwards, R. (2006). Preparing Ross Edwards' *Kumari* for performance: Conceptual planning. In S. Macarthur, B. Crossman & R. Morelos (Eds.), *Intercultural music: Creation and interpretation* (pp. 111–115). Sydney: Australian Music Centre.

Blom, D. (2010). *Genji, the shining prince, and the koto player*. Wollongong: Wirripang Pty. Ltd.

Blom, D. (2010). *Lady Huang's album*. Wollongong: Wirripang Pty. Ltd.

Blom, D. (2012). *White rabbit climbs Mt Kosciusko*. Wollongong: Wirripang Pty. Ltd.

Blom, D. (in press). *The golden bird*. Wollongong: Wirripang Pty. Ltd.

Boyd, A. (1989). *Black Sun*. York, UK: University of York Music Press.

Broinowski, A. (1992). *The yellow lady: Australian impressions of Asia*. South Melbourne: Oxford University.

Brown, J. (2011). *Flow in collaborative music performance: An autoethnographic study of the phenomenon of flow for a piano accompanist*. EdD thesis, Central Queensland University.

Chang, H. (2013). Individual and collaborative autoethnography as method. In S. H. Jones, T. Adams & C. Ellis (Eds.), *Handbook of autoethnography* (pp. 107–122). Walnut Creek, CA: Left Coast Press Inc.

Clough, P. T. (2000). Comments on setting criteria for experimental writing. *Qualitative Inquiry, 6*(2), 278–291.

Cook, N. (1998). *Music: A very short introduction*. Oxford: Oxford University Press.

Covell, R. (1967). *Australia's music: Themes of a new society*. Melbourne: Sun Books.

De Vries, P. (2000). Learning how to be a music teacher: An autobiographical case study. *Music Education Research, 2*(2), 165–179.

De Vries, P. (2012). Autoethnography. In S. Delamont (Ed.), *Handbook of qualitative research in education* (pp. 354–363). UK: Edward Elgar Publishing Ltd.

Denzin, N. K. (2014). *Interpretive autoethnography*. Thousand Oaks, CA: Sage.

Ellingson, L. L., & Ellis, C. (2008). Autoethnography as constructionist project. In J. A. Holstein & J. F. Gubrium (Eds.), *Handbook of constructionist research* (pp. 445–465). New York: The Guilford Press.

Ellis, C. (2004). *A methodological novel about autoethnography*. Walnut Creek, CA: Altamira Press.

Ellis, C. S., & Bochner, A. P. (2006). Analyzing analytic autoethnography: An autopsy. *Journal of Contemporary Ethnography, 35*, 429–449.

Gerster, R., & Bassett, J. (1991). *Seizures of youth*. Melbourne: Hyland House Publishing.

Giorgio, G. A. (2013). Reflections on writing through memory in autoethnography. In S. H. Jones, T. Adams & C. Ellis (Eds.), *Handbook of autoethnography* (pp. 406–424). Walnut Creek, CA: Left Coast Press Inc.

Green, L. (2011). Introduction: The globalization and localization of learning, teaching, and musical identity. In L. Green, *Learning, teaching and musical identity: Voices across cultures* (pp. 1–19). Indiana: Indiana University Press.

Hannan, M. (1982). *Peter Sculthorpe: His music and ideas, 1929–1979*. St. Lucia: University of Queensland Press.

Horne, D. (1964 reprinted 1984). Epilogue 1971. *The lucky country*. Victoria, Australia: Penguin Books Australia Ltd.

Johnson, T. A. (1994). Minimalism: Aesthetic, style or technique? *The Musical Quarterly, 78*(4), 742–773.

Jones, S. H., Adams, T. and Ellis, C. (2013). Introduction: Coming to know autoethnography as more than a method. In S. H. Jones, T. Adams & C. Ellis (Eds.), *Handbook of autoethnography* (pp. 17–48). Walnut Creek, CA: Left Coast Press Inc.

Kerry, G. (2009). *New classical music: Composing Australia*. Sydney: UNSW Press.

Khoo, O. (2000). Folding Chinese boxes: Asian exoticism in Australia. *Journal of Australian Studies,* June, 200–210.

Kidd, J., & Finlayson, M. (2009). When needs must: Interpreting autoethnographical stories. *Qualitative Inquiry, 15*(6), 980–995.

Kok, R.-M. (2011). Music for a postcolonial child: Theorizing Malaysian memories. In L. Green, *Learning, teaching and musical identity: Voices across cultures* (pp. 73–90). Bloomington and Indianapolis: Indiana University Press.

Macarthur, S. (2006). The cultural work of the musical work: Light Sorrow (1985), Black Sun (1989). In S. Macarthur, B. Crossman & R. Morelos, *Intercultural music: Creation and interpretation* (pp. 14–26). Sydney: Australian Music Centre.

Pelias, R. J. (2013). Writing autoethnography. In S. H. Jones, T. Adams and C. Ellis (Eds.), *Handbook of autoethnography* (pp. 384–405). Walnut Creek, CA: Left Coast Press Inc.

Roth, W.-M. (2005). *Auto/Biography and auto-ethnography praxis of research method*. Rotterdam: Bold visions in educational research, Sense Publishers.

Rubidge, S. (2004). Artists in the academy: Reflections on artistic practice as research. Paper presented at Dance Rebooted: Initializing the Grid, Deakin University, December, originally published on 1 July 2004 in Dance rebooted: initializing the grid, http://ausdance.org.au/articles/details/artists-in-the-academy-reflections-on-artistic-practice-as-research (accessed 5 November 2014).

Said, E. (1978–2003). *Orientalism*. London: Penguin.

Schutte, A. J. (1976). Carlo Ginzburg. *The Journal of Modern History, 48*(2), 296–315.

Scott-Hoy, K. M. (2009). Beautiful here: Celebrating life, alternative music, adolescence and autoethnography. In B.-L. Bartleet & C. Ellis (Eds.), *Music autoethnographies: Making autoethnography sing/making music personal* (pp. 39–56). Bowen Hills, Queensland: Australian Academic Press.

Sculthorpe, P. (1999). *Sun Music*. Sydney: ABC Books.

Spry, T (2001). Performing autoethnography: an embodied methodological praxis. *Qualitative Inquiry, 7*(6), 706–732.

Spry, T. (2011). Performative autoethnography: Critical embodiments and possibilities. In N. K. Denzin & Y. S. Lincoln (Eds.), *The Sage handbook of qualitative research 4* (pp. 497–511). Thousand Oaks, CA: Sage.

Stanford, M. (1994). *A companion to the study of history*. Oxford, UK: Blackwell.

Tokita, A. (1996). Anne Boyd and Asian music: The formation of a composer. *Japan Review, 7*, 185–198.

Tuchman, B. (1983). *Practising history: Selected essays by Barbara Tuchman*. London: Macmillan.

Wang, Y. (2009). The road to becoming a musician: An individual Chinese story. In B. L. Bartleet & C. Ellis (Eds.), *Music autoethnographies: Making autoethnography sing/making music personal* (pp. 167–180). Bowen Hills, Queensland: Australian Academic Press.

29

INTERDISCIPLINARY, INTERCULTURAL TRAVELS

Mapping a spectrum of research(er) experiences

Liora Bresler

A pig and a chicken are strolling down the road on a fine morning. The chicken notices a restaurant and suggests they go in. The pig seems doubtful. Looking cautiously at the Eggs and Bacon sign, he says: "For you it's only partial donation; for me it's a full commitment."[1]

There is potential, promise and peril, in all travels, as fairy-tales and other types of travel narratives illustrate well (e.g., Hearne, 2011). One way to conceptualize interdisciplinary and intercultural travels, I suggest, centers on the spectrum of commitment, from partial donation to full commitment, and what it means for travelers' experiences and their identity. Full commitment travels may result in transformation for the traveler (in the case of the pig, a transformation of who he is as a pig). Another kind of travel involves collaboration within a liminal space for interchange and absorption of perspectives, an "interpretive zone" (Bresler, Wasser, Hertzog, & Lemons, 1996), towards an expanded identity. My goal here is not to create a hierarchy of the "goldilocks model" (too little, too much, just right) but to consider the distinct style of each kind of intercultural travel, the social interactions and practices it involves, and, drawing on my own experiences, the outer and inner journeys it engenders. Given the positionality of this handbook as an academic artifact, I focus on academic interculturality, addressing the cultural aspects of interdisciplinarity within, across and beyond the arts.

Excursions, habitats, and zones

The culture of modern universities and arts academies organizes intellectual and artistic work within disciplinary structures. The centrality of specialization[2] as a fundamental value means that only fellow specialists can judge the merit of work being done. There are important reasons why expertise within a discipline is highly valued. Academic ethos is characterized by sophisticated skills, rigor and meticulousness, and is expected to stand up for posterity at best (or, in a version of the scientific model (Popper, 1963/2004) a trustworthy stepping-stone for the next refutation). Accordingly, the processes of enculturation within a discipline and the incubation of research and artistic output are lengthy. Scholarly and artistic contributions are typically created after years of immersion in a field.[3]

Interdisciplinarity assumes interculturality. Disciplines are cultures of their own, some more homogenous than others, complete with their value systems, languages, etiquette, and customs. Academic interculturality is manifested in the increasing crossing of artistic genres, media, and institutional boundaries (Bresler, 2003). Complicating these dynamics are social and national issues, examples of which will surface as I describe my own journey.

In his discussion of academia and interdisciplinarity, philosopher Walter Kaufmann distinguishes between scholastics and visionaries.[4] Scholastics, writes Kaufmann, "travel in schools, take pride in their rigor and professionalism, and rely heavily on their consensus or their 'common-how'" (Kaufmann, 1977, p. 9). Originally the term scholastics referred to medieval philosophers who taught at universities, prized subtlety and rigor, and depended heavily on consensus that they did not question (ibid.). Most professors, Kaufmann claims, are scholastics. Both scholastics and visionaries have their good and not so good specimens. Still, Kaufmann makes a case that academia is limited by the over-riding culture of scholastics (ibid.).[5] "Those who work on the frontiers of knowledge must cross the frontiers of their departments," he declares (Kaufmann, 1977, p. 43).

This distinction—essentially between those working within an existing framework or paradigm versus those who create a paradigm shift—"incommensurable ways of seeing the world" (Kuhn, 1962/1970, p. 4)—has been articulated by Thomas Kuhn, himself a traveler across disciplines. Kuhn considers how both visionaries and "normal" scientists, whom he defines as puzzle-solvers within an accepted framework, have operated in the history of science.[6] In the realm of the arts, Harry Broudy draws a similar distinction among anticipatory, summarizing, and seminal works of art as organizers of curriculum (Broudy, Smith, & Burnett, 1964). Anticipatory artworks are pioneering; summarizing artworks operate within established traditions; seminal works combine both, in that they are catalysts for change. Kaufmann, Kuhn, and Broudy convey a range of attitudes towards the cutting edge versus the traditional, with Kaufmann enthused by the former, and Broudy by the latter (a view that is related, it seems, to how each sees himself. Broudy is ever the realist, the neo–Aristotelian (1958); Kaufmann regards himself as the heretic (1959).[7]

Given the structures and ethos of academia, the ability to create impact in several different domains is uncommon. Occasionally, we encounter a scholar who initiates a voyage across domains, making a mark on each of them and moving on to the next. One well-known example is psychologist Jerome Bruner. Bruner made significant contributions to cognitive learning and theory, then language development, later focusing his thinking on narrative construction of reality, and most recently on legal psychology. Examining his oeuvre, we can note the connections among these contributions. Yet, the disciplinary contributions are distinct.

Artists' journeys can manifest a similar trajectory. While for most, the artistic evolution has been gradual and stays within one style, there are also those, like Picasso, who went through several noticeable styles—from realism, through modernism, to different types of cubism—to conceive new ways of representing and seeing in each. Some intercultural artists' work evolves to incorporate new genres and styles, for example, Yo-Yo Ma and Daniel Barenboim. Others, like Osvaldo Golijov and Meredith Monk, have consistently drawn on their broad foundation of multiple artistic genres and forms. Another issue concerns the impact of the intercultural work. The juxtaposition of diverse cultural traditions practiced, for example, by Golijov and Ma opened up possibilities within classical music. Impact can also reach across multiple artistic communities, evidenced by Monk's impact on music, dance, and the visual arts worlds.

A close examination of intercultural work unravels complex relationships among disciplines. Some disciplines and artistic styles are closer to each other in worldviews, traditions and methods than others. Some intercultural work involves diverging from established practices whereas

others require the application of disciplinary skills to specific problems. In the former, the discipline itself might undergo change as it absorbs the insight of other disciplines; in the latter the discipline is largely unaffected by the focus of its inquiry. Just like the contributions of the chicken and pig, each kind of intercultural encounter can have its merits.

Obviously, traditional disciplines and domains, like artistic and cultural styles, are far from static. They have a flow of their own. Most contemporary disciplines have evolved from a mother discipline, as psychology and physics once did from philosophy when issues shifted and methods expanded to the empirical. Sometimes, new disciplines are created, in the style of Venn diagrams, by the convergence of territories that were traditionally part of two separate disciplines, as in biochemistry or social psychology. Sub-disciplines, initially part of disciplines, often acquire a culture and ethos of their own, as, for example, did ethnomusicology, a branch of musicology (e.g., Nettl, 2014). These shifts have ramifications for the positionality of scientists in the field—mainstream, periphery, or outside.

We now recognize the crucial role of positionality in knowledge. Where we are positioned, as the ancient story about the six blind men and the elephant illustrates vividly, shapes what we perceive.[8] Interdisciplinarity can enable awareness of a larger picture and bigger connections, solving problems most important for humanity (e.g., Leavy, 2011). For example, the area of informal learning was generally considered beyond the scope of music education research when Eve Harwood conducted her study of children's musical learning in the playground (1987). She drew on research by children's folklorists and cognitive theorists in her analysis (Harwood, 1998). Along with work by Kathryn Marsh and Patricia Campbell, this approach expanded the focus of music education to informal learning, now a thriving domain (Campbell & Wiggins, 2013; Marsh, 2008). The evolution of a discipline depends on what borders we cross: the discipline of music education research emerged in early 20th century as an interaction of music and experimental psychology, emphasizing musical aptitude and experimental work. Its incorporation of anthropological and phenomenological worldviews in the past 25 years has generated naturalistic, experience-oriented scholarship.

Research topics go in and out of fashion. Knowledge does not come neatly packaged within boxes even when the views of the disciplinary community make it seem so. Institutionalization of disciplines supports the creation of knowledge through forming communities of members/ audiences and venues for conversation, and these very actions confine knowledge by constructing boundaries around disciplines. Claire Detels laments the existing "hard boundaries" of music, advocating for a softening (Detels, 1999). Hard boundaries prevent us from grasping a larger picture (Leavy, 2011), and protect us from an encounter with the other. Opening boundaries expand artistic and scholarly possibilities for creation.

Hindrances to interdisciplinarity and interculturality are external, institutional and structural, but also internal—our resistances and fears: fear of looking/being ignorant within a culture of experts. Socrates claimed that his wisdom consisted of his awareness of not knowing, his unknowing. Clearly, ignorance, unknowing without awareness and openness, can be damaging and self-perpetuating. My use of unknowing is similar to Suzuki Roshi's notion of *beginner's mind* (Suzuki, 1970). A full head, as a Buddhist story shows, prohibits learning: the Zen Master continues pouring tea into his visitor's full cup to the visitor's alarm, alerting him that until he empties his head, there is no space for new knowledge. We academics tend indeed to have full heads and stay within our comfort zone. Admittedly the feeling of an empty head is unsettling. However, in my own research I have found again and again that it is when I am lost, when the hold of familiar conceptualizations and assumptions is weakened and I am confronted with not knowing, that there is space for new understanding and ways of seeing. While acknowledging the purpose and judiciousness of the academic and artistic ethos of rigor

and specialization, I worry that a culture of experts is in danger of losing the importance of recognizing "beginner's mind."

It took Socrates forceful and persistent encounters with his fellows to shake their full headedness (and look where it got him!). Intellectual journeys that aspire to significant learning are typically facilitated by sustained encounters with others. Just as the social aspect has been identified in philosophy of science in the past 50 years,[9] the role of the social in intercultural and interdisciplinary interactions deserves systematic examination, for example, in the encounters of indigenous and classical community members, or those of different artistic genres.

Experiences of tourists, habitat dwellers, and zone members

Just as most tourists see the other through limited and prescribed interactions or the lens of a camera, what I refer to as donation-based, touristic interdisciplinary and intercultural work is conducted through the lens of one's original discipline. Location shapes encounters. Edward Bruner's notion of the *diurnal rhythm of touring* provides a fitting metaphor regarding residence and social interaction: sightseeing during the day, hotel accommodations at night (Bruner, 2005, p. 17). The ethos and structures of organized tourism are constructed to minimize culture shock. Bruner coined the notion of a *touristic border zone*, a point of conjuncture, a behavior field that is a distinct meeting place between the tourists who come forth from their hotels and the locals, the "natives" who leave their homes to engage the tourists in structured, prescribed ways (ibid.). The concept of the touristic border zone focuses on a localized event, limited in space and time, as an encounter between foreign visitors and locals. Tourists are mobile, and they rarely return. Locals remain in the area (ibid.). Likewise, cultural and disciplinary tourists stay grounded within their own domains, in conceptualizations, vocabulary, and contributions.

While the tourist excursion can be achieved through surface encounters with natives, a shift in habitat requires being replanted in new soil, becoming part of a new culture, resembling the experience of anthropologists. Tourist travels are typically marked by packed, hurried schedules on a path from one attraction to another. In contrast, shifting a habitat takes time and requires immersion. Surrounded by natives, habitat dwellers acquire their language, ways of being, doing and interacting. The kind of knowledge and understanding these travelers/scholars absorb is not only cognitive but also visceral, becoming a part of who they are.[10]

A third kind of journey involves the sustained exchange of perspectives among travelers who aspire to mutual learning across disciplines and cultures. Working in the context of an interdisciplinary project, Judy Davidson Wasser and I proposed the concept of the "interpretive zone" as an intellectual collaborative realm (Bresler et al., 1996; Wasser & Bresler, 1996). While scientists take working in teams for granted as the way to make progress in a field, in the humanities and in education, including arts education, the model of the lone researcher is still prevalent. In the interpretive zone, researchers bring together their various areas of knowledge, cultural background and beliefs, to forge new meanings through the process of joint inquiry in which they are engaged. In our conception of the interpretive zone, we combined two important and closely linked hermeneutical traditions: the philosophical, as represented by such thinkers as Dewey, Dilthey, and Rorty; and that which stems from interpretive anthropology and the work of Geertz, Turner, and Myerhoff.

The concept of zone assumes two or more parties contributing, negotiating, and interacting from different perspectives. The characterization of zones differs according to the context and the aspects of the collaborative interactions that are emphasized. Zones range from the neutral (information), through the conflictual (wars) to the amicable (alliances). In our reference to

zone, we draw upon diverse scholarly uses of the term as well as non-academic uses. Among these we noted Vygotsky's (1986) *zone of proximal development*, Bakhtin's (1986) *character zones*, and Giroux's (1992) *border zones*. Non-academic uses include "speeding zone," "demilitarized zone," "comfort zone," and "intertidal zone." What is similar about these notions of zones is that they refer to unsettled locations, areas of overlap or contestation. It is in a zone that unexpected forces meet, new challenges arise, and solutions have to be devised with the resources at hand (Wasser & Bresler, 1996). Navigating cultural zones suggests dynamic processes—exchange, transaction, intensity, and absorption. Absorption indicates incorporation of new understandings rather than merely the accumulation of experiences. Unlike tourists who stay on familiar routes, and the habitat dwellers who gradually make the strange territory their own, zone members keep the strange and the familiar in dialectical tension.

Within an intercultural framework, a zone is a place of interchange for scholars and artists from diverse disciplinary and cultural traditions who are committed to collaborate. As important to interculturality as the aforementioned "beginner's mind" is an inquiring, thoughtful, critical mind—the same qualities that characterize all academic and artistic travels—juxtaposed with listening that is tuned to understanding the context and worldview of the other. Zone members are attentive to what it is that they do not know as a learning opportunity, wishing to share their perspective with the same awareness of their listeners' need.

Can you summarize the key points you have made that inform intercultural research journeying?

My own intercultural and interdisciplinary journeys discussed in the next section illustrate the distinctions among the three types of travel. Each type has proven useful for its respective research goals. The first, conducted in Israel within the discipline of musicology, involved a touristic excursion into art history. The cultural, intellectual and methodological territories were familiar. This journey deepened, rather than challenged, my identity as an Israeli, musician, and musicologist. The second travel involved shifting to a new habitat, from Israel to the USA, from music to education. It took full commitment (more circumstantial than intentional) and ended up being transformative in spite of my ambivalence. The third set of travels conducted within the territorial continent of education in the USA, was facilitated by sustained interpretive zones—some that I discovered, others that I created as a project director.

My interdisciplinary research journeys

A touristic excursion

My excursions in interdisciplinary research started with my Masters thesis in Musicology at Tel Aviv University, following years of performing both folk and classical music on the piano. During a three-year research project, I explored the Mediterranean Israeli musical style of the 1930s, 40s and 50s, tracing its characteristics to historical and sociological contexts (Bresler, 1982). As I was hunting for and analyzing musical works, I realized that their stylistic and thematic characteristics were also evident in other artistic (e.g., dance, drama, visual arts) and educational media. I ended up dedicating a whole chapter of the thesis to the analysis of visual arts of the period.

G. K. Chesterton's famous adage that "The traveler sees what he sees. The tourist sees what he has come to see," was apt. The detour from the familiar musical language and concepts to the visual art sphere was brief, with a predictable return to my music home. I was looking for particular characteristics paralleling those I identified in the musical style: for example, a thematic focus on landscape and working the land; stylistic elements that highlighted simplicity and

rejected a heavy romantic European style. My excursions to the art-world of this time period were through the lenses of my musical background, attending to artistic elements (e.g., form; color); subject matter; and type of expression, rather than, for example, evolution of technique and visual representation. Learning about Israeli visual art, its ethos and aspirations, I gained a better appreciation of the meaning of the musical style by perceiving how it was part of a larger phenomenon of historical aesthetic ideology. These visual artworks have become part of my own artistic and intellectual landscapes, much like the Alhambra and the Taj Mahal I encountered in my travels abroad. Similar to tourists' visits (Bruner, 2005), my visit to visual arts functioned as a self-development project, expanding my knowledge, vocabulary, and store of images.

I have occasionally found myself conducting similar explorations in my academic and cultural travels, meandering to the humanities, to the arts, to other social sciences, in order to become acquainted with concepts of interest and import. This is similar to my occasional visits to different countries, noting new sights, foods, and experiences. Still, I remain firmly grounded in my own geographical, disciplinary, and methodological soil.

A shift in habitat: culture and discipline

Next came a very different kind of journey, not one that I initiated or wished for. It entailed an exit from my comfort zone, a shock, and eventually a change of identity—not unlike the pig—one that transformed me from a musician to an educator, from an Israeli to a hyphenated, multi-layered identity that comes with a memory of the earlier enculturation, a constant (now experienced as heartening) sense of otherness.

The short version of the story is that I left Israel for Stanford University to join my husband who had embarked on his doctorate. I was resigned to do a doctorate in musicology there, the logical continuation of what I did in Israel but not one that I was excited about, since the musicology faculty there did not share my enthusiasm about musical styles as historical and ideological. An unexpected invitation by Elliot Eisner to be his research assistant in education, a field that I never considered before (or knew anything about in terms of scholarship), instigated a change of direction. A devout musician, I found myself immersed in the foreign territory of educational research. I became acquainted with new vocabulary and bodies of knowledge. Instead of the musical language on which I grew up—performing, doing harmonic analysis, ear training, solfege, and counterpoint—I dealt with educational issues and communicated through writing papers. Beyond academic knowledge, introduced to notions of individuality and privacy, I grappled with the unfamiliar understanding of the self as espoused in the US. I learned that intense eye contact, signifying connection in my familiar Israeli cultural code, could be interpreted as confrontational; that speaking counter-punctually (that is, simultaneously), which I associated with engagement, was rude; that telling colleagues how to improve their paper/worldview, my sure sign of caring and honesty, was insulting.

The transition to an unknown disciplinary field was facilitated through courses and learning new content. The real challenge came through grappling with dissonance: the confrontation of discrepancies in underlying value systems of the familiar and the new disciplines. I was startled to be told that Music Theory, a fundamental subject of all music learning in the Music Academy and Musicology department, was not considered a theory in the social sciences. The most glaring clash of cultural values pertained to the belief in the collective versus the individual, and its associated expectation of familiarity versus distance. A disciplinary clash between music and education concerned its *raison d'être*. The Music Academy (home of my BA) centered on the texts of the most inspired and inspiring. There are few geniuses whose music deserves to be listened to for hundreds of years and could be assumed to last for as long. Exceptional talent was

expected of students in both performance and composition. The culture of music emphasized excellence, requiring full dedication to one's art. In contrast, while the field of Education has its gifted area, it is a tiny, marginal territory. The general culture of education is committed to the many rather than the few, those who are struggling rather than the exceptionally talented. While I missed the commitment to high achievement, I recognized that exceptional high standards come with a price that does not fit with the goals of public education. The culture of education was indeed a new world, and I was not feeling brave in the encounter; I was just trying to make sense of it.

As I made the strange familiar, the familiar became strange. I noted for the first time, through the acquisition of a new frame of reference that my home discipline of music had distinct learning cultures (Perkins, 2013) and a strong hierarchal system, what ethnomusicologist Bruno Nettl has called a caste system (Nettl, 1995).

My total commitment to the new habitat meant that I lived in Stanford, and that all my courses, taught in English, were in education, as was my professional community. I spoke with professors and students of education, attended educational conferences, read educational scholarship, and conducted educational research. I did retain my immigrant identity, strong accent and equally strong eye contact (it took me some time to note them), appreciative that it did not seem to be held against me. Since my entry to education, I have been methodologically intrigued by the musical sensitivities that supported my meaning making in educational research, including attention to musical dimensions as an important part of lived experience (Bresler, 1983); improvisation as responsiveness to what we encounter; embodiment as methodological tool; a particular kind of listening and attending that I identify with the aesthetic (Bresler, 2013); and the use of resonance and dissonance to identify compelling issues (2013). More broadly, I notice variations across cultures in the expression and communication of dissonance and unknowing; in embodiment; and in the use of improvisation in everyday life.

In traditional ethnography, anthropologists started out "here" and then went "there" to study "them," returning to write about "them" in descriptive studies (Geertz, 1988). I stayed "there," eventually becoming an insider. Nonetheless, my culture and discipline of origin have shaped my current worldview. My earlier sense of unquestioned connection to the world and value- system of music has loosened and become less of a dogma now, more of a nurturing home in an ever-evolving journey.

Interpretive zones for joint inquiry

Once I acquired citizenship in the land of Education through academic degrees, publications, and teaching (and, having dual citizenship, American and Israeli passports), my taste for "inter" travels intensified. I appreciate working on projects with colleagues from different continents, making connections across disciplines and drawing on multiple worldviews to explore an additional frame of reference. My courses in arts and aesthetic education draw on readings from diverse disciplines, and on experiences from music through tea ceremony to landscape architecture. Guest speakers include artists from a broad array of disciplines, including such intercultural artists as choreographer Mark Morris, dancer Ralph Lemon, and director Anne Bogart. My research methodology courses incorporate performances in different media and genres as sites for observations and interpretations of micro-cultures, attending to etiquette, embodiment, and the aesthetic expression of multiple forms of representation.

I regard courses as opportunities to create spaces for interpretive zones. Assignments and class discussion center on students' cultural and disciplinary lenses and values as shaping observations and interpretation. The diversity of students, a representation of multiple ethnicities and

cultures in the US as well as Asian, African, South-American, and European students make a rich and rewarding arena for learning about other ways of seeing and expanded understanding. Similarly, the short courses and workshops I give in different countries are designed to elicit diverse cultural ways of seeing and understanding (tremendous learning opportunities for me!). A continuum of periodic and sustained collaborations with wise and intellectually curious colleagues on projects in many countries facilitated productive interpretive zones.

Most of my interdisciplinary travels involve anthropology—where I first became explicitly acquainted with the notion of interculturality—and the stepsister disciplines of Music Education, Visual Arts Education, Dance Education, and Drama Education. I perceived each of these arts disciplines as a hybrid, with one common parent—Education—and the other, a specific art discipline. Each arts education discipline established its distinct community, belonging to different academic units within the university, in charge of organizing its bodies of knowledge, conferences, venues for publications, teacher education program. While sharing in the underlying concerns and mission of creating curricula and responding to the educational institutions where they occurred, each discipline developed its own practices, pedagogies, evaluation practices, and ideologies (e.g., within art education: self-expression, Discipline Based Art Education, and visual culture), and was influenced by the traditions and cultures of the parent discipline and practice (e.g., within music education: choral and instrumental).

Several of my multi-year research projects—case-studies within the National Arts Education Research Center funded by the NEA; the Arts in Education project funded by the Bureau of Educational Research at the University of Illinois; the Arts Integration in Secondary Schools project, funded by the Getty Center/College Board—encompassed the four arts disciplines. These were rich and rewarding opportunities for intensified learning as I noted the commonalities and differences between the various arts education subjects, their perceived role in the curriculum, their deeply held beliefs about education and the meanings and purposes of children's artistic engagement.

It was in the three-year, multi-sited Arts in Education project, aimed to investigate the ways that the arts, as disciplines and human experience, are translated into a broad range of school settings, that the interpretive zone emerged as a key aspect of the study. In my position as a principal investigator I appointed research assistants with diverse cultural, disciplinary and artistic background and expertise. Judy Davidson Wasser served in the role as an ethnographer-in-residence, skillfully documenting the interchange and contributions of different members from their disciplinary perspectives in what we named the *interpretive zone* (Wasser & Bresler, 1996). In addition to weekly classroom observations and teacher interviews, we conducted extensive meetings where multiple disciplinary and experiential viewpoints mingled in the process of interpretation. This process calls for heightened attention to individuals' a-priori and emergent codes. Judy's notes from the meetings helped us acquire meta-awareness of the *group as an interpretive* tool, unfolding in tandem with the deepening awareness of our reflexive process, and considering the ethical issues implied in the various roles we occupied in relationship to each other (Bresler et al., 1996).

In this process, we developed a more systematic notion of interpretation in the group. Initially we approached interpretation as linear. As we shifted from fieldwork to more analytic modes, the underlying beliefs of the individual researchers rose to the surface as dissonance, anxiety and conflict about the processes we were following. Establishing trust was essential. We noted how individual fieldwork data translated into collective products. We learned that for an interpretive zone to have methodological value, there must be time allotted to the collaborative work, time that in other circumstances would go to fieldwork or writing activities. We recognized the parallels and intersections between the role of the fieldworkers entering the culture of

the school, and the role of researchers entering the interpretive zone team. Seeking, over time, a position within the group, both deal with the acquisition of a new knowledge and expansion of understanding.

A less structured but no less important interpretive zone operated in my other research projects and was supported by active membership in both music and art education societies, and by excursions through readings, social interactions, and conferences in all four arts education communities. These multiple memberships allowed me to note the culture, ethos, and doctrine of disciplines, manifested, for example, in the role of canon in the curricula, in underlying goals and beliefs about children's engagement with the arts discipline as reflected in pedagogies, and in assessment.

While the notion of interpretive zone was conceptualized in the context of a research project, it proved a useful frame for curriculum integration. The Getty Center/College Board study of Arts Integration in Secondary Schools manifested the existence of practice interpretive zones for deliberation between various arts specialists (e.g., visual art, drama) and so-called academic subjects (e.g., history, English, math, sciences) towards the creation of an innovative curriculum. In the process of being integrated, school subjects were reconsidered and reconceptualized, shaped by the identities, experiences, and beliefs of the group members as they opened to assimilate others' perspectives (Bresler, 2003).

Within intercultural arts contexts, "interpretive zone" can be observed in rehearsals and in materials (see, for example, Yo-Yo Ma's discussion of his work with Mark Morris: https://www.youtube.com/watch?v=9RgW_ljAxTg); or Anne Bogart's reflections on her dance background as shaping her practice as a director (Bogart & Landau, 2005).

Disciplines have generated conferences, journals, and other venues, face-to-face meetings and printed material that interact with and support each other. Clearly, interdisciplinarity requires supportive venues. Towards that end, I co-founded with Tom Barone and Gene Glass (2000) the *International Journal of Education and the Arts*, a space for music, art, dance, and drama educators to read, write, and be read. Similarly, *the International Handbook of Research in Arts Education* (Bresler, 2007) has 13 sections (including Curriculum; Creativity; Informal Learning; Child Culture; Social Issues; Technology; and Spirituality) where each features contributions by international scholars from the fields of music, art, dance, drama, and literature; a prelude that provides an overview of the topic within the different disciplinary cultures; commentaries reflecting scholarly and cultural perspectives of research in 35 different countries; and original artwork corresponding to the respective themes.

Cultivating interculturality: connecting inner and outer

Recognizing the negative power of dissonance as instigator of hostilities and disconnection, scholars have suggested dialogical approaches conducive to understanding the other (e.g., Buber's "I-Thou," Gadamer's "fusion of horizons"). Indeed, one can say that the history of disciplines such as anthropology, phenomenology, and qualitative research is shaped by the quest to understand "the other." Yet, academia seems to be as challenged as the outside world by interculturality. Full commitment to interdisciplinarity and interculturality requires addressing inner journeys: cultivating habits of a connected mind and heart, juxtaposing expertise with a beginner's mind, bringing to dissonance an inquisitive attitude that aspires to understand. Inner journeys, I learned, are no less venturesome than outer.

Unknowing and dissonance pull us from our comfort zone, evoking judgment of self and others, often triggering an "Us-Them" (Buber, 1971) view, where the "other" is considered wrong in service of one's own rightness of worldview. Judgment is a double-edged sword. It is

useful when we need to make decisions. Given the normative nature of education, all educational matters require wise judgment for wise practice. However, the quest for understanding, precursor to practice, requires different qualities. If not handled with care and curiosity, judgment triggered by ignorance and dissonance thwarts perception and understanding. Lingering with dissonance helps expand our interpretation towards informed judgment, one that comes from comprehending a broader perspective.[11]

Assuming as a student that once I had a PhD I would be forever knowledgeable and secure, I learned as a professor to respect the "wisdom of insecurity" (Watts, 1951), striving to cultivate a compassionate appreciation of being off-balance and a periodic emptying of the head.[12] Inner journeys, requiring inner tuning, are fundamental to the arts, humanities, and social sciences. Hearne, a scholar of children's stories and folklore, alerts us that "It takes a story to know/ understand one" (in Hearne & Trites, 2007, p. 207). Philip Graham's (2009) words on the experience of reading literature are equally relevant to the process of research: "the external journey is strengthened by an accompanying, echoing inner journey . . . When one is able to lean into the strange pull of another country or culture, one's inner landscape is correspondingly altered." Graham's observations come out of his travel experiences and collaborative writing with his wife, anthropologist Alma Gottlieb, described in their "Parallel Worlds" (Gottlieb & Graham, 1994): the parallels of the Beng village in Ivory Coast and the US, and the parallel voices of an anthropologist and a fiction writer create a richly textured intercultural understanding, for authors and readers, along with continued support for the Beng villagers.

To support researchers-in-training in their interdisciplinary and intercultural travels, I aim to teach students in my qualitative research courses to stay with both dissonance and unknowing as an opportunity to investigate beyond their habits and comfort zone. One regular activity I conduct in art museums is assigning students from a variety of disciplines to choose two artworks, one that evokes positive, the other negative responses, and linger with each for 40–50 minutes. Students are often amazed by what transpires through the prolonged engagement with dissonant artwork. It is not that they always like it in the end (and liking it, of course, is not the point), but their perception and relationship to it are expanded in ways that, in their words, are surprising and powerful. Many of them say that engagement with the artwork they initially disliked is considerably more meaningful than with one that they liked. Indeed, dissonance can be a forcefully effective door to learning about our own subjectivities, values, and commitments, including ones that we have not been fully aware of. (For specific examples and cases, see, for instance, Bresler, 2013.) This learning is crucial to intercultural encounters. Articulating in writing and sharing with a diverse student community, essential to research in the social sciences, supports an exploration process from dissonance through curiosity to complex interpretations.

In addition to drawing on the power of dissonance as a generative element towards expanded discernment, I use dissonance in course materials to develop deeper interpretation. One such use of dissonance in story telling functions as the main organizer of the classic Akira Kurasawa's *Rashomon* (1950), a movie I often show when I teach qualitative research. It is the incompatibility of narratives among the characters—a bandit, a husband, a wife, and a woodcutter—that enables us to discern the ethos of the time, and how this ethos shapes perception and self-presentation.

The role of writing as a means to process and communicate has been widely acknowledged (e.g., Richardson, 1994). The attention to actual experience rather than its idealization is key. Kuhn writes about the distorted image of science as presented in the study of finished scientific achievements from which each new scientific generation learns to practice its trade (1962/1970). The aim of textbooks is persuasive and pedagogic. However, a concept of science drawn from them, Kuhn cautions, is no more likely to fit the enterprise that produced them than "an image

of a national culture drawn from a tourist brochure of a language text" (1962/1970, p. 1). Indeed, Kuhn's work aspires to sketch a different concept of science that emerges from the record of the research activity itself (ibid.). The *Handbook of Intercultural Arts Research* promises to advance the field for a greater understanding of processes and products, offering creative conceptualizations and impetus to engage in dynamic creation of new scholarship and practice. The three types of travel experiences portrayed in this chapter—tourist excursion, change of habitat, and interpretive zone—are presented as an invitation for others to come up with their own layered textures of relevant conceptualizations.

Notes

1 A story that I heard from Vipassana teacher Jack Kornfield.
2 The pursuit of a highly focused line of study.
3 Fields vary, with dance, music, and math typically at an earlier age; visual art, literature, and history later.
4 His taxonomy of academics also includes Socratics and journalists.
5 Kaufmann claims that a visionary could hardly feel at home in academia, presenting the cases of Spinoza, Nietzsche, and Wittgenstein (Kaufmann, 1977, p. 11).
6 Though, as Imre Lakatos has pointed out, paradigm shift is often initiated *within* the discipline (Lakatos, 1976).
7 Crossing disciplinary boundaries is a feature of entrepreneurship and innovation, an important aspect of artistic practice. Bresler (2009) refers to crossing disciplines in the context of intellectual entre-preneurship. Griffin, Price, and Vojak (2012) discuss serial innovators as able to reframe problems, a consequence of branching beyond one's discipline.
8 Each blind man positioned at a different spot—leg, tusk, head, ear, trunk, tail—provides a different description of the elephant.
9 See, for example, Kuhn (1962/1970) and Latour (1987).
10 The difference between anthropologists and immigrants is that anthropologists are motivated by the quest for knowledge and understanding, whereas the immigrant's quest is typically driven by practical concerns.
11 An example of a quick judgment that reduced understanding is my own Easter Bunny (in Bresler, 1992) where, instead of expanding interpretation of the stereotypical artifacts of school art, I used (implicit, but obvious) disparagement. A masterful example of dealing with dissonance is Gottlieb and Graham's portrayal of the Beng villagers' values clashing with those of the researchers (Gottlieb & Graham, 1994).
12 Including, as my daughter Ma'ayan has pointed out, emptying it of fear.

Acknowledgments

In the spirit of interdisciplinary interactions, I am indebted to Betsy Hearne who has provided insightful, wise companionship since the beginning of this chapter. I am grateful to Kimber Andrews, Sven Bjerstedt, Walter Feinberg, Eve Harwood, Ray Price, and Sue Stinson for their reading of this chapter and their excellent comments. Heartfelt thanks go to Pam Burnard for nudging me, kindly but firmly, to include those intercultural aspects close to my heart.

References

Bakhtin, M. M. (1986). *Speech genres and other late essays*. Austin, TX: University of Texas Press.
Bogart, A., & Landau, T. (2005). *The viewpoints book*. New York: Theater communication group.
Bresler, L. (1982). *The Mediterranean style in Israeli music*. Master's thesis in Musicology, Tel Aviv University, Israel.
Bresler, L. (1983). A case-study of elementary lesson through musical dimensions. Unpublished paper. Stanford University.
Bresler, L. (1992). Visual art in primary grades: A portrait and analysis. *Early Childhood Research Quarterly, 7*, 397–414.

Bresler, L. (2003). Out of the trenches: The joys (and risks) of cross-disciplinary collaborations. *Council of Research in Music Education, 152*, 17–39.

Bresler, L. (Ed.). (2007). *International handbook of research in arts education*. Dordrecht, the Netherlands: Springer.

Bresler, L. (2009). The academic faculty as an entrepreneur: Artistry, craftsmanship and animation. *Visual Art Research, 35*(1), 12–24.

Bresler, L. (2013). Cultivating empathic understanding in research and teaching. In B. White & T. Costantino (Eds.), *Aesthetics, empathy and education* (pp. 9–28). New York: Peter Lang.

Bresler, L., Wasser, J., Hertzog, N., & Lemons, M. (1996). Beyond the lone ranger researcher: Teamwork in qualitative research. *Research Studies in Music Education, 7*, 15–30.

Broudy, H. (1958). A realist philosophy of music education. In N. Henry (Ed.), *Basic concepts in music education* (pp. 62–87). Chicago: University of Illinois.

Broudy, H., Smith, B. O., & Burnett, J. R. (1964). *Democracy and excellence in American secondary education*. Chicago, IL: Rand McNally.

Bruner, E. (2005). *Culture on tour*. Chicago, IL: University of Chicago Press.

Buber, M. (1971). *I and thou*. New York: Simon and Schuster.

Campbell, P. S., & Wiggins, T. (2013). *The Oxford handbook of children's musical cultures*. New York: Oxford University Press.

Detels, C. (1999). *Soft boundaries: Re-visioning the arts and aesthetics in American education*. Westport, CT: Bergin & Garvey.

Geertz, C. (1988). *Works and lives: The anthropologist as author*. Stanford, CA: Stanford University Press.

Giroux, H. (1992). *Border crossings*. New York: Perigee Books.

Gottlieb, A., & Graham, P. (1994). *Parallel worlds*. Chicago, IL: University of Chicago Press.

Graham, P. (2009). All writing is travel writing. http://www.philipgraham.net/2009/11/all-writing-is-travel-writing/. Retrieved on December 30, 2014.

Griffin, A., Price, R. L., & Vojak, B. (2012). *Serial innovators: How individuals create and deliver breakthrough innovations in mature firms*. Stanford, CA: Stanford University Press.

Harwood, E. (1987). *The memorized song repertoire of children in grades four and five in Champaign, Illinois*. Unpublished doctoral dissertation, University of Illinois.

Harwood, E. (1998). Music learning in context: A playground tale. *Research Studies in Music Education, 11*, pp. 52–60.

Hearne, E. (2011). Folklore in children's literature: Contents and discontents. In Wolf, S. A., Coats, K., Enciso, P., & Jenkis, C. A. (Eds.) *Handbook of Research on Children's and Young Adult Literature*. London: Routledge.

Hearne, B., & Trites, S. R. (2007). *A narrative compass: Women's scholarly journeys*. Carbondale: University of Illinois Press.

Kaufmann, W. (1977). *The future of the humanities*. New York: Reader's Digest Press.

Kuhn, T. (1962/1970). *The structure of scientific revolutions*. Chicago, IL: University of Chicago Press.

Lakatos, I. (1976). *Proofs and refutations*. Cambridge: Cambridge University Press.

Latour, B. (1987). Science in action: How to *follow scientists and engineers through society*. Cambridge, MA: Harvard University Press.

Leavy, P. (2011). *Essentials of transdisciplinary research: Using problem-centered methodologies*. Walnut Creek, CA: Left Coast Press.

Marsh, K. (2008). *The musical playground: Global tradition and change in children's songs and games*. New York: Oxford University Press.

Nettl, B. (1995). *Heartland excursions: Ethno-musicological reflections on schools of music*. Urbana, IL: University of Illinois Press.

Nettl, B. (2014). A Life of Learning (Occasional Paper no. 71). Charles Homer Haskins Prize Lecture for 2014. 1–15. New York: American Council of Learned Societies.

Perkins, R. (2013). Learning cultures and the conservatoires. *Music Education Research, 15*(2), 196–213.

Popper, K. (1963/2004). *Conjectures and refutations*. London: Routledge & Kegan Paul.

Richardson, L. (1994). Writing: A method of inquiry. In N. Denzin & Y. Lincoln (Eds.), *Handbook of qualitative research* (2nd ed., pp. 516–529). Thousand Oaks, CA: Sage Publications.

Suzuki, S. (1970). *Zen mind, beginner's mind*. (T. Dixon, Ed.). New York: Weatherhill.

Vygotsky, L. (1986). *Thought and language* (A. Kozulin, Trans. & Ed.). Cambridge, MA: MIT Press.

Wasser, J., & Bresler, L. (1996). Working in the interpretive zone: Conceptualizing collaboration in qualitative research teams. *Educational Researcher, 25*(5), 5–15.

Watts, A. (1951). *The wisdom of insecurity*. New York: Pantheon books.

30

MUTUALITY, INDIVIDUATION AND INTERCULTURALITY

Violeta Schubert and Lindy Joubert

Introduction

Drawing on Bourdieu's notion of 'fields' as 'structured spaces', where positionality within the spaces can be 'analysed independently of the characteristics of the occupants' (1993: 72), we argue that an intercultural, and interdisciplinary gaze presents profound possibilities for exploring the dynamism of culture. This *intercultural field* is inherently relational, that is, it incorporates both the physical and symbolic space of performance within which there is *inter*action or dialogue between people. We argue that this intercultural field is important for the analysis of notions of interculturality, as it is a site of creativity and boundary transgression. It enables us to consider the inventiveness that emerges in endeavours to reinforce and validate cultural distinctiveness and reinforce shared cultural practices and meanings. Indeed, this field speaks to a dynamic process of intercultural dialogue that is premised on the tensions between the desire to balance *mutuality* (that is, what we share) and *individuation* (the assertions of difference or distinctiveness that make us stand apart from others) and enables creativities and newness to emerge from the 'in-betweenness' (Burnard, Mackinlay & Powell, this volume).

It is important to note here our understanding of the notion of 'culture'. It is perhaps a truism to say that culture is everything and everything is culture. Nonetheless, there is in all aspects of human life, in terms of behaviour, modes of thought, organisation and constructions of meaning, an element of a foregrounding about the rules of engagement and the canvass upon which we are able to paint the expressions and meanings of human society. But culture is a moving target that can make it difficult to enclose in some kind of coherent or encompassing definition whereby one can categorically state '*This is what culture is*'! Nonetheless, whether it is the totality of what is shared, rituals and symbols, traits and behaviours[1] or a fluid analytic concept, it is vital to gain a measure of the complexities associated with 'culture', especially given that the term is so readily used by people we encounter in our research.

We draw upon our *intercultural experiences* to suggest that, though our respective disciplinary fields of practice are different (Joubert's arts and crafts 'project' gaze, and Schubert's anthropological 'ethnographic fieldwork' gaze), they have a shared emphasis on culture as it is expressed by people and drawn upon for sustainable community development that is also part of the *intercultural field* and speaks to the inventiveness that emerges from the performative presence of actors engaged in dialogue both within and across cultures. The relationship between

cultural performance, preservation and the interplay between mutuality and individuation within and across cultures has been a focus of our respective research and practice. Moreover, as we draw on critical reflexivity in this chapter to present examples and case studies that put into the spotlight the challenges associated with intercultural research and practice, we note that there are inherent complexities and fluidities in the *intercultural field* as it typically involves subjective, if not emotive, interpretations and perceptions of what 'culture' means. For example, the process of objectifying cultural distinctiveness by external 'development' actors is enmeshed with that of internal actors engaged with strategies of preservation and sustainable development. Thus, the chapter highlights interdisciplinarity itself as part of the dynamic *intercultural field of interactions* within which the meanings of 'culture' become further refashioned, challenged and negotiated.

We take as a starting point the view that 'reflexivity and flexible research designs' are 'de rigueur for improving the validity and credibility of the research' (Abraham & Purkayastha, 2012, p. 126). Thus, approaching complex and entrenched development problems undoubtedly requires critical reflexivity that calls for the objectifying of our own 'cultures', be they the ones that we are born into, migrate or adapt to, or as in this case, become unconsciously immersed in as part of our disciplinary pedagogy and practice. There is, indeed, a call for reflective practice,[2] and in this critical self-awareness of our disciplinary pedagogies it is vital in understanding how we too negotiate and challenge meanings. Disciplinary pedagogies (as the body of tacit and explicit knowledge of ways of seeing the world, engaging and doing things in the efforts to solve problems or understand the world around us) govern the mode of professionalism and how we interact with people. But, they also follow similar processes typically assumed of 'cultures', in the sense that there is an *a priori* need to assert distinctiveness in order to cross the boundaries into interdisciplinarity. That is, *interdisciplinarity is an intercultural field of interaction* that is premised on a tension between mutuality and individuation.

Anthropology in the *intercultural* field

The utility of the concept of 'culture' as an anthropological and analytic tool that facilitates understanding of relationships, symbols and processes within and across societies, is increasingly being questioned. Nonetheless, despite the numerous critiques and analytic posturing on issues of culture, it is a concept that continues to be one of the most salient starting points for the understanding of people. Thus, though it crosses disciplinary boundaries, an anthropological gaze provides the *de rigueur* for the standard definitions of the concept of *inter*culturality.

Given that we typically do not think about what our culture is except when a need arises to express, perform or articulate it to others, we take for granted that at the point of interaction there is a process of construction and negotiation of the meanings of culture that become most apparent. Further, be they between people of different cultures or between different generations within a culture, interactions provide opportunities to consider processes of *intercultural transmission*, adoption and exchange, or, to put it in other words, of 'acculturation'. As noted by Berry, the process of acculturation and globalisation leads to 'highly variable cultural and psychological outcomes that follow from intergroup contact' (2008, p. 328).

But, for us, this process can also occur intra-group as well. In contrast to the notion of 'acculturation', as a product of two cultures coming into contact, anthropologists and sociologists typically refer to 'enculturation' to refer to the context where knowledge is gained as of birth through the process of socialisation and learning (see Parsons, 1991[1951]). The problem, however, is that people are not necessarily born into a single, cohesive or bounded culture – in fact, they are most likely to be part of multiple cultures and value systems from the onset of their

lives. Gaining *cultural and intercultural competence* in an increasingly complex and global context, in other words, presupposes that there are tensions from the early years of one's life. As such, this requires various kinds of intercultural competencies to emerge alongside relationships and interactions. For example, children of migrants,[3] while acquiring the language and other cultural aspects of their parents 'at home', are also simultaneously exposed to the *intercultural experience*, that of the recipient society they engage with as well as that which is represented via television and other media.

Exploring the *intercultural field as a dynamic process* of construction and deconstruction of meanings is especially significant in the case of discourses relating to globalisation and modernity (and its distinction from 'tradition'). This intercultural field also encompasses the tensions within intergenerational relationships as spaces within which landscapes are drawn and redrawn about one's individual and collective identity. In particular, modernity is generally seen in terms of 'the disruptive creativity of "youth" in collective opposition to old authorities and old ways' (Gable, 2000, p. 201; original emphasis). Nonetheless, as Rasmussen suggests for the Tuareg, age groupings are fundamentally relative and socially constructed categories; more so than, as she puts it, 'biological or chronological markers' (2000, p. 133). Irrespective of the 'opposition' or tension between Elders and youth, however, in most Indigenous communities cultural survival is essentially viewed by youth as a matter of the co-option and championing of the traditions, customs and identities. This typically occurs as part of a process of 'inter-generational dialogue', to borrow Rasmussen's phrase (2000, p. 134).

Moreover, in relation to *intercultural contact*, it is often assumed that a process of change occurs as people engage with outsiders, and, more broadly, with changing technologies and knowledge systems. Youth, especially, are assumed to be more actively engaged in reinterpreting and adding layers on what is known and how they situate themselves within the past, present and future. As with the experiences of second-generation migrants reported by Giguere, Lalonde and Lou (2010, p. 15), heritage cultural knowledge that is acquired by youth cannot be considered to be of the same kind as the direct experiences of their parents. To be sure, second-generation youth engage in an intercultural field that generates personal tastes and identities that go beyond the separate components of what is referred to as 'mainstream' or 'normative' culture, 'global' (enabled via information technologies), as well as that of their parents' and grandparents' generations. This undoubtedly produces a set of differing cultural constructs and conflicts and calls for variations in self-identification[4] by individuals and groups to situate themselves in multiple genres of cultural meaning and space, within and across cultural categories. Overall, in this process of interaction it is difficult to omit from consideration issues of power, as the positionality of individuals and groups are continually challenged in terms of status, authority and authenticity whereby, as Holland, Lachicotte, Skinner and Cain note, 'systems of power and privilege render the participants of encounters more or less equal, more or less like agents, and more or less *inter*personally powerful' (1998, p. 146; our emphasis).

In short, the *intercultural context* and performative presence of Indigenous communities in spaces of interaction with people across and within their own culture is a critical place for gaining a better understanding of issues relating to heritage, preservation and the process of revitalisation and innovation of culture. Moreover, the extent to which 'traditional' arts and crafts can interculturally collide as vehicles of expression for creativity and innovation, both sits in and crosses the imposed boundaries of understandings of 'culture'. For this reason, interculturality poses both opportunities and challenges to 'Indigenous' artistic presence and authenticity. This field of interaction can produce what one could describe as a 'sudden knowing about what his culture is' as he engages in a performance for an audience comprised of outsiders from across different cultures. Nonetheless, there is also an ever-present danger of essentialisation and locking

in of individuals' personal and collective identities according to that extracted, performative, component of culture. Overall, the intersubjectivities of meanings of what 'traditional culture' is occur through performance but are not limited to the production of difference from either within the community or the outsider audience. That is, *culture resides in intercultural spaces* that require ongoing production of an imagined and bounded 'traditional culture' to juxtapose 'modern' culture. Further, the creativity and innovation that emerges through interaction and intercultural exchange is an interesting interplay between 'old' and 'new'. This interplay requires an interdisciplinary research gaze that explores the notions of creativity and authenticity as an intercultural field, rather than categorical labels such as 'traditional', 'Indigenous', 'non-Western', 'Western' or 'modern' – meanings shift with the specificities of the interaction between the performer and audience that might be present in a particular space and at a particular point in time. Endeavours for cultural preservation, therefore, are not necessarily about locking in bounded notions of what a culture is, but about providing the space to highlight the fluidity and creativity of cultural production that nonetheless brings with it a measure of individuation and mutuality.

Overall, we argue for *expanding the research gaze* on arts, crafts and performance so that it pays due attention to issues of *interculturality* in more than a superficial way. As explained earlier, our research is 'action' based research, going into the field, working closely with communities. In many ways, our research is centred on 'making and doing' by drawing on people's own stories, myths and legends. Further, there is no point to thinking of the *intercultural* in the singular: that is, as a coherent, bounded entity that can be articulated, objectified or preserved. It is indeed, a field of interaction that is fluid and often difficult to capture without due attention to the *intercultural space* generated between individuals, and between different groups. The experience of working with communities, being advised by their Indigenous Elders, means that you are working with cultural forms, processes, habits, and symbolisms which do not remain unchanged but are continually inflected and threaded through new experiences and engagements precisely because you are involved in an interaction field of interactions. In this, cultural preservation strategies are fundamentally about understanding the subjective meanings and processes that are generated and negotiated in the *intercultural field*. In the interaction process, there is, though, an enmeshing of subjectivities that often provide the requisite boundedness and constancy of notions of culture that communities seek for the preservation of heritage.

In short, the anthropological gaze on the *intercultural field* is a useful tool for paying attention to the subjectivities of interactions, performance and dialogue. As an Elder Spokesperson for the Boon Wurrung people of Victoria advised the architects and architecture students involved in a project with Joubert, 'Listen. Just listen to the Elders, hear their voice, their stories, myths and legends, their history, dreams and ways of living'. In a similar way, Eberhard writes of the *intercultural encounter* as a matter of the basic capacities to listen, dialogue and wonder, 'similar to the "participant observation" required as an anthropologist in a field study' (2008, p. 10; original emphasis).

Moving beyond 'traditional' culture and the role of intercultural dialogue?

Notwithstanding the fact that what is inscribed on culture identities, in terms of representations, authenticity and expressions of power or disempowerment, is typically made more visible during the process of *intercultural interaction*, they are also significantly reshaped and renegotiated within this *intercultural field*. The relational and personal tensions in the face of *intercultural interaction*

highlight the space within which both 'tradition' and 'change' reside. Or, put in other words, the issues of 'culture' and *intercultural dialogue* are especially complex, if not problematic, because 'tradition' and 'culture' presuppose constancy when in fact they are only rendered salient because of the interactions that are brought about through a changing societal landscape where external actors are making their presence in the society either in situ or symbolically (such as through media). Though *mutuality* of sorts is pursued between actors within the *intercultural field*, such as the need for acknowledgement, if not championing, of culture by both internal and external actors, there is also an intrinsic process of distinction (*individuation*). That is, there is a danger of either being locked into a seemingly less powerful category of the 'traditional' peoples, and yet, equally, of being denied cultural distinctiveness.

Moreover, cultural preservation is typically viewed as the work of the elder members of a community, while youth abstract themselves in mind and body from the 'local'. In calling for greater youth engagement in preserving their cultural heritage, the tension that emerges across generations is in many ways akin to those of a complex web of intersecting, *intercultural* actors, spaces and dialogues. In short, as an avenue for youth to assert individuality and identity, engaging in the preservation of their 'traditional' cultures requires that they too negotiate and engage in what can be an *intercultural dialogue* of sorts because of the intergenerational element to interaction. It is impossible to ignore the fact that in a global context of expansive imaginaries brought on by such things as ICTs, for example, that youth will not engage in objectifying and refashioning their traditional culture even as they endeavour to assert or showcase it. Youth are not only more technology savvy than older generations but also have differing worldviews and aspirations that become attached to their interpretations of their traditional culture, something that might not sit well with older generations but that is vital for cultural innovation and the rejuvenation of 'tradition'.

From the perspective of development practice, there is a constant danger in settling for understandings of culture based on static views that do not account for how it is shaped pre-dominantly through the interaction (intercultural field), the appearance of things – based on self-identification of local communities, and/or dress, customs and other visible markers of difference that suggest that a well-bounded culture is present. Many community develop-ment advocates of the culture-based approach, for example, will invite both the young and old to 'tell' the practitioners about their culture. Representations and activities relating to this showcasing of culture, however, can easily become tokenistic and lock individuals and groups into some kind of essentialised, objectified culture commodity (e.g., for 'tourists'). It becomes even more complex when you consider that for some communities, such as those who have experienced significant conflict and are looking for a way out of their current developmental circumstances, outsider interpretations and reiterations about what they have can be very cathartic. That is, the *intercultural field* can serve as a vital springboard for the emergence of cultural innovation that is crucial for the rejuvenation of interest in culture even within communities.[5]

An incident that stands out as an example of this is a conversation with a young East Timorese woman who casually asked, 'Do you know things about our history, our culture?' As she explained, there was nothing 'written' that she could draw on to help her understanding of 'their' history. She felt that it was a gaping hole that impacted on how she presented her-self to foreigners involved in community and development projects, especially as they would often ask her things about her culture. Understandably, with the extensive and brutal colonial experiences of the country, and the everyday challenges post-independence, there is often no time to ponder in any depth the meanings and identities one has and how one's culture plays a role in them. However, with the flurry of development activities in the country, such issues as

culture become central. This injection of attention on culture by external development actors rejuvenates interest in 'our' culture. This *intercultural field* has indeed produced various kinds of objectifications, including those on the part of locals that are spurred on by external actors as well as the significant intergenerational gap in the post-conflict society predominated by youth. As with the Timorese woman above, this *intercultural dialogue* provides the impetus for self-reflection and revitalisation. In short, the intercultural dialogue facilitates the production of new meanings to 'culture'.

Further, as there is no culture that is static, so too, no 'tradition' is impermeable from the influence of fashions and changing social contexts. That is, in seeking to assert cultural presence – in such sayings as, 'this is who we are', people can often become retrospective and reactionary about the origin, history and meaning of culture. Nonetheless, the *intercultural field of interaction* is a crucial site of innovation and ingenuity because having a 'rich' or 'traditional' culture to assert or perform before others is an important mode of redressing, at least on some level, the unequal power typically between those that 'help' and those that 'receive help' ('intended beneficiaries' in development jargon).

Typically, this assertion or performance of culture (*individuation*) can pose a challenge for how people construct *mutuality* of the meanings and understandings required for interaction between different actors. That is, the *intercultural field of interactions* both creates and transposes the tension between *mutuality* and *individuation* and is a vital space within which youth negotiate with their 'traditional' culture. Assertions and performance of culture by younger generations are especially vital spaces for *intercultural* rejuvenation. Younger generations are more likely to be skirting on the edges of more than one *intercultural* space and this complexity of where to situate oneself can often lead to statements of totality – either outright rejection or wholehearted (if not zealous) adoption of their perceived traditions and culture ('neo-traditionalism').

Resistance, development in the *intercultural* field

As argued here, interactions are significant fields of rejuvenation of culture, either through the search for distinction (*individuation*) or *mutuality* (symbiosis and dialogue between generations, individuals or community groups). In some ways, interculturality is a field of performance even within cultures, typically in terms of interactions between generations or those who consider themselves 'cultural bearers' whose responsibilities to the preservation of heritage and culture compels interaction and dialogue with youth as well as with external (development) actors. That is, within a given culture there are not only distinctions between individuals or classes but also tensions between generations, between what 'the old people do' and what the young want to do, free of gerontocratic authority. As the codes of identification and distinction may or may not serve the needs of individuals in the ever-changing context of their society, the motivation of youth to engage with their culture is in many ways dependent on the ongoing saliency of the meanings associating with identifying with it. In the case of Maasai young men, for example, the distinctions between young and old are significant in negotiating individual modern identities in relation to activities such as the jump dance, as it is automatically assumed that 'old men don't do it'. It is not about physical ability so much as a distinction and positionality of youthful identity – as a 'warrior' class that is essentially of a certain age category. Irrespective, the role of youth is vital and most community development strategies of Indigenous communities are concerned with keeping youth within or engaged with their cultural community.

As culture bearers, Maasai youth are one of the great exponents of, 'This *is what culture is*'. By their own account, they are a proud and resilient Indigenous group of people. A model

for cultural preservation provided by Maasai youth speaks to a strategy of replication of the 'glorious' past in an ever-changing world. The UNESCO Observatory experience with them was to design a cultural village.[6] The Maasai have been very successful, unlike many other Indigenous groups, in maintaining a high degree of their traditional ways of herding cattle and goats, dancing, singing, food and the role of men, women and youth.

Nonetheless, as is the case of youth in Guinea-Bissau reported by Gable (2000), there are younger generations of Maasai who have their own views on sustainable development in which there is a certain level of questioning of 'customs' or distinctive cultural practices. The tension that arises from the questioning of certain customs was evident, for example, in a discussion with a group of young women: they shyly admitted they did not want to forgo the ancient custom of female genital circumcisions. Progressive community leaders vigorously campaign to eliminate the practice, but change becomes impossible when the women themselves fear the change as making them ineligible for marriage because they have not adhered to the practice. In this sense, the *intercultural field of interaction* simply serves to reinforce cultural distinctiveness (*individuation*) and there is no sense of *mutuality* being reached either with external or internal development actors.

Culture learnings: arts and tourism

There has been an increasing demand for tourism practices that focus on maximising benefits while minimising the negative effects to poor or Indigenous communities; yet, there is little evidence that benefits have reached local communities. In the following case studies where eco-tourism is an important component of sustainable community development projects, we explore ideas about what it takes for interaction between culturally and developmentally con-scious tourism and local communities where wider participation among locals is a focal compo-nent of the strategy for gaining benefits. But, as it is beyond the scope of this chapter to explore the potential of a 'pro-poor tourism'[7] strategy, we instead provide examples of the cultural expressions and representations that emerged in the projects. These expressions and representa-tions are important avenues for exploring how creativity and innovation both sit in and cross the imposed boundaries of culture. In this sense, we draw on the concept of interculturality to illustrate the range of challenges to Indigenous artistic presence and authenticity that emerges through arts, crafts and performance.

Linking the connection between learning and place grounds the *interculturality* brought on through exchange with outsiders with that of the shifting internal dynamics and interactions between people within a culture. The 'global nature of the educational crisis facing indig-enous peoples' (McKinley, 2005, p. 228) and the problem of high school attrition rates among Indigenous youth are well documented. Most often, this educational crisis is assumed to relate to a lack of fit with the culture of the youth relative to the normative culture that is represented and embedded in institutions and formal education systems. A typical argument that is put forward for countering the Indigenous education disadvantage is to incorporate, into schooling, aspects of the 'traditional' culture. From a psychosocial perspective, there is understandably a concern with how to make a truly sustainable and effective education system for Indigenous youth that draws on the strengths of culture. Keeping this in mind, a number of projects incorporating the idea of drawing on a culture's strengths in the arts and crafts were initiated by UNESCO Observatory to provide an 'at home' feeling of a school environment that is safe and comfort-able – that is, changing the learning environment so that it reflects culture and heritage through vernacular architecture and incorporating arts, craft and performance to make it more condu-cive and appropriate.

Technology as a medium of Indigenous education and interculturality

As an alternative strategy, where youth are reluctant to follow the path of preservation and engagement with their culture as it is portrayed by elder generations within their communities, drawing on technology as a medium of education and interculturality can serve as a useful development strategy. With a focus on encouraging a more expansive localism, it is often possible to bridge the intergenerational divide by embedding cultural preservation within the forms that are enabled in the technological age. According to O'Connor, 'culture in the liquid modern world' is about 'the global pacing to a rhythm of technologically mediated communication' (2013, p. 4). Technology is interculturality and mutuality per se. It links distance and people (globalisation) but it also presents the forum for intergenerational questioning and conflict over tradition and culture. That is, of finding *mutuality* and a sense of shared community that is typically assumed to occur within specific local contexts in a greater intertwining of the global and the local (or, 'glocalism'[8]).

In a project aimed at linking youth and technology to enhance Indigenous Australian educational outcomes, the issue of culture and distance were of central concern. Using broadband technologies, the project[9] sought to connect Australian Indigenous students in the Fitzroy Crossing in the Kimberley Region of Western Australia with students studying at Wesley College in Melbourne. Yirramalay is a unique educational partnership between Wesley College (Melbourne) and the community of Fitzroy Crossing (WA) that aims to provide links between Aboriginal and non-Aboriginal Australians, and expand life opportunities and learning pathways for students in both communities. It is the first endeavour to offer senior high school level (i.e., Years 11 and 12) education in the region. Given the vast geographical distance the role of technologies in facilitating this is integral to its success.

The project incorporated visual spatial learning based on Indigenous myths, legends and symbology. Teaching Indigenous students through elements of their own culture automatically became more meaningful and effective. Through the use of iFish technology, students devised their own symbology and *intercultural learning* systems that were relevant to their culture. The structure of the medium was based on elements of their own culture and thus it became a more meaningful and effective teaching strategy through the use of imagery to serve as an anchor or reference point for the learner.

From the perspective of *interculturality*, and working against the tide of perceived loss of traditional culture and a sense of alienation of Indigenous youth from education, it is vital to find ways and means to improve schooling and provide a relevant curriculum for Indigenous students. The project found successful ways for students to express their culture and foster a better understanding between Indigenous and non-Indigenous students. Further, the fact the project was conducted at a school with Indigenous and non-Indigenous students provided an environment in which to investigate and explore ways in which a climate of reconciliation in relation to Indigenous Australians can be fostered among all young people. That is, the extent to which the *intercultural field* can serve as the focal point for reconciliation and exploration of new and effective ways to 'bridge the gap'[10] to improve Indigenous education.

Concluding remarks: intercultural field of interaction as a site of innovation

Arts and culture can be incredibly potent in bringing about change. A potent aspect of human expression and mutuality is that, through arts and culture, it is possible to assert individuality and

individual agency via the trope of conforming to cultural norms and expectations. For example, in following a traditional form of arts practice or in craft making, the artist, artisan or crafts person is also able to assert distinctiveness. That is, individuation emerges just as well from following or excelling as it does from diverging from the traditional or collective modes of practice. The extent to which this is recognised or acknowledged can significantly impact on achieving successful outcomes for sustainable community development.

Throughout this chapter we have highlighted the creativity and innovation that emerges through interaction and intercultural exchange as an interesting interplay between 'old' and 'new' and as a site for cultural conflict, rejuvenation and change. This interplay requires an interdisciplinary and intercultural research gaze that critically interrogates the notions of creativity and authenticity as lying within and across bounded notions of culture. And yet, it is only through interactions that issues of representation become most apparent.

As with the UNESCO Observatory cultural village projects, the emphasis on establishing guiding protocols and shared understandings about what working with culture means is essential. The sustainability issue is, fundamentally, then, about 'culture' that is able to allow others to come to a point of empathy, understanding and engagement, without locking it into some kind of essentialised 'tourist' object, in terms of addressing issues relating to how to showcase it and for whose benefit. To do that, individuation, mutuality and interculturality are continually negotiated and the process of this negotiation needs to be communicated as such from the onset. Arts and culture can be incredibly potent in bringing about change, even when they appear to be locked in a traditional or timeless form. Moreover, a potent aspect of human expression and mutuality is that, through art and culture, it is possible to assert individuality and individual agency via the trope of conforming to cultural norms and expectations in relation to the technique of doing art or craft. For example, in following a traditional form of art practice or craft making, artists, artisans or crafts people are also able to assert individual distinctiveness.

Certainly in relation to development, the more successful projects endeavour to get 'buy-in' from individuals and communities who are interested in reaching out to the broader (or mainstream) societies about showcasing and drawing on their culture to find avenues for improving their current circumstances. But this relies on individuals being engaged with their culture in a way that objectifies, selects and rejects aspects of it. Culture can serve as a useful tool for collective and individual identity as well as being a burden if it is not vibrant and able to accommodate fluidity and creativity.

Moreover, the tensions between interculturality and intergenerationality need to be better understood as a vital point of creativity and rejuvenation or preservation of culture. Certainly, these tensions can often be omitted from consideration in development practice and yet need to be critically examined and incorporated throughout the process. In this sense, 'culture', and the complex issues of interculturality, mutuality and individuation, call for stepping outside of bounded disciplinary discourses, and yet are fundamentally influenced by many of them.

In short, we suggest that the concepts of 'interculturality', 'mutuality' and 'individuation' as they are referred to in this chapter lend themselves well to an understanding of issues relating to seeing culture as an inherently *relational and interactional* field. These concepts speak to the potential of focusing not only on processes but also on symbolisms that are 'in play' in the interactions between people across cultures and across generations within a given culture. Further, the notion of an *intercultural field of interactions* provides an opportunity to consider the tensions in the process of cultural preservation as fundamentally embedded in relationships and interactions between actors who simultaneously seek *mutuality*, as referring to how people come together in harmony with aligned passions and experiences, and *individuation*, or the need for distinction in asserting both individual and collective identities.

Notes

1 We allude here to the definition of culture by Edward Tylor that, though prolifically debated by anthropologists, continues to encapsulate the concept, i.e., as 'that complex whole which includes knowledge, belief, art, law, morals, custom, and any other capabilities and habits acquired by man as a member of society' (1871, p. 1).
2 For a good summary of reflective practice, see Reason and Bradbury (2001).
3 See, for example, Choi, He and Herachi (2008) for an account of tensions between parents and children of Vietnamese and Cambodian immigrants.
4 For an account of immigrant youth and cultural dissonance and variations in ethnic self-identification see Hallett et al. (2008, p. 63); Choi et al. (2007); McKinley (2005).
5 Our work spans a number of societies and communities: Schubert in the Balkans and Timor Leste and Joubert's UNESCO Observatory Cultural Village projects – Lapland, Kenya, Torres Strait, Timor Leste, Cook Islands, Indigenous Australia and Papua New Guinea.
6 Students from various disciplines at The University of Melbourne travelled to Maasai land with Lindy Joubert, an architect and a marketing expert.
7 The 'pro-poor tourism' concept emerged in a more significant way as a strategy for sustainable development by the United Nations World Tourism Organization (see http://www.unwto.org/step/), and the call to enable the tapping into tourism by poor communities drawing predominantly on natural resources (see, e.g., Manyara & Jones, 2007). There are also many critiques of the pro-poor tourism idea (see, e.g., Harrison, 2008).
8 For an interesting exploration of the concept of 'glocalism' see Brodeur (2004, pp. 192–193).
9 The project was supported by IBES, International Broadband Enabled Society and conducted by Joubert with partners at the University of Melbourne aimed at connecting Australian Indigenous students via technology over vast distances with the Yirramalay/Wesley Studio School.
10 For an overview of the Closing the Gap in Indigenous Disadvantage policy, see https://www.coag.gov.au/closing_the_gap_in_indigenous_disadvantage.

References

Abraham, M., & Purkayastha, B. (2012). Making a difference: Linking research and action in practice, pedagogy, and policy for social justice: Introduction. *Current Sociology, 60*(2), 123–141.

Berry, J. W. (2008). Globalisation and acculturation. *International Journal of Intercultural Relations, 32,* 328–336.

Bourdieu, P. (1993). *The field of cultural production.* Cambridge: Polity Press.

Brodeur, P. (2004). From postmodernism to glocalism: toward a theoretical understanding of contemporary Arab Muslim constructions of religious others. In B. Schäbler & L. Stenberg (Eds.), *Globalization and the Muslim world: Culture, religion, and modernity* (pp. 188–199). Syracuse, NY: Syracuse University Press.

Choi, Y., He, M., & Herachi, T. W. (2008). Intergenerational cultural dissonance, parent–child conflict and bonding, and youth problem behaviours among Vietnamese and Cambodian immigrant families. *Journal of Youth Adolescence, 37,* 85–96.

Eberhard, C. (2008). Rediscovering Education Through Intercultural Dialogue. Contribution to the International Meeting of Experts, Cultural Diversity and Education, UNESCO/UNESCOC at Barcelona, 14–16 January 2008.

Gable, E. (2000). The culture development club: Youth, neo-tradition, and the construction of society in Guinea-Bissau. *Anthropological Quarterly, Special Issue: Youth and the Social Imagination in Africa, 73*(4), 195–203.

Giguere, B., Lalonde, R., & Lou, E. (2010). Living at the crossroads of cultural worlds: The experience of normative conflicts by second generation immigrant youth. *Social and Personality Psychology Compass, 4*(1), 14–29.

Hallett, D., Want, S. C., Chandler, M. J., Koopman, L. L., Flores, J. P., & Gehrke, E. C. (2008). Identity in flux: Ethnic self-identification, and school attrition in Canadian Aboriginal youth. *Journal of Applied Developmental Psychology, 29,* 62–75.

Harrison, D. (2008). Pro-poor tourism: A critique. *Third World Quarterly, 29*(5), 851–868.

Holland, D., Lachicotte Jr., W., Skinner, D., & Cain, C. (1998). *Identity and agency in cultural worlds.* Cambridge, MA: Harvard University Press.

Manyara, G., & Jones, E. (2007). Community-based tourism enterprises development in Kenya: An exploration of their potential as avenues of poverty reduction. *Journal of Sustainable Tourism, 15*(6), 628–644.

McKinley, E. (2005). Locating the global: Culture, language and science education for indigenous students. *International Journal of Science Education, 27*(2), 227–241.

O'Connor, P. (2013). Applying hybridity: Rhythms of the Hajj, Tumbler, and Snowden. *Glocalism: Journal of Culture, Politics and Innovation, 1*, 4–15.

Parsons, T. (1991) [1951]. *The social system. With a new preface by Bryan S. Turner*. London: Routledge.

Reason, P., & Bradbury, H. (Eds.) (2001). *Handbook of action research: Participative inquiry and practice*. London: Sage Publications.

Tylor, E. B. (1871). *Primitive culture: Researches into the development of mythology, philosophy, religion, art, and custom*, Vol. 1. London: John Murray.

Rasmussen, S. J. (2000). Between several worlds: Images of youth and age in Tuareg popular performances. *Anthropological Quarterly, Special Issue: Youth and the Social Imagination in Africa, 73*(3), 133–144.

31

GLOCALIZATION AND INTERCULTURALITY IN CHINESE RESEARCH

A planetary perspective

Samuel Leong

This chapter discusses some of the critical considerations when undertaking intercultural arts research, and proposes a "planetary-commonality" approach that is sensitive to global–local interactions as the point of departure for generating cultural understanding. It sees "interculturality" as involving positive interactions *between* different cultures on a number of levels, including sub-cultures, artistic cultures, gender cultures, linguistic cultures, and learning cultures. This distinguishes itself from a "fusion" approach by taking *togetherness* as the starting point and having the synthesis of "multiple identities" as its essence (see Rentschler & Huong Le, 2008). The three issues of identity, power relations and presence are examined and discussed with reference to three intercultural arts phenomena in Chinese cultural contexts: the transmission of the Cantonese opera tradition, the adaptive resiliency of Chinese diaspora musicians and the development of 'Cantojazz'[1] in a post-colonial society.

Globalization and interculturality

Globalization has witnessed more and more migrant populations interacting interculturally through transnational fields such as trade, finance, manufacturing and culture. Migrants continue to interact with people in their ancestral homelands while attempting to be integrated in their host countries (Portes & Zhou, 2012; Vertovec, 2004). This has markedly affected cultures through the "processes of 'glocalization', whereby local cultures adapt and redefine [what constitutes] cultural product to suit their particular needs, beliefs, and customs" (Giulianotti & Robertson, 2004, p. 546). It has been argued that "a profusion of 'glocal' cultures" have resulted from "long-running processes of transnational commingling and interpenetration," whereby the traditional demarcations of "'here-it-is' local and 'out-there' global cultures becomes increasingly untenable" (Giulianotti & Robertson, 2009, p. 46). Since communist China opened its doors in 1986 and joined the World Trade Organization in 2001, a new China has emerged in what has been labeled the "Asian Century" (Asian Development Bank, 2011). The 2008 Olympics witnessed the awakened economic giant showcasing herself as a contending world player. The post-Mao Chinese society in Mainland China, traditionally labeled a Confucian

nation, has been referred to as "consumerist postmodernity," characterized by consumerism, fragmentation and individualism (Lu, 2000, p. 146). Widespread consumerism, coupled with Chinese young people's learned "pragmatism" after the 1989 Tiananmen Square incident, has led the Chinese people to refocus their attention on their personal lives and well being. Even Western-influenced Confucian societies such as Korea, Singapore, Taiwan and Hong Kong (HK), with their unique established legacies and histories, are experiencing shifts in cultural values and norms as they become globalized—being increasingly mobile, diverse and mediated by modern technologies. Consequently, the widely held assumptions of what constitutes Chinese culture no longer hold water.

Changes in people's material circumstances have transformed their thinking about traditional cultures; and debates about nationalism, internationalization, and their relationship to a global world economy have raised cultural questions that are being focussed increasingly on people's attempts to understand "who we are" at both the individual and societal level (Crouch, 2010). The seminal work of Hofstede (1980) on cultural dimensions has been expanded to include a fifth dimension that acknowledges global cultural interactions with Confucianism (Hofstede & Bond, 1988). There is a new valuing of interculturality that gives recognition to "common human needs across cultures and of dissonance and critical dialogue within cultures" as well as the rejection of the claim that "only members of a particular group have the ability to understand the perspective of that group" (Nussbaum, 1997 cited in Kolapo, 2008, p. 135). Interculturality has been valued as a means by which member states in the European Union can promote social cohesion (European Commission, 2007). It has also been advocated by the United Nations Educational, Scientific and Cultural Organization (UNESCO) as a viable approach for addressing cultural challenges in increasingly pluralistic societies through emphasizing "universally shared values" that emerge from the interplay of "cultural specificities" (UNESCO, 2009, p. 43). In education, interculturality is considered a "transferable" competency, applicable to "dealing with cross-cultural contact in general, not just skills useful for dealing with a particular other culture" (Bennett, 2010, p. 2). The constructed nature of "learning cultures" in educational research is also an important aspect of interculturality (see Perkins, 2013).

While discourses surrounding multiculturalism and cross-cultural issues have been around for some time, the permeation of advanced communications technologies, globalization and glocalization processes, together with common concerns such as transparency, participation, power relations, social justice and gender equity have highlighted the impact of interculturality on world communities. Interactions between diverse cultures in continuously evolving social-cultural contexts have confronted researchers with the need to re-examine a whole host of issues. These include how culture is conceptualized, how it is manifested, how meaning is constructed, how to make sense of alterity, and how to devise research approaches that encapsulate the valuation of intercultural polylogue.

Intercultural arts and research

In today's globalized world, intercultural arts are characterized by catalytic coalescence between culturally diverse arts practices that integrate elements of each. This usually results in new artistic outcomes with multiple identities that cross cultural borders and involve exploration of the plethora of cultural modes of representation comprising the auditory, linguistic, visual, gestural and spatial. Some intercultural approaches may give partial attention to specific cultural factors such as ideology and discourse patterns, yet neglect other interpersonal and cultural factors that could impact on cultural exchange and understanding (Scollon & Scollon, 1995). Barth (2002) has pointed out that each cultural "tradition of knowledge" is characterized by its "distinct and

in their own ways stringent criteria of validity" (p. 10); but earlier intercultural approaches have tended to categorize and generalize differences between cultures (see Triandis, 1995; Hofstede, 1990; Hall & Hall, 1990). These have been criticized for their relativistic and deterministic points of view on culture, and the use of cultural typologies is cautioned for reinforcing ste-reotyping (see Zhu, 2004). The "ethnorelativism" approach accords equality and validity to all groups and does not judge others by the standards of one's own culture (Bennett, 1993). In order to value *the other*, the practice of defamiliarization has been advocated, i.e., making strange the dominant positions and assumptions, and challenging the limitations of cultural constructs that may be bound by a particular place and social position (see Emberley, 2007; Marcus & Fisher, 1986). "Cage painting" has been used to describe the reflective inquiry process in which the participants gradually become aware of their own cultural perspective and the cultural perspective of the other (Rimmington & Alagic, 2008). Recent approaches are paying more attention to Eurocentric intellectual imperialism, indigenous perspectives, equality and mutual-ity in communication (see Asante, Miike & Yin, 2008), and a "renewed framework of critique" (Otto & Bubandt, 2010, p. 20).

The ubiquity of interculturality presents new challenges and possibilities for modern researchers, who can no longer apply a monolithic view of identity. Interculturality exposes researchers to the potentiality of new meanings and outcomes when different cultural worlds and symbolic systems as well as individual and collective cultures come together. This interac-tive dynamic of *positive togetherness* creates a *catalytic* and *coalescent* impact upon the customs, values and beliefs of the communities involved, forming a complex intercultural system of identity, power relations and presence that continually evolves. The three salient characteristics of positive togetherness, catalytic coalescence and transformed intercultural system are dem-onstrated in the unique contexts of three selected Chinese cultural arts phenomena, which are described in the next sections.

Phenomenon 1: transmission of Cantonese opera tradition

Traditional Cantonese opera is located in a globalized and intercultural environment of the Pearl Delta region comprising HK (a former British colony), Macau (a former Portuguese colony) and Guangdong (Mainland China). The region has been identified as the world's first and largest "mega-region" in a United Nations' State of World Cities Report (Vidal, 2010). Cantonese opera carries a regional identity that dates back to the Southern Song Dynasty in the 13th century, and has been a popular art form since the Qing Dynasty (1644–1911). It uses the Cantonese language and involves music, singing, martial arts, acrobatics and acting. Defined by its distinct performance style, stage practices, and regional- and dialect-based iden-tities, Cantonese opera originated as a traditional art form performed by itinerant companies in temple courtyards and rural market fairs. In the early 1900s, Cantonese opera began to capture mass audiences in the commercial theaters of colonial HK and Guangzhou. During the 1950s, HK witnessed a golden age of traditional Cantonese opera, with many actors in lead roles (known as "*wenwusheng*") commanding the scene (e.g., Yam Kim-fai, Ho Fei-fan, Lam Kar-sing, Mak Bing-wing, Chan Kam-tong and Sun Ma Sze-tsang). By creating classics in their repertoires and cutting a distinct profile as virtuosos, they became icons of Cantonese opera. Unfortunately, Cantonese opera suffered a decline with the introduction of Western pop music and movies in the 1970s in HK (Chan, 1991). But its cultural status and identity was given a boost when UNESCO recognized it as "intangible cultural heritage of humanity" in 2009. The HK government has also given support by setting up the Cantonese Opera Advisory Committee (in 2004), the Cantonese Opera Development Fund (in 2005), and injecting nearly

US$9 million (in 2010–11) for projects and activities relating to the study, promotion and sustainable development of Cantonese opera.[2]

Unlike most other varieties of Chinese, Cantonese—a southern Chinese dialect from the native areas of Guangdong and Guangxi—enjoys a de facto official status (in HK and Macau), and has an independent tradition of written vernacular. Since 1997, the former British colony has been accorded a high degree of autonomy as a modern, international, metropolitan city of 7 million people, governed as a Special Administrative Region (SAR) of the People's Republic of China (PRC). But central government policies that affect the Cantonese language could threaten the sustainability of Cantonese opera. Another threat to Cantonese opera is the way its artistic traditions and practices are transmitted to the next generations. As Chinese societies modernize, the transmission of operatic traditions from master to apprentice is no longer viable and sustainable, and modern academies and conservatories are taking over the role of Cantonese opera training. Moreover, it has evolved from a fundamentally rural tradition into a form of urbanized entertainment distinguished by a reliance on capitalization and celebrity performers. Its growth into a global phenomenon has been catalyzed by waves of Chinese emigration to Southeast Asia and North America that re-shaped Cantonese opera into a vibrant part of the ethnic Chinese social life and cultural landscape in the many corners of a sprawling Chinese diaspora (see Ng, 2015).

The oral transmission process requires extensive insider knowledge and intensive "professional" immersion experiences and future artists cannot easily be "trained" via academic programmed approaches. As Cantonese opera artist training moved away from the master–apprentice oral tradition, future artists would be nurtured through an academy system[3] that features a pre-determined curriculum, limited teacher–student contact hours, and limited exposure to staged master performances (see Leung, 2014a). These trainees would learn from different teachers who might come from different styles and would not "inherit the artistry of a specific sect" (Leung, 2014b, p. 18). This practice could "generate different artists with analogous artistic styles," considered to be "detrimental to the creative development of this traditional art form." It would be useful for academies to shift their learning culture to accommodate key elements of the apprenticeship model that include closer teacher–learner relationship, non-formal learning contexts, and "intensive peripheral participation" (ibid., p. 18).

The intercultural evolution continued over the years and the media also played an important part in the transmission process of Cantonese opera. During the 1960s and 70s, HK people gained exposure to Cantonese opera through films, many of which were televised. These provided an important means of giving prominence to opera actors and improving their status, with enormous numbers made by Wong Hok-sing (1913–1994).[4] An example is the well-known collaborative production of *The Flower Princess* (帝女花) by Tong Dik Sang (1917–1959), Yam Kim-fai (1912–1989) and Pak Suet Sin (1928–), which was premiered in 1957, and underwent two film adaptations (1959 and 1976) in addition to a 1960 audio recording. The media not only contributed to its popularity but modern technologies of representation also shaped the audience's sensory experience and memories of this traditional operatic genre. The 1960 recording was repeatedly reissued in various audio formats and lauded as the "authoritative interpretation" of the work for more than 50 years (Tong, 2010, p. x).

The living reality of Cantonese opera in 21st-century HK illustrates the dynamism of intercultural arts. The interactions between Chinese, colonial, Western and south-east Asian cultural as well as artistic elements are embedded with a mix of different identities, interplayed with global and local forces, and promulgated by the media and performance opportunities. Its rich cultural tapestry is layered with a host of issues pertinent to research design (including the Chinese language and dialects, musical and stage conventions, evolving aesthetics, issues of

training and production and the impact of technology) that defy the limitations of traditional cultural paradigms.

Phenomenon 2: adaptive resiliency of Chinese diaspora musicians

The Chinese diaspora is another dimension of direct relevance to intercultural research. The complexities of the development of identity are increased when a foundational culture is displaced and re-established in another location. As the glory days of the Qing Dynasty waned and China was hit with economic hardship and civil disorder (from 1850 to 1930), millions of Chinese men and women sought their fortunes overseas, many journeying south into French Indochina as well as HK, Indonesia, Borneo, Malaysia and Singapore (see Barrett, 2012; Zheng, 2011). One of the groups was the Chaozhou people, native to the Chaoshan region of eastern Guangdong province, who speak the Teochew dialect. More than one million Chaozhou people are estimated to live in HK, most of them having arrived in the mid-20th century, although some had migrated to HK a century earlier (Sparks, 1978, p. 25).

A form of string ensemble folk music from the Chaozhou region is Chaozhou *xianshi* (Dujunco, 1994), and diasporic *xianshi* musicians have continued to maintain their practices, performances and musical traditions since settling in HK. *Xianshi* music belongs to the Chinese folk category of *sizhu* (silk and bamboo; 絲竹) music that is played indoors on a variety of stringed and wind instruments (ibid.). The term *xianshi* literally means "string poems," suggesting its repertoire had included accompanied songs, but none of the lyrical or vocal traditions have survived the times (Jones, 1998, p. 324). Chaozhou music clubs can be found in nearly all Chaozhou communities in different parts of the world (Dujunco, 1994). These clubs have served as the main traditional venue for the transmission of *xianshi* music as well as the central performance setting where musicians meet regularly to perform their favourite pieces. In HK, the music division of the Hong Kong Chiu Chow Merchants Mutual Assistance Society has served as regular meeting place for the weekly music gathering since the 1950s (see Ng, 2006). Generally speaking, *xianshi* musicians learn their instruments and practice for the purpose of self-cultivation (ibid.). Although *xianshi* musicians come from diverse social backgrounds and occupations, they are usually male and belong to the tradition of amateur music making. Women's traditional subservient status in Confucian Chinese society is reflected in *xianshi* musical practice. Gender had been a major determinant of what musical activities were "open" to an individual, and many instrumental ensembles both amateur and professional were restricted to men until the 20th century (see Herndon & Ziegler, 1990). Women usually played plucked string instruments such as the *zheng* and *pipa*, a status symbol of belonging to the elite and literati classes (Ng, 2006, p. 81). *Xianshi* music has been transmitted by enculturation and in an informal way through a process of listening and imitation (Ng, 2006), and the musicians are closely bonded by their sense of *identity* as Chaozhou people. While they value their music and musical practices and put in enormous efforts to retain the authenticity of their performance practices, there have been significant changes in recent years. The *xianshi* ensemble has incorporated the cello as it traditionally lacks a lower register instrument, and some ensembles make use of microphones to amplify the voices of singers (see Mok, 2010). The role of women has also changed, and male *xianshi* musicians are adopting a more welcoming attitude towards women, "allowing them to participate, become involved, and to understand the music"—with the hope that their music will be passed down to the next generation (Mok, 2014, p. 250).

The story of the diasporic *xianshi* musicians illustrates the complex interactions of social-cultural dynamics occurring at different stages, places, and layers of the intercultural intercourse. Each individual and specific group of actors would have a different take on their

"story"—not only in terms of how they construct meaning from their experiences but also the manner by which these are shared. It would also depend on how different aspects of their experiences are perceived, received and given weight—and by whom. As traditions, conventions and boundaries change over time, "home truths" will inevitably become outmoded. This is applicable to disciplines and research methodologies. Emerging notions of artistic cultures, gender cultures, linguistic cultures, popular cultures and learning cultures not only offer new areas of research, they necessitate the development of new research approaches that can cater for complex research problems distributed across disciplines, and which may manifest in many different forms. This calls for creative intercultural approaches to research in communities, education, and art worlds.

Phenomenon 3: development of cantojazz in a post-colonial society

Soon after the Second World War, artists and capitalists from Shanghai began migrating to HK, bringing with them a variety of entertainment including Mandarin pop songs. The latter quickly found favour with upper class Chinese, giving them some relief from societal and personal sorrows and grief, and melodies by popular singers such as Zhou Xuan, Li Xianglan and Bai Guang were widely played on the radio and in nightclubs. Other Chinese who spoke different dialects also developed their own music, but the Cantonese masses remained faithful to their Cantonese opera. Although HK is predominantly Cantonese speaking, this was not always the case. In the 1950s, immigrants came in from different regions of China, and many were more familiar with Mandarin than with Cantonese. Theme songs or tracks sung by the leading actors and actresses were widely featured in local Mandarin and Cantonese movies. Some of these tunes contributed greatly to the cultured images of film stars and became all-time favourites; and many of the Cantonese theme songs appealed to the masses with their true-to-life colloquial lyrics.

Following the upturn in HK's economy in the 1970s, stable livelihoods empowered locals with greater spending power, which in turn fostered the development of local culture. The backdrop of political stability, sustained social development and strong economic growth aided the rise of Cantopop. By this time, the television was fast becoming a household item that offered free entertainment to the public and exerted great cultural influence on all classes of society, particularly the post-1970s generation which grew to accept works of entertainment that were primarily written and performed in Cantonese. Cantopop's success was built on this foundation of popular culture fanned by broadcasts on both radio and television. Seeing how Cantopop had taken the local music scene by storm, recording companies began investing in Cantopop records, and many singers who used to sing English and Mandarin pop songs switched to Cantonese. The rise of Cantopop coincided with China's open borders policy and Cantopop songs were successfully exported into China. About the same time, HK television programs started to find new audiences on the Mainland and in Southeast Asia, with exported television productions opening up new markets for Cantopop music (see Wong, 2003; Chow, 2007).

Cantopop reached its height of popularity in the 1980s and 1990s before striking a slow decline in the 2000s. This period saw the rise in popularity of Korean pop, along with a diverse range of imported musical styles from regions around the world that contributed to a greater stylistic diversity of Cantopop music. Its decline could be attributed to the limited access to popular music training, as such training was only available outside the established education sector that did not emphasize the value of the arts. It was not until 2008 that popular music and jazz studies were first offered as part of a bachelor's degree program at a government-funded higher education institution. In the same year, an education-focussed Choral Jazz Festival commissioned

a theme song that incorporated Chinese and European musical and American jazz elements. This coincided with the first ever *Hong Kong International Jazz Festival 2008* organized by the Hong Kong Jazz Association. The following year saw a creative and collaborative Cantojazz project initiated at the Hong Kong Institute of Education that involved university administrators, staff and students of two tertiary institutions (one in HK and one in USA), and a local music education professional association. Recognizing the importance of pre-service teachers gaining knowledge and skills beyond the classical traditions, the project targeted students from the Bachelor of Education program. The task was for students to create musical arrangements of selected songs by the Chinese composer Huang Zi (1904–38) from a published song collection (Wong, Lai, Ng & So, 2004). These were to be Cantojazz choral arrangements that integrated Cantonese, Chinese and Western European cultural and musical elements. The project encouraged intercultural interactions between the different cultural elements while maintaining a strong sense of identity and authenticity, giving respect to the various components involved. A full choir and jazz ensemble performed selected Cantojazz arrangements by students and the most promising arrangements were published as a collection (Lai, 2011).

The inclusion of Western popular and jazz music cultures in the tertiary music curriculum of a post-colonial setting is the subject of a study which investigated students' new awareness of Cantojazz and their responses to this new "cultural product." Student arrangers were positive with this intercultural experience and believe Cantojazz could be transformed into a new music genre in HK. The study has identified Cantopop as "the mainstream culture" in HK, and suggests the inclusion of Cantojazz elements in primary and secondary music education (Chen, 2014, p. 81). Another study investigated HK primary school students' responses to the use of jazz warm-up exercises in a traditional choir practice context. Students were found to be interested in jazz warm-up exercises and positive towards increased exposure to jazz music (Chen & Han, 2013).

The three phenomena described above show how intercultural arts are multidimensional and multilayered, coalescing with multiple identities, multiple truths and multiple manifestations. Each of the intercultural arts phenomena demonstrates how single entities contribute towards a catalytic effect on the emerging whole. It also illustrates how affirmative social-cultural interactions of diverse arts practices have transformed customs, values and beliefs of the communities involved, with the resultant creation of a new complex intercultural system that supports a new artistic outcome. Because every specific issue that matters can mean different things locally and individually, it can never be changed from above and nobody can really be in control. Moreover, change requires processes that are resistant to prediction, and takes time and negotiation as well as adjustment to the various aspects of the cultural eco-systems at play.

Complex issues in intercultural arts

In the previous section, we have discussed how intercultural arts are characterized by positive togetherness, catalytic coalescence and the transformation-creation of a new intercultural system at the macro level. In this section, three complex and interconnected issues of significance to researchers at the micro level will be discussed. These are: identity, power relations and presence.

Identity

Identity plays a central role in the intercultural relationship with *otherness* and it evolves through the engagement with the *other*. It embeds a wide range of socio-cultural parameters that

include gender, age, social class, ethnicity, race, generation, nationality, language, religious faith, sexual orientation, profession, socio-economic status, and place/space (see Brubaker, 2006; Bauman, 2004; Ewing, 1990). In relation to the Cantonese and Chaozhou dialect-groups residing in HK, their Chinese cultural identity is intricately rooted in their particular regional cultural heritage, the evolving globalized HK culture, and the strength of their ongoing cultural awareness of their Chinese heritage. Their specific dialect-group cultures are also influenced by Chinese core values and the contextual socio-economic and political specifics that continue to evolve. This is complicated in a globalized world that is mediated by technology, where large diasporic Chinese communities are spread around the world and where there are increased non-Chinese interests in Chinese culture. For those affected by the Chinese diaspora, the different cultural art forms are constantly being reshaped and reconstructed as the Chinese adapt to the different societies in which they live/work and to the tenure of the times. As noted earlier, Cantonese opera directly contributed to the development of Cantopop, and both genres were popularized by HK cinema with Western technology. Even the traditional "identity" of Cantonese opera is being challenged—as evident in a celebrative event of the 50th anniversary of the famed *Flower Princess* (帝女花) that included a "Youth Edition" production of the play. Featured as part of the "International Cantonese Opera Academic Conference 2007," organized by the Chinese University of Hong Kong, this "Youth Edition" had a rerun in 2009.[5]

A prevalent question today is: what is meant by *Chineseness*? How *Chinese* is Cantonese HK? A recent Chinese University of HK survey[6] conducted during the October 2014 Occupy Central protests found a decline in the number of HK residents choosing to identify themselves as Chinese. Only 8.9 percent of respondents identified themselves as "Chinese," compared to 26.8 percent who chose "Hongkongers," 42 percent "Hongkongers but also Chinese," and 22.3 percent "Chinese but also Hongkongers" (Siu & Cheung, 2014). Indeed "Chineseness" is not something that is fixed but constantly being renegotiated and recreated by the individuals and groups concerned. Chinese identities continue to shift in response to social, economic and political situations as well as the relationship between the "Chinese" and the dominant society in which they live or work. The identities of the Chinese in diaspora are fluid or flexible, and "a postmodern notion of ethnicity . . . can no longer be experienced as naturally based on tradition and ancestry" (Ang, 1993, p. 14). The renowned film director, Ang Lee, has described Chineseness as an "abstract" concept: "Wherever you come from, whether it's China or Hong Kong or Taiwan, or New York, you're just Chinese; it's sort of generalized and merged, and people are drawn to each other by that abstract idea of being Chinese" (cited in Berry, 1993, p. 54).

Wang (1988) has argued that "Chineseness" was never conceptualized as an "identity" until the 20th century (see pp. 19–20). It is unfortunate that the categories through which people have understood "Chineseness" and its transformation since the mid-19th century are the "universal" categories through which anthropologists and historians have constructed an understanding of how the world has come to be as it is in the early 21st century. It is unfortunate, too, that these categories have derived from, or are informed by, the modern conceptions of sovereignty: national vs. transnational, colonial vs. post- (or neo-)colonial, local vs. global, emplaced vs. de-territorialized, traditional vs. (post-)modern (Clayton, 2010, p. 18).

The identity of the *self* is forged through a process of recognition; and it can happen at a number of levels. In relation to the three phenomena in question, the *self* can be viewed from at least five dimensions: international, national, provincial/city, cultural, arts. This can involve a *comparison* between the self and the other—when the self attempts to determine perceivable similarities and differences before arriving at self-identity or "Who I am." It can also be a process

of self-clarification in *relation* to the other as a particular being. While the other may be different from the self, the self cannot attain self-consciousness or a sense of self-identity without understanding the other. In this way, the other is closely related to the self, functioning as a reflection for the self to review itself. By having the other as a mirror for the self, the self is assisted in recognizing its own image which, in turn, aids the conceptualization of self-identity.

Power relations

Countries in powerful positions capitalize on their economic, political and military advantages to exert influence on less developed countries through globalization. A socially dominant cultural mode is usually asserted as the desired goal for others to achieve. This process of identifying the self with the other in the process of globalization has significantly impacted on modern Chinese identity. While post-colonial HK has to face motherland China, the latter has to confront a stronger "other" in Western developed countries. China's modernization process requires intercultural resolutions to maintain independency and cultural traditions while courting West-centric cultures and values. The dynamics of China's "new identity crisis" have been analyzed as follows: (1) intercultural interactions between modern commercial fundamentalism and traditional parochialism, and (2) integration at the top with collapse at the bottom. The first recognizes how expanding global commerce and the corporate control of the political process have weakened the autonomy and power of local communities, threatening the identity and culture of smaller communities while at the same time leading to the reassertion of ethnic and religious identities. The second laments the negative consequences of the globalized economy such as the erosion of established traditions, cultural morality, and identity despite the improvement in the living standards of people at the grassroots. The elites of the different regions and industries have also become more united and integrated behind the benefits of shared economic interests (Wang, 2014).

The transmission hurdles of Cantonese opera and *xiangshi* music, and the inclusion of Cantojazz into the curriculum demonstrate the presence of different power dynamics and power relations at various levels. These dynamics affect the proper role or "place" accorded to the other, the controls behind people's lives, how they present themselves, and more importantly, the power relationships. The latter influence intercultural matters such as language, equity, access (provision) to the art forms, space and place given for staging the art forms, business and community support and government policies. For the cultural arts, the authoritative status, position, voices and traditions/modus operandi of the masters, elders, leaders and dominant society as a whole, had to negotiate with new players and societal forces for cultural continuity, sustainability and innovation. The threat of these cultural and intercultural realities being ignored or neglected in decision-making processes by dominant powers should be of concern to researchers. Their adoption of appropriate research approaches is critical for challenging underlying assumptions and exercising diligence in the careful consideration of sensitive issues. Indeed researchers possess the power to decide on the extent to which such issues would be addressed.

Presence

The issue of presence is closely interconnected with that of power relations—in what ways and to what extent is the less powerful given *presence* within the dominant culture? The three different genres of Cantonese opera, *xiangshi* music and Cantojazz had to seek and be allocated space for their respective presence in post-colonial HK, capitalist-communist China,

and in places that host the diaspora. But the kind of presence would very much depend on the power solution to the demand for more than tokenistic presence. Apart from seeing the tension as between the dominant culture *against* the less dominant culture, an intercultural solution views the dominant *in relation* with the less dominant—together seeking a *third culture* space (see Patel, Li & Sooknanan, 2011; Lee, 2006). This *third culture* space is created by diverse cultural communities interacting through dialogue, negotiation and meaningful engagement to blend globalization with localization in the process of glocalization. This means rejecting any form of relativism and ethno-centrism. It also means confronting local and global realities and encountering the world collaboratively in relation to individual and collective sustainable futures.

Coda

This chapter has proposed a "planetary-commonality" intercultural approach that is sensitive to global–local interactions, locating *togetherness* as the starting point. At the macro level, three salient characteristics of intercultural arts have been revealed by the three phenomena described in this chapter: positive interactions between different cultures, catalytic coalescence, and an eventual transformed intercultural system. At the micro level, a variety of *multiple* and *evolving* identities interface in a complex interplay with power relations and presence. These are offered as a framework for research into interculturality (see Figure 31.1).

The three intercultural arts phenomena in this chapter can serve as *stories* of identities that reflect the multiple selves being transformed over the process of time. It would be impossible for these stories to be told over and over again as finished products, but hopefully some sense of unity, coherency and continuity could emerge. As identity and otherness are not stable realities, perceptions on the way cultures represent themselves may be more appropriately treated as "constructs" rather than "truths." Instead of just focussing on "somebody's identity,"

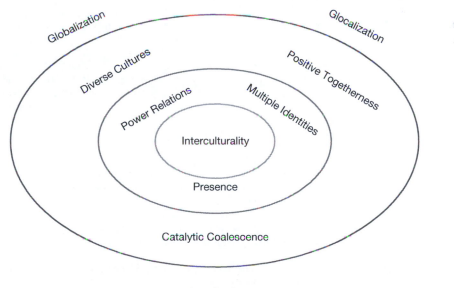

Figure 31.1 Research issues in interculturality.

researchers might also be interested in how different people construct what they present as their identity and how they identify themselves. Research studies might need to question what could compromise methodological paradigms, discipline-based beliefs, assumptions, values, and aims of inquiry, as well as how methodological paradigms are socially sensitive and constituted. Wimmer (2007) has alerted researchers to the "fallacy of assuming communitarian closure, cultural difference and strong identities. The study has to ask, rather than take for granted, whether there is indeed community organisation, ethnic closure in networking practices, a shared outlook on the host society" (p. 28).

Consideration may also need to be given to "interactions between inequality-creating social structures (i.e., of power relations), symbolic representations and identity constructions that are context-specific, topic-orientated and inextricably linked to social praxis" (Winker & Degele, 2011, p. 54).

With the world facing massive global, regional and local changes, the possibilities of intercultural interactions are vital for the future of local and regional cultures. These entail a deliberate re-evaluation of long-held values pertaining to power influences, continuity, cultural pride and obligation, resilience and openness. Researchers of interculturality can play a significant role here. They can shed new insights into shared cultural futures that need to be re-imagined and co-created with a sense of exploration and adaptability. And they can advocate for intercultural arts to lead the way in embracing a multi-perspective worldview that celebrates the positive contributions and the beneficial attributes of participating cultures without imposition on, and threat to, cultural values and beliefs.

Notes

1 Cantojazz is an emerging music genre from the 1990s that combines classic Cantopop (Cantonese popular music) styles and jazz.
2 The government has also developed venues of different scales to cater for the development needs of Cantonese opera, including the conversion of Yau Ma Tei Theater and Red Brick Building into a Xiqu activity center, the construction of the Ko Shan Theater Annex with a medium-sized theater and a planned Xiqu center in the West Kowloon Cultural District (WKCD). The Cantonese Opera Development Fund together with the Leisure and Cultural Services Department and Arts Development Council, organize or subsidize thematic and large-scale arts education, community promotion and audience development projects, such as the Research and Pilot Scheme on the Teaching of Cantonese Opera, District Cantonese Opera Parade, the Pilot Scheme for Senior Secondary School Students and the Cantonese Opera Promotion Scheme for the Youth and Community. Since 2012, the WKCD Authority has been hosting the annual Cantonese opera performances and film screenings at its West Kowloon Bamboo Theatre during the lunar new year. The HK Heritage Museum has a hall devoted to artifacts related to the Cantonese opera and its history, including a reconstructed theater, librettos and multimedia programs. It also runs a weekly Cantonese opera appreciation class in English on Saturday afternoons that feature a performance by a local troupe.
3 In 2013, a four-year Bachelor of Fine Arts (BFA) degree program in Cantonese Opera was launched at the Hong Kong Academy of Performing Arts. The new program addresses both the globalization and localization issues by balancing between practical courses for skill development and liberal arts and general education, including English and Putonghua. Students would develop a comprehensive awareness of history, script writing, Chinese literature and culture, local culture, arts administration, as well as all backstage practices including lighting, costume making, and prop making. Graduates are expected to be able not only to perform the traditional art form but also work in relevant fields such as troupe management, promotion and education of the genre.
4 See http://www.info.gov.hk/gia/general/201311/15/P201311150603.htm
5 This was organized by the Chinese University of Hong Kong; a rerun of this "Youth Edition" took place in 2009.
6 See http://hkupop.hku.hk/english/release/release1150.html

References

Ang, I. (1993). To be or not to be Chinese: Diaspora, culture and postmodern ethnicity. *Sojourn, 21*(1), 1–17.

Asante, M. K., Miike, Y., & Yin, J. (2008). *The global intercultural communication reader*. London: Routledge.

Asian Development Bank (2011). *Asia 2050: Realizing the Asian century*. Manila, Philippines: Author.

Barrett, T. C. (2012). *The Chinese diaspora in South-east Asia: The overseas Chinese in Indochina*. New York: I.B. Tauris.

Barth, F. (2002). An anthropology of knowledge. *Current Anthropology, 43*(1), 1–11.

Bauman, Z. (2004). *Identity*. Cambridge, UK: Polity Press.

Bennett, M. (1993). Towards ethnorelativism: A developmental model of intercultural sensitivity. In M. Paige (Ed.), *Education for the intercultural experience* (pp. 21–71). Yarmouth, ME: Intercultural Press.

Bennett, M. (2010). A short conceptual history of intercultural learning in study abroad. In W. Hoffa & S. Depaul (Eds.), *A history of U.S. study abroad: 1965–present* (pp. 419–449). Special publication of *Frontiers: The Interdisciplinary Journal of Study Abroad*.

Berry, C. (1993). Taiwanese melodrama returns with a twist in *The Wedding Banquet*. *Cinemaya, 21*(Fall), 52–54.

Brubaker, R. (2006). *Ethnicity without groups*. Cambridge, MA: Harvard University Press.

Chan, S. Y. (1991). *Improvisation in a ritual context: The music of Cantonese Opera*. Hong Kong: Chinese University Press.

Chen, C. W. C., & Han, W. L. (2013). A pilot study of using jazz warmup exercises in primary school choir in Hong Kong. *Music Education Research, 15*(4), 435–454.

Chen, C. W. C. (2014). The new awareness of Canto–jazz in the jazz arrangement project. In S. Leong & B. W. Leung (Eds.), *Creative arts in education and culture: Perspectives from Greater China* (pp. 69–81). Dordrecht: Springer.

Chow, Y. W. S. (2007). *Before and after the fall: Mapping Hong Kong Cantopop in the global era* (LEWI Working Paper Series no. 63). Hong Kong: David C. Lam Institute for East-West Studies.

Clayton, C. H. (2010). *Sovereignty at the edge: Macau and the question of Chineseness*. Cambridge, MA: Harvard University Asia Center.

Crouch, C. (Ed.). (2010). *Contemporary Chinese visual culture: Tradition, modernity, and globalization*. Amherst, NY: Cambria Press.

Dujunco, M. M. (1994). *Tugging at the native's heartstrings: Nostalgia and the post-Mao "revival" of the Xian Shi Yue string ensemble music of Chaozhou, South China*. Unpublished PhD thesis, University of Washington.

Emberley, J. V. (2007). *Defamiliarizing the aboriginal: Cultural practices and decolonization in Canada*. Toronto: University of Toronto Press.

European Commission (2007). *A European agenda for culture in a globalizing world*. COM (2007), 242 final, 10 May 2007. Available at: http://aei.pitt.edu/38851/

Ewing, K. P. (1990). The illusion of wholeness: Culture, self, and the experience of inconsistency. *Ethos, 18*(3), 251–278.

Giulianotti, R., & Robertson, R. (2004). The globalization of football: A study in the globalization of the "serious life." *British Journal of Sociology, 55*(4), 545–568.

Giulianotti, R., & Robertson, R. (2009). *Globalization and football*. London: Sage.

Hall, E. T., & Hall, M. R. (1990). *Understanding cultural differences*. Yarmouth and London: Intercultural Press.

Herndon, M., & Ziegler, S. (Eds.). (1990). *Music, gender and culture*. New York: Peters.

Hofstede, G. (1980). *Culture's consequences: International differences in work-related values*. Newbury Park, CA: Sage Publications.

Hofstede, G. (1990). *Culture's consequences: International differences in work-related values*. Newbury Park, CA: Sage Publications.

Hofstede, G., & Bond, M. H. (1988). The Confucius connection: From cultural roots to economic growth. *Organizational Dynamics, 16*(4), 5–21.

Jones, S. (1998). *Folk music of China*. Oxford: Clarendon.

Kolapo, F. J. (2008). *Immigrant academics and cultural challenges in a global environment*. Amherst, NY: Cambria Press.

Lai, S. P. (Ed.). (2011). *Huang Tzu song's collection* [jazz version]. Hong Kong: The Hong Kong Institute of Education.

Samuel Leong

Lee, S. (2006). Somewhere in the middle: The measurement of third culture. *Journal of Intercultural Communication Research, 35*(3), 253–264.

Leung, B. W. (2014a). Transmission and transformation of Cantonese Opera in Hong Kong: From school education to professional training. In S. Leong & B. W. Leung (Eds.), *Creative arts in education and culture: Perspectives from Greater China*. Dordrecht: Springer.

Leung, B. W. (2014b). Utopia in arts education: Transmission of Cantonese opera under the oral tradition in Hong Kong. *Pedagogy, Culture & Society, 22*(3), 1–21.

Lu, S. H. P. (2000). Global postmodernization: The intellectual, the artist and China's condition. In A. Dirlik & X. Xudong (Eds.), *Postmodernism and China* (pp. 145–174). Durham, NC: Duke University Press.

Marcus, G., & Fisher, M. (1986). *Anthropology as cultural critique*. Chicago, IL: University of Chicago Press.

Mok, O. N. A. (2010). Diasporic Chinese xianshi musicians: Impact of enculturation and learning on values relating to music and music-making. *International Journal of Education & the Arts, 12*(1). Retrieved 20 May 2014 from http://www.ijea.org/v12n1/.

Mok, O. N. A. (2014). The indigenous culture of Chaozhou xianshi music and diaspora musicians in Hong Kong. In S. Leong & B. W. Leung (Eds.), *Creative arts in education and culture: Perspectives from Greater China*. Dordrecht: Springer.

Ng, C. H. D. (2006). *The impact of exposure to Chaozhou Xianshi music on pre-service teachers' development as music educators*. Unpublished PhD thesis, University of New South Wales.

Ng, W. C. (2015). *The rise of Cantonese opera: From village art form to global phenomenon*. Champaign, IL: University of Illinois Press.

Nussbaum, M. C. (1997). *Cultivating humanity: A classical defense of reform in liberal education*. Cambridge, MA: Harvard University Press.

Otto, T., & Bubandt, N. (2011). Beyond the whole in ethnographic practice? In T. Otto & N. Bubandt (Eds.), *Experiments in holism: Theory and practice in contemporary anthropology* (pp. 19–27). West Sussex, UK: Wiley-Blackwell.

Patel, F., Li, M., & Sooknanan, P. (2011). *Intercultural communication: Building a global community*. New Delhi, India: Sage.

Perkins, R. (2013). Learning cultures and the conservatoire: An ethnographically-informed case study. *Music Education Research, 15*(2), 196–213.

Portes, A., & Zhou, M. (2012). Transnationalism and development: Mexican and Chinese immigrant organizations in the United States. *Population and Development Review, 38*(2), 191–220.

Rentschler, R., & Huong Le, A. O. (2008). *Western Australia intercultural arts research project*. Victoria, Australia: Centre for Leisure Management Research, Deakin University.

Rimmington, G. L., & Alagic, M. (2008). *Third place learning: Reflective inquiry into intercultural and global cage painting*. Charlotte, NC: Information Age Publishing.

Scollon, R., & Scollon, S. W. (1995). *Intercultural communication*. Oxford: Blackwell.

Siu, P., & Cheung, T. (2014). Poll finds fewer Hongkongers identifying as Chinese, thanks to Occupy. *South China Morning Post*, 11 November, 2014. Available at http://www.scmp.com/news/hong-kong/article/1636818/poll-finds-fewer-hongkongers-identifying-chinese-thanks-occupy?page=all

Sparks, D. W. (1978). *Unity is power: The Teochiu of Hong Kong*. Unpublished PhD dissertation, University of Texas at Austin.

Tong, D. S. (2010). *The flower princess: A Cantonese opera*. Hong Kong: Chinese University Press.

Triandis, H. C. (1995). *Individualism and collectivism: New directions in social psychology*. Boulder, CO: Westview Press.

United Nations Educational, Cultural and Scientific Organization (2009). *UNESCO World Report: Investing in cultural diversity and intercultural dialogue*. Paris: Author. Available at: unesdoc.unesco.org/images/0018/001847/184755e.pdf

Vertovec, S. (2004). Migrant transnationalism and modes of transformation. *International Migration Review, 38*(3), 970–1001.

Vidal, J. (2010). UN report: World's biggest cities merging into "mega-regions." *The Guardian*, 22 March 2010. Available at: http://www.theguardian.com/world/2010/mar/22/un-cities-mega-regions

Wang, G. W. (1988). The study of Chinese identities in Southeast Asia. In J. Cushman & G. W. Wang (Eds.), *Changing identities of the Southeast Asian Chinese since World War II* (pp. 1–19). Hong Kong: University of Hong Kong Press.

Wang, Z. (2014). China's new identity crisis. *Time Ideas*, September 30, 2014. Available at http://time.com/3449551/chinas-new-identity-crisis/

Wimmer, A. (2007). *How (not) to think about ethnicity in immigrant societies: A boundary making perspective.* Oxford, UK: COMPAS.

Winker, G., & Degele, N. (2011). Intersectionality as multi-level analysis: Dealing with social inequality. *European Journal of Women's Studies, 18*(1), 51–66.

Wong, J. S. J. (2003). *The rise and decline of Cantopop.* Unpublished PhD thesis, The University of Hong Kong.

Wong, W. Y., Lai, M. T., Ng, C. H., & So, M. C. (2004). *Huang Zi choral literature collection.* Hong Kong: Longman.

Zheng, S. (2011). *Claiming diaspora: Music, transnationalism, and cultural politics in Asian/Chinese America.* New York: Oxford University Press.

Zhu, Y. (2004). Intercultural training for organizations. The synergistic approach. *Development and Learning in Organizations, 18*(1), 9–11.

32

INTERCULTURALITY IN THE PLAYGROUND AND PLAYGROUP

Music as shared space for young immigrant children and their mothers

Kathryn Marsh and Samantha Dieckmann

This chapter discusses the potential for intercultural dialogue and expression of interculturality provided by the music of two oral traditions closely associated with children, those represented by children's playground singing games and lullabies. While pertaining to this potential for intercultural expression and exchange to occur on a general basis, the chapter outlines its enactment in relation to two contexts that were studied as part of an investigation into the musical lives of refugees and newly arrived immigrant children in Sydney, Australia, a city that is a final place of settlement for people from more than 100 birthplace nations.

Culturally diverse populations of children and adolescents were the focus of this ethnographic study, which took place in a number of contexts, comprising schools (a primary school and two Intensive English Centres for newly arrived adolescents) and community groups. The latter included playgroups and a Sierra Leonean youth group, in addition to a number of informal settings, such as large-scale outdoor celebrations by the Sierra Leonean and South Sudanese communities. Children and young people were observed as they participated in musical activities, both those organised by adults, and those in which they engaged at their own instigation. Such activities, along with musical pursuits and preferences enacted at home or in other locations outside of the observed settings, were discussed with the children and young people in informal research conversations conducted as the musical experiences progressed or in semi-structured interviews following observations. In addition, adults who had an organisational or participatory role in children's musical activities (such as teachers, parents, co-ordinators, group facilitators and migrant resource workers) were also interviewed, both formally and informally.

The forced migration of children and their families is a global phenomenon, precipitated by a range of constantly evolving geopolitical events. The social, emotional and cultural challenges faced by refugees relate to geographical and cultural displacement and trauma experienced in the country of origin, en route and during relocation and resettlement (Azima & Grizenko, 2002; Fazel & Stein, 2002; Hamilton & Moore, 2004; Loughry & Eyber, 2003; Machel, 2001; Reyes, 1999; Stewart, 2011). Although the level of trauma might not be as significant, issues of

social integration, identity construction, cultural maintenance and change and associated stresses are similarly experienced by newly arrived immigrants. In the process of resettlement, both refugees and newly arrived immigrant children and their families must adapt to a new country and culture, despite possible culture shock, racism, language difficulties, social isolation and changes in family structure and roles (Berry, 1997, 2001; Fazel & Stein, 2002; Frater-Matheison, 2004; Marsh, 2012). In this chapter, we examine playground singing games in a primary school and a lullaby sharing project within a mothers' and children's playgroup held at a Schools as Community Centre (SACC).[1] We argue that these musical activities constitute manifestations of intercultural expression and exchange that assist participants to renegotiate their sense of being 'out of place' (Couldrey & Herson, 2012).

Interculturality in the playground

The playground can be constructed as a liminal space, simultaneously representing a place of adult control and ownership, but populated by children who own and control the playforms that are enacted within. The nature of the playforms is also transitional and evolutionary. Playground singing games have the characteristics of many orally transmitted musical genres, in that they are constantly reformulated in a process termed 'composition in performance' (Lord, 1995, p. 11) where formulae (segments of known and new text, music and movement) are used as a generative matrix from which to create new games and game variants on a continuous basis (Marsh, 2008). Games from various traditions are therefore recreated, shared and recast in new forms, interpolating novel text, music and movement from both child-derived and adult-derived sources. Playground singing games are therefore inherently intercultural and intertextual, in that they bridge musical, textual and kinaesthetic characteristics from different times, places and cultures (in all senses of this term). The game aesthetic of innovation, in addition to its frequently occurring trait of semantic redundancy, enables children from different ethnocultural groups to play with others within the playground milieu. Such play occurs in both socially and culturally integrative ways, despite differences in language and levels of familiarity with game conventions. Musical play in the playground is, therefore, a space where the 'out of place' immigrant child can find a place to belong.

Musical play allows children to physically and socially connect with others while acknowledging and accommodating difference, utilising, among other things, what Coates (2012), in describing theatrical choreography, terms 'intercultural kinesis'. This, in keeping with the tenets of oral transmission and creation,

> understands cultural exchange as movement through other individuals' worldviews, and they through yours, which may be identifiable as coming from this culture or that but, on closer scrutiny, fractures into a million fragments of human experience that we internalize, select, and reassemble, consciously and not.
>
> *(p. 14)*

Because play is imaginative, it also allows children to reconnect with past events, 'rearranging the past into something new and different' (Bruce, 2011, p. 10), and also manipulating symbols originating in varying cultural conventions and situations to acquire new meanings, often in quite sophisticated ways. Bruce notes that versatile, imaginative and creative symbol use in childhood play means that play can be used to relieve the anxieties and dangers that are an inherent part of life through 'laughter and cathartic experiences' (p. 86).

The anthropologist Gregory Bateson has also engaged with children's symbol use in play in *Steps to an Ecology of Mind* (1973, p. 153), stating that 'play is a phenomenon in which the actions of "play" are related to, or denote, other actions of "not play". We therefore meet in play with an instance of signals standing for other events.'

Bateson (1973) notes that play requires the metacommunicative exchange of signals that carry the message 'this is play' (p. 152) rather than 'this is real'. This signal is provided by a 'frame', a meaningful action through which one player organises the perception of another to 'Attend to what is within [the play] and . . . not attend to what is outside' (p. 160). What is happening in play can, therefore, be seen by the players as being simultaneously real and unreal, as occupying a place between reality and unreality, with the players simultaneously 'being' and 'becoming' themselves and a different 'other'.

Ani Li Lingi

An example of the dualism of play as an intercultural mechanism was found in the singing game *Ani Li Lingi*, performed in Arabic by two Iraqi Assyrian refugee girls in the Sydney primary school, which had the highest population of refugee children in the state of New South Wales. These girls, Shamiran and Sawrina,[2] played many games, including those with English text, and with the non-meaningful vocables that characterise many playground singing games. However, Shamiran, who had only migrated to Australia during the previous year, expressed a strong preference for games and songs from her homeland. Sawrina's game and other musical preferences were slightly more eclectic, drawing on her combined experiences since migrating six years earlier, but her game knowledge had been replenished by a very recent visit to family in Syria.[3] Both girls drew on strong Assyrian music and dance traditions transmitted through regular participation in Assyrian (Chaldean) church services, weddings and other celebrations; satellite television and the Internet provided further popular song material from the homeland.

The notion of 'homeland' itself is somewhat problematic for Assyrians, a persecuted minority Christian group that has existed in some diasporic form across the Middle East (particularly in what is currently northern Iraq, Syria and Turkish Kurdistan) for millennia (Gow et al., 2005; Lamassu, 2007; Zubaida, 2000). Since the early 20th century, 'the Assyrians have been banished from one place to another and remained terminally caught between hostile government strategies, pan-Arabism, colonial/neo-imperial interventions . . . and the adverse determinations of transnational institutions' (Gow et al., 2005, p. 4). Deeply rooted religious and cultural traditions are therefore combined with a chronic diasporic condition, as outlined by Gow et al., citing a member of the Sydney Assyrian community:

> 'We [Assyrians] are nowhere because we are refugees everywhere.' In other words, in the collective mind, the label 'Assyrian' is synonymous with 'refugee' and 'displacement'. Masses have made their way out of Iraq and into urban centres in the Middle East, Europe, America and Australia.
>
> *(2005, p. 4)*

A history of violence perpetrated by insurgents, religious extremists, politically condoned militants, particular ethnocultural groups, members of the Iraqi army and the police has been exacerbated recently by further discrimination in Iraq since 2003, due to the perceived close affiliation of Assyrians with the Western invading troops and reconstruction personnel (Gow

et al., 2005; Lamassu, 2007; Zubaida, 2000). This history forms the socio-political backdrop to the current situation of Assyrian diaspora.

Against this backdrop, the game *Ani Li Lingi* is of particular interest. The text (translated by the children and an adult translator) and movements are outlined in Table 32.1.

This game is 'framed' or designated as 'play' by the initial stance of the girls, who position themselves about two metres apart and facing each other prior to its commencement. They immediately begin to inhabit alternate selves, by using representational movements, some of which might be seen to be essentialist (for example, in the case of 'Indian'). This inhabiting of alternate beings enables them to escape from the steadily more sinister and threatening acts insinuated by the textual pleading to 'stay away from me' and either 'forgive' or 'help' the at–risk persona in the game, initially represented by the first person pronouns 'I' and 'me' but later in the game further distanced by the use of the third person. The possible perpetrators of real or unreal violence, soldiers and police, appear toward the end of the game and are seemingly countered by a physical joining together of the two players to negate an increasing sense of risk, enacted at the final point in the game by actual competitive hitting of the other player (symbol-ising a blow from a police baton, as explained by Sawrina).

Table 32.1 Text translations and movements of *Ani Li Lingi*

Translation provided by girls	Adult translated version	Movements
I'm mandarin, a mandarin, a mandarin	I'm mandarin, mandarin, mandarin	Hands in turning motion above heads. Girls walk towards each other and back.
I'm Indian, I'm Indian, I'm Indian	I'm Indian, Indian, Indian	Hands in prayer motion, lower hands and shake head.
Please can you go away from me?	Please stay away from me,	Brushing gesture both hands on right shoulder.
Away from me? Away from me?	Stay away from me, stay away from me	Place both hands on left shoulder then right shoulder.
Help me, help me	Please forgive me, forgive me, forgive me	Place hands across chest then spin around + 3 claps.
Biscuit, biscuit (3 claps)	Biscuit, biscuit (3 claps)	
Biscuit, biscuit (3 claps)	Biscuit, biscuit (3 claps)	
This is how a bird flies	This is how a bird flies	Skip towards each other to swap places, flapping wings.
This is how a bird sleeps	This is how a bird sleeps	Stop and rest head on hands.
This is how a bird flies	This is how a bird flies	Skip towards each other to swap places, flapping wings.
This is how a bird sleeps	This is how a bird sleeps	Stop and rest head on hands.
This is how a soldier shakes hands	This is how a soldier shakes people's hand	March towards each other with right arms straight in front.
This is how a soldier salutes	This is how a soldier does a salute	March towards each other with right arms saluting forehead.
[No exact translation given. Instead, participants explain that this section of the game requires one of the players to mimic how a policeman hits people with his baton, while the other player aims to avoid the blow.]	Can see my fire, my fire, our fire	Girls link elbows and skip around in circle.
	Why the police came	Hit each other quickly on the arm and break apart
	Police don't like	

Through movement and text, this game allows the players to occupy the spaces of other entities, for example a mandarin, a bird, and an 'Indian', enabling the development of 'a fleeting sense of belonging . . . expanding one's sense of self, in discovering that there are other subjectivities out there with which to identify' (Coates, 2012, p. 13). The two players belong with each other as long as this identification continues, and the movement of one player not only mirrors the other but, during the act of clapping, also depends on the other. This interrelation is sustained until the game 'leads to the paradox represented in the choreographic play with membership, as if to say, "You don't really belong here"' (p. 13), because the two players then abruptly embody opposing forces and compete against one another as corrupt policeman and citizen, demonstrating in symbolic form the violence which has been experienced or threatened in real life. However, the symbolism and pleasure of the playform combine to verbally and kinaesthetically disempower the powerful sources of threat and oppression. Such techniques may be seen to enact a subversion of trauma, either in public or private performative spaces.

The fluidity of identity and inherent ambiguity of meaning in this form of musical play also works together with the two players' concerted and synchronised efforts to overcome a threat that is both perceived and also representational not only of past trauma, but of the social and emotional uncertainties with which they are confronted on a daily basis as a result of their displacement. Cross (2005) has postulated that music itself exhibits an essential ambiguity that facilitates social interaction in such 'situations of social uncertainty' (Cross & Woodruff, 2009, p. 113):

> Music's capacity to guarantee the success of social interaction makes it an excellently adapted framework for interaction in situations that are on the edge, situations where outcomes are neither clear beforehand nor retrospectively (easily) definable . . . But it also means that music is able to act as a medium within which a capacity for flexible social interaction may be rehearsed and perhaps formed.
>
> *(Cross, 2005, p. 122)*

Thus music can be seen to be an activity in which people can come together to work concertedly toward a joint goal, which may have strong participatory benefits, in addition to possible performative outcomes.

Creating a shared intercultural space and intercultural identity through lullaby sharing

We will illustrate this further with reference to a joint enterprise involving another group of participants who, by virtue of their pre- and post-migration experiences and recency of arrival, could be seen to inhabit 'situations that are on the edge' (Cross, 2005, p. 122). As part of our investigation of the role of music in the lives of refugee and newly arrived immigrant children, we spent some time with a group of mothers, all of whom were recently arrived in Australia, and who came together as part of a joint initiative of a migrant resource centre and a community centre operating within a primary school. The group aimed to provide a social space for migrant and refugee women who were new to the area, many of whom were experiencing various resettlement difficulties. Although their children varied in age, the women had decided to exchange lullabies with other members of the group as an enjoyable way of sharing an aspect of culture that was meaningful and common to them all. Several of the women had babies or young children who attended the group sessions, playing with toys and musical instruments, both autonomously and in conjunction with adults and other children.

Over a period of time the members of the group had demonstrated and taught lullabies in their first languages to the other women and, depending on the recency and regularity of their attendance, the participating women were relatively comfortable with this form of intercultural exchange, freely singing both their own and others' lullabies. The young children who attended were active receivers of and responders to the transmitted lullabies, even those that were in an unfamiliar language.

The balance of links with the 'old' home culture, for which there is often a longing, and the 'new' host culture, was evident in the performance of a Filipino lullaby, translated and sung by three Filipino women in the group. The lyrics of the song reflected the yearning for the security and personal bonds of the home culture, as embodied by the figure of the far away mother:

> I hope my memories with my mother never fades away,
> Whilst[4] I was a young one in my mother's arm,
> I wish to hear my mother's sweet lullaby once more.
> A song of love, whilst I was in a cradle.
> Whilst I was asleep, a very deep sleep,
> The bright stars were my guards,
> The moon was my security.
> Being with my mother, life was like heaven.
> My heart is aching, how I long for the cradle swing.
> I wish to fall asleep once more in my old cradle.
> Mother, oh mother.

However, the security provided by the lullaby group meant that these women felt free to sing and explain this expression of longing for the home culture within their new environment. The other women sang along with the lullaby and clapped at the end, perhaps identifying with the yearning but being accepting of and participating in this freely shared and exchanged form of cultural expression. The offering up of such personally and culturally meaningful repertoire for intercultural sharing enabled these women to acquire what Kim (2015, pp. 6–7) refers to as individuation, 'a solidified sense of self . . . authenticity, and a feeling of certainty about one's place in the world', part of the notion of intercultural identity development. Such individuation served not only to reinforce aspects of their home culture, but also assisted them to conceptualise a specific role for their home culture within their new lives in Australia.

For the mothers this activity created an intercultural space of shared comfort in the familiarity of their own traditions, combined with the social safety of new friendship and growing knowledge and familiarity with lullabies from diverse other traditions. It is notable that this level of comfort and pride in the lullabies was genuinely felt by the women within this situation, probably in many ways due to the endorsement provided by the group facilitators and the warm support that emanated from the facilitators and permeated the group activities. While Ilari's (2005) Canadian study indicates a similar disposition of immigrant mothers to listen to and sing songs, rhymes and lullabies 'of their culture and in their native language' (p. 653) rather than of the dominant culture and languages, the immigrant mothers in Young's (2008) UK study seemed to adopt the songs of the dominant culture, possibly reflecting a reliance on repertoire learnt in baby and toddler groups of a more assimilative nature. Thus the endorsement of musical diversity within this group, which functioned both as women's support group and playgroup, assisted in the transmission of new songs and the creation of a joint, musically diverse repertoire of lullabies representing the home cultures of all of the women and children.

It should be noted that familiarity with the 'new' lullabies was increased by the level of enjoyment experienced by the mothers. There were favourites, such as *Bella Mama*, that came from traditions to which no member of the group belonged, which were sung more frequently and were therefore more quickly recognised and enjoyed both by the women and by the participating babies, even though they were in an unfamiliar language. This enjoyment sometimes related to the repetitive nature of some texts and melodies, such as that of *Bella Mama*, whose text consisted almost entirely of the two words of the title, reiterated against a highly repetitious melody. At other times enjoyment was produced by the musical characteristics of the songs, for example, the upbeat nature of the Turkish bouncing song *Mini mini bir kuş* (shown in Musical example 32.1), a favourite of both the mothers and the Turkish baby alike.

It is notable that the text of *Mini mini bir kuş* (shown in Table 32.2) illustrates a 'rebirth', perhaps symbolising, in its manifestation as a favourite song within this shared communal context, the taking on of a new intercultural life with a concomitant expression of freedom.

Not surprisingly the diversity of the lullabies was also increased by the accessibility of source material on the Internet. Another favourite lullaby, the Cantonese *Siy Bo Boy*[5] had been found on YouTube and proved popular with both mothers and babies, despite the absence of Cantonese speakers within the group. Similarly some of the Hindi lullabies contributed by mothers had originated in Bollywood songs, which provided a constant source of new material repurposed and used as a form of cultural maintenance.

The singing of others' songs and songs from cultures to which none of the members belonged, in addition to the thematic similarities in all of the lullabies, served another function of intercultural identity development. Complementary to the process of individuation previously discussed, lullaby sharing generated a universalisation of mental outlook, whereby individuals developed a synergistic awareness of the relative nature of values and the universal aspects of human nature (Kim, 2015). Thus this form of musical engagement allowed the participating women to proudly embrace and represent their own culture while also relating deeply to Others, to an extent enabling them 'to relate to others in a less categorical and more individuated and universalized self–other orientation that allow[ed] them to create an outlook on life that transcend[ed] the parameters of any given cultural tradition' (Kim, 2015, p. 9).

Musical example 32.1 Music and text of the Turkish song *Mini mini bir kuş*.

Table 32.2 Text of *Mini mini bir kuş*

Turkish lyrics	Translation
Mini mini bir kuş donmuştu	A tiny tiny bird had been frozen
Pencereme konmuştu	(It) has landed on my window
Aldım onu içeriye	I took it inside
Cik cik cik ötsün diye	For it to sing as "cik cik cik"
Pır pır ederken canlandı	While whirring, it became alive
Ellerim bak boş kaldı	Look my hands became empty

Nevertheless, as Marotta (2014) notes, intercultural or in-between cultural selves are still embedded in and subject to the pre-existing prejudices and meanings of their social and cultural world, which cannot always be suspended in new contexts: 'In-between cultural subjects are not ahistorical social actors who float above those who are socially and historically located. Cultural actors, and their understanding of the world, are formed in the context of customs, traditions and prejudices' (Marotta, 2014, p. 98).

This was evident in the discussion of the meaning of *Ghumparani mashi pishi*, a Bengali lullaby contributed by a Bangladeshi member of the group. It is part of a Bengali genre of *chhara* (songs for children) specifically the *Ghumparani chhara* (*chharas* used to put babies to sleep) (Bajpai, 2012). As part of a tradition that is transmitted both orally and in written form, *chharas* are documented as being subject to frequent creative change, with many newly created versions, some by major poets such as Rabindrath Tagore. Many *chharas* were created as a vehicle for nationalist sentiments during the period of Partition of Bengal at the turn and early part of the 20th century (Bajpai, 2012). Despite their seeming melodic and rhythmic simplicity, and repetitive structure (as shown in Musical example 32.2), *Ghumparani chharas* may still be embedded with nationalist content.

The lullaby *Ghumparani mashi pishi*, like many examples of its genre, focuses on fairies or guardian angel figures that appear in the form of aunts or grandmothers (Bajpai, 2012). Two Bangladeshi women in the group (one a new arrival to Australia and the other a migrant resource centre facilitator) provided the following explanation of the meaning.

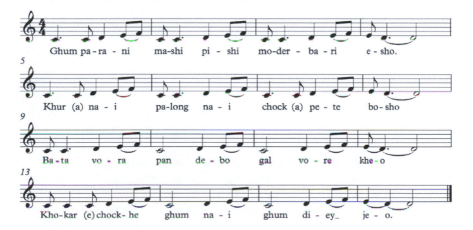

Musical example 32.2 Bengali lullaby *Ghumparani mashi pishi*.

It's a very old Bangladeshi lullaby. *Ghum parani mashi pishi*, that's means this song is talking about aunties from father's side and the mother's side. They will come and put the baby to sleep. Kind of, they're kind of angel, fairy. And they're also saying . . . 'Come to our house, um, there's no place to give you any seat, but you can sit on my eyes so that I feel sleepy. There's no place to sit, no chairs, no beds, nothing. Just sit on my eyes, and bring all the seats from other places, and put it into my eyes, so that I fell into sleep.' That's the meaning.

(Mina, research conversation, 10 October, 2009)

The singer of the song, Shirin, corrected Mina's version, saying that 'my eyes' should actually be 'my son's eyes'. However, they both went on to talk about how the song changed when sung by 'the modern people', taking on nationalist content and meaning following the war for Independence from Pakistan in 1971.

The new lines are related with that war. Put into that. Like the bad people who come to this country, they will destroy everything, but that's why you have to wake up and join in with the fighting . . . That bit means like that.

(Mina, research conversation, 10 October, 2009)

On another occasion Mina and another Bangladeshi woman sang the 'modern' nationalist version of the lullaby relating to the conflict with Pakistan, in which the political history is explained to the child, who is explicitly named in the lullaby.

The transplanted Bangladeshi lullaby, therefore, brings with it a sense of national identity in the knowledge of the encoded meaning, with the 'modern' lyrics imparted to others in this shared lullaby setting, in addition to the endorsement of personal identity for the named child to whom the lullaby is sung. However, the tensions between universalisation and individuation and the inhibiting nature of pre-existing determinants of meaning were evident here, requiring a laughing apology by Mina to a Pakistani member of the group for the possibly culturally offensive content.

Kim's (2015) notion of intercultural transcendence therefore has limitations, as cultural histories and distinctions are explicit within the group's cross-cultural musical engagement. This requires an acknowledgement and maintenance of the concept of difference in addition to an acceptance of this difference in order for interculturality to flourish, as discussed by Marotta (2014, p. 94), who states that:

interculturality involves a subtle balancing act between recognising the similarities underlying Self and Other – which will become the foundation for dialogue across difference – while maintaining difference and thus sustaining boundaries between Self and Other. The intercultural moment . . . manifests itself through a paradoxical situation where one adopts universalising (identifying commonalities) and particularising (acknowledging distinctions) practices.

In the case of the lullaby group, the distinctiveness of cultural traditions was documented in the labelling of each lullaby by its culture of origin (e.g., 'Filipino', 'Turkish', 'Tibetan', 'Susu'[6]), as each lullaby was sung, with the contributor of the lullaby being invited to demonstrate or lead the singing, if she was in attendance. The commonality was acknowledged by the joint enterprise of lullaby sharing and the performance of as many songs as possible by the whole group. Marotta (2009) notes that what is important is not the existence of essentialist practices acknowledging

distinctions, but 'whether these practices are used to exclude and repress the other rather than respect and value the other on their own terms' (p. 281). In relation to the mothers' lullaby sharing, this mutual respect and value was maintained through the continued interchange of lullabies, the appreciative words of praise following the performance of a lullaby that was considered to be very beautiful, the clearly evident enjoyment of group performance of 'favourite' lullabies, and the joint wish to permanently document the lullabies for sharing at home.

However, the extent to which intercultural personhood could exist for participants outside of the context of the playgroup is questionable because of how they would be perceived in other environments, as discussed by Sparrow (2000). For some of the participants who were marginalised women with limited English skills, the women's and children's playgroup might have been one of the few places where intercultural personhood could be enacted. The playgroup was a safe space, like 'home', where the women interacted with other interculturalists and were empowered to construct new identities and 'express more fully all parts of themselves' (Sparrow, 2000, p. 190).

Conclusion

In this chapter we have explored two examples of ways in which intercultural experiences involving music of two oral traditions have assisted newly arrived immigrant children and mothers with processes of identity development, social integration and emotional expression. For the Iraqi Assyrian refugee girls, the interculturality of the playground singing game genre, played anew in the Australian playground, enabled the players to re-engage with and process traumatic events, reinventing themselves to create a new and better lived experience. For the members of the mothers' playgroup, the sharing of lullabies provided ongoing intercultural interaction with cultural elements beyond the familiar, enabling the participants to incorporate new concepts, sensibilities and attitudes, in time developing 'a broader and more integrative understanding of the human condition' (Kim, 2015, p. 6). As Kim states, such experiences result in an 'increasing capacity to participate in the emotional and aesthetic experiences of cultural strangers, and the resourcefulness with which to make appropriate behavioral adjustments to specific situations and to manage them effectively and creatively' (p. 6), thereby empowering them as active agents in their own resettlement.

Notes

1 This playgroup was cooperatively organised by personnel from the SACC and a nearby migrant resource centre.
2 All names are pseudonyms, for ethical reasons.
3 The fieldwork in this school took place prior to the outbreak of civil war in Syria.
4 This translation was derived from a Filipino mother who read it to the group from a written version of the translation that she had brought with her. 'Whilst' was slightly mispronounced. The text is reproduced as recorded.
5 Many of the texts of the songs were written in roughly transliterated form by the group facilitator for the purpose of providing a memory and pronunciation aid for the members of the group. Titles and wording of some texts come from this source and thus may not be a linguistically accurate transliteration of the original.
6 *Susu* is an ethnocultural group from Sierra Leone.

References

Azima, F. J. C., & Grizenko, N. (2002). *Immigrant and refugee children and their families: Clinical, research, and training issues*. Madison, CT: International Universities Press.

Bajpai, L. M. (2012). Oral written nexus in Bengali Chharas over the last hundred years: Creating new paradigm for children's literature. *SAARC Culture, 3*, 137–171.

Bateson, G. (1973). *Steps to an ecology of mind: Collected essays in anthropology, psychiatry, evolution and episte-mology*. St Albans, UK: Paladin.

Berry, J. W. (1997). Immigration, acculturation, and adaptation. *Applied Psychology: An International Review, 46*(1), 5–68.

Berry, J. W. (2001). A psychology of immigration. *Journal of Social Issues, 57*(3), 615–663.

Bruce, T. (2011). *Learning through play*. London: Hodder Education.

Coates, E. (2012). Moving between, among, in the midst. *Theater, 42*(1), 11–19.

Couldrey, M., & Herson, M. (Eds.) (2012). Being young and out of place [Special issue]. *Forced Migration Review, 40*, 2–52.

Cross, I. (2005). Music and social being. *Musicology Australia, 28*(1), 114–126.

Cross, I., & Woodruff, G.E. (2009). Music as a communicative medium. In R. Botha & C. Knight (Eds.), *The prehistory of language, Vol. 1* (pp. 113–144). Oxford, UK: Oxford University Press.

Fazel, M., & Stein, A. (2002). The mental health of refugee children. *Archives of Disease in Childhood, 87*(5), 366–370.

Frater-Matheison, K. (2004). Refugee trauma, loss and grief: implications for intervention. In R. Hamilton & D. Moore (Eds.), *Educational interventions for refugee children: Theoretical perspectives and best practice* (pp. 12–34). London: RoutledgeFalmer.

Gow, G., Isaac, A., Gorgees, P., Babakhan, M., & Daawod, K. (2005). *Assyrian community capacity building in Fairfield City*. The Centre for Cultural Research, University of Western Sydney, Sydney, Australia.

Hamilton, R., & Moore, D. (Eds.) (2004). *Educational Interventions for refugee children: Theoretical perspectives and best practice*. London: RoutledgeFalmer.

Ilari, B. (2005). On musical parenting of young children: musical beliefs and behaviors of mothers and infants. *Early Child Development and Care, 175*(7–8), 647–660.

Kim, Y. Y. (2015). Finding a 'home' beyond culture: The emergence of intercultural personhood in the globalizing world. *International Journal of Intercultural Relations, 46*, 3–12.

Lamassu, N. (2007). The plight of the Iraqi Christians. *Forced Migration Review*, June, pp. 44–45.

Lord, A. B. (1995). *The singer resumes the tale*. Ithaca, NY: Cornell University Press.

Loughry, M., & Eyber, C. (2003). *Psychosocial concepts in humanitarian work with children: A review of the concepts and related literature*. Washington, DC: The National Academies Press.

Machel, G. (2001). *The impact of war on children*. London: Hurst.

Marotta, V. (2009). Intercultural hermeneutics and the cross-cultural subject. *Journal of Intercultural Studies, 30*(3), 267–284.

Marotta, V. (2014). The multicultural, intercultural and transcultural subject. In B. E. De B'beri & F. Mansouri (Eds.), *Contextualising multiculturalism in the twenty-first century* (pp. 90–102). Abingdon, UK: Routledge.

Marsh, K. (2008). *The musical playground: Global tradition and change in children's songs and games*. New York: Oxford University Press.

Marsh, K. (2012). 'The beat will make you be courage': The role of a secondary school music program in supporting young refugees and newly arrived immigrants in Australia. *Research Studies in Music Education, 34*(2), 93–111.

Reyes, A. (1999). *Songs of the caged, songs of the free: Music and the Vietnamese refugee experience*. Philadelphia, PA: Temple University Press.

Sparrow, L. M. (2000). Beyond multicultural man: Complexities of identity. *International Journal of Intercultural Relations, 24*(2), 173–201.

Stewart, J. (2011). Supporting refugee children: Strategies for educators. Toronto, Canada: Toronto University Press.

Young, S. (2008). Lullaby light shows: Everyday musical experience among under-two-year-olds. *International Journal of Music Education, 26*(1), 33–46.

Zubaida, S. (2000). Contested nations: Iraq and the Assyrians. *Nations and Nationalism, 6*(3), 363–382.

33

INTERCULTURAL PRACTICE AS RESEARCH IN HIGHER MUSIC EDUCATION

The imperative of an ethics-based rationale

Sidsel Karlsen, Heidi Westerlund and Laura Miettinen

Introduction

This chapter aims to demonstrate how intercultural practice in music education can be considered as, and turned into, research – and vice versa – by taking into account various ethical issues. Drawing on a wide range of intercultural practices and research currently taking place at the University of the Arts Helsinki, Sibelius Academy in Finland, our overview will be underpinned by practical experiences gained through three projects: a Finnish-Cambodian intercultural project, a project on co-constructing Nepalese music teacher education through Finnish-Nepalese collaboration, and a collaborative project on visions for intercultural music teacher education in two higher music education contexts in Israel and Finland. These projects have been designed in response to the emerging needs for music teacher education to move beyond the model of expert silos, characteristic for universities (Davidson & Goldberg, 2010), and to change the 'conservatoire culture' of music teacher education that preserves and cultivates rather than encourages teachers or students to step out of their comfort zones. This stepping out of comfort zones has also become necessary in arts education, which needs to recognise the increasing plurality of frameworks in our societies and the related need to deal with potential conflicts and uncertainty. In these projects, the exposure to larger societal issues, gained through intercultural collaboration, has aimed at existential learning experiences and evoking educational change, both within higher music education institutions and in wider educational systems.

In this chapter, the notion of 'intercultural practice' is explored mainly on the higher music education level, and refers to projects that involve international collaboration and emphasise one or more of the following aspects: research; developmental work; and student and/or teacher exchange. Such collaboration is strongly encouraged in university policy documents worldwide, institutions of higher music education being no exception in this regard. However, for university leaders, professors and students it might not always be clear what the benefits of such work are, or what is considered as a fruitful outcome in intercultural practices. In this context, we argue that one of the main learning outcomes of intercultural practices is related to ethical deliberation when dealing with changing situations and unexpected and insecure routes. While ethics is pertinent to all research, ethical deliberation becomes even more crucial when

the work is conducted inter- or cross-culturally between partners that exhibit a high degree of cultural difference and under circumstances in which issues of unevenly distributed power, marginalisation, vulnerability, ethnocentrism and possible exploitation might constitute potential dangers (see also Liamputtong, 2010, p. 31). In a diverse and interconnected reality, it is perhaps more crucial than ever to ask the simple question, 'Who does this research benefit?', but also more difficult to find a straightforward answer. Although the principle of *primum non nocere* (first, do not harm) has perhaps become accepted in all research (Liamputtong, 2010, p. 37), this chapter aims to illustrate how even this basic ethical principle may raise complex challenges in intercultural practices.

First, we will revisit the ideological background of multiculturalism and interculturalism in music education scholarship in order to provide a background for the specific cases, mentioned above. Through these cases, we then aim to highlight how intercultural practice and research might aid and spur the development of music education and how, at the same time, they are embedded with potential ethical pitfalls. Finally, the chapter closes with a discussion that brings forward ideas regarding cultural plurality and suggests how these ethical aspects can be seen as fundamental features in the process of turning intercultural research into practice in music education.

From multicultural music education to interculturality – a brief outline

Despite attempts to introduce 'intercultural' views in Britain in the 1980s (see e.g., Swanwick, 1988), the 'project of multiculturalism' has remained one of the main ways of thinking about plurality in music education. Multicultural discourse was promoted particularly in the 1990s when the International Society for Music Education published the *Policy on Musics of the World's Cultures* (Lundqvist, Szego, Nettl, Santos & Solbu, 1998). At the ideological core of multiculturalism in general lies the belief that immigrants or minority representatives should participate fully in 'the socio-economic life of the host country' (Silj, 2010, p. 1), and that diversity should be recognised and perceived as something positive and desirable. Such recognition is perceived to be key, not only to the successful integration of immigrant and minority groups, but also to the unity of the entire nation-state and to social cohesion among its inhabitants. In alignment with these overarching ideas, the major goal of multiculturalism has been to reform education 'so that students from diverse racial, ethnic and social-class groups will experience educational equality' (Banks, 2004, p. 3). However, in music education, multiculturalism has mainly referred to the teaching of a broad spectrum of music cultures, 'primarily focusing on ethnocultural characteristics rather than the larger definition of multiculturalism accepted in education today' (Volk, 1998, p. 4). In this discourse, the ethical imperative has highlighted the right to see one's own music represented in the music curriculum and the necessity to aim at musical and cultural authenticity so as to respect the music of the 'other'.

Despite some common ideological grounds, multiculturalism (and multicultural education) has taken strikingly many forms. While some scholars claim that multiculturalism 'has become institutionally embedded in liberal democracies' (Kivisto & Wahlbeck, 2013, p. 5) all around the world, others would remind us that this same ideology has led to an unfortunate form of identity politics, expressed as 'claims-making by minority groups' (p. 5), instead of the promised national unity. According to the philosopher Martha Nussbaum (1997), this identity politics has been one of the main reasons why interculturalists have questioned multiculturalism and have striven to build other bases for achieving justice and equality in culturally heterogeneous societies.

Compared to the main ideas of multiculturalism, interculturality has focused more on exchange and cooperation between cultural groups than on highlighting their differences and

their right to preserve their uniqueness. In the words of Abdallah-Pretceille (2006), intercultural reasoning 'emphasizes the processes and interactions which unite and define the individuals and the groups in relation to each other' (p. 476). Hence, less emphasis is put on culture and its various expressions 'and more on the subject that acts and therefore interacts' (p. 480). In such an understanding, culture does not become a means for determination and modelling; rather, what is interesting is 'its instrumental functioning' (p. 480) for the individual or the group. According to Coulby (2006), most education is, and should be, intercultural, and if it so happens that it is not, 'it is probably not education, but rather the inculcation of nationalist or religious fundamentalism' (p. 246). The theorisation of intercultural education is, however, not only about 'spotting good practice in one area and helping to implement it in another' (p. 246). Rather, it concerns a complete reconceptualisation of schools' and universities' practices and of their obligation to partake in global discourses and discussions.

Interculturality in higher music education

In recent years a number of research and developmental projects have been undertaken in higher music education which may be deemed 'intercultural' and whose main emphasis has been the interaction between cultures rather than the highlighting of differences. Writing on a project that involved masters students, teachers and academic leaders from a joint Nordic study programme visiting Ghana for a ten-day music camp, Sæther (2013) suggests that 'the most fundamental learning takes place when comfort zones have to be abandoned as a consequence of intercultural collaboration' (p. 37). In this project, *discord* came through as one important state that would, most likely, be experienced through intercultural collaboration, and which could be particularly fruitful for knowledge and skill enhancement. Sæther states that, '[i]t is through tensions, the longing for consonance, that learning takes place' (p. 47) and, given that intercultural collaboration produces such tensions, the efforts to handle them will elicit learning.

Reporting on an exchange project that involved Norwegian student music teachers participating in community music activities in a refugee camp in Lebanon, Broeske-Danielsen (2013) argues that the students experienced learning that she characterises as 'existential' (p. 304). Existential learning was connected both to understanding the value of music, and musical communication, as an integral part of teaching, as well as recognition and confirmation that they were actually well suited for the teaching profession for which they had been trained. Burton, Westvall and Karlsson (2012) further argue that the outcome, from the students' perspective, of a collaborative intercultural immersion course involving music education majors from the United States and Sweden, was to provide 'a scaffold for the participants to consider what and why they teach the content that they do and the ramifications of making such decisions on their potential teaching practices' (p. 92). In other words, intercultural collaboration involving student teachers seems to be an efficient way to make them reflect critically on their own taken-for-granted teaching-related attitudes and practices, as well as for them to expand their understanding of themselves as professionals. Rowley and Dunbar-Hall (2013) bring these two dimensions together in their research on Australian students studying music and dance in Bali, Indonesia, claiming that the cultural difference experienced in this context pushed students into reconsidering many aspects of their lives – be it musical, pedagogical, social or cultural – and at the same time functioned as a force 'in the development of identity showing students moving from their current identities as music students towards emergent identities as music educators' (p. 41). Sometimes, reflections originating from intercultural collaboration may also span wider societal issues, as exemplified by Bartleet (2011), who shows how, for Australian music students, the building of cross-cultural collaborations with indigenous musicians, can,

at the same time, be about learning music as well as about 'issues of colonial guilt [and] the construction of Otherness' (p. 11).

Ethical lessons learned from intercultural practice at the Sibelius Academy

The outcomes of the research, developmental and exchange projects in higher music education described above may promote the development of 'intercultural competences' as outlined by Deardorff (2008) and, as such, the projects may have significant impact both on the levels of the participating individuals and of the partaking institutions. In what follows we will present three corresponding projects carried out at the Sibelius Academy. As with any other cross-cultural research they were 'rife with methodological and ethical challenges' (Liamputtong, 2008, p. 4), and therefore exemplify some topics that are crucial for teachers and researchers to consider when developing intercultural practices in higher education – ethical imperatives that will be highlighted as the narratives of the three different projects unfold. In order to theorise the experiences from the projects, they will be reflected through the writings of a cross-cultural researcher Liamputtong (2007, 2008, 2010, 2011) as well as literature discussing ethical challenges in ethnographic research (Lather, 2007; Skeggs, 2007; Van Loon, 2007).

Case 1: the Finnish–Cambodian bi-cultural project

The Finnish–Cambodian bi-cultural project, *Multicultural Music/Arts University: Promoting Understanding and Sensitivity Through the Traditional Arts in Cambodia and Finland (2011–2013)*, funded by the Ministry for Foreign Affairs of Finland, aimed to advance ethically sustainable education into pluralism in both Cambodia and Finland through collaboratively fostering intercultural understanding and sensitivity in Cambodian educational settings through culturally contextualised teaching, learning and research. The project aimed to introduce Finnish music education students to Cambodian traditional music and dance in two non-governmental organisations (NGOs) that offered traditional Khmer music, dance, and theatre programmes designed for disadvantaged children in three different settings around the country. It also aimed to introduce the Cambodian children in these NGOs to some Finnish music and dance traditions. The Finnish students were expected to teach in small groups with their peers and share their pedagogy in a student-centred way. Each visit to Cambodia took place over a period of three weeks, which were preceded by preliminary studies and guidance. The Finnish groups of 7–12 masters, doctoral students and teachers visited the NGOs, trying to fulfil the hosts' specific wishes (e.g., to teach popular music songs including hip hop plus instrumental tuition in Western instruments), with the wish that the Cambodian children would be empowered by teaching their traditions to adult beginners. During the visits the groups followed, and had to adapt to, the NGOs' regulations, rhythms and wishes since information about the practicalities was minimal prior to the visits.

The research conducted during the two cycles of the project focused on the Finnish students' experiences (Westerlund, Partti & Karlsen, 2015) as well as on the Cambodian music and dance teachers (Kallio & Westerlund, 2015), in the latter case exploring how music, dance and theatre teachers and NGO staff perceived their roles and responsibilities in teaching in locally specific cultural and educational situations, and at the same time, in an increasingly cosmopolitan Cambodia. Extended biographical research was undertaken with one female Yike theatre teacher who was eager to share her story and tell about her art. This teacher was a Pol Pot regime survivor, as were so many others of the NGO teachers, who had either fled the country

(and then returned), or hidden their education and artistic skills during the political uprisings. Several ethical issues were considered during this particular project, including:

1 the possibility for exploitation;
2 whose voice is presented in research; and
3 the limits of stress in intercultural learning.

First, the justification for working with vulnerable children was discussed with the NGO leaders during each visit and also reflected upon among the Finnish students. The latter became conscious of their own privileged situation and critically discussed whether their visit was more of a luxury for the Western university students rather than actually beneficial for the children, many of whom were orphaned or abandoned. The children easily became emotionally attached to the new adults who came into their lives with music, and there were mutual emotional outbursts when the visit was over. In fact, one of the NGOs did not accept voluntary workers because of these emotional ruptures, and our visit was a rare exception since it offered musical experiences not otherwise available. Moreover, despite these NGOs being under severe economic pressure, we were not able to offer any direct economical support besides small donations of instruments, technological or school equipment, clothing or toys.

Second, although the teachers of the NGOs were eager to tell their personal stories, our constant worry was that there was not much we could do within the given project except to 'give them voice' through research. Lather (2007) points out the dangers of these romantic aspirations of ethnographic traditions, and reminds us that there is a fine line between giving voice to the voiceless, and manipulation, violation and betrayal (p. 483). For one Cambodian manager who acted as an interpreter in the teacher interviews, our research opened new windows to the lives of the teachers and bettered her understanding of their situation. Yet, the interviews also involved lots of reflection and questioning on the researchers' part, during the entire process. For example: even if the interviewee is extremely anxious to be the central figure of a Western study, is it ethical to ask her to discuss past experiences when these have been traumatic, violent and inhumane beyond our imagination? And, is it fair to let her believe that we, as researchers, actually will have the power or opportunity to let *her* voice be heard without it being dominated or obstructed by our voices? As Lather writes: 'To give voice can only be attempted by a "trickster ethnographer" who knows they cannot "master" the dialogical hope of speaking with . . . let alone the colonial hope of speaking for' (2007, p. 483). Van Loon (2007), however, reminds us that if we accept the argument that researchers can never truly speak in the voice of their research subjects, then it must not necessarily follow that the researcher 'is an impostor and a voyeur who merely appropriates his or her research subjects for his or her own career benefits' (p. 280). Furthermore, according to Liamputtong (2008), the most important moral-ethical question when including vulnerable and historically marginalised people in research, is the relevance of the research to the cultural groups and the likely outcomes: 'Research can only be justified if the outcome will benefit the community rather than further damaging it' (pp. 3–4). Even if our intercultural project was evaluated as beneficial by the Cambodian NGOs, it is harder to evaluate the outcome of the research, and we cannot know for sure whether it was relevant to the institutions or the teachers who worked there.

A third ethical question is related to the Finnish master's students' ability to respond to the situation. The students had to undergo a considerable amount of stress while adapting to a new pedagogical culture, under tough physical conditions and in emotionally straining contexts. For most of the master's students this journey was a strong reflective learning process, but for some, the stress created emotional turbulence that shook their self-integrity (see Westerlund

et al., 2015). Similar outcomes are well documented in scholarship concerning cross-cultural collaboration (e.g., Tange, 2010); however, even in an educational project where adult students participate voluntarily and are prepared for difficult conditions, the ethical question of putting individuals through a 'culture shock' remains. Liamputtong (2007) states that '[r] esearchers have [a] responsibility to ensure the physical, emotional and social well-being of [their] research participants' (p. 37), and we believe this also applies to teacher educators who facilitate intercultural collaboration for their students.

Case 2: co-constructing Nepalese music teacher education

The Finnish–Nepalese bi-cultural exchange project run by the Sibelius Academy, *Developmental Project on Nepalese Music Teacher Education (2013–2014)*, also funded by the Ministry for Foreign Affairs of Finland, was initiated by the Nepalese partners. In 2012 the Sibelius Academy was contacted by representatives of the Nepal Music Centre (NMC) in Kathmandu to collaborate in establishing and developing the first music teacher preparation programme in Nepal. As the Ministry of Education in Nepal had introduced music as an elective subject in general schooling for the first time, the country found itself in urgent need of music teachers and music teacher educators. This situation became an opportunity for the Nepalese parties and the Sibelius Academy to engage in collaborative developmental work and research on music teacher education and cultural diversity, taking the institutional needs on both sides as a point of departure for identifying joint areas of future development. Given that the emerging Nepalese system of music education has recognised a need to take into account the country's approximately 100 ethnic groups, and that the student population in Finnish music teacher education has been seen as fairly homogenous, the two contexts are vastly different, making this project a 'maximised opportunity to learn' (Stake, 1995, p. 6) and a relevant continuation of the research in Cambodia on the complexity of cultural diversity in music teacher education beyond Western contexts. The ethical imperatives dealt with in the Finnish–Nepalese project, concerned issues such as:

4 language barriers and the limits of mutual understanding; and
5 institutional power and dangers of colonialism.

As in the project in Cambodia, there was an obvious language barrier, given the researchers' unfamiliarity with local languages. Therefore, it was necessary to recruit moderators and interpreters who were fluent in local languages and familiar with the contexts and the teachers (see Liamputtong, 2011, pp. 132–133). The moderators in both countries were able to ask further questions whenever they saw that a potential misunderstanding could arise, acting as 'bi-cultural workers' and translators of two cultures. The interpreter bias was avoided in some interviews by producing translations of the whole interview, and in Nepal, full translations of earlier interviews were used as a basis for conducting the following ones.

Although the Nepal project has aimed at mutual learning, it involves a basic, ethical concern related to the power balance between the two institutions. Despite having a number of minority and indigenous population groups, some of which have been oppressed historically (such as the Sami and Roma people), Finland is not known as a colonial power. Rather, the reverse is in fact true, with Finland's centuries-long history of being under Swedish and Russian governance. Currently, however, education is not only one of the areas that Finland's international reputation is built upon (see Sahlberg, 2011), but also one of the main areas of developmental aid. Nepal is one of Finland's long-term partner countries for educational development (e.g., receiving

consultancy on writing and implementing a curriculum for basic education). There is thus the ethical imperative to support the development of Nepalese music education, particularly as, in this case, the idea to collaborate came from Nepal. Yet, as Skeggs (2007) writes, '[c]enturies of colonialism designates some people as knowers and some as strangers' (p. 435), as 'others', in the given field, in this case music teacher education. Moreover, research involving collaboration with partners in a developing country may become ethnographic exoticism, referred to by post-colonialists as 'a mainstay of global capitalism, imperialism and power, which is able to establish the terms for the categories of others' (p. 433). This question is not overcome simply by aware-ness, since it is omnipresent in every interaction. The main question thus remains: Is it possible within these unequal power relations to use one's knowledge, helping a developing music educa-tion context without becoming to some degree a coloniser?

According to Skeggs (2007), '[r]ecognition of the positioning and channels of power may be one way of not engaging in normalising power relationships', but rather, '[t]aking responsibility for the reproduction of power may be more possible than equalizing power' (p. 434). In our collaboration, it has been central to include the Nepalese partners in our ordinary institutional international work, and hence offer an insider perspective to conferences, seminars and research practice; to teach without teaching in the areas in which we have more experience, but at the same time making efforts to find expert positions where Nepalese insights and experiences are presented at their best. Our consultancy has been searching for possibilities to influence policy makers and envision bigger structures of music education together. Our research has aimed at creating networked expertise between various agents in the Nepalese context, to highlight unique solutions in the local practices that can be discussed more widely in the Nepalese context and that can also educate music teacher educators in Finland and beyond. Failures and challenges in Finnish music education have also been discussed in workshops.

Case 3: co-constructing visions for intercultural music teacher education in Israel and Finland

This on-going collaborative project aims to initiate mobilising networks between two music teacher programmes, one in Finland and one in Israel, in order to explore music teacher educa-tors' perceptions of their own intercultural competences as well as the competences that their respective programmes provide for the students. The study, which is conducted by a multina-tional research group, is a form of developmental-practitioner research (Cochran-Smith & Lytle, 2009), in which institutional collaboration is central. Instead of a comparative approach, the study aims to co-create visions for intercultural music teacher education through the exchange of knowledge, and reflecting and sharing research outcomes between the two institutions.

Data has been gathered through focus group interviews and workshops with music teacher educators at the Sibelius Academy, University of the Arts Helsinki, and the School of Music Education, Levinsky College of Education in Tel Aviv. As mentioned earlier, the Finnish popu-lation structure has until recently been seen as relatively homogenous, whereas the Levinsky College of Education is located in a country characterised by vivid ethnic and cultural hetero-geneity, both within and between population groups. Within the Israeli educational system, Levinsky College belongs to the state-secular Jewish stream of study where the degree is con-nected to the K-12 state-secular Jewish schooling. The ethical issues that can be discussed by sharing experiences made in this particular project relate to:

6 research interpreted as a political stance; and
7 integrity of participants.

First, in the Nordic context, collaboration with an Israeli state-funded organisation could be considered politically controversial due to Israel's current domestic politics. Thus, this is an issue that Nordic researchers have to consider while conducting research in this particular context. However, in our understanding, the study advocates intercultural communication and interaction within education in order to strive for a better understanding and peaceful living between people from different cultural, religious and ethnic backgrounds.

Second, in the analysis of the data it has been important to keep the focus on the developmental aspects of the project. The focus group interviews in Israel and Finland dealt with issues commonly experienced, but not necessarily commonly discussed. Hence, as higher music education teachers are used to mainly taking care of their own courses, many of the interviewees commented that the group interviews were the first time they heard their colleagues' opinions. They also identified a need to continue the discussion on an institutional level. Indeed, according to Liamputtong (2011), in many cases the participants perceive the interviews as 'beneficial educational time' (p. 145). However, even though the interview situations were described as interesting and useful by the interviewees, they might still have felt that the presence of native researchers influenced or compromised the way they could address topics related to their work and institution since, in both cases, the researcher was also their colleague. Although there would be no reason to suspect the integrity of the informants, the possibility remains that they would leave things unsaid or embellish their opinions on issues at hand to please the native researcher. This is why it is particularly interesting to search for ruptures in the interview transcripts; places in which the interviewees contradict themselves or make remarks that suddenly show the discussed issue in a totally new light. However, when later analysing the interview data and interpreting these ruptures, it becomes crucial to consider 'the tensions between the weight of members' meaning and the ethnographer's interpretative responsibility' (Lather, 2007, p. 484); to reflect how ethically just and beneficial it is for the researcher to 'reveal' and report informants' contradicting ideas or politically incorrect thoughts on the discussed topics.

As mentioned earlier in this chapter, according to Liamputtong (2010, p. 39) the researchers have a moral obligation to the people they are working with. Reflexive researchers are expected to eliminate all harm that participating in the study might cause. Hence, this obligation might compromise the depth of the analysis if data becomes unusable or findings become shallow due to vast precautions taken to protect participants. In the case of this study, this moral obligation is particularly pressing since by exploring the music educators' experiences on interculturality in their teaching and on a programme level, individual voices can be recognised. The researchers need to take into account that possibility: to identify individual voices might compromise teachers' position within the institution, especially if they are critical of the workplace and its practices. Indeed, it might be impossible to ensure complete anonymity, as individual voices might be recognised, at least by close colleagues; also a colleague was always present as the translator. In this particular study, the overall epistemological aim frames choices in both the data collection process and analysis. The ultimate goal of the study is to improve the level of reflexivity and teaching in these two institutions through intercultural exchange of knowledge; and to be a constructive tool in institutional change processes instead of simply criticising or supporting the current reality.

Concluding discussion: future higher music education and 'the art of living with difference'

It has become increasingly clear that higher music education and music teacher education need to reconsider the education that they provide in relation to processes of globalisation, which bring people closer to each other but at the same time foster confusion and even conflicts. According

to sociologists such as Zygmunt Bauman (2007, 2008), our societies have undergone a passage from 'solid' to 'liquid' modernity, and are now characterised by an often-overwhelming fluidity. This fluidity is 'a condition in which social forms (structures that limit individual choices, institutions that guard repetitions of routines, patterns of acceptable behaviour) can no longer (and are not expected) to keep their shape for long' (Bauman, 2007, p. 1). This liquid phase comes with a number of consequences, some of them crucial within the context of intercultural practices in higher music education. First, as professor of multicultural education, Fred Dervin (2012) rightly claims, we need to give up the solid conception of identity in which teachers or students are associated with static cultural elements and with defining their borders – be it national, cultural or gender ones. Instead, we need to focus on *processes of identification* (Bauman, 2008, p. 86). These processes of forming ourselves involve multiple belongings, a state of affairs that is not just a choice, but a necessity, and which cannot be confined to the individual level only. Moreover, '[t]he powers that shape the conditions under which we all act these days flow in *global* space' (Bauman, 2007, p. 82), and this implies, among other things, that '[n]othing is truly, or can remain for long, indifferent to anything else – untouched and untouching' (p. 6). In other words, we are all connected in one way or another, and must therefore also be accountable to one another, since our realities are deeply intertwined. If Glazer (1998) saw all of us as 'multiculturalists' already in the 1990s, more recent views not only identify us as globally connected with a multiplicity of belongings, but argue that, at least in some areas, our societies have reached a whole new level of complexity of identification named *super-diversity*. According to Vertovec (2007), the super-diverse condition 'is distinguished by a dynamic interplay of variables among an increased number of new, small and scattered, multiple-origin, transnationally connected, socio-economically differentiated and legally stratified immigrants' (p. 1024), and denotes a form of intersectional intricacy hitherto never encountered.

It is within these contexts that we navigate as teachers and researchers, often with the purpose of building a scientific platform for facilitating institutional, staff and student growth. Some of these efforts, such as those described above, involve intercultural practices through exchanges, collaborations and co-constructions in which institutions, researchers, staff and students stretch out to one another in order to reach goals which, in our globalised world, may not be achieved within the borders of locality alone. However, if the contemporary sociologists' view of the deepening plurality is accepted, there might be a need to better recognise the super-diversity within our own neighbourhoods and surroundings: super-diversity that might include 'many diverse and incompatible conceptual and moral frameworks, many belief systems and ultimate values, without there being an overarching criterion to decide between them as the "truth"' (Baghramian & Ingram, 2000, p. 1). Since the old established societal norms no longer offer a frame for ethical thinking, and as we do not consider total relativism to be the answer for unavoidable choices in educational contexts, there is a growing need for us to: become more conscious of our educational interests and the ends in view that influence our choices; see the processes of identification as life-long, and for all practical purposes unfinishable; practise constant ethical reflection and deliberation; and learn to deal with uncertainty. In view of the foregoing, Dervin (2010) reminds us that intercultural competence is not something permanent or static 'for life', but rather 'its practice and learning never end'.

Higher music education cannot teach the truths of the world of musics. It can only strengthen the ability to *navigate* within rapidly changing musical belongings. It can provide examples of how to sail and how to anchor musically, and how to strive towards ethical interaction. In Bauman's words, it can lead to 'the art of living with difference' (2010, p. 151).

By institutions stretching out and engaging in intercultural collaboration and research, be it on a global scale or within our neighbourhood super-diverse contexts, the ethical imperatives

that are followed – such as the seven highlighted above – and the co-occurring challenges experienced, can be brought back into educational practice and constitute a whole new ground for ethical reciprocal conduct, highly needed if we wish to master, on any level, the difficult art of living with difference. Higher music education institutions would then not only be sites for intercultural practice conducted *as* research, but also for such research being crucial in constructing ethical premises for future practices.

References

Abdallah-Pretceille, M. (2006). Interculturalism as a paradigm for thinking about diversity. *Intercultural Education, 17*(5), 475–483.

Baghramian, M., & Ingram, A. (2000). Introduction. In M. Baghramian & A. Ingram, *Pluralism: The philosophy and politics of diversity* (pp. 1–14). London: Routledge.

Banks, J. A. (2004). Multicultural education. Historical development, dimensions, and practice. In J. A. Banks & C. A. McGee Banks (Eds.), *Handbook of research on multicultural education* (pp. 3–29). London: Macmillan.

Bartleet, B.-L. (2011). Stories of reconciliation: Building cross-cultural collaborations between indigenous musicians and undergraduate music students in Tennant Creek. *Australian Journal of Music Education, 2,* 11–21.

Bauman, Z. (2007). *Liquid times: Living in an age of uncertainty.* Malden, MA: Polity Press.

Bauman, Z. (2008). *The art of life.* Malden, MA: Polity Press.

Bauman, Z. (2010). *44 letters from the liquid modern world.* Malden, MA: Polity Press.

Broeske-Danielsen, B. A. (2013). Community music activity in a refugee camp: Student music teachers' practicum experiences. *Music Education Research, 15*(3), 304–316.

Burton, S., Westvall, M., & Karlsson, S. (2013). Stepping aside from myself: Intercultural perspectives on music teacher education. *Journal of Music Teacher Education, 23*(1), 92–105.

Cochran-Smith, M., & Lytle, S. (2009). *Inquiry as stance.* New York: Teachers College Press.

Coulby, D. (2006). Intercultural education: Theory and practice. *Intercultural Education, 17*(3), 245–257.

Davidson, C. N., & Goldberg, D. T. (2010). *The future of thinking: Learning institutions in a digital age.* London: MIT Press.

Deardorff, D. K. (2008). Intercultural competence: A definition, model, and implications for education abroad. In V. Savicki (Ed.), *Developing intercultural competence and transformation: Theory, research, and application in international education* (pp. 32–52). Virginia: Stylus Publishing.

Dervin, F. (2010). Assessing intercultural competence in language and teaching: A critical review of current efforts. In F. Dervin & E. Suomela-Salmi (Eds.), *New approaches to assessment in higher education* (pp. 157–173). Bern: Peter Lang.

Dervin, F. (2012). Cultural identity, representation and othering. In J. Jackson (Ed.), *The Routledge handbook of language and intercultural communication* (pp. 181–194). New York: Routledge.

Glazer, N. (1998). *We are all multiculturalists now.* Cambridge, MA: Harvard University Press.

Kallio, A., & Westerlund, H. (2015). The ethics of survival: Teaching the traditional arts to disadvantaged children in post-conflict Cambodia. *International Journal of Music Education.* http://dx.doi.org/10.1177/0255761415584298.

Kivisto, P., & Wahlbeck, Ö. (2013). Debating multiculturalism in the Nordic welfare states. In P. Kivisto & Ö. Wahlbeck (Eds.), *Debating multiculturalism in the Nordic welfare states* (pp. 1–21). Houndmills: Palgrave Macmillan.

Lather, P. (2007). Postmodernism, post-structuralism and post(critical) ethnography: Of ruins, aporias and angels. In P. Atkinson, A. Coffey, S. Delamont, J. Lofland & L. Lofland (Eds.), *Handbook of ethnography* (pp. 477–492). London: Sage Publications.

Liamputtong, P. (2007). *Researching the vulnerable.* New Delhi: Sage Publications.

Liamputtong, P. (2008). Doing research in a cross-cultural context: Methodological and ethical challenges. In P. Liamputtong (Ed.), *Doing cross-cultural research: Ethical and methodological perspectives* (pp. 3–20). Dordrecht: Springer.

Liamputtong, P. (2010). *Performing qualitative cross-cultural research.* Cambridge: Cambridge University Press.

Liamputtong, P. (2011). *Focus group methodology: Principles and practice.* Los Angeles, CA: Sage Publications.

Lundqvist, B., Szego, C. K., Nettl, B., Santos, R. P., & Solbu, E. (1998). *Musics of the world's cultures: A source book for music educators.* Reading, UK: ISME.

Nussbaum, M. C. (1997). *Cultivating humanity: A classical defense of reform in liberal education*. Cambridge, MA: Harvard University Press.

Rowley, J., & Dunbar-Hall, P. (2013). Cultural diversity in music learning: Developing identity as music teacher and learner. *Pacific-Asian Education, 25*(2), 41–50.

Sæther, E. (2013). The art of stepping outside comfort zones: Intercultural collaborative learning in the international GLOMUS camp. In H. Gaunt & H. Westerlund (Eds.), *Collaborative learning in higher music education* (pp. 37–48). Farnham: Ashgate.

Sahlberg, P. (2011). *Finnish lessons: What can the world learn from educational change in Finland?* New York: Teachers College Press.

Silj, A. (2010). Introduction In A. Silj, *European multiculturalism revisited* (pp. 1–10). London/New York: Zed Books.

Skeggs, B. (2007). Feminist ethnography. In P. Atkinson, A. Coffey, S. Delamont, J. Lofland & L. Lofland (Eds.), *Handbook of ethnography* (pp. 426–442). London: Sage Publications.

Stake, R. E. (1995). *The art of case study research*. London: Sage Publications.

Swanwick, K. (1988). *Music, mind, and education*. London/New York: Routledge.

Tange, H. (2010). International education as intercultural learning: An employee perspective. In M. Hellstén & A. Reid (Eds.), *Researching international pedagogies: Sustainable practice for teaching and learning in higher education* (pp. 99–114). New York: Springer.

Van Loon, J. (2007). Ethnography: A critical turn in Cultural Studies. In P. Atkinson, A. Coffey, S. Delamont, J. Lofland & L. Lofland (Eds.), *Handbook of ethnography* (pp. 273–284). London: Sage Publications.

Vertovec, S. (2007). Super-diversity and its implications. *Ethical and Racial Studies, 30*(6), 1024–1054.

Volk, T. M. (1998). *Music, education, and multiculturalism: Foundations and principles*. New York: Oxford University Press.

Westerlund, H., Partti, H., & Karlsen, S. (2015). Teaching as improvisational experience: Student music teachers' reflections on learning during a bi-cultural exchange project. *Research Studies in Music Education*.

34

INTERACTING ORCHESTRAS, INTERCULTURAL GAMELAN LEARNING IN BALI AND THE UK, AND REFLECTIONS ON ETHNOGRAPHIC RESEARCH PROCESSES

Jonathan McIntosh and Tina K. Ramnarine

Ethnographic researchers who focus on exploring musical and social practices around the world implicitly refer to interculturalism.[1] Within ethnomusicology, researchers often discuss issues around musical encounters and modes of transmission (meaning learning and teaching processes). It is useful to consider interculturalism as an integral aspect of the discipline of ethnomusicology itself, which is premised, in part, on intercultural music experiments, especially when learning a new musical tradition informs methodological research design. From this perspective, it is instructive to reflect on Mantle Hood's (1960) essay on 'bi-musicality' in which he argues for the importance of researching music performance in ethnomusicology through the acquisition of practical performance skills. Integrating this philosophy in his own pedagogical practice, Hood established a gamelan ensemble at the University of California, Los Angeles, a prime example of intercultural gamelan learning, which also provided a model for the teaching of ethnomusicology in other institutions. As a result, gamelan music has become a popular 'world music ensemble' in various universities (Vetter, 2004), a feature of symphony orchestra community projects, as well as being used as a rehabilitative and therapeutic tool (McIntosh, 2005; Mendonça, 2010). Gamelan music is an iconic orchestral practice especially associated with the Indonesian islands of Bali and Java. Due in part to its display in world exhibitions and ethnomusicologists' interests, gamelan music has become a global phenomenon. A virtuosic tradition, gamelan music is rich in cosmological significance and is based on complex musical theories related to modes, emotions, the natural environment and the spiritual world. Gamelan ensembles comprise various gongs, metallophones, drums and other instruments including spike fiddle (*rebab*) and bamboo flute (*suling*). Although no standardised tunings exist, gamelan instruments in Bali are gendered, and pairs of instruments often play complex, interlocking rhythmic patterns.

With reference to formal training in ethnomusicology, Hood notes that when a student learns a 'foreign music', such as gamelan music, the initial challenge is the development of an

ability to 'hear'. Students tend to 'correct' unfamiliar intervals, and thus it is more rewarding to use traditional pedagogic practices that rely on imitation and rote learning. This tendency to revert to familiar modes of musical thinking does not indicate an intercultural learning process, but the initial encounter with new musical sounds is the beginning of a longer musical transmission process that may lead to deeper intercultural understandings and engagements. Ultimately, therefore, Hood suggests that a methodological approach based on practice serves to develop 'musical' not just 'bi-musical' skills. Scholars often overlook this point when contemplating Hood's idea of 'bi-musicality', but it is crucial when considering intercultural arts-based concerns around equity, collaboration, ethics, as well as the links between theory and intercultural practice. Such an approach suggests that diverse forms of understanding lead to deeper ways of 'knowing', whether in terms of exploring different traditions of knowledge or using a variety of methodological tools to generate (inter)disciplinary insights. The overall aim of this chapter is to reflect on ethnographic research processes within the disciplinary frameworks of ethnomusicology as being grounded within empirical, practice-based, creative and human-centred methodologies. For many ethnomusicologists, participating in musical performance is integral to the process of conducting ethical and culturally sensitive research. Such practice, which relies on collaboration and involves listening to many voices, resonates strongly with intercultural aspirations. There are (inter)disciplinary anxieties concerning ethnographic work, however. One anxiety concerns the representation of people as 'insiders' or 'outsiders', and ethnographers have long contemplated how best to bridge the divide between the two. But, what if the model of 'insider' and 'outsider' is itself the conceptual problem? By exploring intercultural gamelan learning, and the interaction in and between musical ensembles, this chapter shows how ethnographic disciplines might reject 'insider' and 'outsider' distinctions in favour of broader ideas about collaboration and equity in researching musical performance. Such a rejection does not dismiss the social distinctions people make in everyday contexts although it does raise questions about (inter)disciplinary assumptions.

This chapter introduces some of the intricacies of learning gamelan music in two different contexts and reflects, more broadly, on the implications of interculturalism vis-à-vis ethnographic research processes. In doing so, the chapter highlights creative approaches, especially the ways in which musical encounters generate musical creative processes, as well as the importance of thinking about musical transmission in both intercultural learning and teaching. The examples examined here point to the possibilities for reciprocal exchanges, towards which contemporary ethnographic work strives.

To begin, the discussion focuses on an intercultural project in Bali, Indonesia – the Pondok Pekak international women's gamelan group – which is bound up with gendered musical performance issues as its name suggests (also see McIntosh, 2016). A preliminary discussion concerning the gendered dimensions of childhood musical learning in Bali contextualises the practices of the Pondok Pekak international women's gamelan group, since until recently gamelan has traditionally been a male musical practice. Women's participation in gamelan music challenges established gender roles in Balinese society, and the Pondok Pekak international women's gamelan group shows how gamelan ensembles are also important sites for intercultural collective music making. The UK context is discussed by way of introducing a comparative perspective and focuses on the London Symphony Orchestra (LSO) Gamelan as an example of orchestras in interaction (gamelan and symphony). Such a mode of interaction demonstrates how, in an increasingly globalised world, symphony orchestras attempt to reach out to new communities and audiences through repertoire choices, outreach projects and interactive digital technologies. These initiatives, based on ideas about inclusiveness, multiculturalism and diversity, indicate the symphony orchestra's potential to contribute to the making of civil society in

the UK context (also see Ramnarine, 2011). The significance of everyday intercultural musical processes for music research paradigms is that participatory and performance-based methodologies correspond with them, thus highlighting the experiential, transformative and social aspects of musical interculturalism in both research and practice. These aspects are discussed below in relation to learning gamelan music in Bali.

Learning gamelan music in Bali: children's education, gender and external influences

From a young age, Balinese children embody specific gender codes that are integral to the construction of traditional gender roles. For example, if children choose to learn traditional Balinese dance, boys and girls are taught to perform in a highly stylised manner that reflects deep-rooted gendered forms of movement and performance, with girls being more restricted in their movement patterns than boys. Similarly, as children grow up, boys are allowed to roam far from home whereas girls are required to stay close to the family compound in order to look after younger siblings, assist with the making of daily religious offerings and undertake other domestic obligations, such as cooking, cleaning and washing clothes. Despite state attempts to promote female emancipation (*emansipasi*), the Indonesian education system generally reinforces traditional gender roles (Parker, 1997), resulting in boys becoming 'more active and outgoing' and girls 'more passive and restrained' (Downing, 2012, p. 22). Consequently, the dearth of women's gamelan ensembles prior to the 1960s has little to do with the fact that females were prohibited from participating in this activity. As Susilo (2003, pp. 12–13) highlights, 'it was not that women were forbidden from playing *gamelan* [music], they just *didn't*; *men* played *gamelan* [music]' (emphasis in original). In choosing to play gamelan music, and as a result of Indonesian government policies, it is now possible for Balinese women and girls to utilise traditional collective music-making practices as a means of 'moving into a different space' (Susilo, 2003, p. 45).

Balinese women, like men, choose to participate in a gamelan ensemble not only because of a strong desire to play music but also as a form of Balinese-Hindu religious devotion (*ngayah*). Performances in ceremonial and secular contexts also provide women with 'an opportunity to dress up, be involved, and sparkle artistically' (Diamond, 2008, p. 235).[2] Furthermore, choosing to learn gamelan music is a powerful indicator of female agency within a patriarchal society, although women often rely on male gamelan teachers, who tend to instruct ensembles in simplified works performed at slower *tempi* (Bakan, 1997/1998, p. 41).[3] Since the 1980s, however, the performance standards of women's gamelan ensembles have gradually improved. Despite such progress, Balinese women continue to 'find themselves caught in a double bind' (Diamond, 2008, p. 237), overcoming a long-standing inequity in the traditional performing arts and being judged against the aesthetics of, and standards attained by, male gamelan ensembles (Bakan, 1997/1998, pp. 58–59). Traditional gender discourse continues to influence the way in which Balinese women perform gamelan music. For instance, it is commonly believed that women should adopt a 'soft and calm, not strong or ambitious' (Willner, 1992, p. 138) demeanour when playing gamelan music.[4] For this reason, it can be difficult for female groups to project the strong enigmatic performance modes (*gaya*) required to present compositions originally intended for presentation by male gamelan ensembles. In an attempt to overcome preoccupations with an 'ideal' feminine presentation style that is, in many cases, 'often not reality' (Susilo, 2003, p. 31), several male musicians, including the performer and scholar I Wayan Dibia, believe that women should not 'force themselves to perform like men but [instead] create their own style' (Palermo, 2009, p. 4). However, and according to Diamond

(2008, p. 237), such a development, could potentially essentialise women's gamelan groups even further by restricting them to a 'feminine mode of playing'.[5]

There is no doubt that women's increased participation in the traditional Balinese performing arts in general has influenced debates concerning the construction of an 'ideal' female demeanour within the context of gamelan performance. Historically, young girls who performed *legong* tended to cease dancing once they reached puberty.[6] Female dancers and actors also often retired from public performances once they married. Today, however, many women continue to dance publicly (in some circumstances, well into middle age and beyond) in both traditional and tourist performance contexts.[7] Indeed, and as a result of the development of cultural tourism in Bali, tourists have not only created more opportunities for female dancers and actors but some have also played a significant role in fashioning new performance opportunities for Balinese women. The Italian actress, performer and artist Cristina W. Formaggia (1945–2008) is an example of one such individual. A founding member of the group Topeng Shakti, a company comprising Balinese and non-Balinese members, Formaggia encouraged Balinese women to develop skills in *topeng* (a genre of Balinese mask dance performance originally performed by men). Formaggia's involvement in this process demonstrates the agency of Western female performers who wish to promote new opportunities for Balinese women. As another example of intercultural performance, one that intentionally combines Balinese and Western approaches to learning and performance, Keith Terry's (2000) *Body Taj* (in collaboration with the Balinese performer and scholar I Wayan Dibia) involves a mixed chorus comprising Balinese and Americans, men and women, who perform body percussion with Balinese *cak* (vocal chant). According to Diamond (2008, p. 250), such a work demonstrates 'once again the impact of foreign collaborations in altering perceptions of gender appropriateness' in the Balinese context.

Ubud and the Pondok Pekak Library and learning centre

The preceding details provide a context within which to consider the case study of the Pondok Pekak. Unlike the beach resorts of Kuta and Sanur in southern Bali, Ubud – which is situated in the south-central administrative district of Gianyar – is intentionally marketed as being remote, or 'non-touristic', in order to induce tourists to 'discover' (MacCannell, 1973, p. 594) what is, in effect, a lively and ever-expanding village heavily dependent on tourism. Promoted as the 'cultural centre' of Bali (Bakan, 1999, p. 23; Picard, 1996, pp. 83–89), Ubud also attracts a substantial number of visitors (and researchers), many of whom choose to attend the numerous cultural performances staged every evening in and around the village (McIntosh, 2014). In addition to being a tourist centre, Ubud is home to a large expatriate community. Many members of this community are married to local Balinese or Indonesian citizens living in Bali. Several also operate their own businesses in and around Ubud, with some also working for international companies with business interests in Indonesia. Consequently, although many businesses in Ubud primarily cater for tourists, some also become hubs for members of the expatriate community. The Pondok Pekak Library and Learning Centre, commonly referred to as the 'Pondok Pekak', is one such site.

Established in 1995 by American expatriate Laurie Billington (1958–2009) and her Balinese husband, I Made Sumendra, the Pondok Pekak is a private organisation frequented by tourists, expatriates and local Balinese residents. *Pondok* means 'a small house in a rice field' and this organisation is built within the confines of I Made Sumendra's family compound, which used to be in a rice field very close to the Ubud Royal Palace. The Pondok Pekak offers a variety of services, including library-lending facilities and a range of educational programmes for adults

and children such as language lessons (in Indonesian and Balinese) and traditional performing arts training (gamelan music, traditional dance and mask carving). The income generated as a result of these activities, as well as additional private donations, ensures that the organisation can employ local teachers to provide Balinese children who live in the area immediately surrounding the library with access to free gamelan music and traditional dance lessons.

According to Billington, the provision of free music and dance lessons to children was an important factor that served to encourage local Balinese residents to become aware of, and use, the Pondok Pekak.[8] For example, and as an avid reader herself, Billington initially established the Pondok Pekak to offer library-lending services for the Balinese. Given that there is no tradition of borrowing library books in Bali, at first the local Balinese thought that the library was simply an organisation for tourists. In establishing a specific traditional arts programme for Balinese children, however, the Balinese living near the library became interested in the organisation. As a result of accompanying their children to weekly music and dance lessons, Balinese mothers, in particular, learned more about the library's mission, as well as how to use the Pondok Pekak as a space in which to socialise before, during and after children's music and dance lessons. The fact that Balinese women socialise in the Pondok Pekak as a public space that is also a part of a family compound underscores the unusual or 'liminal' position of the organisation.

Like the local Balinese, tourists were also slow to discover the library. Furthermore, when tourists did start availing themselves of the Pondok Pekak's library-lending services it was difficult for the library to maintain the consistent membership that such an organisation requires in order to offer a proficient service. As the reputation of the Pondok Pekak increased, notably as a result of entries in various tourist guidebooks, such as the *Lonely Planet* or the *Rough Guide to Bali*, tourists and members of the expatriate community living in Ubud also became aware of the organisation. As a result of tourist- and expatriate-generated revenue, the library expanded from a few small rooms to also encompass a purpose-built building. Children's music and dance lessons, as well as a weekly tourist performance utilise the latter two venues. Indeed, the library's decision to stage a weekly tourist performance led to the organisation purchasing a *gamelan gong kebyar* ensemble.[9] The procurement of this ensemble eventually resulted in the establishment of the Pondok Pekak international women's gamelan group in late 2002. Such a female gamelan group is unusual given that it comprises approximately an equal number of Balinese and non-Balinese members who live in and around Ubud.

Balinese members choose to participate in the ensemble primarily because they wish to take part in a music-making activity, such as when the group performs publicly at various events and temple ceremonies in Ubud and in the surrounding area. In contrast, many of the non-Balinese members choose to participate in the ensemble because of links to the library, which for many includes being personal friends with Billington. Whether staying in Bali on short-or long-term visas, or permanently residing in Ubud, many non-Balinese members also participate in order to gain either an entrée into or, if they have an established connection with Bali, a further understanding of Balinese culture and society. Thus, the coming together of such a diverse cohort exemplifies the way in which involvement in gamelan music not only serves to generate important social processes, but also opens up an intercultural space for the negotiation of traditional gamelan teaching and learning practices. For example, male teachers employed to coach the ensemble utilise myriad methods to instruct the group's diverse cohort. Although such approaches are largely based on the traditional 'holistic demonstration and imitation mode of transmitting musical knowledge from teacher to student' (Bakan, 1999, p. 281), the teachers also recognise that many of the non-Balinese members struggle to learn gamelan music in this manner. Consequently, the teachers also use a number system (*kepatihan*) to represent the various gamelan tones, a method which empowers non-Balinese members to devise individual

forms of notation that serve as *aide-memoires* during rehearsals and performances. In addition, the teachers employ Balinese and Indonesian verbal commands to communicate important concepts and instructions to ensemble members. Such an intercultural approach to gamelan learning enables the group to attain a proficient performance standard. Since 2010, however, the group has rehearsed and performed on a more ad-hoc basis, including periods of disbanding when not enough players are available to attend regular rehearsals.[10]

In 2014, the Pondok Pekak underwent further renovation and expansion, which I Made Sumendra was able to undertake because of revenue from another business venture, a traditional healing space (*boreh*). The popularity of Elizabeth Gilbert's (2006) book, and especially of the subsequent film, *Eat, Pray, Love* (Murphy, 2010) resulted in an increase of tourists wishing to experience traditional Balinese healing practices.[11] In the low season for tourism (October to April), the Pondok Pekak greets between fifty to one hundred visitors, both locals and non-locals, of whom some choose to study gamelan music with I Nyoman Parman, who has been teaching the international women's gamelan group since 2004. Parman is an active drummer (*pengendang*) in his village and in tourist venues across Bali, including a major tourist venue in the village of Batubulan, situated just north of the island's capital city, Denpasar. In this latter location, tourists can observe a performance of *barong* (a mythical masked beast presented by two male dancers) during the daytime (rather than the evening), a practice originally established in the 1930s so that the American anthropologist Jane Belo could photograph the event (see Belo, 1960). Today, descendants of musicians photographed by Belo continue to perform in the Batubulan tourist presentation. I Nengah Susila is one such performer, a Balinese composer who has also worked with the LSO Gamelan and LSO members, and whose work, *Inguh*, was premiered in the LSO St Luke's site in London in April 2011.[12] International circulations are apparent likewise in Parman's pedagogic practice since his students come from various places, including UK, France, Holland, USA and Canada (during 2013–14). Thus, intercultural gamelan learning and performance projects highlight the circulation of cultural practices, collaborative learning and performance work. These are seen in the performances such as those at the Pondok Pekak and the LSO Gamelan that are supported by the encounters of musicians from across the world as well as in institutional contexts, another of which is discussed in the following example.

Gamelan learning in the UK: the LSO gamelan

The LSO Gamelan is part of the LSO's community programme, which is called 'LSO Discovery'. This programme brings a Balinese gamelan orchestra into interaction with the symphony orchestra, thus highlighting different methods of orchestral transmission. Weekly rehearsals on Monday evenings take place at the LSO's St Luke's site in Old Street, Islington, London. The LSO Gamelan also gives concerts regularly, often in the same programme as its teacher's (Andrew Channing's) gamelan ensemble, Lila Cita. Processes of working on a new *gamelan gong kebyar* composition for the LSO Gamelan and members of the LSO are outlined elsewhere (Ramnarine, 2011). The following discussion extends insights into how traditional Balinese systems of transmission are adapted in the UK.

The LSO Gamelan brings together two orchestral traditions, both of which have spread globally. Just as in the above discussion of women's gamelan performance in Bali, social analyses of the symphony orchestra highlight gender as an important factor shaping employment opportunities (see, for example, Goldin & Rouse, 2000). The open access policy of the LSO Gamelan, however, means that notions of traditional Balinese comportment do not inform the instruments members may play in the orchestra.[13] Bakan compares gamelan and Western art

music in order to consider what pedagogical lessons might be applied from the former to the latter. In pondering Colin McPhee's (1970, p. 232) statement, 'the teacher does not seem to teach', Bakan (1999, p. 5) states that:

> both Western and Balinese musicians are faced with the challenges of musical reper-toires that feature complex, virtuosic, pre-composed, multipart works. Yet the differ-ences between means of transmitting and acquiring the necessary skills to perform such works are so great that even to recognise the Balinese teacher as a teacher presents a challenge for the Western analyst.

In noting that the practice of seeming 'not to teach' relies on little or no verbal instruction, Bakan highlights how such an approach emphasises gestural learning in which the student fol-lows the teacher's mallet. By not conceding to beginners in terms of speed of performance and not breaking down compositions into smaller passages, this approach permits players to join in whenever they feel like doing so. Such a technique contrasts with that utilised in the transmis-sion of Western art music where students, more often than not, are encouraged to first listen before trying to reproduce a specific sound. Given that gamelan students also learn in an ensem-ble environment from the outset, such an approach encourages a more holistic approach to the learning of new repertoire. When studying *gamelan beleganjur* drumming, however, Bakan was tempted to transcribe various patterns as part of the learning process.[14] Transcription is adopted by many of the participants in the LSO Gamelan. Instead of relying on memory, LSO Gamelan members often write down the numbers assigned to particular gamelan tones (the same process, while not traditionally used in Bali, has been adopted in a similar way by the members of the Pondok Pekak women's gamelan ensemble) as Andy Channing calls them out during rehearsals. In contrast, others audio record the initial demonstration of the main melodic line (*pokok*) on mobile phones and other recording devices, such as dictaphones. Nevertheless, the longer play-ers stay with the gamelan ensemble the less reliant they become on such memory aids, trusting that the rehearsal processes will be sufficient to secure musical memory. Another concession to non-traditional Balinese pedagogic practice includes playing compositions at slower *tempi* in the initial learning process, although the ensemble does attempt to observe and sometimes perform works at approximate 'Balinese speeds'. This is a clear example of how interculturalism in music learning is not simply about the reproduction of music from one context in another. It illustrates how initial encounters with new musical practices may lead ultimately to deeper intercultural engagements, thus building, as Hood (1960) suggested, overall musical rather than bi-musical skills.

In other respects, the LSO Gamelan attempts to create a more traditional learning environ-ment. For example, there are only a few moments in rehearsals when the gamelan teacher focuses on a specific section of the ensemble. In such cases, other sections are brought back into the playing as soon as possible. In this respect, the teaching conforms to traditional practices even more than the gamelan lessons offered at Pondok Pekak where most international stu-dents tend to receive tuition on an individual basis. Whenever possible in such lessons, Pondok Pekak's Parman teams up players who are studying with him. He usually fills in other instru-mental parts by singing and playing as appropriate. However, the practicalities of individually focused work means that it is not easy to impress a holistic concept of the ensemble on students who choose to study gamelan music in this manner. Consequently, such students often attend gamelan performances in the Ubud area to acquire further knowledge of compositions as ren-dered in ensemble situations. Similarly, long-standing LSO Gamelan players are quite commit-ted to learning about *gamelan gong kebyar* in its Balinese context. For instance, many participants

travel to Bali to further study gamelan, returning to London with renewed enthusiasm and appreciation for gamelan music and its traditional performance contexts.

Similarities as well as differences emerge when focusing on transmission processes in intercultural projects in Bali and the UK. One important difference lies in compositional processes. Although I Nengah Susila worked intensively for three months when composing for the LSO Gamelan, he claimed that he did not remember his own composition (at least offhand) two years later (in 2013). Composers in the symphonic tradition are likewise inspired by gamelan music (as indeed by traditions all around the world), but they maintain a strong idea of authorship, one that adheres to the concept of 'the work'. Ideas about authorship and ownership thus extend from thinking about 'my work' to 'my culture' and also underpin ethnographic distinctions between 'us' and 'other'. Nevertheless, Susila's claim that it is not important for him to remember exactly what he composes is much closer to actual processes of musical creativity, and resonates with the points highlighted in intercultural gamelan learning about the importance of collaborations and processes. Indeed, such an admission offers routes to ethnographic theorisation of process rather than artefact and of the potential reciprocities of intercultural as well as ethnographic research projects.

A few reflections on interculturalism and ethnographic research processes

One reason for emphasising the idea of developing overall musical skills with reference to intercultural learning is that such a process avoids the pitfalls and limitations of thinking that musical engagement somehow facilitates insights into an insider's cultural perspective. In fact, such an approach calls into question the very idea of the 'insider'. The idea of cultural 'insider' and 'outsider' status is still alive in ethnomusicology despite new conceptual models of cultural processes in flow, transnational cultural transmissions, border crossings, cultural mobility and identities as processes of becoming. However, 'insiders' and 'outsiders' are no longer as clearly defined as they once were in ethnomusicological writing, and the presumed roles of researcher and research subject have been renegotiated. In doing so, 'informants' are now recognised as 'co-researchers' and, although the remnants of 'insider' and 'outsider' thinking often underpin intercultural projects, the terms of engagement are different, instead stressing new understandings in cultural encounters. In recognising such a shift, and as Curkpatrick (2016) suggests with reference to his study of the Australian Art Orchestra's intercultural project *Crossing Roper Bar*, 'a fresh approach to performance and an ethnomusicological method emerges', one that is premised on collaboration and changing interpretations. Accordingly, individuals become 'caught up in a game of engaged performance, a back-and-forth play of conversation and involved interpretation that is ever shifting beyond any contained event of iteration'. Reflecting on his experiences of intercultural experimentation, Bakan (1999) likewise rejects ethnographic tropes about reaching for musical understanding from an insider's perspective. With reference to his study of Balinese *gamelan beleganjur* drumming, Bakan used his own prior musical skills as a practical strategy to accelerate the learning processes. In doing so, Bakan also asked his teacher to modify his teaching style in order to help him learn in a way with which he was familiar. These modifications included playing shorter passages at a slower tempo so that Bakan could transcribe material and have a notated copy from which to learn. This approach worked well until the drumming teacher realised that Bakan had not consistently memorised the material and renegotiated the terms of his learning. Thus, Bakan continued his learning under the teacher's more traditional methods of instruction. Although he did not learn the material as quickly, the traditional learning methods helped him to better memorise it. Bakan's account of the

ethnographic learning processes obviously presents his individual perspective but it is clear that the intercultural experiment was of interest to his teacher who likewise learned about different approaches to learning and performing music via intercultural practice (Bakan, 1999, chapter 8). Bakan's account is but one example of how ethnomusicologists often reflect deeply on their music learning and performing processes as part of research methodologies. But as Bakan notes, this is not a one-sided approach to intercultural learning and performance.

Intercultural learning and performance also holds the capacity to subvert the standard trope of 'insider' and 'outsider' altogether. For instance, in the New Zealand project, *With Strings Attached*, the musician Tiki Taane subverts dominant representational practices of the nation's past by positioning himself as both the coloniser and colonised. As Wilson observes, 'the project therefore exemplifies some of the complexities of post-colonial identity politics in contemporary New Zealand'. In light of this, and by re-representing identities through intercultural practice, 'new historical readings and a view of a potential, more integrated, future' (Wilson, 2016) seems possible, especially when one considers the link between (inter)disciplinary theory and practice.

In thinking about the links between ethnomusicological theory and intercultural practice it is worth emphasising that interculturalism exists all around us. In looking for recordings of gamelan music in Bali, for example, one quickly notices CDs with titles such as *Bali Meets Asia Oceans of Tranquillity: The Sound of Relaxation* (Doré, 2014) and *Bali Spa Part 7: Piano Meets Gamelan* (See New Project, 2014). As such, expanding the theoretical potential of interculturalism might be worthwhile in moving towards ever more ethical and conversational ethnographic research methods. With reference to this point, Bakan (1999, p. 323) ultimately arrives at a 'transformative moment' in his intercultural learning (as other ethnomusicologists also describe). In his final drum lesson, Bakan's teacher urges him to just play and listen. Consequently, Bakan reaches a level of musical understanding that has eluded him previously, one that is based on research interdependence. Following this realisation, Bakan (1999, p. 329) writes that good drumming is premised on trust and that as the different strands of drumming 'are woven together in a balanced and integrated way, each gains significance and purpose as a unique but ultimately indistinguishable part of something greater'. His insight resonates with Hood's (1960) argument that overall musical skills are developed in encountering different musical traditions.

Building on these insights, this chapter has argued that interculturalism is not simply about a meeting of musical cultures. Neither is it about the ethnomusicologists' shifting perspectives from the unfamiliar to the familiar as they immerse themselves in trying to understand the world's musics. Rather, the opportunities provided by ethnographic research approaches (which depend on human interactions and musical participation) centre on the potential for transformation and empathetic understandings for all those involved in such processes. Such models of interaction and collaboration promote intercultural arts-based concerns around equity and highlight the links between theory and intercultural practices. With the integrative potential of musical interculturalism in mind, one could argue that the promises of further interrogating the nexus between intercultural musical learning and ethnographic research methods (both resting on collaborations and processes) serve to advance musical skills and greater awareness of one's place in the wider world.

Notes

1 This chapter is based on fieldwork conducted by Jonathan McIntosh in Bali (October 2003–2004, December 2007–January 2008, July 2013) and by Tina K. Ramnarine in Bali (July–August 2013, November 2014) and London (2009–14), with the latter two fieldwork trips funded as part of Ramnarine's AHRC project on global perspectives on orchestras, undertaken within the AHRC Centre for Musical Performance as Creative Practice. The research also draws on Ramnarine's work

for a PALATINE project on participatory research. Funding from these sources is gratefully acknowledged. Thanks are also due to Andy Channing, I Nyoman Parman and I Nengah Susila, as well as other gamelan musicians with whom Ramnarine studied as part of participatory research.

2 When participating in ceremonial events, women's gamelan ensembles usually perform in the outermost courtyard (*jaba*) of a Balinese temple (Susilo, 2003, p. 12).

3 Although women's gamelan ensembles largely study compositions intended for performance by male musicians, some teachers instruct female groups to present compositions considered to exhibit feminine characteristics (Downing, 2008, p. 60). Recently, some male composers have also devised works specifically for female musicians (Diamond, 2008, p. 237).

4 In Bali, sitting cross-legged (*mesila*) to play various gamelan instruments, as well as sitting cross-legged with the drum (*kendang*) on one's lap, is not considered feminine (Susilo, 2003, p. 30).

5 For a detailed discussion concerning how local and national debates inform female representation in Bali see Creese (2004) and Allen and Palermo (2005).

6 *Legong* is a 'classical' Balinese dance form historically performed by two or three pubescent girls.

7 Since the 1980s, women have performed other traditional 'male' dramatic forms, including mask dance (*wayang wong* and *topeng*) and *kecak*, a form of dance drama that has its roots in *sanghyang*, a trance-inducing exorcism dance (Diamond, 2008, p. 234).

8 Laurie Billington in conversation with McIntosh, 20 October 2003, Ubud, Bali.

9 Performed in ceremonial and secular contexts, *gamelan gong kebyar* is the most popular form of gamelan ensemble in Bali.

10 For a detailed examination of how intercultural dimensions shape the music activities and performances of the Pondok Pekak international women's gamelan group see McIntosh (2016). Details on the group's activities during the period 2005–2014 were given by I Nyoman Parman in conversation with Ramnarine, 18–19 November 2014, Ubud, Bali.

11 I Made Sumendra in conversation with Ramnarine, 11 November 2014, Ubud, Bali.

12 I Nengah Susila in conversation with Ramnarine, 1 August 2013, Batubulan, Bali.

13 More often than not, Balinese gamelan musicians perform the same instruments in public presentations. While male musicians tend to have practical experience of various orchestral parts, this is often not the case in female ensembles.

14 A *gamelan beleganjur* ensemble consists of numerous large crash cymbals, kettle chimes of various sizes, gongs and drums.

References

Allen, P., & Palermo, C. (2005). *Ajeg Bali*: Multiple meanings, diverse agendas. *Indonesia and the Malay World, 3*(97), 239–255.

Bakan, M. (1997/1998). From oxymoron to reality: Agendas of gender and the rise of Balinese women's gamelan beleganjur in Bali, Indonesia. *Asian Music, 29*(1), 37–85.

Bakan, M. (1999). *Music of death and new creation: Experiences in the world of Balinese gamelan beleganjur.* Chicago, IL: University of Chicago Press.

Belo, J. (1960). *Bali: Rangda and barong.* Seattle: University of Washington Press.

Creese, H. (2004). Reading the Bali post: Women and representation in post-Suharto Bali. *Intersections: Gender, History and Culture in the Asian Context,* 10. http://intersections.anu.edu.au/issue10/creese.html (17 November 2014).

Curkpatrick, S. (2016). Voices on the wind: Eddies of possibility for Australia's orchestral future. In T. K. Ramnarine (Ed.), *Global perspectives on orchestras: Essays on collective creativity and social agency.* Oxford: Oxford University Press.

Diamond, C. (2008). Fire in the banana's belly: Bali's female performers essay the masculine arts. *Asian Theatre Journal, 25*(2), 231–271.

Doré. (2014). *Bali meets Asia: Oceans of tranquillity, the sound of relaxation.* Denpasar: Maharani Record, MCD016, CD recording.

Downing, S. (2008). *Arjuna's angels: Girls learning gamelan music in Bali.* Ph.D. thesis, University of California, Santa Barbara.

Downing, S. (2012). Embodied learning of music and gender in Balinese children's gamelans. In C. Lim & P. Whitman (Eds.), *Musical childhoods of Asia and the Pacific* (pp. 1–35). Charlotte, NC: Information Age Publishing.

Gilbert, E. (2006). *Eat, pray, love: One woman's search for everything across Italy, India and Indonesia*. New York: Penguin.

Goldin, C., & Rouse, C. (2000). Orchestrating impartiality: The impact of 'blind' auditions on female musicians. *The American Economic Review, 90*(4), 715–741.

Hood, M. (1960). The challenge of 'bi-musicality'. *Ethnomusicology, 4*(2), 55–59.

MacCannell, D. (1973). Staged authenticity: Arrangements of social space in tourist settings. *American Journal of Sociology, 79*(3), 589–603.

McIntosh, J. (2005). Playing with teaching techniques: Gamelan as a learning tool amongst children with learning impairments in Northern Ireland. *Anthropology in Action, 12*(2), 12–27.

McIntosh, J. (2014). Negotiating musical boundaries and frontiers: Tourism, child performers and the tourist-ethnographer in Bali, Indonesia. In S. Krüger & R. Trandafoiu (Eds.), *The globalization of musics in transit: Music migration and tourism* (pp. 59–85). New York: Routledge.

McIntosh, J. (2016). The women's international gamelan group at the Pondok Pekak: Intercultural collective music making and performance in Bali, Indonesia. In T. K. Ramnarine (Ed.), *Global perspectives on orchestras: Essays on collective creativity and social agency*. Oxford: Oxford University Press.

McPhee, C. (1970 [1939]). Children and music in Bali. In J. Belo (Ed.), *Traditional Balinese culture* (pp. 212–239). New York: Columbia University Press.

Mendonça, M. (2010). Gamelan in prisons in England and Scotland: Narratives of transformation and the 'good vibrations' of educational rhetoric. *Ethnomusicology, 54*(3), 369–394.

Murphy, R. (dir.). (2010). *Eat, pray, love*. USA: Columbia Pictures.

Palermo, C. (2009). *Anak mula keto* 'It was always thus': Women making progress, encountering limits in characterising the masks in Balinese masked dance-drama. *Intersections: Gender and Sexuality in Asia and the Pacific,* 19. http://intersections.anu.edu.au/issue19/palermo.htm (17 November 2014).

Parker, L. (1997). Engendering school children in Bali. *Journal of the Royal Anthropological Institute, 3*(3), 497–516.

Picard, M. (1996). *Bali: Cultural tourism and touristic culture* (trans. D. Darling). Singapore: Archipelago Press.

Ramnarine, T. K. (2011). The orchestration of civil society: Community and conscience in symphony orchestras. *Ethnomusicology Forum, 20*(3), 327–351.

See New Project. (2014). *Bali spa part 7: Piano meets gamelan*. Denpasar: Maharani Record, MCD203, CD recording.

Susilo, E. (2003). Gamelan wanita: A study of women's gamelan in Bali. Southeast Asia Paper no. 43. Center for Southeast Asian Studies: University of Hawaii at Manoa.

Vetter, R. (2004). A square peg in a round hole: Teaching Javanese gamelan in the ensemble paradigm of the academy. In T. Solís (Ed.), *Performing ethnomusicology: Teaching and representation in world music ensembles* (pp. 115–125). Berkeley: University of California Press.

Willner, S. (1992). Kebyar wanita: A look at women's gamelan groups in Bali. In Pertemuan Tahunan Lembaga Pengkajian Budaya Bali, *Lembaga Pengkajian Budaya Bali* (pp. 137–149). Denpasar: Lembaga Pengkajian Budaya Bali.

Wilson, O. (2016). Tiki Taane's *With Strings Attached*: Alive & orchestrated and post-colonial identity politics in New Zealand. In T. K. Ramnarine (Ed.), *Global perspectives on orchestras: Essays on collective creativity and social agency*. Oxford: Oxford University Press.

35

DEVELOPING DIALOGUES IN INTERCULTURAL MUSIC-MAKING

Amanda Bayley and Chartwell Dutiro

Introduction

Understanding the processes involved in intercultural music-making requires exploring the space between cultures, as defined by the prefix 'inter'. This space takes a different shape for each collaboration because it is determined by the individuals involved as much as by the cultures themselves. The Chinese pipa player, Wu Man, clearly articulates this space as a middleground, not only between two cultures but between three in the case of Terry Riley's Indian-influenced piece, *The Cusp of Magic*, written for her and the Kronos Quartet in 2004 (interview 12 June 2013, see video clip 1; video clips are available online at www.routledge.com/9781138909939). Intercultural music-making can be understood by studying the way ideas are communicated between musicians, how roles and responsibilities are defined and how a middleground is negotiated.

The anthropologist, Bob White (2012, p. 6), has recently explained how

> relatively little scholarship has focused on the actual encounters – the chance meetings, coordinated misunderstandings, and ongoing collaborations – that bring people of different musical or cultural backgrounds together or the ways that these encounters condition musical practice and knowledge about the world.

Following a chance meeting between Bayley and Dutiro in August 2013 (at a performance where he was playing with a string quartet he had previously worked with in 2006), a dialogue began. Dutiro was keen to work with strings and pursue a new collaboration as part of his personal ambition to bring mbira into twenty-first century repertory. Bayley invited local musicians to work with Dutiro specifically to research how dialogues develop between musicians throughout the process of creative collaboration and across diverse cultures.[1] A collaboration was set up in 2014 to combine Dutiro's mbira music from the Shona tradition of Zimbabwe with the string quartet from Exeter Contemporary Sounds (hereafter ECS).

Engaging in dialogue makes this mbira and string quartet collaboration different from previous experiences within Dutiro's thirty-year career as an international soloist and ensemble player. The starting point for this research was his criterion of 'building bridges between cultures', the mission of his recently founded Mhararano Mbira Academy, Dartington, Devon (UK), founded on the values of connecting, learning and changing, and Bayley's research

on composer–performer collaborations (2011; forthcoming). By representing two traditions coming together the authors' dialogue transcends the inside/outside: Dutiro's role as a participant and Bayley's role as participant-observer and facilitator of the collaboration. The creative components afforded by the participants that help to define a new music are interpreted by these respective emic and etic perspectives, Dutiro also contributing an auto-ethnographic approach to the research. The dialogue between the authors is particularly significant in a postcolonial context because it resists promoting the viewpoints of a colonising culture, instead acknowledging Dutiro's perspectives as representative of the historically colonised and marginalised. The co-authorship of this chapter also helps to minimise 'construct bias' which occurs 'when the construct measured is not identical across cultural groups' (for example, 'incomplete overlap of definitions of the construct across cultures' (van de Vijver & Leung, 1997, p. 11)).

Defining the field

The generally accepted distinction between the terms 'cross-cultural' and 'intercultural' is clearly articulated by Gary Weaver (in the context of business management): 'intercultural communication includes the actual interaction of people from various cultures' whereas 'cross-cultural communication involves comparing and contrasting cultures' (1988, p. 5). In relation to theatre, Ric Knowles (2010, p. 4) justifies intercultural rather than alternative terms (such as cross-cultural, multicultural, transcultural, transnational, etc.) because it is

> important to focus on the contested, unsettling, and often unequal spaces *between* cultures, spaces that can function in performance as sites of negotiation. Unlike 'cross-cultural', 'intercultural' evokes the possibility of interaction across a multiplicity of cultural positionings, avoiding binary codings.

The mbira-string quartet collaboration interprets performance in its broadest sense to include rehearsal and any form of intercultural practice. From theatre, the word devising is preferred to composition because the word composition often brings a set of Western assumptions that are unhelpful in an intercultural setting.

Resulting from the International Symposium and Festival on Intercultural Music (organised by the Centre for Intercultural Music Arts in London in 1990), the first volume of the journal devoted to the topic defines intercultural music as:

> that in which elements from two or more cultures are integrated. The composer of this music usually belongs to one of the cultures from which the elements are derived, but this does not necessarily have to be the case. Indeed, this type of intercultural activity is thematic, being inherent in the music itself and, therefore, the origin of the composer is irrelevant to the definition. There is another type of intercultural creative activity in which the origin of the composer is the determining factor. A composer writing in an idiom acquired from a culture other than his or her own is involved in an intercultural activity, even though the music that he or she produces is not necessarily intercultural. For example, when an African composer writes a fugue in the style of Bach, in which he or she makes no use of African resources, intercultural activity takes place but the music itself is not intercultural.
>
> *(Kimberlin & Euba, 1995, p. 2)*

The rationale for a composer, the question of authorship, and the status of notation all need to be interrogated. For example, to what extent does a composer perpetuate a Western hegemony

when performers themselves are co-creators in the compositional process? This question pertains to any collaboration that involves the combination of oral and notated traditions. While compositions are the products of notated traditions attributed to an individual, the study of which belongs to musicology, in oral traditions they may be products of creative practice attributed either to an individual or a group (see Nettl, 1954; Merriam, 1964).[2] Oral traditions define a performance practice which therefore attracts (ethno)musicological, analytical and anthropological approaches.

Many intercultural characteristics may also be apparent in situations where genres *within* a culture are combined, for example when jazz musicians meet classical musicians, or when folk music meets art music. However, when musicians from different cultures come together to create new music, a specific branch of intercultural activity identifies itself from their interactions: an intercultural practice begins to emerge from the content and structure of verbal and musical exchanges that take place. Interactions between musicians across stylistic and cultural boundaries have been explored in considerable detail through Benjamin Brinner's overlapping constellations of analytical concepts – interactive network, interactive system, interactive sound structure, and interactive motivation (2009) – which will be used to evaluate observations of the musicians.

A summary definition of intercultural musicology (as distinct from intercultural music) is provided on the Music Research Institute website:

> (a) one's own indigenous music culture using techniques applicable to other music cultures (b) music cultures other than one's indigenous culture (c) music created by combining elements from various cultures, and (d) other forms of intercultural activity, for example, the study of performers who specialise in non-indigenous music idioms.
>
> *(http://www.music-research-inst.org/*
> *subs/im4_1/im.htm)*

The mbira–string quartet collaboration fulfils descriptions (b) and (c), although in the process of sharing and discussing music from different cultures commonalities are discovered, regarding 'techniques applicable to other music cultures', from (a).

Arising from the initial Intercultural Music Symposium, Kimberlin and Euba provided a summary of the qualities of intercultural music, identifying four factors that appear to be common to composers, performers, teachers and scholars who articulate intercultural music. The first two of these provide a suitable starting point for evaluating the mbira–string quartet collaboration:

- Value highly intimate knowledge and understanding of creative and performance processes of other cultures;* these can be achieved by synthesizing indigenous and foreign** compositional processes and techniques; analysing music and music making processes; participating in musical performances; collaborating with other scholars, musicians and composers from other cultures; and by becoming bi-musical,*** which is fundamental to understanding one's own as well as other musical cultures;
- Maintain integrity of their indigenous value systems while utilizing musical elements, processes and techniques from other cultures to expand their modes of expression for the creation and performance of new music;

*	The term 'culture' may refer either to the specific or the general.
**	'Foreign' merely means outside one's own culture and does not necessarily refer to Western music.

*** The term 'bi-musical' can also be interpreted as 'multi-musical' if one considers cultural differences including those from within specific cultural and geographical boundaries as well as those outside these boundaries.

(Kimberlin & Euba, 1995, pp. 4–5)

Synthesis

Knowledge and understanding achieved through synthesis, analysis, participation and collaboration would all be more satisfyingly achieved in a larger time frame than the present project allowed. After an initial meeting in March 2014 the funded project was based on six exploratory, devising days and two rehearsal days between October 2014 and March 2015 (see Table 35.1). This provided the opportunity for Dutiro and ECS to combine their interests in creative and imaginative music-making without knowing the shape of the final outcomes. Maintaining the integrity of indigenous value systems while utilising musical elements, processes and techniques from each culture is an idealistic projection reinforced elsewhere. For example, the band at the centre of Brinner's research, Bustan Abraham (comprising Arab and Jewish musicians), claims to pioneer 'a unique form of instrumental music which combines elements of both Eastern and Western forms without sacrificing the musical integrity of either' (Brinner, 2009, p. 123). The balance between integrity and transformation varied considerably during the mbira–string quartet sessions and the following examples will demonstrate how the players embraced the experimental without losing sight of tradition.[3]

A consequence of the study of intercultural music and cross-cultural collaborations over the last fifty years or so is the pervasive use of the words 'hybrid' and 'fusion' to refer to the end product; this has grown out of the commercialisation of world music (a subgenre of which

Table 35.1 Documenting the creative process

Date	Activity	Instruments/personnel
7 March 2014	First meeting with instruments	mbira (Dutiro) + quartet (ECS)
1 August 2014	Interview	Dutiro
20 August 2014	Interview	Dutiro
26 August 2014	Composer-performer dialogue	Dutiro + composer (Linker)
31 October 2014	First devising session	mbira + quartet + composer
31 October 2014	Interview	Dutiro
21 November 2014	Second devising session	mbira + quartet + composer
5 December 2014	Third devising session	mbira + quartet + composer
28 January 2015	Education workshop	mbira + cello + dancer (Rowe)
30 January 2015	Fourth devising session	mbira + quartet + composer + dancer
31 January 2015	Fifth devising session	mbira + quartet + composer + dancer
8 February 2015	Sixth devising session	mbira + quartet + composer + dancer
6 March 2015	First rehearsal day	mbira + quartet + composer + dancer
7 March 2015	Second rehearsal day	mbira + quartet + composer + dancer
10 March 2015	Education workshop	mbira + quartet + dancer
27 March 2015	Education workshop	mbira + cello
22 April 2015	First public performance (Bath Spa University)	mbira + quartet + dancer
26 April 2015	Second public performance (Ariel Centre, Totnes)	mbira + quartet + dancer

includes world fusion) since the 1980s. *The New Oxford Dictionary of English* describes fusion as 'the process or result of joining two or more things together to form a single entity' (Pearsall, 1998, p. 747) and hybrid as 'a thing made by combining two different elements; a mixture' (p. 897). Dutiro is not the first musician to find the terms hybrid and fusion inappropriate and, it would seem, for precisely the same reason that one of the band members studied by Brinner 'objected strongly to the use of "fusion" or "hybrid" to label the band's music[:] because he saw their accomplishment as nothing less than the creation of a new musical language that promised to continue to develop in the future' (Brinner, 2009, p. 124). Despite Dutiro's wealth of experience, playing mbira (and saxophone) with musicians from different traditions and cultural settings worldwide since the 1980s, his previous collaborations have all been 'fusions' rather than founded on creativity inspired by dialogue, historical context, empathy and education: 'it's not a hybrid or a fusion but new music if it's done in a way that has a historical context' (interview 20 August 2014). 'People need to understand the history of where the music is coming from and what has happened to the development of that music. Let people find their voices. That's what we're aiming for' (interview 20 August 2014). 'We can't separate the history and say, oh let's forget about that. Let's just take these notes and do something; that's fusion to me' (interview 20 August 2014). This often misconceived notion of hybridity and fusion is addressed by Bob White's 'strategies for non-essentialist listening' in the context of world music production (White, 2012, p. 207).

In the context of pan–African jazz, Joseph Stanyek observes that '[m]uch musical scholarship has emphasized hybridity without dealing frontally with the human relationships that produce hybrid forms' (Stanyek, 2004, pp. 100–101), a point developed by Brinner: '[l]istening to mixing of resources we need to ask what the musicians are doing and how they do it. . . . Some of the most interesting and significant negotiations of diverse musical resources take place in rehearsal and performance' (Brinner, 2009, p. 216).

While acknowledging that nine days is insufficient time to understand the history of any music, it has nevertheless enabled the musicians to collaborate and interact in a meaningful way, exposing the kinds of negotiations that take place when creating new music that reaches beyond fusion. It is unanimously recognised by the participants that the collaboration has really only just begun.[4] Ethnographic research methods involved participant observation, both live and from examining video footage. Observations from exploratory sessions since 7 March 2014 and composer–performer dialogues are supplemented with comments from, and interviews with Dutiro, both prior to and reflecting upon the creative process (see Table 35.1).

Synthesis involves building bridges and breaking down boundaries, eradicating any sense of hierarchy, and challenging notions of difference invoking power. Despite Kofi Agawu's significant essay from 2003, 'Contesting Difference', there have been few attempts in musicology to emphasise similarities rather than difference,[5] yet similarities emerge to be at least as important as differences. At a practical and spiritual level, Dutiro's approach to taking mbira into uncharted territory parallels that of the Welsh harpist, Catrin Finch, and West African kora player, Seckou Keita, reflected in their album *Clychau Dibon* (2013) and discussed in detail by Andy Morgan (2013). Their collaboration has resulted in what Morgan describes in the album's sleeve notes as 'strange symmetries and fabulous coincidences' (2013). In an academic context, as part of The Six Tones project, a collaboration between the Swedish guitarist, Stefan Östersjö and Vietnamese đàn tranh player, Nguyễn Than Thủy, was set up for a similar purpose, its main point of departure being 'to create a foundation for a meeting between two distinct cultures on equal terms' (Östersjö & Thanh Thuy, 2013, p. 185). For them 'the starting point of equality implies the questioning of what is "centre" and what is "periphery"' (Östersjö & Thanh Thuy, 2013, p. 185). Without prior knowledge of their research, in interview Dutiro expressed exactly

this equality, regarding his intention for collaborating with a string quartet 'not [to be] a hybrid with mbira hanging on classical music, or strings on the periphery of mbira music' (interview 20 August 2014). The mbira–string quartet collaboration was approached with no fixed expectations but a specific keenness from both sides for the process to be a two-way interaction. Factors contributing to future directions and approaches to defining an intercultural practice depend on the interaction of the participants and are as varied as the personalities involved.

Roles and responsibilities

Interpersonal relations/interactive network

The interpersonal relations between the four string players are defined by having played together for six years, sometimes as a quartet but more often in different instrumental configurations within the ensemble of ECS. All the quartet's decisions, whether musical or organisational, are made through consultation and negotiation, sometimes to an extent that can be regarded as too democratic. On a practical level too much democracy can be detrimental to progress, resulting in delayed decisions or none at all.

A working relationship (or interactive network, defined by Brinner as 'the roles of musicians, their relationships and domains in which they operate' (2009, p. 138)), relies on developing trust between people who have not worked together before. None of the string players knew the mbira player, composer/arranger or dancer before they first met in January 2014, July 2014 and January 2015, respectively. The division of labour was pre-determined, based on Dutiro's prior experience and Bayley's research on the Kronos Quartet collaborating with non-Western musicians (see Bayley, forthcoming), then discussed with three of the quartet members in January 2014. The first practical session in March 2014 was arranged to test the viability of ideas, transferring them from theory to practice, before funding enabled fuller exploration from October 2014.

Roles and relationships in play

Dutiro's role and inspiration behind the collaboration, combined with his breadth of professional experience means he often determined the direction taken in rehearsal. Although there was an element of pre-planning in advance of some of the sessions, rules were not laid out because the musicians were working with a blank canvas. Even when a plan was devised in advance, this was not necessarily followed on the day. The interactions evident from the initial meeting between five musicians (March 2014) and each of the devising sessions, involving six (October 2014 onwards) then seven musicians (including the dancer, from January 2015), can be explained through Brinner's research as a maximally connected, interactive network structure: communication passes between each musician (or node of the network) to each of the others; there are no subnetworks (Brinner, 2009, pp. 166–167). However, more importantly, Brinner provides a framework for considering how roles are played out: '[r]elationships in an interactive network are characterized not only by the amount of control or influence exerted, the domains affected, and the responsiveness of others but by *directionality* – the flow of influences and information' (Brinner, 1995, p. 176).

Crossing the gap

When considering how different musics are combined Martin Stokes observes that 'music doesn't simply "flow" across the gap as some, talking more generally about cultural globalization and transnationalism, like to imply' (Stokes, 2012, p. 99). Observations about the creative

process in terms of the relationship between musicking and dialoguing help to identify the complexities, problems and solutions that arise across this gap. Interactions between musicians characterise the nature of a two-way 'flow', suggesting an alternative is needed to the hourglass model for studying intercultural theatre put forward by Patrice Pavis (1992). Whether horizontal or vertical, Knowles identifies the inadequacy of the hourglass model for 'twenty-first century, cross-cultural intersections [that] tend to be both horizontal . . . and more multiple' (Knowles, 2010, p. 60), calling for a new theoretical approach for their analysis.

It is rarely possible to begin research of this nature on neutral ground where participants have equal knowledge of and familiarity with each other's cultures. In this case the string players have always lived in the UK whereas Dutiro's experience of Western culture originates from his colonial childhood in what was then Rhodesia and extends to the last twenty years he has lived in the UK. Apart from being a master of mbira, in Zimbabwe Dutiro was also educated in Western music, learning saxophone, music theory and notation. By comparison, the string quartet players first became acquainted with mbira when they agreed to get together with Dutiro in March 2014. A lack of familiarity with mbira meant that, to begin with, the flow of influences and information travelled from mbira to string quartet.

In the performers' dialogue, within an hour of the first devising session (7 March 2014), Dutiro comments on the importance of energy, which corresponds with Brinner's notion of directionality and creative flow (2009, p. 137). This comment comes at the end of Dutiro demonstrating different tunings associated with different people, regional differences in singing, including subtle dynamics, melodic variations and styles of yodelling which violinist, Emma Welton, relates to ornamentation in Irish and Shetland folk music:

CD: But it's not just yodelling around, it actually connects the people with the spirits of their ancestors. That's the bottom line. So, that's where I'm coming from. But I'm meeting the quartet. We have to take it somewhere that my ancestors might like as well [laughing].

JP: Or *our* ancestors.

CD: Yes, of course, definitely, definitely. We cannot judge what comes out of it. You might produce sounds here which inspire me to take the sound on a different level and that is going to touch my heart as well, and think 'Wow, I never thought that was going to happen' [pause]. That's the energy we have to create for each other (7 March 2014, video clip 2).[6]

Documenting and demonstrating intercultural practice: sounds and structures, rules and rituals

Another video extract from the first meeting in March 2014 begins with the viola player responding to Dutiro's playing and singing, explaining that he does not want to change anything about the mbira and he does not want the quartet to detract from its qualities (video clip 3). When demonstrating the tunings of different mbiras, following a prompt from Welton, Dutiro illustrated the characteristic non-sequential ordering of pitches and tapped the keys to demonstrate the overtones. One reaction to this was for the strings to try to imitate the sounds by playing *col legno*. With sound being a primary focus, the musicians discuss various timbral possibilities and to what extent sounds need to blend or remain separate (video clip 4). Important for Dutiro was to listen to the string instruments being played, so that he could find his way in.

Collaboration that is performance-led rather than composition-led generates experimentation through the freedom of dialogue, and listening to and playing with sounds (musicking) (video clip 5). Working through these possibilities early on in the collaboration

demonstrates Brinner's observation that 'musicians frequently think of some aspect of the overall sound as predominant and that this colors the conception of texture and interaction' (Brinner, 1995, p. 195).

Questions of tuning, metre and pulse lie at the interface of intercultural music-making and determine the foundations upon which the building blocks for a new music can be created (see Figure 35.1). Metrical structure required clarity for the quartet. Welton asked how Dutiro was feeling the pulse, which he explained and demonstrated, also eager to know how the quartet felt it.[7] The viola player (Andrew Gillett) drew a comparison with Schumann's metrical ambiguities and the cellist (Jane Pirie) mentioned Handel's sometimes displaced phrasing. Dutiro wanted to change the direction of the investigative process so that he could join in with the quartet. Schumann was therefore the starting point for the second session, 31 October 2014, with the quartet wanting to discover how Dutiro interpreted ambiguous metres. The quartet's familiarity with subtle metric shifts in minimal music also fed into the conversation. In the third session (21 November 2014) it was decided that the *Chaconne* by Henry Purcell was a suitable piece for Dutiro to join in with, Purcell having been chosen for his ground bass structures in common with looping mbira melodies. In subsequent sessions and in performance both Dutiro and Rowe integrated mbira parts into the Purcell; they learned by ear typical interlocking mbira patterns that would fit the *Chaconne* (video clip 6).

Collaborative composition

Although the classically trained string players were used to experimenting and improvising in the context of contemporary Western art music it proved necessary to provide some kind of notation as an *aide memoire*. A composer/arranger (Daniel Linker) was therefore recruited to the project to notate the ideas and decisions made in the devising sessions. In his role as arranger, in November 2014 Linker provided a transcription of the Shona song, *Marenje* (Musical example 35.1). He adapted boxes used for his own quasi-improvised compositions. However, a significant shift in directionality occurred the next month when Welton produced an arrangement of this song to try out (Musical example 35.2). The violinist's alternative included an introduction that responded specifically to the yodelling characteristic of Dutiro's singing. It created a turning point in the project for Dutiro because it demonstrated a creative engagement with the materials and discussions from the devising sessions (see video clip 7 from the performance on 22 April 2015).

A second significant shift occurred when the dancer, Denise Rowe (who has performed with Dutiro for fourteen years) first joined the collaboration on 30 January 2015 (see Table 35.1). Rowe had been involved in discussions about the project before it started and joined partway through because the idea was for her to bring her dance to what the musicians had produced. Rowe's contribution, however, transformed the project, bringing alive the way the string players

Figure 35.1 Modelling the co-creative process.

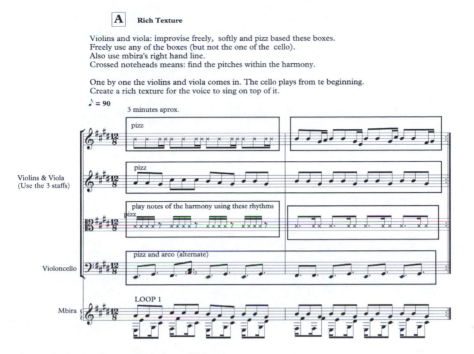

Musical example 35.1 First transcription of *Marenje*.

could understand mbira melodies and rhythms, through an alternative physical experience of clapping and from dance steps. From 30 January the previously egalitarian dynamic of the collaboration, with everyone freely inputting comments, ideas and suggestions, now turned into a collaboration with clear directorship – from the dancer.[8] The way that Rowe explained the rhythms integral to mbira in terms of clapping (e.g., threes against twos), steps and movements completely transformed the way the players understood the hocketing patterns of mbira melodies. Video clip 8 shows the players clapping their individual rhythms assigned to them by the dancer (in performance), which they then transfer to their instruments, with Rowe clapping then dancing the rhythms. The interactions in the clip perfectly illustrate Brinner's interactive structure, by showing how simultaneous relationships of the different musical strands and the sequence of music in the course of a piece are organised, in this instance by the dancer. Referring back to the building blocks (Figure 35.1), decisions about texture and form had been made through the joint efforts of the musicians and dancer in the devising sessions from January to March 2015.

Evidence from these examples shows how the concept of composition, or re-composition in the case of Purcell, needs to be reconsidered as a product that evolves through a highly creative and collaborative process achieved through trial and error, consultation and negotiation, an example of what Bruce Ellis Benson describes as: 'a participatory model . . . in which performing and listening cannot be clearly separated from composition, precisely because they end up being part of the compositional process' (Benson, 2003, p. 23).

Conclusion: co-creating a specific intercultural practice

There are two ways in which collaboration fails to work properly: (1) when the emphasis is placed on an end product for promotional purposes and commercial gain; and (2) when

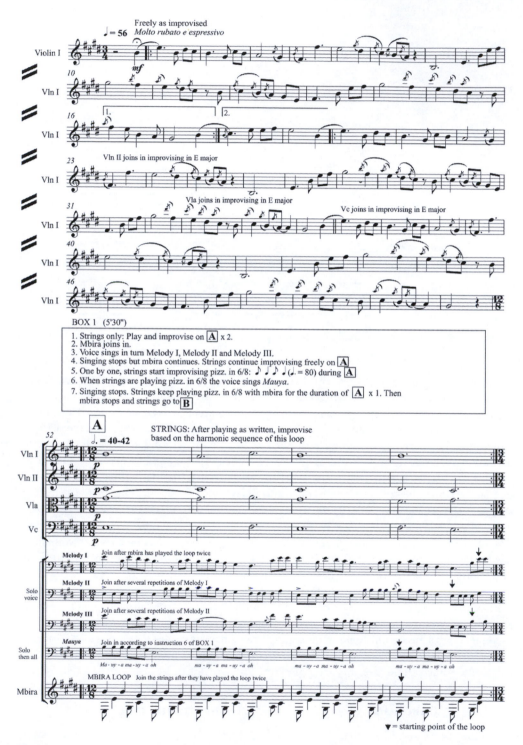

Musical example 35.2 Second version of *Marenje*, copy-edited by Linker.

presented with notation to play from; the relationship is immediately directive rather than collaborative and means a dialogue cannot take place. This does not, however, mean that mbira music cannot be notated in order to be played by another instrument, and Dutiro welcomes such developments. Because he learns from sounds that are memorised rather than from notation, for him notation for mbira has a descriptive rather than a prescriptive function. Engaging in dialogue makes the present collaboration different from previous ones because it is centred on education and understanding each other's backgrounds, rather than on notation.

Documenting the musicians' creative processes has allowed the themes and challenges that emerge from initial conversations and negotiations to be traced in order to discover how dialogues develop in relation to sounds and musical structure when notation is not the starting point. Figure 35.2 summarises the actions arising from interactions and dialogues between participants.

Characteristics arising from the encounters described above contribute toward an understanding of intercultural music-making that is co-creative, built on collaborative composition rather than a hierarchical composer–performer relationship. Different combinations of musical ideas were tried and tested showing how negotiations contextualise the way the musical components of, for example, melody, rhythm, timbre, texture and instrumentation co-exist in a stratified system, a system that Mark Slobin calls 'code-layering: style upon style upon style'; any number of these variables can shift (in a later section of the music) 'to produce a new kaleidoscopic code combination' (Slobin, 1993, p. 87).

Approaching the creative process by listening to and then interacting with sounds rather than notation has strong affinities with intercultural trends in the making of contemporary theatre. For example, Jen Harvie and Andy Lavender identify an ongoing theatrical trend to interrogate the roles of text and director by examining 'the methods of groups who devise theatre collectively, often led by or working with a director, but always with self-reflexive attention to the dynamics and ethics of power and authorship circulating amongst all participating makers' (Harvie & Lavender, 2010, p. 2). Also resonating with Harvie and Lavender's observations, the musicians (including Rowe) 'understand devising to be a method of performance development that starts from an idea or concept rather than a play text; [it] is from the start significantly open-minded about what its end-product will be; and uses improvisation . . . as a key part of its process' (Harvie & Lavender, 2010, p. 2). Whether the starting point is a piece by Purcell or a Shona song, specific melodic and rhythmic characteristics are adopted, or adapted and transformed through a dialogic process, a conversation between cultures.

The qualities emerging from the characterisation of intercultural music-making are represented in Figure 35.3: a vertical line intersects each horizontal line to give a crude estimation of overall tendency along a spectrum from one extreme to another. The democratic/didactic duality has two intersections because this quality showed the most extreme fluctuations. It highlights the shortcomings of this diagram which does not show changes in flow, directionality and variations in energy level of musical dialogue and musicking which reflect the way musical elements are shared between cultures or cross from one to the other.

Further complexities to be analysed include detailed processes of interpretation and translation (of terminology as well as musical language), when specific elements of musical traditions

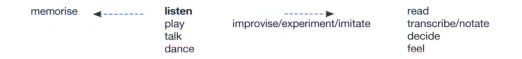

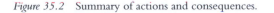

Figure 35.2 Summary of actions and consequences.

Figure 35.3 Qualities showing the emerging characterisation of intercultural music-making.

and styles are transformed in an intercultural space. Crucial also is breaking down the performer–audience barriers in the context of creating new music across the participatory and presentational performance practices of the respective Zimbabwean and British cultures, thereby giving the music 'a sense of purpose', as described by Gillett, after the second performance on 26 April 2015.

The intercultural elements of this collaboration clearly represent what Mark Slobin describes as '*diasporic interculture*, which emerges from the linkages that subcultures set up across national boundaries' (Slobin, 1993, p. 64). Considering the way Stanyek has developed this idea in a pan-African context identifies another striking resemblance: 'In putting communication and the construction of communities at the centre we move (away from a notion of diaspora as dispersal plain and simple) to a view that recognizes the intimate connection between diaspora and dialogue' (2004, p. 100). On one level, focusing on a new 'community' of musicians provides an opportunity to identify how creative practice can create a new musical language while, on another level, addressing performer–audience relationships helps to bring people together and provides a role for new communal music.

Notes

1 We are grateful to Arts Council England and Bath Spa University for supporting the project, 'Crosscultural exchanges: mbira and string quartet', and to the quartet members for consenting to the use of their exploratory ideas and materials: Emma Welton, Julie Hill (violins), Andrew Gillett (viola) and Jane Pirie (cello). They are all regular members of Exeter Contemporary Sounds, which formed in 2001 to specialise in contemporary music for new audiences.
2 Concepts of composition and improvisation in relation to creativity are discussed in detail by Laudan Nooshin (2015).
3 Tradition versus modernity is a familiar dualism in the context of musical creativity more generally (see, for example, Nooshin, 2015, p. 21).
4 Interestingly, Stefan Östersjö and Nguyễn Than Thủy state that 'three years is just about enough time to create a platform from which to start' (Östersjö & Than Thuy, 2013, p. 195).
5 Exceptions include Lucy Green (2012) and Östersjö and Than Thuy (2013).
6 The significance of the ancestors in mbira music and the *Bira* ceremonies is explained by Paul Berliner (1993) and Thomas Preston (2007).
7 The ambiguities of pulse that were felt by the quartet are explained by Manuel Jimenez (2007).
8 Rowe's introduction to the materials being worked on within the project was at an education workshop with trainee music teachers on 28 January 2015. For this event the cellist represented the quartet, with Dutiro and Rowe on mbira, and Rowe dancing. The purpose was to introduce the trainee teachers at Bath Spa University to intercultural music-making that they could incorporate in their teaching practice.

References

Agawu, K. (2003). *Representing African music. Postcolonial notes, queries, positions.* New York and London: Routledge.

Bayley, A. (2011). Ethnographic research into contemporary string quartet rehearsal. *Ethnomusicology Forum, 20*(3), 385–411.

Bayley, A. (forthcoming). Cross-cultural collaborations with the Kronos Quartet. In E. Clarke & M. Doffman (Eds.), *Creativity, improvisation and collaboration: Perspectives on the performance of contemporary music.* Oxford: Oxford University Press.

Benson, B. E. (2003). *The improvisation of musical dialogue.* Cambridge: Cambridge University Press.

Berliner, P. F. (1993; first published 1981). *The Soul of Mbira: Music and traditions of the Shona people of Zimbabwe.* Chicago and London: University of Chicago Press.

Brinner, B. (1995). *Knowing music, making music: Javanese gamelan and the theory of musical competence and interaction.* Chicago and London: University of Chicago Press.

Brinner, B. (2009). *Playing across a divide: Israeli-Palestinian musical encounters.* New York and Oxford: Oxford University Press.

Finch, C., & Keita, S. (2013). *Clychau Dibon.* Astar Artes Recordings Ltd and Theatr Mwldan.

Green, L. (2012). Musical identities, learning and education: Some cross-cultural issues. In S. Hawkins (Ed.), *Critical musicological reflections: Essays in honour of Derek B. Scott* (pp. 39–59). Farnham: Ashgate.

Harvie, J., & Lavender, A. (Eds.) (2010). *Making contemporary theatre: International rehearsal processes.* Manchester and New York: Manchester University Press.

Jimenez, M. (2007). Never-ending musical invention: The music of the mbira. In C. Dutiro & K. Howard (Eds.), *Zimbabwean Mbira music on an international stage: Chartwell Dutiro's life in music* (pp. 41–47). Farnham: Ashgate.

Kimberlin, C. T. & Euba, A. (1995). Introduction. *Intercultural Music, 1,* 1–9.

Knowles, R. (2010). *Theatre and interculturalism.* Basingstoke: Macmillan.

Merriam, A. P. (1964). *The anthropology of music.* Evanston, IL: Northwestern University Press.

Morgan, A. (2013). *Finding the One: The strange and parallel lives of the West African Kora and the Welsh Harp.* Cardigan: Theatr Mwldan.

Nettl, B. (1954). Notes on musical composition in primitive culture. *Anthropological Quarterly, 27*(3), 81–90.

Nooshin, L. (2015). *Iranian classical music: The discourses and practice of creativity.* Farnham: Ashgate.

Östersjö, S., & Than Thủy, N. (2013). Traditions in transformation: The function of openness in the interaction between musicians. In H. Frisk & S. Östersjö, *(Re-)thinking improvisation: Artistic explorations and conceptual writing* (pp. 184–201). Malmö: Lund University.

Pavis, P. (1992). *Theatre at the crossroads of culture.* London and New York: Routledge.

Pearsall, J. (Ed.) (1998). *The New Oxford Dictionary of English.* Oxford: Oxford University Press.

Preston, T. M. (2007). Spiritual continuity amongst musical change. In C. Dutiro & K. Howard (Eds.), *Zimbabwean mbira music on an international stage: Chartwell Dutiro's life in music* (pp. 17–25). Farnham: Ashgate.

Slobin, M. (1993). *Subcultural sounds: Micromusics of the West.* Hanover: Wesleyan University Press.

Stanyek, J. (2004). Transmissions of an interculture: Pan-African jazz and intercultural improvisation. In D. Fischlin & A. Heble (Eds.), *The other side of nowhere: Jazz, improvisation, and communities in dialogue* (pp. 87–130). Middletown, CT: Wesleyan University Press.

Stokes, M. (2012). Musicians between the hegemonies: A response. *Journal of Levantine Studies, 2*(2), 93–104.

van der Vijver, F. J. R., & Leung, K. (1997). *Methods and data analysis for cross-cultural research.* Thousand Oaks, CA: Sage.

White, B. W. (Ed.) (2012). *Music and globalization: Critical encounters.* Bloomington and Indianapolis: Indiana University Press.

36

EXPLORING 'AFRICAN' MUSIC IN DUBLIN

Researching intercultural music practice

John O'Flynn

Introduction

In this chapter I discuss a number of approaches to researching intercultural music practice. I consider 'intercultural music practice' as constituting phenomena, events and conceptions in which different socio-cultural and/or national/ethnic groups engage with diverse music practice. This is explored primarily with reference to research that commenced in 2011 and has continued to date, a project that began with the name 'Perceptions and Happenings of "African Music" in Dublin' and in which I have been involved at various stages as participant-observer since then.

The project is presented here more in the way of a process than a product. This is partly because the research itself is incomplete, and to a large degree open-ended, as my own perceptions and experiences of intercultural music practice have developed considerably over this time. The research approach also takes into account considerable changes in demographic patterns and intercultural arts practice in Ireland during the period in question.

My earlier research on intercultural music practice was primarily education-oriented (O'Flynn, 2005, 2008) While this remains important in my overall consideration of intercultural arts, my focus has shifted to events and interactions that are observable in society at large. Nonetheless, my more recent, open-ended approach to engagement with 'African music' in Dublin has revealed, among other findings, how learning and teaching remain central to such encounters.

In documenting and, to a large degree, interrogating this study of 'African' music in Dublin, the chapter also aims to uncover a number of issues and possible approaches in researching intercultural music practice. Accordingly, I reflect on my own subject position throughout, whether as observer or musical participant, and do so for two reasons.

First, I take a lead from established approaches in anthropology and ethnomusicology in positing that, for intercultural arts research, researchers themselves are involved in the dynamics of intercultural arts exchange, whether through the creative act of narrativizing practice and/or through participation in the intercultural engagement itself.

Second, I have found myself questioning and at times revising theoretical positions and methodological positions that I have adopted at various stages throughout the course of my project. This evolving, overarching perspective arises from my experiences and development as a musician, researcher and person over the past couple of years, through engagement with other

artists, researchers and other persons/groups, and also by co-experiencing demographic and socio/economic/cultural change in the society where I have lived for most of my life.

The reader of this chapter might at first apprehend a largely critical, cultural studies approach to the phenomena observed.[1] This is moderated somewhat – though not entirely disregarded – as my focus moves from interpretation to participation.

Later in the chapter I concentrate on aspects of intercultural music practice by considering the global phenomena of *djembe* playing and drum circles, and by relating these to my own participatory experience. Finally, I report on recent observations, largely through the collation and interpretation of video materials, and close the chapter by proposing the continuation of my research into a particular instance of intercultural music practice by way of an ethnographic film.

Background to the ethnography

According to the last census carried out by the Central Statistics Office in the Republic of Ireland in 2011, about 2 per cent of its 4.6 million population were born in Africa (Central Statistics Office, n.d.). Moreover, figures from both the 2006 and 2011 census results indicate a growing number of Irish-born citizens identified under various 'black' categories, a pattern that acts to interrupt perceptions of Ireland as culturally homogenous or of the Irish as essentially 'white' (neither of which, it could be argued, have ever been the case).

Associations between Irishness and blackness – a critical view

It seems fair to suggest that Irish people's engagement with multicultural arts and with intercultural arts practice can only have increased with the scale of demographic change noted above. I distinguish between 'multicultural' and 'intercultural' arts practice, here, by considering the former in terms of a diversity of relatively bounded (sub)cultures and associated artistic practices and traditions within any given society, while the latter suggests a multiplicity of potential interactions between and among individuals, groups, cultures, traditions and artistic genres. My main focus on intercultural rather than multicultural music practice should not be interpreted as valorizing one orientation over the other.[2]

I would also stress that a focus on the more spectacular demographic changes in Ireland over the past two decades should not be read to infer that multicultural and/or intercultural arts practice did not feature in the past. Indeed, much of the discourse surrounding Irish popular music since the 1960s has invoked claims that align that music with the Otherness[3] or 'soul' of 'black' music, in particular, of African-American artists and genres (see McLaughlin & McLoone, 2000; McLaughlin, 2014).

Imaginings of links between musical Irishness and the Otherness of 'black' cultures and genres have included Van Morrison's adaptation of the musical term 'soul' as well as the implied homology between African-American soul music and the socio-cultural values of a fictitious group of working-class youths living in Dublin's northern suburbs in Roddy Doyle's novel *The Commitments* (1989), later adapted for film by Alan Parker (1990). Similarly, a number of cultural entrepreneurs have constructed imaginative links between 'Celtic' and 'African' cultures, in what might be considered as an appropriation of Paul Gilroy's conception of the 'Black Atlantic' (Gilroy, 1993). The most prominent of such projects to date has been the Afro-Celt Sound System, which was recorded under the Real World label. The positioning of this intercultural music act within the economic dominion of 'world music' has led to contrasting readings of the project's musical and cultural integrity (see, for example, Vallely, 2003; Veblen, 2014).

More broadly, in recent years a number of cultural critics have problematized claims to cultural and musical associations between Irishness and blackness (Carby, 2001; Onkey, 2009; McLaughlin, 2014). Brannigan (2008) charts how collaborations between white and black musicians in 1970s Dublin – Phil Lynott/Thin Lizzy presenting the best-known case – were contemporaneous with racist depictions of African culture and/or black minstrelsy within popular music acts. More recently, I have questioned hagiographic accounts of Irish musical Otherness linked to blackness, arguing that in some cases the production and marketing of Irish-Celtic music might, inadvertently or otherwise, be involved in articulating and demarcating 'white' identities (O'Flynn, 2014).

My overall standpoint is informed by a similar critical stance, and this does not diminish later as I describe participation in a West African drumming class. But I also adapt Gilroy's (1991) 'anti anti-essentialism' wherein the hegemonic either/or of essentialism/anti-essentialism can be viewed as largely unhelpful in understanding the social and individual complexities of intercultural consciousness and agency. Gilroy's (1991) theorization presents an alternative to perspectives based on colonial or postcolonial worldviews and is grounded in considerations of contemporary black experience. Rejecting biological determinism he nonetheless argues against the erasure of racial consciousness, which he contends can be key to identity formation, socio-political activism and reflexive subjectivity. Gilroy's oft-cited conception of the 'Black Atlantic' considers 'the syncretic complexity of black expressive cultures', with particular reference to music (1993, p. 101). By adapting this perspective to a study of intercultural music practice based in Ireland, I concur with Helfenbein (2003, p. 11) who, in a broader, critical appraisal of multicultural education suggests that '"anti anti-essentialism" embraces both the concept that there are no essential, guaranteed relationships (i.e., determinism) and the concept that relationships can and do exist within a material context that matters'.

The stages of the research described below reveal how my initial position of anti-essentialism comes to be revisited when acknowledging my own subject position in 'intersubjective'[4] experience. In particular, I discuss how observations made as a participant-researcher resonate with ideas of West African drumming's 'cultural mobility' (Stokes, 2004, p. 68), adumbrating to some extent Mark Slobin's (1993) conception of 'affinity musical intercultures'. These suggest ways in which instances of intercultural music practice can be interpreted positively while maintaining a necessary critical viewpoint.

Africa day 2011

Exploring the initial idea

My exploration of 'African' music in Dublin took the shape of an open-ended interpretive ethnography. As already indicated, my initial interest was to look closely at the music of African diasporic groups, having first become acquainted with an ethnography carried out by Matteo Cullen that investigated the musical-social networks of various sub-Saharan national groups. Cullen's study presented an original perspective in its encapsulation of the rapid demographic changes and attendant cultural diversity in Dublin around this time. It was subsequently rewritten in chapter form in the collection of essays *Music and identity in Ireland and beyond* (Fitzgerald & O'Flynn, 2014). Significantly, this was the first time that the music of migrant and diasporic groups would feature in an academic volume on music in Ireland.

Another welcome development in recent years has been the undertaking of doctoral studies at University College Dublin that include investigations of music among specific sub-Saharan migrant groups in Dublin, notably, Sheryl Lynch's (2012) research on the *Bamenda* North-West

Cameroonian diaspora and Rebecca Uberoi's (2014) study of Nigerian Christian communities. My review of literature also explored emerging research on the experiences of Africans living in Dublin (Mutwarasibo, 2002; Ugba, 2004) and more generally on what might collectively be grouped as African (as opposed to Euro-American) perspectives on African migration and diaspora (Zeleza, 2005). All of these studies would contribute greatly to my knowledge and understanding of the experience of sub-Saharan diasporic groups in Dublin as well as globally, and, in both factual and ideological terms, would give me cause to revisit previous understandings and positions regarding 'African music' in Dublin or in other diasporic contexts. This preliminary reading also led me to surmise an acute gap between the cultural experience of most Dubliners and that of its newly established minority populations, an impression that would soon become identified as part of the research problem.

My questions at the time could be represented thus: What was taking place in Dublin under the broad umbrella of 'African music'? What were the differences between 'imaginings' and 'happenings' of music that was labelled or otherwise perceived as 'African'? What differences might there be in respect of 'African' and 'European' participation in various events and activities billed as 'African'? The description and analysis that now follows could be neatly represented as a two-part ethnography, the first part of which involved my attendance at a number of 'African' themed musical events, while for the second I became engaged as participant–observer in a West African drumming class. In reality though, the pathway of my own involvement in the research would evolve quite organically.

Ethical issues in respect of both phases were considered and addressed. For events labelled under 'Africa Day 2011' I notified organizers and received permissions to make fieldwork observations. For the West African drumming class I sought and received permission from co-participants to make written observations and a note of general discussions during weekly classes. As the leader of the drumming class later comes to be named in this chapter, a draft of relevant sections were forwarded to him and subsequently approved. Finally, permission to carry out both parts of the ethnographic research was granted by the research ethics committee of St Patrick's College, Dublin City University.

Entering the field

My fieldwork began with observations carried out over several events during Africa Day, Dublin in 2011. Held on 25 May each year, Africa Day is an initiative of the African Union. Since 2008 celebrations have taken place in Dublin and other Irish cities under the aegis of, and with funding from, Irish Aid, a statutory agency promoting economic development in overseas countries. The 2011 events in Dublin took place over the period 21–29 May and included workshops in West African drumming, North African belly dancing, a screening of *U-Carmen eKhayelitsha* (Dornford-May, 2005) – a film version of Bizet's 1875 opera set in the township of Khayelitsha in Cape Town and sung in *Xhosa* – and a gig fronted by Congolese guitarist Niwel Tsumbu at the Irish Aid Centre, Dublin. In contrast to the programming schedules for Africa Day in previous and subsequent years, most of the 2011 events took place indoors.

I now briefly report on two events that I attended during the Africa Day schedule for 2011, namely, the screening of *U-Carmen eKhayelitsha* and the Niwel Tsumbu gig, both of which took place at the Irish Aid Centre. This government-funded centre primarily functioned as an information/training centre for those intending to carry out volunteer work overseas. It also had the feel and aesthetic of a curated gallery/performance space, displaying extensive series of photographic portraits featuring 'ordinary' individuals from various parts of sub-Saharan Africa, along

with museum-style stands detailing aspects of Irish government-funded development projects and/or initiatives of Irish voluntary organizations in African countries.

The screening and discussion of *U-Carmen eKhayelitsha* was, in the first instance, notable in respect of the intercultural music-film production itself; however, in terms of audience diversity it fell short of what might be expected from an Africa Day event. One Irish participant's question during the post-screening discussion, 'Why are there no African people here?' resonated to some degree with my own unease, and was also partly influential in reshaping my research focus from cultural practices of African music in Dublin (among Africans) to dominant representations of 'Africanness' as well as perceptions of, and engagement with, African music on the part of Irish people and other Europeans living in Dublin. This re-orientation was also influenced by observing videos of previous Africa Day celebrations and by my own video-recorded observations during the 2011 Dublin City Soul Festival (which took place over the same period), all of which pointed to the self-conscious engagement of 'white bodies' (Duffy, 2005; Dyer, 1997) with the reproduction or appropriation of elements drawn from (or imagined in relation to) sub-Saharan African and, by extension, African-American/Afro-Caribbean music and dance.

The Niwel Tsumbu gig was a very different affair. Tsumbu had been established in Ireland for several years and significantly, at the time, was the designated 'artist-in-residence' at the Irish Aid Centre. The evening was presented as an 'African' or 'world' music event, but given Tsumbu's career trajectory, his eclectic guitar-playing style, and the fact that he was joined by two Irish musicians, respectively, on *djembe* and bass guitar, the event might more usefully have been considered in intercultural terms. The searching question, 'Why are there no African people here?' could also have been posed on this occasion, given that the audience almost entirely comprised Irish people or persons of other European nationalities. This was in stark contrast to ethnographic observations made by Bradby and Put (2007) at a gig featuring Congolese musician Koffi Olomide at the SFX venue in North Dublin, 2005 which had been organized by a Congolese diasporic group and whose audience predominantly consisted of Congolese people and persons of other sub-Saharan nationalities. Irish and other European residents of Dublin were absent from this event, largely because it had not been billed officially as 'world music' and also because they would not have been connected to the social networks of African diasporic groups throughout the city, such as those researched by Cullen (2014), Lynch (2012) and Uberoi (2014).

Bradby and Put's research and the other cases mentioned here point to the often separate universes that 'world music' and 'migrant music' occupy (see also Krüger & Trandafoiu, 2014). While this often leads to distinct sets of socio-cultural groups and nationalities attending different types of gigs, it also illustrates how cosmopolitan musicians can successfully bridge these apparently parallel worlds. This observation raises an important challenge for those promoting intercultural music practice, namely, how successes in intercultural music composition and performance might translate into meaningful socio-cultural interaction on the part of audiences and communities, thereby breaking down borders between separate spheres of cultural engagement.

By the end of this stage of my ethnographic observations and on further reading and reflection, I realized that my inquiry was firmly shifting towards perceptions of, and engagement with 'African music' in Dublin by Irish and other European people. In deciding to focus on established ethnic groups (including Irish) rather than recently arrived migrants, I was conscious of Samuel Araújo's (2009) call for ethnomusicologists to research established groups as well as migrant groups within their own city. Another theorization that proved useful in locating (and

sometimes questioning) my own subject position and original critical perspective was Michelle Duffy's (2005) sophisticated analysis of how pre-conceived ideas of gender, nationality and race can act to de-authenticate the participation of 'white bodies' in intercultural music and dance practices, a process that in turn reinforces 'exoticist' assumptions about 'black', 'oriental' or 'Other' bodies.

Looking back on my evolving perspective, I now reflect that this was a turning point. Following Gilroy (1991), and in the light of initial ethnographic observations, I had become increasingly aware of the interpretive limitations of an unyielding anti-essentialist approach. If 'white bodies' (including my own) were displaying interest in, or were more actively seeking engagement with sub-Saharan African musical practices in Dublin, then such phenomena merited closer investigation.

Learning *djembe* in a drum circle

My motivation to move towards a more direct participation in the ethnography did not arise solely from a change in research orientation; also influential in that decision was the fact that learning *djembe* was something I had wanted to do for a long time. Before describing this, I would like to set out some broader contexts to this part of the ethnography by looking briefly at recent global phenomena of drumming circles based on West African practice, with particular attention to the *djembe*.

The *djembe* in international contexts

In spite of its seemingly ubiquitous presence across many genres of world popular music today, the *djembe* was largely unknown in international contexts until the first dance troupes from the West African countries of Guinea, Mali and Senegal made visits to North America, Europe and beyond from the 1950s onwards (Charry, 1996, 2000; Price, 2013). *Djembe* playing, and more broadly, West African drumming and its associated polyrhythmic textures (see Locke, 1987) also began to interest experimental composers of Western art music during the 1960s (including Steve Reich) as well as occasionally being absorbed into the fabric of some Western popular music bands throughout the 1960s and 1970s. However, we might say that the *djembe* was catapulted to global recognition with two significant developments of the 1980s: the 'invention' and marketing of 'world music' in 1986 by multinational recording and distribution interests, and the 'burgeoning' of community music activity (McKay & Higham, 2011) which embraced intercultural approaches to musical–social engagement. Since then drumming workshops have featured across the globe in a range of community, healing/therapeutic, 'transformational', and even 'corporate team-building' contexts (see Higgins, 2008; Lee, 2010; Onishi, 2014; Price, 2013; Skeef, 1999; Stephens, 2003). Tanice Foltz (2006), meanwhile, interprets the popularity of drumming circles outside of original West African contexts as representing a form of 'spiritual re-enchantment' for alienated individuals in societies where there are no longer any certainties with regard to traditional religious values.

While the *djembe* is now integrated as a standard percussion instrument in various international contexts and, moreover, enjoys considerable popularity in many community contexts, it nonetheless retains its continuity with 'local tradition' through engagement with authentic cultural contexts and through prolonged drumming studies with masters of the tradition; Mamady Keita of Guinea and his *Tam Tam Mandingue* drumming school notable in this regard (see Billmeier, 1999).

Group drumming classes with Wassa Wassa

Through researching this topic I have come to know several Irish people who have spent a considerable period studying *djembe* and other drumming (primarily *dundun*) with Mamady Keita and others, and this includes Niall Delahan of the Dublin-based group Wassa Wassa, whose elementary and, later, intermediate drum circle classes I attended during 2012. These classes involved two to three exhilarating hours each Friday night in the basement of a well-known Dublin music venue, with a mixed group of Irish and other Europeans (mostly Polish and Italian) living in Dublin.

Niall had spent prolonged periods living and studying drumming in various parts of West Africa. He displayed a very relaxed teaching style, with considerable time given each evening to a discussion of technique, theory and cultural observations arising from his experiences. It was very clear from his approach to teaching *djembe* and *dundun* that he had given significant attention to the cultural contexts of the various call, break and *echauffement* patterns we learned by ear (and eye) and practised each night (for example, *foli* and *yogui*). So much so in fact that I found myself unreasonably irritated at times, as body heat built up through earlier sets of practice would dissipate as we waited for the action to recommence. Gradually, though, I began to appreciate this holistic approach and eventually developed a greater intercultural interest that, in turn, enhanced my feeling for the music.

The ethnography revealed a number of significant education-related findings. As already alluded to, the predominant teaching and learning style adopted at the workshops was aural in nature, and was regularly contextualized through the benefit of Niall's intercultural experiences. He complemented this approach by occasionally sharing tabulated rhythm notations and mp4 files via email to provide visual support for the intermittent practice of more complex drumming patterns. As a musician trained primarily through Western classical methods I was somewhat surprised to discover that notated rhythms did little to help with my progression as a *djembe* player whereas the video files (with beating patterns considerably slowed down) were greatly beneficial.

Generally though, and this was a view shared by others in my circle, learning to play worked best when performing in the whole group setting, with technical obstacles often forgotten in the 'musical flow' (Turino, 2008, pp. 4–5; after Csikszentmihalyi) of prolonged polyrhythmic practice that always seemed to move towards faster *tempi*. Although I had read Thomas Turino's (2008) compelling treatise on participatory music culture some years previously, this was the first time I experienced something akin to musical flow when performing at beginner level. The impact this made went beyond the experience of musical and social-synchronic fulfilment, rewarding as that was for itself. Now that I had begun to be at least momentarily caught up in an intercultural participatory practice, it also led me to reappraise my earlier critical stance of the attraction of 'white bodies' to West African musical cultures, and to reconsider my scepticism towards generalized claims regarding the 'benefits' of African drumming. These did not dissipate entirely, but it did allow me a greater sense of empathy with those who are genuinely involved in such endeavours. My experience here resonates with Akom (2008, p. 259) who employs critical reflexivity to decentre 'whiteness', arguing for the incorporation of this approach into narrative accounts of intercultural research and practice.

The cross-cultural appeal of West African drumming described above and directly experienced by myself is somewhat perplexing if we consider analytically its rhythmic complexities that in 'authentic' transmission might require years of study with a master drummer immersed in 'local' cultural tradition. Ethnomusicologist Martin Stokes offers some explanation for the international popularity of drum circles and similar phenomena when he states:

[T]he generative potential of a twelve-pulse figure that never fully settles on a duple or a triple gestalt appears to be easily grasped and communicated across significant cultural borders. One factor may be their indexical or iconic "groupiness" (Lomax, 1968).[5] Many such socio-musical practices quickly communicate to listeners, observers, and dancers the very processes of intense social interaction and physical activity through which they come into being, as a consequence of either visual or aural cues in transmission: interlocking, phrase marking, call and response, droning, simultaneous group improvisations, varied repetitions, etc. What is heard implies forms and processes of embodied social interaction. While such forms and processes may not be highly valued at the level of sanctioned cultural discourse, they may be broadly recognizable in the more submerged repertoires of fantasy, play, and pleasure, and it is this recognition that facilitates their cultural mobility. This is not to argue for a culture-free picture of global music interactions. It is, however, to stress that musical, as well as political, social, and economic, explanations exist as to why particular practices circulate, and to suggest that any properly cultural analysis of the global music order should consider them.

(Stokes, 2004, p. 68)

I quote at length from Stokes here, partly because his speculative analysis directly relates to the intercultural music practices featured in this chapter. But it also serves to remind us more generally that intercultural arts practice involves *artistic* as well as *cultural* levels of engagement and experience.

Stokes's reflections further prompt us to consider a 'relative autonomy' (Chester, 1970; Middleton, 1990) and international mobility for some music systems when compared with others. Western popular music (including Anglo-American, African-American and Afro-Caribbean sub-styles) can be identified as sharing an ever-evolving syntax that by now extends to all parts of the globe, leading to multifarious, hybrid popular music cultures. Additionally, the worldwide appeal of more culturally distinct music systems – 'distinct' yet historically linked to what we imagine as 'Western' or, in more recent contexts, 'World' popular music – suggests more self-contained forms of international mobility. This would be the case with Euro-American classical music, Irish traditional music and West African drumming. However, I concur with Stokes (2004, p. 68) who argues that the identification of relatively mobile music systems and traditions should not lead to a 'culture-free picture of global music interactions'. Rather, they underline the need for more interdisciplinary and comparative approaches in researching growing phenomena of intercultural music practices.

Further explorations

In this concluding section I briefly report and reflect on additional research activities carried out during and subsequent to my participation in drumming circles in 2012. This includes a web ethnography approach, primarily through the collation and analysis of videos relating to Africa Day events as well as to performances and education/outreach events involving Wassa Wassa. I close the chapter (but not the research) by considering activism in intercultural arts practice, and go on to contemplate the making of an ethnographic film as the next phase in this research journey.

Review of video-recorded materials

For ethical reasons, I confined the web ethnography components of my study to professional videos that had been uploaded to either Vimeo or YouTube websites and whose creators would

have sought permissions to film and subsequently re-use footage that included participants. Perhaps the first and most obvious point to note is how much broader a picture of 'African Music' in Dublin I received through including this method. To begin with, the video archives for Africa Day(s) from 2012 to 2015 provided evidence of much greater participation by residents of various African nationalities than I had observed in 2011 (I also attended some of these events in person). One YouTube video in particular led me to revisit an observation made during the earlier stages of the research, and summed up by the question, 'Why are there no African people here?' The video in question[6] revealed a series of scenes filmed at an open workshop featuring Wassa Wassa with master *kora* musician Sadjo Sissokho from Guinea Bissau during Africa Day celebrations in 2012. The event, which took place in Dublin's docklands area, was filmed and promoted by Irish Aid.

If my earlier interpretations regarding Irish Aid's 'curation' of Africa Day events came to be affirmed following a close viewing of this film, the video evidence also acted to challenge another impression I had earlier made, namely, that learning and participating in African drumming appeared to hold more interest for 'Europeans' than for 'Africans' based in Dublin. The 2012 Africa Day workshop video strongly suggested that, for many persons of African descent living in Dublin, the *djembe* and *dundun* appeared as items that were largely unfamiliar, but which arouse curiosity and interest (just as, perhaps, many people of European descent might react if confronted by a range of 'indigenous' European percussion instruments during a 'Europe Day' celebration). Moreover, the video showed a far greater proportion of persons of African and other non-European nationalities participating in this one-off beginner workshop than I had observed during my Friday evening sessions (which were attended by Europeans only). This was a finding that resonated to some extent with research carried out as part of Lena Slachmuijlder (2005) and Ghanaian master drummer Nicholas Kotei Djanie's extensive programme of facilitated drum circles in post-conflict regions of Burundi and South Africa, areas in which the *djembe* would have been as unfamiliar to most people as it would have been in Sweden or Texas).

Overall, the Africa Day 2012 video montage suggested to me that there probably was, and remains, much greater scope for facilitating intercultural participatory practice in the city, other than at key annual events and festivals. The video evidence suggested a greater balance in terms of 'African' and 'European' participation than previous stages of my ethnography had revealed. Seeing people of so many nationalities attend a workshop given by musicians from Guinea Bissau and Ireland reaffirmed my appreciation of the many African drumming workshops that are regularly held in schools and colleges around Dublin and elsewhere in Ireland.

Giving voice to intercultural arts practice

Having explored this topic previously (O'Flynn, 2005, 2008), I acknowledge how my subject position towards, and more importantly, my own *experience of*, intercultural arts practices, has changed. I retain to some degree a critical approach that is wary of the fetishization of 'black' and 'African' music(s) and the attendant attractions of that music (and dance, which space did not permit me to explore) on the part of 'white bodies'. I also consider it important to interrogate the circumstances and discourses through which intercultural arts practices are presented. This chapter has revealed, for example, how various African music events come to be mediated in different ways, depending on organizing groups, as well as on musicians and audiences. I have problematized the celebration of African culture in contexts

of overseas aid and development policy, while also acknowledging the positive outcomes of such initiatives.

At the same time, through further engagement with the literature and through close observations, I have found it helpful to counterbalance anti-essentialism with 'anti anti-essentialism' – and sometimes even, to put aside critical perspectives altogether, albeit temporarily – not only to facilitate the experience of optimal flow in participatory intercultural performance, but also because of my growing appreciation of all those involved in drumming workshops and related events in Dublin and elsewhere.

The presence of several West African drumming experts who not only perform professionally but are also willing to share their deep engagement of rich West African musical traditions with Irish residents of all backgrounds and geographical origin is surely a positive development. All of these practitioners are already involved in important social action by integrating intercultural arts practice with intercultural education. Moreover, in the past couple of years I have become acquainted with a number of groups and individuals who adopt a more social activist role in promoting awareness of political as well as intercultural issues,[7] while continuing to promote performances by frontline African artists, drumming and dance workshops, and African-themed dance events. One such group is the Afro-Eire collective, established by Dublin-born percussionist Paul McElhatton and whose mission is described thus: 'Originally created . . . out of the need to create an outlet for traditional African drumming and dance in Ireland, the group has since moved towards projects that link African music with political and developmental debate' (Afro-Eire, n.d.). Initiatives led by Afro-Eire and similar groups not only celebrate the diverse socio-cultural and artistic traditions of sub-Saharan Africa, but also provide a forum wherein discourses pertaining to Africa – on the part of Europeans as well as Africans – can be critically explored.

Bearing all this in mind I find myself increasingly drawn towards further exploration of this topic through the making of an ethnographic film. This approach promises to give expression to various musician viewpoints, while also making explicit the relationships that will emerge between the researcher-as-filmmaker and the artists involved (following Zemp, 1988). It also offers opportunities whereby participants in intercultural music workshops and similar events could themselves become involved as visual anthropologists (Araújo, 2009; Wang, Burris, & Yue Ping, 1996). Now that my interest has begun to shift towards Dublin-based collectives that promote participation in sub-Saharan African arts alongside broader education and social activism concerns, this is perhaps the optimal methodology for promoting a greater sense of collaboration and mutuality, allowing the ethnography greater scope to act as stimulus for social change (Araújo, 2009; Harris, 2012, 2014).

In the meantime, and in an endeavour to retain an approach to intercultural practice and research that is at once grounded and reflexive, I intend to return to the drumming.

Notes

1 By this I mean that I consider specific intercultural music practices from the perspectives of postcolonialism and critical race theory.
2 My main focus on intercultural rather than multicultural music practice should not be interpreted as valorizing one orientation over the other. Here I concur with Meer and Modood (2012, p. 175) who argue that 'interculturalism cannot, intellectually at least, eclipse multiculturalism, and so should be considered as complementary to multiculturalism'.
3 'Otherness' is adapted here to highlight comparative perceptions of whole groups or societies in dichotomous pairings such as coloniser/colonised, white/black or Western/oriental.

4 See Davidson (2001) and Gillespie and Cornish (2009).
5 Alan Lomax (1968) *Folk Song Style and Culture*, Washington, DC: The American Association for the Advancement of Science.
6 https://www.youtube.com/watch?v=16dwVCXrldc (last accessed 6 June 2015).
7 See Fischlin, Heble and Lipsitz (2013).

References

Afro-Eire (n.d.). http://www.afroeire.com/about/ (last accessed 10 March 2015).

Agawu, K. (2003). *Representing African music: Postcolonial notes, queries, positions*. London and New York: Routledge.

Akom, A. A. (2008). Black metropolis and mental life: Beyond the 'burden of "acting white"' toward a third wave of critical racial studies. *Anthropology & Education Quarterly, 39*(3), 247–265.

Araújo, S. (2009). Ethnomusicologists researching towns they live in: Theoretical and methodological queries for a renewed discipline. *Muzikologija, 9*, 33–50.

Billmeier, U. (1999). *Mamady Keïta: A life for the djembé: Traditional rhythms of the Malinke*. Kirchhasel-Uhlstädt: Arun-Verlag.

Born, G., & Hesmondhalgh, D. (2000). *Western music and its others: Difference, representation, and appropriation in music*. Berkeley, CA: University of California Press.

Bradby, B., & Put, B. (2007). World music or migrant music? The global network of popular music performance. In K. Fricker & R. Lentin (Eds.), *Performing global networks* (pp. 88–104). Newcastle: Cambridge Scholars Publishing.

Brannigan, J. (2008). 'Ireland and Black': Minstrelsy, racism and black cultural production in 1970s Ireland. *Textual Practice, 22*(2), 229–248.

Carby, H. (2001). What is this Black in Irish popular culture? *European Journal of Cultural Studies, 4*(3), 325–349.

Central Statistics Office (n.d.). *Census 2011 Profile 6 Migration and Diversity – A profile of diversity in Ireland*. http://www.cso.ie/en/census/census2011reports/census2011profile6migrationanddiversity-aprofile-ofdiversityinireland (last accessed 10 March 2015).

Charry, E. (1996). A guide to the jembe. *Percussive Notes, 34*(2), 66–72.

Charry, E. (2000). *Mande music: Traditional and modern music of the Maninka and Mandinka of Western Africa*. Chicago, IL: University of Chicago Press.

Chester, A. (1970). Second thoughts on a rock aesthetic: The band. *New Left Review, 62*, 75–82.

Cullen, M. (2014). Positive vibrations: Musical communities in African Dublin. In M. Fitzgerald & J. O'Flynn (Eds.), *Music and identity in Ireland and beyond* (pp. 219–232). Farnham, Surrey: Ashgate.

Davidson, D. (2001). *Subjective, intersubjective, objective: Philosophical essays, Volume 3*. New York and Oxford: Oxford University Press.

Doyle, R. (1989). *The commitments*. London: Vintage.

Duffy, M. (2005). Performing identity within a multicultural framework. *Social and Cultural Geography, 6*(5), 677–692.

Dyer, R. (1997). *White*. London and New York: Routledge.

Fischlin, D., Heble, A., & Lispitz, G. (2013). *The fierce urgency of now: Improvisation, rights, and the ethics of cocreation*. Durham, NC: Duke University Press.

Fitzgerald, M., & O'Flynn, J. (2014). *Music and identity in Ireland and beyond*. Farnham, Surrey: Ashgate.

Foltz, T. G. (2006). Drumming and re-enchantment: Creating spiritual community. In L. Hume & K. McPhillips (Eds.), *Popular spiritualities: The politics of contemporary enchantment* (pp. 131–146). Aldershot, England and Burlington, VT: Ashgate.

Gillespie, A., & Cornish, F. (2009). Intersubjectivity: Towards a dialogical analysis. *Journal for the Theory of Social Behaviour, 40*(1), 19–46.

Gilroy, P. (1991). *'There ain't no black in the Union Jack': The cultural politics of race and nation*. Chicago, IL: University of Chicago Press.

Gilroy, P. (1993). *The Black Atlantic: Modernity and double consciousness*. London and New York: Verso.

Harris, A. (2012). *Ethnocinema: Intercultural arts education*. Dordrecht, Heidelberg, New York and London: Springer.

Harris, A. (2014). Ethnocinema and the impossibility of culture. *International Journal of Qualitative Studies in Education, 27*(4), 546–560.

Helfenbein, R. J. Jr. (2003). Troubling multiculturalism: The new work order, anti anti-essentialism, and a cultural studies approach to education. *Multicultural Perspectives, 5*(4), 10–16.

Higgins, L. (2008). The creative music workshop: Event, facilitation, gift. *International Journal of Music Education, 26*(4), 326–338.

Krüger, S., & Trandafoiu, R. (Eds.) (2014). *The globalization of musics in transit: Music migration and tourism.* New York: Routledge.

Lee, H. K. (2010). The rise of African drumming among adult music learners in Hong Kong. *International Education Studies, 3*(4), 86–93.

Locke, D. (1987). *Drum Gahu: The rhythms of West Africa.* Crown Point, NV: White Cliffs Media.

Lomax, A. (1968). *Folk song style and culture.* New Jersey: Transaction Publishers.

Lynch, S. (2012). Music and creative stimuli: The case of Ireland's Bamenda diaspora. Paper read at ICTM Ireland Annual Conference, Trinity College Dublin, 26 February.

McKay, G., & Higham, B. (2011). *Community music: History and current practice, its constructions of 'community', digital turns and future soundings.* Project Report, Arts Humanities Research Council, Swindon.

McLaughlin, N. (2014). Post-punk industrial cyber opera? The ambivalent and disruptive hybridity of early 1990s' U2. In M. Fitzgerald & J. O'Flynn (Eds.), *Music and identity in Ireland and beyond* (pp. 179–204). Farnham, Surrey: Ashgate.

McLaughlin, N., & McCloone, M. (2000). Hybridity and national musics: The case of Irish rock music. *Popular Music, 19*(2), 181–199.

Meer, N., & Modood, T. (2012). How does interculturalism contrast with multiculturalism? *Journal of Intercultural Studies, 33*(2), 175–196.

Middleton, R. (1990). *Studying popular music.* Buckingham: Open University Press.

Mutwarasibo, F. (2002). African communities in Dublin. *An Irish Quarterly Review, 91*(364), 348–358.

O'Flynn, J. (2005). Re-appraising ideas of musicality in intercultural contexts of music education. *International Journal of Music Education, 23*(3), 191–203.

O'Flynn, J. (2008). An interpretation of Irish student teachers' understanding of multicultural/intercultural issues with specific reference to group compositions in music. In B. Roberts (Ed.), *Sociological explorations: Proceedings of the 5th International Symposium on the Sociology of Music Education* (pp. 271–296). St John's, Newfoundland: The Binder's Press.

O'Flynn, J. (2014). *Kalfou Danjere?* Interpreting Irish-Celtic music. In M. Fitzgerald & J. O'Flynn (Eds.), *Music and identity in Ireland and beyond* (pp. 233–258). Farnham, Surrey: Ashgate.

Onishi, P. C. (2014). Drumming for community building: The development of the Community Drumming Network (CDN) and its impact in Singapore society. *International Journal of Community Music, 7*(3), 299–317.

Onkey, L. (2009). *Blackness and transatlantic Irish identity: Celtic Soul Brothers.* London and New York: Routledge.

Price, T. Y. (2013). Rhythms of culture: Djembe and African memory in African-American cultural traditions. *Black Music Research Journal, 33*(2), 227–247.

Skeef, E. (1999). African drumming: A perfect tool for a more open and inclusive approach to intercultural education and development. *European Journal of Intercultural Studies, 10*(3), 329–338.

Slachmuijlder, L. (2005). The rhythm of reconciliation: A reflection on drumming as a contribution to reconciliation processes in Burundi and South Africa. Working paper. Waltham, MA: Brandeis University.

Slobin, M. (1993). *Subcultural sounds: Micromusics of the West.* Hanover, NH: University Press of New England for Wesleyan University Press.

Stephens, C. (2003). *The art and heart of drum circles.* Milwaukee, WI: Hal Leonard Corporation.

Stokes, M. (2004). Music and the global order. *Annual Review of Anthropology, 33,* 47–72.

Turino, T. (2008). *Music as social life: The politics of participation.* Chicago, IL and London: The University of Chicago Press.

Uberoi, R. (2014). 'We are pentecostal; We are evangelical; We are an AIC': Musical indices of group identity and belonging in an African immigrant church. Paper read at ICTM Ireland Annual Conference, National University of Ireland Galway, 23 February.

Ugba, A. (2004). *A quantitative profile analysis of African immigrants in 21st century Dublin.* Dublin: Trinity College Dublin/Know Racism.

Vallely, F. (2003). The Apollos of shamrockery: Traditional musics in the modern age. In M. Stokes & P. V. Bohlman (Eds.), *Celtic modern: Music at the global fringe* (pp. 201–217). Lanham, MD: Scarecrow Press, Inc.

Veblen, K. (2014). Dancing at the crossroads remixed: Irish traditional musical identity in changing cultural contexts. In M. Fitzgerald & J. O'Flynn (Eds.), *Music and identity in Ireland and beyond* (pp. 151–164). Farnham, Surrey: Ashgate.

Wang, C., Burris, M. A., & Yue Ping, X. (1996). Chinese village women as visual anthropologists: A participatory approach to reaching policymakers. *Social Science and Medicine, 42*(10), 1391–1400.

Zeleza, P. T. (2005). Rewriting the African diaspora: Beyond the Black Atlantic. *African Affairs, 104*(414), 35–68.

Zemp, H. (1988). Filming music and looking at music films. *Ethnomusicology, 32*, 393–427.

Filmography

Dornford–May, M. (2005). *U-Carmen eKhayelitsha*.

Parker, A. (1990). *The Commitments*.

37

MEDIATING CULTURES AND MUSICS

Researching an intercultural production of *A Midsummer Night's Dream*

Helen Julia Minors

A new production of Shakespeare's *A Midsummer Night's Dream, Sogni di una note di mezza e state*, was performed during the International Sferisterio Macerata Opera Festival (August 2013).[1] Shakespeare's play (acted in a modernised Italian translation) is placed in dialogue with both Mendelssohn's incidental music (sung in English translation) and Britten's operatic setting. The performance fuses these three versions of the play, forming the plural, *Sogni* (Dreams). These elements were combined with dynamic surtitles (condensed translations of the sung text, situated on the centre stage wall), revealing Italian translations of the English sung text and English subheadings during the Italian spoken sections. This production mounted on the outdoor, stone walled stage of the Sferisterio, led by artistic director Francesco Micheli, fuses 'intercultural' elements within a dramatic work. The intercultural elements are diverse, incorporating multiple attributes: a combination of musics from different cultural contexts to generate a new work; the bringing together of text(s) and music(s) across cultural borders; the intersection of multiple interpretations, or responses to, a source text; and a fusion of multiple languages. Intercultural elements refer to a melding of different texts, musics, gestures and languages. Micheli rises to the challenge of 'recast[ing] in a new language the gossamer delicacy and colloquial buffoonery of a play ranking with the most universally popular comedies conceived by Western civilization' (White, 1960, p. 350). Micheli projects his premise that: 'Opera is always a good way to meet our past, our culture, in a brilliant alive way' (20:03).[2] In so doing, the diversity of musical styles and multi-linguistic components in this experimental project act as a dynamic mediator of Shakespeare's narrative.

In this chapter, I create a critical interpretation of the intercultural agenda which informed the collaboration, which was ultimately borne out in performance. The intercultural agenda explores the interface between artistic elements from different historical-cultural contexts, to generate a new work, which, by fusing multiple intercultural elements, forms a network of interactions. As Nicholas Cook establishes in 'relational musicology' (2010, p. 1), there are 'transactions between cultures'. Projecting these transactions in performance is central to the festival's agenda and situates it as intercultural. I assert that an intercultural opera production requires an act of mediation that crosses media, cultures and languages. An intercultural opera is formed from a dynamic exchange of lingual, geographic, historical, stylistic, and therefore,

cultural components. I aim to illustrate how mediation operates within this intercultural arts context, and in so doing, I make a case for a new strand of musicology, that of an intercultural musicology. Projection of an intercultural agenda, via this opera, produces an intercultural performance: by the very prefix, inter-, the cultural elements are subject to transformations across media. In what way is an intercultural agenda projected in *Sogni*? I consider that 'no one element of culture can be fully understood alone', but 'that music can illuminate' both the creative 'cultural context' (Fulcher, 2013, abstract) and performance context.

This chapter utilises recorded interviews filmed during the Sferisterio festival, to critique the intercultural agenda of this operatic adaptation of Shakespeare. These interviews explore how musical texts are translated to ensure effective delivery of sense across cultures and include: the festival director, Luciano Messi; artist director, Francesco Micheli; and translator, Daniele Gabrieli. The rehearsal process is referred to, which I documented to illustrate how the production was understood to be intercultural.

First, I explore the challenges of an intercultural agenda, defining interculturality within this context. Second, I claim that intercultural praxis requires mediation. Namely, that the intercultural agenda provides a framework within which the intercultural elements are melded. As Philip Auslander (1989, p. 53) has iterated, the live event, the 'im-mediate', is reliant on mediation. The notion of 'reciprocity' is presented to question this process of mediation. Ultimately, I propose a field of intercultural musicology: a study of cultural transactions between the music(s) and text(s) from different cultural contexts. Relational musicology looks 'across contiguous musics defined by their difference' (Born, 2010, p. 222), promoting 'an expanded analytics of the social and cultural in music' (ibid., p. 231). Intercultural musicology observes also the differences and intersemiotic mapping between language, gesture and musical texts.

Sferisterio Macerata Opera Festival: agenda

Britten's setting of Shakespeare radically condenses the play, removing Act I (and Athens) and most of Act V, creating only a single new line of text (Cooke, 1993, p. 246). Britten, and his collaborator Peter Pears, produced a setting that dramatised the magic effect of the fairies on the Athenian lovers. Composed for his Aldburgh Festival (11 June 1960), Britten and Pears place the setting in the forest during the night, emphasising nature and the supernatural quality of the fairies: 'I have always been struck by a kind of sharpness in Shakespeare's fairies . . . Like the actual world, incidentally, the spirit would contain bad as well as good' (Britten, in Kildea, 2013, p. 443). Once associated with 'pagan gods', Britten responds to the fairies' 'devilish spirits' (Albright, 2007, p. 196).

The magical view of fairies in English folklore appears often in Shakespeare's plays; they act as a dramatic catalyst using magic to modify human behaviour. Over the nineteenth century their menacing attributes reduced (Wood, 2014, pp. 229–233); their presence in children's literature developed, as seen with Tinkerbell in J. M. Barrie's *Peter and Wendy* (1911). It is notable then that Britten's perspective of fairies as malicious beings is drawn from Shakespeare and not his own cultural context. The adaptation by Micheli responds to the entrancing characteristic of the fairies in Britten's work. Stark contrasts are created in juxtaposing scenes composed by Mendelssohn with those of Britten. Mendelssohn's initial overture (1826) and incidental music (1843) present a nineteenth-century response to Shakespeare. Tonal language, melodies and instrumental use differ, but both composers utilise register, timbre and rhythmic energy to distinguish between fairies and those controlled by magic. Messi explains that: 'We made a pastiche from Mendelssohn to Britten, mixing this music with the original text from Shakespeare, in order to have a new opera, *A Midsummer Night's Dreams*' (13:04).

The plural content and title, *Sogni*, both allegorise the issue of interculturality. But, what was the agenda of this 2013 Sferisterio festival? And moreover, what theme was applied to this operatic invention that prompted such an intercultural pastiche? Micheli explains that the goal is 'to break the opera wall' (4:36). The wall depicts a barrier between musical genres, cultures and nations. Removing such barriers would enable people to 'get at the opera on the street' (4:38). The guiding principle of the festival is to 'look to foreign peoples' (Messi 1:18:11) and to speak across cultural boundaries. This is core to the intercultural agenda of *Sogni*: different compositional voices from different cultures are brought together, fused side by side. A notion of interculturality is embedded within the festival agenda: Messi and Micheli both assert their aim to work with the between-ness of cultural differences by bringing those differences into a relation. The combination of musics asserts its interculturality – difference is projected and borne out in performance. The accessible strategy incorporates the hard of hearing, partially sighted and blind, physically impaired, as well as children, foreign audiences and those new to opera. Messi asserts a connection across cultures by widening the brief in regard to accessibility. The Sferisterio festival, as such, welcomes operatic experimentation. Messi is aware that: 'Britten is very tied to our way to make a theatre in Macerata because we want to get in touch with new generations' (7:15). In referring to music as a universal language (rehearsal discussion, 1 August 2013) he seeks a way to utilise music to speak across lingual and cultural boundaries. The translator, Gabrieli, is astute to easing the transfer of sense across lingual and cultural borders: 'Translation is about taking something very foreign and making it familiar' (2:48). Like Britten, Gabrieli 'worked from the original' Shakespeare text (11:10), avoiding 'anything between me and [Shakespeare]' (11:22).

Recognising that 'Britten's goal was so clearly the comprehension of the public' (Micheli 24:27), *Sogni* is modelled so as to render clarity of narrative delivery. Although fusing an opera, incidental music, a play, three languages, spanning four centuries, may appear complex, the experiment is founded in European theatre history: 'This year we do Britten . . . In English! Here! In Italy! It's completely new for our theatre!' (14:44) . . . 'The Britten production is a pas-tiche . . . It means to take different operas, the best of, and create a new opera' (Micheli 17:02).

The intercultural agenda of *Sogni* imposes a dialogue between composers and playwright. Despite the cultural division Micheli (20:50) stipulates:

> It's exciting because you feel a German composer has a conversation with an English composer, in the same time, the same space Mendelssohn represented the more romantic, positive idea of Shakespeare, in the forest . . . But Britten shows us the dark side of the moon the overtures by Mendelssohn, and one minute after the Britten overture, really give a more complete idea of nature. Nature is a friend but it is also something completely different. You must have respect because you cannot know what nature can do.

Dialogue is promoted in an intercultural context: multiple voices are presented as though in conversation. Shakespeare's source text sets a story which remains of its era, but its setting by Mendelssohn and Britten re-interprets it, fusing their own cultural idioms to the source text. The original sense is adapted by the translator and target context (Minors, 2013). The past is brought to the present, emergent 'through the interaction between texts and practices' (Cook, 2010, p. 1). Messi is aware that Shakespeare is active within the new work: 'the [surtitles] become part of the show, becomes part of the set in some way, part of the wall' (Messi 14:29). The collaboration between artists following the intercultural agenda of this festival is manifest by fusing works for different cultural-historical contexts. The division between artistic cultural locations is mitigated by placing all performance activity into a single location, that of the

magical forest, within which the different text(s) and music(s) combine. The festival agenda and the source text are literally and metaphorically present.

Figure 37.1 illustrates the content of this operatic pastiche from the source text (Shakespeare) to the target text (*Sogni*) and illustrates the intercultural elements. The festival agenda provides the context for the artistic blend. The different cultural contexts feed the production, contributing to breaking the opera wall, as each version of the work must adapt to accommodate its new place within the pastiche. An intercultural exploration must go 'beyond the literal, the textual, and the philosophical or metaphoric' (Fulcher, 2011, p. 7). The negative connotations about delineation of 'walls and divisions' are erased in favour of a positive combination of intercultural elements.

> I chose to code this edition of the festival, walls and divisions, because my dream was, in this opera temple, [to] prepare [to] pay [respect to] the production of *The Wall*, by Pink Floyd, because I think *The Wall* is an opera.
>
> *(Micheli 2:30)*

In 'breaking' the wall Micheli refers to the perceived exclusivity of opera. Reference to Pink Floyd engages with a popular culture, known internationally. Pink Floyd's work is utilised to connect to both the opera theatre, due to the Sferisterio's large stone wall, as well as to Britten's approach to Shakespeare. Micheli appropriates Pink Floyd's title in referring to Britten's opera as presenting the 'dark side of the moon' (album, 1973). A subliminal reference to the play is made, as Micheli 'dreams'. Furthermore, the modernised text, for example at scene 5 A, details: 'They have the whole forest at their disposal. A space too large for the characters so small, in this space without borders each run, each look' (Micheli, 2013a). The performative nature of Micheli's remarks crosses cultural borders: in recognition of British popular music, as well as Italian opera and local references, he asserts difference to iterate the importance of accepting the multiple subjectivities of audiences. The festival agenda demands that different cultural idioms are brought together to amplify the intercultural elements. The distinctive content of an intercultural production are multiple: asserting differences without censorship; co-presenting texts across lingual-medial dimensions promoting dialogue across boundaries, to develop work that is coherent.

Introducing an intercultural musicology

Sogni presents a coherent adaptation of Shakespeare's play, but how does the audience mediate this experience? Abbate suggests that music can become a 'ventriloquist's dummy' as it is utilised within a linguistic, culturally defined context (1991, p. 18). Music is seen as a malleable device that bends to the festival agenda. What and who speaks is important, but how the opera delivers a message to the spectator is central to a discussion of intercultural musicology. 'Opera is team work' (Messi 20:08): the transfer of a coherent narrative produced from an intercultural conglomeration of artistic creativity requires assessment. Duncan has challenged the capacity of voice in opera to go beyond traditional interpretations of 'vocal disembodiment' and moves toward 'theories of performativity' to reveal that, ultimately, 'the voices of these singers are no less gestural, no less material than their bodies' (Duncan, 2004, pp. 283–284, 305). Hearing and seeing the boundaries between the elements is essential to proclaim a state that is intercultural. The intercultural elements, presented via musical, linguistic, gestural and spatial media all utter something of the work. In order to establish how spectators mediate *Sogni*, it is necessary to put forward a new strand of musicology – that of intercultural musicology – to give voice to the various elements of the production within the critical discourse.

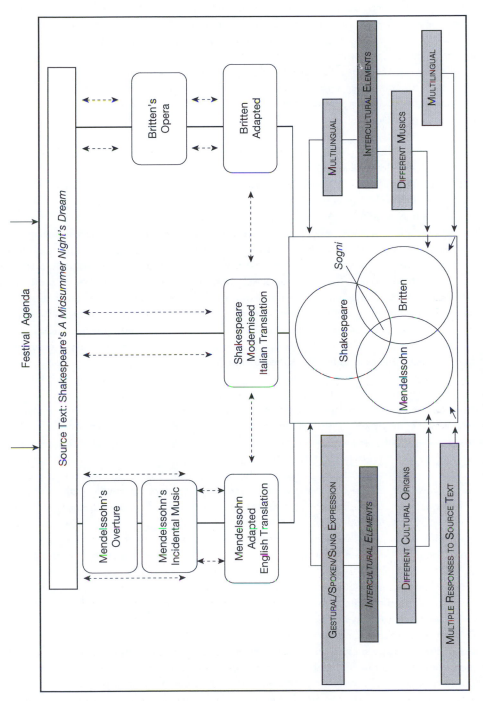

Figure 37.1 *Sogni* context and content, overlaid intercultural elements.

In line with Derrida's notion of phonocentrism, a cultural voice is not diluted due to its performance across fused works. Rather, the necessary act of mediation makes possible a dynamic, intercultural performance. In affinity with Derrida and Baudrillard, the 'components of the performance space' in *Sogni* promote 'a sense of "reciprocity" between actors and spectator' (Copeland, 1990, p. 30). *Sogni* superimposes the live performance with a multimedia, multilingual and accessible presentation.

To bring together different musics from distinct cultures is to propagate an intercultural performance. Such a performance requires that the creative collaborators share an artistic aesthetic to guide the joining of disparate musics (festival agenda). For the intercultural nature of the work to emerge, each of the intercultural elements must be projected clearly. The different artistic elements are emphasised as musical sections move between composers without need for a transition.

The production of an intercultural performance of *Sogni*, which breaks down 'walls and divisions', ensures that '[t]he spectator is active': Micheli notes that this requires the audience 'to put imagination [into it] . . . to understand what is happening' (8:55). The audience must be active for a dialogue to be propagated between performance and spectator. The resulting interculturality supplements new meaning to an established repertory staple.

How we might consider the performance has in recent years been affected by the prevalent agenda concerning accessibility in opera, to make 'storytelling palatable and opera relevant' to contemporary society (Desblache, in Minors, 2013, p. 10). Grounded in the assumption that one must understand the plot to appreciate opera, there have been efforts to expose the text (via surtitles) and to preface any performance with programme notes and videos. Such mediation draws attention to the live quality of the event and to the intercultural location of opera in particular. As Micheli is aware, 'it is very important . . . for occidental culture to be more open' (2:17). The accessible agenda seeks audience engagement: reciprocity therefore is a prerequisite of operatic dialogue and of an intercultural musicology.

Intercultural art, notably opera, has become a 'commercial art form' broadcast live internationally from the opera house to cinema. Opera mediatisation 'needs to be responsive to its environment' (Levin, 2004, p. 266). The Sferisterio festival utilises themes relating to current cultural-political concerns (economic and political instability in Europe), which parallels the fragility of the collaborative operatic production. Meaning is not stable: each spectator will mediate the work to produce their own interpretation.

It is imperative that an intercultural work develops reciprocity. The ability to associate different media across cultural signifiers is a state of reciprocity; it produces an intellectual, meaning bearing, response from the audience: an emotive response is likewise a result of an interpretative understanding. In order for communication to occur it must foster recognition, understanding and questioning in the audience. This concept was defined by Sartre 'as the maximum distance permitting the immediate establishment of relations of reciprocity between two individuals' (1960, p. 207, in Auslander, 1989, p. 131). In other words, in *Sogni*, the performers must formulate relations between the diverse cultural elements of this collage work, to make it familiar. These links need not be refined completely: asserting the content of the media, leaving room for interpretation itself fosters reciprocity and therefore spectator inclusion. An active response from the audience is their translation of the symbols, and consequently, the plot. Multiple perspectives of the work are inevitable. Connections across medial and cultural boundaries must be made if the performer is to inhabit the world of the magical forest at night, without revealing their own fragility. This operatic production, as a post-modern performance, activates and demands reciprocity on multiple levels: the modernisation of text, with reference to the internet and inclusion of a white and a red sports car driven by Bottom in Part Two, for example. A new context is imposed; a forest setting that is able to span European cultures, with a combination of

sweet fairies sung by children and adult magical fairies with sinister qualities; the fused musical elements pitch different approaches to the characters. Such a complex production expects much of its audience. Rather than subscribing to a simpler presentation to ensure wider appeal, it incorporates a range of elements to challenge.

> [P]resence in the theatre has less to do with the distinction between speaking and writing than with the way in which the architectural and technological components of the performance space either promote or inhibit a sense of 'reciprocity' between actors and spectators.
>
> *(Copeland, 1990, p. 30)*

The live nature of the performance fuses the actor's voice, the singing voice, the textual-voice and that of the stage image. The text is projected across Anglophone–Italophone spectators.

For Baudrillard, 'communication . . . is primarily concerned with the reciprocity of symbolic exchange' (Smith, 2010, p. 122). The basic act of communication requires an exchange. There is a response, in an emphatic sense. Reciprocity comes from the Latin for a reciprocal, cyclic, action. The replicating connotation suggests that an audience translates the performance and makes a version of it. Translation theorist Roman Jakobsen (1960) referred to the notion of reciprocity, forming a clear outline of this process: as Baudrillard notes: 'The message itself is structured by the code and determined by the context' (Baudrillard, 1981, p. 178). Jakobsen presented this as: 'Transmitter–Message–Receiver (Encoder–Message–Decoder)' (Baudrillard, 1981, p. 179). Interesting here is the relation to liveness: Baudrillard's commentaries refer to a lack of reciprocity in mediatised events, whereas a live speaking voice is seen to communicate with the supplement of gesture.

As in language, to borrow Baudrillard's analogy, 'producers and consumers are the same people', in that we speak and listen in order to have a conversation (1975, p. 97). As a spectator our understanding of the story impacts upon our continued recognition and response. As the festival was live, there is an immediacy which enables the physical context to impact upon the notion of reciprocity. The outdoor stage, with trees and bushes covering it, pitched against a setting sun all impact on the spectator experience. The removal of anticipation, by fusing works by various artists, ensures the audience remains active and is not lulled into a false sense of expectation.

The location of the forest seems to refer to the natural world, but its magic and its fairies make it a forest not of this world. It is both present on stage and a sign for a forest we can identify, but it is also a sign for the forest of Shakespeare's text, of our collective cultural imagination and of the joining of the characters. 'Is it ever possible to suspend this process of theatrical signification and representation?' (Blau, 1983, p. 60). The experience of *Sogni* relies on mediation of what is beyond. The need for signification and representation is the catalyst for this fascinating work. The suspension of belief and a willingness to explore the hyperreal enable the multilayered dreams to develop. We can understand *Sogni* as a lived experience of the dreams: it is a reproduction of our own dreams, as well as those of the characters. The simulation is made real, as it invites our imagination and day-dreaming to complete the play. The recognition of the simulation underpins the creative aims of this production, to speak across divisions.

Music setting Shakespeare

The content of *Sogni* is a consolidated blend of Shakespeare, Mendelssohn and Britten. In order to foster a production that speaks across European cultures, Gabrieli, in translating the play, considers the cultural origin of the work, that an audience can '[e]njoy the play, enjoy the story,

enjoy the Britishness [of it] . . . but also [they can] find something of its own culture, its own fairy-tales . . . what is common between all traditions in Europe' (13:16). Gabrieli, Micheli and Messi have comparable concerns: a single culture, a British culture, may reside in two of the three source texts, but ultimately a European culture develops from the pastiche.

By formulating a series of scenes that have a concise focus, the task of making the 'foreign' appear 'familiar' (Gabrieli 2:48) is supported. The shared qualities of European culture are utilised to 'break the opera wall' (Micheli 4:36), to move away from a restricted view of culture to an open intercultural dialogue. The rhetoric is positive but the difficulties of reducing specific cultural codes acknowledged. As Micheli is aware, 'hybridity is a good medium to be more open to all the people' (19:23): the contrasting presentation of the fairies is a catalyst for an active exchange with the spectator. The exchange is not 'an immediate reciprocity of exchange *through language*' (Baudrillard, 1975, p. 97) in that there are multilingual processes at play. Music is used as the vehicle to communicate across cultures.

Table 37.1 illustrates the structural content of *Sogni*. It shows the precise lines that were retained from Shakespeare's play in relation to the musical settings. Mendelssohn's music frames that of Britten: the older, tonal score sets the scene before Britten's music is used to demonstrate much interaction between the characters. The final production of *Sogni* is equally divided between the two composers, though consistency is ensured in sections, notable in Part Two, with sequential dramatic scenes (7–9 Britten, 10–12 Mendelssohn) presented by a single composer. Mendelssohn's overture had become a repertory staple in many theatre productions of *A Midsummer Night's Dream*. It is appropriate then to retain it. Likewise, the *Wedding March* has become a staple for married couples across Europe. The familiarity of this music within European culture invites a spectator to experience a revision of the work. Moreover, the reference to *The Tempest* and to John Donne's famous poem, *The Dream*, ensures the spectator is invited to think across their experience of each art form and across their intercultural experience.

With Act I cut, the role of both overtures is complex: beyond introducing the main musical themes, they serve to induct the spectator into the revised world of the forest at night, inhabited by fairies, visited by four lovers who are subjected to magical trickery. Without a curtain, the Sferisterio stage is visible at all times. The scene is ever present, facilitating the acclimatisation of the visual scene, before the musical-textual elements are introduced.

The intercultural elements are introduced one at a time: the overtures are used in chronological order, while black and white footage of the four Athenian lovers are projected, introducing their love interests with titles including 'Hermia loves Lysander'. Within a few titles, Act I of Shakespeare's play is summarised. In a mediatised society, a 'commodified world of mass entertainment' (Auslander, 1989, p. 119), the inclusion of video projection in live performance is common. In a production formed from quite diverse features, such a delivery avoids narrative confusion by introducing each element, and so, invites the spectator into the live performance. With the aspiration to reach wider audiences, through the intercultural agenda, such a mediatised presentation seems fitting. Micheli (7:44) confirms that:

> I think it is important for opera to use different media, the contemporary media, because our time is [that of] the internet time, Facebook time . . . this is the place we use to meet other people . . . it is not a good idea to avoid this, as it is our ground.

Multiple dimensions are introduced: words have been set to music, supplementing the original play and music responds to the symbols in the play. There are two musics, two languages; it is spoken, sung and written, combining live performance and filmed footage.

Table 37.1 The textual and musical content of *Sogni*

Sogni	Shakespeare's *A Midsummer Night's Dream*	Music
Scenes	*Act, scene, lines*	*Musical sections*
PART ONE		
1 Overture	Quotation: Prosperso, *Tempest*, IV, I, 156–158.	Mendelssohn Overture
2 Overture, continued		Britten, Overture, up to figures 6
3 Over Hill and Dale	II, i, 1–59.	Mendelssohn
March of the Fairies	II, i, 60, 145–146, 175–6, 246–247, 268.	No. 2, L'istesso tempo
4 Fair Love	II, ii, 43–52, 70–81, 86–91, 86, 92–99, 98, 102–103, 108–110, 111–122, 131–132, 137–140, 143–144, 143, 151–152, 153, 155–162.	Britten Figure 73–94
5 Lullaby	II, ii, 1–34.	Mendelssohn No. 3, Lied mit chor
5a Spell 1	II, ii, 35–43, 85–91.	Mendelssohn No. 4, Andante bars 1–9.
6 Intermezzo		Mendelssohn No. 5, Allegro appassionate
6a Spell 2	III, ii, 86–91.	Mendelssohn No. 4, Andante bars 11–20.
PART TWO		
7 The woosel cock	III, i, 113–121, 125–127, 135, 136–137, 138–140, 143, 148–157, 160–168, 170–173, 175–6, 179–181 IV, i, 1–13, 17–22, 25–28, 36–46.	Britten Figure 30–56
8 Captain of the Fair Band	III, ii, 110–116, 122, 130, 134, 136–146, 162–163, 176, 183, 195–206, 211–212, 215–217, 220–221, 137–139, 243–249.	Britten Figure 69–87
9 Up and Down	III, ii, 396–402, 403–404, 404–405, 407, 409, 411, 412, 417–422, 425–430, 431–433, 435–458, 460–464.	Britten Figure 91–End
10 Nocturne		Mendelssohn No. 7, Notturno
11 Wedding March	Celebration prepared by quotation: John Donne, *The Dream*	Mendelssohn No. 9, Hochzeitsmarsch
12 Finale	V, i, 375–382, 385–423.	Mendelssohn Finale

The symbolic basis of this narrative music is important: it acts as an audio-description of what is to follow and asserts the different musical responses to Shakespeare. There is an active dialogue between all the intercultural elements. Micheli uses both overtures, which enables him to project, outright, the linguistic and musical differences in their respective settings.

Mendelssohn's overture projects a musical symbol of the fluttering fairies (Musical example 37.1). The move to Britten's overture, however, is connected by Puck, paraphrasing Prospero, from Shakespeare's *The Tempest*: 'We're made of stuff dreams are made of' [*Siamo fatti della stressa sostanza*

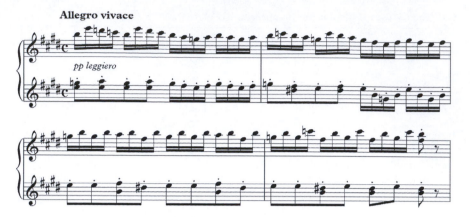

Musical example 37.1 Mendelssohn's overture, bars 7–10.

di cui sono fatti I sogni . . .'] (Micheli, 2013a, p. 13). The move from the musical overture to declared action introduces the first change within this production. The contradiction between magical and non-magical being is striking. This difference presents an analogy of Mendelssohn and Britten who both set Shakespeare's text but through very different musical means. The reliance on contrast to iterate the sinister aspect of the fairies' world is consolidated by Britten: whereas Mendelssohn uses descending octave leaps to depict the human nature of Bottom, Britten uses string glissandi which cut across the defined tonal melodic shape of Mendelssohn's score. The extreme reaches of Britten's glissandi ascend throughout bars 1–21, utilise all twelve tones, avoiding a stable tone centre (Musical example 37.2). Harmonic contrast further establishes distinct approaches to Shakespeare.

In speaking across cultures, cultural symbols are juxtaposed and inserted where they are otherwise lacking. This was evidenced during Micheli's rehearsal direction, during which he articulated the need to emphasise specific cultural tropes. An intercultural opera performance, should avoid removing cultural signifiers – rather, intercultural elements (re-)animate reciprocity by ensuring the word-music content is supplemented with the gestural stage setting. In scene 8, 'Captain of the Fairy Band', the lovers have been subjected to a magic potion: as their love interests change their reality becomes questionable, they then come to the forest. Britten's sinister world presents the magically altered humans. Notable is the importance of gesture. During rehearsals Micheli identified specific moments where culturally identifiable features were required. In all cases they produced friction to contribute to the sinister magical forest, and to iterate that the characters were no longer in control of their own decisions. Specifically, requests were made for the singers to gesture in a 'very British' fashion (rehearsal notes, 1 Aug 2013). The request for stereotypical gestures maps movement and verbal articulation onto the

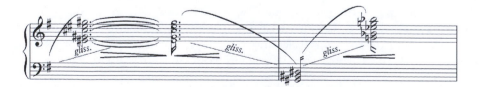

Musical example 37.2 Britten's overture, bars 18–19.

sonic characteristics imposed by the composers. To include the local attitudes to the phrase 'I love you', the singers were requested to 'think Oxford' (ibid.), in order to move in a more restrained manner. There is a light–hearted mocking that the British quality should arise out from Britten's score, which is not tonal or traditional. Contrast and difference is further propagated between Shakespeare and Britten to establish their different historical-cultural contexts.

Scene 8 is a useful example to illustrate the meeting of cultures. A combination of duets, trios and quartets accompany the lovers' battle. The music and text in-put a response to the source text, modified by the festival agenda, but the performance gestures facilitate a meeting of cultural symbols. The restrained Britishness of the male characters is pitted against Helena and Hermia's physical fight (Rehearsal figure 77 in the opera score), in which they were asked to 'move like a boxing trainer' (1 August 2013). The quick, low level movements supplement the sinister approach of Britten's score. Figure 37.2 is presented as an analogy to this 'boxing' match: certain intercultural elements will form comparisons and break through the wall to meld, while others will display their distinction. Messi's aim of breaking the wall is illustrated here by the cultural divisions: they act as a fragmented, broken, barrier through which the elements attempt to pass, in order to interact with other intercultural elements.

The contrast between the two overtures and between the gestural requests in performing scene 8 both emphasise the importance of representing difference. Accessible cultural symbols advance reciprocity: by pitching contrasting elements side by side the spectator is invited to mediate the fusion of the multiple perspectives of Shakespeare. Reciprocity is a key feature of an intercultural musicology: Micheli's rehearsal directions all seek clarification in projecting

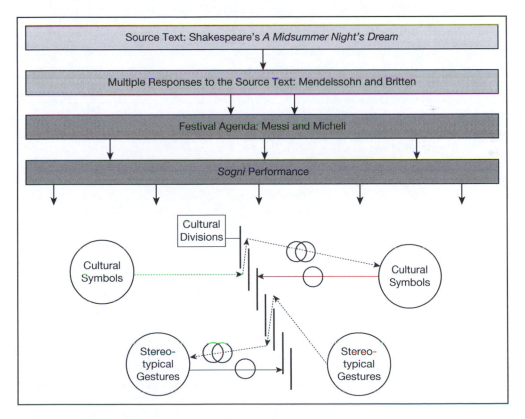

Figure 37.2 Scene 8, illustration of the meeting of cultures.

cultural symbols. A symbolic exchange is produced which requires decoding; likewise, multiple voices transfer sense between the arts and between the stage and the spectator. Differences are asserted, challenging the spectator to search for coherence.

Conclusion

The meaning of the text acts as an intercultural catalyst for composers, the operatic interpretation by the festival and artistic directors, and, moreover, for ensuring 'reciprocity'. To open opera to a wider audience, Micheli produces an intercultural opera production. To ensure the spectator is active he has insured himself against 'anything which cannot be exchanged or symbolically shared [as this] would break the reciprocity' (Baudrillard, 1975, p. 79). Significantly, there is a creative rendezvous (Shakespeare) from where both composers and festival director generated their response. There is, moreover, a shared mythological interest in fairies and magic across European folklore. This intercultural context embedded in the festival agenda seeks spectator engagement, though: 'There can be no direct translation, and no unproblematic collaboration' (Dayan, 2011, p. 3). In order to meet the festival goals, the spectator must be given direction to search for the meaning of the opera, and to search for familiar symbols:

> The first goal is that we needed to break the walls between people, . . . to use the opera to break the contemporary walls that we have in cultural life. I feel that opera has a lot of power to call the different people in the same place, because in itself, opera is a complex mass medium.
>
> *(Micheli 00:40)*

Baudrillard's notion of 'reciprocity' and Micheli's strategic aim both require a work to form 'a *new* reality' (Dayan, 2011, p. 3). The contribution of interculturality in art is that something new is created, which utilises variance to seek reciprocity. The spectator is challenged to think across cultural boundaries due to the overt fusing of intercultural elements, produced according to an intercultural agenda. There is a conceptual difficulty: the key features of the interart aesthetic include the impossibility of uttering equivalences or identifying commonalities between media. The difficulty for Baudrillard and Derrida is the break that occurs when a symbol cannot be transferred. As such, Dayan's assessment of the interart aesthetic is of relevance, not only to an interdisciplinary work, but also to an intercultural work: art should present 'one medium as if it were operating in another' (2011, p. 3). Micheli asserts that 'opera is a cultural service' (25:57), most notably when it engages in intercultural dialogue. An intercultural performance is facilitated by music, largely due to the fact that music has a 'special character of being understandable by everyone, without needing a specific translation' (Messi 35:00).

To utter a definition of an intercultural performance, a work should present a combination of artists and cultural elements together, operating across and through the characteristics of each other, in dialogue. There is a reliance on the other to depict and to situate each element. Intercultural musicology requests that differences should be articulated and questioned to foster better understanding.

Notes

1 This research, conducted during the International Sferisterio Macerata Opera Festival, was funded by the Arts and Humanities Research Council, under the theme Translating Cultures, for a network entitled Translating Music, which consisted of Lucile Desblache (translator, researcher) and Helen Julia Minors (musician, researcher), supported by Elena Di Giovanni (translator, local researcher).

2 Reference to all interview material refers to the name of the interviewee and time code, denoting the start of the quotation (hours: minutes: seconds). All interviews are available at http://www.translatingmu sic.com/styled-3/styled-13/index.html.

References

Abbate, C. (1991). *Unsung voices: Opera and musical narration in the nineteenth century*. Princeton, NJ: Princeton University Press.

Albright, D. (2007). *Musiking Shakespeare: A conflict of theatres*. Woodbridge, UK and Rochester, NY: Rochester University Press.

Auslander, P. (1989). Going with the flow: Performance art and mass culture. *The Drama Review: The Journal of Performance Studies, 33*(2), 119–136.

Baudrillard, J. (1975). *The mirror of production* (trans. M. Poster). Candor, NY: Telos Press.

Baudrillard, J. (1981). Requiem for the media. In *For a critique of the political economy of the sign* (trans. C. Levin) (pp. 164–184). St. Louis, MO: Telos Press.

Bayliss, S. (1934). Music for Shakespeare. *Music and Letters, 15*(1), 61–65.

Blau, H. (1983). Ideology and performance. *Theatre Journal, 35*(4), 441–460.

Born, G. (2010). For a relational musicology: music and interdisciplinarity, beyond the practice turn. *The Journal of the Royal Musical Association, 135*(5), 205–243.

Britten, B. (2010). A midsummer night's dream [CD], cond. Richard Hickcox, London Sinfonia, EMI, B0040UEHY6.

Clayton, M., Herbert, T., & Middleton, R. (Eds.) (2003). *The cultural study of music: A critical introduction*. New York: Routledge.

Cook, N. (2010). Intercultural analysis as relational musicology. First Conference on Analytical Approaches to World Music, The University of Massachusetts Amhurst, http://www.aawmconference.com/ aawm2010/images/1aawmcookpaper.pdf (last accessed 14 February 2015).

Cooke, M. (1993). Britten and Shakespeare: dramatic and musical cohesion in 'A midsummer night's dream'. *Music and Letters, 74*(2), 246–268.

Cooke, M. (Ed.) (1999). *The Cambridge companion to Benjamin Britten*. Cambridge: Cambridge University Press.

Copeland, R. (1990). The presence of mediation. *The Drama Review: The Journal of Performance Studies, 34*(4), 28–44.

Dayan, P. (2011). *Art as music, music as poetry, poetry as art, from Whistler to Stravinsky and beyond*. Farnham: Ashgate.

Derrida, J. (1978). *Writing and difference* (trans. A. Bass). Chicago, IL: University of Chicago Press.

Desblache, L., & Minors, H. J. (2014). Translating music. http://www.translatingmusic.com (last accessed 30 March 2015).

Duncan, M. (2004). The operatic scandal of the singing body: Voice, presence, performativity. *Cambridge Opera Journal, 16*(3), 283–306.

Fulcher, J. (Ed.) (2011). *The Oxford handbook of the new cultural history of music*. New York: Oxford University Press.

Gabrieli, D. (2014). Sogni di una note di mezza estate: a new opera. MA Dissertation unpublished, Universita degli studi de Macerata.

Griffiths, T. (Ed.) (1996). *A midsummer night's dream*. Cambridge: Cambridge University Press.

Jakobsen, R. (1960). Closing statement: Lingustics and poetics. In T. A. Sebeok (Ed.), *Style in language* (pp. 350–377). Cambridge, MA: MIT Press.

Kildea, P. (2013). *Benjamin Britten: A life in the twentieth century*. London: Penguin.

Kramer, L. (2002). *Musical meaning: Toward a critical history*. Berkeley: University of California Press.

Levin, D. J. (2004). Opera out of performance: Verdi's 'Macbeth' at San Francisco opera. *Cambridge Opera Journal, 16*(3), 249–267.

Mendelssohn, F. (2000). A midsummer night's dream [CD], cond. Seiji Ozawa, Boston Symphony Orchestra, Tanglewood Festival Chorus, Deutsche Grammophon, B000001GM6.

Micheli, F. (2013a). Sogni, score of the new production of 'A midsummer night's dream', including sections incorporated from Shakespeare, Mendelssohn and Britten. Rehearsal Copy. Sferisterio Macerata Opera Festival.

Micheli, F. (2013b). Da Verdi a Patti Smith. Cronachemaceratesl.it, http://www.cronachemaceratesi. it/2013/07/13/da-verdi-a-patti-smith-vi-racconto-la-mia-macerata-opera/350892/ (last accessed 18 November 2014).

Minors, H. J. (Ed.) (2013). *Music, text and translation*. London: Bloomsbury.

Shakespeare, W. (rpt. 1992). *A midsummer night's dream*. London: Wordsworth Classics.

Smith, R. G. (2010). *The Baudrillard dictionary*. Edinburgh: Edinburgh University Press.

White, K. S. (1960). Two French versions of 'A midsummer night's dream'. *The French Review, 33*(4), 341–350.

Wood, J. (2014). Fairy. In J. Weinstock (Ed.), *The Ashgate encyclopedia of literary and cinematic monsters* (pp. 229–233). Farnham: Ashgate.

38

FRAMING INTERCULTURAL MUSIC COMPOSITION RESEARCH

Valerie Ross

Intercultural music plays a significant role in cultural exchange. Interculturality reflects knowledge and understanding of peoples from different cultural backgrounds using language, symbols and action. Intercultural compositions offer insights into how musical cultures develop through the exploration of new harmonies, genres and practices. This chapter discusses research methodologies associated with intercultural music research and intercultural compositions as artefacts of music research practice. It examines salient features of qualitative, quantitative and mixed methods of inquiry, and elucidates the different research approaches of three intercultural music studies. It further extrapolates compositional techniques of three original intercultural compositions. These six exemplars serve to illustrate the multifaceted perspectives associated with intercultural music research and practice contributing to the creation of a framework for Intercultural Music Composition Research (IMCR).

Introduction

The term 'interculturality' implies interaction among multiple cultural entities. It suggests the communication of peoples from different places and cultural backgrounds using language, symbols and action that demonstrate knowledge of the participating cultures. International organisations such as UNESCO promote intercultural awareness, fostering links which are centred on the foundations of interculturality, research, education and global networking (UNESCO, 2007). Cultural identity is continuously evolving with societies constructing cultural boundaries in the context of belonging to and interacting within multiple social groups. Koegeler-Abdi and Parncutt (2013) attempt to fuse diverse content-specific strategies to achieve a more comprehensive meta-perspective on interculturality.

Interculturality is a *sine qua non* of global networking in which music plays a significant role. Intercultural music compositions offer insights into how musical cultures develop and transmogrify through the exploration of new harmonies, genres, instrumentation and performance practices. However, research in this domain is under-explored. This chapter discusses the hybrid features of intercultural compositions and intercultural musicology. It deliberates on the qualitative, quantitative and mixed methods of approach in music inquiry. It elucidates the research methods of three intercultural music studies and further describes compositional techniques of three original intercultural works, namely, 'Tathagata', 'Cycles' and 'Blue Spot'. These six

examples of intercultural research practice provide insights as to the manner in which the writer approaches intercultural music research and composition. This multifaceted approach is portrayed through four spectral screens of (i) intercultural musicology, (ii) socio-cultural dimensions, (iii) methods and (iv) musical elements illustrated in a framework of IMCR.

Intercultural compositions represent creative expressions of interculturality. Broadly speaking, they may be defined as works that comprise compositional features drawn from more than one cultural base. This may be evidenced through their form and structure, the use of musical instruments, intercultural engagement and the performative practice of participating groups (CIMACC, 2015; Blackburn & Penny, 2014; Johnson, 2013; Ross, 2001). Probing the trajectories of intercultural musicology may promote a deeper understanding as to its interconnectivity and discursiveness since musical meaning arises through scores, practice, interactions and intercultural relationships.

Intercultural musicology

Drawing upon definitions of the two words 'intercultural' and 'musicology' (Cambridge Dictionaries Online, 2015), the term 'intercultural musicology' can be described as a scholarly study of the history, theory and science of music relating to or involving more than one culture. It draws features from the more established fields of historical musicology and ethnomusicology (Nettl, 2010; Stobart, 2008). As historical musicology studies the performance, creation, reception and criticism of music over time, intercultural musicology attempts to rationalise 'what' and 'why' musical events occur in its socio-historical context. It further seeks to understand the evolution of distinctive musical styles and genres as well as examine the social, practical and aesthetical functions of music. Like ethnomusicology, intercultural musicology not only observes music-making in specific cultural contexts but expands its horizons to examine how multiple cultural groups interact and interrelate with one another in the age of global communication (Utz & Lau, 2013; Fulcher, 2011; Kimberlin, Euba, & Kwami, 2007). Hence, while historical musicology generally refers to the study of western art music and ethnomusicology examines non-western musical cultures through ethnography and comparative musicology, intercultural musicology may find itself at the centre of discourse concerning the composition and performance practices of intercultural music belonging to both western and non-western traditions.

Research approaches in music

Music research, like any other field of scholarly research, requires the adoption of appropriate methods and methodology, the former focusing on the 'how and what' (ways of gathering information and types of data) and the latter on the 'why' (applying theoretical and musicological arguments) in analysing and discussing outcomes. A sound methodology encourages critical reflexivity at every stage of the research process. It is purposeful and positional, requiring discourse that interrelates the objectives, research questions and field questions to the specific musical inquiry. This, in turn, determines the most appropriate way to answer questions for knowledge building.

Research in general may be classified as (i) basic research (undertaken in pursuit of new or further knowledge through the gathering of evidential information about existing phenomena), (ii) applied research (seeks new knowledge directed towards a particular objective/application) and (iii) experimental research (drives towards scientific and innovative creations). Rigorous procedures to establish validity and reliability are needed to support knowledge claims made through heuristic, interpretative and scientific avenues (Athens, 2010; Clarke & Cook, 2004).

Comparing quantitative, qualitative and mixed method research

The primary difference between quantitative and qualitative research lies in the use of numbers to explain meaning for the former and words to explain meaning for the latter, thereby shaping its overall design, data acquisition, use of analytical tools and presentation of outcomes. In the case of music, the interjections of musical language and visual data embedded in scores, audio-visual recordings and spectrograms provide added spheres to its analytical framework.

Quantitative studies might include experimental techniques to elicit musical responses by the use of control and experimental groups. They might involve longitudinal studies (over extended periods), cross-sectional studies (different respondents over time) or studies to predict patterns of change, all with highly structured designs from onset to completion (Franklin et al., 2008).

Unlike quantitative research, new data sources in qualitative studies may alter the original research direction so as to include additional information to enrich and enhance validity even as the study progresses (Jackson & Mazzei, 2012; Lampard & Pole, 2002). Qualitative studies include historical research, action research, ethnographic research and case studies. Theoretical orientation may be premised on grounded theory, critical postmodern theory, feminist theory or phenomenology to capture, analyse and (re)interpret data acquired from naturalistic settings (Pendle & Boyd, 2010; Bryant & Charmaz, 2010; Lather & St. Pierre, 2013).

An emerging feature of qualitative research in the creative arts is practice-led research (Smith & Dean, 2010; Freeman, 2010). As the term suggests, practice-led research examines the relationship that exists between theory and practice, and the relevance of theoretical and philosophical paradigms for the music practitioner. It involves the identification of significant moments, specific details of materials, methods and processes as well as comparisons of works by other practitioners and contemporaries in the field of practice. Practice-led music research is a relatively new generative enquiry that draws on subjective, interdisciplinary and emergent methodologies (Draper & Harrison, 2011; Haseman, 2007). Various fields of practitioner-driven research, including research about one's own performance or composition, have given rise to interrelated terms such as practice-led research, practice-based research, creativities in practice and practitioner research (Burnard, 2012; Barrett & Bolt, 2007). However, some limitations have been associated with practice-led research. These include limited recognition and validation of the processes and outcomes of studio-based enquiry as scholarly activity or 'research'. Creative arts research is sometimes difficult to comprehend and quantify in terms of traditional scholarship since it is often personally situated within diverse and less familiar methodologies (Nelson, 2013). Nevertheless, the innovative and critical potential of practice-led research lies in its capacity to generate richer knowledge and new ways of modelling information (Hultman & Taguchi, 2010; Rust, Mottram, & Till, 2007; Durling, Friedman, & Guntherson, 2002).

As the name suggests, mixed method studies engage research methods from both the qualitative and quantitative domains, thereby offering greater choices, options and strategies in research inquiry. Debates in this emerging mode have included discourse on theoretical integration and issues arising from data collection procedures from different disciplines and how analytical tools may inform and influence measurement, meaning and interpretation (Coleman & Ringrose, 2013; Annechino, Antin, & Lee, 2010; Tashakkori & Creswell, 2008). Mixed method research has grown in practice and recognition by engaging methodologies from the humanities and the sciences (Tashakkori & Teddlie, 2003). Its approach has drawn much interest from the post-paradigm generation of scholars as it seeks more robust measures of association while explicitly valuing the depth of the experiences, perspectives and histories of research participation.

Within this three-paradigm methodological frontier, the choice of a dominant orientation in mixed method approach is important because quantitative evaluations (explanatory–deductive) and qualitative evaluations (exploratory–inductive) are conducted in different ways and for different aims (Creswell, 2004; Johnson, Onwuegbuzie, & Turner, 2007). This segment compared research methods associated with qualitative, quantitative and mixed method studies laying the groundwork for deliberations in the research approaches of the three following intercultural music studies.

Research approaches of three intercultural studies

The research approaches used in three music studies conducted by the writer are discussed. The first study examined challenges faced by performers and composers of intercultural music, the second study compared music learning strategies of western trained and non-western trained musicians while the third study recorded brainwave activity of two groups of musicians comprising violinists who played by reading and then by memory, and traditional rebab players who played by ear. The design of the three studies adhered to standard formats of research, namely, the elucidation of objectives, review of literature, methodology, data analysis and discussion of outcomes. These three studies were selected as they provided examples of intercultural music research using mixed method, qualitative and quantitative research methodologies, respectively.

Study 1: Composing and performing intercultural music – a mixed method approach

This study was situated in Malaysia, a nation noted for cultural and musical diversity due to its multicultural society. The study, entitled 'Challenges faced by performers of cross cultural music' (Ross, 2011), examined the different types of intercultural music played, musical experience of participants and problems in rehearsing and interpreting intercultural music. What was distinctive here was the role played by the composers in charting the performance directions of the music and unravelling challenges in working with different tuning systems, tone and temperament of traditional and western instruments. This study engaged a sequential mixed method, dominant qualitative approach. Data was secured from (i) survey questionnaires, (ii) individual interviews with performers of intercultural music, (iii) focus group discussions with composers, (iv) participant observation at an international new music festival featuring intercultural music, and (v) recording and analysis of Malay, Chinese and Indian traditional music played by members of the Malaysian Traditional Orchestra (MTO, 2015).

Study 2: Delineating intercultural music learning strategies – a qualitative approach

This investigation engaged a qualitative research approach in delineating learning strategies adopted by western trained musicians and traditionally trained musicians. 'Music learning and performing: applying written and oral strategies' (Ross, 2013a) explored fundamental differences (literacy vs orality) in the learning and playing of western instruments (by reading music notation) and non-western instruments (by ear). It examined the complexities of formal and informal learning as behaviours and practices influenced by the social and cultural environment of music-making and music learning–teaching milieus in different societies (Hargreaves, 2011; Folkestad, 2006; Colwell & Richardson, 2002). Data secured through semi-structured

interviews with western trained musicians and traditional music practitioners was transcribed and interpreted. Visual data from video recordings of practice sessions was analysed.

The study argued that orality and literacy should not be viewed as a dichotomy between two conditions but, rather, as a continuum where cultures have different types and notions of literacy that serve distinct purposes. Both the written and oral-aural strategies for music learning have similar goals in striving for performance excellence, but the approaches to such goals take a different point of embarkation and pursue different paths. This study concluded that the embodiment of musical experiences in intercultural music-making can be viewed from the position of (i) how music is learnt and played, (ii) the impact of learning intentionality as an expression of individualism versus collectivism, and (iii) how cognitive-affective learning domains are triggered by the different music learning strategies adopted. These outcomes contributed to a better understanding of intercultural music research and the significance of score representation in intercultural compositions.

Study 3: Brainwave activity of performing musicians – a quantitative approach

This example was included to illustrate the interdisciplinary dimension of music research where researchers from three different disciplines, namely, music, electrical engineering and medicine, collaborated in a music neuroscience study. It also demonstrated the adoption of a quantitative methodology in an experimental study using EEG (electroencephalography) to examine the brainwave activity of violinists and rebab players during performance. Unlike the previous two studies where empirical data was collected 'in the field', this study was conducted following an approved protocol in a biomedical laboratory. In 'Violinists playing with and without music notation during performance: Investigating hemispheric brainwave activity' (Ross, Buniyamin, Murat, & Mohd-Zain, 2014), the brainwave patterns of nine violinists were recorded as they played a piece of music (Kreisler's 'Rigaudon') first by reading the score and then playing the same piece by memory. In the second part of the study, EEG was recorded from nine rebab players as they performed a traditional piece ('Menghadap Rebab') from memory. The results of the experiment indicated a significant increase in the amplitude of the alpha brainwave recorded during performance indicating greater cognitive processing during musical performance thus supporting current research findings that music listening and learning promotes brain plasticity (Hassan, Murat, Ross, Zain, & Buniyamin, 2011; Will & Berg, 2007; Gaser & Schlaug, 2003).

Significance of the three studies

These three studies can be regarded as intercultural discourses that engaged multiple facets of music research, framed by an understanding of intercultural musicology, socio-cultural interaction, research methods and musical elements. The studies unveiled distinctive features of intercultural music research and yielded significant outcomes. First, intercultural music can be grouped by instrumentation, musical style, cultural affiliation and performance practice traditions. Second, there appears a close relationship between ethnicity and the types of traditional instruments played, highlighting the significance of socio-cultural upbringing in musical engagement and methods of training (formal vs informal; western vs non-western). However, the learning and performance of western music appeared to transcend cultural affiliations. Third, the composition and performance of intercultural music posed unique challenges due to the diverse temperaments and tuning systems of the instruments, multiple concepts of time,

different performance practices, questions on 'authentic' interpretation, scoring and the 'gap' between musicians trained by reading music notation and those trained by the oral tradition. Fourth, studies in music neuroscience provide compelling evidence as to how brainwave patterns of performers were influenced by the manner in which they were trained, suggesting the need for novel ways of 'notating' music for composers of intercultural music. Last, research in intercultural music necessitates drawing on multiple methods and methodologies that serve to unravel the complexities inherent in the cultural embodiment of the music and practices it attempts to comprehend and identify (Dervin & Risager, 2014).

Compositions as artefacts of intercultural music research

Composition, or *componere* in Latin, means to 'put together' and musical composition implies an act of conceiving, structuring and creating/notating the desired musical expression. This segment posits three original compositions, namely, 'Tathagata', 'Cycles' and 'Blue Spot', as artefacts of intercultural composition research. All three works were written for a combination of western and ethnic instruments, scored using multiple musical conventions and performed by western trained musicians and traditional music practitioners.

'Tathagata'

'Tathagata' is scored for a large eclectic ensemble comprising clarinet, tenor trombone, harmonium, tabla, temple bell, clapper, harp, male voices, female voices (including one Cantonese opera singer), violin, ye-hu and tambura. Commissioned by the Commonwealth Foundation for the 40th Anniversary Celebrations of Queen Elizabeth II as Head of the Commonwealth, 'Tathagata' was dedicated and presented to Her Majesty in Lancaster House, London in November 1992. Michael Finnissy conducted its premiere.

The performers came from different parts of the world. The tabla and tambura players were from India while the ye-hu player and opera singer were from China, all of whom were musically trained in the oral tradition. The challenge was to create a score that incorporated the overt (and covert) musical intentions of the composer through a symbolic representation that could be understood, interpreted and performed to reflect the practice of participating musical traditions in a new light. Most importantly, the score permitted 'space' for performance practice features of traditional music but yet precise enough to enable accurate portrayal in repeat performances. Cook (2013) postulates that performances afford the production of meaning, describing it as an art of telling detail. Written in real-time with different scale systems ranging from pentatonic, raga, well-tempered to microtonal scales in mind, the work beckons a new approach to the study of harmony, counterpoint and orchestration in intercultural music. An excerpt of 'Tathagata' (see Musical example 38.1) illustrates how the melodic pitches of western and non-western instruments are situated within the real-time score, enabling the flexibility of performance practice interpretations and juxtapositions of different temperament systems within bounded time-frames.

'Cycles'

Time is a universal motion of forward movement. In Hindu and Buddhist philosophies, a man's lifetime on earth is but one cycle of his physical psyche. Musical time provides a platform upon which the passage of sound and movement ride. 'Cycles' explored the concept of time. Commissioned by the Kuala Lumpur Chamber Players as part of a Swiss-Malaysian cultural

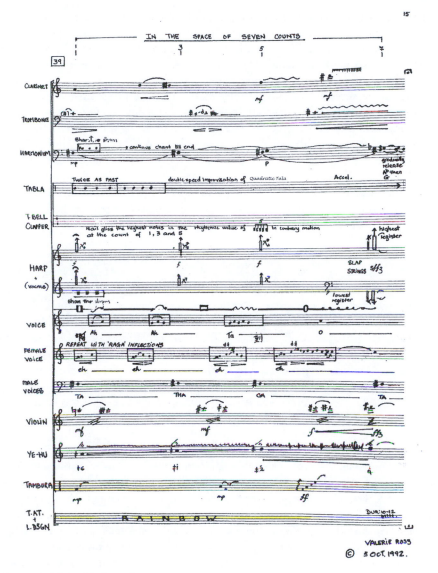

Musical example 38.1 'Tathagata'.

exchange programme, 'Cycles' for oboe, piano and tabla or mridangam was presented in Bern, 1998 by a Swiss oboist, a Malaysian pianist and an Indian tabla player. The work was influenced by the concept of the 'tala' (a Sanskrit word meaning to 'clap') in Indian classical music. Its beat-patterns were variously referred to as 'bol' or 'konnakkol', being onomatopoeic syllables which support the conceptualisation of rhythmic beat-patterns that correlated to the various strokes of Indian percussion instruments. Generally, Indian classical music has two fundamental components comprising the *räg* (melodic framework based on a fusion of scalar melodic figures) and *täl* (cyclic time measures). Philosophical engagements as to the aesthetical role of the 'bols' in devotional music and its inherent pedagogical attributes in the study of time captured the imagination of the writer who has worked with traditional Indian musicians and dancers for many years (Ross, 2013b).

In 'Cycles', either the tabla or the mridangam can be used. The tabla is a common instrument used for keeping rhythm in north Indian Hindustani music. The mridangam is a two-headed barrel drum used as a primary rhythmic accompaniment instrument in South Indian Carnatic music. In this work the traditionally trained tabla/mridangam player had the unconventional task of playing changing rhythmic patterns in multiple cycles of 4-beats (*chatusra*), 5-beats (*kanda*), 7-beats (*misra*) and 9-beats (*sankirna*) scored in representative notation ('bols' with corresponding rhythmic patterns). The pianist is also the time keeper, cuing the percussionist to commence the rhythmic cycles while creating interlocking patterns with the melodist as notated in the score (Ross, 2010). This composition was thus created for three performers trained in two different musical traditions, the pianist and oboist in the western tradition of reading conventional music notation and the tabla player, who was trained 'by ear' in the Indian tradition. Musical time was realised through a juxtaposition of conventional notation and 'tala' patterns written in 'bols' to enable musicians from both traditions to interpret and participate in intercultural music-making.

'Blue Spot'

Premiered at the 1st International Conference 'Building Interdisciplinary Bridges Across Cultures', 24–26 Oct 2014, University of Cambridge, 'Blue Spot' embodied the creative consciousness of the composer in crafting an electro-acoustic work as an artefact of intercultural composition research (BIBAC, 2014). The title of the work took its name from the blue exterior of the locus coeruleus or blue spot of the human brain responsible for chemical release of adrenaline flow to connect synaptic nerve cells that trigger the transmission of brainwave signals. As part of a series of electro-acoustic intercultural works stemming from research in auditory entrainment (Ross, 2014), the compositional structure of 'Blue Spot' encompassed several instruments from Asia (Indian tabla, Japanese shamisen, Anatolian saz), an extended voice singing in Sanskrit and three layers of original recorded sounds comprising gamelan music, isochronic tones and electronic soundscapes (see Figure 38.1). The gamelan (saron barung) was played by the composer while listening to the isochronic tones at 40 hz using headphones in a recording studio. The recorded gamelan part was plotted onto the isochronic tones using Ableton Live audio software and further layered with electronic soundscapes. The design took into consideration the sonic compatibility, textural shape and spatial relationships of the live and recorded sound structures. A dancer played the part of the 'body' (as musical instrument) to personify the brainwave activity as its neurons interacted with the sonic impulses in performative intercultural arts practice.

To summarise, the three compositions demonstrated how creative ideas germinate through research and were transformed into original works that encompassed the application of music theory, composition techniques, western and non-western instrumentation, intercultural musicology, electro-acoustic technology and intercultural performing arts practice. These six exemplars (three intercultural music research studies and three intercultural compositions) thus represent a snapshot of the intricate trajectories of intercultural music research practice contributing to the design of a framework for IMCR that follows.

Framework for IMCR

The multiple angles associated with composition research were built upon the idea of concept mapping. The framework for IMCR (see Figure 38.2) serves as a conceptual design for incorporating musicological strands, social dimensions, methods of securing data and musical elements when addressing intercultural music and composition research. The framework aims to:

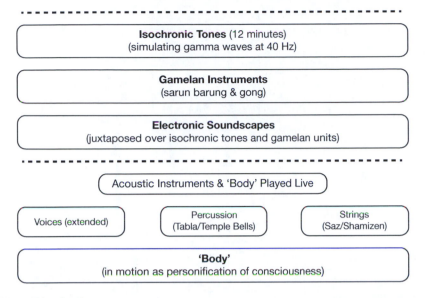

Figure 38.1 'Blue Spot'.

- provide a comprehensive view of areas associated with IMCR;
- assist in the design of socio–musicological and theoretical frameworks for music research;
- facilitate the selection of appropriate methods for data collection, analysis and evaluation;
- delineate musical elements associated with intercultural music-making and music composition;
- aid intercultural music research.

Intercultural compositions combine musical elements, instrumentation, theoretical systems and performative practice drawn from multiple musical cultures (Euba, 2014; Penny, Blackburn, & Ross, 2013; Mueller, 1991; Isacoff, 2003). Hence, its research necessitates the study of its epistemology and theoretical perspectives with a knowledge of the relevant paradigms at play (for example, post positivist, constructive, transformative, pragmatic) so as to facilitate a deeper understanding of music and music-making in the lives of the participating social groups (Mikawa, 2014; Dunbar-Hall, 2007). The IMCR framework posits four primary tenets, namely, (i) intercultural musicology, (ii) socio–cultural dimensions, (iii) methods and (iv) musical elements.

The first tenet examines musicological concerns, promoting epistemological understanding through the lens of intercultural musicology. The second tenet discusses the multifaceted social and cultural dimensions of the study. The third tenet determines the most appropriate research methods to be used and the fourth tenet delineates specific musical elements associated with intercultural composition research. Each tenet draws input from different resources. For instance, intercultural musicology is influenced by features of historical musicology and ethnomusicology. The social-cultural dimension may be informed by relevant information pertaining to (i) the musical purpose, function, place and context of music-making, (ii) musical relationships: education, ethnicity, belief system, experience and music learning opportunities, (iii) the application of relevant theories and the design of a theoretical framework which assist in understanding and explaining action, (iv) the selection of relevant literature that reflects prior and current research in the topic studied, and (v) the specific field/s of music studies such as composition, performance, music education, music technology, music therapy and music neuroscience.

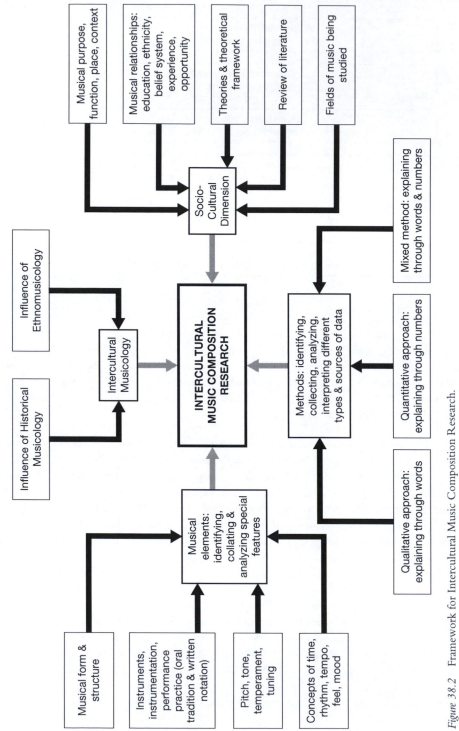

Figure 38.2 Framework for Intercultural Music Composition Research.

Under the third tenet, the selection of an appropriate methodology and the associated methods of data collection are to be considered. The features of quantitative, qualitative and mixed methods of approach have been discussed earlier and further exemplified by three intercultural music studies. The methodology engaged determines the type, form and treatment of data to be collected and analysed. For instance, rich descriptive information is acquired from interviews, participant observation and portrayals with increasing use of digital technologies to analyse audio–visual recordings and spectrograms of compositions (Walker & Don, 2013; Alegant, 2013; Markle, West, & Rich, 2011). This is contrasted with experimental, quasi-experimental, causal comparative, correlational or survey methods involving the generation and analysis of numerical data. Increasingly popular is the application of mixed method research where both qualitative and quantitative data are collated to strengthen validity and reliability using sequential, concurrent or transformative approaches (Mertens, 2010). This is especially useful for interdisciplinary music studies which incorporate both naturalistic and scientific domains of inquiry.

Last, there are several ways of juxtaposing musical elements in creating intercultural works, as with the various processes and techniques used to identify, adopt, adapt and assimilate key features associated with specific musical cultures. These processes are represented in the fourth tenet and they involve delineating musical elements of participating cultures in relation to (i) the musical form and structure, (ii) types of musical instruments, the instrumentation of particular works and performance practices involving oral traditions and written notation, (iii) pitch, tone, temperament and tuning systems, and (iv) concepts of time, rhythm, tempo and mood as elucidated in the IMCR framework.

Conclusion

This chapter examined salient features of qualitative, quantitative and mixed methods of enquiry in music research. It discussed features of intercultural musicology and reflected upon the different research approaches of three intercultural music studies. It further extrapolated compositional techniques of three original intercultural compositions. These six exemplars serve to illustrate the multifaceted angles associated with intercultural music research and practice contributing to the creation of a framework for IMCR. The four tenets of the framework with their trajectories enable researchers to situate, select and expand on areas pertinent to the research questions posed, encouraging (re)connectivity and probing intercultural relationships between peoples and musical practices through transformative research methods, methodologies and sound practice.

References

Alegant, B. (2013). A picture is worth a thousand words: Road maps as analytical tools. *Current Musicology, 95*, 162–176.

Annechino, R., Antin, T., & Lee, J. (2010). Bridging the qualitative, quantitative software divide. *Field Methods, 22*(2), 115–124.

Athens, L. (2010). Naturalistic inquiry in theory and practice. *Journal of Contemporary Ethnography, 39*(1), 87–125.

Barrett, E., & Bolt, B. (2007). *Practice as research: Approaches to creative arts enquiry*. London: I.B. Tauris.

BIBAC (2014). 'Blue Spot', Personifying Interculturality Concert. 1st International Conference, Building Interdisciplinary Bridges Across Cultures, University of Cambridge, Video and Audio Collections (B14) available at http://sms.cam.ac.uk/media/1888122 (25 May 2015).

Blackburn, A., & Penny, J. (2014). Imaginary spaces: New Malaysian performance context for intercultural exploration. *Organised Sound, 19*(2), 164–172.

Bryant, A., & Charmaz, K. (Eds.) (2010). *The Sage handbook of grounded theory*. London: Sage.

Burnard, P. (2012). *Musical creativities in practice*. Oxford: Oxford University Press.

Cambridge Dictionaries Online (2015) Definitions of 'musicology' and 'intercultural'. http://dictionary.cambridge.org/dictionary/british/musicology (22 May 2015).

CIMACC (2015). Centre for Intercultural Musicology at Churchill College, University of Cambridge, www.cimacc.org.

Clarke, E., & Cook, N. (2004). *Empirical musicology: Aims, methods, prospects*. New York: Oxford University Press.

Coleman, R., & Ringrose, J. (Eds.) (2013). *Deleuze and research methodologies*. Edinburgh: Edinburgh University Press.

Colwell, R., & Richardson, C. (2002). *The new handbook of research on music teaching and learning*. New York: Oxford University Press.

Cook, N. (2013). *Beyond the score*. New York: Oxford University Press.

Creswell, J. (2004). *Research design: Qualitative, quantitative, and mixed methods approaches*. London: Sage Publications.

Dervin, F., & Risager, K. (2014). *Researching identity and interculturality*. London: Routledge.

Draper, P., & Harrison, S. (2011). Through the eye of a needle: The emergence of a practice-led research doctorate in music. *British Journal of Music Education, 28*(1), 87–102.

Dunbar-Hall, P. (2007). Intercultural music: Creation and interpretation. *Musicology Australia, 29*(1), 199–201.

Durling, D., Friedman, K., & Guntherson, P. (2002). Debating the practice-based PhD. *International Journal of Design Sciences and Technology, 10*(2), 7–18.

Euba, A. (2014). *J.H. Kwabena Nketia: Bridging musicology and composition: A study in creative musicology*. Richmond, CA: MRI Press.

Folkestad, G. (2006). Formal and informal learning situations or practices vs formal and informal ways of learning. *British Journal of Music Education, 23*(2), 135–145.

Franklin, M., Moore, K., Yip, C. Y., Jonides, J., Rattray, K., & Moher, J. (2008). Effects of musical training on verbal memory. *Psychology of Music, 36*(3), 353–365.

Freeman, J. (2010). *Blood, sweat & theory: Research through practice in performance*. Faringdon: Libri Publishing.

Fulcher, J. (Ed.) (2011). *The Oxford handbook of the new cultural history of music*. Oxford and New York: Oxford University Press.

Gaser, C., & Schlaug, G. (2003). Brain structures differ between musicians and non-musicians. *Journal of Neuroscience, 23*(27), 9240–9245.

Hargreaves, D. (2011). Intercultural perspectives on formal and informal music learning. Dedica. *Revista De Educação E Humanidades*, 1 March, 53–66.

Haseman, B. (2007). Rupture and recognition: Identifying the performative research paradigm. In E. Barrett & B. Bolt (Eds.), *Practice as research: Approaches to creative arts enquiry*. London: I.B. Tauris, 147–157.

Hassan, H., Murat, Z., Ross, V., Zain, Z., & Buniyamin, N. (2011). Enhancing learning using music to achieve a balanced brain. Engineering Education, 3rd International Congress, IEEE, 66–70.

Hultman, K., & Taguchi, L. (2010). Challenging anthropocentric analysis of visual data: A relational materialist methodological approach to educational research. *International Journal of Qualitative Studies in Education, 23*(5), 525–542.

Isacoff, S. (2003) *Temperament: How music became a battleground for the great minds of western civilization*. New York: Vintage Books.

Jackson, A.Y., & Mazzei, L. A. (2012). *Thinking with theory in qualitative research: Viewing data across multiple perspectives*. Abingdon: Routledge.

Johnson, B., Onwuegbuzie, A, & Turner, L. (2007). Towards a definition of mixed methods research. *Journal of Mixed Methods Research, 1*(2), 112–133.

Johnson, H. (2013). Contemporary approaches to transcultural music research in Australia and New Zealand. *Journal of Musicology Society of Australia, 35*(1), 1–2.

Koegeler-Abdi, M., & Parncutt, R. (Eds.) (2013). *Practice meets research*. Newcastle upon Tyne: Cambridge Scholars Publishing.

Kimberlin, C., Euba, A., & Kwami, R. (2007). *Intercultural music*. Intercultural Music Series, Vol. 6. Richmond, CA: MRI Press.

Lampard, R., & Pole, C. (2002). *Practical social investigation: Qualitative and quantitative methods in social research*. Harlow: Prentice Hall.

Lather, P., & St. Pierre, E. (2013). Post-qualitative research. *International Journal of Qualitative Studies in Education, 26*(6), 629–633.

Markle, T., West, R., & Rich, P. (2011). Beyond transcription: Technology, change and refinement of method. *Forum: Qualitative Social Research, 12*(3), Art. 21.

Mertens, D. (2010). Transformative mixed method approach. *Qualitative Inquiry, 16*(6), 469–474.

Mikawa, M. (2014). Aesthetic meaning of mixed-media and intercultural composition: Water music (1960). Proceedings of the Electroacoustic Music Studies Network Conference, Electroacoustic Music Beyond Performance, Berlin.

MTO (2015). Malaysian Traditional Orchestra, Istana Budaya, www.istanabudaya.gov.my/malaysian-traditional-orchestra-otm (22 May 2015).

Mueller, R. (1991). Bali, Tabuh-tabuhan, and Colin McPhee's method of intercultural composition. *Journal of Musicological Research, 11*, 67–92.

Nelson, R. (2013). *Practice as research in the arts: Principles, protocol, pedagogies, resistances.* Basingstoke: Palgrave Macmillan.

Nettl, B. (2010). *Nettl's elephant: On the history of ethnomusicology.* Champaign, IL: University of Illinois Press.

Pendle, K., & Boyd, M. (2010). *Women in music: A research and information guide.* New York: Routledge.

Penny, J., Blackburn, A., & Ross, V. (2013). Electroacoustic music as intercultural exploration: Synergies of breath in extended western flute and Malaysian nose flute playing. Performance Studies Network Conference, University of Cambridge.

Ross, V. (2001). Craft of Karma. In C. Kimberlin & A. Euba (Eds.), *Intercultural Music*, Vol. 3. Richmond, CA: MRI Press.

Ross, V. (2010). *'Cycles' for oboe, piano and tabla or mridangam.* University Publication Centre, Universiti Teknologi MARA.

Ross, V. (2011). Challenges faced by performers of cross-cultural music. AHRC Research Centre for Musical Performance as Creative Practice. Performance Studies Network International Conference, July, 2011. Online Resource. http://www.cmpcp.ac.uk/conferences_PSN2011_Saturday.html (1 Feb 2015).

Ross, V. (2013a). Music learning and performing: Applying written and oral strategies. *Procedia Social and Behavioral Sciences, 90*, 870–873.

Ross, V. (2013b). Cue from Cage: Designing ragaslendro. *Malaysian Music Journal, 2*(2), 1–11.

Ross, V. (2014). Stimulating the brain through auditory entrainment. In C. Chan & J. Penny (Eds.), *Sustainability in music and the performing arts* (pp. 201–220). University Pendidikan Sultan Idris.

Ross, V., Buniyamin, N., Murat, Z., & Mohd-Zain, Z. (2014). Violinists playing with and without music notation during performance: Investigating hemispheric brainwave activity. *Intelligent Systems for Science and Information, 542*, 153–169.

Rust, C., Mottram, J., & Till, J. (2007). *AHRC research review: Practice-led research in art, design and architecture.* Arts and Humanities Research Council, UK.

Smith, H., & Dean, R. (2010). *Practice-led research, research-led practice in the creative arts.* Edinburgh: Edinburgh University Press.

Stobart, H. (2008). *The new (ethno)musicologists.* Lanham, MD: Scarecrow Press.

Tashakkori, A., & Creswell, J. (2008). Mixed methodology across disciplines. *Journal of Mixed Methods Research, 2*(1), 3–6.

Tashakkori, A., & Teddlie, C. (Eds.) (2003). *Handbook of mixed methods in social and behavioral research.* Thousand Oaks, CA: Sage.

UNESCO (2007). Chair in Memory, Cultures and Interculturality, United Nations Educational, Scientific and Cultural Organisation, http://www.univ-catholyon.fr/university/unesco-chair (20 May 2015).

Utz, C., & Lau, F. (2013). *Vocal music and contemporary identities: Unlimited voices in East Asia and the West.* New York and Abingdon: Routledge.

Walker, J., & Don, G. (2013). *Mathematics and music: Composition, perception, and performance,* Boca Raton, FL: CRC Press.

Will, U., & Berg, E. (2007). Brain wave synchronization and entrainment to periodic acoustic stimuli. *Neuroscience Letters, 424*, 55–60.

39

INTERCULTURALISM NOW

How visual culture has changed formal and informal learning

Kerry Freedman

Interculturalism with regards to visual art is complicated. Across cultures, art is assumed by many to have a common, visual language, which has the capacity to reduce human conflict through intercultural communication. In colonial contexts, during cold wars, and in boundary disputes, art has often been called upon to communicate in a way that overcomes people's differences and promotes cross-cultural learning and understanding. The arts are used by social and political groups who aim to achieve (or be seen as aiming to achieve) stability through what is taken-for-granted as common emotions, aesthetic qualities, and artistic goals.

However, one of the goals of the arts is to destabilize, challenge, interrogate and criticize cultural conditions and positions. What may be thought of as universal and stabilizing about the arts is only a small part of the complex and wide-ranging character of the aesthetic. There is not one visual language, but many, and even the notion of visual "language" reduces the complexity of the visual. Typically, the fine arts or "high arts" such as ballet, theatrical performance, classical or traditional music, and gallery arts are believed to have inherent, inspirational aesthetic and didactic qualities, which are universally appreciated, but when these are presented in a decontextualized manner (without, for example, their traditions of meaning or aristocratic pedigrees), they tend to be received as entertainment rather than an intercultural, educational viewing experience.

Henry Jenkins (2007) has pointed out that people now live in a "participatory" culture. This culture depends on the shift in focus from a consumer or viewer society to a producer society involving a highly productive public, heavily invested in art and other visual forms of communication. Jenkins sees this public of creator audiences as acting on the blurred borders of "a culture with relatively low barriers to artistic expression and civic engagement, strong support for creating and sharing one's creations, and some type of informal mentorship whereby what is known by the most experienced is passed along to novices" (2007, p. 3).

In this milieu, the visual arts must increasingly be viewed from an intercultural perspective. The idea of a participatory culture points to the increasing intercultural translations and critiques of images, objects, and meanings from the cultural confines of a museum or studio to a digital culture of websites freely open to all, where works of art are re-imagined, re-designed, and re-dispersed by any member of the participatory public. The visual arts (fine art, popular arts, and design) produced by this public are best referred to as being part of "visual culture" to reference both the broad range of artistic forms being produced and the diversity of people

who produce them (Freedman, 2003). The translations, combinations, and relocations of these visual arts forms cross social, geographical, and ethnic boundaries, becoming intercultural visual culture.

Visual culture is made up of the ideas, forms, and critiques of all things humanly made that affect people mainly through our sense of vision or visualization; this includes fine art as well as popular art and the various forms of design (Freedman, 2003). Specific forms of visual production, such as fine art, fashion design, filmmaking, medical illustration, video games, landscape design, street art, comics, and television production may be considered sub-sets of visual culture. Aspects of performance arts, such as theater, music, and dance, all have visual culture properties, such as stage sets, music videos, dance costumes, and the many other visual aspects of performance. For example, a symphony orchestra performance may be characterized by the black formal clothing of the musicians, which works to focus the audience on the music, rather than the individuals playing it, and to suggest the rigor and tradition of such a performance. In sum, the realm of visual culture is largely made up of the visual arts, which are produced by people who have formal or informal arts training and, at some level, seek to be recognized for the aesthetic qualities of their work. The concept of intercultural visual culture embraces the visual arts that have become so interconnected and cross-referential that it is difficult to consider each art form as belonging to a single cultural tradition or contemporary context.

Boughton and Mason (1999) demonstrated by the country-specific chapters in their edited text on art education that terms like multiculturalism and interculturalism have multiple and changing definitions. Visual culture must be understood as in flux, de-contextualized, manipulated, and re-contextualized by professionals and students of art and design who use previous forms of visual culture as new sources of inspiration. The visual culture housed in any natural history museum illustrates these conditions existing from pre-historical times when different cultural groups first made contact with one another; but now, such contacts occur globally and on a daily basis.

Some cultures have striven to protect their art forms by teaching young artists the same things that have been taught for generations, which can help to continue long-standing traditions. Historical examples of controlled artistic practices, such as the religious regulation of color use by artists in the Middle Ages, the strict curriculum of the 19th-century European academies, and the careful production processes used by Native American artists who seek to maintain tradition, have limited form to a single cultural ideal. But, regardless of how much people try to reproduce culture with the integrity of traditional form, human creativity leads to the production of intercultural forms, often in informal learning contexts. Over time and with increased intercultural activity, the art of any particular culture will be influenced by the art of other cultures and result in creative hybrids as a result of exchange and appropriation. It is these transversals of form, media, and meaning that make such visual culture learning and production inherently intercultural. The case of Native American artist Edgar Heap of Birds' work titled *Pow-Wow Chair* demonstrates this point. As I have discussed elsewhere (Freedman, 2003), Heap of Birds became tired of people asking him about the traditional pow-wow and whether he sat cross-legged on the ground during the event. So, he created a work of art titled *Pow-Wow Chair* by putting a plastic, woven lawn chair on a box of dirt to teach viewers about how he tends to watch pow-wows.

Increasingly diverse populations of young people make intercultural visual culture forms, including various types of popular arts that live outside of school, online, and in face-to-face groups. Outside of school, adolescents and young adults of many backgrounds participate in creative production by, for example, making and uploading videos, "writing" graffiti, designing computer games, recycling materials for wearable art, drawing and painting concept art,

and producing fanart. With great persistence, otherwise disenfranchised young people now immerse themselves in and produce art that reflects integrated, collapsing, and conflicting ethnic and youth cultures.

Hernandez (1999) defines interculturalism as the interactive engagement between or among cultures for the purpose of learning. It is in this context that young people have initiated a cross-cultural, visual "dialogue" that depends on global, auto-didactic learning and peer teaching within sub-cultures where individuals and groups pass on ideas, images, and practices, from one to another, based on their commitment to artistic forms. This is based on a transformative fusion of international visual culture as part of a creative, intercultural learning process.

In the following section, I demonstrate the conditions of the intercultural visual culture defined above through the example of "Amerimanga," a term used to represent a hybrid of Japanese and American comic book arts. I further explore these ideas, and intercultural learning processes, through the example of a large-scale, international study of visual culture learning communities (VCLCs) I conducted in collaboration with researchers in several countries (Freedman, Heijnen, Kallio-Tavin, Kárpáti, & Papp, 2013). The study involved adolescents and young adults who belonged to creative groups without institutional or older adult supervision. Participants in the study spoke of a generation gap in understanding the complex cultural relationships that exist today in and through the visual arts. VCLC members belonged to their group because they were looking for a community of friends, but also because they wanted a diverse community of learners focused on the production of one visual culture form. The data from this project illustrate intercultural learning in and through the visual arts. In this chapter, I lay the groundwork for reconsidering the intercultural character of art in the context of participatory practices so as to understand some of the larger implications of these new conditions for art and education.

Intercultural visual culture: the example of Amerimanga

Manga, or Japanese comics, have had an extraordinary impact on global popular culture and fine arts. The original sources of manga are many. Sources of some visual conventions in contemporary manga appear in ancient Japanese handscrolls and historical *ukiyo-e* and *shunga* woodblock prints (Schodt, 1983). Kern (2006) argues that 18th-century Japanese picture books are another source that led to 20th-century graphic novels and Japanese manga styles. However, near the turn of the 20th century, originators of contemporary manga, Rakuten Kitazawa and Ippei Okamoto, studied American artists' caricatures and the "Sunday funnies" (MacWilliams, 2008). Important characteristics of contemporary manga also originated as a combination of Japanese and American popular culture styles based on comics and other visual arts forms brought to Japan by U.S. soldiers during World War II (e.g., Patten, 2004; Schodt, 1983; Tatsumi, 2006). From then on, transnational and intercultural cross-overs have continued to shape the popular culture of comics in both countries and globally.

Although forms of popular visual culture have long had an uneasy relationship with the fine arts, and were famously criticized by Theodore Adorno, a member of the early 20th-century Frankfurt School, as being the lowest common form of entertainment and common in their uniformity, contemporary manga theorists have a different view. East Asian scholar Mark MacWilliams (2008, p. 9) states:

> Manga are anything but homogeneous in style, content, characterization, themes, or meanings, as they are aimed at different sub-cultures, age levels, and genders, and produced within ever-changing social-historical contexts. Moreover, the fantasies

they evoke are not homogeneous either; they do not uniformly convey any master narrative or transcendent system of capitalistic values to their audiences.

Manga have some common stylistic conventions that connect various versions of this intercultural form. For example, manga are often black and white and the frames used in the comics may be considered cinematic as a result of a storyboard type format with close-ups, dynamic angles, and images that exceed the frame. Some manga include the use of conventions, such as large eyes. But, more than American comics, manga generally tend to have lightweight lines, simplified abstraction, and dynamic movement shown through the use of exaggerated frame shapes. These are used to suggest high emotion and energy, but not always in the same way. The shounen manga designed for males and the shoujo manga intended for females have stylistic and content differences. For example, in a shounen fight scene, tension might be enhanced through the use of several angled frames, whereas in traditional shoujo manga emotion is paced more slowly through the use of large, page-sized frames.

In the late 20th century, translated versions of Japanese manga became extremely popular among English language audiences, particularly in the United States. Anime and manga critic, Fred Patten (2004), claims that the first manga sold in the United States appeared at a shop called *Wonderworld*, which he and his partner established in 1972. Starting in the early 1990s, original English language (OEL) manga began to be published in the United States. OEL has grown to become an influential art form and creative industry. The term "Amerimanga" was first used to describe OEL manga as a result of a series of that title published by Tokyopop. The term is contested, in part, because some analysts believe that manga cannot be produced appropriately outside of Japan. Other publishers of OEL manga have included the Japanese publishing house Kodansha, Antarctic Press, Dark Horse Comics (recently purchased by Random House), and Studio Ironcat.

One of the first professional comic book artists to incorporate manga characteristics and American comics stylistic qualities was Adam Warren, who created the OEL version of *Dirty Pair* (1988–2002) and the manga-influenced *Empowered* series (2007–present). Warren had been influenced by well-known American comic book artists Jack Kirby and John Buscema, as well as alternative comics. In the middle 1980s, while a commercial illustration student, he encountered manga. At that time, American fans mostly gained access to manga as a comic book passed from friend to friend (Warren, 2014, personal communication). Warren also watched Japanese anime, such as the movies of Hayao Miyazaki and preferred the energetic storytelling of manga and anime over the more deliberate, heavily-texted style of American comics. As a result, he decided to incorporate elements of manga into his work. Warren (2014, personal communication) explains:

> When manga artists began to influence my style, this was truly an alien concept. My teachers were mystified. . . . The manga I read had such energy and freshness, such a sense of fun and visual intensity, that I was profoundly inspired and influenced. Japanese comics tended to be less dialogue-based and more visually oriented in their approach to storytelling, unlike the much "talkier" norm for most American comics, both then and now. My hope is to achieve an emotional connection with the reader, whether through humor or sadness or hyper-kinetic action. That's what first attracted me to manga, the fact that my favorite Japanese comics were so emotionally charged and addictive and compelling.

Warren's work led the way for manga influences on other American comics, and most of the major comics franchises, such as those of Superman, Batman, Spiderman, and Wonder Woman have since been influenced by manga.

As well as having different characteristics for different audiences, individual styles have emerged that combine the cultural remnants of Japanese manga, American comics, and comics made in other countries. My own research has demonstrated that American manga have both individual expressive and conventional stylistic qualities (Freedman, 2015). Traditionally, professional Japanese manga artists (*manga-ka*) worked under the tight control of an editor. Some manga-ka still work under these conditions and must replicate a style or realize an editor's mandate. However, American manga artists tend to work in less controlled environments, often creating independently or being hired because of their work to do their own project or do a part of a project that will benefit from their vision. As creators of an intercultural form, these artists are influenced by multiple iterations of the form, but at the same time, push the form in new directions, each imbuing his or her characters and stories with different visual characteristics to create a signature style (Freedman, 2015).

In developing an understanding of the conditions under which manga are created in the United States, a good comparison might be to Impressionism. In the case of Impressionism, a group of late 19th-century artists developed what became referred to as a style, but the individual styles of the leading artists of that group could be easily distinguished. Since that time, artists originating from North America, Japan and other countries have long worked interculturally in "the Impressionist style" and continue to paint using Impressionist methods and techniques, such as breaking up the painted surface to suggest natural light, while at the same time, changing those methods and techniques as a result of their own backgrounds and capabilities. This is similar to the case of manga.

Learning intercultural art forms: visual culture outside of school

Collaborative interactions enable young people to learn about art and aid in the development of identity and social skills, as well as artistic production (Freedman, 2003). Internationally, a wide range of visual culture forms are produced by adolescents and young adults in or connected to informal, self-initiated groups. I have found that membership in these groups is particularly motivated by an interest in learning, so refer to them as visual culture learning communities (VCLCs). The focus of VCLCs ranges from esoteric popular culture forms to fine art collectives where high school students hone their concepts and skills to prepare for life as professional artists. And many of these groups learn about and produce intercultural mixes of artistic forms on local and global scales. Contemporary learning theorists conceptualize learning as a process of participation in meaningful group practices "where moments of understanding and new forms of knowledge emerge from social contexts. Knowledge in this sense is not so much an object to possess, but an activity to engage" (Sefton-Green & Soep, 2007, p. 847). From this perspective, knowledge is not a static possession, but rather is continually and actively obtained, shared and renewed, leading to intercultural learning.

This process was illustrated by a large-scale, international study of young people's art practices, forms, and motivations I conducted with colleagues from several countries. Thirteen VCLCs were studied. In a previous publication (Freedman et al., 2013), the research, conducted in Amsterdam, Budapest, Chicago, Helsinki, and Hong Kong, was discussed in terms of group members' auto-didactic and peer teaching activities as part of their social interactions while making art. Each of the countries in the study has a different culture, but all share an intercultural immersion in visual culture forms across international borders. The project included group members aged 14–25 years that met face-to-face and online. The research was conducted through focus group interviews. Each participant interviewed had membership in a group that focused on a particular international visual culture form. The same set of focus group interview

questions was used by all researchers across sites; otherwise, each VCLC was treated as an independent case. Participants' original artworks and photographic and/or video documentation of group activities were collected and analyzed along with the focus group interview transcripts using common phrase and close-reading thematic content analyses.

I now turn to issues related to the artistic forms that emerged within three of the case studies I conducted as part of the larger study: a manga group in Hong Kong, and a gaming group and a fanart group in the Chicago area. Each of these VCLCs studied and created forms of intercultural art, crossing local cultures in these highly diverse urban areas and crossing global cultures online.

The Hong Kong manga group exemplified the high level of cross-fertilization that has occurred across cultures and sub-cultures in their locale. In recent history, the people of Hong Kong have been especially influenced by Japanese, Chinese, and American cultures, becoming part of China again in 1997. One member of the manga VCLC explained: "we are deeply influenced by the Japanese culture . . . some people can't find their identity. Before 1997, our identity is so weak, so we were influenced by Japanese culture. But, even now some people think that they want to be Japanese." Another of the artists said, "We use characters from Japanese or Western games, movies, and print dramas." Another stated, "Most of my characters have Japanese facial features, but some have combination of European and Japanese."

In the Chicago area gaming VCLC, group members created art based on games. They explained the importance of their learning about the art and cultures in which games are produced, which influence game design and their own art-making. One gamer stated, "you have to immerse yourself in Japan in order to understand anime, and also with video games . . . 'cause in anime there's a lot of cultural references . . . I think you have to learn about the culture." Another gamer explained, "I actually learn a lot about different kinds of culture styles, you know, there's styles for different video games." One of the gamers discussed why knowledge of cultures is important. He said, "in art class, I realized I want to be an architect . . . I like to observe different cultures . . . I think it helps me get to know people a little better," which he felt would help him with his future work. Another gamer gave this example: "I like to incorporate styles and stuff like that when I draw." These VCLC members pointed out that games connect people. One stated, "it's also good for getting to know other people. When you have something in common it gives you a bigger spectrum, it gives you diversity, the spice of life."

The manga VCLC and members of the fanart VCLC create and sell drawings, graphic novels, bookmarkers, postcards, pins, and other small items to raise money for art supplies and other things. These items illustrated the young artists' interests in diverse cultures, which support the interests of potential viewers and customers. One of the manga artists stated: "Some people are interested in other countries, such as Japan, and so we tell stories about these other places or we use it as the background." These artists understand the cross-fertilization that continually occurs in the intercultural upbringing of young people in post-industrial countries now. A manga artist stated it this way:

> We saw Superman on TV and other places when we were small. We often combine all things, some Disneyland, some movies, like Pirates of the Caribbean. We were easily affected when we were very small. Disney is also affected by Japanese style.

Part of the intercultural slide involves mixing forms and artists. A fanartist explained: "[Fanart] seems to sell, that seems to be why people go to [an anime and manga convention] 'cause they like to see their characters with maybe other characters from a different series just doing whatever."

Some of the members of the Hong Kong manga group also dress Lolita. Lolita dressing began in Japan as a fashion sub-culture in the 1980s and is based on what has been considered doll fashion, drawing upon Victorian and Edwardian styles of clothing and behavior, particular children's styles. It soon became connected to Japanese *visual kei* (visual artist) music bands in which mostly male band members wore historically referenced, flamboyant male dress or cross-dressed in Lolita clothing and make-up. Lolita groups exist in many countries and some of their members dress for fan conventions. These young people (and the group I spoke with were insistent that this is a young person's occupation), do not consider what they do as cosplay. Rather, those I interviewed view it as a way of life inspired by the intercultural community that extends the consciousness of the visual feminine to a form of visual art.

The parents of the Hong Kong Lolita VCLC members were largely unaware of the 1958 English language book, *Lolita*, and appreciated that this style of dressing actually covers up the body more than some contemporary, Western clothing. Although the book is about pedophilia, it also addresses the power of the feminine, on which many serious, contemporary Lolitas reflect. Since the 1980s, several iterations of Lolita have developed in various countries, with mixes of Asian and European cultures apparent in the clothing of Lolita dressers. One Lolita said, "I dress as a comic character who came from a Japanese game translated into Chinese." Members of this group learned from movies and television, not exactly copying Japanese style because, as one member of the Lolita group said, "Hong Kong is more conservative, so people may not accept Japanese style exactly. Chinese tradition is one of the reasons that most people [here] don't accept manga, Lolita, or cosplay."

The aesthetic of Lolita has rules that much of the global community follows. These rules range from appropriate dressing for each of the different styles of Lolita, and the imperative of "lady-like" behaviors, to body shape. One member of the VCLC explained:

> Too thin is not beautiful, too muscular is not beautiful. Lolita can hide parts of my body that are not good, if my legs are too fat. Lolita is suitable for a short girl, not too fat or too thin because of the proportion. Some European girls wear Lolita, but they make [their skirts] longer.

Another stated:

> Many girls and some boys wear Lolita in the comics convention. The boys wear goth-loli. Boys use make-up with dark shadows under their eyes. The boys who have a good body shape look good. If they are too fat, the body shape will distract from the clothing. A good body shape will not be too muscular, thin and some muscle, but not much. Usually they wear black and white colors. Boys' shoes will have high heels and pointed toes. Some grow out their hair and they might have a ponytail. Others might curl their hair or color their hair white. They don't smile, so they look cool and they act as a gentleman.

This preference for intercultural beauty is becoming increasingly popular among young people. It can be seen in contemporary advertising, television, and film. For one of the male members of the manga VCLC, "an intercultural face is most beautiful."

The idea of multiple, crossed, and shifting identities is a fundamental aspect of interculturalism. In part, to become intercultural is to adopt another point of view. For the participants in this project, that was achieved at times through the use of fantasy and role play. One of the gamers explained gamers' motivations for playing massively multiplayer online (MMO) games:

It's also the fact of fantasy and wanting yourself to—it's based on one's own long-ing to . . . morph into another being, someone else they can be, someone else's per-sonality that they can merge into, whose mind they can enter. . . . That's why they play it 'cause they want to experience what this person's, action, gaming figure is experiencing.

The participants in the VCLC study viewed their visual culture form as art. A gamer explained:

I would like to say that games are definitely an art form because they have the chance to tell an interactive story with you, and they can lead you through a plot or so; and it seems like it would be more like a book, but you're seeing the visuals and the sound and the music. If you combine visuals, which are considered art forms; and sounds, music which is considered an art, and you just make it interactive I do not see why it would not be considered an art because you have to combine everything together to make an experience and art has to do with experiences as well.

Narrative is an important aspect of most manga, fanart, and video games, but the adolescents and young adults in this study understood that the visual qualities of their imagery are also vital to the success of the work. The group members all valued aesthetics and art forms from other cultural contexts. In the Chicago area VCLCs, the members also valued the cultural back-grounds that different group members brought to their group. For example, the fanart group had several members of Asian descent and their cultural backgrounds were, at times, drawn upon, or they were consulted when individuals worked on Asian figures or topics. When one of the fanartists was asked what she learned by being in the group, she responded: "What did I learn about art? Everyone has their own perspective and you learn from those perspec-tives." Later in the interview, she added, "Every piece of art that I make—it's not copied from someone—it's influenced."

As discussed above, manga is a personal form of expression that depends on certain stylistic conventions, which many of the participants appropriated and recreated to produce an intercul-tural style. A manga-influenced fanartist stated:

I do have a concept that I consider my own; I term it as my own style—that's a very broad term—but just the particular way that I visualize say anatomical features, the technique I use for brush strokes, my color sense, the color palettes that I favor all fall under that concept.

Another fanartist gave an example:

I believe that artists bring their own interpretation to fanart even if the character is not their own. The styles usually vary with what they favor. I guess, for an example, there's one piece that I've done that's for the videogame Okami, and in the game, the main character is actually a wolf—like, she's literally a wolf—but in the fanart that I have done, I interpreted her into a humanoid figure and that's completely my own creation even though it's based off of a character from a videogame. This is done quite often in the fanart community.

All of the VCLC members balance their individuality with various cultural influences. Intercultural collaboration that facilitates learning within and across groups is important to the

development of these visual culture forms. As a manga artist said, "we enjoy communicating with the other groups to get advice." Although they are heavily influenced by the conventions of this intercultural style, and by each other, most of the VCLC members maintain a belief in their own independence of thought, which is common to this age group with regards to visual culture (Beach & Freedman, 1992). One of the manga artists stated, "We may put our own personality into one of the characters. Through my characters I show that I don't want to be influenced by others." At the same time, a fanartist stated about his membership in the group, "With the group, since everybody is excited about something, when you contribute to an idea and everyone accepts that idea, you feel very much connected together."

How art learning is changing in response to intercultural visual culture

VCLCs are what schools tend not to be: places of authentic learning where learners act on intrinsic motivations in an atmosphere of sharing. The characteristic qualities of VCLCs that motivate and facilitate learning among their adolescent and young adult members are often at odds with classroom instruction. As standardized testing increasingly dictates school practices, auto–didactic practices, cooperative learning, and peer-initiated teaching and learning are becoming less typical, even in art classrooms. Most schools, with their large student populations, inflexible schedules, and limited student access to outside directed experiences, such as field trips, are not well-suited for authentic, situated learning. And, when well-intentioned instructors try to initiate auto–didacticism using traditional techniques, a laissez-faire approach often results that lacks the structures of rules, leadership, and student accountability that this research has demonstrated are important aspects of VCLC learning. VCLCs are based on situated rules of ethics and aesthetics (such as, copying is acceptable under certain conditions), leadership based on mentor knowledge and experience, and accountability through group forms of assessment.

The results of the VCLC study demonstrate that a new form of interculturalism has emerged through young people's informal visual arts practices. Young people have created a participatory interculturalism that builds on their commitment to an international form of visual culture. They seek the skills to produce the form, but also develop an interest in the culture source and the ways in which other cultures relate to it. In fact, Amerimanga and the VCLCs discussed in this chapter demonstrate that the study and production of contemporary intercultural visual culture involves a commitment to learning on a global scale. This interculturalism is based on the idea that the production of international forms of visual culture is inherently a didactic cross-fertilization of images, designed objects, and artistic practices.

One message of the VCLC research is the need to open up discourse with regards to interculturalism, alternative art forms, informal learning, and formal education.

Interculturalism is no longer just about the integration of cultures for understanding. It is the global appropriation and recreation of cultures for the purposes of producing new knowledge and forms, particularly among young people, which has become a taken-for-granted assumption of contemporary life. Interculturalism can no longer be considered in terms of a rarefied event; rather, for many young people, it is a condition of daily practice in participatory culture as they recreate, remix and redistribute forms, styles, and contents of the arts.

Further, intercultural art learning is no longer just a personal path to enlightenment. It is the result of intercultural, communal practices dependent on overlapping and integrating subcultural production that is highly creative, dependent on visual technologies, crossing international borders, and actively promoting and defusing cultural difference. What is individual now

is the way interculturalism is uniquely filtered by each individual in a particular cultural milieu. Interculturalism has become more a process of appropriation than one of integration, but here, appropriation refers to the construction of knowledge whereby new information is laid upon old with the intention of building fresh ideas and forms.

Finally, interculturalism is also a fusion of sub-cultures, which cross over and among many related forms of visual culture. This integration of sub-cultures may seem to be a process of free intermingling, but instead can be highly structured and rule-driven. The VCLCs in our study demonstrated this with policies for entrance into a VCLC and some even had rules that could not be broken without the culprit being forced to leave the group. For example, in the fanart group, an artist could not treat a character created by another artist (such as an original manga character) with disrespect by putting that character in a situation inconsistent with the character's moral code.

If we truly seek to understand the character of intercultural arts now, we need to think of interculturalism as including the ideas, processes, and meanings of the broad range of participatory visual culture forms, which move quickly across geographical boundaries as they become distributed through digital and other means. Students of art are increasingly seeking and finding membership in virtual, informal intercultural groups. With regards to formal education, we can now reconceive what it means for students to be part of this internationally diverse population of young artists who mix and remix cultural convention and personal expression, fluidly viewing, creating, and showing their art on a global scale. In doing so, we must recognize the complexity, craft, and power of the visual arts to which these young artists are committed.

References

Beach, R., & Freeedman, K. (1992). Responding as a cultural act: Adolescents' responses to magazine ads and short stories. In J. Many & C. Cox (Eds.), *Reader stance and literary understanding*. Norwood, NJ: Ablex Press.

Boughton, D., & Mason, R. (Eds.) (1999). *Beyond multicultural art education: International perspectives*. New York: Waxmann Munster.

Freedman, K. (2003). *Teaching visual culture: Curriculum, aesthetics, and the social life of art*. New York: Teachers College Press.

Freedman, K. (2015). Exhibition essay for "*Amerimanga!* Convention and Expression" (March 24–May 22, 2015). DeKalb, IL: Northern Illinois University Art Museum.

Freedman, K., Heijnen, E., Kallio-Tavin, M., Karpati, A., & Papp, L. (2013). Visual culture learning communities: How and what students come to know in informal art groups. *Studies in Art Education, 53*(2), 103–115.

Hernandez, F. (1999). Cultural diversity and art education: The Spanish experience. In D. Boughton & R. Mason (Eds.), *Beyond multicultural art education: International perspectives* (pp. 103–114). New York: Waxmann Munster.

Jenkins, H. (2007). *Confronting the challenges of participatory culture: Media education for the 21st century*. Cambridge, MA: MIT Press.

Kern, A. (2006). *Manga from the Floating World: Comic book culture and the Kibyoski of Edo Japan*. Cambridge, MA: Harvard University Press.

MacWilliams, M. K. (Ed.) (2008). *Japanese visual culture: Explorations in the world of manga and anime*. New York: M.E. Sharp.

Patten, F. (2004). *Watching anime, reading manga: 25 years of essays and reviews*. Berkeley, CA: Stone Bridge.

Schodt, F. L. (1983). *Manga! Manga! The world of Japanese comics*. Tokyo: Kodansha.

Sefton-Green, J., & Soep, E. (2007). Creative media cultures: Making and learning beyond the school. In L. Bresler (Ed.), *International handbook of research in arts education* (pp. 835–854). Dordrecht: Springer.

Tatsumi, T. (2006). *Full metal Apache: Transactions between cyberpunk Japan and avant-pop America*. Durham, NC: Duke University Press.

40

PERFORMATIVE RESEARCH IN MUSIC AND POETRY

An intercultural pedagogy of listening

Peter Gouzouasis and Carl Leggo

From our familiarity with the Reggio Emilia literature concerned with listening to children, it makes sense that we, as adults, also learn to attend to each other and honor an intercultural pedagogy of listening. In our collaborative and creative inquiry of composing and performing music and poetry, we have learned that we must listen carefully, not only to the words, but also to the images, rhythms, melodies, thoughts, and feelings that the words *and* music evoke. As we perform poetry and music together and as we listen to each other, complex layers of sound and meaning are evoked. Above all, we learn to attend to the liminal spaces that exist around, through, in-between, and within music and poetry. Our reference to liminal is inspired by the Greek root, *limni* (λίμνη; of or relating to a lake), and relates to the (s)p(l)ace that exists at the surface of a lake, the "mist and midst" that is neither lake nor air, but the consubstantiation of both to create something that is holistic and new. By engaging collaboratively, we learn to listen attentively to the intersections of music and poetry, and we learn how to shape our performative research in pedagogically innovative ways.

One of the challenges of working with poetry as lyrics is to write music with melodic, harmonic and formal integrity, while respecting the intent of the poet. Through our chapter and performances we hope to demonstrate how musicians and poets from contrasting cultural and ethnic backgrounds can create spaces for performative research. For us, aesthetic sensibilities brought us together and enabled us to traverse and, ultimately, transcend intercultural borders to create something that is intracultural. We are able to linger in a (s)p(l)ace (de Cosson, 2004) that emerges through the coalescence of music and poetry, to compose arts songs as research. As we perform, we learn more about our selves, our practices, and our notions of pedagogy. What emerges is a relational act of composition that lingers in that mist and midst where music and poetry merge to form song.

Thus, the purpose of this inquiry is to call forth a series of insights that are only possible through our intercultural collaboration, a coming together, a braiding of our intents and practices. Through the processes and products of our compositions, we seek to learn how arts song-based inquiry leads us to new understandings of autoethnography as pedagogy.

Beat it

It's all about the beats.

When Dick Cavett, a North American late night talk show host, asked Paul Simon why Joe DiMaggio was the hero of the song *Mrs. Robinson*, and not Mickey Mantle, he politely replied,

"It's about syllables, Dick. It's about how many beats there are."[1] In that 1970 interview with Cavett, Simon related how *Mrs. Robinson* was "made up on the spot" and that the chase scene (Dustin Hoffman running to the church when his car runs out of gas) at the end of the movie was composed of the initial riff that starts the song:

> I don't know what I was playing, I was just playing a riff on the guitar [NB: he plays the opening lick in E] . . . I was just playing a fill and it wasn't working . . . there were no words except for the chorus, so we sang "dee dee dee dee dee dee, dee dee, dee dee dee dee dee . . . doo doo doo doo doo doo doo doo doo" . . . the actual recording of the song was done after the movie was finished . . . it's very pleasurable to write in a stream of consciousness style, and very often you find that what is in your mind is relevant but it doesn't always seem so . . . then I asked myself what it meant, and then I said "It'll all mean *something*".

When Carl and I were young, Dick Clark would invite two dancers to rate the quality of the weekly Top Hit. Inevitably, the dancers said, "It feels groovy and has a good beat, Dick. I'll give it a 10."

> Two of us wearing raincoats
> Standing solo in the sun
> You and me chasing paper, getting nowhere
> On our way back home
> > (Two of Us, *Lennon & McCartney, 1969*)

Carl and I both began our careers at the University of British Columbia in 1990. A Philadelphian and a Newfoundlander, born over 1,300 miles apart and occupying two separate buildings at UBC for the past 25 years. Many years passed before we collaborated, but in 2004 we formed a quartet with Rita Irwin and Kit Grauer, and we called ourselves The A/r/tographers. We were blessed with abundant research funding and unbounded energy to create a new form of research called a/r/tography that represented the integrity of our roles as artists, researchers, and teachers. Finally, we could theorize and publish academic scholarship, as well as explore music, poetry, visual arts, and digital media and use arts-based research to sustain our life's work as artists in academia. For 15 years, I had lived as an academic researcher stilted by the positivist rules of my profession, music education. With Carl's help, I found my "way back home" in the spring of 2005.

Like two young boys in a candy shop, we gleefully prepared a paper for the first Arts Based Education Research conference in the UK (Belfast, Northern Ireland, June 2005). That was our first duet, our first performance of the music, poetry, and song—"Eye/I" and "Written in the Light Heart"—featured in the present inquiry.

> Hello, hello, hello, hello
> Goodbye, goodbye, goodbye, goodbye
> That's all there is
> And the leaves that are green turn to brown.
> > (Leaves That Are Green, *Paul Simon, 1965*)

A decade has come and gone. Every time we saw each other at various meetings, in the hallways and at conferences, I would always wonder: Why haven't we performed more together? Why

didn't we get together and see what we could create? Why not record our works? Why did we never publish a paper?

> Time hurries on
> And the leaves that are green turn to brown
> And they wither with the wind, and they crumble in your hand.
> (Leaves That Are Green, *Paul Simon, 1965*)

With the storyteller's inimitable penchant for distilling living experience into an evocative tale full of heart and imagination, Peter recounts our academic and creative journeys with both specific details and pressing questions. Peter and I understand that our scholarly lives have often demanded precedence over our creative lives. We know that we have not always felt safe, and certainly not encouraged, to explore the intersections of our research-driven agenda and our creative pursuits as a musician and a poet. I do not really want to complain that I have lived with too much fear in the academy, but now that I am old, it is hard to avoid the realization that I might have done so much more if I had just been braver, if I had just been less concerned about playing by the conventional rules of the academy, if I had just pursued my first love to make poetry and explore the possibilities of poetry.

As a student in elementary and secondary classrooms in the late 1950s and 60s, my experiences with any kind of creative activity in school, including writing, visual art, music, or drama, were distinctly unpleasant! I remember clearly, as if it was only a few days ago, the nauseous sense of fear I knew in music classes. In school I was required to listen to recorded music; the teacher stopped the music abruptly and randomly picked a student to identify the instrument just played. I lived in fear of being chosen, and I always answered "piano"! Meanwhile, at home I carried my mother's pots and pans and wooden spoons and plastic bowls into the bathroom where I joyfully drummed my heart out—an early version of the contemporary percussion performances of Stomp. *My school experiences did not nurture creativity or creative living.*

In my early thirties when I was pursuing graduate studies, a drama education professor asked me what I remembered about school that had supported my creativity. I could not remember a single experience in school that had nurtured my creativity. I confessed sadly that I was a late bloomer. (My grade eleven English teacher once told me I would never be a writer.) I came to poetry only in my late twenties. During a time of personal crisis, I began to write in a journal, and I began to hear a vibrant voice in my writing that I had never heard before. Then I started to write poetry, and I discovered that I had much I wanted, even needed, to say about my daily life and world. Above all, I discovered that I love to revel in the possibilities of language. As a poet and educator, I seek to encourage my students to write poetry as a way to know their worlds, as a way to be, and become, in the world. I am now old, and I know myself as a creative person committed to creative living and thinking and becoming. But I am creative in spite of my experiences in school, not because of them.

Griffin (1995) notes wisely that "in the ecological view, instead of one creator there are a multitude of creators, and the many different kinds of creative consciousness that exist are all equally significant to the whole" (p. 40). The word "enthusiasm" means "inspired by a god." I think we live in a world that is afraid of gods and goddesses, of wonder and mystery, of the heart and spirit. Music is derived from the word "Muse." In the ancient world there were nine Muses with lyrical names like Calliope, Erato, Melpomene, Polyhymnia, Artemis, Terpsichore, Clio, Thalia, and Urania. They were all goddesses who inspired with enthusiasm the musicians, dancers, orators, storytellers, actors, and poets of their time. We need the Muses. I invite my students to wander for wonder, to be open to the world around them, to hear with their hearts, to see with the eyes of their hearts. The world is miraculous and mysterious, and every day is an invitation to learn and become and savor wonder.

I am critical of my school education, especially critical about the ways that as a writer I was constrained and even wounded by the kinds of experiences that comprised my teachers' curriculum and pedagogy. What I remember most vividly are the repetitive exercises, and the focus on drills and discrete activities and correctness. What I remember least are opportunities to write in experimental and creative ways, to take risks in writing, to experiment with diverse discourses. Bohm (2004) does not mince words in his judgment that "generally speaking, what we learn as children, from parents, teachers, friends, and society in general, is to have a conformist, imitative, mechanical state of mind that does not present the disturbing danger of 'upsetting the apple cart'" (p. 20).

Peter and I have been colleagues for over two decades. I wish Peter and I had learned to upset the apple cart more frequently. I wish we had collaborated more. I wish we had explored and performed the possibilities of intercultural research and pedagogy more. I wish we had learned to listen to one another more, as well as to our arts and our hearts. But I am glad we keep circling back to our first loves, to the places where music and poetry surprise and startle us, where music and poetry remind us that the Muses are always ready to amuse and amaze.

Entasis

Is there *entasis* (ἔντασις, meaning "tension" in Greek) in the marriage of poetry and music? I expected our endeavor to be a tedious process, as on the surface, Carl's poetry does not look like traditional, measured (i.e., "measurable") lyrics. However, once I became immersed in the process and began to trust the process (McNiff, 1998) the lyric nature of his work revealed itself.

In our works, we honor traditions that began with the "Art Song." In the days of Schubert, Schumann, Beethoven, Wolf, and Brahms—throughout the 1800s—these great composers used the poetry of German poets such as Schiller, Goethe, Muller, and Heine to draw their musical inspiration.[2] Usually, the songs were accompanied by the piano; however, some scholars believe that Schubert wrote many of his *"lied"* using a guitar in his bedroom because he could not afford a piano. Regardless of that story being factual, fictional, or factional,[3] those songs are sung, but there are segments where the vocal parts feel as if the poetry is spoken, because the melody emphasizes the words as much as particular pitches, harmonic devices, and accompaniment textures "paint" the text.

While we do not employ the exact compositional devices demonstrated in the highly descriptive compositions of the Germanic tradition, we are composing 21st-century "arts songs" with contemporary music making techniques. We bring aesthetic standards, qualitative research sensibilities, creativity, pedagogical ideas, and artist identities to the processes of composing, performing, and recording our works that are similar to those of our predecessors. We each have our own separate practices, but when they are interwoven something special and unique is formed and a new type of inquiry emerges. In this new form of inquiry, the music is not merely a decorative device. Rather, when the poetry is expressed with music it becomes *arts song-based inquiry*. Our praxis is intensified, infused with *physis* (φύσις)—a natural life force—and it becomes multidimensional.

I do not read music or play a musical instrument. I am always in awe of Peter's wide-ranging knowledge of music. Peter has devoted his life to rehearsing, hearing how to hear in new ways, listening carefully for the possibilities of rhythm, measuring the world by the beat or the lack of the beat. I always enjoy listening to Peter's playing one of his many guitars. He holds the guitar with intense tenderness, as if he and the guitar are really one. I love to listen to Peter's music. While I cannot read music or play a musical instrument, I am always listening to music, always wanting more. So, when Peter composes and performs musical

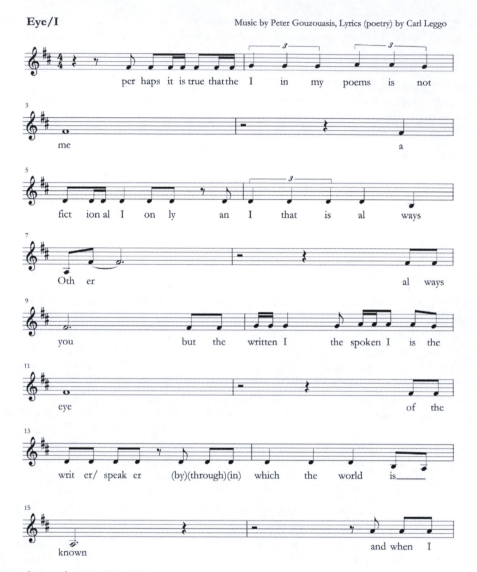

Musical example 40.1 "Eye/I."

interpretations of my poems, I am always fascinated by his understanding. Instead of interpreting my poems, Peter performs new poems that are ecologically connected to the poems I have written. Peter's performances offer new renderings, new possibilities, new questions, and new perspectives.

Eye/I
perhaps it is true
that the I
in my poems
is not me
a fictional I only
an I that is always
Other

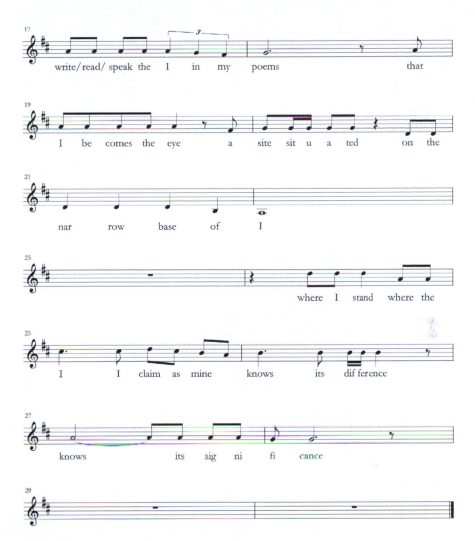

Musical example 40.1 (continued).

always you
but
the written I
the spoken I
is the eye
of the writer/speaker
(by)(through)(in) which
the world is known
and when I
write/read/speak
the I in my poems
that I becomes the eye
a site situated
on the narrow base

of I
where I stand
where the I
I claim as mine
knows
its difference
knows
its significance

(For a performance version of "Eye/I," please listen to the MP3 file available at www.routledge. com/9781138909939.)

While I had created and memorized a melody and accompaniment for our performance in 2005, I did not notate "Eye/I." The present version is similar to what I performed 10 years ago; however, it is now more refined and considered. It has a more mindful quality, fueled by a few cups of sweetened Greek coffee and the inspiration of early Joni Mitchell tunes. I considered how the poetry would function with the harmonic and melodic patterns, and I played with notions of repetition and contrast to create a sense of unity in the overall composition. The nature of the poetry, and the relationship between notions of "eye" and "I" called me to compose his song using non-standard, open D tuning (D-A-D-F#-A-D). Open tunings evoke a sense of openness in my playing, as well as in the vast, open (s)p(l)ace (de Cosson, 2004, p. 127) in and around the concept of "perspective" inspired by the poem. Carl's poetry enabled me to create a sense of *ekstasis* (ἔκστασις), of playing and singing inside and outside of myself. Thus, the poem drew out the soulful qualities of Joni Mitchell in my playing and singing. The overall form that emerged is Introduction–AAB–coda.

I used a recitative style, using the rhythm of how I spoke the poem with many repeated notes in segments of the melody, to compose portions of the song. Thus, the repeated notes enable me to emphasize the text rather than an overly embellished tune.[4] I evoke the image of mottled greens, reds and yellows of autumn leaves to breathe musicality into the text.

When I wrote "Eye/I," I considered it a language-focused poem that might not even readily invite an oral performance. I thought the reader should see the poem on the page, perhaps read it silently while pondering the connections between the eye and I. So, when Peter first sang the poem while we were rehearsing for an ABER conference presentation, I was delightfully startled. Peter's performance opened up resonant possibilities I had never considered. I always cherish the memory of Peter's singing the poem while we sat in a coffee shop in Belfast years ago. Now that we have revisited the poem, and Peter has continued to explore the musical possibilities inspired by the poem, I am reminded how the Greek etymology for poem is poiesis (ποίησις)—to make or compose.[5] Together, Peter and I are continuing to compose the poem. As Neilsen Glenn (2011) reminds us, "To write poetry . . . is to enter a long, never-ending conversation" (p. 108). So, as Peter and I continue our conversation, we continue to find other possibilities. So much of academic life is spent rushing from one activity to another. The daily pace of academic life is often frenetic, creating only an arrhythmia of the heart. When Peter and I collaborate, we not only compose poems and songs and arts songs, but we also compose ourselves, and find composure where our creative spirits have been too little nurtured.

Written in the Light Heart
(for Lana)
I have never known another
so constant through seasons, decades.

We met in G. A. Mercer Junior High,
we were thirteen, joy-filled, you always laughing.

Marcus was reading the entire dictionary,
had reached D and called you and all
your girlfriends daft distaff.
I didn't know what he meant, I knew only
that I was in love with you, eager to please,
though none of you saw me.

My whole world had been Lynch's Lane
and boring facts in textbooks I had consumed
for no better reason than the promise of a prize
at the bottom like a sculpin might suck barnacles.

Years ago on Saturdays we strolled Duckworth
and Water Street, went to Woolworth's
for strawberry shortcake and milk.
At Afterwords bookstore we purchased
for a couple of dollars another armful
of books discarded from Gosling Library.
We waited for the bus outside Silver's and Sons,
dreaming of weddings and rings,
and married at twenty, ready for the world.

Except I wasn't as ready as you were.
I lived recklessly in the world, amidst
the wreckage of words, forgetting the tale
of a tower's collapse around language.

I shattered faith, was mesmerized
by the possibilities of other prepositions.
Like Silas Marner my heart was stone,
but light still found the crack.

So last summer we walked the beach
in Robinson's where we often used to
walk, where the ocean sweeps everything
into indecipherable shapes and lines,
and I took photographs for writing
faraway in winter in Steveston.

Now, July salt air blows hair across your face,
your hands are full of stones, shells, and driftwood,
while your eyes hold potent dreams,
writing always with the heart's light,
this poem also written in the light heart.

(For a performance version of "Written in the Light Heart," please listen to the MP3 file available at www.routledge.com/9781138909939.)

I was deeply touched while reminiscing during our recording session for "Written in the Light Heart." In the summer of 2003, I had reached a point in my guitar playing where I needed a

new challenge, so I turned my attentions to learning to play guitar in DADGAD tuning.[6] This tuning originated in the UK in the early 1960s, was proliferated by guitarists Davey Graham and Bert Jansch,[7] and migrated to Ireland where it has been adopted by many expert Irish guitarists as a (somewhat) standard Irish tuning. Many guitar solos and accompaniment parts develop from motivic ideas because the tuning lends itself to riffs and interesting fingering and picking patterns. Because the poem evokes ideas of constancy, time passing, strolling, and walking, I started playing around with a repetitive Travis-style picking pattern on an open G chord to capture a sense of movement, particularly movement in, and over, time and space. There are four sections to the guitar part (intro–A–B–C) and I use them to accompany the distinct sections of the poem in an improvisatory manner as Carl's reading leads my musical interpretation.

"Written in the Light Heart" is a very personal autobiographical poem. My wife Lana and I have now celebrated forty years of marriage. We have enjoyed a long story together, but years ago I ruptured that story catastrophically when I fell in love with another woman, and left my family to live with her. I was gone for more than a year when I left the woman I had fallen in love with to return to Lana who I simply could not fall out of love with. Still in love with my first love, I returned to her and our children because the story written with Lana in the light heart is the love story that sustains me. So, when Peter composed music for this poem, and we rehearsed in his home studio, and I heard the poem, as if for the first time, now refracted through Peter's musical responses to my words, and my performative responses to Peter's music, I was moved by an abiding sense of grace that inspirited our collaboration with bountiful hope and light.

Exegesis

My mind wanders to the notion that Pelias (2000) and Banks and Banks (2000) introduced regarding the pedagogical nature of autoethnography and new interpretations of the notion "auto" (Gouzouasis & Ryu, 2014). Autoethnography, in and of itself, may be interpreted as pedagogy (Banks & Banks, 2000, p. 235).[8] One reason is that the aim of autoethnography, especially in artistically written stories, is to convey meanings and not merely portray facts (Ellis, 2004, p. 116). Autoethnography enables us to examine the *self* and the *other* in relation to others in various settings. A close examination of the prefix *auto* reveals that autoethnographies are the joining of the self (i.e., the *auto*, pronounced "afto," from the Greek, αυτό), that (in Greek, *that* is also referred to as αυτό), him *and* her (αυτόν, *auton* and αυτί, *auti*), them (εαυτών, *eauton*), those (αυτά, *auta*), they (αυτοί, *auti*), culture (i.e., the *ethno*, εθνό), and writing (i.e., the *graphy*, γραφή). This confluence of ideas on the notion of αυτό brings us to new, holistic understandings of the self in relation[9] to the world around us.

Our inquiry provides complex, multidimensional, artful pathways for understanding the arts-based researcher as artist/researcher/teacher (i.e., a/r/tographer) that also help explain the notion of *becoming pedagogical* (Gouzouasis et al., 2013). As we learn about music and poetry and the complex relationships between the two art forms, we learn to become more reflective, we learn to compose, we learn to listen to each other, we learn trust, we learn to lead a critical life (Pelias, 2000), we learn to become reflexive (Etherington, 2004), and we learn new meanings of "that" (i.e., a secondary definition of αυτό in Greek)—*that* which it means to create anew and *that* which is meaningful to poets, musicians, and arts-based researchers. As we become more open to change, professional growth, listening, trust, and arts-based praxis, and we learn to better inquire through disciplinary and interdisciplinary frames of mind and co-create new arts-based forms we *become pedagogical* (see Gouzouasis et al., 2013).

We believe that making music and poetry is not an either-or proposition. At the most connected and meaningful level, making music, poetry and conceptualizing *those* (i.e., another secondary definition of αυτό in Greek) art forms as *song* is a holistic, interactive, and intra-active

endeavor for groups and individuals. It is neither mono-dimensional nor mono-directional. There is no single compositional device, style, or repertoire for creating and performing music and poetry. Rather, making music and poetry is an intercultural *relational process* for all who are engaged with music, poetry and making meaning with those art forms. The process has confirmed that, as artist/researcher/teachers (i.e., "artistresearcherteachers;" Gouzouasis, 2008a, 2008b, 2013), we need to implement a broad variety of approaches in different situations—with different music, poetry, settings, and styles—to demonstrate the depth and breadth of understanding our art forms and to discover new pedagogical outcomes. Considering a song composed of "this" music and "that" poetry, by "me" (Peter) and "you" (Carl) for a book (a thing) provides us with a holistic sensibility. We have composed an autoethnography that embodies a relational pedagogy—in us, in our readers, in our listeners, and in our art forms.

Also, I contemplate what we are doing, as scholarly activity, embodied not only in the performative nature of arts-based research, but the activity of composing and notating music and lyrics (poetry), in the same way that academic colleagues who are composers and poets are considered as scholars. Surely, Carl and I are playing and enjoying our performances, but we are engaged with *téchne* (τέχνε) and *poiesis* (ποίησις) at a level where education and arts scholars can recognize the quality of our craftsmanship and aesthetic decision-making.[10] When we interpret our inquiry through this lens, and consider that the primary definition of *téchne* is *art* (Oxford Greek Dictionary, p. 185) and *poiesis* is the *making* (i.e., production) of art and other useful things (i.e., artistic productions, poetry, recordings, performances), we have created a new praxis—arts song-based inquiry—that emanates from a fusion of poetry and music.

Finally, autoethnographies frequently feature an epiphany (Ellis, Adams, & Bochner, 2011). As a form of enlightened realization, an epiphany (in Greek, ἐπιφάνεια, "*epiphania*") is often sparked by an event that enables the individual to make an inference or develop a new, deeper understanding of a phenomenon. The notion of sharing epiphanies is an early feature of autoethnography, and was particularly developed within this genre (Bochner & Ellis, 1992; Banks & Banks, 2000; Gouzouasis & Lee, 2002, 2007; Leggo, 1995). In our present performative essay we share "epiphonies," realizations that are evoked through *sound*, specifically, music (i.e., guitar), spoken poetry, stories, and song.[11] We recognize that important discoveries about the self and others (e.g., the audience) are often based upon acoustic experiences. And acoustic experiences require sound production, performance processes, and listening—to ourselves and to others.

In my autobiographical and autoethnographic and a/r/tographic research, I investigate many questions and issues, including effective strategies for teaching poetry, the curriculum of joy, arts-based approaches to pedagogy, and the therapeutic effects of creative writing. But, above all, in all my researching, I am always seeking to learn to "live poetically." I first heard the phrase "living poetically" from a former student named Mike. Several years after completing his Bachelor of Education studies, Mike dropped by my office. Mike had produced a memorable portfolio of creative writing in a course focused on language, curriculum, and creativity. I asked Mike if he was still writing poetry, and he responded, "I've been so busy lately, there hasn't been much time for writing." Perhaps Mike saw a flash of disappointment in my eyes because he added, "But, you know, even though I'm not writing poetry, I am living poetically." Mike's claim that he was "living poetically" was a generous gift and I have been researching and writing about living poetically ever since (Leggo, 2011a, 2011b, 2007a, 2007b, 2005a, 2005b, 2004a, 2004b). In the midst of all my researching and writing, I am seeking to learn how to live poetically. And now in my collaboration with Peter, I am gaining courage that the academy needs the arts and arts-based research, needs the collaboration of musicians and poets who can call together the Muses who will inspire our research, teaching, and living.

We are all creative in diverse and wonderful ways, but creative living is still a daily and lifelong practice that requires attention and devotion. Csikszentmihalyi (1996) recommends that "the most important message we can learn from creative people" is "how to find purpose and enjoyment in the chaos of existence" (p. 20). He notes that the diverse creative people he and his research team interviewed "all agree that they do what they do primarily because it's fun" (p. 107). Also, he notes, "the first step toward a more creative life is the cultivation of curiosity and interest, that is, the allocation of attention to things for their own sake" (p. 346). Scholars need to nurture an ongoing experience of creative engagement with diverse kinds of researching that embrace the possibilities of engaging with differences in histories, disciplines, arts practices, contexts, places, and paradigms. We need to learn to listen to one another.

In Peter's thoughtful and eloquent exegesis of our process, he reminds me that our collaboration is founded on trust. On the one hand, we admire one another's well-honed creative gifts. We both know that we both take our music and poetry very seriously. And, on the other hand, we trust one another to call out in an intricate tango where the pronouns you *and* I *learn to hear one another. So, instead of adding more exposition, I will draw to a temporary close with a final poem. I hope Peter and I will meet again soon in his recording studio to explore this poem and others.*

Yo-Yo
I & you
the two most used
words in English

full of Buber's
tensile tension

in Spanish
I is *yo*
you is *tú*

I-you you-I I-I you-you yo-yo

yo-tú tú-yo yo-yo tú-tú I-I

I know you
you know me

the stranger within
the stranger without

all connected on a string
that knows the limits
of gravity, or at least
its seductive attraction

the constant challenge
of yo-yo tangles

common and idiosyncratic
DNA, in the mirror,
the conjunction AND

everything, all of us
entwined like vines

Acknowledgments

We wish to offer our sincere thanks to David Murphy, a Ph.D. student of Peter's at UBC and an instructor at Simon Fraser University, who engineered our recording session for this project.

Notes

1 I recently saw this episode of the Dick Cavett Show on late night television, but it is also available on YouTube at http://www.youtube.com/watch?v=WtJRq28itxQ

2 In German, these songs were referred to as "*lied*."

3 Available at http://www.jacaranda-music.com/Schubert.html.

4 On another level, I considered the relationship of what emerged from the creative process that Carl and I shared as a 21st-century form of spoken song (i.e., *sprechtstimme*), but our work is not expressionist in the style and sensibility that Schoenberg and Berg developed that concept in the early 20th century.

5 See our discussion below of *poiesis* (ποίησις)

6 DADGAD tuning is also referred to as "Open Dsus4" tuning because the pitch, G, is "suspended" four steps above the open D on the open 6th and 4th strings. Also, when the guitarist places a finger at the second fret of the 3rd string G, the guitar sounds an open DADAAD.

7 The song "Black Mountain Side," in DADGAD tuning, was originally recorded by Jansch in 1966 and subsequently made famous by Jimmy Page of Led Zeppelin.

8 And for that matter, autopedagogical. A few years ago, I discovered the Banks & Banks (2000) essay; their idea is in reference to Ron Pelias's paper, *The critical life*, which is cited herein. Given the space restrictions of this chapter, new notions of *autodidacticism* and *autopedagogy* will be further explored in another essay.

9 Peter has discussed the notion of relationality and relational metatheory in other papers (see Gouzouasis, 2008a, 2008b, 2013).

10 I say this not to denigrate what some arts-based researchers may do when they sing a song (with little musical skill) in decorative manner at a conference presentation, but to differentiate the processes and product of "music" and "poetry" as research when performed by those who have dedicated their lives to their art forms.

11 The suffix, "phony" (in Greek, φωνή) means "sound."

References

Banks, S. P., & Banks, A. (2000). Reading "the critical life": Autoethnography as pedagogy. *Communication Education, 49*(3), 233–238.

Bochner, A. P., & Ellis, C. (1992). Personal narrative as a social approach to interpersonal communication. *Communication Theory, 2*(2), 165–172.

Bohm, D. (2004). *On creativity*. London: Routledge.

Csikszentmihalyi, M. (1996). *Creativity: Flow and the psychology of discovery and invention*. New York: Harper Collins.

de Cosson, A. F. (2004). The hermeneutic dialogic: Finding patterns midst the aporia of the artist/researcher/teacher. In R. L. Irwin & A. de Cosson Eds.), *A/r/tography: Rendering self through arts-based living inquiry* (pp. 127–152). Vancouver: Pacific Educational Press.

Ellis, C. (2004). *The ethnographic I: A methodological novel about autoethnography*. Walnut Creek, CA: AltaMira Press.

Ellis, C., Adams, T. E., & Bochner, A. P. (2011). Autoethnography: An overview. *Forum: Qualitative Social Research, 12*(1). Available at http://nbn-resolving.de/urn:nbn:de:0114-fqs1101108.

Etherington, K. (2004). *Becoming a reflexive researcher: Using our selves in research*. London: Jessica Kingsley.

Glenn, N. L. (2011). *Threading light: Explorations in loss and poetry*. Regina: Hagios Press.

Gouzouasis, P. (2008a). Toccata on assessment, validity, and interpretation. In S. Springgay, R. L. Irwin, C. Leggo, & P. Gouzouasis (Eds.), *Being with a/r/t/ography* (pp. 219–230). Rotterdam: Sense Publishers.

Gouzouasis, P. (2008b). Music research in an a/r/tographic tonality. *Journal of the Canadian Association for Curriculum Studies, 5*(2), 33–58.

Gouzouasis, P. (2013). Tonality as metaphor in music. *The UNESCO Observatory E-Journal*. Available at http://web.education.unimelb.edu.au/UNESCO/ejournal/index.html.

Gouzouasis, P., & Lee, K. V. (2002). Do you hear what I hear? Musicians composing the truth. *Teacher Education Quarterly, 29*(4), 125–141.

Gouzouasis, P., & Lee, K. V. (2007). Sticky knot Danish. In J. G. Knowles, A. L. Cole, L. Neilsen, & S. Promislow (Eds.), *Creating scholartistry: Imagining the arts-informed thesis or dissertation* (pp. 15–25). Halifax: Backalong Books.

Gouzouasis, P., Irwin, R. L., Gordon, C., & Miles, E. (2013). Becoming pedagogical through a/r/tography in teacher education. *International Journal of Education & the Arts, 14*(1). Available at http://www.ijea.org/v14n1/v14n1.pdf.

Gouzouasis, P., & Ryu, J. Y. (2014). The use of story in early childhood music education research: A pedagogical tale from the piano studio. *Music Education Research,* DOI: 10.1080/14613808.2014.972924.

Griffin, S. (1995). *The Eros of everyday life: Essays on ecology, gender and society.* New York: Doubleday.

Leggo, C. (1995). Storing the word/storying the world. *English Quarterly, 28*(1), 5–11.

Leggo, C. (2004a). The curriculum of becoming human: A rumination. *International Journal of Whole Schooling, 1*(1), 28–36.

Leggo, C. (2004b). Living poetry: Five ruminations. *Language & Literacy, 6*(2), 74–81.

Leggo, C. (2005a). The heart of pedagogy: On poetic knowing and living. *Teachers and Teaching: Theory and Practice, 11*(5), 439–455.

Leggo, C. (2005b). Pedagogy of the heart: Ruminations on living poetically. *The Journal of Educational Thought, 39*(2), 175–195.

Leggo, C. (2007a). Learning by heart: A poetics of research. *JCT: Journal of Curriculum Theorizing, 22*(4), 73–95.

Leggo, C. (2007b). Living poetically: Pensées on literacy and health. *Canadian Creative Arts in Health, Training, and Education Journal, 6,* 3–12.

Leggo, C. (2011a). A heartful pedagogy of care: A grandfather's perambulations. In J. A. Kentel (Ed.), *Educating the young: The ethics of care* (pp. 61–83). New York: Peter Lang.

Leggo, C. (2011b). Living love: Confessions of a fearful teacher. *JCACS (Journal of the Canadian Association for Curriculum Studies), 9*(1), 115–144.

McNiff, S. (1998). *Trust the process: An artist's guide to letting go.* Boston, MA: Shambhala.

Pelias, R. (2000). The critical life. *Communication Education, 49*(3), 220–228.

INDEX

eBooks
from Taylor & Francis
Helping you to choose the right eBooks for your Library

Add to your library's digital collection today with Taylor & Francis eBooks. We have over 50,000 eBooks in the Humanities, Social Sciences, Behavioural Sciences, Built Environment and Law, from leading imprints, including Routledge, Focal Press and Psychology Press.

Choose from a range of subject packages or create your own!

Benefits for you
- Free MARC records
- COUNTER-compliant usage statistics
- Flexible purchase and pricing options
- All titles DRM-free.

Benefits for your user
- Off-site, anytime access via Athens or referring URL
- Print or copy pages or chapters
- Full content search
- Bookmark, highlight and annotate text
- Access to thousands of pages of quality research at the click of a button.

REQUEST YOUR FREE INSTITUTIONAL TRIAL TODAY

Free Trials Available
We offer free trials to qualifying academic, corporate and government customers.

eCollections

Choose from over 30 subject eCollections, including:

Archaeology	Language Learning
Architecture	Law
Asian Studies	Literature
Business & Management	Media & Communication
Classical Studies	Middle East Studies
Construction	Music
Creative & Media Arts	Philosophy
Criminology & Criminal Justice	Planning
Economics	Politics
Education	Psychology & Mental Health
Energy	Religion
Engineering	Security
English Language & Linguistics	Social Work
Environment & Sustainability	Sociology
Geography	Sport
Health Studies	Theatre & Performance
History	Tourism, Hospitality & Events

For more information, pricing enquiries or to order a free trial, please contact your local sales team:
www.tandfebooks.com/page/sales

www.tandfebooks.com